THE
PHOTOGRAPHY
CATALOG

edited by

NORMAN SNYDER

with

Carole Kismaric and Don Myrus

HARPER & ROW, PUBLISHERS
New York, Evanston, San Francisco, London

For Sima, Lisa and Michelle

A Norman Snyder Studio Book

Library of Congress Cataloging in Publication Data
Main entry under title:
THE PHOTOGRAPHY CATALOG. Includes index.
 1.Photography — Apparatus and supplies — Catalogs. 2. Photography —
Catalogs.
I. Snyder, Norman, 1936- II. Kismaric, Carole, 1942- III. Myrus, Don,
1927-
TR 197.P52 770.28 76-9202 ISBN 0-06-013979-X pbk.

INTRODUCTION

The Photography Catalog is several things.

It is a catalog—a highly selective one. Here together, in one place, are the best tools and materials for making photographs. They have been expertly selected on the basis of our experience. Not content to just present these items, we have told you how they are best used and included techniques that go beyond the manufacturers' instructions. Many selections will be familiar because they have withstood the test of time. A surprising number of cameras, films, developers and processes have remained on the market for years because of their extraordinary qualities. There are also selections you most likely never heard of—some because they are very new, and many because we have not hesitated to include the unique or highly specialized.

The Photography Catalog is also a compendium—that is, a summary of a field of knowledge. We have compiled a work whose scope touches upon every facet of still photography, and we have written a quarter of a million words to describe this vast subject. At no time did we lose sight of the fact that the end result of the photographic process is the photograph itself. Half the book is devoted to the photographers, books, magazines, museums, agencies and schools that contribute to the enjoyment and understanding of photography.

And this is a sourcebook—a guide to further information, a fount of never-ending ideas. We have tried to be inspiring and to turn you on. Even if you are not a collector, you might see a presentation of an antique camera that will stimulate your acquisitive nature. Or if you have only been exposed to the academic side of photography, you might come to appreciate the skills and craft of the commercial photographer. Because of the great interest in photography as a life-style, we have paid a great deal of attention to the business of succeeding or at least surviving in the field. We have included examples of people who are successful as photographers, as well as those who have found interesting careers as camera salesmen, editors, writers, lab technicians or repairmen.

Finally, we have sought to make *The Photography Catalog* a good read. We have told some tales along with the tricks and, in the belief that photography should never cease to be fun, injected a bit of levity whenever things were getting too serious.

Norman Snyder

TABLE OF CONTENTS

The Staff of The Photography Catalog

Publisher and Editor: Norman Snyder
Associate Editors: Carole Kismaric and Don Myrus
Graphics Director: Virginia Gianakos
Assistant Editor: Peter D. Collins
Copy Editor: Barbara Lobron
Art Assistants: Ann Meng and Michael Merlin
Staff Photographer: John Garbarini
Editorial Assistants: Sima Snyder and Alison Stewart
Contributing Writers: Lester Lefkowitz (pages 84-126), Joe Novak
(pages 174-180), Al Francekevich (pages 74-82), Martin Hershenson
(pages 182-186) and George Gilbert (pages 58-64)
Other Contributors: Michael Edelson, Hank Ganz, Peter Moore and
Amy Stromsten
Legal Consultant: Walter Censor

Acknowledgements

*We gratefully acknowledge all those photographers who supplied us
with pictures and wish to thank the following persons for their
invaluable assistance in the preparation of this book:*

James Alinder, Associate Professor of Photography, University of
Nebraska, Lincoln; Bomze/Jaybee Photos, New York City; Tony Chiu,
Writer, New York City; Marty Forscher, President of Professional
Camera Repair, New York City; Marta Hallet, Editor, Harper & Row,
Publishers, Inc., New York City; Jim Hughes, Editor of *Popular
Photography* Special Market Publications, Ziff-Davis Publishing Co.,
New York City; Mel Ingber, Indexer, New York City; Ken Kay,
Photographer, New York City; Karen Skove, Manager/Book
Department, The Witkin Gallery, New York City; Norbert Kleber,
President of Foto-Care, New York City; Phillip Leonian,
Photographer, New York City; Heinrich Riebesehl, Director of
Spectrum Gallery, Hannover, Germany; Nachum Waxman, Editor,
Harper and Row,

Printer: George Banta Company, Inc.
Typesetters: Lexigraphics, Inc. and Topel Typographic Corp.

ABOUT THE COVER: Rest assured. We really do
respect the integrity of the photographic image and
believe that the way a photographer prints a
picture is the way it should be seen. But since there
was no single picture that could effectively
encompass the scope of this book, we chose to
create one by juxtaposing examples from eleven
fine photographers. We wish to thank the following
for their cooperation and understanding: Henri
Cartier-Bresson, who has always been a champion
of the photograph's integrity; Marie Cosindas for
her portrait of a woman with flowers; Gerd Sander
for use of the August Sander print of German
musicians; Larry Schiller for Neil Leifer's picture of
Muhammad Ali; Robert Garro for his shot of a
dancing girl at a rock festival; Francisco Hidalgo for
his New York skyline; Polaroid Corp. for use of the
orange pussycat; William Bell for his redheaded
child; Siwer Ohlsson for his blonde nude. We also
acknowledge the contributions of Eadweard
Muybridge for his horse sequence and Neil
Armstrong for his moon shot.

Prices for new and used equipment are included in THE PHOTOGRAPHY
CATALOG for comparison purposes only. Used equipment prices are always
subject to negotiation, and discounts from list prices vary considerably from
store to store. As always, inflation is a factor. We suggest you write to
manufacturers for the latest price information.

1

Duke Mander

CAMERAS

CAMERAS

CAMERA WORK

A frequent question asked of photographers is "What camera should I buy?" In order to answer intelligently, one must ask in return, What do you want to photograph and for whom? The commercial still-life food photographer has an entirely different problem from the daily newspaper photographer, and they each in turn need different equipment to function effectively. The point being that cameras are tools, and as such are more suited to performing one type of work than another. The famed Henri Cartier-Bresson has spent a lifetime making extraordinary photographs with the simplest equipment—a Leica, mounted with a 50mm lens. For his objectives, the combination was the perfect choice. The Leica is the camera for reportage, the art of moving in an environment, of recording and interpreting it while disturbing it as little as possible. The work is fast, instinctive and never that precise. One of the fascinating things about framing through a plain viewfinder is that the photographer is never absolutely certain of what the film captures. For this reason, the Leica is also popular among serious "art" photographers working in the documentary tradition. These photographers are open to the happy accident and are willing to take chances—even to fail! By adding the concept of "performance" to the art of making a photograph, they open up the possibilities for capturing something extraordinary.

On the other hand, the professional photographer must always deliver—in fact, to stay on top, must always bat one thousand. Because he is in business, it makes economic sense for his 35mm camera to be a single-lens reflex that is part of an entire modular system. If he is called upon to photograph through a microscope or must do some remote control work, he doesn't want to have to buy a different machine to do the job, only another part. The professional will gladly invest in another lens or screen or back, since they all eventually become a part of one versatile basic outfit. The idea is to avoid having lots of accessories and cameras around that don't fit one another, and a system camera is the best way to accomplish this.

Choosing a systems camera is somewhat like getting married. Basically, you must like the machine, but also you must consider its durability. Once you get to know a camera intimately, you want to stick with it, and so you hope it will serve your purposes for years to come. When Gjon Mili says, "the camera you know is the camera you like," he means that after working with a machine for some time, its operation becomes second nature—like driving a stick shift car. It is the photographer who becomes automated, being able to double shutter speeds or change f-stops instinctively, without looking or searching for the adjustments. The same sense of the controls applies to the focusing mechanism. The best sports photographers can "feel" whether to focus clockwise or counter clockwise when following the action on the field.

It's also important that the accessories be part of a continuum. After getting used to a camera, one hates to see it become obsolete for lack of parts or accessories. Nikon cameras made twenty years ago will still accept the latest lenses. This fact is gratifying to those who have committed themselves to Nikon, and probably is one of the prime reasons it has been the pre-eminent SLR system among those who depend on photography for their livelihood.

Though the SLR system is the most successful and versatile, the camera does have limitations. Commercial still life photographers, who mostly serve advertising agencies, use studio view cameras because larger size film can be easily retouched, a big negative is impressive to a client and most engravers can do a better job with a larger chrome.

For unusual, exciting and different visual effects, cameramen seek out specialized equipment, and when they can't find an exotic enough device, they resort to improvisation by going to the camera mechanic or even to the manufacturer for a special order. Many specialized cameras, such as the Widelux, produce unique results that only a panoramic camera can achieve. The problems when taking a grand landscape photograph is that one never gets the expansive feeling of wide open spaces when looking through a normal lens. Using a wide-angle lens gets the expanse, but reduces the size of details, such as trees and rocks, so that they become insignificant. The panoramic camera uses a more normal lens and sweeps across the horizon, rendering both size and scope. It is a special camera for a special job. There are many photographers who use an arsenal of different machines for different work. Nowhere is the concept of camera work more clearly demonstrated than in the use of specialized cameras.

To the professional, an automatic camera is considered a specialized tool, useful only in those situations when lighting conditions vary so widely that the constant changing of the camera settings makes taking photographs too difficult. The manufacturers of automatics don't see things this way and think their innovations will replace manually operated cameras. But being electronic, they all need batteries to operate. Some have to be switched on or off, and all are so sophisticated that their repair requires equally sophisticated testing equipment to discover what is wrong. The major idea, of course, is to eliminate the possibility of losing a picture for lack of the correct exposure. The problem with this thinking is that the correct exposure isn't always the best. Very often the best Kodachrome is one that is underexposed, and we have seen a few that were even better overexposed. For some strange reason, to lose a photograph because of a wrong exposure is embarrassing (unless you can blame the camera), but failing because the moment was wrong is acceptable. Whatever the logic, the experienced worker knows that pictures can be lost for twenty other reasons, most of which have to do with the nature of the photographic medium—the inability to be in perfect control of all the elements that make a photo special. The best photographers want to have as much control as possible in order to be able to predict results. Delegating to the automatic camera what the photographer should know only leads to a loss in the skills of knowing what to do or what you can get away with.

The selection of cameras on the following pages are not necessarily the very latest, but in our opinion they are the very best tools for doing the kind of work we feel they are suited for. With the exception of a few "future shots," these cameras have proven themselves by performance in the field. Our testing lab is the experience of those who spend their lives making photographs. We have described each camera's virtues and idiosyncrasies and whenever possible have recommended, by example, a way to work with them. Some of our choices are no longer in vogue, such as the Rollie, but we feel we should remind you of its existence, tell you of its usefulness as a portrait camera and mention one or two great photographers who used it successfully.

FOR QUICK WORK

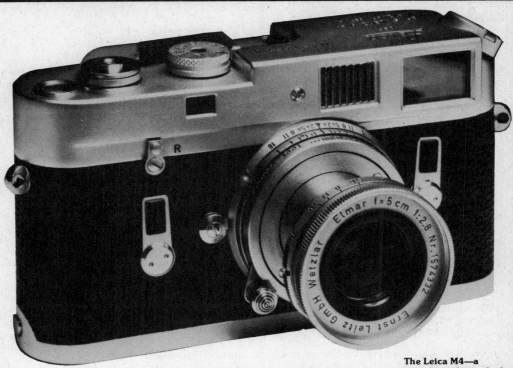

"Candid" is a seldom heard word these days among photographers; that's a pity because it best describes "miniature" photography—miniature being a word not much around anymore, either. The Leica M4 is the best camera for this candid photography now, as Leicas have been since their commercial birth in 1925.

Said another way, the M4 is most suitable for the photographer who desires the least intrusion by a machine. It is for those of us who wish to immerse ourselves in a photographic situation, who want to see that situation with the least possible interference and who want to record it as quickly as possible with the minimum of noise and jarring. The Leica's relative quiet is another virtue . . . soothing to the sensitive photographer who is often attempting to be as unobtrusive a voyeur as possible.

As for not having a built-in exposure meter, in this, the dawn of the automatic-camera era, we believe that since the Leica was conceived to be an easy-to-handle, light-in-weight tool, it shouldn't be over-elaborated. A half-century after the Leica I, the M4 has grown heavy enough and big enough as it is. Besides, if anything can get in the way of concentration, of intuitive viewing, it can be one of those built-in meters with cross hairs, colored lights and the like.

To be overly concerned about setting a "perfect" exposure is a neurosis many people never overcome. Often to get a picture at just the right moment is the object. Film has latitude, development can be shortened or pushed, prints can be manipulated; but if you're studying the meter you may never get a chance to push the shutter-release button. Be prepared. The important technique is to have determined the exposure before it becomes time to take the picture. A meter carried in your pocket will do the job just fine.

There are many ways to lose a photo—and the time taken to focus is a common one. Zone focusing is a way to get acceptably sharp photos by pre-focusing the lens so that the depth of field scale encompasses the near and far limits of the subject. Viewfinders are vastly superior to SLR cameras when employing the technique of zone focusing, since out-of-focus subjects are always clearly visible through the finder as they are not on the groundglass of an SLR.

It is directness-of-viewing that gives the Leica and its coupled rangefinder the psychological sense of immediacy. That there is no momentary black-out from a moving mirror means you can see the subject you want to record on film at all times. When using electronic flash, the instant of exposure is frozen in the finder . . . the moment the subject is lit. It is a reward that no SLR camera can bestow.

The M4 is for the poets of photography . . . for the grab-shooters who never want to be about without a camera. If you can imagine

The Leica M4—a superb machine which took over fifty years to evolve—is made for the hand. With the 35mm Summicron lens, balance between size and weight is perfect. We also like the old-fashioned idea of the collapsible lens, which makes the camera compact enough to carry in your pocket or purse. The collapsible 50mm Elmar f/2.8 shown above is fast enough for most situations. Besides, if you develop a taste for photos with some depth of field, you will prefer shooting at f/5.6.

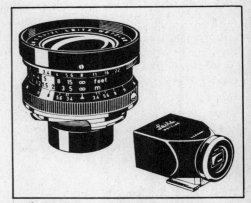

The Leica's sturdy one-piece body requires that you load the film by removing the baseplate. Back in the days of the M3 it also meant taking about a half-minute to load, that is, if you didn't drop the spool, which was even known to roll away and get lost. With the M4 came the nonremovable take-up claw mechanism, and nimble fingers began loading in fifteen seconds without fear of fumbling—a little slower with gloves on. An authorized repairman can install this improved three-pronged rapid-loading take-up spool in an old M2 or M3.

yourself doing the kind of camera work Garry Winogrand does, the M4 is for you. There you are, crossing the street—M4 hanging from your shoulder—when you catch sight of a girl in an outdoor phone booth, her leg teasingly positioned against the door jam. You aim and click the shutter. That's a Leica job.

Leica/E. Leitz Inc./Rockleigh, NJ 07647

The Super-Angulon is a proven ultra-wide-angle design—sharp and practically free of distortion. The 21mm f/3.4 Super-Angulon cannot be used on the CL Leica (see page 11) since the lens fits deeply into the camera body, too close to the focal plane to permit through-the-lens metering. Although the lens couples to the Leica rangefinder, viewing is through the special finder, which fits in the accessory shoe. The Super-Angulon is a journalist's lens for use in very cramped quarters where an all-encompassing view is needed.

THE LEICA MYSTIQUE

There is something mysterious—some magic, some marvel—about the class of cameras named Leica (from E. *Leitz*'s *Ca*mera) that has set men and women to doing things and feeling emotions that no other camera quite has. One thinks of the enthusiasm with which Model A and Model T Fords are driven and of how old, green-glass, six-ounce Coca-Cola bottles are cherished.

Rolf Fricke, the foremost American collector of Leicas—who exhibited part of his collection at the Leitz U.S. headquarters in Rockleigh, New Jersey, for the fiftieth anniversary of the camera—and Alfred C. Clarke discuss the ramifications of the Leica gestalt in a chapter they contributed to the fifteenth edition of the *Leica Manual.* Collectors, they tell us, are motivated by some particular characteristic of the Leica itself: "the superb craftsmanship, the degree of precision, the velvet smoothness of operation, the difficult-to-describe 'feel' or the aesthetic aspects."

Fricke and Clarke point out that the Leica is the oldest 35mm camera still in production, that it is the first camera to have its own formal collecting society and now has many clubs devoted to it throughout the world, that some enthusiasts think of the Leica as "a kind of photographic jewelry" and that it has been presented to "kings, presidents, scientists."

As with most collecting, the unusual gets the recognition and often is worth the most. Here are some unusual Leica items:

The 72-Shot Leica: a special model of the screwmount series that was made in a Canadian Leitz plant to take 72 half-size (18×24mm) frames on the standard 36-exposure film roll.

The 250-Shot Leica: a 1934 (and later) special screw-mount model with barrel-like ends to hold 33 feet of 35 mm film for 250 exposures prior to reload.

The Leica Gun: a rifle-stock of wood designed to assist long-telephotography in which the gun trigger is linked to the exposure button of the camera.

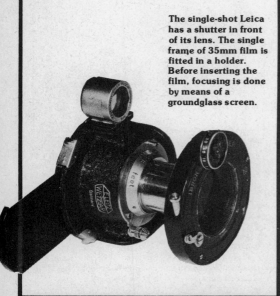

The single-shot Leica has a shutter in front of its lens. The single frame of 35mm film is fitted in a holder. Before inserting the film, focusing is done by means of a groundglass screen.

A SAMPLE OF LEICA LITERATURE

The *Leica 1939 Catalogue* illustrated price list ($5.95, reprint) covers all Leica cameras, accessories, projectors, enlargers and Leitz prism binoculars made *prior* to May 1, 1939. It is instructive to learn that the autofocal camera model IIIb sold for $309. Jews fleeing Hitler's Germany during the 30s brought Leicas out with them so they could turn them into cash in their new lives.

The *Leica Illustrated Guide* ($7.95, reprint) has forty-three profusely illustrated sections devoted to models manufactured since 1913. The handsome color cover shows the famous gold-plated, lizard-skin-covered model.

The *Leica 1928 Instruction Book* ($2, reprint) booklet gives directions for using the Leica I and the now rare Compur.

Reprints available through Morgan & Morgan, Inc., 145 Palisade St., Dobbs Ferry, N Y 10522

THE MAN WHO MADE THE LEICA

Oskar Barnack wanted to be an artist; that turns out to be a role not much different from that of an inventor—which he most certainly was. As a boy, Barnack dreamed of landscape painting, but he had one of those practical German fathers who told him that he'd have to make a living and should get a trade. So, after graduating with an enviable record from the technical high school in Lichterfelde, a suburb of Berlin, Oskar became an apprentice in a machine shop where he helped make planetariums driven by clockwork. At the age of 23, he went to work for Carl Zeiss in Jena; eight years later he became the master machinist (mechanikermeister) at Ernst Leitz, microscope makers in Wetzlar.

Oskar was already at work on a 35mm camera. When he offered it to Herr Leitz, the old gentleman jumped at the opportunity. Although they were separated by more than thirty years in age, they had a close relationship—the older being very protective of the younger, who was in delicate health. It has even been suggested that Oskar, suffering as he did from bronchial asthma, was motivated to invent the Ur-Leica because he wanted a light camera to carry with him when he took walks through the countryside, seeking relief from his affliction. However that may be, there is absolutely no question of Oskar being a photographer. When one first sees his pictures and knows they are by the inventor, there is a remarkable reaction—wonderment that a technologist could be *so* gifted—for his portraits, cityscapes *and* photojournalism foreshadow the work of prominent photographers of

several decades later. In spite of his father's admonition, Oskar had indeed remained an artistic dreamer.

Here is his explanation of how he invented the Leica: "I gave complete freedom to my penchant for the unusual and for the novel. I was not restricted by a set assignment or by a specific direction, which are customary in a design department. It was more a personal hobby."

In 1920, Leica-inventor Barnack was taking pictures in quick succession; there are at least several almost-simultaneous views by him of the flooded Lahn river. The fact that Barnack could photograph rapidly in a quickly changing situation is one aspect of how a tool can revolutionize the artist's technique.

THE LIGHTEST LEICA FROM LEITZ

When Willi Stein, one of "Barnack's Boys," designed the thirteen-ounce Leica CL he brought the company full circle to Barnack's original intention: providing a small, light, rangefinder camera with interchangeable lens capability. Oskar would probably be very pleased that Willi was able to build in a through-the-lens exposure meter—without adding much weight—although he'd no doubt be disturbed by the vertical shutter. He was very proud of his shutter, which operated horizontally. (Focal plane shutters that operate vertically can distort the shape of fast-moving objects traveling parallel to the ground. Barnack spent some time photographing the wheels of speeding trains to demonstrate this.)

The CL—with its metal body covered in ersatz leather plastic and its matte-black anodized top—looks classy enough, but has none of the feel of the larger Leicas. Certainly it is small enough (4¼×3×1¼ inches) and light enough to carry around at all times and not feel burdened.

The standard lens is a 40mm Summicron-C f/2; a 90mm Elmar-C was also designed for the camera, but neither lens can be used on the Leica M's. With the exception of the 21mm Super Angulon, all M lenses fit the CL but not all permit focusing

with the rangefinder. The barrel of the 50mm Summilux and 90mm Summicron, for example, will block the view through the rangefinder window. Also, any collapsible lens would damage the meter.

The Leica CL is a fun camera, but its no toy. Cartier-Bresson likes it; why shouldn't you?

The CL is the result of a unique East/West collaboration between two former competitors: Leitz produces the lenses in Germany and Minolta the bodies in Japan. Whether this camera will appreciate in value, as the "pure" Leicas have in the past, remains to be seen.

B 2 4 8 15 30 60 250 500 1000

28111-112 R

CL's viewfinder is a bit messy. The frame for the 40mm lens is always visible. On fitting either the 50mm or 90mm lens, the corresponding bright line frame also appears. The frames of the CL, like the M models, automatically correct for parallax error. Scale at top shows the selected shutter speed; meter needle on right should be centered for "correct" exposure. The Leitz rangefinder patch is still the brightest.

THE LEICA AND LEICAFLEX WAY
by Andrew Matheson
Focal Press, London, New York/distributed by Amphoto, Garden City, NY/$16.50

M2/M3/M4 FINDER

The optical system of the M2 to M4 finder consists of:
1. Main finder window showing the full view of the subject.
2. Illuminating window for the frame plate 9.
3. Movable frame mask uncovering the additional finder frames for long focus lenses in the frame plate 9. The frame plate and frame mask also move together to compensate for parallax.
5. Swinging lens coupled to the camera lens barrel through the focusing mechanism 4.
6. Eyepiece.
11. Rangefinder window providing the central rangefinder image reflected into the eyepiece by the prisms 7, 8, 10, 12.

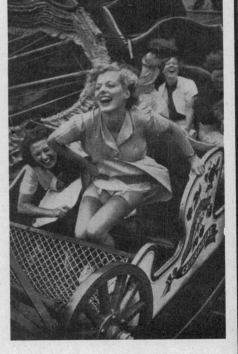

"Fun fair, 35mm lens, fast pan film, 1/500 sec., f/3.5." K. Hutton. From *The Leica and Leicaflex Way*

The Leica and Leicaflex Way has all the information you want on all the M cameras and lenses made, as well as the Leicaflex and its earlier models. This, the eleventh edition, is similar to the tenth, which is similar to the ninth; except that each is more up-to-date. However, the basic book retains the same beginning, with a neat chart and description

of the most practical Leicas of the past, and ends with a 35-page appendix of facts and figures on every aspect of Leica photography. In between, more detailed information on equipment, such as the Visoflex, as well as on techniques for telephotography, close-up work, high-speed action, lighting and portraiture round out the

book. Darkroom technique, however, is ignored.

The diagrams are excellent and the photographs, which date back to the first edition, provide a graphic sense of photographic taste in the late forties.

THE LATE AND FAMOUS NIKON F

This camera is no longer manufactured. But there are plenty of used ones around. The F wasn't phased out because it was unpopular; in fact, it was embraced by ad men and motion-picture directors as the status camera of the sixties—any actor or model pretending to be a photographer most certainly sported a Nikon. Despite the media hype, for more than a decade the F *was* the best of the 35mm SLRs, and—all things considered—still is, for several reasons. It is reliable, sturdy and relatively cheap ($150-$200 for a used body) and, as the original heart of the Nikon system, it still accepts the latest Nikkor lenses.

Nikon's professional reputation is rooted in its lenses. In 1949 Nippon Kogaku (Japan Optical) introduced the first four Nikkors, which were designed for the company's rangefinder Model 1.

These lenses were tested by photojournalists Horace Bristol and David Douglas Duncan. The results prompted Duncan to adapt Nikkors (50mm, f/1.5; 85mm, f/2; 135mm, f/3.5) to his Leicas for coverage of the war in Korea. Word spread quickly and "Made in Japan," once a synonym for tacky, dime-store junk, soon rivaled "Made in Germany."

For the next ten years Nippon Kogaku produced several rangefinder cameras to compete with the Leicas. Although never equaling the precision insisted on by E. Leitz, the Nikons got an ever-increasing share of the market.

After the F arrived in 1959, there were few SLRs that could compete with Nikon's reputation, and Leitz missed completely the importance of the SLR.

Amazingly, the F proved capable of accepting ever new viewfinders, focusing screens, camera backs, motors and myriad accessories—all of which only a *Life* photographer might need. As for the *Life* photographers, they loved the F. Its versatility matched theirs, and no matter how bloated it got, it could be stripped down to the bare essentials—to that little brass box with the moving mirror.

George Silk took his F to the Arctic and Eliot Elisofon took his to the jungles of Java. When the news photographers finally gave up their Graphics they too adopted the F. Even today you can see a photojournalist working with as many as three Fs hanging from neck straps, two from the shoulders, and one in hand—all swinging and banging in the rush to get the picture. The F endures.

1. Depth-of-field preview
2. Lens aligner
3. Lens-release button
4. Flash terminal
5. Self-timer
6. Mirror-lock knob
7. Exposure counter
8. 20 or 36 frames
9. Shutter release
10. Rewind release
11. Flash synch selector
12. Color synch code
13. Shutter speed dial
14. Eye-level viewfinder
15. Flash accessory shoe
16. Film rewind crank
17. Cordless flash contact
18. Depth-of-field scale
19. Focusing ring
20. Aperture indicator
21. Lens aperture ring
22. Diaphragm-meter coupler

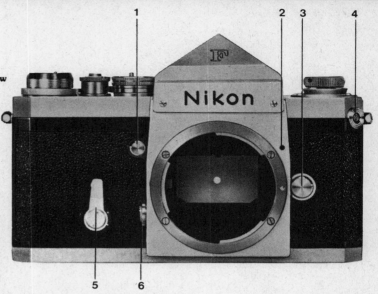

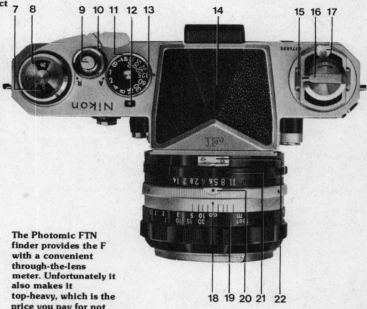

The Photomic FTN finder provides the F with a convenient through-the-lens meter. Unfortunately it also makes it top-heavy, which is the price you pay for not wanting to carry a separate meter, and for not having memorized the exposure settings for different lighting conditions. One Photomic finder is enough—even when you're working with several cameras. (Transfer the meter information to the other cameras.) Two meters seldom agree, especially when readings are made through lenses of different focal length.

A great feature is the ability to change focusing screens to suit your needs. Split screens are best for quicker, more precise focusing with wide-angle lenses. The diagonal design of the (L) screen has the advantage of splitting both horizontal and vertical edges. (B) is particularly good for lenses of 85mm and over. (E) is the same as (B) but with an etched grid for precise alignment in architectural and copy work. Professional photographers also use these screens like the groundglass of a view camera, masking out special formats or shapes on the flat surface of the screen.

L

B

E

The F36 motor drive with cordless battery pack, no longer manufactured, is still reliable. It had to be bought as a unit with the F or factory-mated at a later date with a specific camera. It can fire up to four frames per second, but most photographers prefer using it in the single-shot mode—simply to advance the film rapidly. Since the tripod attaches to the motor, not the camera, it is possible to change film without removing the camera assembly from the tripod head.

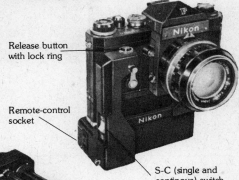

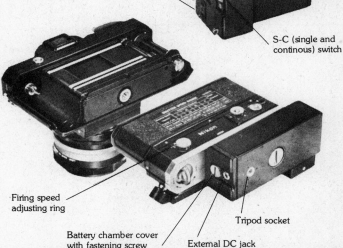

Release button with lock ring

Remote-control socket

S-C (single and continous) switch

Firing speed adjusting ring

Tripod socket

Battery chamber cover with fastening screw

External DC jack

This is the view through the Photomic DP-1 finder, which shows 100 percent of the focused image. The aperture setting, shutter speed and matched-needle meter scale are not easily seen in low light and require an additional illuminator to light up the finder information. In this regard the Photomic F2S DP-2 finder is better since it employs light-emitting diodes that glow in the dark.

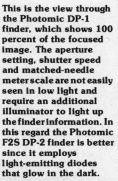

f5.6 250

PROGRESS AND THE F2

Cameras, like automobiles, have an innate obsolescence; even when they function effectively, like all machines they can—indeed must—be changed. It is the mandate of technology.

The durable F has one annoying deficiency: the back is unhinged, so that to load it you may feel you need three hands, and end up holding the back between your teeth. The sensible solution is to hold camera body and back together in one hand so the other is free to load the film. Another solution is to hinge the back. The F2 has a hinge.

The unhinged F also had to be removed from the tripod before the film could be changed—a serious problem for the photographer who wanted to maintain an exact camera position for more than one roll of film.

The F2 also allows for double exposure, which the F doesn't, except with a great deal of trouble.

For the F2, Nippon Kogaku introduced a new motor that attaches to the baseplate without your having to remove the back. It not only winds the film forward in single frames or bursts but also rewinds it, and has a built-in relay for remote control by wire or radio. For the gadget-minded, the F2 has forty new accessories.

The successor to the F is a more sophisticated machine, and therein lies the problem. One camera repairman, a longtime admirer of the F, says of the F2: "It's too complex . . . that new motor has a lot of bugs."

However, Marty Forscher, who has been servicing professional equipment for thirty years says, "When it first came out, that was true, but since then Nikon made changes in its motor drive and we haven't seen any serious problems in over two years."

E.P.O.I./101 Crossways Park W./Woodbury, NY 11797

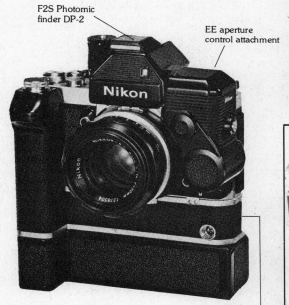

F2S Photomic finder DP-2

EE aperture control attachment

Motor drive MD-1

The F2S all decked out. Unlike the older motor, the MD-1 motor drive attaches to any F2 without modification. The motor can also power a 250-frame magazine, mounted in place of the standard hinged back. With DP-2 finder, the F2 becomes the F2S, capable of accepting the EE aperture control attachment, which automatically adjusts the f-stop as the light changes. A great setup for photographing animal behavior from a remote position.

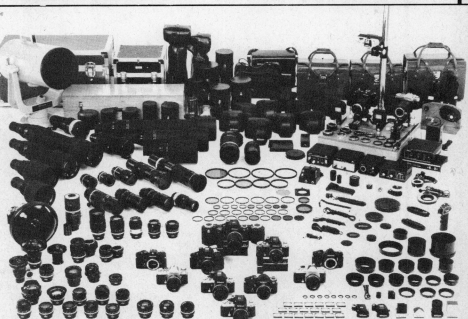

It is the rare photographer who would ever need a complete system, but it makes a fascinating study. In fact, to understand the system is to know photographic technique.

NIKKOR LENSES FOR NIKON CAMERAS BY NIPPON KOGAKU

The range of Nikkor lenses, with their comparative angle of view, are described in the chart and diagram below. (Chart information is accurate for all other lens manufacturers, too.) The choice of which ones to acquire depends on the work to be done and the photographer's personality. For location work, each lens should be about twice the focal length of the next, e.g. 35mm, 85mm, 180mm, 300mm; or 20mm, 50mm, 105mm, 200mm.

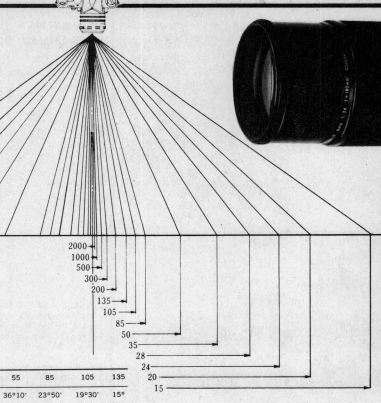

The 180mm f/2.8 Nikkor-P Auto is sharp wide open. At f/2.8 Kodachrome can be exposed in hand at 1/250th of a second in open shade, at 1/2000 in bright sunlight. This means that if you are assigned to cover a football game, you can capture tight-in action from the sidelines. Or if you are a photojournalist at a congressional hearing, you can highlight a single person, in sharp focus, while the background goes soft due to the characteristic short depth of field of telephoto lenses.

Focal Length	15	20	24	28	35	45	50	55	85	105	135
Horizontal Direction	99°	83°	74°	64°	53°	42°	39°	36°10'	23°50'	19°30'	15°
Vertical Direction	76°	61°	53°	45°	37°	29°	26°	24°40'	16°	13°	10°

Focal Length	180	200	250	300	400	500	600	800	1000	1200	2000
Horizontal Direction	11°30'	10°20'	8°10'	6°50'	5°10'	4°10'	3°30'	2°30'	2°	1°40'	1°
Vertical Direction	7°40'	6°50'	5°30'	4°30'	3°30'	2°50'	2°20'	1°40'	1°20'	1°10'	0°40'

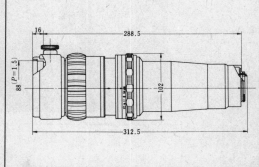

The 600mm f/5.6 Nikkor-P Auto is one of a series of super telephoto lenses that require an accessory focusing unit. The 600mm magnifies twelve times that of the 50mm. It is used to photograph wildlife, the heavens and other things at great distances. Super telephotos can do a job, but at a price. They must be supported from a rigid base, and the slightest shake means fuzziness. The nearest the 600mm can be used is thirty-five feet from the subject. It weighs almost eight pounds, without the focusing unit. The latter is an intermediate tube that fits between the camera body and a series of super telephotos: 400mm, 600mm, 800mm and 1200mm. They are threaded into the unit, which has a diaphram that operates automatically on all but the 1200mm, in which case the lens must be stopped down manually. You focus with the large scalloped ring.

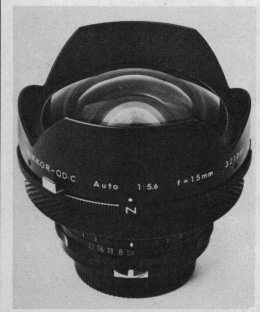

The Nikkor Auto 15mm f/5.6 covers 110 degrees yet keeps straight lines straight. Its retrofocus design allows you to actually view through the lens while composing. Since the lens is sharp from one foot to infinity, and since such a short lens can greatly exaggerate perspective, it can be put to imaginative use. Think, for example, of a foreground consisting of a woman's high heel shoe (five-inch spike) that is one foot from the lens, with a model in the background positioned as far away as is necessary so that she'll stand just as high as the heel. To do this shot, get paid well, for the lens is priced at $1,249.

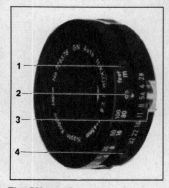

The GN sets the aperture for flash as the camera is focused.

Nomenclature for the 45mm f/2.8 GN Auto Nikkor:
1. focusing ring
2. aperture-indicator dot
3. meter-coupling prong
4. aperture ring

Three-inch square filters are held flat by pair of hinged frames. Two holders for the frames are made: one for 52mm front lens mounts, another for 72mm mounts.

THE AUTOMATIC NIKKORMAT—TAKE IT EASY OR PAY ATTENTION.

The point about automatic cameras is that they make operating easier, taking care of what many consider to be the worrisome business of correct exposure and thus freeing the mind for other concerns, such as when to depress the shutter button or where to stand. The price for this ease is a nuisance tax in the form of a $4 battery to run your camera. Yes, automatic means electronic and woe begone if on a Sunday afternoon in the mountains you need a six-volt silver-oxide battery. No battery means no camera, so along with film you must carry extra power.

A toll is also paid in loss of experience. Going automatic means delegating to a machine decisions you, as a photographer, should be making. Doctors practice and learn to recognize diseases; photographers must practice to learn to recognize picture situations. You can't learn from your successes or failure when you don't know what you did in the first place. Also, going automatic isn't foolproof. Light sources in the picture fool the machine toward underexposure, while bright subjects on dark backgrounds are usually overexposed.

For reasons such as this, the Nikkormat EL—as most automatic cameras—can be operated manually. Used as a matched-needle camera, the photographer can easily bracket his color exposures, stopping down the lens for deeper color saturation. If you work with mirror lenses with fixed aperture, the electronic shutter provides in-between speeds and in the automatic mode homes in on the precise exposure, even if it be 1/97th of a second. Which brings us back to automation.

The automatic camera is relaxing to work with; that's its real point, isn't it . . . so you can be loose enough to create. But too much relaxation can make for simple oversights—thinking the camera is on automatic when it isn't or even not checking to see if the film is properly loaded. Perhaps it's a question of temperament.

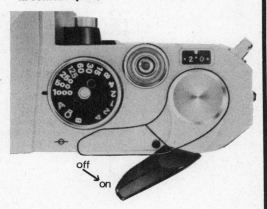

As the shutter-speed dial locks the camera into automatic mode, a green marker in the finder (above) moves to "A." Moving the film advance lever away from the body (below) switches on the meter, and the floating needle indicates the shutter speed at which the camera is prepared to operate. Electronic shutters can select any in-between speed, such as 1/177th of a second, shown in the example. This feature is particularly useful when working with fixed-aperture catadioptric lenses. Unfortunately, the shutter does not operate unless the meter is switched on. To find the release button locked just as you're about to take the picture is most frustrating.

NIKON-NIKKORMAT HANDBOOK
by Joseph D. Cooper
Amphoto/Garden City, NY 11530/two volumes, $29.50.

This is a two-volume course in photography, using Nikon equipment. To explain the use of so extensive a system, it is necessary to touch upon many techniques—copying, underwater, medical, etc. Thus the book provides enough general information to be of valuable use to owners of other cameras as well.

The volumes cover Nikon's complete line. They are in loose-leaf format and can be kept up-to-date by subscribing to the publisher's periodic data supplements, which are available in volumes containing three supplement issues at $7.95 per volume. Along with the supplements come instructions for replacing old pages with the updated versions—a tedious but necessary half-hour job. Black-and-white and color photographs illustrate many points the author wishes to make, but the book's greatest value lies in its detailed information, with charts and diagrams galore, about the system. Similar books on the Pentax, Minolta and Canon systems were also originally written by the late Joseph Cooper.

THE INTELLIGENT PERSON'S GUIDE TO TELESCOPIC PHOTOGRAPHY BY A TEENAGE PRACTITIONER

You can take magnificent pictures of planets, stars and galaxies by mounting your camera on a telescope. The procedure is simple and can be learned by anyone.

A single-lens reflex with the lens removed can be mounted by means of an adapter (available at a camera store, mail-order house or telescope manufacturer). The camera is placed where one normally looks through the eyepiece of the telescope and focused. Because of the dimness of most astronomical objects, it is difficult to focus the eyepiece accurately; so if your camera has interchangeable focusing screens, it is advisable to use a screen with a clear center portion. Exposure will range from a fraction of a second for the sun and moon to a few seconds for planets, possibly hours for stars and galaxies. Never observe the sun through a telescope or you can seriously burn your eyes without being aware of it. (See Kodak publication AC-20, *Astrophotography with Your Camera*, 15¢.)

To prevent the images from trailing on the film as the earth turns, the telescope must be guided during exposures. For easiest guiding, a small telescope is mounted on the main telescope so that it points to a star (the guide star) included within the picture area or as close as possible to it.

The whole assembly can be moved to follow the guide star accurately. To simplify guiding even more, use a clock drive (this consists of a motor, which turns the telescope to follow the stars automatically and needs only occasional slight adjustments). If your camera has a mirror lock-up, use it to cut down on vibrations during exposure. If not, set the shutter to the B setting. With a black card held in front of the telescope, wait for vibrations to die down, make exposure by removing the card, replace the card and close the shutter. A cable release will help to cut down on vibration time. Make your first exposure a scene of an ordinary brightly lit subject. This will serve as a guide for the processor who has to cut and mount your slides. Finding frame marks on a roll that sometimes looks like dust specks on black is difficult.

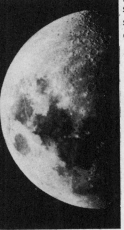

This shot of the moon was made by the author with a Criterion Dynamax 9 telescope, the equivalent of an f/11, 2110mm lens.

For astrophotography and general astronomy, the easiest telescope to use is of the catadioptric design. These light and compact telescopes use both lenses and mirrors in their optical system. The three major manufacturers of these are Celestron, Criterion and Questar.

The Celestron 5 & 8, and the Criterion Dynamax 8 are less expensive than the Questar. They are slightly larger but still of excellent quality.

by Doug Nelson

Celestron International/2835 Columbia St./Box 3578-AM/Torrance, CA/90503

Criterion Manufacturing Co./620 Oakwood Ave./West Hartford, CT/06110

Questar Corp./RD 1/New Hope, PA 18938

SEDUCING THE PRO

Twenty years ago Nikon began its bid for supremacy in America when Joe Ehrenreich agreed to take on the line at his Penn Camera Exchange in New York and to handle distribution throughout the U.S. He was a superb PR man and every pro worthy of a page in *Life* was sedulously cultivated. We were surprised, then, when recently one of this number switched to Canon. Why? "They treat me better."

A photographer can be won over when a special lens is available on short notice or a problem given quick and thorough attention. Competitive rivalry is also exemplified among the camera companies by who shows the flag where. It used to be that Nikon was the official "loaner" and service station provider for pros at the Olympics; but in 1976 at Montreal, Canon got the nod—it seems it is a matter of the highest bidder; that is, who is willing to pay the most to impress the pros.

But, of course, no pro is going to use inferior equipment just because he is treated nicely. Canon has the stuff.

Unlike the Nikon system, which sort of grew like Topsy, the Canon F-1 was conceived from the drawing board as a modular system and has by now become *the* contemporary workhorse because it *is* newer, *is* totally engineered and because its lenses are automatically and internally indexed to the built-in meter—not one that is removed when the pentaprism viewfinder is detached. There are those who also believe it to be the more attractive camera, because it doesn't have a goiterlike mass atop the viewfinder. But in our opinion, when it comes to machinery, beauty is a thing that works.

Anyway, the canon is now the modern system. And as a system it offers more possibilities than most photographers ever need (or can afford), but does enable starting out with a basic tool and then later adding any device needed to do any job called for. An appealing proposition.

Canon U.S.A., Inc./10 Nevada Dr./Lake Success, Long Island, NY 11040.

A B C D

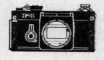

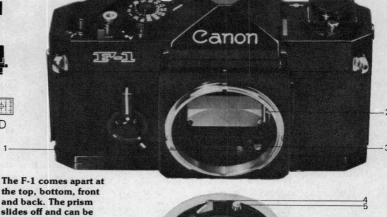

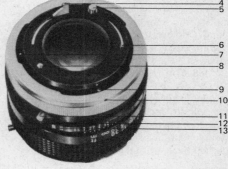

The F-1 comes apart at the top, bottom, front and back. The prism slides off and can be exchanged for other finders or when you want to exchange one of the nine focusing screens. These are A: microprism; B: split-image; C: matte; D: matte with grid. Also available is alternate unique Speed Finder (see below). The two motors and a 250-exposure back fit any F-1 without modification. Lenses mounted on the body by a breech-lock mechanism rather than the more usual bayonet mount should be checked for tightness whenever there is an extraordinary amount of vibration.

1. Stopped-down Coupling Lever
2. Aperture Signal Coupling Lever
3. Lens Speed Adjustment Pin
4. Automatic/Manual Aperture Lever
5. Full Aperture Signal Pin
6. Aperture Signal Lever
7. EE Switch Pin
8. Pin (reserved)
9. Positioning Pin
10. Red Dot
11. EE Lock Pin
12. Green Mark
13. Coupling Pin to Flash-Auto Ring

Since the metering system is built into the camera body rather than the prism finder, the meter is operable with any accessory prism or viewer. Light enters the lens and is reflected from the reflex mirror to the pentaprism. As it passes through the focusing screen, a beam splitter within reflects part of the focused light to the meter's cadmium sulfide cell at the rear of the camera body.

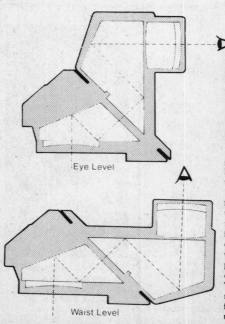

Eye Level

Waist Level

Canon's Speed Finder enables the user to see the entire screen and meter information while keeping the eye up to 2½ inches away from the eyepiece. This comes in handy when shooting sports events or in trying to get photos over the heads of a crowd. As the manual states, "The most outstanding feature in this viewfinder is its revolving head. With it, the level can be changed easily from waist to eye and the position of the camera can be chosen freely." The Speed Finder makes it easy to shoot from the ground for unusual angle shots.

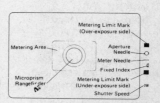

Metering Limit Mark (Over-exposure side)
Metering Area
Aperture Needle
Meter Needle
Fixed Index
Microprism Rangefinder
Metering Limit Mark (Under-exposure side)
Shutter Speed

The greatest exposure accuracy is achieved with a spot meter. The center rectangle shows the area of the meter's coverage, which is twelve degrees. At the right of the diagram of the viewfinder is the match-needle and circle that are aligned for correct exposure, with the shutter speed indicator below. Under very low light conditions, it's almost impossible to read this scale.

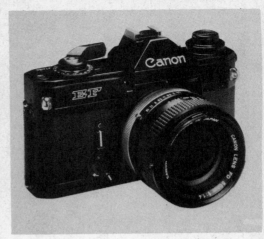

1. Camera Holding Lever
2. Open/Close Knob
3. Lever Lock Holder
4. White Dot
5. Camera Holder
6. Pressure Plate
7. White Dot
8. Camera Holder
9. Open/Close Knob
10. Camera Holding Lever
11. Back Cover Lock
12. Open/Close Index
13. Frame Counter Setting Gear
14. Supply Magazine Chamber
15. Frame Counter
16. Claw
17. Direct Connector Pins
18. Film Guide Roller
19. Take-Up Magazine Chamber
20. Strap Attachment Ring
21. Magazine Attachment Knob
22. Claw
23. Connector Release Lever
24. Magazine Attachment Knob
25. Back Cover
26. Inner Case
27. Projection
28. Release Button
29. Projection
30. Spool Shaft
31. Film Insertion Slit
32. Outer Case

TRUSTING THE MACHINE—THE CANON EF

The Canon EF auto-exposure camera takes all the Canon lenses. Unlike the F-1, the EF prism is not removable nor the screen interchangeable. Below the screen, there is a scale that indicates the user-selected shutter speed. The needle of the aperture scale to the right of the screen indicates the f-stop the auto-meter will choose. None of the automatic features work if the battery dies. However, shutter speeds from ½ to 1/1000th of a second, which are mechanically driven, continue to function.

Think about picture-taking situations. Imagine photographing a political candidate campaigning around town. First, talking to a shopkeeper in the subdued light of his doorway . . . darting into the street to greet a well-wisher in the sunlight . . . then just as quickly jumping into the rear of his limousine. You grab the seat next to the chauffeur, shooting pictures all the while. The interior is dark, but as the car moves through each intersection the bright morning sun streams in to light the candidate.

In other words, the lighting conditions are constantly changing, and you find yourself spending an awful lot of time fussing with the camera's controls. It would be nice to have a camera that would allow you to set the shutter at 1/125th of a second and let the f-stops take care of themselves. The Canon EF is just such a camera, fully automatic and of the shutter-preferred variety. After choosing the optimum shutter speed, the lens automatically sets a viable aperture when pointed at the subject.

It's a good tool for such a situation, and when John Durniak shows the editors of *Time* your beautifully exposed contact sheets, he'll be proud that he gave you the assignment.

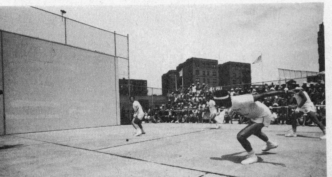

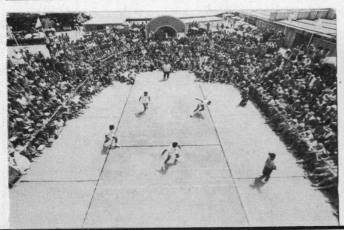

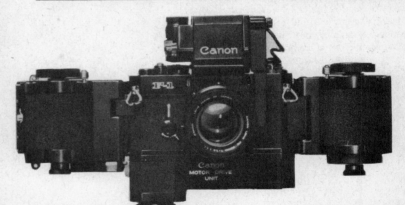

The Canon remote motor-drive unit and 250-exposure film back make the impossible quite possible, as seen by the two photographs at left. The problem was to simultaneously produce two photographs of a handball game from two different positions. At the top of the handball court (top), you can see the camera mounted with the motor-drive and back. By remote control, this was connected to the hand-held camera used by the photographer as he shot the action on the court. When fired on the ground, the mounted unit also went off since it was connected to the PC-outlet of the hand-held camera. This unit provides eight shooting intervals, ranging from one frame-per-minute to three per second. Power can be provided by a belt pack or by a battery in the handle. A smaller unit, the Motor Drive MF, is designed for hand-held shooting, with the battery compartment acting as a grip mounted on the right side. A high-speed motor camera is also available.

OLYMPUS OM-1: A GOOD THING IN A SMALL PACKAGE

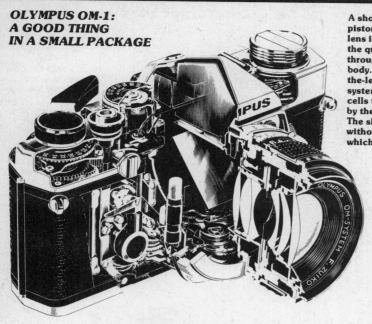

A shock-absorbing piston to the left of the lens is indicative of the quality to be found throughout the OM-1 body. A through-the-lens metering system uses two CDS cells that are powered by the 1.3V battery. The shutter works without battery power, which is reassuring.

All but three or four of the OM lenses promised in 1972 are currently available. The majority, from 21mm to 200mm, take a 49mm filter.

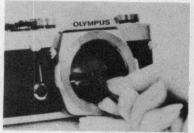

Once upon a time tucked away in the bottom of many camera bags was an Olympus Pen FT half-frame camera, prized for its compactness and sharp optics. It struck the fancy of quite a few working photographers, even the likes of Eugene Smith. And why not? It handled magnificently and had the feel and inconspicuous profile of a rangefinder camera. Why, the pros asked, didn't Olympus produce a full-frame SLR equal in quality and handling to the half-frame machine?

In the fall of 1972 Olympus did just that by introducing the OM-1: small, lightweight, innovative, an exceptional value and promising a system as extensive as the Nikon's. Although it has a traditional pentaprism, the camera is smaller than an M-series Leica, has a brighter, larger viewfinder than the competition's and is exceptionally quiet and vibration-free. The camera's attributes drew immediate response from many photojournalists. When you work, as they do, with four bodies and lenses hanging from your neck, a light camera is a joyous idea. But smaller means thinner parts, which means a less durable machine, and the heavy work load eventually takes its toll—particularly in the automatic mechanism of the lenses. The craft of photography, however, thrives on compromise, and photographers were willing to sacrifice sturdiness for size and weight.

For this reason, the OM-1's foothold in the professional market continues to grow. The busy pro who is flying from factory to factory for months at a time during the corporate annual season from November to February cannot fail to appreciate being able to slip four SLR bodies, eight lenses and a full compliment of accessories under his plane seat.

It was always obvious that small-format cameras should be small. With SLR cameras, this was a design problem; but the people at Olympus were the first to see the *light*.

The OM system auto-bellows has the same high quality construction and finish that is found in the famed Olympus microscopes. Shown with a slide copier, it becomes a fine setup for making dupes.

The thirteen focusing screens for the OM-1 have no condenser lens since one is designed into the camera's pentaprism, lowering the cost of each unit. Proper placement of the screen with the tweezers supplied is critical for proper focusing.

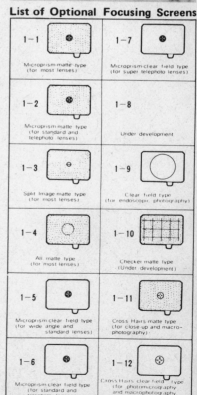

Many pros actually prefer the handling of the OM cameras with the five frame-per-second motor and battery pack/hand grip attached. The grip attaches to a cord for remote triggering. The motor drives the camera via an opening in the baseplate. If the camera is to be used without the motor, you must cover the opening to prevent dust and other matter from clogging the gears. A socket cap is provided for this purpose, but since you're bound to lose it, black tape will do as well.

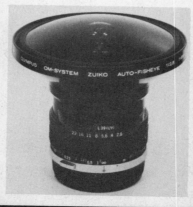

The 16mm f/3.5 Zuiko fish-eye typifies the compact design of the OM system lenses. The lens weighs a bare six ounces and is just over one-inch long. Although it is a full 180-degree fish-eye, the image covers the full 35mm frame. Built in are 1A, yellow and orange filters.

List of Optional Focusing Screens

1-1 Microprism-matte type (for most lenses)	**1-7** Microprism-clear field type (for super telephoto lenses)
1-2 Microprism-matte type (for standard and telephoto lenses)	**1-8** Under development
1-3 Split image matte type (for most lenses)	**1-9** Clear field type (for endoscopic photography)
1-4 All matte type (for most lenses)	**1-10** Checker matte type (Under development)
1-5 Microprism clear field type (for wide angle and standard lenses)	**1-11** Cross Hairs matte type (for close up and macrophotography)
1-6 Microprism clear field type (for standard and telephoto lenses)	**1-12** Cross Hairs clear field type (for photomicrography and macrophotography greater than life size)

PROGRESS AND THE OM-2

The OM-2 can do everything the OM-1 can do, and more. It connects up with the motor drive and all accessories in the system. It is totally automatic, however, incorporating two separate metering systems—match needle, plus a unique automatic system in which two silicon cells measure the light falling onto the film during exposure. You simply set the lens at any aperture and the shutter automatically exposes the film, deciding at the moment of exposure whether 1/500th of a second or ½ second is correct.

In practice, the camera is turned on and the brain is turned off. Picture after picture is taken without a care in the world, and when the box of Kodachrome is returned, all frames are evenly, blandly—albeit, adequately—exposed. No highs, no lows. In short, the roll lacks the photographer's thumb print. Whether a photographer should or shouldn't allow the camera to make exposure decisions is a philosophical question. For routine work, automation has its place; but the art of photography still lies in the hands of those who are inspired—who want to express their own feelings about a subject. Automation reduces the human element and, what is worse, it doesn't allow the learning process to function. The OM-2 can be used manually; an exposure indicator needle in the viewfinder display tells you when you're on your own.

Ponder & Best/1630 Stewart St./Santa Monica, CA 90406

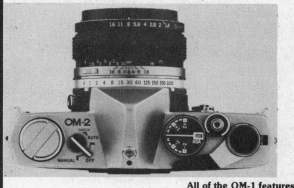

All of the OM-1 features have been retained, except for the mirror lock-up. The automatic meter will continue to work if the meter switch is accidently left in the "off" position, but only from 1/30th to 1/1000th of a second. Always carry an extra battery on the job, since no battery means no camera. Remember, too, that standard silver oxide batteries are cold sensitive and should be replaced with alkalines when working in low temperatures.

In automatic, two silicon cells (left) read right from the film plane, which is theoretically ideal, but their shift from a center-weighted to an average reading as the shutter speed becomes slower makes it harder to learn the OM-2 meter's characteristics.
Diagram courtesy of *Modern Photography.*

FUTURE SHOTS: THE CONTAX RTS

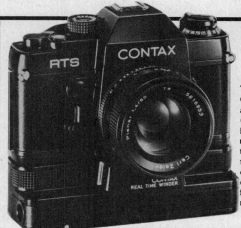

The Porsche-designed Contax RTS body, although typically German in its solidity, is streamlined and uncluttered, with all the controls located in the right places. The end result is esthetically pleasing, feels good and handles magnificently. The on-off switch is in the shutter release, so the camera's system does not have to be "turned on" to take pictures. The compact two frames-per-second motor drive shown below is triggered by the same microswitch shutter release on the camera body.

Along the top of the Contax viewfinder, a green aperture indicator tells you what f-stop *you* set. Along the right of the finder, light-emitting diodes indicate the shutter speed the *camera* sets. The latter information glows in the dark, while the former can be difficult to see under low-light conditions.

The Contax RTS, using Zeiss lenses and promising a complete system in the future, is obviously designed for professional use. It departs from traditional system camera design in that the camera body is automatic and depends on electronics more than mechanics. Whether or not pros should use automation has been and will continue to be debated for some time. The important thing is to practice and get to know your tools.

When utilizing automation, it is essential for the photographer to understand the characteristics of the camera's metering system. Photographs that have failed as a result of the meter's inability to read a particular lighting situation correctly should be analyzed for the amount of compensation needed to attain the desired results. Only then will you know how to use the exposure compensation dial, which can modify the exposure as much as two stops in either direction.

Since automatic cameras can't think, provisions are made for manual operations. This is most important in aperture-preferred cameras, especially under low to very low lighting conditions. For example, the camera may be operating at 1/30th of a second at f/4. Suddenly, a subject emerges from the shadows; you shoot and the camera reads the darkness and operates at a quarter of a second, registering a blur. In the manual mode at 1/30th of a second, you would have held the highlights you saw in the first place. By laboratory standards, the negative might be considered underexposed, but "wrong" exposure sometimes produces the most interesting photographs. Technique in photography is very often knowing what you can get away with.

A motor drive called a winder is easily attached to the baseplate of the camera with a ¼"×20 set screw. It is shown here with the battery compartment open and a battery case removed. The six AA batteries that drive the unit are good for fifty rolls of film.

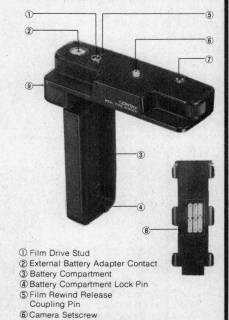

① Film Drive Stud
② External Battery Adapter Contact
③ Battery Compartment
④ Battery Compartment Lock Pin
⑤ Film Rewind Release Coupling Pin
⑥ Camera Setscrew
⑦ Film Drive Signal Terminal
⑧ RTW Battery Case
⑨ 3P External Power Socket

Yashica Inc./50-17 Queens Blvd./ Woodside, NY 11377

ODE TO THE NON-SYSTEM 35MM SLR

For some commercial photographers assignments vary widely. We think especially of the on-location illustrator and those working for newspapers and magazines. What the customer wants can mean the carrying of many lenses or the use of several different focusing screens or the option of attaching a motor drive . . . in short, of having a camera body (or bodies) with all parts modular and interchangeable. (The preceding eight pages have been devoted to presenting just such 35mm SLR systems cameras.)

There is another kind of photographer, though, who not only doesn't need the many parts of a system, but who simplifies work as much as possible by using one camera, one or two lenses, generally the same film. We refer to that man or woman who photographs to self-order only. That is, to the amateur, the artist, the documentarian—to anyone who doesn't have to fulfill an assignment or to satisfy the ad agency's client. If this photographer prefers to work with an SLR, it need not be a systems camera.

There are many cameras capable of producing quality work, but ultimately it is the photographer who makes the photograph, who works the camera. Many of George Krause's classic photographs were made with a simple Pentax H3V with a 50mm screw-mounted lens, without a built-in meter. It's getting to know your camera that's important, so that ultimately you can forget about its controls and concentrate on the picture.

So if an uncle gives you one of the cameras shown below, you should not only be grateful, but should realize that no one will ever know from looking at your photographs whether they were taken by a systems camera or not. Photography is so much more than its tools.

THE LAST LEICAFLEX

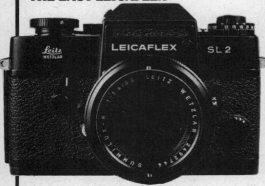

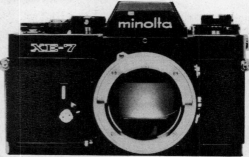

Being a conservative company, E. Leitz hesitated bringing out a single-lens reflex, until it became obvious that the SLR was going to become the most popular design in camera history. The first Leicaflex, a strange design, was soon followed by the more modern SL and SL2, both of which took the lenses of the older model. The latter—the last camera to be called Leicaflex—is a finely crafted machine and works beautifully with the light 400mm f/6.8 Telyt and 180mm f/2.8 Elmarit lenses. Optics, of course, is E. Leitz's raison d'être.

E. Leitz, Inc./Rockleigh, NJ 07647

The Angenieux zoom could be the one lens you need. With it, you continually adjust focal length between 45mm and 90mm, where most pictures are taken. As a zoom, point of focus stays the same, even though the focal length is changed.

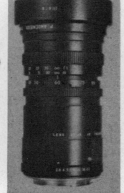

A fingertip is poised to press the button that will illuminate the viewfinder aperture needle when working under low-light conditions.

MINOLTA—A CONTENDER

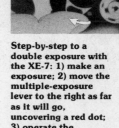

This progressive company in Osaka makes an impressive line of cameras, lenses and accessories. The XE-7 and the stripped-down, lower-priced XE-5 have electronic, metal-blade shutters with stepless speeds from 4 seconds to 1/1000. The company's Rokkor-X lenses, which range from a 7.5mm fish-eye to a 1600mm mirror-reflex telephoto, operate as smoothly as any we've ever used. Top of the company's line is the XK motor drive. It is an automatic exposure camera with interchangeable finders and screens (the XE's have fixed pentaprisms), lenses and accessories. The motor is built-in, however, and can't be detached. For a lighter, mechanically operated equivalent, you would have to get the XK, which can't take a motor. As a system, not quite, but close.

Minolta Corp./101 Williams Dr./Ramsey, NJ 07446

If you had your eye to the viewfinder of this XE-7, you would see a matte Fresnel screen with a central split-image focusing spot, surrounded by a microprism band. At the top of the finder in a small rectangle, the f-number is always visible—the f-number that you select. Shutter speed, which is set automatically, shows up too.

Step-by-step to a double exposure with the XE-7: 1) make an exposure; 2) move the multiple-exposure lever to the right as far as it will go, uncovering a red dot; 3) operate the film-advance lever to cock the shutter for the next exposure— the film and counter do not advance; 4) fire again.

THE POPULAR PENTAX

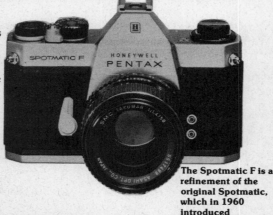

Asahi Optical in 1951 gave Japan its first 35mm SLR and the world its first instant-return mirror in 1954. In 1959 Asahi joined with Honeywell, selling all cameras in Mexico and the United States with the label Honeywell Pentax. In 1960 another big breakthrough came with the Pentax Spotmatic and its behind-the-lens meter. The camera was widely popular and, with improved metering, is still in production as the Spotmatic F. It takes screw-mounted lenses. The company makes other 35mm SLRs—some automatic; some with screw mounts, others with bayonet. The line is not a fully integrated, interchangeable system.

Honeywell Photographic/P.O. Box 22083, Dept. 201-841/Denver, CO 80222

The Spotmatic F is a refinement of the original Spotmatic, which in 1960 introduced through-the-lens metering to a welcoming world.

The XK with motor was introduced in mid-March, 1976. Minolta was pretty excited, calling it "the world's first 35mm electronic single-lens reflex specifically designed for integral motorized operation with aperture-priority automatic and manual silicon-cell through-the-lens exposure control, plus automatically governed framing rates . . . with single-frame and continous-burst motorized film advance at rates up to 3.5 frames per second." All good, if you need it.

MAN AND MACHINE

No photographs came out of the Civil War showing little children fleeing down a road to escape bombardment—nothing comparable, that is, to Huynh Cong Ut's terrifying picture of that screaming, burning little girl. Mathew Brady and his associates just couldn't take such a picture, not with slow lenses and film that required virtually immobile subjects.

For the contemporary photographer, both too little and too much can be made out of the tools used. *Too little* is the fatuous notion that any camera can take any picture. Given a situation, there is a logic to camera choice. It's not likely that an Ansel Adams using an 8×10 view camera would be set up to get a picture similar to the one of President Allende emerging from his palace, the one where he carries a rifle and his bodyguard is alert for snipers. The photographer is unknown, but we'll bet the picture was taken with a hand-held camera. Just as surely, *too much* can be made of which camera for what. Look at a news magazine. Can you be sure which pictures were taken with an SLR 35mm, which with a rangefinder 35mm? Not likely.

The camera to use depends on the type of work to be done, the temperament of the worker and the style sought.

Railway station, Moscow, 1960. *William Klein*

This is a "quick work" picture if there ever was one. Not surprisingly, William Klein works with a Leica and Tri-X. Klein manages to combine some dramatic visualization with photojournalistic information. For his efforts he is not without laurels: at *photokina* in 1963 he was voted one of the thirty most important photographers in history. His books are *New York, Rome, Moscow, Tokyo, Mr. Freedom.* He also makes movies. An American, Klein has lived in Paris since 1948.

Grandeur, Louisville, 1948. *Barney Cowherd*

Karsh is a popular photographer who is not much in fashion among the serious appreciators of photography as art. To some, his portraits of the famous and/or rich have a too-dramatic quality; yet, we wonder if his work won't bring pleasure to millions for a long time to come. If so, that is the reward of having a unique style. Certainly, when children in the twenty-first century are shown what Winston Churchill looked like, you can be sure they'll see the Karsh portrait. He usually uses an 8×10 view camera.

Jean Sibelius. *Yousuf Karsh.*

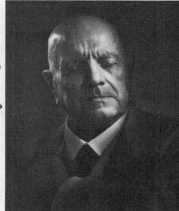

Barney Cowherd (1922 to 1972) was one of those amazing newspaper photographers who rose above taking routine photographs. He used a 4×5 Speed Graphic and a Graflex flash gun, a rig which was conducive to recording lots of detail. Cowherd also worked for *Life* on contract, and he was represented by Magnum. A book called *Barney Cowherd, Photographer* is available for $5.50 from *The Courier Journal*, Louisville, Kentucky 40202.

Surfers, 1963. *George Silk*

Silk is an outstanding example of a photographer who fits the equipment to the job. In the shot, converted from color, the surfer fired the shutter (of a plastic-housed motorized Nikon) as he repeatedly pulled a line held in his left hand—another case where a view camera just wouldn't have done.

Beny personifies the artist who simplifies his work with a one-lens camera (in his case a Rolleiflex). For years he has traveled all over the world to make his romantically evocative photographs of antiquities, which he uses to illustrate his many books.

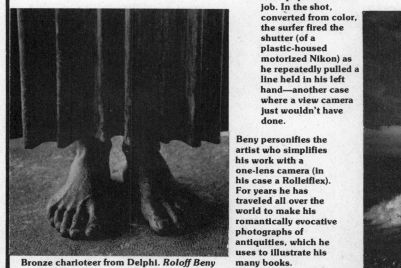
Bronze charioteer from Delphi. *Roloff Beny*

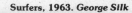

SOONER OR LATER A HASSELBLAD

"Sooner or later a Hasselblad" was the way the ads read in the fifties when the 500 C emerged. If you were around then, sooner would have meant cheaper, since today's 500 C/M is virtually the same camera. If you weren't around then, you missed the zenith of photographic editorial and advertising illustration. In those days, before TV grabbed the lion's share of the advertising budget, picture magazines were richer and bigger. Consumer magazines like *McCall's* thought nothing of plastering a photo of a giant kosher pickle in full color across its 13x20-inch double-spread format. Photographers called upon to illustrate fashion, still life or any peopled-environment situation an art director might conjure up found the Hasselblad to be just the tool needed to deliver imaginative variations without sacrificing technical quality.

This still holds true for today's advertising photographer, although many now prefer the motorized 500 ELM which accepts the same versatile array of accessories. And the mirror pops right back, so you can see what you're doing. Al Francekevich, a New York City professional photographer, says that "models really groove to the whirring of that motor." After making sure all is in order by shooting tests on Polaroid, photographers usually start with the Hasselblad on a tripod. During the shooting, when new ideas develop, off it comes and from then on it's used in hand. To keep the momentum going, an assistant, counting off the exposures, stands by with a freshly-loaded film back.

You can spend a fortune on Hasselblad equipment, but the basic professional outfit costs no more than the family car. They do break down so two bodies provide insurance; you'll need a rapid rewind crank if you choose the manual 500 C/M; the 50mm wide-angle Distagon, the "normal" 80mm Planar and 150mm Sonnar for head shots—all musts; a focusing hood to keep sharp; bellows lens shade to keep cool; three roll-film backs—one for color, one for black-and-white and the third for the assistant to keep loaded; and most important, the Polaroid back (God bless Dr. Land). With hard work, with talent, and a good sales "rep," you can get some of that rich advertising work—which you'll need to pay for all these mechanical and optical delights.

Hasselblad/ Braun North America/
55 Cambridge Pkwy./Cambridge, MA 02142

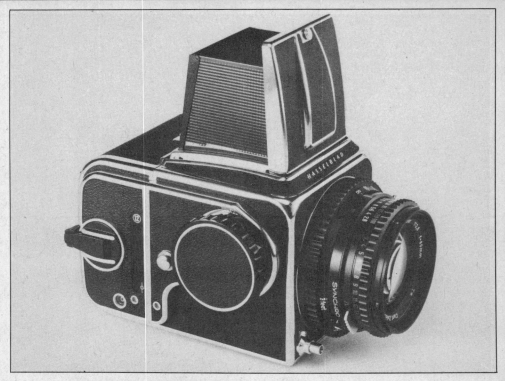

Heart of the line—the 500 C/M, a manually operated, single-lens-reflex mechanism with interchangeable lenses that have built-in shutters. It takes 2¼×2¼ roll film and has removable backs. The rewind knob advances the film and cocks the shutter simultaneously. To speed things up, smoothly use the rapid-winding crank.

For hand-held work, cradle the camera in your left hand with your left index finger on the release button. The right hand winds the film and focuses. A neck strap, which attaches to studs at the side of the camera, is helpful. It takes up weight, allowing the hands to hold and operate the camera smoothly.

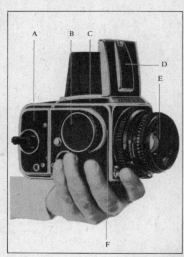

The magazine must be removed to slide in any of eight special finders. The chimney hood (left) can be used with the camera, upside-down like a periscope, to shoot, say, above crowds, or when the camera is at floor level. As with the folding hood, the image is right-side-up but reversed. For eye-level use, the prism viewfinder (far left) provides an enlarged, unreversed image.

For a photographer, the ability to make test shots on Polaroid film is worth any price. Marty Forscher used to do a booming business supplying custom Polaroid roll-film backs to professionals. Called the "Wisner" back, they are on the verge of obsolescence since there is a distinct possibility that Polaroid will discontinue making the Type 32 roll-film it uses. These days Hasselblad supplies its own adaptation of a Polaroid pack back. This model fits all Hasselblads without modification and can instill more confidence in a photographer on assignment than two double Scotch whiskeys.

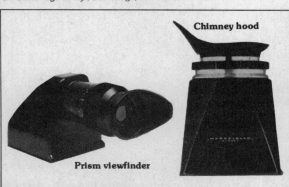

Chimney hood

Prism viewfinder

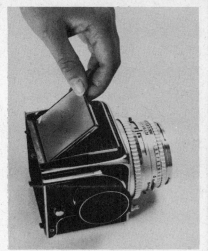

The 500 C/M, with its provision for interchangeable finders, became available in 1971. Except for its accepting any one of the four different focusing screens available, the camera is exactly the same as the old 500 C introduced in 1957. Repairmen can install different screens in the older model.

THE HASSELBLAD WAY
by H. Freytag
The Focal Press/London and New York/cloth, $18.95

Freytag, a third-generation photographer, wrote his first book in 1936, on the Contax. After his release as a German prisoner of war in 1949, he went to work for Zeiss, was editor of the German monthly *Foto-Prisma* and wrote four other books in the *Camera Way* series.

The Hasselblad Way covers fundamental functions and applications of the entire system. It includes chapters on history, the reflex principle, current and earlier models, finders, magazines, lenses, films, filters, flash and various specialized photographic uses. There is also a chapter on data, which includes a depth of field chart for all lenses.

THE HASSELBLAD EVOLUTION

The original model 1600F appeared in 1948 and featured a focal plane shutter with a top speed of 1/1600 second.

The model 1000F of 1952 was closely similar, but had a top speed of 1/1000 second and minor operational changes.

The Super Wide of 1954 with a fixed 38 mm. ultra wide-angle lens covers a 90° angle of view. It is thus not a reflex camera and has a diaphragm shutter. But it takes the Hasselblad magazines and certain other accessories.

The Super Wide C of 1959 is a modified version of the Super Wide with a more modern shutter and certain improvements in styling and operating convenience.

The Hasselblad 500C has since 1957 been the standard Hasselblad model. The interchangeable lenses each have their own diaphragm shutter, coupled with the camera tensioning system. In 1971, this model became the 500C/M with the introduction of interchangeable focusing screens

The 500EL of 1965 features an electric motor drive for the transport operation, and permits electric releasing at a distance, for completely remote controlled operation. It became the 500EL/M in 1971 with the introduction of interchangeable focusing screens

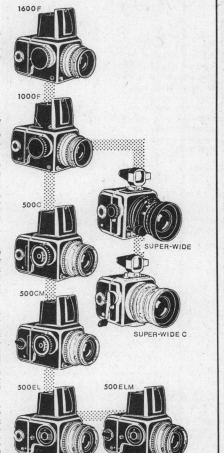

1600F

1000F

500C

SUPER-WIDE

500CM

SUPER-WIDE C

500EL 500ELM

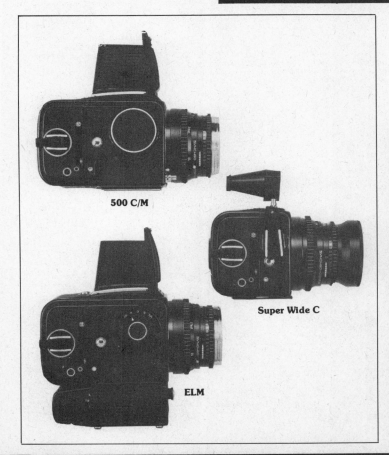

500 C/M

ELM

Super Wide C

There are three different Hasselblads. The 500 C/M (top) and ELM (bottom) share all lenses and accessories. The ELM is powered by two rechargeable nickel cadmium batteries, each capable of delivering 1,000 exposures. It takes fourteen hours to recharge one battery. The Super Wide C is a box with a 38mm f/4.5 Zeiss Biogon lens permanently attached. It uses the same film magazines as the other Hasselblads. For critical work, you can view directly through the lens with the focusing screen adapter and magnifying hood (right). Normally, the combination viewfinder/spirit level does the job.

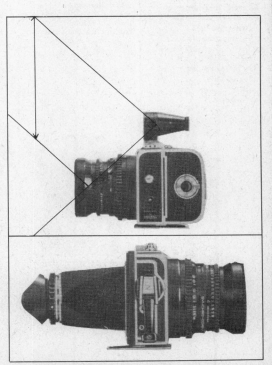

CAMERAS/roll film

FROM THE MANUAL: LOADED IN EIGHT STEPS

Some nice safety features—The shutter release will not operate until the magazine slide has been withdrawn. Also, the film magazine itself can not be removed from the camera unless the magazine slide is inserted.

Loading

1. Fold out the roll holder key (41) and turn it counter-clockwise. Pull roll holder (L) out of the magazine.

2. Now turn the roll holder key (41) clockwise again. This releases the film clamp (F).

3. Flip up the spool clips (N) and (R). Insert an empty take-up spool under the clip (N), the one with the knurled knob on top, and flip down the clip. Insert the roll of film under the clip (R) with the roll positioned as shown in the figure. Flip down the clip (R). Make sure both clips fit.

4. Pull out 4—5 inches of paper backing and guide it under the film clamp (F).

5. Insert the tongue of the paper backing into the take-up spool. Turn the knurled knob (N) until the transverse arrow on the paper backing is in line with the arrow (P) on the spool clip.

6. Turn the roll holder key (41) counter-clockwise so that the paper backing is held down by the film clamp (F).

7. Holding the roll holder by the key (41), slide the roll holder into the magazine and lock in place by turning the key (41) clockwise. This also releases the film clamp (F). Fold down key (41).

8. Fold out the film winding crank (23) and turn it clockwise until it stops (about 10 revs). The figure 1 is now visible in the frame counter (21). Fold back the film winding crank and flip down. The magazine is now ready for use.

THE SWEDISH CONNECTION: MR. HASSELBLAD AND MR. ZEISS

Super-sharp Hasselblad lenses made by Carl Zeiss of West Germany have helped many a photographer pay his rent. Also important to the professional is the fact that since each lens has its own leaf shutter, flash synchronization is possible at any speed setting, including 1/500 second. This feature gives the photographer the option of mixing flash and available light in any proportion he wishes—a sophisticated technique.

30mm f/3.5 F-DISTAGON (T*)
This is a "fish-eye" lens with 180° diagonal and 112° side to side coverage. Outstanding resolution right out to the corners of the field, even when used wide open. A problem-solver of a lens for photographing interiors and a fascinating lens for e.g. landscape and fashion photography. Sharpness and composition can be checked on the focusing screen so that the undesirable perspective distortion is avoided. Or the lens can be used when exaggerated perspective is desired. The lens is supplied with three filters and a compensation glass. This glass or a filter constitute integral parts of the lens' optical system and must always be used with the lens.

40mm f/4 DISTAGON (T*)
The 40mm f/4 Distagon has an 88° diagonal angle of view (69° from side to side). Thus, it has almost the same angular field as the Biogon of the SWC. In spite of the unusual combination of speed, angular field and a long back focal distance, distortion could be kept to a minimum. The lens can be focused down to 19 inches. For the best possible results, the smallest f/stop should be used in the 19—35 inch focusing range. A detent on the focusing ring at 35 inches is to remind you of this. The 40mm f/4 Distagon can also be used for close-up photography with the shallowest extension tubes. An outstanding lens for architecture, interiors, fashion and press photography.

50mm f/4 DISTAGON (T*)
The 50mm Distagon can be termed a "normal wide-angle" lens. Its moderately wide angle of view (75° diagonal, 58° side) provides a wide range of use. Many photographers prefer this lens as a normal angle lens. The short focal length produces great depth-of-field, making critical focusing less important. A big advantage to the press photographer. The angular field is still wide enough for work with interiors and architectural subjects. The smallest possible f/stop should be used in close-up work so as to make the best use of the optic's resolution.

80mm f/2.8 PLANAR (T*)
The 80mm Planar is the standard Hasselblad lens and is supplied with the Hasselblad 500C/M and 500EL/M. Its focal length corresponds approximately to the diagonal of the 2¼"-square format. Extremely uniform edge-to-edge sharpness, even when the lens is used wide open, is characteristic of the 80mm Planar. The lens is designed for extreme flatness of the image field. Hence the name Planar. The largest f/stop, f/2.8, is also useful when lighting conditions are poor.

100mm f/3.5 PLANAR (T*)
The slightly long focal length of the 100mm Planar has made it popular as a standard lens for many photographers, just as the 50mm Distagon is the standard lens for some other photographers, depending on their way of working. The 100mm Planar differs from almost all other camera lenses, irrespective of make, in being almost fully corrected for distortion. This was achieved by virtue of a no-compromise design and an ideal combination of lens speed and focal length. The 100mm Planar is especially suitable when exact rendition of details and high brilliance are required, as in technology and science. But the lens is just as useful for all kinds of photography. The lens has been put to use in survey work owing to its outstanding correction for distortion.

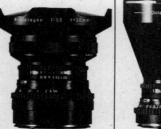

Max. aperture/ focal length	3.5/30mm	Max. aperture/ focal length	4/40mm	Max. aperture/ focal length	4/50mm	Max. aperture/ focal length	2.8/80mm	Max. aperture/ focal length	3.5/100mm
Angle of view, diagonal	180°	Angle of view, diagonal	88°	Angle of view, diagonal	75°	Angle of view, diagonal	52°	Angle of view, diagonal	43°
side	112°	side	69°	side	58°	side	38°	side	32°
Diaphragm	3.5—22	Diaphragm	4—32	Diaphragm	4—22	Diaphragm	2.8—22	Diaphragm	3.5—22
Focusing range	11½ in—∞	Focusing range	19 in—∞	Focusing range	19 in—∞	Focusing range	3 ft—∞	Focusing range	3 ft—∞
Filters	Supplied	Front lens mount	diameter 104 mm	Front lens mount	diameter 63 mm	Front lens mount	diameter 50 mm	Front lens mount	diameter 50 mm
Weight	48 oz.	Weight	48½ oz.	Weight	31 oz.	Weight	16 oz.	Weight	21½ oz.

Photo: Joachim Pfaff

Backlighting is exciting. The Hasselblad Professional lens shade provides efficient lens shading. This lens shade can be extended to about 4 inches and has markings for the different focal length lenses.

From Hasselblad's *Architectural Photography.* **Photo by** *Joachim Pfaff*

FREE FROM SWEDEN—A LIBRARY OF SPECIALIZED BOOKLETS

Elaborately illustrated written essays show only Hasselblad equipment, but then we know there is no free lunch. In *Architectural Photography* we learn that the lens shade is ideal for greatly reducing glare (non-image light); many photographers adapt it to use on their 35mm cameras as well.

Braun North America/55 Cambridge Pkwy./Cambridge, MA 02142

120mm f/5.6 S-PLANAR
The 'S' stands for "special". In contrast to most other lenses, which are corrected for optimum results at long lens-to-subject distances, the S-Planar is especially corrected for close-up photography. The lens is ideal for the reproduction of drawings, for example, due to its lack of distortion. An ideal lens for all kinds of close-up photography calling for the highest standards of image reproduction. The S-Planar can also be used to advantage for work at longer lens-to-subject distances. At distances less than 3 ft, an extension tube or bellows extension must be used. Proxar close-up lenses do not provide perfect results with this lens. The S-Planar is a dream for fascinating close-up photography.

135mm f/5.6 S-Planar
The 135mm f/5.6 S-Planar is a special-purpose lens which can only be used in combination with a bellows extension. The bellows extension is used for focusing, since the lens has no focusing facilities. Without any other accessories, it is possible to focus down to 21 inches (1:1).
The lens is very suitable for studio work with portraits and advertising. Without any need to change lenses, the photographer can cover everything from full figure portraits to extreme close-ups, all with outstanding resolution and without distortion. The lens can be stopped down to f/45 so as to provide maximum depth-of-field at short lens-to-subject distances.

150mm f/4 SONNAR
Many photographers feel that the 150mm f/4 Sonnar is the most important accessory in the Hasselblad system. Basic equipment is often supplemented with this lens and the 50mm Distagon. Most photographic situations can be tackled with these lenses. Without any other accessories, it is possible to focus down to 21 inches (1:1).
The lens is very suitable for studio work with portraits and advertising. The modestly long focal length of the 150mm Sonnar in combination with its relatively high speed, make the optic suitable for a wide variety of situations. It is easy to use for hand-held work and can be employed for assignments outside the studio. For example, in portraits, press, sports and theater photography.

250mm f/5.6 SONNAR
An easy-to-use telephoto lens. Only 6 inches long, despite its long, 250mm focal length. This makes the lens suitable for hand-held shots. The lens produces outstanding results even when used wide open, and quality is not improved by stopping down. The long focal length provides opportunities for interesting effects. Distance can be compressed and close-ups can be taken at a distance. The portrait photographer is able to work at a discreet distance from his subject. Therefore, the 250mm Sonnar is especially suitable for photography of children. In outdoor portraits, a large f/stop can be used, curtailing depth-of-field, so that the model stands out against a fuzzy background. Unsharp foreground details can be used to frame a subject.

350mm f/5.6 TELE-TESSAR
A long focal length (350mm), high speed (f/5.6) and compact design (8⁷/₈ in long). Three properties which put the Tele-Tessar high up on the list of many Hasselblad photographers. The lens is very suitable for photography of animals in their natural surroundings. Like other long focal length lenses, it can be used to achieve special effects, such as isolating a subject from its background or compressing perspective in landscape photography. The lens provides full resolution even when used wide open.

500m f/8 TELE-TESSAR
The Tele-Tessar has the longest focal length in the Hasselblad lens series. Like the 350mm Tele-Tessar, its optic is very compact (only 12¹/₂ inches long). Its main use is probably to be found among photographers working with animal subjects in their normal environment. But it is also often used by advertising photographers seeking new, creative approaches outdoors or in the studio. The Tele-Tessar lets you stand off from your subject without isolating you from the center of things. That makes it a dream lens for both sports and news photographers.

Max. aperture/ focal length	5.6/120mm	Max. aperture/ focal length	5.6/135mm	Max. aperture/ focal length	4/150mm	Max. aperture/ focal length	5.6/250mm	Max. aperture/ focal length	5.6/350mm	Max. aperture/ focal length	8/500mm
Angle of view, diagonal	36°	Angle of view, diagonal	32°	Angle of field, diagonal	29°	Angle of view, diagonal	18°	Angle of view, diagonal	13°	Angle of view, diagonal	9°
side	26° (at infinity)	side	23° (at infinity)	side	21°	side	13°	side	9°	side	6.5°
Diaphragm	5.6–45	Diaphragm	5.6–45	Diaphragm	4–32	Diaphragm	5.6–45	Diaphragm	5.6–45	Diaphragm	8–64
Focusing range	3 ft–∞	Focusing range (with bellows extension)	21 in–∞	Focusing range	5 ft–∞	Focusing range	8¹/₂ ft–∞	Focusing range	16¹/₂ ft–∞	Focusing range	28 ft–∞
Front lens mount	diameter 50 mm	Front lens mount	diameter 50 mm	Front lens mount	diameter 50 mm	Front lens mount	diameter 50 mm	Front lens mount	diameter 86 mm	Front lens mount	diameter 86 mm
Weight	22¹/₂ oz.	Weight	20 oz.	Weight	25 oz.	Weight	33 oz.	Weight	47¹/₂ oz.	Weight	74 oz.

THE ROLLEI: FOR PEOPLE, DOGS, CATS AND FISH

This is a grand old camera with an important photographer here and there still using it for fashion and portraits. Many good photos were made with the Rollei, and during the thirties and forties—before 35mm cameras all but swept it away—picture data credits in the photo annuals (people and pets, especially) credited Rollei by an overwhelming majority. Moreover, in those days, although there weren't many formal photography courses, most high schools had their camera clubs and a faculty advisor who was forever recommending, "If you can afford it, get a Rollei."

The camera is sturdily made and the 2¼×2¼ negative yields 16×20-inch prints that say quality. For its time, the Rollei was a bit of a radical machine. Large-format cameras were still the most common. Portrait photographers used view cameras and newspaper photographers used Speed Graphics. The photographer who wanted to go smaller, to have more mobility, went to the Rollei.

Now, as then, its rigid body maintains the close tolerances for optimum sharpness, and there are no bellows to collect dust or to cause light leaks. Working with a fixed focal length lens forces the photographer to adapt to the camera's inflexibility. If you want to get a close-up, you move in, and vice versa; the limitation of non-interchangeable lenses simplifies the decision-making process. A telephoto and wide-angle Rollei were made but never became popular. The latter was difficult to focus. There is no question that in practice the Rollei helped photographers get sharp pictures. The wide-open viewing lens permits precise focusing, and the fact that the shutter is released by pushing it toward the body greatly reduces camera shake.

To see what you are going to get at the moment of shutter release, there is nothing quite like a twin-lens reflex—especially for photographing people. You would have to depress the exposure button and hear the whir of its finely made shutter (and know that at that instant a picture is being taken) to understand why the Rollei is so well thought of.

A used Rollei can be bought for about a quarter of the price of a new one today (about $900). The later models have such features as a removable hood to which a pentaprism can be added, but all this is contrary to the design—to see the image with both eyes at the moment of exposure.

Labels on diagram:
Finder magnifier
Eye-level focusing magnifier
Interchangeable focusing screens
Reflex mirror
Film feed
Film pressure plate
Film feeler system
Tripod bush
Finder lens
lens Camera
Film take-up

The principle of the twin-lens reflex is simple. Two identical lenses are mounted on a single focusing track. The image made by the top one, which is always open, is reflected to a groundglass for viewing and focusing. It is laterally reversed. The bottom lens exposes the film when the shutter is released. No flopping mirrors and no black-out.

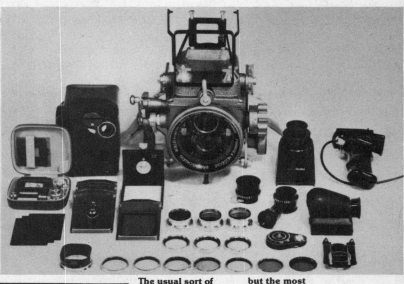

The usual sort of accessories—a grip, film adapters, exposure meter, filters, a case, special prisms—are available, but the most interesting is the underwater housing, the Rolleimarin. It's pressure-proof down to 330 feet.

FRITZ HENLE'S GUIDE TO ROLLEI PHOTOGRAPHY
by Fritz Henle
Studio Publications, Inc./New York, 1956/out of print

Author and Afghan. All the book's other pictures are by Henle. Now out of style, the photographs have their nostalgic value. You can't tell which camera was used from the picture it took; but with this collection, you can sure tell the decade the pictures are from.

Axel Grosser

It seems fitting that a camera no longer in vogue should be studied in a book now out of print. This is a clear guide to the subject, as well it might be, since it was written by a successful Rollei user.

Henle doesn't assume much in the way of previous information; so if you don't know the camera but want to, check with a second-hand book dealer or try the library. For information on the latest models, you should consult *The Rollei Way* by L.A. Mannheim, published by Focal Press and sold at $13.95.

The Tele Rollei with a 135mm lens is no longer made. It is a great camera for portraits because it allows you to keep your distance, which results in less pronounced noses. Your subject will be grateful.

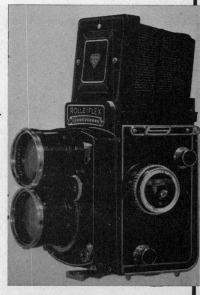

DOUGLAS FAULKNER: GETTING DOWN WITH A ROLLEI

For seventeen years, Doug Faulkner has been photographing marine life all over the world. He considers himself an artist. When he was a student at the University of Miami, he studied English and marine biology, intending to become a poet. He struck up a correspondence with e.e. cummings that lasted till the poet's death. Today he refers to cummings in his books and lectures.

The color and beauty of underwater life was to claim him when he took his first photograph—even though it was in an aquarium. He enthusiastically began photographing the living sea, but it was four years before he sold another photo.

He works almost always with a Rolleiflex in a Rolleimarin housing—usually diving from a small boat fitted with tanks of oxygen, film and flashbulbs, and a couple of cans of cold spaghetti and meat balls to keep him going. An exhaustive worker, he exposes seven or eight rolls of Ektachrome-X in a twelve-hour day. Striving for perfection, he tries to make every shot count—carefully choosing and composing his subjects. An expert diver, when he was struggling to sell his work, he would try to conserve oxygen by breathing as little as possible.

To reveal the full spectrum of color beneath the sea, Faulkner uses flashbulbs close up to his subjects. A lever on his Rolleimarin positions a close-up lens for distances from twelve to twenty inches. He positions the light at different angles, depending on the subject. Exposures are all based on experience, and he rarely loses a photo because of a wrong setting.

His training in marine biology is a definite asset when it comes to identifying the subjects in the editing process; in fact, several specimens have been discovered by Faulkner. His picture collection is remarkable. Rejects are immediately destroyed and the selects are carefully labeled. So-called "super" selects are put away for making dye-transfer exhibition prints and for his own book projects, such as *The Hidden Sea* (Viking, 1970, out of print), *This Living Reef* (Quadrangle/N.Y. Times Book Co., 1974, $27.50) and *Dwellers In the Sea* (Reader's Digest Press, 1976, $40).

A dedicated photographer, he believes in and fought strongly for the photographer's right to own his pictures—no matter who made the assignment. His files, which are kept in a humidity-controlled room, are a testimony to this concern. To order stock pictures, write to Sally Faulkner, 46 Parkview Terrace, Summit, NJ 07901.

Hawkbill Turtle at a six-foot depth, Barrier reef channel, Aulong Island, Palau Islands, 1967. *Douglas Faulkner*

MAMIYA: A CAMERA FOR ENVIRONMENTAL PORTRAITS

Bell & Howell/Mamiya Co./7100 McCormick Rd./Chicago, IL 60645

Diane Arbus spent her early years as a photographer in the world of fashion working with a Rollei—as did most fashion photographers in the forties, when she began photographing. It's not surprising, then, that when she turned to non-commercial photography in 1959, she chose the Mamiya, a camera similar to the Rollei, yet one that from its inception was more versatile . . . and more akin to the work she did.

She made portraits, usually straight-on pictures of people where they lived, worked or played—not in a studio. A twin-lens reflex is made for that sort of work. The subject knows he is being photographed, so a substantial machine is no handicap. Arbus said that a camera is "a kind of license" to get close to people because "a lot of people want to be paid attention to." Faced with a bulky Mamiya and a flash gun, you know you are being paid attention to. Arbus also got "terribly hyped on clarity," and if one wants sharp, detailed portraits there is nothing like 2¼, short of a view camera. And she was fascinated that flash revealed what often wasn't visible in normal light.

Mostly the Mamiya was good for her because it could accept various lenses. She used a wide-angle lens to make the picture in the small living room titled "A Jewish giant at home with his parents in the Bronx." And she used a long "portrait" lens for "Woman with a veil on Fifth Avenue." Artistically, the Mamiya was the right camera for her: "If I stand in front of something, instead of arranging it, I arrange myself." Or she changed the lens.

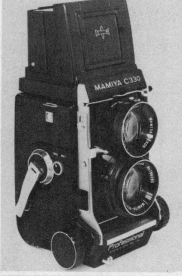

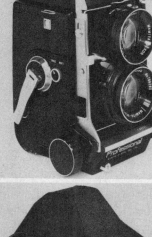

The Mamiya's "normal" lens is the 80mm f/2.8; it has stops to f/32. There are seven other lenses in the interchangeable system, from 55mm f/4.5 to 250mm f/6.3 Between-the-lens shutters have speeds from 1 to 1/500th of a second plus B. There are interchangeable focusing screens and three prism finders (one of which has a CdS exposure meter) that show the image right-side-up and correct, right to left.

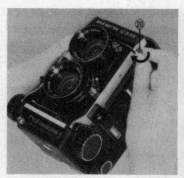

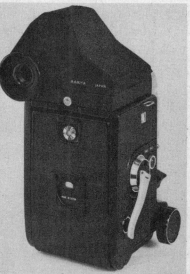

The Mamiya has interchangeable lenses all right, but changing them isn't the easiest thing. First you have to tip the camera so that the lens faces upward. Then, while firmly grasping the lens barrel, you pinch the head of the lens catch bracket. Then you have to press the bracket toward the camera body and push it down to release the lens catch. Now the lens is removable. To attach another lens, cock the shutter so that its lever and the one on the camera connect and reverse the drill.

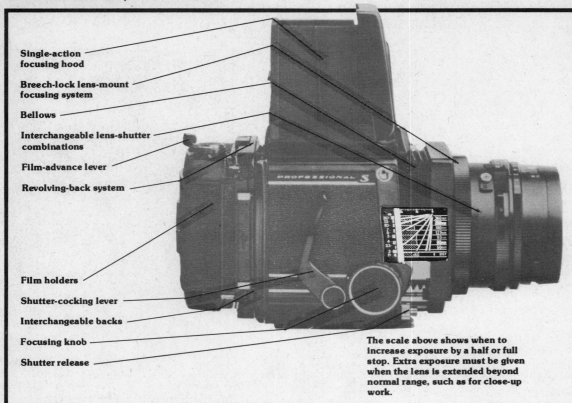

Single-action focusing hood

Breech-lock lens-mount focusing system

Bellows

Interchangeable lens-shutter combinations

Film-advance lever

Revolving-back system

Film holders

Shutter-cocking lever

Interchangeable backs

Focusing knob

Shutter release

The scale above shows when to increase exposure by a half or full stop. Extra exposure must be given when the lens is extended beyond normal range, such as for close-up work.

NO TILTS, NO SWINGS, BUT VIEW CAMERA QUALITY— MAMIYA'S RB67 PRO-S

Here is just the outfit for the slow-working, meticulous, serious amateur photographer, who doesn't want to haul around a view camera or 8x10 film holders, but who does want to have *control*. Think of it, by changing the back adapter this SLR with a between-the-lens shutter can be fitted with 120 and 220 roll-films, 70mm film, dry plates, cut films, film packs or Polaroid pack film. Label three or more roll-film backs for normal, plus, or minus development. Choose the back that corresponds with your pre-vision, and Ansel Adams' Zone System becomes practical for 120 film. And for those like Ansel Adams, who *demand* sharp pictures, the mirror can be locked up to eliminate unwanted vibrations. The RB67 Pro-S can obviously be used to make all sorts of pictures under varying conditions, but we really do expect to see it, tripod-mounted, in Yosemite.

Bell & Howell/Mamiya Company/7100 McCormick Rd./Chicago, IL 60645

Mamiya RB67 Pro-S System Chart

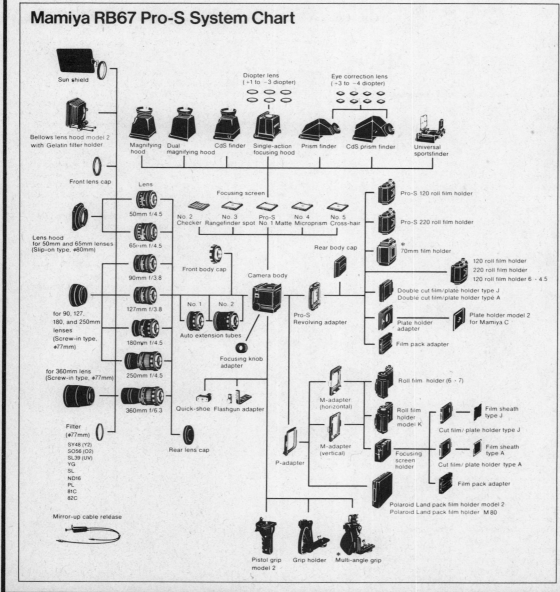

Sun shield

Bellows lens hood model 2 with Gelatin filter holder

Front lens cap

Lens hood for 50mm and 65mm lenses (Slip-on type, ⌀80mm)

for 90, 127, 180, and 250mm lenses (Screw-in type, ⌀77mm)

for 360mm lens (Screw-in type, ⌀77mm)

Filter (⌀77mm)
SY48 (Y2)
SO56 (O2)
SL39 (UV)
YG
SL
ND16
PL
81C
82C

Mirror-up cable release

Lens
50mm f/4.5
65mm f/4.5
90mm f/3.8
127mm f/3.8
180mm f/4.5
250mm f/4.5
360mm f/6.3

Rear lens cap

No. 1 / No. 2 Auto extension tubes

Focusing knob adapter

Quick-shoe / Flashgun adapter

Front body cap

Camera body

Diopter lens (+1 to −3 diopter)

Eye correction lens (+3 to −4 diopter)

Magnifying hood / Dual magnifying hood / CdS finder / Single-action focusing hood / Prism finder / CdS prism finder / Universal sportsfinder

Focusing screen
No. 2 Checker / No. 3 Rangefinder spot / Pro-S No. 1 Matte / No. 4 Microprism / No. 5 Cross-hair

Rear body cap

Pro-S Revolving adapter

P-adapter

M-adapter (horizontal)

M-adapter (vertical)

Focusing screen holder

Pro-S 120 roll film holder

Pro-S 220 roll film holder

* 70mm film holder

120 roll film holder
220 roll film holder
120 roll film holder 6 · 4.5

Double cut film/plate holder type J
Double cut film/plate holder type A

Plate holder adapter

Plate holder model 2 for Mamiya C

Film pack adapter

Roll film holder (6 · 7)

Roll film holder model K

Film sheath type J

Cut film/plate holder type J

Film sheath type A

Cut film/plate holder type A

Film pack adapter

Polaroid Land pack film holder model 2
Polaroid Land pack film holder M 80

Pistol grip model 2 / Grip holder / * Multi-angle grip

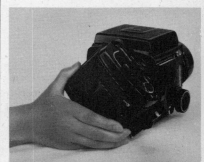

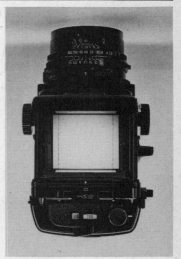

When the revolving adapter is positioned horizontally, red lines appear on the groundglass to indicate a horizontal picture format. When the revolving adapter is positioned vertically, the red lines disappear. Compose the picture within the broken lines on both sides.

VIVE LA DIFFÉRENCE

8×10

6×7cm

2¼ SQ.
(6×6cm)

35mm

With the 6×7cm format, you can enlarge—full frame, full bleed—to 8×10. Both 35 mm and 2¼ square (6×6cm) either have to be cropped to get to 8×10 or printed full frame with plenty of paper margin left over. The latter situation doesn't bother us, but then each to his/her own.

MAMIYA RB67 OPERATION DIAGRAM

1 Shutter setting condition

Shutter blade

Aperture blade

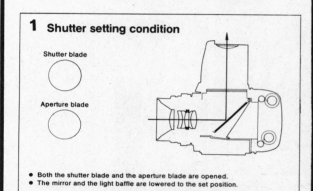

- Both the shutter blade and the aperture blade are opened.
- The mirror and the light baffle are lowered to the set position.

2 Just after pressing the shutter release button

Shutter blade

Aperture blade

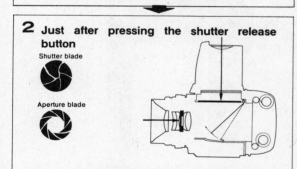

- The shutter blade is closed and the aperture blade begins stopping down.
- The mirror is raised and the light baffle starts rising.

3 Exposure

Shutter blade

Aperture blade

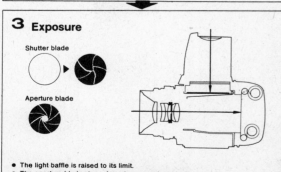

- The light baffle is raised to its limit.
- The aperture blade stops down to a preselected value.
- The shutter blade is closed after being fully opened.

A BIGGER BAT—THE PENTAX 6×7

1 Rapid wind lever
2 Shutter button
3 Shutter lock lever
4 Frame number control dial
5 Neck strap hooks
6 Safety device release button
7 Depth-of-field preview lever
8 Shutter speed dial
9 Accessory positioning button
10 Bayonet lock
11 Distance scale
12 Diaphragm scale

It is an over-sized 35mm, styled that way and used that way; you hold it at eye level and shoot in the time-honored 35mm tradition. Like most things big, it's heavy, so professionals who use it often find themselves putting it on a tripod. But then with all the miniaturization in our world, photographers are probably getting soft. If the Pentax 6×7 had been around when newspaper photo editors still had their prejudice against 35mm negs, hardened news photographers would have jumped at the opportunity to exchange their little Speed Graphic for this overgrown Pentax.

The contact sheets are brilliant, the kind clients like to see. If you promised your subjects a picture, simply cut up a set of contacts and voilà, "instant wallet-size."

Shoot negative color film and the color contacts are little gems. And while Ektachrome 2¼ × 2¾ transparencies won't fit your 35mm Carousel projector, they do yield superior quality color prints—in this, the age of do-it-yourself color printing.

Annual report photographers have used it. Wolf von dem Bussche, who has tried several different camera systems, worked with it for about eight months. "Very pleasing black-and-whites," was his expected comment. Why did he get rid of it? "A big klutz." Then again, Bill Owens used it as one of two cameras for his documentary study, *Suburbia*. He says he handheld the camera—which is just what we would expect from a guy who has been working as a newspaper photographer.

Honeywell Photo Graphic Inc./5501 S. Broadway/Littleton, CO 80120

Resembling a 35mm SLR camera, it takes roll film (10 frames on 120 or 21 on 220), which does not have to be rewound into its cassettes after the last frame is exposed. Just like the Kodak Brownies of yesteryear, the film is simply wound up onto the take-up spool and removed for processing. Light-proof paper, backing up the film, keeps the latent images in the dark. The normal lens, a 105mm, corresponds to the view of a 55mm lens on a 35mm camera. Interchangeable bayonet lenses with automatic diaphragms range from a 35mm f/4.5 fish-eye, to a 300mm f/4 telephoto. A single-stroke rapid-wind lever transports film and cocks the shutter. The electronically-timed focal-plane shutter synchronizes with electronic flash at 1/30 second. Shutter speeds run from 1 second to 1/1000 second and include "bulb" and a provision for making time exposures. The power source for the shutter is a six-volt silver-oxide battery with a lifetime of from 8,000 to 10,000 exposures. As with all electronic cameras, it's wise to have an extra battery in your bag. There are two additional interchangeable viewfinders besides the normal eye-level pentaprism finder—a rigid magnifying hood with an adjustable eyepiece to accommodate individual eyesight and a folding focusing hood with a hinged magnifier shown below. Both are handy for waist-level viewing. These hoods show the image right-side-up but reversed.

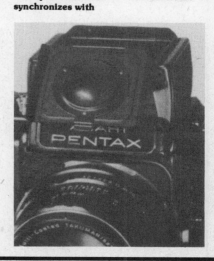

A PRESS CAMERA SHOULD BE JUST THAT

The most famous of all press cameras, the Speed Graphic, was designed to be more than just that. Evolving from the view camera—with its groundglass; double extension bellows; rising, tilting and laterally moving lens standard—it was promoted as a versatile camera that could take on any job.

The practicing photographer soon discovered that all these movements were cumbersome to use. That when changing from groundglass viewing to viewfinder viewing, he very often forgot to zero the controls and didn't get the framing he expected. And that the camera really worked best in hand—so much so that the Speed Graphic came to symbolize the working press photographer of the thirties and forties. With its rangefinder and shutter speeds as fast as 1/2000th of a second, it was a rapid-working hand camera that produced the larger negative they needed.

The lesson learned was that no machine can excell at doing everything, and a sensible press camera user today dispenses with the idea that it can. Both the Mamiya Universal and the Rapid Omega handle well and serve the documentary photographer, wedding photographer, or whoever feels the need to have a larger than 35mm negative. The fact that they both utilize roll film only makes them lighter and faster to operate than their predecessors.

The relatively wide distance between the viewfinder and rangefinder window makes for fast, accurate focusing of the Mamiya Universal camera. The holder handles both 120 and 220 film. There is no double-exposure prevention, since the film advance on the holder and shutter cocking are independent actions.

Bell & Howell/Mamiya Co./7100 McCormick Rd./Chicago, IL 60645

A variety of lenses from 50mm to 250mm with Seiko shutters mount on the Mamiya Universal camera and couple to the rangefinder. The viewfinder automatically corrects for parallex and adjusts for 100mm, 150mm and 250mm lenses. Accessory finders are needed for other lenses. The camera accepts a Polaroid pack holder.

Berkey Marketing/25-20 Brooklyn-Queens Expwy W./Woodside, NY 11377

Because the controls are large and neither the Mamiya Universal nor the Rapid Omega has a bellows (bellows vibrate in the wind and are easily damaged), they are good for aerial work since they provide large-format negatives with excellent resolution. When you are up in that plane, you can fire very fast with the Rapid Omega, even with the gloves on. Film advance and shutter cocking are coupled. A pull-push stroke of the advance knob with your palm transports the film, cocks the shutter and moves the exposure counter.

GRAPHIC GRAFLEX PHOTOGRAPHY
by Willard D. Morgan, Henry M. Lester and thirty-seven contributors
Morgan & Morgan/Dobbs Ferry, NY 10522/$16

Subtitled "The Master Book for the Larger Camera," this opus about two historic cameras and how to use them is still full of relevant information. It is a reprint of the eighth and last edition, which was published in 1952. Among the contributors are R. Kingslake ("Your Lens"), Ansel Adams ("A Design for Printing"), Lloyd Varden ("Ansco Color"), Laura Gilpin ("Portrait Photography"), Berenice Abbott ("Composition and the View Camera"), Barbara Morgan ("Photographing the Dance"), Frank Scherschel and Stanley Kalish ("News and Press Photography"). If experience *does* count, and we don't doubt it, you couldn't learn from a better group.

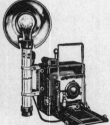

LENS-COUPLED RANGE FINDER FOCUSING

Out of Focus

In Focus

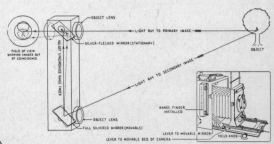

14. This drawing shows the working principle of the Kalart Lens-Coupled Range Finder. The small drawing at the lower right shows the Range Finder in position on a Speed Graphic Camera. Note how the bottom Range Finder mirror is adjusted. The small drawing at the left gives a very good idea about the double image and the single image, showing the out-of-focus and in-focus positions of the Lens-Coupled Range Finder.

ACCESSORIES

Some people seem to prefer accessories to fundamentals, a camera gadget to a camera and both to the process of taking pictures. It's understandable what with so many ingenious accessories that boggle the mind. For the photographer, however, a well-designed accessory—just the right camera strap, for example—can help keep cameras out of the repair shop.

Occasionally, things a photographer needs are borrowed from other activities. For example, the Jon-E Hand Warmer—the fluid burner originally intended for duck hunters and the like—is just the thing for Ron Galella (America's foremost paparazzo) waiting on a blistery winter's night for Jackie to exit from Twenty One.

Other photographers eschew accessories specifically designed for their trade—preferring a fisherman's bag to a camera bag or a briefcase if they travel and photograph among the tie-wearing set.

It's mostly a matter of getting the gadget that fits a need and a temperament. Some workmen work best with the fewest tools; but remember, next to loading film into a good camera, it's a comfortable pair of shoes that really counts.

This company makes the sturdy Adapt-a-Case line with its thickly padded partitions that can be re-arranged. They look like ordinary attaché cases and so are less tempting to would-be thieves.

Fiberbilt Products/601 W. 26 St./New York, NY 10001

Everybody knows that aluminum is light-weight and strong. The people at the company with the unlikely name of Zero Halliburton have done a series of cases (in black or silver) that are made as long as two feet, as wide as eighteen inches and as deep as seven inches. Don't get a black case. They absorb heat (especially in the sun), which is damaging to film and cameras. All are supplied with replaceable multi-layered inserts of polyester foam, which are accompanied by a layout template, knife and instructions so that compartments may be tailored to match equipment. Each item can be isolated from damaging shocks, yet each one remains easily, instantly accessible.

You don't have to have a gadget bag; you can wear a jacket with big pockets; but for sensible convenience this classic piece of luggage seems just right. It is of hand-waxed top-grain cowhide. The inside is fully lined and can be sub-divided.

En Garde Camera Bag Service Mfg./155 Saw Mill River Rd./Yonkers, NY 10701

GOODIES FROM CAPRO

This Capro three-way plug goes into the PC terminal. It's for connecting up extension cords to simultaneously fire multiple flash units.

Camera shake is a bane that can be lessened by holding steady, not breathing and squeezing gently. Capro's soft-release button for your Nikon should help.

Want to take your own picture from up to twenty feet away? Try this air release that screws into the cable-release socket.

Lintless gloves eliminate fingerprints on negatives. One size fits all. Ten to a package.

For all Capro products shown above: Ehrenreich Photo-Optical Industries, Inc./101 Crossways Park W./Woodbury, NY 11797

STRAPS

If you hang a strap around your neck, the camera bounces as you move along; if you hang it from a shoulder, then there is a danger it will slip off, especially if you have to bend over. Designers have faced these problems with middling success. Broad webbed straps, having a greater surface, stick to the shoulder fairly well. We like the idea of sewing on Velcro patches—one to the shoulder of a jacket, one to the camera strap. In practice, we find the epaulets of bush jackets and pit suits to be just the thing to keep a strap secure.

The Mac Strap sticks to the shoulder better than any other strap. The line includes straps for one and two cameras, for the Nikon with motor drive and for a camera bag. Shoulder sections, a unique patented design, keep straps from slipping.

Leedal, Inc./2929 S. Holsted St./Chicago, IL 60608

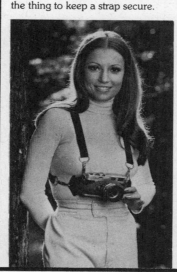

Kuban Hitch secures a camera to the chest so the camera doesn't bounce when running, hiking, etc. Rubber binders can be slipped off to free the camera for use.

Kuban Hitch/5280 N.E. Main/Minneapolis, MN 55421

UNDERWATER HOUSING FOR 35MM SLR

Ikelite of Indianapolis makes this plastic case with rubber gaskets so an SLR can be operated at depths of 300 feet. The case can be plugged into flash units, either strobe or bulb. Other accessories include three ports: a macro for short telephoto and the 55mm Micro-Nikkor lenses; a dome port for wide-angle lenses down to 17mm, and an extension port for long telephotos and the 55mm Micro-Nikkor with "M" ring. Several different thicknesses of rubber are supplied to obtain a good fit with almost any lens. A few very large lenses, like the standard f/1.2, will not fit the case.

Ikelite Underwater Systems/3303 N. Illinois St./Indianapolis, IN 46208

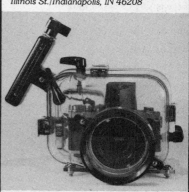

MADE TO ORDER

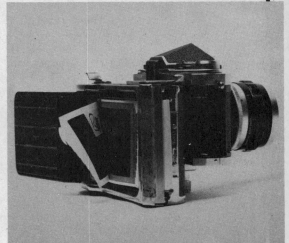

The most exciting part, if the least profitable, of a repair business is the camera modifications that professional photographers want. It's obvious that fixing broken cameras can become routine after a while. But always a new modification is a challenge, calling upon experience, intuition, high skill—in short, it's the creative part of the job.

Modifications are often desired because photographers are always pushing the limitation of their tools. And camera manufacturers eventually follow suit and incorporate these ideas in their future models, having learned that the key to the amateur market is through the professional.

In the early days, special mirrors were put on Hulchers for better focusing and motor drives adapted to the 250-exposure Leicas. There was never time to design from the ground up. Available parts were altered to produce a functioning, workmanlike prototype.

In the mid-fifties, studio photographers were making test shots with Polaroid cameras with Type 32 Polaroid roll film, ASA 400. Soon they were besieging repairmen to make adapters for their Hasselblads. Now, for pros who work with cameras that have removable backs, the neutral-density filter technique is used with Type 105 (ASA 75) in a pack-film adapter to get proper color-exposure ratings.

The photographer, though, who wants to use Polaroid film to test composition and exposure with his 35mm cameras, must still go to the modifier. Carl Fischer and Dan Wynn are two photographers we know of who are fortunate enough to have the roll-film back of the Polaroid J33 camera, which takes Type 32, mated to their Nikon Fs. Whether your repairman can do the same for you depends on his being able to still get J33s. If so, and if you supply the Nikon, the price should be about $300. It's worth the money. Imagine Polaroid testing in 35mm.

Dan Wynn, photographic illustrator, uses his Nikon F with a custom-made back to check for critical exposures—especially when he's using flash. It also provides a preview of the picture's composition. Wynn can spot necessary last-minute adjustments before shooting the take on normal film.

THE PROFESSIONAL'S PROFESSIONAL

If you ask a professional photographer in the New York area who a good camera repairman is, the answer you'll get is almost certainly going to be "Marty Forscher." And what is more, you detect in the tone of the answer, if not in a long addendum, that he is to be considered the *only* camera repairman. Now, you *know* there are others, but you also can understand that if your living depends on whether your cameras work, then you better go to the very best man you can.

After graduation from Stuyvesant High School, one of New York City's elite schools where entry is by competitive examination, Forscher went to work selling photographic paper and supplies. After a while he got bored and asked the boss to transfer him to the camera repair department, which in those days was considered a déclassé place to be. About a year later Forscher applied to join a special photographic unit in the Navy. The year was 1942; the unit was the one started by Edward Steichen, who was 62 years old at the time. In the unit were photographers Wayne Miller, Charles Kerlee, Fenno Jacobs, Horace Bristol, Victor Jorgensen, Barrett Gallagher, John Swope, Paul Dorsey and Fons Ianelli . . . and a camera repairman, Marty Forscher. Considering he hadn't had much experience, it is amazing that he was able to handle the job. What he did was to teach himself by completely stripping down one type of each camera used (Rolleiflex, Leica, Contax, Medalist, Speed Graphic). He put all the parts in a box, shook it up, dumped it out and began to reassemble them. "I developed a

Norman Snyder

familiarity with those cameras which remains with me to this day," he said.

After the war, he returned to New York with the woman he had married in Washington, D.C. Forscher knew the late Bennett Saltzman, the head of J.G. Saltzman, the manufacturer of enlargers, light stands, etc. "I was wondering," Forscher remembers telling Saltzman, "whether it would be possible to get a little money and some space to start fixing cameras, the sort of thing I did in the war." Saltzman, who had a penchant for helping people, showed Forscher a workroom, and when Marty asked "How much for rent?" Saltzman responded, "Fifty dollars a month, if you can afford it." The Professional Camera Repair Service began.

It wasn't long before the men of Steichen's Unit, some of them

already with the big picture magazines and services, began to bring him cameras. The company is now located at 37 W. 47 St. in Manhattan and today employs thrity people—twenty three of them, technicians.

Forscher has a fondness for the older mechanical cameras and believes a great deal is lost for the professional by the shift from mechanical to electronic operation. In short, he regrets the manufacturers' compulsion to make cameras ever easier to operate. "Performance has been victimized by the photographic explosion of the sixties. With so many companies reaching out for super sophistication in design to attract the mass market, it was inevitable that economies would be sought in production methods to keep prices low and competitive. Stampings instead of machined

parts—reduced thicknesses in critical areas—plastics in place of metal, even reduced-tolerance controls in some cases. It is, therefore, understandable that the breakdown factor for equipment in the hands of professionals is much higher today than it was in the past."

The change in camera technology has made a difference in how the repairman works. Years ago there was no special camera repair or testing equipment, so Forscher had to build his own, thereby developing skills which probably wouldn't be learned now because needs have changed, and certain testing can only be done by sophisticated electronic equipment. For example, we remember taking lenses to Forscher to be checked. He put them down on his bench and examined them by *eye*; from experience he was able to detect optical aberrations. A factor here is that lens quality varied a great deal in the old days, and quality control was not very good. Also, it used to be that a lens designer would have a concept, then three years would be spent checking out the mathematical formulas. Today, with computers, it only takes seconds; besides, the computer can be so programmed that it even improves on the designer's concept.

As with all kinds of technology, change has been the one constant. Forscher might not like it, but he has kept up. As for the would-be camera repairman, Forscher suggests going to school, because the skills needed are "sophisticated enough so that they ought to be learned in a classroom." There aren't many to choose from. He suggests the National Camera programs at Englewood, Colorado—but if you are willing to work as an apprentice, there are opportunities for on-the-job training even at Professional Camera Repair.

A PRO CHECK

If you are a professional and you take a camera to Marty Forscher's, you will get a C/L/A job—clean, lube and adjust. The cost—two to three hours at $25 per hour, plus parts. If you depend on your camera to feed yourself, then Forscher feels you should see that your equipment gets a C/L/A once a year. It's good insurance, for all the ways to lose a photo, camera failure is the most frustrating.

To bring the camera up to factory standards here is what happens:

- Complete strip down
- Parts washed
- Worn parts replaced

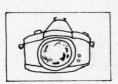

- Reassembly with lubrication where required
- Check/Adjust/Align—shutter speed, body-and-lens, focus mechanism, built-in meter, flash synchronization. (In the case of an SLR, particular attention is paid to the workings of the stop-down diaphragm, which is susceptible to malfunction, causing exposure failure.)

If you are an amateur, a seriously interested knowledgeable photographer who takes pictures for an avocation, Forscher recommends a C/L/A/O/A/N, which stands for clean, lube, adjust, *only as necessary*. Your camera is physically inspected; if all is working well, the charge is $6. If, in his estimation, adjustments are necessary, you pay only for the work performed. Trust him.

Proper Care of the Camera:

● Cleaning the Camera Body

Moisture, dirt, and dust are harmful to your camera. Use a camel hair or blower brush to remove external dust from the camera and inside of the film chamber. Use silicone cloths to wipe and remove dust particles from the surface of the instant-return mirror simply by brushing, you should not attempt to clean the mirror yourself with tissue and cleaning liquid. Only an authorized serviceman should undertake this delicate task. Actually dirt on the mirror has absolutely no effect on the quality of your photographs.

● Cleaning the Lens

If the lens surface is not clean, the picture will come out with flare and low contrast. Dirt remaining on the surface of the lens for a long period of time may permanently injure the surface. Usually, optical glass is softer and more subject to abrasions than ordinary glass. Therefore, care and maintenance is most important. General cleaning procedure should be as follows: First, blow off any loose foreign matter by using camel hair brush specifically made for lens cleaning. Followed by using commercially-available lens cleaning tissue and good quality lens cleaning liquid. Put one or two drops of cleaning liquid on the tissue and lightly wipe the lens in a circular motion from the center toward the outer edges. Do not use a handkerchief or silicone cloth, which may permanently scratch the lens element.

● Storing the Camera ●

● A camera is not in use for an extended period of time should be stored in the manner listed below:

- Leave the shutter uncocked.
- Remove all batteries. Store them in a cool and dry (not cold) place.
- Clean all fingerprints, moisture, or dirt from the camera body and lens.
- Take the camera out of its eveready case and wrap it up in a soft towel and pack with silica gel to keep it dry.
- Store camera in a cool and dry place.

THE CAMERA CRAFTSMAN
Editor: Ann McLendon
National Camera
Englewood, CO 80110

If you want to be a professional camera repairman, National Camera operates a school (both resident in Englewood and by mail) to train you, and, it publishes this magazine to keep you up to snuff, in what is a fast-changing trade.

Cameras are not just reviewed but analyzed down to the most minute nut. It is intended, after all, to be followed step-by-step, right at the workbench. It is also a small businessman's trade journal with articles such as, "How to Make a Customer Pay Up." Help wanted ads are placed free.

A straightforward, unpretentious journal for a craft that didn't much exist when National Camera began twenty-four years ago.

Subscription: Order from publisher/every other month, $5

Besides training camera repairmen and publishing *The Camera Craftsman*, National Camera markets tools and equipment for testing and repair through its catalog *The NC Flasher*. Among hundreds of items (anvils, brake switches, etc.) the Comparascope, which checks all functions of photographic equipment, caught our attention; the price did, that is, $1,375.

The Star Tester, shown, gives accurate readings of shutter speeds at an economy price, $179.

Service Tips for Japanese Cameras and Where to Get Them Fixed

When you are experiencing an operational problem with your camera, you should never attempt to disassemble or repair the camera by yourself! If the camera ceases to function properly, it should be serviced by an authorized repair facility.

When you are sending equipment to the repair facility, please note the following in order to expedite the period of repair and benefit for both of us.

- When requesting in-warranty service, attach the warranty card or copy of sales slip for proof of warranty.
- Write a note explaining the trouble in detail, together with a sample print or negative.
- If the camera has suffered light water damage in the past, please notify us because when we prepare our regular estimate, we will not disassemble the camera. In such cases, there is a possibility of misestimation and sometimes requires adjustment later on, thereby causing double time in repair.
- Shipments should be packed to withstand the hazards of transport. Often, heavier pieces of equipment are not adequately packed. Whenever possible, use the original shipping carton with the inserts. If the original carton is not available, place the equipment in a container large enough to allow plenty of space for packing material. We suggest that you take out insurance for all packages in sending them to factory service centers and authorized service facilities.

HONEYWELL-PENTAX	HONEYWELL PHOTO PRODUCTS 24-30 Skillman Ave. Long Island City, N.Y. 11101 212—392-4300
ASAHI	ASAHI OPTICAL (AMERICA) INC. 15 East 26th Street New York, N.Y. 10010 212—532-4876
BELL & HOWELL	BELL & HOWELL CO. 2201 Howard Street Evanston, Ill. 60202 312—491-6800
CANON	CANON USA INC. 10 Nevada Drive Lake Success, N.Y. 11040 516—488-6700 (Manhattan Service Station) 600 3rd Ave. (39th St.) N.Y.C. 212—697-9720
COPAL **SEKONIC**	COPAL CORPORATION OF AMERICA 56-01 Queens Blvd. Woodside, N.Y. 11377 212—779-5252
ELMO	ELMO MFG. CORP. 32-10 57th Street Woodside, N.Y. 11377 212—626-0150
FUJICA	FUJI PHOTO FILM USA INC. 341 Michelle Place Carlstadt, N.J. 07072
KAKO	KAKO STROBE AMERICA INC. 24-12 Jackson Avenue Long Island City, N.Y. 11101 212—392-7868
KONICA	KONICA CAMERA CO. 25-20 Brooklyn-Queens Expressway Woodside, N.Y. 11377 212—5455-2998
KOWA	BERKEY MARKETING CO., INC. 25-20 Brooklyn-Queens Expressway West Woodside, N.Y. 11377 212—932-4040
MAMIYA	BELL & HOWELL/MAMIYA CO. 2201 Howard Street Evanston, Ill. 60202 312—491-6800
MINOLTA	MINOLTA CORPORATION 101 Williams Drive Ramsey, N.J. 07446 201—825-4000
MIRANDA	AIC CORPORATION 168 Glen Cove Road Carle Place, N.Y. 11514 516—742-7300
NIKON **NIKKORMAT** **NIKONOS**	EHRENREICH PHOTO-OPTICAL INDUSTRIES 623 STEWART AVENUE Garden City, N.Y. 11530 516—248-5200
OLYMPUS	PONDER & BEST INC. 58-20 Broadway Woodside, N.Y. 11377 212—672-9500
PETRI	PETRI INTERNATIONAL CORP. 150 Great Neck Road Great Neck, N.Y. 11021 516—466-4111
RICOH	BRAUN NORTH AMERICA 55 Cambridge Parkway Cambridge, Mass. 02142 617—492-2100
SANKYO	SANKYO SEIKI (AMERICA) INC. 149 Fifth Avenue New York, N.Y. 10010 212—260-0200
YASHICA **CONTAX**	YASHICA INC. 50-17 Queens Blvd Woodside, N.Y. 11377 212—446-5566
ZENZA BRONICA	EHRENREICH PHOTO-OPTICAL INDUSTRIES 623 Stewart Avenue Garden City, N.Y. 11530 516—248-5200
(GENERAL)	CAMERA DIVISION JAPAN LIGHT MACHINERY INFORMATION CENTER 1221 Avenue of The Americas New York, N.Y. 10020 212—997-0452

a. Rotating knob to remove format frame.

b. Shutter

c. Tripod-locking lever

d. Clamping knob

f. Locking lever for coarse tilt

g. Fine-focusing drive

h. Rise-and-fall drive

i. Shift drive

k. Swing-and-tilt drive

k' Change-over lever
Position H tilts
Position V swings

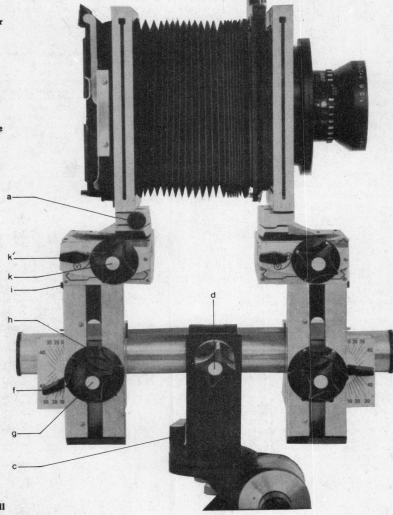

When not in use and broken down into rails, standards, holders, bellows, lenses, frames, the full meaning of a *system* begins to unfold. The rail clamp, which attaches to a tripod, grips the camera's monorail. The monorail takes screw-in extentions of six, twelve or eighteen inches. For photomacrographs, rails have been extended for as much as twelve feet. Top left, the film holder with a groundglass screen frame, which fits into the image standard (rear). The interchangeable lensboard with lens fits into the lens' standard (front). Both standards are rack-and-pinion operated, which provides fine adjustment of the swings, tilts, shifts and focus. Metric scales make possible the keeping of precise records. For wide-angle work, when front and rear standards are close, the folding bellow is replaced by the bag bellows, which does not interfere with camera movements.

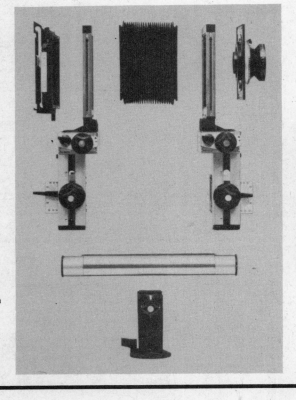

FOR THE PHOTOGRAPHER WHO KNOWS DR. SCHEIMPFLUG

For seventeen years, Carl Koch, general commercial photographer in the town of Schaffhausen, Switzerland, kept a data card on every single photograph he took. When Koch analyzed his equipment, he decided it was not efficient for his task, so he conceived of and began to build the first Sinar. Today, twenty years later, we have the Sinar-p, designed by a working photographer and the heart of a sophisticated modular system.

It's a professional tool, and studio photographers will have enough extra rails, frames and bellows in the system to make up two or three cameras. Why? So that set-ups awaiting client approval can be left undisturbed. On the other hand, the components can be combined to effect a huge optical bench for macrophotography or for working with extremely long focal-length lenses.

In the advertising world, art directors expect photographers to follow their sketches. Most of the time the relationship of sizes or space is mostly exaggerated and doesn't conform to the laws of perspective (the camera is the original perspective machine). However, the Sinar is capable of taking on limitless configurations; for the photographer who knows what to do with camera movements, the picture can be distorted. Large can become small, or oval can be made round. In fact, the studio photographer serving advertising and editorial clients has to be a magician. Products float, glow, shiver and shake or, rather, they appear to. Many of these tricks are done by retouchers, but just as often the photographer is called upon to deliver the special effects. As the mind churns to solve photographic problems, the Sinar's capabilities become a factor, even a creative catalyst—along with everything else. Multiple exposures with micrometer displacement of the film or tilts of the image plane between exposures . . . anamorphic lenses, those used for Cinemascope film in front of a Sinar shutter . . . or maybe a mat box, bellows extended in front of lenses, masking out shapes in the picture. The photographer is limited only by his own imagination.

E.P.O.I/101 Crossways Park W./Woodbury, NY 11797

With the Sinar/Copal shutter, view camera work becomes semi-automatic. The shutter remains open for viewing and focusing and closes automatically when a film holder is inserted.

The shutter eventually pays for itself, since lenses in a barrel without shutters are cheaper. It attaches to the back side of the lens standard and has shutter speeds from eight to 1/60 second.

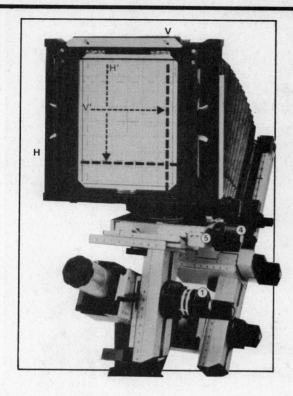

Revolutionary and unique, both front and rear standards of the Sinar-f tilt and swing around a stationary axis (H) and (V), which are clearly marked on the groundglass. This invention takes much of the trial and error out of employing the Scheimpflug principle to increase "depth of field" without stopping down the lens. The idea is to change the normal plane of focus to conform to the requirements of the subject—for example, a tile floor which recedes away from your point of view. The Sinar reduces this technique to a mechanical operation. First focus a point in the image on the H axis. Now tilt the camera back until the image is also sharp at H.' Read off the tilt angle and return back to the original position. Transfer the tilt angle to the lens standard by tilting in the opposite direction. Finesse the focus. Swings can be done the same way using the V axis.

The binocular magnifier attaches to the bag bellows, eliminating the need for a focusing cloth.

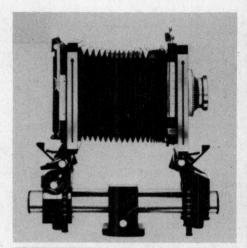

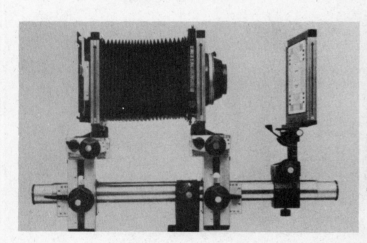

Components of all Sinar models are completely interchangeable. In the illustration (left), the rear standard of the Sinar-f, with its fine focusing drive, becomes a convenient copying stage for the Sinar-p. This kind of set-up is particularly good for critical work, since any camera movement is similarly transferred to the subject.

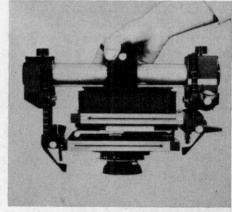

The Sinar-p belongs in the studio. For field work the Sinar-f is more practical. It's lighter and can even be folded up. All its components—its multi-purpose standards and bellows—are useful accessories to the Sinar-p and can be bought in anticipation of a studio business.

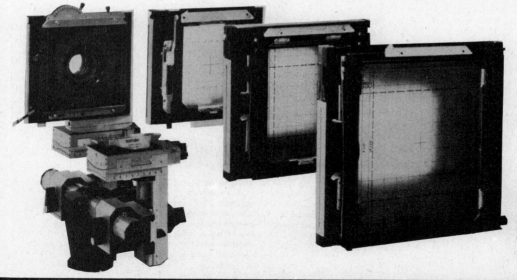

The special standard bearer, which incorporates all the camera movements, allows you to assemble the camera as either an 8×10 or 4×5. (5×7 too, but who shoots 5×7?)

THE OLDER BROTHER

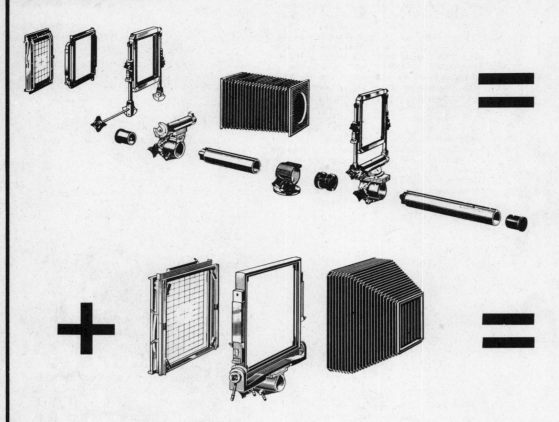

Carl Koch did not invent the monorail view camera—Joseph Petzval made one in 1857—but he did follow the principle of modular construction. His first camera design, the Sinar Standard, is still compatible with the Sinar-p. The rail, standards, bellows—all mate with the latest models. This is not to say that it is not a good design in its own right. The Sinar Standard is beautifully machined of light aluminum alloy and can be folded into a neat package. No longer manufactured, it is in demand; Norbert Kleber of Foto-Care in New York says there is even a waiting list. A used 4×5 Standard, which cost $400 in 1970, costs about $500 today. By comparison, you can buy a new Sinar-p for $1375 and a Sinar-f for $500. All cameras take the Sinar Copal shutter with the automatic feature described on page 34.

The old Sinar 4×5 could also be converted to an 8×10 camera. Starting with the same lens standard, an 8×10 frame, groundglass and tapered bellows completes the conversion. Cost today for the rear assembly, $650 used.

VIEW CAMERA TECHNIQUE
by Leslie Stroebel
Hastings House/New York/$19.50

You can't tell a book by its cover, but you sure can tell a lot about it by its author. Stroebel is a professor of photography at the School of Photographic Arts and Sciences at the Rochester Institute of Technology, and he co-authored *An Introduction to Photography* with C.B. Neblette. *View Camera Technique* is well-illustrated, with eleven chapters that cover view camera types, evolution of the view camera, applications of view cameras, focusing and camera movements, lenses and shutters, films, filters, exposure and exposure meters. It is indexed, of course. Stroebel writes clearly and concerns himself with both the advantages and disadvantages of various camera designs: "The camera bed serves as a support for the lens and back standards. Flatbeds, which were used on most of the early view cameras, have now been largely replaced by monorails. There are manufacturing advantages in the monorail, since it is less complex, with a single support bar and single focusing track The desire to keep the weight of view cameras as light as possible is not compatible with maximum rigidity, although the use of lightweight metals has helped to satisfy these two objectives."

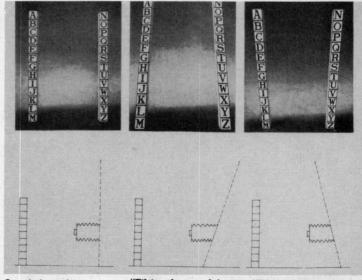

Stroebel on tilting: "Vertical subject lines are rendered parallel when the camera back is in the zero position, parallel with the subject."

"Tilting the top of the back away from the subject causes vertical lines to converge toward the top of the print. This creates the illusion that the camera has been lowered."

"Tilting the top of the back toward the subject reverses the direction of convergence. The camera lens is still level with the center of the columns."

NEW DIMENSIONS FOR SUPER WIDE-ANGLE PHOTOGRAPHY

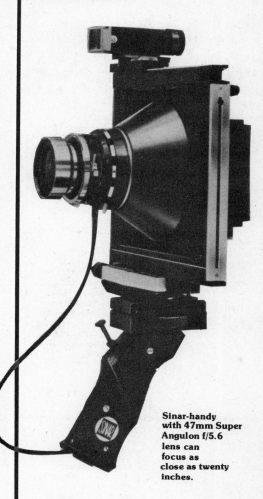

Sinar-handy with 47mm Super Angulon f/5.6 lens can focus as close as twenty inches.

The Sinar-handy is one of the world's sexiest looking cameras—and if you're into 4 × 5 film, it'll excite you in other ways as well.

The camera is designed around a series of special helical-focusing Super Angulon lenses. When it's mated with the 47mm lens, you get a 100° angle of view, which completely covers a sheet of 4×5. By comparison, you'd need an 18mm lens on a 35mm camera to achieve somewhat the same effect. Of course, 4×5 film offers a greater choice of emulsions, plus a larger image area, critical in extreme wide-angle photography when a picture's individual elements are greatly reduced.

The Sinar-handy is dandy for interiors, and you can also obtain stunning surrealistic effects with it.

The machine weighs less than four pounds with the lens. It has a two-way spirit level to help you align the film plane with the subject. The camera can be used in hand with an optional pistol grip and viewfinder.

As a bonus, the Sinar-handy is compatible with the Sinar-p view camera system.

Ehrenreich Photo-Optical Industries, Inc./ 623 Stewart Ave./Garden City, NY 11530

SO DON'T LET THEM KID YOU, A CAMERA DOES COUNT

Ken Kay, an advertising illustrator, says "I got my first Sinar in 1955. For me, there was nothing *ever* like it . . . it transformed my work. I was an industrial photographer at the time with Bethlehem Steel and taking countless construction pictures. The Sinar meant no more recessed lensboards and changing apertures with a pencil and a mirror. Also it was light, and I didn't have to *schlep* so much around. An assistant didn't go with that job. Then in 1971, I was asked to work on the view camera section of the *Life Library of Photography*. I heard there was a new Sinar, the p. I got the first one in the U.S. We featured the camera, and I've used it since."

In his Sinar system, Ken Kay does not use camera lenses but enlarger lenses—Schneider Componons because they are of "spectacular quality . . . because they are color-corrected and matched more exactly than any camera lens . . . because they are designed to operate from flat field to flat field, as my pictures are." Regular lenses are designed for infinity work; enlarger lenses, for a 1:10 ratio, which is generally the maximum at which he works, sometimes doing tight close-ups greater than 1:1. The Sinar behind-the-lens shutter makes this approach possible since enlarger lenses don't usually have shutters.

Don Myrus

Ken Kay (above) made the shot below for a chapter opener on sewing techniques. Art Director Virginia Gianakos provided a sketch and instructions that the **elements should "move" to suggest work. Ken, who bills about $100,000 per year, used multiple-exposure technique to solve the problem.**

Ken Kay is very realistic about just how important any particular camera is to getting a job done. He tells the story of Hy Peskin, the sports photographer, many years ago going to Yankee Stadium on a dare with a Brownie. "Hy came back with the most incredible pictures, considering that Brownie. He had a slider just hooking second, a third baseman leaping for a line drive, all that sort of thing, taken just at the peak of action, that mini-second between the end of upward thrust and the beginning of the downward fall. Hy must have had fantastic reflexes to have been such a great sports photographer. It's difficult work, I know. The hardest job I ever did was cover a prizefight, tense every moment for a punch that would mean a picture. I did all right, but I'll tell you one thing about cameras, if Hy had covered that fight with a Brownie and I had covered it with a Hulcher, bang . . . bang . . . bang, there is no way that even Hy would have gotten the better pictures. So don't let them kid you, a camera does count; even in the hands of a top professional, it can make the difference."

How did he get into the business? "After my Bethlehem Steel days, I realized the ambition of my youth, to shoot for *Life* magazine. But I found out that wasn't for me, that I didn't like living out of a suitcase. I went out and bought every magazine I could find and discovered that the most pictures used in the expensive ads were still lifes. For two years, I shot a roll of Kodachrome every day of a different still-life setup. I taught myself. Which was stupid. I could have learned twice as much in half the time had I gone to work as an assistant to a real pro."

Now Kay shoots mostly in large formats. Advertising agencies almost always prefer a 4×5 or 8×10 sheet of film for products. And since he specializes in complicated still lifes, there is no need for the rapid, improvisatory work of small-format photography. Thus, his fondness for the Sinar system. It is a case of the workman praising his tools.

37

TOYO VIEW CAMERAS—AH SO

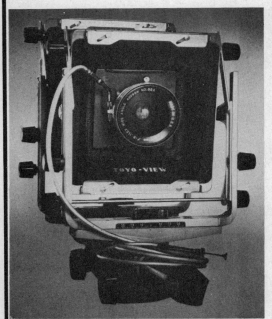

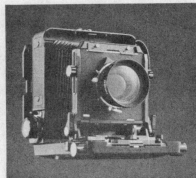

The Japanese, who virtually created the 35mm SLR market, are now here with low-cost view cameras that not only work but work well. Outstanding for value and features are the Toyo twins, a matched pair of 4×5 cameras. The D45A is the only system monorail reaching the U.S. with a price tag under $400. The slightly more expensive D45M offers geared rise, fall and shifts, a revolving back and modular monorails.

Toyo's field cameras pack large-format advantages into small, easily carried bodies. If mobility's your bag, but you're unwilling to sacrifice large-format quality, the answer may lie in a compact, bed-type, folding camera. Like a turtle, the Toyo 4×5 field camera pulls in its head to protect its fragile optics. Sacrificed are extensive back rises and shifts and long bellows draw, valuable in the studio. Gained are ruggedness, fast setup and the ability to throw a camera and a few holders into a shoulder bag for an afternoon's ramble.

A large camera will slow you down, make you think, discipline your seeing and build up your back, as well as your portfolio.

Burke & James, Inc./44 Burlews Ct./Hackensack, NJ 07601

The best thing about the D45M is the rack-and-pinion mechanisms of the vertical and lateral movements, which hold any position without locking. Unlike most cameras in this price range, the

Toyo has a 360-degree revolving back that allows for precise framing of unusual shots without tripod movements. Bellows are interchangeable to take all focal length lenses.

The lunchbox-sized Toyo field travels easily and safely in rough going. It weighs a bit over five pounds, takes lenses from 65mm to 300mm, has convenient and powerful locking controls and costs about the same as a good 35mm. Toyo also makes an 8×10 folder with 24 inches of bellows, with an interchangeable and reversible back. It takes lenses from 65mm to 600mm. Weight is fourteen pounds; price is over $1,000. It's not for dilettantes. But what 8×10 is?

CAMBO, A DUTCH TREAT

Here is another monorail camera—modular, with all parts (including bellows and back) interchangeable. Monorail cameras, which permit greater flexibility for corrective photography (shifts, tilts and wide-angle lenses), are best suited for studio work but can be taken on location.

Focusing cloths are forever falling to the floor or flying away in the wind. By setting a couple of grommets at one end of a cloth it can be conveniently anchored to the rear standards of a Cambo. Slip holes over the standards vertical members and you've dealt the nuisance factor of focusing cloths a severe blow.

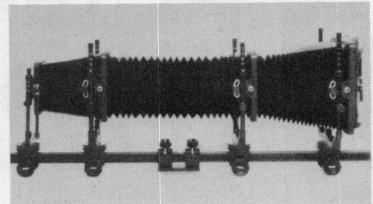

Burleigh Brooks, Inc./44 Burlews Ct./Hackensack, NJ 07601

Cambo is a monorail design. Rails, which can be joined together, are available from four to forty inches. Standards for 8×10, 5×7 and 4×5 all fit on the same rail. Additional bellows can be added, too. Theoretically, the system could be extended indefinitely to get macro pictures, but there is a practical limitation—the rig starts to shake.

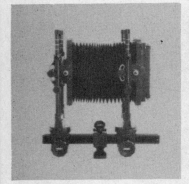

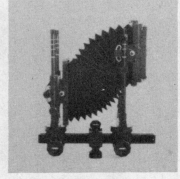

Centered: The Cambo at rest. All controls are centered. Spirit levels on front and rear standards help align the camera.

Rise & Fall: Both standards move in a vertical direction. The illustration shows the camera in a "look-down" position. In this position, the parallel sides of an object will not converge when photographed from above. It's a common setup for still life product shots.

Tilts: Back and front standards tilt across the central axis. Center tilts are convenient on lens standards for shifting the plane of focus.

Shifts: Both standards shift left and right. The ability to shift the rear standard is a great convenience when composing in the frame—the simple way to center a picture without moving the camera.

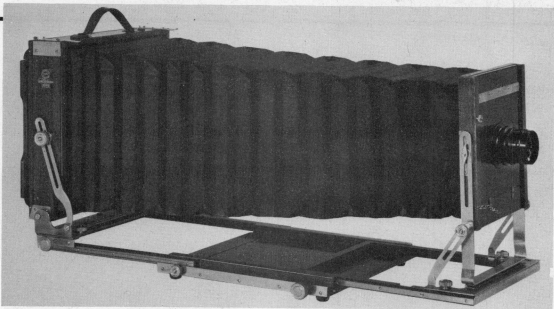

OLD WORLD CRAFTMANSHIP ON PEORIA STREET IN CHICAGO

The Deardorff factory in downtown Chicago has a nineteenth-century feel about it, a small group of workmen and women seriously going about their jobs of handcrafting the extended flat-bed folding view cameras (4×5, 5×7, 8×10, 11×14) that have been used all over the world since the 1890s. The camera was created by L.F. Deardorff, who died in 1952. His son Merl took over the company, and he has been joined by a third generation Deardorff, Jack.

There is no automation, and production is slow, due to exacting quality control. The innovative accounting practices preached at the Harvard Business School find little acceptance by Merl. For example, he will not cash a check made in advance payment for an order until he has in hand receipt of delivery—sometimes weeks having passed in between. It may be old fashioned, but such integrity is reassuring.

The Japanese are heavy buyers of the camera, which in fact could mean a lot of things but probably means that they —being experts themselves—value meticulous work. And because Deardorffs are in short supply, there is a considerable used trade among professional photographers. A Deardorff isn't likely to wind up in a closet. Being of wood, they can be repaired and refinished easily.

The Deardorff catalog, itself inspiring

Bellows, fully extended here, resist sagging; the tripod socket is in the center of the main bed. **Bellows can be folded and the camera closed for easy carrying. See below how wide-angle lenses can be** positioned close to the film plane with normal bellows. A sliding front panel allows for either look-up or look-down photography, although the bellows is tightly compressed. At right is a reducing back that permits the use of 4×5 film on an 8×10 Deardorff.

confidence with its tone of certain authority, proclaims that the cameras "are strongly built and especially designed for precision photography, yet the weight is always kept at a minimum consistent with good engineering practice. The materials used in the construction are Central American Mahogany, Brass, Steel, Aluminum Alloy, and all springs are made of Phosphor Bronze . . . The extra-quality Cabinet Work is a mark of distinction." Right.

*L.F. Deardorff & Sons, Inc./
11 S. Des Plaines St./Chicago, IL 60607*

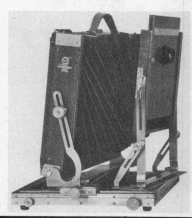

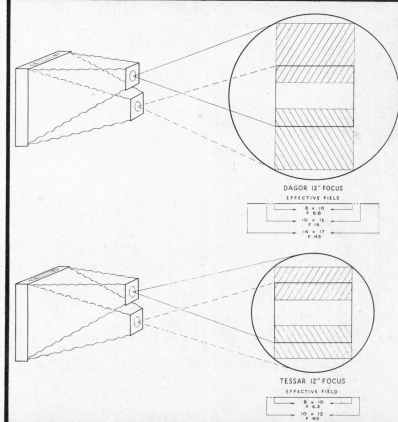

DAGOR 12" FOCUS
EFFECTIVE FIELD

| 8 x 10 F 6.8 |
| 10 x 12 F 16 |
| 14 x 17 F 45 |

TESSAR 12" FOCUS
EFFECTIVE FIELD

| 8 x 10 F 6.3 |
| 10 x 12 F 45 |

CORRECTIVE PHOTOGRAPHY
by Lewis L. Kellsey
L.F. Deardorff & Sons/Chicago, IL/out of print

This small book is so tastefully written and put together that it fills one with nostalgia for the time when bookmaking, like camera-making, was still an art. If you come across a copy, grab it.

LENSES THAT HAVE GREAT COVERING POWER; FOR EXAMPLE:

Fig. 66

THE DAGOR, 12-INCH EQUIVALENT FOCAL LENGTH

The circle of illumination and area of critical definition in this type of lens are very large, as seen by the diagram. This type of lens, in the 12-inch focal length, is listed to cover an 8 x 10 plate at f/6.8, a 10 x 12 plate at f/16, and a 14 x 17 plate at f/45. Because of its great covering power, the lens or plate may be moved much more than is possible with other types of lenses of the same equivalent focal length.

LENSES THAT HAVE MEDIUM COVERING POWER; FOR EXAMPLE:

Fig. 67

THE TESSAR IIB, 12-INCH EQUIVALENT FOCAL LENGTH

In this type of lens, the circle of illumination and the area of critical definition are smaller than in the Dagor. The Tessar IIB, in the 12-inch focal length, is listed to cover an 8 x 10 plate at f/6.3, and a 10 x 12 plate at f/16. It will not cover larger sizes than 10 x 12 even when stopped to f/45. The lens or plate may be moved, but the amount by which either may be moved is restricted more than in the case of the Dagor.

LINHOF'S KARDAN B

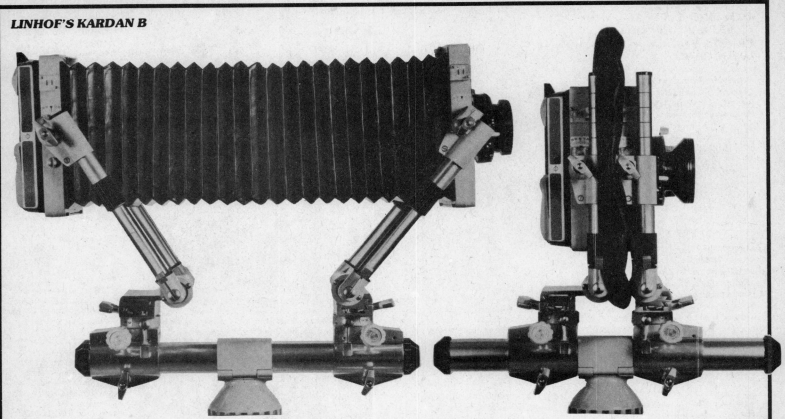

This is the most luxurious monorail-system view camera ever made. The finish, detailing and choice of materials are superb.

The Linhof company long considered the virtues of central (axis) tilt over base tilt. The first Kardan utilized base tilt; later models, central tilt. Central tilt is convenient where a lot of work involves application of the Scheimpflug rule. Base tilt is important for steep downward or upward shots. In this position, vertical displacement of lens and back can be made without disturbing focus, since the image plane does not shift and the image remains sharp. The Linhof Kardan B incorporates both tilting systems. And that's not all that has been designed into this camera. The B can be trimmed for wide-angle work, using lenses as short as 65mm on flat boards, while remaining balanced on its central tripod support. Yet when the need for longer extension than provided by the basic monorail arises, front and back standards can be kneed out with their base tilts and resquared with their central tilts. The B does not mechanically restrict the use of modern wide-field optics. (It's hard to imagine a lens with more covering power than the camera can accommodate.) The B has gear-driven horizontal shifts, telescoping rise and falls locked by collets, slide-in format-changing adapters. What's more, it has revolving, reducing and carriage backs; roll-film holders; focusing devices; interchangeable bellows; boards; compendiums; filters and hoods; tripods and accessory stands; even adapters for enlarging. Finally, the B, like other monorails, can grow up to an 8×10 and out to more than forty inches. It weighs only 8½ pounds.

How much? The basic outfit, without lens, has a list price of around $1,700.

HP Marketing/98 Commerce Road/ Cedar Grove, NJ 07009

As shown above, the Kardan B, the classiest of view cameras, can stretch out for a long shot and pancake in for a wider view. The ability to make rapid extension movements easily speeds lens changes and eases work. Precision levels, scales, central click-stops, convenient and secure locks and coarse and fine focus make for a comfortable camera, fast to work with on location and in the studio.

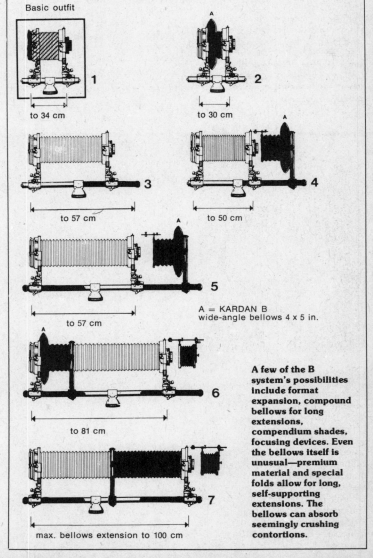

Basic outfit

1 — to 34 cm

2 — to 30 cm

3 — to 57 cm

4 — to 50 cm

5 — to 57 cm

A = KARDAN B wide-angle bellows 4 x 5 in.

6 — to 81 cm

7 — max. bellows extension to 100 cm

A few of the B system's possibilities include format expansion, compound bellows for long extensions, compendium shades, focusing devices. Even the bellows itself is unusual—premium material and special folds allow for long, self-supporting extensions. The bellows can absorb seemingly crushing contortions.

4×5s AND 8×10s FROM CALUMET

Calumet Scientific, Inc./1590 Touhy Ave./ Elk Grove Village, IL 60007

Compared to other monorail cameras (Sinar and Linhof, for example) Calumets are a lot less expensive. Without a lens, you can get a 4×5 for about $180. The result is that Calumet sells most of the view cameras in the world.

A small studio photographer could buy three 4×5s and still not spend anywhere near what he would for those brilliantly designed and meticulously engineered systems from Europe. The three he might buy are the 4×5 with a normal sixteen-inch double-extension bellows, the 4×5 with extra-long twenty-two inch triple-extension bellows and the 4×5 wide-field camera, which has a short bellows. There isn't much a photographer so equipped couldn't do. If he feels the need for larger format, or his clients do, there is the Calumet 8×10, a flat-bed view camera, which also takes the 4×5 backs. It is priced at about $600.

These studio workhorses and mainstays of photography schools are sturdily made of die-cast aluminum alloy, and they fold up and have a handle so they can be carried on location.

The weak points are that there is no rise on the back, bellows can't be interchanged (that's the reason for buying three cameras) and the 4×5 backs are not removable (though Calumet does make a roll-film holder).

The 4×5 monorail, far left, has a rise-and-fall lensboard, front-and-back swings and front-and-rear side shifts. The camera back revolves 360 degrees for quick-format alignment. There are separate horizontal and vertical spirit levels to align the back. Focusing is by drive mechanism inside the monorail. Calumet view cameras are noted for rigidity. 8×10 is a flat-bed view camera with a bellows that can be extended thirty-four inches.

The first sketch, near left, shows the 6×6 opening of the 8×10 Calumet's lensboard. The middle sketch shows the board fitted with a recessed adapter so that lenses mounted in a 4×4 lensboard (the size used by the 4×5 Calumet) can be attached. The sketch at far left shows how a super recessed lensboard may be added for 90mm and 65mm lenses so that the lenses fit back into the bellows and, therefore, can be focused.

PHOTOGRAPHY
by Phil Davis

Wm. C. Brown Company Publishers/ Dubuque, IA/cloth, $14.95; paper, $9.95

This book came out at the right time: in 1972, when formal instruction in photography in high schools and colleges was just cresting. The author served the new audience very well. He put together a large-size, spiral-bound primer using the time-tested technique in text books of subheading just about every new thought. What's important in this case is that the approach works. It is not only possible to learn photography—equipment, processes, principles, famous examples—but to enjoy while doing so.

"If you are a beginner in photography (and art), you are probably a fairly typical product of this culture . . . Most disastrously, you are probably blind—not in a functional sense, but in the ability to perceive. The ability to see is the most important single qualification that a photographer can have. In the normal procedure of taking a "straight" picture, a photographer will see his subject, visualize it as he would like it to appear, then select the variables of the process to make the visualized image. This is called previsualization."

Even if you don't own a Technika, the multifocal finder (shown in the accessory shoe and at the bottom of this page) will enable you to quickly get the best viewpoint and lens choice. Before using, it is important that the rotating scale for the parallax compensation be set at infinity. The tube is then pulled along the scale until it audibly clicks into the required focal length. For parallax compensation with subject distances nearer than 100 feet, the range is set on a rotating scale beneath the eyepiece. Interchangeable slip-on masks are provided for various formats.

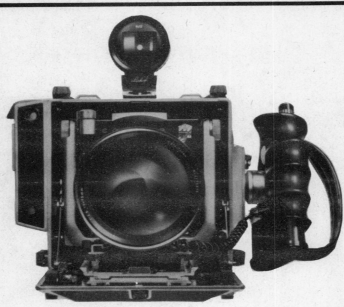

THE APOTHEOSIS OF THE TECHNICAL

The whole point about the Master Technika is that it is intended to be an all-purpose "universal" camera, something we don't believe really possible; although we do recognize that if you want to make 4×5 pictures in the field (including fast work) and in the studio (including macro photography) and you want the same camera for both purposes, well, this is some machine.

Specifically, it has a built-in, coupled precision long-base dichroic rangefinder; distance scales and cams to match each rangefinder-coupled lens—they are interchangeable; a flap on top of the camera housing for increased wide-angle efficiency; a lift lever for vertical displacement of the lens standard; fully adjustable swing back; revolving universal groundglass back with focusing hood; cable release incorporated in the hand-shaped grip and thirty-five accessories, from a focusing hood to a Polaroid film holder.

HP Marketing/98 Commerce Road/ Cedar Grove, NJ 07009

At left, is a top view of a Technica skewed full right to tackle an oblique subject plane. Enlarged back and front movements rival monorail performance.

For wide-angle works, the Technika can handle lenses as short as 75mm, rangefinder-coupled, without dropping the bed.

Hand-finished diamond-cut triple tracks permit stable macro work without adding parts to the basic camera.

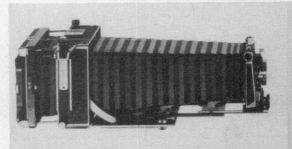

LARGE FORMAT PHOTOGRAPHY
by Joachim Giebelhausen and Herbert Althann
Verlag Grossbild Technik/Munich, Germany/$39.50

This combination catalog (of the Linhof line) and camera work manual is superbly illustrated with photographs, charts, diagrams and technical drawings. If you are thinking of large-format photography with Linhof equipment, you would be foolish not to get a copy. It is that sort of required book that is also a pleasure.

As an introduction to photographic technique, it covers all the expected topics and does so with clarity. For example, in the chapter "Optical Equipment," under a subhead "One Lens is Not Sufficient," the authors tell us there is no "dream" lens.

"There are, it is true, so-called universal lenses available which can cope, with reasonable accuracy, with many jobs, but are incapable of an absolutely first-class performance in any one of them. Users of large-format cameras rightly expect

exceptional perfection. . . . It is therefore obvious that the possession of only *one* lens must severely limit the range of professional work which can be undertaken."

Verlag Grossbild-Technik also publishes *International Photo Technik,* a lavish technical magazine.

large format photography

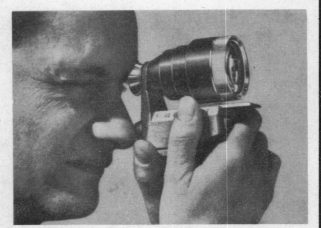

Fig. 92. The multifocus optical viewfinder is also useful detached from the camera for subject selection.

Vertical lines of tall buildings can be kept parallel with the film plane by making use of the Technika's front and rear tilts and hinged body top; the latter allows full rise even with short focal lengths.

CAMERAS/specialized

WIDENING YOUR HORIZONS

Remember those monstrous banquet-circuit cameras that captured in one photograph gatherings like the guests at a wedding thrown by Don Vito Corleone? The Widelux is the modern portable version of that camera, with a 140° field designed for wide, basically static compositions. Unlike the photographs you get with wide-angle lenses, though, the Widelux employs a unique moving lens to produce panoramas that do not diminish the subjects.

Its 26mm lens sits in front of a curved film plane. When activated, it travels in an arc, wiping the image onto the film.

The Widelux uses 35mm film, though its 24 × 59 mm frame size means you'll get only 21 exposures on a roll designed to give 36. Color slides need special mounts, which can be shown on a standard 2¼ inch projector.

Because the lens takes time to completely expose a frame, even at the camera's fastest setting of 1/250, the Widelux is impractical for most conventional reportage, and if you want to be sure of a sharp landscape or group portrait, you should use a tripod.

The Widelux has potential as a creative camera. Unfortunately, so far few photographers have used it as imaginatively as Gjon Mili—while photographing the stained glass windows of Chartres Cathedral in France, Mili set up the camera vertically and got almost the entire nave into one picture.

Harrison Camera/249 Post Ave./ Westbury, NY 11590.

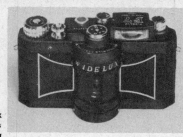

The turret of the Widelux houses a lens that rotates on its nodal point during exposure to make 140° pictures.

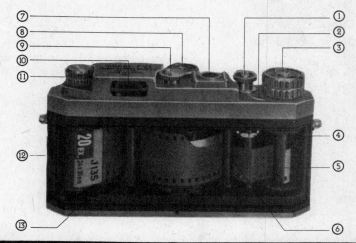

1 Shutter-release button
2 Frame counter
3 Film-transport knob
4 Film-sprocket gear
5 Film take-up spool
6 Forward film-guide roller
7 Spirit level
8 f-number indicator (aperture)
9 Shutter-speed dial
10 Viewfinder
11 Film-rewind knob
12 Film cartridge
13 First film-guide roller

PHILLIP LEONIAN: IN THE TRADITION OF YANKEE INGENUITY

Leonian, a successful free-lance photographer with a strikingly handsome studio on Fifth Avenue, knows more than most about the importance of constantly emphasizing his specialty, which for him is photographing motion. To this end, Leonian designs and has craftsmen build specialized cameras and high-speed repetitive flash units. "A month doesn't go by that I'm not doing somebody running, somebody jumping or somebody walking." And at very high prices, we might add—as high as $2,000 a day.

So as not to give away trade secrets, it was with some reluctance that he finally agreed to talk about and show us his "Cherry Bomb" . . . the camera that he uses once in a while . . . an exotic machine, a tool that allows him to make photos others can't. He even told us of a fantasy: "I dream of taking one picture of the St. Patrick's Day Parade. Imagine it—one picture a hundred-feet long and three-quarters-of-an-inch high of people marching."

"This is a real mutt," says Phil Leonian, owner and user of the streak camera called the "Cherry Bomb." The streak camera has no shutter and the film moves past a slit; it's sort of like the camera used to record a photofinish at the racetrack. Leonian's Cherry Bomb has a Nikkor lens, a Canon lensmount with a Bell & Howell Converter-N adapter and a Leitz magnifier. The body is a Hulcher modified by Norman Goldberg, technical editor of *Popular Photography.* Next to it is an electronic box that regulates the speed of the film.

This photo is unretouched. The box was not tampered with, except to be rotated. It is an example of what Phil Leonian can do with his "Cherry Bomb"—the streak camera made from a modified Hulcher. The shot was delivered the day phosphates were banned; the ad of course was killed.

Leonian at his specialized best: photographing motion with powerful repetitive strobes. High-speed repetitive flash was developed by Harold Edgerton, a scientist.

THIS CAMERA CAN GOBBLE UP TWO ROLLS OF TRI-X IN JUST 1.1 SECONDS

Perfected as a tool for science, industry and the military, the Hulcher can take 65 frames per second; the ball dropping into the water below was shot at 50 fps.

A number of still cameras today can expose film sequences faster than a speeding bullet, but none is as portable and as relatively affordable as the 35mm Hulcher 112.

It was precisely to photograph such high-speed actions as bullets being fired that Hulcher developed a still camera with the extraordinary capability of accurately taking between five and sixty-five exposures per second. Why this instead of a movie camera? Movie film is exposed by a rotor as it glides past the lens. The results are clear if you project the print, but the image on any single frame is blurry. The Hulcher has a shutter, and it uses an ingenious mechanism to stop the film for each exposure. The result: a print as sharp as that made with a conventional 35mm camera.

The camera was originally designed in the 1950s to allow the analysis of such impossible-to-study actions as hummingbirds humming or golf balls compressing when struck. But since then, news photographers covering NASA launches and sports

cameramen like John Zimmerman have found decidedly nonscientific, nonindustrial uses.

Hulchers must be custom-ordered. The basic 112 body, which weighs 3½ pounds, takes Nikon lenses and holds 100-feet film spools. By adding accessories like beam splitters and timing lights and specialized gear like fiducial marks and an infinitely variable speed control, you can easily double this camera's $1,700 base price.

Charles A. Hulcher Co./ 909 G St./Hampton, VA 23661

Photographer John Zimmerman admires fast-firing Hulcher, which he uses to cover sports.

THE MP-4 COPIER

Have you ever had to make accurate photographic copies of pictures with a standard view camera? It's a tedious routine of aligning, lighting, framing and focusing, a drill that the Polaroid MP-4 System shortens immensely.

The System comes in three models, and as you can see, each comes with umpteen accessories. For the best setup, begin with the XL model. This includes a camera body, four lights, two electrical outlets, a baseboard and a column twenty inches taller than the standard model's. Add the all-purpose 105mm lens and the self-cocking shutter.

Also order the 4 × 5 Land film holder. The MP-4 can accommodate most standard holders, but it was really designed for Polaroid film. For "instant" prints you will be limited to the 4 × 5 format, but Type 55 Land film will yield a conventional b/w negative that can be enlarged.

Finally, get the sliding camera head with reflex viewer. When you slide this head into the view position, the shutter automatically opens for framing and focusing. When you slide the head into the take position, the shutter closes and the film is positioned for exposure.

The MP-4 System comes with two sets of calibrations that in time can make copying even faster. A scale engraved on the camera column marks camera position, while a scale on one focusing column marks the bellows extension.

By noting the position of these scales, as well as exposure time and lens reproduction ratio, you'll have a chart that will make copying a piece of cake.

One last note about Polaroid: the company has great customer relations. It maintains a phone—(617) 547-5176—that you can call collect on business days between 9 am and 5 pm with questions about the MP-4 or, for that matter, any Polaroid product.

Polaroid Corporation/549 Technology Sq./Cambridge, MA 02139

To increase image size To decrease image size

To increase image size (left), lower camera and increase bellows extension until subject is sharply focused. To decrease image size (right), reverse the movements. A homemade chart correlating previous camera and bellows positions speeds accurate placement of these elements on the MP-4's scaled columns.

The versatile MP-4's accessories allow micro- and macro-photography, slide-making and veloxing.

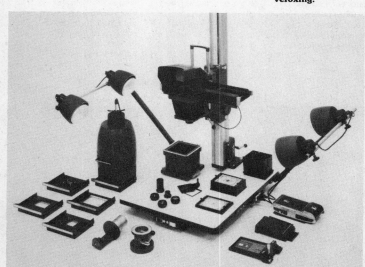

Universal self-cocking shutter accepts any of the MP-4's five available lenses. Its speeds range from 1 to 1/125 seconds.

GORDON LIDDY TOOK THIS CAMERA TO WATERGATE

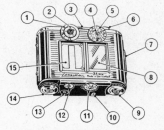

1. Diaphragm scale
2. Exposure counter dial
3. Sliding lens cap
4. Depth-of-field indicator
5. Distance scale
6. Release button
7. Catch of backlock
8. Groundglass
9. Winding knob
10. Rewind release lever R
11. Shutter speed dial
12. Synchronization dial
13. Flash contact
14. Rewind knob R
15. Accessory shoe

Both portable and precise, the subminiature Tessina uses standard 35mm film which can be bought in special thin cassettes to fit in the 2½ × 2 × 1 inch camera.

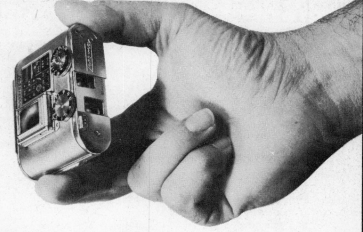

A few seasons back, a TV hero carried the ultimate spy camera—it was planted in one eye socket. But until fact catches up to fiction, the Tessina is the machine that dirty tricksters, including the Watergate bunglers, prefer, for it's tiny enough to slip into a pack of Camels with room left over for some camouflaging butts.

The camera has a 25mm lens and a groundglass viewing system that lets you frame and focus accurately. It's driven by a spring motor good for some eight shots per winding. Though you spool it onto special cartridges yourself, the Tessina uses 35mm film. This yields economy—about 70 shots per 36-frame roll—and a 14 × 21mm negative you can process with standard equipment. It's possible to get excellent quality 8 × 10 prints with the Tessina using Tri-X film.

Options on the $300 camera include an exposure meter, a very practical pentaprism viewer and, if you're really into spying, nylon gears that make the machine virtually silent.

The Tessina is obviously more than just a toy for Junior G-Men; it's an ideal camera to keep on you for that unexpected moment. If you're tempted, check with used camera departments—the spy business today seems to be in a depression.

Karl Heitz/979 Third Ave.
New York, NY 10022

STILL GOOD EVEN WHEN IT'S ALL WET

Nobody has ever taken good pictures inside a Turkish bath, but it hasn't been for want of the right camera—the Nikonos II, primarily designed for undersea photography, shields its mechanisms and film from both moisture and foreign particles with a series of "O" rings.

This camera is popular with scuba and snorkel divers for several reasons. It is far more maneuverable than the traditional submarine housings for dry-land machines. It accepts two special Nikkor lenses—one 15mm, the other 28mm—that are ground to compensate for underwater distortions, as well as 35mm and 80 mm lenses that can be used both in and out of water. You can wield the camera with one hand, since the same lever advances the film, cocks the shutter and takes the picture. And the machine is built with a slight negative buoyancy so that when you are underwater, it won't begin to float up toward the surface.

The Nikonos II is good for more than just underwater work. In fact, many photojournalists whose closest contact with water comes when they mix it with Scotch carry this as an emergency camera in their kits. The Nikonos II has typical Nikon durability. In addition, they've found that the same gaskets that keep out the sea also protect the camera's working parts from such occupational hazards as snow, sand, tropical humidity and dust.

Changing film underwater doesn't work.

E.P.O.I./101 Crossways
Park W./Woodbury, NY 11797

Operable down to 160 feet, the Nikonos II and its similar successor, the Nikonos III, have shutter and film carrier in an inner body sealed by gaskets.

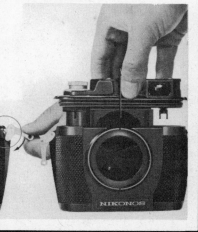

ARTIFICIAL RESPIRATION FOR A DROWNED CAMERA

When the seaside joker yells "shark," you just happen to be up to your neck in surf, running off the last few frames of a roll with some artsy shots of your friends on shore. Well, you've seen the movie, so you stumble for land—and drop your camera into the drink.

What to do?

If the camera is insured, pray that the tide's going out—salvaging it won't be cheap.

But if you don't have a policy, fish the camera out and immediately dunk it in fresh water to stop the corrosive effects of salt. Now you face the same problem as if you had dropped the machine into a lake or stream: that is, a wet camera.

When you get home, heat your oven to 120°. Without rewinding your film, unload it in darkness. Even if the camera seems dry, bake it for 15 minutes, lens and all. Then take it as soon as possible to your repairman and let him clean out any sand that remains and lubricate those parts crying for oil.

Meanwhile, your film can also be saved if you handle it properly —when one movie company's Arriflex fell into the Atlantic, technicians used the fresh-water immersion technique to save valuable footage that ended up in the final cut of *Jaws*.

CAMERAS/buying and selling

BUYING A CAMERA
WHAT'LL IT BE—SCHLOCK OR SERVICE?

There are two kinds of camera stores for the advanced serious amateur and the professional: one gives personal service, the other the lowest price in town.

To a professional photographer, personal service can be very important. If he is out-of-town and needs a special item, and if he has a camera store man who knows what it is and will see that it's air-freighted to him quickly, that's worth money, surely worth paying a little extra for film, chemicals and all the rest of those continuing things that the local "class" store makes its profit on. Then, too, the local friendly man who knows your equipment and how you work will keep an eye out for new products that will interest you and for a used camera or lens, maybe even a used enlarger. If you have a question, "What's the price of the widget?" he'll find the answer.

When *Life* magazine was in its glory and the now-closed Royaltone had its camera and equipment business, the photographer was treated as handsomely as any Victorian gentleman by his tailor. Eliot Elisofon, for example, would order a lens and three would be sent to him, on a pick-the-one-you-like basis, return the other. If anything was bought and, within a reasonable time, decided not to be right, it was taken back—no questions asked, "Sir." In a world where everybody seems to be getting all they can for as cheap as possible, it's surprising to realize that salespeople can be cherished, that there are still women who buy clothes in small shops or in exclusive departments, and who are so appreciative of the service they get that they give presents to the saleslady. We even know of a man who bought a car and was so pleased that he could get just what he wanted that on delivery day he gave the salesman a bottle of Scotch. Price isn't everything. If you are interested in that new camera, or you are not quite sure just which one you want and you don't feel like schlepping around all over the countryside or up and down city streets, then visit the "class" place. You won't get soaked, but you *will* pay more. Care and consideration take time and, in the retail business, time is money.

Don Myrus

It's axiomatic, a store must sell at a profit. Leitz' standard discount to dealers is one-third off list. Other manufacturers have discounts that run higher; an average is said to be forty percent. So how much can a dealer afford to take off? If he'll arrange for repairs, if he'll exchange on a warranty (send the deficient piece of equipment back to the manufacturer), if he'll deliver without charge and all that sort of thing, the answer is that because he too has to make a living, not more than twenty percent will come off list, even if you cry.

But you can get it for less. Where? In the schlock house. How come? Volume, manufacturers' special-discount deals and long-term credit from manufacturer to dealer.

A dealer who wants to go into the fast turnover business has got to have a big enough money bag in the beginning and the smarts to buy for as little as he can, often selling for not much more than he paid, sometimes even less. He advertises this fact and then, like flies to the honey pot, the customers come.

The big dealers charge ten percent above their *cost,* sometimes only five percent, and you better believe it that that is shaving it pretty close. Of course, their *costs* are less than those of the neighborhood store. Manufacturers give allowances for advertising, for buying twelve, more off for sixteen, lots more off for a hundred. None of the big discount houses, not big-city stores or mail-order houses, can survive unless they buy the biggest discount deals. If it costs less for a carload of camera cases, they all buy a carload. Then, there is the matter of credit. It is said that at times Kodak has required C.O.D. payments from as many as sixty percent of the small stores. Yet, high-volume dealers from some photographic distributors

This adventurous figure was seen to make a purchase in 47th Street Photo, the nonpareil discount house, and then to sputter away on his motorcycle. Who is he? None other than Jason Schneider, senior projects and research editor of *Modern Photography.*

get as much as ninety days' credit. That's money in the bank, drawing interest. The customers rush in, pay cash; the dealer has all this money for as long as three months—the short-term interest could help his profit picture. In any case, he cuts it thin to your advantage, making good cameras and equipment widely available at the lowest prices.

If you don't mind being just a cancelled check after the transaction, see the back pages of the photo magazines for the advertisements of the big discounters. Of course, they sell by mail, so anyone, anywhere, can buy.

SHUTTERBUG ADS

Publisher: Glenn Patch
Patch Publishing Co.
P.O. Box 730
Titusville, FL 32780

This 11½ x 17½ inch monthly newspaper calls itself "the national market for anything photographic, amateur, antique"—which is not an exaggeration, as you'll see from studying the tightly packed pages of "for sale" and "wanted" ads. Considering that *Shutterbug Ads* is a shopper's newspaper, it is handsomely designed and well-illustrated with photos. As for the ads, they cover all sorts of cameras and lenses, new and used—"antique and classic." Aerial and

underwater equipment, books, pictures, etc., are also bought and sold.

One often wonders just how careful to be when buying or selling through a mail-order newspaper, such as *Shutterbug Ads.* The publisher, Glenn Patch, addressed himself to this very question in a brief note in which he wrote: "There are a few people who appear unable to go through life without having a hassle over every deal they encounter. If you are this type of person, we prefer not to handle your ad business. Thus far, *Shutterbug Ads'* subscribers have earned a reputation of being extremely honest and helpful. Let's keep this reputation. We will not knowingly publish a classified or commercial ad of which we have information

that the individual or firm is not reputable and fair. If you answer an ad within *Shutterbug Ads* and encounter dishonest treatment, please let us know. If there are several legitimate complaints, we will refuse future advertising and if a subscriber, cancel their subscription."

Subscription: $13 for one year

FOR YOU, A NICE LITTLE CAMERA STORE?

The word—unofficially, of course—from a group of technical reps, the people who are paid to know, is that you could, if you were daring and maybe a bit desperate, start a camera store for $30,000 and a good credit rating. It wouldn't be much of an operation, not anywhere in the league with those mammoths who discount their discounts; but you could make a nice, modest living. There are other limitations to this minimum-investment business. You won't be selling expensive equipment. The photography business isn't a consignment field, and your capital would go to keep the rent paid, the lights on, an occasional ad inserted in the local small-town paper, or a handbill distributed, if in the city.

If you elect to open up in a big city, you won't be affected by the really cutthroat competition since it comes over high-ticket items—the expensive cameras and lenses, which you won't be selling, anyway. If you get a place where there is lots of foot traffic (or in the country, ample parking), your customers will run in, drop off film, and then be back the next day to pick up their satin-finish prints. They'll look through the package and decide, probably, to buy some

more film. At this point, you just might sell them a Kodak Instamatic, or maybe a Polaroid Pronto. Business might not be booming, but your developing and printing will pay for your rent and lights. Cameras, accessories and other supplementary items (books, photo magazines) can put you in the black.

A level business head is what you need, not a vast knowledge of photography. Since a $160 Konica is likely to be the most expensive camera you'll be selling, there is no need for you to have been a camera assistant in a studio studying the Sinar. The reps we spoke to say that most small camera-shop owners know very little when they open up. But you have to start somewhere, and it's possible to learn on the job.

One of the problems the new small business fellow has is that Kodak won't give a franchise to sell film or equipment until a store has been in operation for six months *and* has paid its bills. Even then Kodak will only bestow an "amateur" status. The modifier doesn't refer to your photographic ability or that of your customers, only to the fact that you are not allowed to handle the entire line—so you can't attract the professional. You sell Kodacolor instead of Kodachrome Professional, those little introduction-to-the darkroom kits instead of

Cubetainers of Ektaflow. Polaroid operates similarly. It has been said that the big fellows are even known to have salesmen who require that you handle an entire "amateur" line, instead of just what you think you can sell. But don't despair, while you are waiting for your "amateur" or "professional" standing to be established, you can go right ahead, assuming customers and capital are available, by buying from the wholesalers. You might not even pay much more. The wholesalers operate on a two-percent margin—the spread between what they can get it for at the manufacturer's price tag and what you would get it for, if you could. What's the drawback? You can't play with the big boys—the slashers who sell in such volume that manufacturers give them "performance" deals of all sorts.

Before you risk your $30,000 plus—you should have a bit of a cushion—you might be wise to take advantage of a service offered by none other than Kodak. The company has a school for would-be dealers; when you pass through it successfully, you get a diploma that should certainly give you some sense of security. You will *know*, maybe not enough, but you will know. Sooner or later customers will begin arriving who will know, too. Then you'll have more than a nice, little business— you'll have a place for photography fans.

THAT OLD MAIL-ORDER MAN, RICHARD WARREN SEARS, WOULD HAVE LIKED THIS ONE

The Multi-image Repeater records the subject naturally on half the film area, and creates up to five parallel secondary images on the other half. A rotating mount allows the positioning of the Repeater half of the attachment at any angle. At $24.84 to $39.84, depending on the lens.

"For our part, we would just as soon that manufacturers gave away their 35mm cameras; that way we'd sell more accessories, especially lenses," so half-kiddingly says Bernie Danis, vice-president of Spiratone, a thirty-five-year-old retail and mail order company that in the last few years has been sending out a comprehensive catalog of its accessory offerings. Going through one is quite an event.

It used to be fashionable among the truth-and-beauty types to smile self-satisfyingly when in the presence of the gadget-collectors, the equipment "nuts." But we suspect that even the sort of print collector who never gets a warm feeling holding an old Leica will have a very good time looking at all the paraphernalia, some of which is remarkably ingenious. And when he gets to the back pages, he's in for even a more pleasant surprise. Spiratone now offers a selection of books from the Laurel Photographic Book Catalog, which itself lists 1300

books. If you spend $1 with Spiratone you get the Laurel Catalog free.

Danis claims several factors account for the company's success. For one thing, Spiratone ads in photography magazines take up more space than those of many competitors—space being important because merchandise can be better explained, and a customer who understands what he is ordering is less likely to be disappointed when it arrives. As for price and quality, Danis says Spiratone can charge low rates because the company imports its lenses directly. As for quality, the company has inspectors in Japan at four major lens makers. "That way we get the grade A optics," he says. All this sounds about right to us, but we recommend comparison shopping; look at all the ads, and always remember the Latin saying, caveat emptor.

Spiratone/135-06 Northern Blvd./Flushing, NY 11354

The Spiratone Recordate is an example of the sort of accessory that you have been able to live without. But why continue to, if you really have to know when you took that picture? Or as the ad says, "Its adjustable rotating mount permits placing the date record unobtrusively in the corner of the image area; a simple focus control produces a sharp date record regardless of how you focus the camera lens." It's available to fit standard screw-in mounts up to 62mm and Series VII. $34.95; flash adapter, $1.95.

STARTING AND MANAGING A SMALL RETAIL CAMERA SHOP
by Morrie Bragin

U.S. Government Printing Office/Washington, DC 20402/G.P.O. Bookstore/paper, 80¢

This is one of the volumes in the Small Business Administration's "Starting and Managing Series." It doesn't pretend to tell you all you will need to know in order to get a camera store started well, but it does point out some of the problems and areas about which you should inform yourself, and it suggests where you can go for more information. In a once-over, somewhat generalized manner, it speculates on your chances of success, discusses other competing businesses (mail-order houses, drugstores) and reviews the types of camera shops. It also covers points important to all beginning small-businesses: getting money for the venture; choosing a location; buying an old business or starting anew. There are chapters on buying and pricing, selling, record-keeping, advertising and publicity.

Morrie Bragin is an owner-operator of a photo shop in New York City.

REGISTER YOUR CAMERAS: A STORY WITH A MORAL

Photographers, as a class, are peripatetic, traveling from country to country, continent to continent—the contemporary equivalents of the old-fashioned journalists, complete with trench coats. Since photographers work with tools (very often elaborate rigs) they need to carry a lot of baggage and often to purchase new stuff wherever the job happens to be, which means they pass through the bureaucratic world of trademarks, registrations, import regulations and duties. The photographer inexperienced in international travel should take heed; others have learned, some the hard way.

We know a photographer who went to Japan a while back. It was to be a one-month assignment and he decided, why carry all that stuff when I can buy new there? In a camera store in Tokyo he made his purchases, in those days at 360 yen to the dollar, very much the rich American. He bought two black Nikon Fs and nine Nikkor lenses (a fish-eye, 21mm, 35mm perspective control, 35mm automatic, 55mm micro, 85mm, 135mm, 200mm, 300mm and an aluminum camera-equipment carrying case. He did the job and started home. Port of entry was Honolulu; his cameras didn't make it in, not there, anyway.

Nikon and Nikkor are trademarks registered with the U.S. Customs Service, in those days by the American importer, Ehrenrich (now E.P.O.I.) who, as many importers, consented to let travelers bring in a limited amount for personal use. At that time the limit was one Nikon, one Nikkor; now it is three Nikons (with their lenses) and six interchangeable lenses (see chart below). The importer can give special permission, but Ehrenreich refused. After two days, Japan Airlines wisely turned the problem over to American Airlines, who got a change of venue, so to speak, by shipping the cameras to Kennedy Airport. For strategic reasons, it was decided not to take the one "legal" camera and one lens from the others, but to try to save all. In New York, the photographer's friends, skilled manipulators and string pullers, interceded and somebody gave in. Duty was paid, the cameras released. Had they not been, they would have been impounded and sold at auction.

After it was all over, the lot was priced in New York City. Twice as expensive. The moral? A helleva chancy way to save a buck.

The chart below is from the booklet, "U.S. Customs Trademark Information," which is available from the U.S. Government Printing Office, Washington, DC 20402. The list of trademarked items changes frequently.

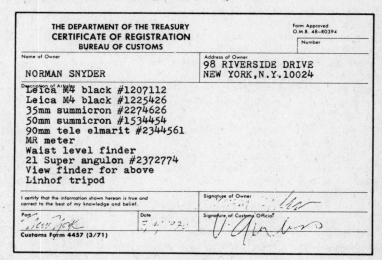

THE DEPARTMENT OF THE TREASURY
CERTIFICATE OF REGISTRATION
BUREAU OF CUSTOMS

Form Approved O.M.B. 48-R0394

Number

Name of Owner: NORMAN SNYDER

Address of Owner: 98 RIVERSIDE DRIVE NEW YORK, N.Y. 10024

Description of Articles:
Leica M4 black #1207112
Leica M4 black #1225426
35mm summicron #2274626
50mm summicron #1534454
90mm tele elmarit #2344561
MR meter
Waist level finder
21 Super angulon #2372774
View finder for above
Linhof tripod

I certify that the information shown hereon is true and correct to the best of my knowledge and belief.

Signature of Owner

Port: New York
Date: 5/4/72
Signature of Customs Official

Customs Form 4457 (3/71)

All foreign-made cameras and lenses are dutiable each time they are brought into the country and, if trademarked, subject to impounding—unless you have acceptable proof of prior possession. To obtain a certificate of registration, write U.S.

Customs for form O.M.B. 48-R0394 (see above). Fill it out and take it with the listed items to a customs officer for signature. He's not always easy to find at an international airport. Have him paged. Allow time. You won't be sorry.

cameras, binoculars, lenses, optical goods, and photographic supplies, etc.

Accura [4]
Aires [1]
Airequipt
Alpex [1]
Altuca
Ansco [1]
AO [1]
Arca-Swiss
Argus [1]
Art-Craft
Asahi Pentax [5] *
Astro
Atco

Balda [1]
Binoctem
Binolux
Biotar
Bolex [1]
Bronica [8] * *
Bushnell Triple Tested [1]

Cadillac
CamBinox
Carrera [1]
Cinerama
Color-Matic
Consol
Contaflex [1]
Contarex [1]
Contessa [1]
Contina [1]
Craig
Crown

Dekarem
Deltrintem
Design Omega
 (Greek Symbol)

EB in circle design [1]
Electromatic
Elevator
Etienne Aigner
EXA [1]

Fastair
Flektogon
Flicker Flame
Fotorite [1]
Foto/Tone [1]
Fujica [1]

Gossen [2]

Hambletonian and design
Heliotron
Horvex [1]

Industrial Instruments Inc. and design
Ionetics

Jelco

Kalimar [1]
Kelvilux
Kollsman [1]
Komura [3] *
Konica [4]
KW in design

Lafayette
Leica [1] *
Leicaflex [1] *
Leicina [1] *
Leitz [1] *
Leitz, Inc., E. [2]
Liberty
Lightomatic
Lithagon
Lunasix [2]

Makro-Plasmat
Mamiya [3] *
Mamiyaflex [3] *
Mariner
Mecablitz [4]
Mecatwin [1]
Metz [4]

Minicord [1]
Minolta [1]
Minox [3]
Minox & Design [5]
Miranda [1]
Mirroscope

Navitimer
Nikkor [6] *
Nikkormat [6] *
Nikon [6] *
Nikonos [6] *
Novar [1]
Novoflex

Olympus [1]
Opiatron
Ozafax
Ozalid

Pan-Cinor [2]
Pancolar [1]
Pan-Tachar
Pentacon [1]
Pentax [4] *
Photocorder
PML
President
Prinz in design
Prism and Lens Design [6]

Radiant
Rangemaster [1]
Regula [1]
Rexo
Ricoh [1]
Ricohflex [1]
Riviera
Robot
Royal [1]

Schneider Kreuznach [1]
Seafix [1]
Silvarem [1]
Soligor [1]

Speedex
Stellar
Steinheil Sohne GmbH, C.A. [1]
Stylophot
Swift in design [1]

Takumar [5] *
Taron
Tasco [1]
Tasco in design [1]
Tasco Imperial in design [1]
Technicolor
Technirama
TelXtender [4]
Topcon [1]
Topcor [1]
Travegon [1]
Travenar [1]
TTL [4]

Ultrablitz

Varotal
Victory
Vivitar [1]
VXII α

Weltax
Welti
Weston
Whitehall
Wild Heerbrugg [1]
Winsum

Zenith [1]
Zenza Bronica [2] *

Note: All trademarks, unless appearing on articles produced within the United States, not followed by an explanatory footnote are prohibited without written specific consent of the trademark owner.

[1] No restriction on any importation of trademarked merchandise.

[2] One article of each named trademark may be imported if in the owner's possession upon entering the United States, and if for personal use and not for sale.

[3] One of these cameras (including a lens attached to the camera) and two interchangeable lenses of each named trademark may be imported if in the owner's possession upon entering the United States, and if for personal use and not for sale.

[4] Two articles of each named trademark may be imported if in the owner's possession upon entering the United States, and if for personal use and not for sale.

[5] One camera (including a lens attached to the camera), one projector, and one each of any accessory of each named trademark may be imported if in the owner's possession upon entering the United States, and if for personal use and not for sale.

[6] Three still cameras (including the lenses attached to each camera), three movie cameras, three binoculars, six interchangeable lenses, and three other optical instruments or accessories of each named trademark may be imported if in the owner's possession upon entering the United States, and if for personal use and not for sale.

[7] One still camera (including a lens attached to the camera) and one camera carrying case, of each named trademark may be imported provided the articles are in the owner's possession upon entering the United States, and if for personal use and not for sale.

[8] Two lenses of different focal lengths of each named trademark may be imported if in the owner's possession upon entering the United States, and if for personal use and not for sale.

* An asterisk means the consent does not apply to working officers or crewmembers of any ship, aircraft, or any other type carrier. However, any such officer or crewmember whose arrival terminates his crew status and who is not employed, signed on, or otherwise engaged to continue or resume crew status on the same or another carrier, is entitled to one-time use of any applicable consent.

2

Duke Mander

LENSES

LENSES: LOOK SHARP, FEEL SHARP, BE SHARP

It used to take a couple of years to do all the calculations necessary to prove out a lens' design. With the use of computers, this task has been reduced to minutes. What's more, the computer indicates how the concept being tried could be improved. The consequence of this technology is that today's lenses are more consistent in quality than lenses made fifteen years ago.

For the consumer, this means that any lenses manufactured by a reputable firm today are sharp enough for general photography. This consistency in quality has practically eliminated the practice by professionals of testing three identical lenses, keeping the best for himself and returning the two others for credit.

Buying old lenses doesn't really pay unless they're cheap and you have the option to return, should one prove to be a dog. There are still some old-time camera repairmen that can eyeball a lens on a bench and deliver an opinion, or you can test the lens yourself with a chart designed for this purpose. The procedure is to carefully line up camera lens and chart, at the distance specified, and copy the test chart on the finest film possible. Using electronic flash as a light source helps eliminate any possibility of camera shake. The final negatives or transparencies are evaluated under a microscope. The idea is to be able to read the maximum number of lines per millimeter on the test object. But testing lenses this way can be deceptive. For one thing, camera lenses are not designed to photograph a flat chart as enlarging lenses are. So many photographers prefer to test a lens by simply using it to take pictures. If the results look sharp, they must be sharp.

Today's multi-coated lenses practically eliminate flair when shooting into light sources. While this is technically quite an achievement, there was a time when photographers sought out lenses that produced flair for dramatic effect, as in this picture at left.

PHOTOGRAPHIC OPTICS
by Arthur Cox
Amphoto/Garden City, NY 11530/cloth, $22.50

This fifteenth revised edition is a classic work. Every aspect of lens design is covered, including discussions on new developments—zoom lenses, automatic focusing and holography, etc. The language is technical, but possible to follow, providing one has the equivalent of a good high school education. There are charts, as well as diagrams of the construction of many popular lenses currently in production.

ANGLE OF VIEW FOR VARIOUS LENS-FORMAT COMBINATIONS

This chart provides a comparison of the horizontal angle of view for different lens and format combinations. For example, a 20mm lens on a 35mm camera yields a horizontal angle of view of 84 degrees. To effect a similar view on 4×5 film, you would need a 67mm lens—but it would have to cover! That is, it would have to project an image large enough to circumscribe the film. By going to the chart on the next page for the covering power of different view camera lenses, you would find that a 65mm Super Angulon would do the job.

WIDE-ANGLE TO "NORMAL" LENSES

Horizontal Angle of Coverage	Focal length on 35mm format	Focal length on 2¼×2¼ format	Focal Length on 6×7 format	Focal Length on 4×5 format	Focal Length on 5×7 format	Focal Length on 8×10 format
100°	15mm	23mm	29mm	50mm	71mm	100mm
97	16	24.5	31	53	75	106
93	17	26	33	57	80	114
90	18	27.5	34.5	60	85	120
87	19	29	36.5	63.5	90	127
85	—	—	—	65	—	130
84	20	31	38	67	94	134
81	21	32	40	70	99	140
77	22.5	34	43	75	106	150
74	24	37	46	80	113	160
72	25	38	48	83	117	166
69	26	40	50	87	124	174
67	27	41	52	90	127	180
65	28	43	54	93	132	186
64°12'	28.6	43.8	55	95.6	135	191.2
62	30	46	58	101	143	202
59	32	48.5	61	106	150	212
57.5	33	50	63	109	154	218
56	34	52	65	113	160	226
54	35	54	68	117	165	234
53	36	55	69	120	170	240
50°34'	38	58	73	127	178	246
49	39	60	75	130	185	260
48	40.5	62	78	135	191	270
46	42.5	65	81.5	142	201	284
45°26'	43	65.7	82.4	143	203	286
44	44.5	67.9	85.2	148	210	296
43°36'	45	70	86	150	212.5	300
42°18'	46.5	71	89	155	219	310
42	47	72	90	156	222	312
40	49	75	94	164	232	328
39°36'	50	76	96	167	236	334
38°54'	51	77.8	97.6	169.7	240.5	339.4

"NORMAL" TO TELEPHOTO LENSES

Horizontal Angle of Coverage	Focal length on 35mm format	Focal length on 2¼×2¼ format	Focal Length on 6×7 format	Focal Length on 4×5 format	Focal Length on 5×7 format	Focal Length on 8×10 format
45°	43mm	66mm	82mm	143mm	203mm	286mm
43°36'	45	70	86	150	212.5	300
42	47	72	90	156	222	312
40	49	75	94	164	232	328
39°36'	50	76	96	167	236	334
36	55	84	105	183	259	366
31	63	96	121	210	297.5	420
30°44'	65.5	100	125	218	309	436
30	68.7	105	131	229	324	458
28	72	110	138	240	340	480
26	78	119	150	261	370	522
24	85	130	163	283	401	566
23	88	135	169	295	417	590
22°37'	90	137.5	172.5	300	425	600
22	94	143	180	313	443	626
20°24'	100	153	192	333	472	666
19°26'	105	160	201	350	496	700
19	108	165	207	360	510	720
17°22'	118	180	225	393	556	786
16	130	199	250	435	616	870
15	135	206	259	450	637.5	900
14	150	229	287	500	708	1000
13°6'	156.5	239	300	521	739	1042
12°32'	163	250	314	545	773	1090
12	180	275	335	600	850	1200
10	200	306	383	667	944	1334
9°50'	209	319	400	696	985	1392
9	229	350	439	763	1081	1526
8°14'	250	382	479	833	1180	1666
6°52'	300	458	575	1000	1417	2000
6°40'	313	478	600	1043	1478	2086
6°18'	327	500	627	1090	1545	2180
5°52'	350	534	671	1167	1653	2334
5°8'	400	611	766	1333	1889	2666
4°56'	417	637	800	1391	1971	2782
4°6'	500	763	958	1667	2361	3334
3°56'	521	797	1000	1739	2463	3478
3°26'	600	916	1150	2000	2833	4000
2°34'	800	1222	1533	2667	3778	5334
2°4'	1000	1527	1917	3333	4722	6666

LENSES/attachments

LOADED FOR CHICAGO BEAR

This is a great item for sports or wildlife photography that permits easy continuous focusing on moving objects. The setup shown above is the full system. Three Novoflex lenses are available: 280mm f/5.6, 400mm f/5.6, 600mm f/9; these can be adapted to more than fifty cameras. Focus is altered by squeezing the trigger on the pistol grip (right hand). The optional bellows permits focusing on objects closer than normal (one foot, three inches for the 280mm lens, as opposed to thirteen feet without it.) The pistol grip shutter release and shoulder stock make this the fastest focusing, most stable hand-held long-lens system around.

Burleigh Brooks/44 Burlews Ct. Hackensack, NJ 07601

EDMUND SCIENTIFIC CO. CATALOG
658 Edscorp Bldg.
Barrington, N.J. 08007

Fascinating browsing awaits anyone who gets a copy of this catalog, containing more than 4500 items—from ant farms to metric bathroom scales. For photographers, the list of useful items is endless. Special effect kits, filters, projectors, Fresnel screens, magnifiers, prisms, simple lenses, lasers, strobes and rangefinders are but a few. There's lots of army surplus devices and inspiration for the inventor and experimenter. The catalog is full of interesting information that explains, for example, the way in which the power of magnifiers is determined.

Cost: 50¢

LENS SHADES AND STUFF

Depending on the lens, the angle of coverage is often greater than the angle captured on film. When light enters the lens from outside the picture frame (non-image light), it bounces around and, in effect, is flashing the film and reducing contrast. In certain situations with black-and-white film, this can help shadow detail, but with the more exacting demands of color work, the effect is to change the exposure and degrade the saturation of the colors.

Lens shades combat this difficulty. Most are not very efficient, particularly on shorter focal length lenses. A good telephoto will have a built-in shade. The way to tell if it is sufficient is to take the lens out in bright sun; if the shade casts a shadow over the entire surface of the lens, voilà. Holding your hand around the lens to shade it from the sun's rays is a good technique, although a piece of cardboard or a film slide is better.

An extendable bellows lens shade, shown here at right, is the most efficient, as its length can be varied to exactly define the picture frame. Extend it until you see it begin to impede on the image in the viewfinder, then pull it back slightly. The two pictures above were made at f/8 with electronic flash from the same camera position. The difference clearly illustrates the point: the one at left was shot with a bellows shade, the one at right without any shade.

LENS POUCH

"AirShield" is an inflatable lens pouch that protects the lens with a cushion of air—in the same way an air bag for auto collisions would protect its occupants. It works and is much cheaper than many of the hard cases that are sold with lenses. They come in small, medium and large sizes and are great for traveling and for use with soft camera bags. Small lenses can be held snuggly in the larger bags, but large lenses tend to get stuck and are hard to remove for fast work.

Sima Products Corp./7380 Lincoln Ave. Lincolnwood, IL 60646/small, medium, $5.95; large, $6.95

Converters double or triple the focal length of a lens, with a proportional decrease in speed and resolving power. They're good in a crunch or for fooling around, but as one pro said, "I wouldn't use them on a job."

For sneaky stuff, Spiratone sells this Circo-mirrotach. Attached to 100mm and longer telephotos by a Series VII adapter ring, it permits "discreet" right-angle shots. With a precision-mounted front-surface mirror, cost is $21.95. For normal and wide-angle lenses, there is the Mirrotach at $14.95.

Lens shades not only shield the glass surfaces from extraneous non-image producing light, but also protect the lens from smudges and hard knocks. Rubber shades are as efficient as metal ones, yet should your camera knock against a wall, they will cushion the shock without transferring the blow to the lens mount. Clip-on shades are useless in this respect, because they fall off at the slightest pressure.

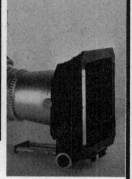

Close-up lenses attach to the front of the lens, allowing close-up work much as a bellows does but without exposure compensation. They come in different strengths, which can be combined. Don't use more than two at a time, always with the strongest closest to the camera.

IF YOU LIKE THE CAMERA, YOU SHOULD LIKE ITS LENSES

The simplest, surest, if most expensive, course is to buy the line of lenses made by the company that made your camera: if Nikon, buy Nikkor lenses, if Leica, Leitz. There are companies, however, that make very acceptable lenses optically, which they sell for considerably less than the camera makers' lenses. Savings result from a fall-off in the construction of housings, focusing and automatic diaphragm movements.

This was hardly a concern back in the days of non-metered, non-automatic rangefinders. With today's automatically operated SLRs, however, the problems increase. If your equipment is likely to get banged around, or if in the rush of work you don't stop to put on a lens cap or rear cap, but just drop one lens in the camera bag as you reach for another, then you had better buy those lenses that have the sturdiest mounts and the surest movements.

The special lens makers have been offering two systems. The first involves making a line of adapters specifically tailored to fit the popular 35mm SLRs. It's a system that works mostly for the benefit of retailers, who can sell a given lens model to owners of different-make cameras. Don't think, though, that you can buy a mixed breed of lenses and interchange them with impunity just because you have a universal adapter: every time you pull a lens off an adapter, the rig weakens. As for the second system, the special lens makers now offer sturdier fixed-mount automatic lenses that are designed with different mounts to fit the most popular cameras.

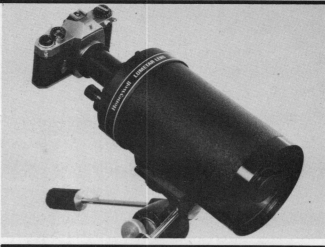

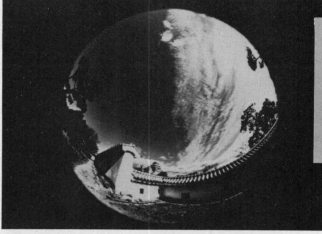

Catadioptric lenses are modified astronomical mirror telescopes that, in effect, compress a long focal length into a short, stubby tube. The convenience that the size provides in handling and transporting is their main advantage. Since they have a fixed diaphragm, the photographer must control exposure by varying the shutter speed.

There are fish-eye lenses that render the image as a circle on the film, and there are those that cover the entire frame of the picture. Some fish-eyes are fixed-focus lenses and need an accessory viewfinder to compose the picture. Others can be focused and composed through the viewfinder from about one foot to infinity. In fish-eye lenses, only lines that radiate from the center of the image circle appear straight.

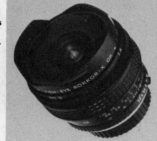

For years, the cardinal rule of lens design was to eliminate perspective distortion. Fish-eyes break it in spades, utilizing as much of the spherical quality of lenses as possible. Used mainly for dramatic effects, particularly exaggerated foreground dominance, they were originally designed for special astronomical and meteorological research. Angles of view range from 170 to 220 degrees.

Perspective control lenses partially approximate the swings and shifts of view cameras for controlling converging lines and increasing depth of focus. The Canon TS 35mm f/2.8 S.S.C. is the best, allowing 11mm shift each side of center and 8mm tilt to each side. It rotates 180 degrees, allowing for these movements in any direction. It is made for Canon cameras, but can be adapted to other bodies for about $75. Both Nikon and Schneider make a 35mm perspective lens, but both have only shifts, no tilts. Schneider also makes a 65mm f/6.8 perspective lens, with both movements.

TS 35mm 1:2.8 S.S.C.

1. Tilt (control of the depth of image field)

2. Shift (perspective correct)

8°

11mm

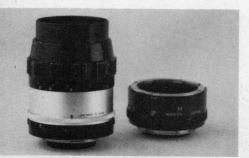

Macro lenses can be used at normal distances, but also allow critical focus up to 2:1 magnification, 1:1 with an adapter. It is not necessary to increase exposure time when working with bellows or extension tubes. The diaphragm enlarges as the lens is extended, automatically compensating for bellows extension.

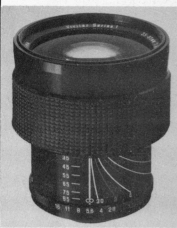

The two pictures at left illustrate the range of the Vivitar 35-85mm variable focus lens, which allows for altering the focal length and thus the composition of a scene from a single point. The end result is like that from a zoom lens, though the shooting process is slower because variable lenses don't maintain focus when shifting focal lengths. The less complex design of the variable focus lens, however, has the advantage of allowing focusing closer to the subject than with a zoom at the comparable focal length.

The Vivitar Series 1 35mm to 85mm variable-focus lens is one in the line of fixed-mount lenses that the company makes for specific cameras—for Olympus, Nikon, Canon and Minolta. If you want a Series 1 lens, you must specify the camera.

These adapters are keys to the Vivitar Automatic TX lens system for 35mm SLR cameras. Adapters are available to fit every popular Japanese-made camera. The Vivitar Automatic lenses then fit into the adapters.

FAR AND WIDE

Wide-angle and telephoto lenses do more, respectively, than include a greater angle of view and bring subjects closer. Each can be used to alter proportion in its own way. Wide-angles are used to exaggerate size differences between foreground and background. Telephotos are used to minimize these differences. Technically, the effect depends on camera to subject distance. The idea is to come in close with the wide-angles and to lay back with the longer lenses.

Two examples of the effect. In the first picture, the two masks—the same size and one foot apart—were shot with a wide-angle. The hill, fifty feet from the lens, and the statue, seventy feet away are juxtaposed by the photographer, who used a telephoto.

Zoom lenses are ideal for the photographer who is covering a play or sports event but can't get in close to the action. A zoom, once focused on a subject, stays in focus no matter how much the focal length is changed. For critical work, focus first at the longest focal length and then zoom back. All things considered, a zoom lens is not as sharp as a good fixed focal length lens, although great progress has been made. See the excellent Nikkor 80-200mm, above.

Illustrated here is the infamous technique of zoom blur. At a slow shutter speed (not faster than 1/15th of a second), rapid alteration of the focal length creates an effect of motion. This picture was made by zooming from 80mm to 43mm. Reversing the direction gives less blur to the principal subject of focus.

CIRCULAR IMAGES FOR RECTANGULAR PHOTOGRAPHS

Since lenses project circular images, the rectangular film must fit within this circle to be completely "covered." Aside from optical quality, the most important consideration in buying a lens for a view camera is the covering power.

View camera work often involves displacing the centered relationship between lens and film. Film and lens standards rise and fall, shift laterally and swing and tilt in relation to each other. Their use is collectively known as corrective photography. In order to utilize these movements, the circle of good definition of the lens must more than cover the diagonal of the film format, about fifteen percent more. Vignetting of the edge of the picture, as with the example at right, results when movements are used with a lens having too little coverage. A lens shade that is too deep will also cause a similar cut-off.

Covering power is increased as the lens is stopped down. The best way to check if a

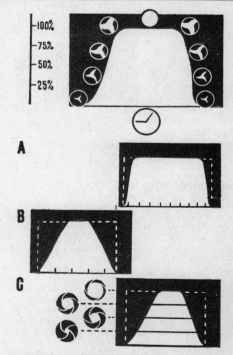

In all lenses, image detail and illumination drop off at the outer edges of the circle of illumination. Thus, covering power is determined in relation to the circle of good definition, which is slightly less than the absolute maximum coverage.

lens is covering is by observing the rear aperture through the openings where the corners of the ground glass have been trimmed. When you can see a circular-shaped opening from all four corners, the lens is covering the film. Remember that the coverage provided by the manufacturer is measured at infinity and increases with bellows extension when focused on closer

subjects. Lenses that won't cover at infinity can work perfectly well in a close-up situation.

Finally, if you want round pictures, the simplest way is to use the wrong lens. Emmet Gowin's haunting circular photographs are made with an 8×10 camera and a lens that won't cover.

The classification of a lens as to normal or wide-angle relates to the diagonal of the format. Thus, according to these charts, a normal lens for a 4×5 is about 160mm or 6-6½ inches; a wide-angle is a maximum of 105mm, 90mm being the most available; and a telephoto is 300mm or 12 inches. These are general classifications.

2X = Telephoto

Wide Angle

Normal

Short Side = Wide Angle
Long Side plus Short Side = Telephoto

TABLE OF NEGATIVE DIAGONALS

Diagonal

Film Size	Inches	Millimeters (mm)
35mm (¹⁵⁄₁₆x1¹⁄₁₆")	1¾	45
2¼x2¼"	3³⁄₁₆	80
2¼x3¼"	3¹⁵⁄₁₆	100
4x5"	6⅜	161
5x7"	8⅝	219
8x10"	12¾	323
11x14"	17⅞	453

CONVERSION TABLE
Millimeters (mm) to Inches

Millimeters	Inches	Millimeters	Inches
25	1	165	6½
50	2	180	7⅛
65	2⅝	210	8¼
75	3	240	9½
90	3½	270	10⅝
105	4⅛	300	12
120	4¾	360	14¼
135	5¼	420	16¾
150	6	480	19

To convert mm to inches, divide by 25.4

THE FOCAL ENCYCLOPEDIA OF PHOTOGRAPHY
Amphoto/Garden City, NY 11530/two volumes, $49.00

Any one book, even with 1700 pages, can't give comprehensive coverage of every aspect of photography. But as a general reference for defining terms, it is the only one of its kind. Many diagrams, such as at right, explain the ins and outs of equipment and are the most valuable part of the book. There's even an entry on "while-you-wait photography." In all, there are 2,400 articles by 276 contributors.

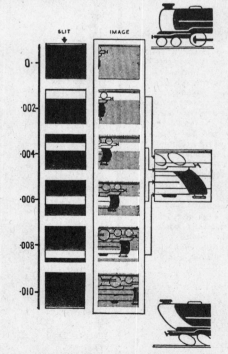

FOCAL PLANE SHUTTER DISTORTION. When the blind of a focal plane shutter and the image of a moving object travel at right angles to each other, a special type of image distortion appears. As the slit of the blind takes longer than the effective duration of the exposure to cross the whole negative area, the image will be in a different position at each instant during the travel of the slit. The assembled effect of all these component images is a picture of the object leaning forward or back. Although undesirable in some cases, it can improve the impression of speed in the picture.

DIAPHRAGM SHUTTER EFFICIENCY. Top: A diaphragm shutter is fully open only during part of the time of its operation; the periods of opening and closing take up some time, and thus result in a certain loss of light. The shutter opening is here plotted against time. Bottom: Comparison of shutter efficiencies. The dotted square represents an ideal shutter opening and closing instantaneously. A, modern shutter at 1/10 second. The time marks represent 1/100 second intervals. B, reduced efficiency of same shutter at 1/250 second. Time marks at 1/1000 second intervals. C, increased efficiency at smaller apertures, as blades clear lens aperture earlier.

CHART OF VIEW CAMERA LENSES

Shopping for a view camera lens can be a confusing experience. Compiled here is a list of the available view lenses in production and a few golden oldies, with pertinent information. Cost quotes for the new lenses mounted in Copal shutters are recommended list prices, so they may vary some in either direction. Prices for used lenses are even less exact. Dealers will charge whatever they can get, so these should be taken as rough guides. The factors defining the footnotes are explained in the introduction on the preceding page. In general, you get what you pay for, and while the optical quality of the less expensive lenses may be comparable, the relative cheapness is in the construction—which affects the usable life of the lens.

WIDE ANGLE LENSES FOR 4 x 5

Lense Name	Focal Length mm	Aperture Range	Image Diameter mm at f/16	Price
Super-Angulon	65	f/5.6-f/45	170[1]	$826.00
Fujinon SW	65	f/8-f/64	155[1]	$379.50
Fujinon SWD	65	f/5.6-f/45	172[1]	$749.50
Super-Angulon	65	f/8-f/45	155[1]	$558.00
Acugon	65	f/8-f/45	155[1]	$360.00
Caltar WII	65	f/8-f/45	155[1]	$299.50
Super-Angulon	75	f/5.6-f/45	198	$941.00
Super-Angulon	75	f/8-f/45	181[1]	$578.00
Grandagon	75	f/4.5-f/45	200	$1,003.00
Fujinon SW	75	f/8-f/64	181[1]	$379.50
Fujinon SWD	75	f/5.6-f/64	200	$825.00
Super-Angulon	90	f/5.6-f/45	235	$1,090.00
Super-Angulon	90	f/8-f/64	216	$621.00
Grandagon	90	f/4.5-f/45	240	$1,152.00
Fujinon SW	90	f/8-f/64	216	$387.50
Fujinon SWD	90	f/5.6-f/64	238	$884.50
Caltar WII	90	f/8-f/45	215	$299.50
Acugon	90	f/8-f/45	219	$420.00
Wide Angle Dagor	90	f/8-f/45	156[1]	$250.00++
Wide Field Ektar	100	f/6.3-f/32	183[1]	$120.00++
Fujinon SW	105	f/8-f/64	250	$784.50
Wide Angle Dagor	111	f/8-f/45	186	$250.00++
Angulon	120	f/6.8-f/45	211	$340.00++
Fujinon SW	120	f/8-f/64	290	$410.00
Super-Angulon	121	f/8-f/64	290	$1,062.00
Wide Field Ektar	135	f/6.3-f/32	229	$225.00++

WIDE ANGLE LENSES FOR 8 x 10

Lense Name	Focal Length mm	Aperture Range	Image Diameter mm at f/16	Price
Fujinon SW	120	f/8-f/64	290[3]	$410.00
Super-Angulon	121	f/8-f/64	290[3]	$1,062.00
Super-Angulon	165	f/8-f/64	390	$2,395.00
Angulon	165	f/6.8-f/64	300[2]	$340.00++
Wide Angle Dagor	165	f/8-f/45	289[3]	$250.00++
Wide Field Ektar	190	f/6.3-f/45	318[1]	$325.00++
Angulon	210	f/6.8-f/64	382	$340.00++
Wide Field Ektar	250	f/6.3-f/45	422	$550.00++

[1]Covers, but not for corrective photography
[2]Covers only when stopped down to f/22
[3]Covers only when stopped down to f/32
++ - No longer manufactured
Prices for used lenses from
Bomze/JayBee Photo, New York, N.Y.

NORMAL LENSES FOR 4 x 5

Lense Name	Focal Length mm	Aperture Range	Image Diameter mm at f/16	Price
Symmar	135	f/5.6-f/45	190	$395.00
Fujinon W	135	f/5.6-f/64	228	$339.50
Caltar S-II	135	f/5.6-f/45	189	$199.50
Sironar	135	f/5.6-f/45	175	$377.50
Caltar S	135	f/5.6-f/45	189	$179.50
Symmar	150	f/5.6-f/45	210	$427.00
Fujinon W	150	f/5.6-f/64	245	$357.50
Acuton	150	f/6.3-f/45	209	$270.00
Caltar S-II	150	f/5.6-f/45	210	$199.50
Golden Dagor	150	f/6.8-f/45	210	$400.00++
Fujinon W	150	f/6.3-f/64	198	$196.50
Caltar S	150	f/5.6-f/45	210	$179.50
Sironar	150	f/5.6-f/64	193	$419.00
Gold Dot Dagor	150	f/6.8-f/45	210	$610.00
Ektar	152	f/4.5-f/45	182[1]	$225.00++
Acutar	165	f/6.3-f/45	163[1]	$228.00
Caltar	165	f/6.3-f/45	206	$125.00++
Symmar	180	f/5.6-f/45	255	$547.00
Fujinon W	180	f/5.6-f/64	305	$419.50
Acutar	180	f/6.3-f/45	219	$299.00
Acuton	180	f/4.8-f/45	252	$315.00
Sironar	180	f/5.6-f/64	234	$515.00
Ektar	203	f/7.7-f/45	216	$425.00++
Red Dot Artar	210	f/9.0-f/64	163[1]	$630.00
Sironar	210	f/5.6-f/64	266	$598.00
Acutar	210	f/6.3-f/45	240	$348.00
Commercial Ektar	210	f/6.3-f/45	270	$475.00++
Acutar	250	f/6.3-f/45	272	$444.00
Red Dot Artar	270	f/9.5-f/90	231	$680.00

NORMAL LENSES FOR 8 x 10

Lense Name	Focal Length mm	Aperture Range	Image Diameter mm at f/16	Price
Fujinon W	180	f/5.6-f/64	305[3]	$419.50
Symmar	210	f/5.6-f/45	297[3]	$637.00
Fujinon W	210	f/5.6-f/64	352[1]	$462.50
Caltar S-II	210	f/5.6-f/45	294[3]	$299.50
Gold Dot Dagor	210	f/6.8-f/45	294[3]	$700.00
Caltar S	215	f/5.6-f/45	301[3]	$219.95
Acuton	215	f/6.3-f/45	305[3]	$360.00
Symmar	240	f/5.6-f/45	336[1]	$990.00
Caltar S-II	240	f/5.6-f/45	336[1]	$499.50
Sironar	240	f/5.6-f/64	298[1]	$923.00
Golden Dagor	240	f/6.8-f/45	340[1]	$650.00++
Gold Dot Dagor	240	f/6.8-f/45	336[1]	$860.00
Caltar S	240	f/5.6-f/45	336[1]	$449.50
Fujinon W	250	f/6.7-f/64	398	$509.50
Commercial Ektar	254	f/6.3-f/45	317[1]	$475.00++
Gold Dot Dagor	270	f/6.8-f/45	378	$1,000.00
Golden Dagor	270	f/6.8-f/45	382	$600.00++
Symmar	300	f/5.6-f/64	402	$1,388.00
Sironar	300	f/5.6-f/64	384	$1,251.00
Caltar S	300	f/5.6-f/45	420	$599.50
Fujinon W	300	f/5.6-f/90	420	$859.50
Acutar	300	f/6.3-f/45	325[1]	$480.00
Caltar S-II	300	f/5.6-f/64	420	$699.50
Golden Dagor	305	f/6.8-f/45	427	$750.00++
Commercial Ektar	305	f/6.3-f/45	380	$450.00++
Caltar	305	f/6.3-f/45	381	$219.95++
Red Dot Artar	355	f/9-f/90	302[3]	$820.00
Commercial Ektar	355	f/6.3-f/45	444	$450.00++
Symmar	360	f/5.6-f/64	500	$1,671.00
Fujinon W	360	f/6.3-f/90	485	$995.00
Sironar	360	f/6.8-f/64	415	$1,450.00
Apo Ronar	360	f/9-f/64	308[3]	$921.00++
Caltar S-II	360	f/6.8-f/64	500	$799.50
Acutar	375	f/6.3-f/45	452	$522.00
Caltar	375	f/6.3-f/45	468	$289.95++
Red Dot Artar	420	f/9.5-f/90	355	$970.00
Red Dot Artar	450	f/11-f/90	396	$1,000.00
Red Dot Artar	480	f/11-f/90	452	$1,110.00
Acutar	500	f/7-f/64	449	$593.00

WHAT YOU SEE ISN'T NECESSARILY WHAT YOU GET

For photographers who want to have every bit of control over the pictures they make, the knowledge of the use of filters is a necessity. The best way to think of filters is in terms of the colors of the spectrum that they absorb, rather than their own color. A yellow filter is not thought of as adding yellow, but rather as absorbing blue. Therefore, with black-and-white film, photographing a blue sky with a yellow filter will darken the sky, yellow being a minus-blue filter. Certain filters are more useful in black-and-white photography, as others are better for color work. The skylight filter, which is a pale salmon color, has little effect on black-and-white, but will warm up the cold (blue) tones rendered on color film exposed without sunlight. To fully explain the numerous effects of different filters on the multitude of films available is a study in itself. Two Kodak books, *Filters & Lens Attachments for Black-and-White and Color Pictures,* AB-1, and *Kodak Filters for Scientific and Technical Uses,* B-3, are the best sources for learning, with a lot of individual experimentation added.

Polarizing filters can screen out light that is polarized. Light can be polarized simply by placing a polarizer in front of the light itself. Ordinary light reflected off a nonmetalic shining surface, such as glass, becomes polarized. And skylight reflected from our atmosphere is polarized, particularly that part of the sky that is 90 degrees from the sun's axis. By using a polarizer on the lens of a camera, you can see its effect on reflections from water, glass, etc., simply by rotating the filter. The only means of darkening blue skies on color film is with a polarizing filter. As with most filters, exposure must be increased to compensate for the light absorbed.

Neutral Blended Ratio Attenuators are filters with graduated density for shots like the one at left, where the setting sun made the range between the sky and the forest too great to record. The results are similar to those achieved when dodging a print while enlarging. Light through one part of the lens is held back so that denser areas can get more exposure.

The Spiratone Sixshooter is a multiple-image prism in which the image is repeated or fractured into six sections for a kaleidoscopelike effect. A rotating screw-mount permits rotation during exposure. Cost is $22.95 to $37.95, depending on the lens size.

Gelatin filter squares are the most practical for the professional who needs a large variety of filters. Screw-ins can cost up to twenty dollars each, as opposed to three dollars for the gelatins. If you have them, you'll need these items: the Kodak gelatin filter holder and mount. Shown here are the filter frame and the

frame holder, and a retainer ring in the foreground for attaching the holder to the lens. Filter squares are the most easily scratched and should be handled with care.

If you get hooked by photography, you could easily have an assortment of lenses with varying diameters, each taking a different-size filter. The way to simplify and save money is to buy filters that will fit your lenses with the largest diameter.

These are then fitted to the lenses of smaller diameters with step-up rings, which are adapters with external threads on one end that screw into the front of the lens and internal threads on the other that accept the filters.

SHOOTING COLOR FILM BY FLUORESCENT LIGHT

Of all the problems with filtering for color film, shooting by fluorescent light presents the worst. Reading the literature is enough to make anybody want to retire its use altogether. For example, the color and brightness of fluorescent, and thus the filtration needed, vary widely—not only from brand to brand, but from lamp to lamp of the same brand. It also varies with voltage fluctuations, the temperature of the lamp and its age. Nor can the effect of fluorescent light be measured with a color temperature meter reading. These problems are just the tip of the iceberg.

For the nonprofessional, shooting with fluorescent is a surefire way to get your

interest redirected toward probability statistics, which one of our editors found more comprehensible. Our expert, however, had it down cold. In the tradition of Thoreau ("simplify, simplify") he said, "30 Magenta with daylight film." This was, of course, based on his own experience and color preference. For others, the advice is a good starting point, but if you really want to know, the only way is to do it. The *Kodak Professional Dataguide* will also give you its recommendations. For consistency of color, shoot longer than 1/60th of a second, because fluorescent isn't a continuous light source. In a darkened room with a moving subject, shutter speeds of around a quarter second will give a stroboscopic effect.

The Tiffen split-image filter is a specialized item. One half is a close-up lens, the other half a normal lens that allows subjects at normal distance and those at extremely close range

to be in focus at the same time. The edge between the two lenses is fuzzy; it is used to best advantage when that split can be minimized by an axis in the picture, like a horizon.

3

From *Photographie im Wandel der Zeiten*

CAMERA COLLECTING

CAMERA COLLECTING

WHY IN THE WORLD WOULD ANYONE WANT TO COLLECT A CAMERA?

Monetary value is very much a part of the collecting ethos. By definition all collectors have acquisitive natures, but what they seek, and why, varies. Some have a sense of wonder at the way cameras work, and they cherish them as other collectors cherish fine watches, classic cars or antique guns. Not surprisingly, what once cost a lot of money often continues to be of value and often continues to increase. Cameras attain special value if they have been used by notable personalities—Dr. Solomon's Ermanox, for example, would be worth about $2,000—if it were found. Yet another measure of value is rarity, which often results from a mistake in marketing judgment, which was the case with the Leica Luxus. It seems that although Leitz produced fewer than one hundred of the matte gold-plated, lizard-skin-covered models, customers didn't buy them—too garish. The model was discontinued, and now they are prized.

Presumably there is a connection between the subjective sense of aesthetic appreciation and what an old thing is worth. A daguerreotype camera is worth as much as $7,500 because it is old and now rare—certainly not because it's beautiful, which it isn't. But the much more recent Phoenix, made in 1924 by W. Kenngott of Stuttgart, is valuable because its "colored bellows, brass-bound woodwork and gilt metal" put it in what Michel Auer calls "the luxury goods class."

Surprisingly, utility is not much of a factor in the appreciation of old cameras. Norbert Nelson, writing in *Camera 35* of May, 1975, describes a Pony Premo No. 6, made by Rochester Optical about 1898: "It has a reversible back for horizontal or vertical formats, back tilt, drop bed and nearly triple extension bellows . . . pneumatically retarded shutter . . . speeds of 1 second to 1/100 second . . . its lens is a 2-element rapid rectilinear type." The camera still takes good pictures. As for price, Nelson reports that it cost up to $100 originally, "a considerable sum when compared to a fancy parlor organ for $28, a man's suit for $8 or a buggy for less than $50." But today you can get all the Premo 6s you want for $45 each. They are too common to be worth much.

Avid camera collectors are knowledgeable about even the rarest of cameras, knowledge they learn in a few months of going to lectures, exhibits, fairs, auctions; reading newsletters, magazines and the emerging reprint literature—catalogs and the like. The collector, who as a boy couldn't remember the date of the first English settlement, finds it exciting to learn that the first Kodak was made in 1888 and that the early glass-plate-loaded Adlake box camera and the roll-film loaded Bull's-Eye both date back to the 1890s.

After a few talks, he has learned the reasons for a stereographoscope (a device to view magnified stereographs), a praxinoscope (a toy dependent on the phenomenon of the persistence of vision—a predecessor to the motion picture projector), a stanhope (a tiny photograph set in a glass magnifying bead), and a mutoscope (a penny arcade peep-show flicker book).

Just as in the collecting of any other scientific instruments (microscopes, telescopes, astrolabes), the photographic collector is very often the only historian seeking data that would otherwise be lost. For example, Matt Isenberg, a Ford dealer in Connecticut, has become one of the world's outstanding experts on the lens and camera-body makers of France from 1840 to 1860.

Most American collectors usually start with Kodak, Ansco, Argus or Graflex cameras; since all were mass-produced of durable materials, many are still readily available. Even if one were only to start with the box cameras of that period, there are ample technological and color differences to provide variety at a very low investment. It is still possible to find cameras reflecting the Art Deco world of the 1920s or to acquire the Ansco Memo, a vertically-held cracker-box-shaped camera, which along with Leica, introduced 35mm photography to America in 1926. In the more immediate past, there are the still readily available original Polaroid cameras, the first Kodak Instamatics and the early postwar imports in 35mm designs from Japan and Germany.

Camera collecting, begun so relatively recently, is certain to be with us for a very long time.

Knowledgeable dealers say New York collector Sam Wagstaff, shown going through a pile of pictures, makes the market in prints—whether daguerreotypes, stereo views or twentieth-century photographs.

After only three years, Matt Isenberg, once a Leica collector, put together the best collection of daguerreotype cameras in the world.

HERE ARE NINE OF THE COUNTLESS MODELS KODAK CREATED AND PEDDLED

Original, 1888. Camera, loaded with film for 100 shots plus processing, was $25; now is $1,500. Screws above and below lens make it an original.

No. 4 Folding, 1890. The sachel is of leather and the front drops down. Picture is 4×5 inches; film, glass plate or roll. Then, $60; now, $175.

No. 2 Stereo, 1901. The only Kodak stereo box camera for roll film in America. Made 1901 to 1905. Then, $15; now, $125.

No. 3A Autographic Special, 1917. Eastman paid $300,000 for patent to write on film. Camera featured first coupled rangefinder. Then, $70; now, $35.

Fiftieth Anniversary, 1930. Back then the Eastman Kodak Company made a half-million cameras to give away free, but only got 400,000 takers; now, $20.

Super Six-20, 1938. The first automatic exposure control camera. Other features: clam-shell folding, split-image rangefinder. Then, $225; now, $900.

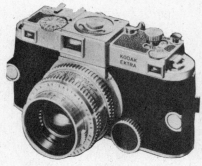

Ektra, 1941. With this honey, Kodak for a while surged ahead of Contax and even Leica. Interchangeable lenses and backs. Only 2,000 made. Then, $304; now, $500.

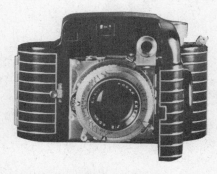

Bantam Special, 1936. This art deco delight has a coupled rangefinder and a fast lens (f/2). Took roll film 1⅛×1⅝. Then, $85; now, $125.

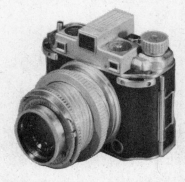

Medalist, 1949. A 6×9 cm camera with a futuristic look but a loser to the 35s. To be cherished in this instant-photography era. Then, $165; now, $200.

ANTIQUE CAMERA DEALERS

Allen Weiner says there is a market in detective cameras, that he recently sold an Anthony box camera concealed in an alligator sachel for $7,500 and that the buyer was delighted. Why? "Because it was unique . . . because hidden cameras are neat things that appeal to the imagination . . . adult toys, mechanical playthings."

Michel Auer would have to agree since he will soon bring forth a book about detective cameras. Auer, who has been collecting since his teens, long before the activity became

Hilary and Allen Weiner in their Manhattan apartment, where they deal in antique cameras.

widespread, lives in Switzerland where he has the world's finest overall collection of antique cameras.

Antique camera dealers of some reputation are:

Michel Auer, CH 1248 Hermance, Geneva, Switzerland/Brian Burford, Collectors Cameras—London, P.O. Box 16, Pinner, Middlesex, England/Barney Copeland, Bel-Park Photo Supply, 2837 Milwaukee Ave., Chicago, IL 60618/John Craig, Classic Photographic Apparatus, P.O. Box 161, Simsbury, CT 06070/Leon and Hilda Jacobson, 161 Genesee Park Dr., Syracuse, NY 13224/Tony Kowal and John Jenkins, Vintage Cameras Ltd., 256 Kirkdale, London, SE 26 4 NL, England/Allen and Hilary Weiner, 392 Central Park West, New York, NY 10025.

THE COMPASS CAMERA

This camera epitomizes the type of instrument that collectors love. Five thousand were made in the mid-thirties by the famous watch company LeCoultre et Cie of Switzerland. Though that number would indicate that its production was a serious commercial venture, it was immediately labeled a novelty camera and an expensive one at that (30£s, in 1937). But the sophistication of its design and the range of its features are enough to satisfy an aerospace engineer's heart. Weighing only seven and three-quarter ounces, it is equipped with a built-in extinction light meter, a rangefinder and a separate view-finder, which can be used straight or at right angles for the shy photographer. Shutter speeds, which are set and wound like a watch, range from 4½ seconds to 1/500th of a second. The 35mm focal length lens has f-stops from f/3.5 to f/16, a built-in lens shade and three built-in filters—yellow, orange and green mounted in a rotating turret. It has two interchangeable backs: one, with its groundglass focusing screen and adjustable magnifier, takes sheet film 24×35mm, the size of a 35mm frame; the other, specially spooled roll-film on geared spools. Additional features include a spirit level, time release, a built-in panoramic head and an adjustable tripod bush that shifts the camera position for making stereoscopic views. The *Price Guide to Collectible Cameras, 1930-1976,* lists its price today at $1000. Richard Nava, a collector of all kinds of antiques, snatched it up for $150 back in the late fifties.

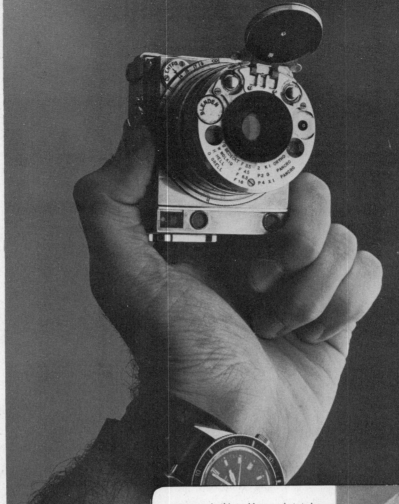

The Compass came with a carrying case, cable release, plate back, plates and roll film. The tripod has a universal head. By folding the legs and inserting them in the shaft of the tripod neck, the tripod is about the size of a fountain pen.

camera. As this enables snapshots to be taken at right-angles to the direction in which the photographer is looking, it is of special value in obtaining natural pictures of camera-conscious subjects.

HOLDING THE CAMERA.

Owing to its exceptionally small size, care must be taken when holding the camera to avoid any part of the hand obscuring any part of the lens or the range-finder or view-finder. (Figs. 5 and 6 illustrate effective methods.)

If the camera is held pressed firmly against the forehead, as its design intends it to be, great steadiness results and comparatively long exposures can be given without the use of a tripod.

30

FIG 5.—HOW TO HOLD THE CAMERA WHEN USING THE RANGE-FINDER.

Spirit Level — Milled Focussing Ring
Distance Indicator — Shutter Speed Ring
Shutter Speed Ring Lock — Shutter Wind Depth of Focus Scale
Instantaneous Release — Lens Cover
— Time Release
Lens Stop Control — Inst. Setting Arrow
— Filter Control
Stop Indication Window — Filter Indication Window
Stereoscopic Head — Lens Hood
Angle View-Finder — Camera Foot

Camera Back Release Clip — Screen Cover
Pressure Plate Release Lug — Focussing Magnifier
Removable Tripod Bush — Focussing Screen
Release Pin for Hinged Back — Pressure Plate Release Lug
Range-Finder — Angle View-Finder Control
Supplementary Exposure Wedge — View-Finder
Tripod Bush — Exposure Meter Slide

CLUB DAGUERRE

This international club was established in 1974 to promote the historical aspects of photography. It is centered in Hanover, West Germany, and the majority of members are camera collectors. Two publications are available to members: the club journal, *Photo-Antiquaria*, with information on current club activities and reviews of subjects being researched by club members, and an extensive camera catalog, with lots of useful info for collectors. Yearly dues run $20, with two meetings per year. For more information write to Ludwig Hoerner, General Secretary, Schlaegerstr. 8, D-3000 Hanover, W. Germany.

TELL THEM, "JOE" SENT YOU

The fastest and most delightful way to get into a club of photographic collectors is to knock on the door. Since the first of these groups was formed in the mid-1960s by engineers and photography enthusiasts in the nation's photographic capital (Rochester), nearly thirty groups have established themselves, meeting monthly in the homes of members or in libraries, even hotels.

Annual membership fees run from $3 to $15. Programs at meetings are lectures by scholars and veteran collectors or show'n tell sessions. Monthly newsletters of the organizations range from one-page mimeo announcements up to the sixteen-page magazine of the *Photographic Historical Society of New York.*

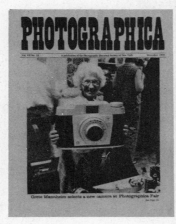

Grete Mannheim selects a new camera at Photographica Fair

NATIONAL GROUPS:

Leica Historical Society—c/o Wayne M. Hull/2036 Brightwater Blvd./St. Petersburg, Fl 70116

National Stereoscopic Association/Stereo collectors in U.S., Canada, Europe and Africa/R.D. No. 1/Fremont, NH 03044

New Pictorialists/For photographers who use early equipment and processes to make soft-focus photographs in the manner of the early pictorialists—c/o Edward H. Romney/Ellenboro, NC 28040

Photographic Historical Society of America/P.O. Box 41/Simsbury, CT 06070

LOCAL GROUPS:

Bay Area Photographica Association/Greater San Francisco area/1178 Crespi Dr./Sunnyvale, CA 94086

Cascade Photographic Historical Society/Southern Washington and Northern Oregon—c/o Ron Panfilio/3155 S.W. 72 Ave./Portland, OR 97225

Chesapeake Antiquarian Photographic Society/Delaware, Maryland, Washington, D.C. and Northern Virginia/P.O. Box 66/Severna Park, MD 21146

Chicago Photographic Collectors' Society/P.O. Box 375/Winnetka, IL 60093

Delaware Valley Photographic Collectors' Association/Southern New Jersey, Eastern Pennsylvania—c/o E.H. Rifkind, Secretary/P.O. Box 74/Delanco, NJ 08075

Great Plains Photographic Historical Society/Kansas, Nebraska and Oklahoma/P.O. Box 13114/Ofutt AFB, NE 68113

Historical Photographic Society of the Western Reserve/Cleveland, Ohio area—c/o Donn Rothenberg/4176 Hinsdale Rd./South Euclid, OH 44121

Michigan Photographic Historical Society/Michigan, Western Ohio, and Southern Ontario/P.O. Box 191/Dearborn, MI 48121

Midwest Photographic Historical Society/Missouri and vicinity/P.O. Box 882/Columbia, MO 65201

Ohio Camera Collector's Society/Columbus, Ohio and vicinity/P.O. Box 282/Columbus, OH 43216

Photographic Collectors of Houston/Houston, Texas and vicinity/2711 Houston Ave./Houston, TX 77009

Photographic Historical Society/Central New York State/P.O. Box 9563/Rochester, NY 14604

Photographic Historical Society of New England/P. O. Box 403/Buzzards Bay, MA 02532

Rocky Mountain Photographic Historical Society/Colorado and Wyoming—c/o Donald Upjohn/Box 577/Aurora, CO 80010

Tri-State Photographic Collectors' Society/Southern Ohio, Indiana and Kentucky—c/o William R. Bond/8910 Cherry Ave./Blue Ash, OH 45242

Western Photographic Collectors' Association/South Central California/P. O. Box 4294/Whittier, CA 90607

GROUPS ABROAD:

Club Daguerre—c/o Ludwig Hoerner, General Secretary Schlaegerstr. 8, d-3000 Hanover/W. Germany

Historical Group/The Royal Photographic Society of Great Britain/14 South Audley St, London W1Y 5DP/England

Photographic Historical Society of Canada/631 Sheppard Ave. W., Downsview, Ontario/Canada

HOW TO FIND OUT WHAT AN ANTIQUE CAMERA IS WORTH—CONSULT MYRON WOLF'S DIRECTORIES

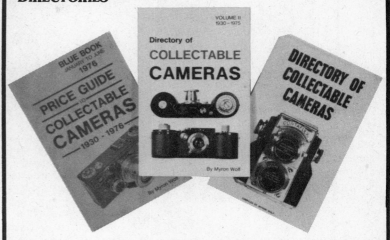

Getting a price, the right price, is important in any nonessential endeavor; the shrewder you are, the more good things you can buy. The way to learn is to jump in and spend. But the way to keep from taking a bath is to have some sort of helper—like the wings kids used to learn to swim with. Anyhow, there are Wolf's directories and the *Blue Book* that he publishes twice a year. Prices listed in the *Blue Book*

represent "purchase prices," since a compilation of the actual price of the cameras is more useful than any averaging of "asking prices." Sellers may ask any price they choose for a camera—most often, a high one. But a camera is worth only what it will bring on the market.

Photographic Memorabilia, P. O. Box 351, Lexington, MA. 02173/Price Guide, $2.95; Directory, Vol. I, $5,95; Vol II, $8.95.

LOOKING BACK

Reprints of old catalogs, carefully studied, can aid in dating, identifying and appreciating early photographic equipment. Collectors of cameras, lenses, shutters, magic lanterns, stereo viewers and the like get trading-wise by relating the prices of yesteryear to the supply and demand of today.

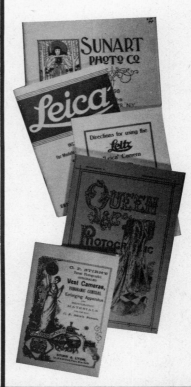

Original catalogs, when they can be found, sell for $15 to $30. Because so many collectors want catalogs that exist in too few quantities as originals, reprint publishers have come forth to fill the need. They include the following:

Classic Photographic Apparatus/P.O. Box 161/Simsbury, CT 06070 (Over 100 reprinted catalogs and camera circulars available for as little as 50 cents each.)

Photo-Historical Reprints/1545 East 13th St./Brooklyn, NY 11230

Morgan and Morgan, Inc./400 Warburton Avenue/Hastings-on-Hudson, NY 10706 (Reprints include *E. & H.T. Anthony & Co. Catalog of 1891* and the *Leica A Operating Instructions.*)

The Western Photographic Collectors' Association/P. O. Box 4294/Whittier, CA 90607 (*1904 Graflex Catalog.*)

D-M Enterprises/144 Happ Rd./Northfield, IL 60093 (*1897 Camera Catalog of Marshall Field and Co.*)

C. P. Stirn/P. O. Box 4246/Santa Barbara, CA 93103 (*Vest and Wonder Cameras, Kombi of 1895* and the *National Directory of Camera Collectors*—directory of 1,000 collectors of early cameras and prints.)

For original catalogs: Lester C. Hehn/30 Manorhaven Blvd./Port Washington, NY 11050

Daguerrian Era/Tom and Elinor Burnside/Pawlet, VT 05761

DATING YOUR CAMERA

Is it shaped like a box? Look for an embossed name on the handle or on the top. None? Open the camera and look inside. Film size reveals the earliest possible date a camera could have been made. Any Kodak calling for film sizes from #101 through #104 had to be made after 1895; #105 through #116, after 1898; #117 through #126 (not the Instamatic #126 of today), after 1900; #127 through #130, after 1912. Any camera calling for Kodak film #616 and #620 had to be made after 1932. The first of the #828 film (for Bantam cameras) was introduced in 1935. A box camera with a glass-plate loading feature would have to be from the 1880s to 1910 when such cameras went out of production.

For a bellows camera folding into a leather-covered box and opened with a hinged door, red leather bellows are a sure sign that the camera was made before 1915. Kodak's first folding camera dates back to 1890. Shutter-operated with a squeeze-type bulb? That's a camera from before World War I. Sears and Montgomery Ward offered such cameras in all catalogs to 1910. German camera with a Compur shutter? If it's the *old-style* Compur (with two levers to *wind* and *fire*) the camera must date back before 1928 when the *new style* (rim-set) Compur was introduced.

German camera with black (enameled) metal parts and black leather bellows? These started about 1905 and were made by dozens of factories up to about 1930 when chromium trim "modernized" their look. Camera with a Zeiss lens? The serial number on the lens will help you date the camera. From 1912 to 1920, #173418 through #419823; from 1920 through 1925, #433273 through #681473; from 1926 through 1930, #666790 through #1239697; from 1931 through 1942, #1239689 through #2799599.

Nineteenth-century camera with wooden lensboard containing or concealing a shutter mechanism? From 1890 to about 1895.

Stereo cameras are more difficult to date since metal-and-leather bodies were common to German and French design from the 1880s to the 1920s. Heidoskop and Rolleidoskop of the 1920s look much like their antecedents. All stereo cameras after 1948 had considerable trim in chrome.

THE ILLUSTRATED HISTORY OF THE CAMERA
by Michel Auer
New York Graphic Society/ Boston, MA/$47.50

Cameras are presented with 70 color pictures (many fully covering the 10×12-inch pages) and 535 black-and-white photographs, engravings, schematic drawings and period advertisements. Michel Auer makes the point that the pictures show "what engineering talents, what thought, and what infinite variety there is in camera design."

The book is a pleasure. Handsome illustrations are well produced and cleanly presented. Auer is a good writer, too. "Studio cameras were once resplendent in polished mahogany and gleaming brass, while the later models are beautiful pieces of industrial design in matte surfaces and clean outlines. . .

Bellows cameras have an appeal all their own, with their smooth sliding lens standards and flexibility of operation. The soft clunk of the mirror in a well-made single-lens reflex, the intricate links and gearing in the twin lens, all are fascinating in their operation and the thought that went into their design."

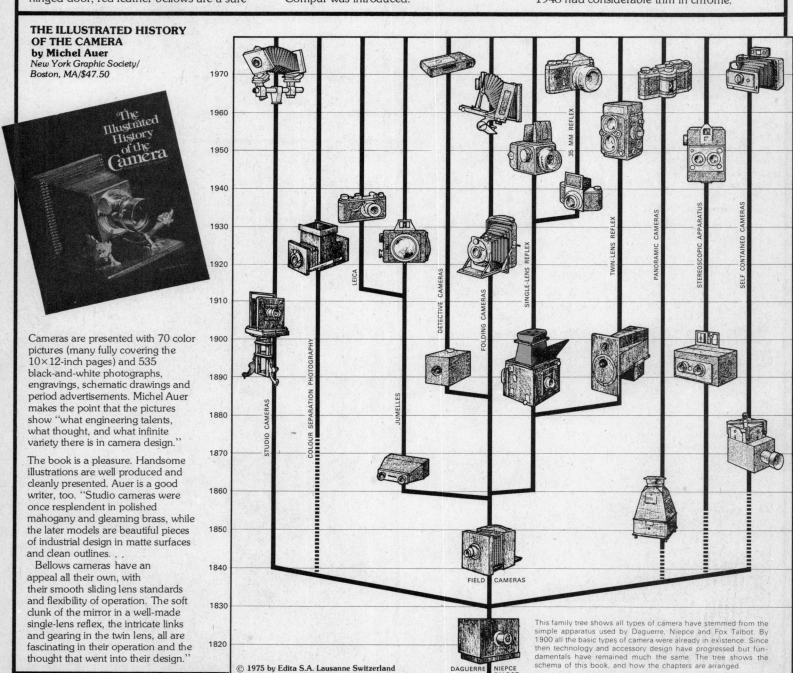

© 1975 by Edita S.A. Lausanne Switzerland

This family tree shows all types of camera have stemmed from the simple apparatus used by Daguerre, Niepce and Fox Talbot. By 1900 all the basic types of camera were already in existence. Since then technology and accessory design have progressed but fundamentals have remained much the same. The tree shows the schema of this book, and how the chapters are arranged.

A CENTURY OF CAMERAS
by Eaton S. Lothrop, Jr.
Morgan & Morgan/Dobbs Ferry, NY/$12

houses one of the world's greatest collections of photographically-related equipment.

Lothrop went as an amateur student of the cameras of the nineteenth century and convinced the staff to engage him to catalog the famed Cromer Collection and material delivered over the years from various Kodak warehouses. The result of his work is recorded in *A Century of Cameras*.

He dates and documents cameras from America, Germany, France, England, Latvia. Latvia? Yes, it is the Minox of Riga, a cigar-shape spy miniature first made in 1937.

In explicit detail, Lothrop introduces readers to cameras as small as a pocket watch (the Expo of 1895) or the Cane-Handle camera of 1902.

Each camera is given a minimum of one page. Illustrations include contemporary advertising.

Lothrop's own special interest is in the detective camera era, the period roughly from 1882 to 1896 during which cameras in wooden boxes, satchels, hats and books first made their appearance. Unfortunately for readers of *A Century of Cameras,* the wit and asides that make Lothrop essays and lectures bright and sparkling are not evident here.

Curators are not embarrassed to admit that most of a museum's holdings will not and cannot be seen by the general public. Storerooms, basements and sub-basements are the study areas for scholars only.

Fortunately for photography, Eaton S. Lothrop, Jr., a science teacher, got to catalog material at George Eastman House (now the International Museum of Photography) at Rochester. Once the home of George Eastman, this giant mansion with its labyrinthine basement and sub-basement

At George Eastman House you can see this ca. 1905 miniature camera in the shape of a pocket watch, which had a daylight loading cassette. The camera sold for $2.50; in silver plate, it was $1 extra.

COLLECTING PHOTOGRAPHICA
by George Gilbert
Hawthorn Books, Inc./New York/$19.95

An illustrated "textbook" (225 photographs and 75 line drawings) that covers all the expected subjects: history—starting with Daguerre; camera types—box, folding, reflex, etc.; instructions for dating photographic equipment (with special sections on Leica and Zeiss); data on Kodak and Graflex; a list of photographic museums; a glossary of photographic terms. A big book (9¼ × 11¼) with 288 pages. Indexed.

THE HISTORY OF PHOTOGRAPHY
by Helmut & Alison Gernsheim
McGraw-Hill/New York/$22.95

Inexplicably, camera collecting got off to a late start; but once begun, it boomed. The beginning came in 1969 with the Parke-Bernet Galleries' auction, where to just about everybody's surprise the dark boxes sold, as did the pictures they once made. It was as if photographic enthusiasts, till then secretly nursing self-conscious passions, came out of their closets to unabashedly buy and sell. Unfortunately, enthusiasm was and is no substitute for disciplined knowledge. All too often, hobbyists are not scholars.

To get camera knowledge without diminishing whatever joys set them to collecting in the first place, caring collectors read and study Helmut and Alison Gernsheim's great work, *The History of Photography.* It was first published in 1955, with a revised edition in 1969, the year of Alison's death.

Unlike Beaumont Newhall's *History of Photography,* which only superficially touches on technology, the Gernsheims' book deals exhaustively with the machines and personalities that are part of the evolution of photography as a science as well as an art.

A magazine camera ca. 1885—"the exposed plate was dropped to the bottom of the camera and the next one pushed forward into the focal plane by a spring at the back of the magazine."

Gernsheim shows this illustration of the enlarger J.F. Campbell made in 1865, which uses sunlight funneled through a hole in his studio roof (B) as a light source. A piece of glass (A) kept out dust or rain. The basic movements of modern enlargers were present. The negative carrier (C) and the lens (D) slid in and out. The exposure time was controlled by a sliding board (E) and a vertically adjusting board (F) doubled as an easel and a focusing screen.

PHOTOGRAPHIC ADVERTISING FROM A TO Z
by George Gilbert
Yesterday's Cameras/5500 Fieldston Rd./Riverdale, NY 10471/$8.95

The advertising collected in this pleasing little softcover book covers cameras from 1888 to 1926, starting with the Acme Camera and Changing Box ("mahogany camera, highly polished, holding 12 plates, with both vertical and horizontal swing, best rubber bellows, attached focusing cloth, sliding and revolving front, lock and key"). The book ends with an entry about the $1 Zar Pocket Camera "which produces pictures 2×2 inches and gives complete satisfaction. Has perfect lens and shutter, makes time or snap exposures and slips easily into the pocket. Simple, complete and convenient. The nicest present for any boy or girl. Thousands in use." The year was 1896.

The ads are picked up from *Scientific American, Christian Herald, McClure's, Cosmopolitan, Munsey's, Photo-Miniature, Camera, National Geographic, Recreation* and from the *Anthony, Queen* and *Lloyd's* catalogs

FIRST EDITION ON PRESS
PHOTOGRAPHIC ADVERTISING FROM A-TO-Z
FROM THE KODAK TO THE LEICA
ACTUAL SIZE FROM THE PAGES OF THE LEADING MAGAZINES OF AMERICA FROM THE 1880s TO THE 1920s
Reproduced in exact detail
CAMERAS—PLATES—NOVELTIES—SCHOOLS—SHUTTERS—MORE!
A UNIQUE COMPILATION
FOR THE PHOTOGRAPHIC HISTORIAN AND COLLECTOR OF CAMERA CURIOSA
A Publication of YESTERDAY'S CAMERAS, NEW YORK

ANTIQUE & CLASSIC CAMERAS
by Harry L. Gross
Amphoto, Garden City/NY/out of print

Gross's book is full of delightful illustrations and informative captions, as shown above and below: "A beautiful enamel-painted daguerreotype case, velvet-covered and small enough to be carried in the vest pocket of an admirer (ca. 1848)."

When collectors meet for an evening of reminiscing, the talk ultimately turns to something remembered from "the Gross book." *Antique & Classic Cameras* is a presentation of amazing items: Wollaston's *camera lucida*, miniature zoetropes, and *camera obscuras.*

Originally $10, many a collector has since paid twice and more for the

book that is the bible of all of the "photographic collector" literature tumbling from the presses since 1970.

The author, originally an entomologist employed in pest control, became a photographer in the 1940s. The zest for photography, and then the early realization that photography's artifacts were as nettable as any of the winged pests he had sought in farmlands of the Northwest led to the collection of a giant museum-full of cameras, lenses, images, books.

Antique & Classic Cameras is like a buffet table at a smorgasbord restaurant where the chef has taken a day off. The fish dishes are mixed in with the desserts and the spicy spareribs are somehow next to the fruit salad.

Unfortunately, the book does not deliver what the chapter titles promised, and just as mysteriously, the index is equally baffling since it is impossible to use it to locate more than a few of the hundred-odd cameras that are illustrated in the pages.

(Fortunately, enterprising Eaton S. Lothrop, Jr., 1545 East 13 Street, Brooklyn, NY 11230 sells a detailed index for $1.)

With its defects, why is this book so important? For one thing, because it has photographs of many classic cameras that collectors seek. For another, it has illustrations of pages from Talbot's *Pencil of Nature,* of the Photo Carnet (the French detective camera in a book shape), and of the Contaflex in the twin lens reflex shape of the 1930s.

Tintype "mug" camera of about 1895 promised "a picture a minute," according to Gross in *Antique & Classic Cameras*. Besides showing us unusual cameras, Gross relates cameras to history. For example: "While the average person today has the opportunity of owning a fine camera which can give him unlimited enjoyment, an average human of three centuries ago was fortunate if he was able to protect himself against starvation and disease."

The Photo Revolver, above, held nine plates, each four centimeters in diameter. The novelty sold for $60 in 1886.

PHOTOGRAPHIE IM WANDEL DER ZEITEN
by Rudolf Skopec
Letteren & Kunst/Amsterdam/out of print

Rudolf Skopec published a book on photography in 1964 that is out of print and rare. It is also much sought after by those who have had a chance to see the amazingly detailed drawings and diagrams of cameras, optical devices and scenes related to the taking of nineteenth-century photographs. In German.

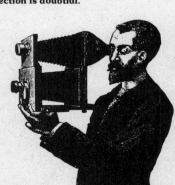

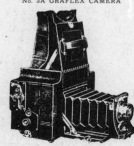

GRAFLEX CAMERAS
Prices from **$50⁰⁰ to $250⁰⁰**

No. 3A GRAFLEX CAMERA

No. 3A Graflex Camera without Lens........$ 75.00
Fitted with Steinheil Unofocal Lens F.4.5........125.00
Carrying Case........10.00

The Graflex, left, was offered in 1910 by Herber & Huesgen of New York City. *Photographic Advertising from A to Z* shows, among a number of reflex cameras, the New Model Hall Mirror. Described as "the acme of perfection," it sold in 4×5 without a lens for $30; in 5×7 for $50. The most expensive Graflex listed is the Century Naturalists' Graflex with B. & L. Zeiss Protar Series VIIa No. 19 lens for $378.50. That's 1908 money.

Twin-lens camera made by Marion & Co. in 1891. Parallax correction is doubtful.

In 1899, if a photographer wanted to turn the darkness into light, he strung a magnesium flasher to the top of his cane.

4

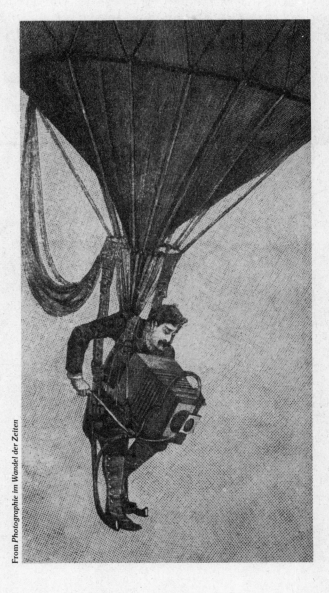

From *Photographie im Wandel der Zeiten*

SUPPORT SYSTEMS

SUPPORT SYSTEMS

FOR THE STUDIO: A SOLID TRIPOD, CLAWS & CLAMPS, PLUS PLENTY OF GAFFER TAPE

Photographers need a very large mixed bag of gadgets, tools and devices that have little to do with chemistry or optics or esthetics, but everything to do with keeping things in place or, if need be, moving things about, such as lights during a shooting session. In this chapter, such supports are presented as a conventional camera stand mounted on a dolly with lockage wheels, a gyro stabilizer for hand-holding heavy cameras at slow speeds and so forth. We also present a few items that are supportive in the sense that they supplement photography: a rear-projection arrangement, as well as a photographer's setup diagram, both shown on this page, are examples of what we mean. Then, too, there are the very amazing beam-splitter front-projection systems, shown opposite, as well as copying stands a few pages on. All are supports of one sort or another. It's our contention, after seeing considerable knuckle busting and countless hours of frustration until a problem is solved, that

photographers deserve all the help they can get.

Perhaps it goes without saying, but we'll say it anyhow, that there are never too many miscellaneous items. Here is a list of supports that you may add to ad infinitum: a high, aluminum stepladder; carpenter's and electrician's tools, including a screwdriver, pliers, saw , nails, fuses, a staplegun; foil, sheet glass, mirrors, knives, tapes of all sorts; reflector boards and, of course, rolls of seamless paper in all colors.

Langford's *Professional Photography* (Amphoto) makes the point that a cupboard is an asset. "It can be used to store oddments such as bricks; wallpaper; aerosols of lacquer, paint, and shaving cream; citric acid; metal . . . pebbles, interesting bits of bark, leaves . . . costume jewelry." All these things might be helpful in making a picture, but never forget that the camera must be steady and the lights secured, so as not to fall on a pretty model's head.

It always amazes us when we consider all the things a photographer has to know and what a hardware freak he has to be. Here the photographer has mounted a plywood base to a stand so as to support the Kodak Carousel, which is projecting a chrome of a barge floating through French wine country onto a black rear-projection screen manufactured by Kodak for viewing in bright light (it was originally used to view black-and-white slides in a plane during reconnaisance). In front of the screen is a light stand, which is also modified: in this case, a metal base has been soldered on the stand to hold the glass. The photographer solved the problem of vibrations by banishing everybody but himself from the studio while he made five-minute exposures with his Sinar-p, loaded with 4×5 Ektachrome.

The setup below is all laid out on paper for an assistant to implement. The photographer is a fastidious type and probably a wise user of time. Not only doesn't he have to do the setting up, but if he has occasion to make a similar shot again, all he has to do is send his assistant to the file.

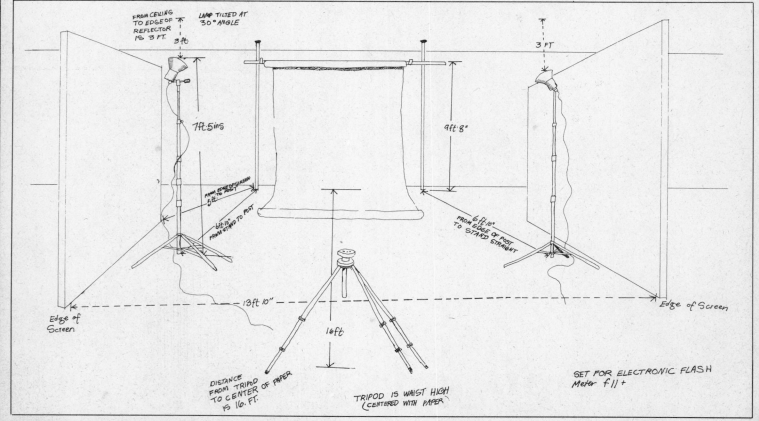

FROM CEILING TO EDGE OF REFLECTOR IS 3 FT.

3 ft

LAMP TILTED AT 30° ANGLE

3 FT

7ft.5ins

9ft.8"

FROM EDGE OF SCREEN 5 FT. TO POST

6ft.15" FROM STAND TO POST

FROM EDGE OF POST TO STAND STRAIGHT 6 ft.10"

Edge of Screen

13ft 10"

16ft

Edge of Screen

DISTANCE FROM TRIPOD TO CENTER OF PAPER IS 16. FT.

TRIPOD IS WAIST HIGH (CENTERED WITH PAPER)

SET FOR ELECTRONIC FLASH Meter f11+

POLECATS

For the photographer who uses a variety of background and lighting sets, the Brewster Polecats are an adaptable support system. The setup consists of spring-loaded, anodized aluminum poles which adjust to any ceiling height up to nineteen feet. Crossbars and clamps can be attached to support a variety of seamless paper rolls, boom lights, and reflectors—up to 300 pounds of equipment—while the poles weighing only five pounds apiece are easily movable.

There is also a portable kit of two foot interlocking sections. At eighteen pounds, it can go anywhere and can be set up floor to ceiling (up to 13½ feet) or free standing with included tripod fittings. Peter Gowland, who favors hard sunlight as a single light source for figure studies, swears by this setup. Extra sections and clamps are available, of course.

Brewster Corporation/Old Saybrook, CT 06475

FRONT PROJECTION SYSTEMS

Front projection is a system whereby a slide is projected from the axis of the camera's lens onto a screen by means of a beam splitter, in such a way that a subject standing in front of the screen and its projected background scene can be more or less realistically photographed. The question is, Why doesn't the projected slide, which photographs clearly on the background, photograph on the subject as well? It's that beam splitter and the fact that the screen is made of such highly reflective material and set up so precisely (positive optical alignment) that the reflection from the screen (3M Scotchlite) is far more intense than the reflection coming back from the intermediary subject.

The devices are used by school-package photographers and by catalog houses. There is the possibility that in the hands of skillful, imaginative photographers, interesting montages could be made, but we have not seen any yet. A pure case of technology not being followed up by creativity.

A Timber-Topper is a poor man's Polecat. All you need is one of these metal containers, which has a couple of springs inside and a rubber nonskid unit on its outer end; a ruler, a saw and a length of 2×3-inch lumber. Measure the height, floor to ceiling; cut the 2×3 just 3½ inches shorter; slide the Timber-Topper on top of the 2×3. The rig holds tightly because of the springs.

Peter Gowland doing his thing on a set held together with polecats. That wild looking camera in the foreground is a 4 × 5 twin lens reflex of his own design called the Gowlandflex.

Nord's front projector is mated to its own make SLR camera. The ideal is to eliminate edge shadow. Built-in electronic flash puts out 50 to 100 watt-seconds and 100 to 200 watt-seconds.

The Background 35 front projection system uses a 200 watt-second unit and enables the user to vary the light output of the front projector in order to be in balance with the subject illumination. A built-in photo slave triggers the projector from the flash units used to illuminate the subject. Virtually any camera can be mounted on the system.
Photo Control Corp. 5225 Hanson Ct. Minneapolis, MN 55429

Nord Photo Engineering/ 529 S. 7th St./ Minneapolis, MN 55415

67

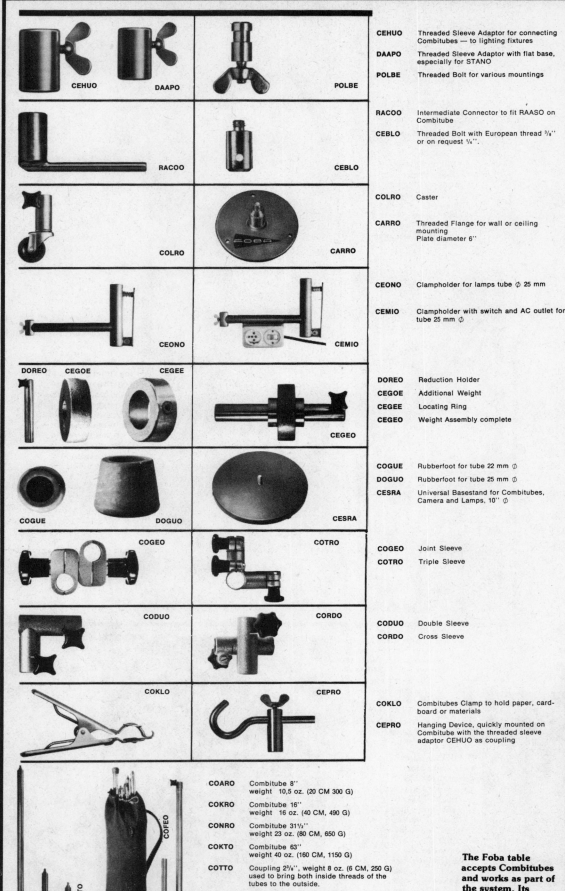

CEHUO		Threaded Sleeve Adaptor for connecting Combitubes — to lighting fixtures
DAAPO		Threaded Sleeve Adaptor with flat base, especially for STANO
POLBE		Threaded Bolt for various mountings
RACOO		Intermediate Connector to fit RAASO on Combitube
CEBLO		Threaded Bolt with European thread ³⁄₈'' or on request ¼''.
COLRO		Caster
CARRO		Threaded Flange for wall or ceiling mounting Plate diameter 6''
CEONO		Clampholder for lamps tube ⌀ 25 mm
CEMIO		Clampholder with switch and AC outlet for tube 25 mm ⌀
DOREO		Reduction Holder
CEGOE		Additional Weight
CEGEE		Locating Ring
CEGEO		Weight Assembly complete
COGUE		Rubberfoot for tube 22 mm ⌀
DOGUO		Rubberfoot for tube 25 mm ⌀
CESRA		Universal Basestand for Combitubes, Camera and Lamps, 10'' ⌀
COGEO		Joint Sleeve
COTRO		Triple Sleeve
CODUO		Double Sleeve
CORDO		Cross Sleeve
COKLO		Combitubes Clamp to hold paper, cardboard or materials
CEPRO		Hanging Device, quickly mounted on Combitube with the threaded sleeve adaptor CEHUO as coupling

COARO	Combitube 8'' weight 10,5 oz. (20 CM 300 G)
COKRO	Combitube 16'' weight 16 oz. (40 CM, 490 G)
CONRO	Combitube 31½'' weight 23 oz. (80 CM, 650 G)
COKTO	Combitube 63'' weight 40 oz. (160 CM, 1150 G)
COTTO	Coupling 2³⁄₈'', weight 8 oz. (6 CM, 250 G) used to bring both inside threads of the tubes to the outside.
COFEO	Spring-tension and locking tube Can be locked at any height between floor and ceiling or between two walls. Minimum length: 33½'' (85 CM) Extended length: 47¼'' (120 CM) In combination with Combitubes other lengths up to 9-12 ft. are possible (3-4 M).
COSAO	Carrying Bag for Combitubes and folding stand

PUTTING IT ALL TOGETHER

The Swiss-fabricated Combitube system may look like an Erector set from childhood, but it is in fact a sophisticated collection of modular parts that takes much of the pain out of setting up or redesigning studio setups.

One of a photographer's most frustrating moments is suddenly discovering that he must jack up a light just higher than his tallest stand or angle a reflector up from the floor. Its at such times that the system demonstrates its value. First, Combitube components are easy to use—you can clamp them together without tools. In addition, you can buy joints and swivels that will connect pipes at any angles, and you can buy pipes in a variety of lengths. With even a small collection of Combitube components, then, you can either build a rig especially to solve your problems, or use selected parts to extend existing setups.

Combitubes are available as single pieces or in sets. The manufacturer, Foba, has put together a plan of such common setup as a universal lightstand and a background table to capture shadow-free pictures. However, the system is so simple in conception and so thorough in execution that after you've worked with some standard components awhile, you'll find it just as easy to design and assemble rigs that are custom-tailored to your needs. Foba has such great confidence in the lightweight Combitube parts that it offers a carrying bag for transporting key pieces to a location.

Typical prices for the components are $5 for a threaded bolt, $8 for an 8-inch length of alloy tubing, $45 for a universal sleeve or a boom clamp. But then, versatility has never come cheap.

Foto-Care Ltd./170 Fifth Avenue/New York, NY 10003

The Foba table accepts Combitubes and works as part of the system. Its translucent surface is great for still life setups. You can change background color by simply backlighting with different colored lights.

AN ODE TO THE CLAMP

It's a very good idea if you are going to do much studio photography or on-location still life stuff, to have an organized collection of clamps. Clamps can be used in conjunction with stands, shelves, doors or ceiling fixtures to hold any number of things—reflectors, scrims, lights, props. Four right-angle clamps combined with four lengths of half-inch doweling make a good frame for mounting diffusion material and, in effect, creating a large light source.

The infinitely unpredictable situations that clamps can get involved in have given rise to a special sub-class of mechanical design of great ingenuity and, to be sure, beauty—witness the laboratory clamps on this page made by the Fisher Scientific company.

Many of the striking affects achieved by imaginative photographers are the result of rings set up outside the periphery of a picture with the subject hanging inside it, seemingly in defiance of gravity. You can be sure a clamp is just beyond the scene.

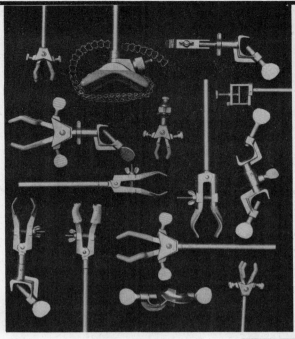

For a third fourth or fifth hand, laboratory clamps are fantastic for holding and positioning props or tools. Many rotate on their axis; several have rubber tips, the better to hold delicate items. Available at laboratory supply houses.

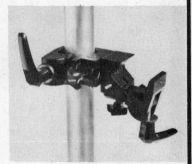

Shown here are two Bogen "super clamps." They open to two inches maximum and have eight accessories for attaching cameras, backgrounds, reflectors and the like. The clamps attach together or to accessories by means of hexagonal studs that fit into six-sided holes (shown). By removing and re-orienting the connection, you can pivot 360 degrees at 60-degree intervals.

Bogen Photo Corp./P.O. Box 448, 100 S. Van Brunt St./Englewood, NJ 07631

This Unifot clamp allows you to make a boom with any size pole or pipe from ¾ inch to 1¼ inches. There are two parts, one of which is anchored to a vertical support; the other half carries the boom pole and can be rotated and clamped in any position. It's wise to counterbalance boom setups with a water bag or other weight. $25.

Foto-Care/170 5th Ave./ New York, NY 10010

A Polecat clamp, appropriately named the "Claw," is a handy tool to have around. Release a pin lock and the two back-to-back screw "C"-clamps rotate against each other and can be secured in sixteen differently angled positions. A light-boom, or any other piece of equipment can be clamped to a chair, table, ledge or ladder. Each clamp opens a maximum of two inches.

STURDIER THAN A TREE AND NO SWAY

A studio photographer wants to get his camera into position for steady operation with minimal effort. Thus, the importance of the camera stand. It can take an 8×10 view camera ten-feet high or secure it at floor level. On wheels, it can be quickly and easily moved about, and its boom allows placing the camera directly over the subject for a straight downward shot.

Since even high-paid studio men are susceptible to lethargy, the thought of moving a camera on a tripod one more time, even if just an inch down and two over, often results in an "ah' the hell with it." Easy operation of a camera stand is an antidote to laziness. For fiddling with a set *after* focusing an in-tight view camera, a stand with its rotating boom is a distinct advantage. Simply mark a point on the set that corresponds to the groundglass cross-hairs, swing the boom (camera attached) out of the way, do what has to be done and then swing the camera right back on target. No readjusting or refocusing is necessary.

Finally, since a studio is likely to be a busy place during a shooting, it is less likely that a worker on the set will bang into a stand.

The Model 30S, which stands 10 feet high, has a main colum 3×3 inches. The stand is no longer made but is available used for about $400. The camera head, left, can be tipped and tilted and turned in all directions. Parts are rare but Ben Vallone, who worked for Saltzman for forty years, can repair most Saltzman equipment and make parts if necessary.

Ben Vallone/17 Union Ave./ Little Ferry, NJ 07643

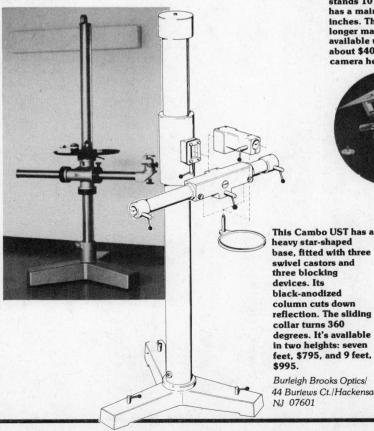

This Cambo UST has a heavy star-shaped base, fitted with three swivel castors and three blocking devices. Its black-anodized column cuts down reflection. The sliding collar turns 360 degrees. It's available in two heights: seven feet, $795, and 9 feet, $995.

Burleigh Brooks Optics/ 44 Burlews Ct./Hackensack, NJ 07601

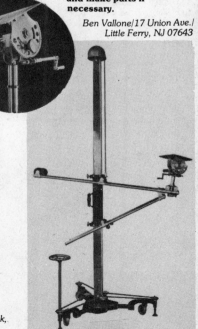

69

GOING STEADY

All things being equal, the heavier the tripod, the steadier the tripod. If a tripod is used that is too light, the camera shakes; if one is too heavy, a field photographer might quit hiking altogether. Tripods made out of die-cast alloys provide a compromise between portability and stability. The 2¼ and 35mm users can also often benefit from a rigid platform. Weight, design (of heads and legs) and adhesion are considerations.

Those tripods are most stable that have the fewest parts. A rule to this proposition is that you should never telescope two units on a leg if you can get away with extending only one.

We prefer tripods that have rack-and-pinion-(geared) operated columns because the camera can be moved up or down without rotating from side to side, as is the case with friction-tightened center columns. Also, tripods that have rubber feet and/or spikes come in handy.

Another thing we've discovered is that if you are going to be working at the beach a lot, you'd be well advised to get one of those old-fashioned wooden tripods, since sea and sand wreck havoc on the alloys.

One photographer harps about "keeping it solid"—about the time his camera swayed in the wind on Telegraph Hill and he had to suspend from it twenty-five pounds of rocks in shopping bags. Another photographer uses the weight of his spare tire as a tripod stabilizer. Light tripods can work with light cameras, a simple 35mm one, for example. Gitzo makes tripods in weights from bantam to heavy with telescoping legs in diameters of ⅝, ¾, 1, 1¼, 1⅜, 1½ inches. Rack-and-pinion or friction columns are interchangeable on models with legs of 1¼ inches or greater. All parts are individually replaceable if damaged. Some of the Gitzo stands have legs designed after the classic French World War II machine-gun rest. (See below.) By replacing the column with a plate and then releasing three catches, you can spread the legs until the plate is just inches off the ground.

Karl Heitz/979 Third Ave. New York, NY 10022

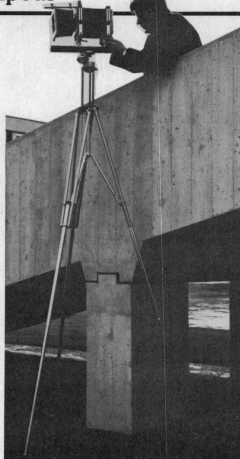

Foba's ASMNO, which can be mounted on a dolly, has several carefully wrought details. Legs are separately adjustable at two points; they may be quick released. Maximum height is sixty-nine inches; but Combitube extensions can be added to the legs for greater height.

Foto-Care/170 5th Ave./ New York, NY 10010

This tabletop tripod has fully adjustable legs. To make them longer, Combitube extensions are available in 8, 16, 31½ and 63 inches (see page 68). The tripod bushing column can be reversed, depending on whether an American (¼"×20) or European bushing (⅜") is desired. Feet are versatile: rubber ends pull off, exposing spikes; feet themselves are interchangeable. Suction cups can be used for very low, spread-out work. The tripod, without, a head, is priced at about $200; heads range from $75 to $250.

Foto-Care/170 5th Ave./ New York, NY 10010

This man would have to focus his camera by standing on a stool, since it extends to six feet, one inch, and he is five foot, nine. A clear case of overreach. The Bogen 3030 weighs 9½ pounds, has three spirit levels, a locking center brace, convertible tip legs, reversible geared center post and nylon rotation stops. The various levels are for use on uneven ground and for panning.

Bogen Photo Corp./P.O. Box 448/100 S. Van Brunt St./Englewood, NJ 07631

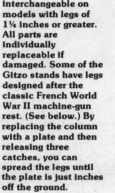

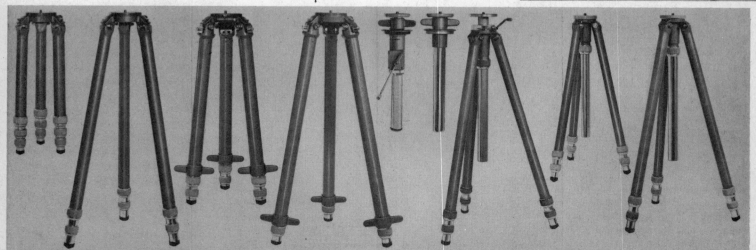

THE END OF ROCK 'n' ROLL

Any photographer who has tried to shoot from a moving vehicle—be it a car, a pitching boat or a helicopter—knows well the sheer muscular strain of trying to hold even a 35 mm camera steady enough to make a sharp picture.

The Kenyon Gyro Stabilizer is designed to ease that job by seeming to make the camera lighter while actually adding to its weight. The Kenyon itself weighs slightly more than two pounds, and the cylindrical machine bolts to the mounting plate of the camera.

When it is activated, two small gyroscopes within the unit begin to spin. As momentum increases, it becomes harder to deviate a gyro from its axis of rotation, and by the time the gyros have reached their full operating speed of 20,000 rpms, they have developed enough momentum to withstand normal vehicular vibrations, and then some. The result is markedly sharper photographs. Meanwhile, the photographer using a Kenyon will feel that the camera is growing

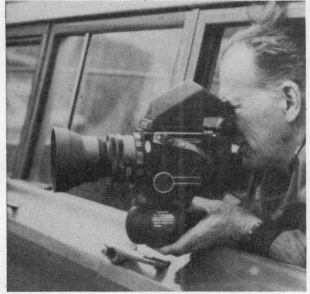

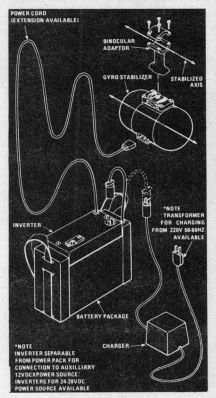

lighter, for as the camera stops jiggling constantly, he'll relax his death-grip on it.

Of the three Kenyon models, the KS-4 is considered the best for normal use. It can stabilize a pair of binoculars fitted with a special

mount, a 35 mm still camera with a 400 mm lens or even a 16 mm movie camera with equal efficiency. The KS-4 costs about $850.

Ken-Lab Inc./Box 128/Old Lyme, CT 06371

THE TILT-ALL STORY

Back in the late thirties, the only tripod available to still photographers was the Crown, which was made by Eastman Kodak out of wood. It didn't have a head; in order to position a camera, a device made from two pieces of wood and hinged like a book had to be attached to the camera and placed on the top of the tripod. (A ball-type head was available from England, but it lacked rigidity.) Caesar Marchioni, a camera fan as well as an ex-ice cream man forced out of business by the Depression, decided that what this country needed was a tripod and head that went forward, backward and sideways. He designed one,

called it the Tilt-All and began selling it. World War II closed him down, and while subcontracting war work, he and his brother Mark, in their spare time, went the whole way: they designed a light-weight *and* rigid tripod, fabricating it out of aircraft aluminum. The war ended and from then on their production never managed to keep up with demand. They worked out of the basement of their home in Rutherford, New Jersey, sometimes, with five employees, managing to produce 5,000 units a year.

"Always," says Caesar, "we hoped to catch up so we could get the time to expand, to plan a factory and so forth, but always the orders kept coming in."

In 1971, a less expensive imitation began to be made available by Star-D. Professional opinion is that it is not as functional as the Tilt-All under rigorous conditions, because it is not as precisely machined, precise (close tolerance) machining being very expensive.

In 1973, the brothers decided to place their product in the best hands they could find. They chose the E. Leitz company.

"When I first went out to their house," says Gene Anderegg, national sales and manufacturing manager of E. Leitz, "I couldn't believe how they had packed such sophisticated equipment into such a tiny space. We bought the tools, dies, plans and machines (and, of course, the trademark)."

Anderegg says that Leitz has tripled production. "We still can't keep up with demand."

Tilt-All: E. Leitz/Rockleigh, NJ 07647

USE YOUR HEAD

With a pair of adjustable vise-grip pliers and a Leitz head, you can make an immensely versatile clamp that is ideal for cramped or unusual quarters. Use a carbide bit to drill into one arm of the pliers. Insert a ¼ inch × 20 bolt and screw the head onto the pliers. Now, you can clamp a camera or light source in awkward situations, since the

vise-grip will tighten around practically anything. One photographer used this device to secure a motorized Nikon onto motorcycle handlebars. Though the bike scrambled over some rough terrain, the pliers held, and he got some dramatic shots.

E. Leitz Inc./Rockleigh/NY 07647

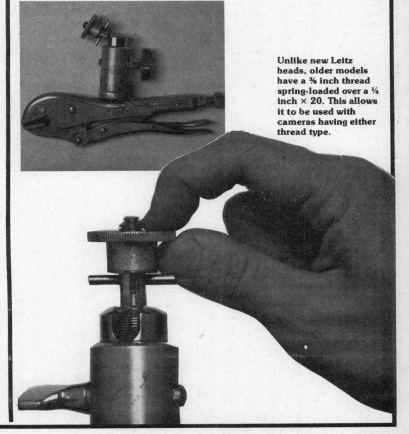

Unlike new Leitz heads, older models have a ⅜ inch thread spring-loaded over a ¼ inch × 20. This allows it to be used with cameras having either thread type.

THERE IS A TIME FOR A LEVEL HEAD AND A TIME FOR ONE THAT IS ASKEW

A tripod has to be steady and the head has to enable the photographer to get the view he wants from the place he's at. When the camera needs tilting in any direction or at any angle, he wants to be able to do it simply. Moreover, if he is working in a restricted area with just too little room and he can't get at the front of the camera to set the lens controls, it is indispensible that he be able to compose his picture in the groundglass, swing the camera around so as to set the shutter, and then swing it back to its original position. That's why some heads have degree circles marked off.

The easiest heads to operate are ball and socket, but they are not as steady as three-way heads. The latter permit a forward, backward and left or right tilt, and rotation. By the way, two-way heads may be the more economical, but our experience is that a saving in money is often at a cost to versatility.

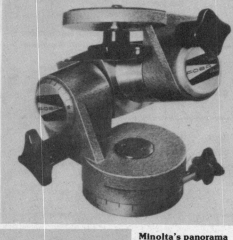

This is Foba's ASMIA double pan and tilt head. Vertical adjustment is locked by an eccentric clamp. With two tilting knobs, the camera can be easily lined up. The price is a tough $220.

Foto-Care/170 5th Ave./ New York, NY 10010

Arca Swiss has a universal ball head. With one knob the camera can be positioned in virtually any direction. Universal heads have one drawback: after the head is "locked," the camera drops slightly. The answer is to aim slightly higher than where you want to "hit."

Bogen Photo Corp./P.O. Box 448/100 S. Van Brunt St./Englewood, NJ 07631

Minolta Corp./101 Williams Dr./ Ramsey, NJ 07446

Minolta's panorama head turns 360 degrees with marked intervals of 12 degrees. Positive click-stops at 24-degree intervals permit the accurate overlapping of sections, so that an entire panoramic view can be taken and pieced together. The built-in spirit level helps achieve a straight horizon.

The Pro Zip Grip is a two-part gadget which permits rapid mating of camera to tripod. The center disc is screwed into the camera. A clamp is screwed on the tripod, and a snapping clamp swiftly joins both. With models costing $75 per hour, it's good for studio work.

Burleigh Brooks/44 Burlews Ct./ Hackensack, NJ 07601

FOR SHOWING OFF, TRY COPYING

For the intermittent copier, whether professional or amateur, who is more interested in making pictures than copying them, there is one tip that we feel is a very good one. When you want to make black-and-white slides of black-and-white pictures, don't use negative reversal film—it's really a pain and full of pitfalls; instead, load up your 35mm camera with Kodachrome 25, a high-resolution film, and shoot outdoors or with strobe. You'll get a sharp transparent black-and-white slide.

We find that most photographers do have a need for copies, especially for presentations. If you want to sell a book idea it's often easier to carry or send a slide presentation; the same is true if you want to show samples of your work. Sometimes large-format film (in color, of course) is easier to show than 35mm; not every customer has a Carousel and it's not always possible to carry one or to set one up. It then makes sense to enlarge copies from 35mm.

Since there are two types of artwork, transparent and reflective, a copy setup should be used that can handle both: lighting from behind for the transparent, from in front for the reflective. In both cases, film should be squared-up and absolutely parallel to the subject, so there will be no distortion. Lighting should be from both sides at a 45-degree angle. For more how-to information, see Kodak's *Copying* booklet, described at right.

The free-standing Copypro accepts cameras up to 8×10. Clear and translucent copy boards are available. Twin 3200° K lights mount to the table, eliminating constant light repositioning; they are swung underneath the glass board to copy transparent art. The camera remains in a fixed position; the copy board is raised or lowered, depending on the size of the subject.

Sickles Inc./P.O. Box 3396 Scottsdale, AZ 85257

One of Kodak's best technical information booklets, this could be titled "Everything you want to know about copying but were too ignorant to ask." Contents cover copy cameras, lenses, illumination, correct exposure, processing, black-and-white copies, restoration, duplicate negatives and tranparencies. Data sheets on seventeen relevant films.

Eastman Kodak/Dept. 454, 343 State St./Rochester, NY 14650/paper, $1.50

KODAK CONTROL PATCHES

For copying in color, it is rare that film straight from the box is going to be satisfactory; it's either too blue, too green, sometimes even too red. Color bars are used as a target to test the color balance of film. The test results are compared with the original and corrected accordingly with Kodak color compensating filters. The gray scale shows the degree of highlight or shadow detail, as well as the neutrality of the blacks. All copying for print reproduction should include the bars as a guide for the printer.

5

Duke Mander

LIGHTS

THE QUALITIES OF LIGHT

All photographers shoot by existing light. A smaller number are clever and resourceful enough to *make* the light exist under their control. To use artificial light intelligently, you must consider three factors—the intensity, the direction and the quality of the light. Intensity means having enough light to shoot by. This is further related to the film you would like to use and the style you want to photograph in. Do you want to stop action or use a very small aperture for depth? This desire could cost you. Direction of light applies universally to electronic flash, tungsten, quartz or a candle. Where you put a light in relation to the subject will interpret the subject differently. A light from a position close to the camera is called "flat" lighting because it tends to interpret a face or an object two-dimensionally. A light from the side will bring out the roundness of the subject. Lights can be placed anywhere in the 360 degrees surrounding the subject. The direction of the light source usually sets the mood of the photograph. Quality of the light source is the most complex factor. It has to do with "hardness" or "softness" and is directly related to the size of the light and its distance from the subject. An ordinary twelve-inch reflector used a few inches away from the brush end of a toothbrush will achieve a quality of light that, to translate the same feeling to a photograph of an automobile, would require a light source over one hundred feet in diameter. A large light source used close tends to wrap around and enhance the subject. A spotlight used ten feet away can be very cruel.

These three aspects of lighting are not as easily separated as it seems. To get a soft quality, such as in a bank light, an umbrella or in bounce light, you use up much of the intensity of the original light source. You might achieve a beautiful quality but not have enough intensity to shoot with. You then have a choice of (a) using faster film, (b) opening up a few stops or (c) buying more lights. Direction is interrelated to quality; it becomes more critical as the light gets harder. With a spot you really must watch direction, but with a bank you can get away with a lot. Your requirements in intensity, direction and quality will eventually determine your physical lighting setup.

THE MYSTERY OF HARD AND SOFT LIGHT

Photographers sometimes talk about their magic light. Francesco Scavullo, in a recent *New York Magazine* article, claims that his special soft light is his secret "beautifier." In fact, the hardness or softness of light is governed by very simple principles: the larger the light source, the softer the effect; and/or the nearer the light source, the softer the light. Thus, a photograph of a fingernail made with a twelve-inch reflector from six inches will be soft light on that subject, while a photograph of a full figure with the same reflector from twelve feet will be hard. All things being equal, the following is a list of lighting situations in an average room, going from softest to hardest light. The subject, a person; the walls, dark grey, and a white ceiling.

1) Bounce off the ceiling from shoulder height (four feet from ceiling)
2) Bounce off the ceiling with flash overhead (two feet from ceiling)
3) Shooting directly through a 3×4-foot translucent screen
4) Bouncing off an umbrella
5) Shooting directly with a large (normal) reflector
6) Shooting directly with a small (wide-angle) reflector
7) Shooting directly with a bare bulb. (In a small room with light walls and ceiling, the use of a bare bulb results in a soft light.)

FILM AND TELEVISION MAKEUP
by Herman Buchman
Watson-Guptill Publications, New York/cloth, $15.95

Studio photographers should know something about makeup. For glamour and fashion work, it is a must and there aren't many sources around for learning it. This book, by a man with years of experience on Broadway and in television and film makeup, is excellent. The text, accompanied by sequences of photographs, explains and documents all the techniques, from de-emphasizing a turned-up nose to creating the Hunchback of Notre Dame. The last chapter, "Gallery of Great Makeup Achievements," is fascinating reading for anyone.

LIGHTING FOR PHOTOGRAPHY
by Walter Nurnberg
The Focal Press/London and New York/ out of print

LIGHTING FOR PORTRAITURE
by Walter Nurnberg
Amphoto/Garden City, NY 11530/ cloth, $13.95

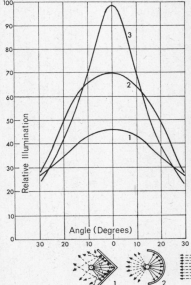

Lighting, like the rest of photography, goes through trends, fads and fashions. The taste of the seventies is the use of large, broad light sources, rather than the spots and multiple lights that were popular in the forties. We mention this because the casual browser might be put off by these two very thorough, classic lighting books. Though it's true that some of the effects shown are not popular today, the information and theory is universal.

Lighting for Portraiture is especially complete in displaying with mathematical exhaustiveness what happens as camera angle and combinations of lights change positions. Parts of the human face are analyzed in terms of lighting; "problem" faces are discussed. Yet with this minute attention to detail, the author never loses sight of the larger job of the photographer—the portrayal of the subject.

Both of these volumes are not books you'll read like a novel, but they contain bits of knowledge that keep you referring back to them.

Typical curves showing the relative distribution of light produced by a conical (1), spherical (2), and parabolic (3) reflector, using the same light source. The parabolic (3) and spherical (2) reflectors compared here have both highly polished metal surfaces, while the conical reflector shown is a cardboard one. It is clearly shown that the relative illumination of the parabolic reflector (3) is the highest, but falls off rapidly towards the edges. The spherical reflector produces a more evenly distributed, softer light, but gives relatively less illumination. The conical reflector (1) leads to very diffused light and appears the least economic.

LIGHTS/stands and reflectors

LIGHT STANDS

Whatever lights you use and whatever your taste in lighting, you'll need light stands. The ideal light stand is heavy, rugged, solid, well made and, at the same time, light, compact, foldable and cheap.

Studio light stands usually have wheels and enough weight near the base so that they are stable; they are usually not collapsed after each use. Location stands, such as the popular Pic stands, are made of aluminum and fold up as small as practicable. Around the studio, these lightweight stands are used as low-light stands, to hold fill-in cards, and occasionally to hold a not too heavy light.

Lowel-Light is a company specializing in serving the location motion-picture photographer, which sells very compact equipment, often in kits. The Water Weight is a gadget of theirs we like. Collapsed, it is an empty plastic container that packs easily in their kits. On the set, it is filled with water, and now serves as twenty-one pounds of weight to attach to the bottom of a stand or to balance a light on a boom stand. Heavy studio stands last a long time and are available used, often from theatrical lighting companies, motion picture sources and other still photographers.

Pic utility light stand #224, with sections that come apart, can be combined with clamps for improvising sidearms or diffuser frames.

Burleigh Brooks, Inc./44 Burlews Ct./Hackensack, NJ 07601

The Lowel-Link system uses component poles and interlinks to make up its Sun Diffuser frame. The Lowel Grip, which can tilt 180 degrees or pan 360 degrees, positions the frame on the stand.

Lowel-Light Mfg., Inc./421 W. 54th St./New York, NY 10019

4 **Interlinks**

4 **Poles**

All black knobs up

The Bogen Super Boom ($280.00) is a pretty sophisticated stand for any studio. The boom arm of ninety-nine inches allows you to get an umbrella light over the center of most setups and to control the exact tilt of the light from the other end of the boom. Boom lights, in general, allow you to position a light very high or very low without being confined by the physical presence of a stand immediately under the light. A similar boom from Calumet is also available, comparably priced.

Bogen Photo Corp./P.O. Box 448, 100 S. Van Brunt St./Englewood, NJ 07631

REFLECTORS

Anything can be a reflector, but the photographer's problem is to place the reflector where *he* wants it. In the studio, large rolling flats are used as reflectors (commonly 4×8 feet), as well as various-sized cards in white, metallic and colored surfaces.

Umbrellas have become popular because of their collapsibility. Some are metallic, others white. Don't automatically conclude that metallic is "better" because it's brighter. The character of each is different and must be suited to the effect wanted.

Larsen Enterprises, Inc./18170 Euclid St./Fountain Valley, CA 92708

The Reflectasol bounce-light systems incorporate both conventional and square umbrellas in a variety of finishes. Besides silver, white, and translucent, they also come in black to absorb unwanted light.

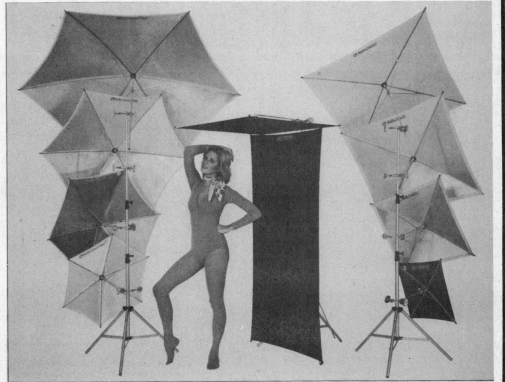

FOTO-CART

When you have all your lights, cameras, stands, etc., all organized and neatly packed for location, you'll discover that you have only two arms with which to schlep it. One solution is to put it all on a Foto-Cart. It comes in two versions, the Foto-Cart Deluxe for loads up to 60 pounds, and the Professional for loads up to 150 pounds. Both break down into two sections for storage in a vinyl bag. They have telescoping aluminum handles and elastic cords, which hold the load on the cart, ready to be wheeled to the next shooting.

Berkey Marketing Companies, Inc./25-20 Brooklyn-Queens Expwy. W./Woodside, NY 11377

SEEING THE LIGHT

The big advantage of tungsten light is that you can see it and know what you are getting. Electronic falsh, as useful as it is in other ways, cannot be "seen." Modeling lights indicate by proxy what that quick, big burst of daylight will give you, but they cannot be as precise because the flashtube and the modeling lamp cannot be in the same place at the same time. In this regard, electronic heads with a single modeling light surrounded by a circular flashtube are best.

For this reason, some studio photographers still prefer tungsten for still life work, especially if they regularly use spotlights. This big plus must be weighed against the minuses of the great heat produced, the longer exposures needed and the change in color that happens when bulbs age. For location, tungsten or quartz lights can make a far smaller package to transport than strobes. The Lowel-Light company has made a successful career out of packaging the greatest amount of continuous light in the smallest space.

A very positive feature of tungsten or quartz on location is that these sources can usually be made compatible with existing light. The light level can be lifted to illuminate the subject without overpowering room lights. This means that background details will record naturally on your film. With strobes, the flash is generally so intense that the small apertures that result will not record anything not directly lit by your strobes. For this reason, the photographer must be prepared to light the entire scene, namely everything that shows in the viewfinder. This often means carrying a great amount of equipment. Also, the low brightness-level of the modeling lights makes them worthless as a lighting guide, unless all existing light can be turned off. Polaroid tests become almost indispensable for location strobe photographers.

Basic equipment is less costly in tungsten. It's a good way to first get into lighting and the best way to learn what it's all about.

A basic Smith Victor studio tungsten light, sixteen inches in diameter, uses a 1000-watt mogul base lamp (insert adapters are available, so a normal base 500-watt bulb could also be used). This kind of light is often used in portraiture, product and other studio photography. It has a heavy-duty reflector and a sensible swivel arrangement that allows you to control the direction of the light without burning your hand to a crisp. It comes with a switch box that's stand-mounted.

Smith-Victor Corp./Griffith, IN 46319

The Model 100UL, above, also by Smith Victor, is a basic socket and clamp arrangement that uses floods or spots with built-in reflectors. The bulbs cost almost as much as the fixture ($5.75). This kind of fixture is good for the amateur as well as the pro who uses tungsten infrequently. They are good for location work since you do not have to carry any separate reflectors. Maximum recommended wattage is 500 watt DXB (spot) or DXC (flood). The wooden handle is cool.

The Lowel-Light is a very sophisticated socket and attachment arrangement built around reflector floods or spots. Instead of a clamp, the light uses a flat piece of notched metal and chain that attaches to light stands, doors, chairs, pipes and, with gaffer tape, even to flat surfaces.

Lowel-Light Mfg., Inc./421 W. 54th St./New York, NY 10019

STAND MOUNTING WITH NOTCH AND CHAIN

Use notch A and slot A for stands, pipes, etc. up to 1¾".

(1) Place notch A around stand, bring end of chain behind stand...

(2) ... spring end of plate downward ½"...

(3) ... pull chain tight, slip it into slot A to maintain the sprung position of the plate.

Use notch B and slot B for small stands, up to ½".

Attach to pipes, columns, etc., up to 4" in diameter, with plate inverted and flat against pipe. Pull chain taut around pipe and slip it into slot B. The end of the chain should be passed over stud E.

QUARTZ

As they burn, ordinary tungsten lights oxidize the tungsten filament and coat the glass shell with a dark film. This causes the light to get dimmer, redder and eventually to burn out. Quartz lights are also tungsten, but are encased in a small quartz tube containing halogen, iodine or bromine gas. As the filament burns, it disperses in the halogen, iodine or bromine atmosphere and redeposits on the filament rather than on the quartz shell. This results in a longer life, no change in color and no diminishment in brightness. The lamps cost more but last longer and are, in the long run, cheaper. You must, of course, have a light fixture that accepts quartz tubes. Contrary to popular misconception (and early advertising), quartz lighting is not significantly brighter. 1000 watts of quartz and regular tungsten produce the same light, though hot spots in some quartz tubes will be more brilliant at that point.

The unit folds up into a neat 11×3×2-inch package, which protects the quartz light bulb inside. The TOTA-Light system can take 500, 750 or 1000-watt bulbs.

Lowel-Light Manufacturing, Inc./421 W. 54 St./ New York, NY 10019

Six TOTA-Lights shown clustered form a bank for a broad, intense light source.

Coverage is controlled by folding reflector doors. Lights must be burned horizontally.

GOING HOLLYWOOD

Several years ago, we had the unique experience in free-lance still photography of working with a full movie crew, a job that is usually reserved for a select group of still-photographer union members. We were very impressed that there was a specific piece of equipment for every photographic problem. In stills, we are used to propping up lights with books and balancing reflectors in the most precarious ways. The Mole-Richardson catalog brings back the memory of the professionalism of the movie crew and the richness and variety of lights and accessories.

For instance, could you guess what an eight-tube Molescent is? Though it might sound like a strong concentration of a terrible odor, it is in fact an esoteric piece of fluorescent lighting equipment. In current movies, much existing-light filming is being done in hospitals, police stations, subways, etc.; the light is often fluorescent, which creates a color problem that can be dealt with by the lab in printing. But to fill in fluorescent, you should use fluorescent so all the light is compatible. The Molescent fixture does just that. It's heartening to see a company think that way.

Mole-Richardson Co. /937 N. Sycamore Ave./Hollywood, CA 90038

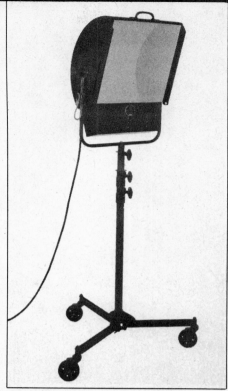

The 1000-watt Molequartz Super-Softlite is an eighteen-inch square light used for fill-in and as a main light for product photography.

All the light produced is indirect, the quartz tubes being located below the curved reflective surface. Accessories include diffusers, silks, etc.

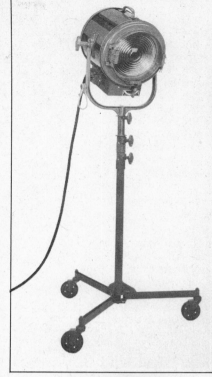

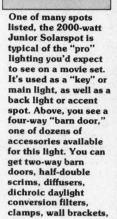

One of many spots listed, the 2000-watt Junior Solarspot is typical of the "pro" lighting you'd expect to see on a movie set. It's used as a "key" or main light, as well as a back light or accent spot. Above, you see a four-way "barn door," one of dozens of accessories available for this light. You can get two-way barn doors, half-double scrims, diffusers, dichroic daylight conversion filters, clamps, wall brackets, etc.

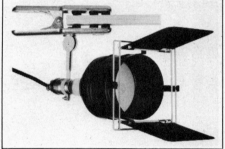

Here's the 500-watt Molegator grip with socket, a reflector bulb, a diffuser holder and a two-way barn door. Look familiar? It's Mole-Richardson's gutsy version of a Lowel-Light or Smith Victor's clamp with socket. This setup, as shown, will cost you $70.33 plus shipping. The price of gutsiness.

The Century stand is a basic Mole-Richardson folding stand. Though it can be used as a light stand, it is usually used in conjunction with single or double-arm accessories for holding flags, scrims, etc. (see above). It doesn't roll around, because there are no casters. The three non-symmetrical legs allow it to be used very close to other stands. It may even be nailed to the floor for extra stability.

This is a type 2428 cloth flag. Flags, cutters, scrims, silks, lavenders, black nets, and cookies (cutout patterns) are a few of the variety of light-modifying devices that are often used between the light and the subject to achieve subtleties in lighting.

The Fogmaker Moleffect is truly one of the more exotic items in Mole-Richardon's catalog. It is used to produce the atmosphere we all associate with Sherlock Holmes' London. Fog Juice comes in gallon, five-gallon or fifty-five gallon drums for really big sets. The fogmaker will also dispense insecticide. Another fogmaker (type 1963), produces low-lying fog cooled with dry ice to hug the floor. It can be used with Fog Chaser to clear fog, Insecticide, Spice Deodorant and Air Clean. The eighteen-inch Wind-Machine Moleffect can also clear fog when it's not creating hurricanes.

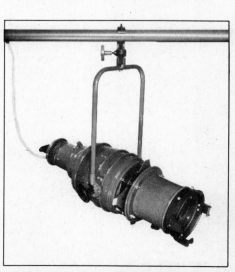

The 2000-watt Molequartz Molelipso is an ellipsoidal spot light used for stage lighting. Shown here with lens-tube assembly, it is used to project patterns of light for special effects. It is shown hanging from an overhead pipe, a capability of most of the lights shown. A variety of mats, irises, and patterns are available to provide a wide variety of projected images. It is useful as a regular spot, since the shape of the light can be easily controlled with the inner blades.

FLASH ON CAMERA

The days of the cigar-chewing, stand-on-the-table, press photographer with the flash on his Speed Graphic ended sometime in the sixties when the wire services bought 35mm single-lens reflexes. Yet flash on the camera goes on, now in the form of portable electronic flash for the amateur, the photojournalist and even the fashion photographer. Flash on the camera produces images of a flat, non-dimensional quality, often with "red eye" (eyes take on a mad red glow because the flash, so close to the axis of the lens, lights up the inside of the subject's eyeballs); the flat lighting has even become a style, as in the fashion work of Helmut Newton.

Sophisticated automatic electronic flash units have evolved that compute the exposure needed, while simultaneously emitting the correct amount of light. Some of these units even save unused power for future flashes. At first, photographers who favored bounce flash could not take advantage of this automation, but the most recent generation of automatic strobes treat both bounce and direct flash automatically. Flash duration is the variable that controls exposure, in some cases approaching 1/50,000th of a second at close distances.

The Auto/Strobonar is Honeywell's automatic portable electronic flash. The 892S has a manual Kodachrome 25 guide number of 90. It uses either NiCad rechargeable batteries or a 510-volt battery, plus AC.

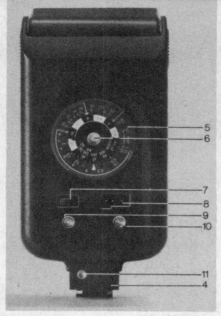

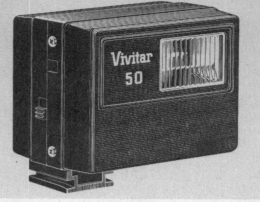

The back of a Braun 2000 VarioComputer automatic electronic flash. An automatic control range is picked to correspond with a fixed aperture. The unit then produces the amount of light needed for exposure at that opening.

Guide Numbers (ASA-feet)										
ASA film speed	25	50	64	80	100	125	160	200	400	800
Flash Guide No.	22	31	35	39	45	50	56	62	87	138

Guide Numbers (DIN-meters)										
DIN film speed	15	18	19	20	21	22	23	24	27	30
Flash Guide No.	7	10	11	13	14	16	18	20	28	40

The Vivitar Model 50 is an example of a low cost, non-automatic, small electronic flash designed primarily to be used in a "hot-shoe" of a 35mm camera. It uses a six-volt battery, which is good for about 200 flashes, according to the manufacturer. With Tri-X in your camera or High-Speed Ektachrome pushed to 400, you can shoot a subject ten feet away at f/9. Not bad for a unit no larger than a pack of cigarettes.

The Sunpak 401 is an automatic electronic flash with variable apertures on the light, which allows the photographer a choice of f-stops along with automation. Also, NiCad or alkaline batteries can be used in additon to AC. The computer can be turned off for manual use.

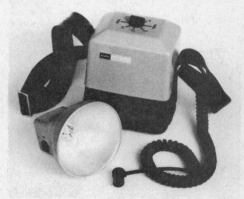

The Singer StroboFlash IV is a non-automatic, heavy, but powerful and dependable portable electronic flash that is still the favorite of many wedding and press photographers. The two batteries pack 450 volts (together, in series). Recycling time varies from two to nine seconds, depending on the selector setting. The maximum "nominal-watt seconds" is 200, with 150, 100 and 50 being available. The maximum guide number for Kodachrome 25 is 83. A set of batteries is good for about 1000 flashes. The unit weighs in at nine pounds, eight ounces; but the weight is on the shoulders, not the camera, the head being exceedingly light.

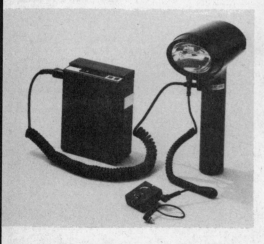

Honeywell Photographic Products/P.O. Box 1010/Littleton, CO 80120

Braun North America/55 Cambridge Pkwy./Cambridge, MA 02142

Ascor Div./Berkey Marketing Cos./25-20 Brooklyn-Queens Expwy./W. Woodside, NY 11377

Vivitar Div./Ponder & Best/1630 Stewart St./Santa Monica, CA 90406

Sunpak Div./Berkey Marketing Cos./25-20 Brooklyn-Queens Expwy./W. Woodside, NY 11377

Singer/Graflite Photo Products/210 Brant Rd./Lake Park, FL 33403

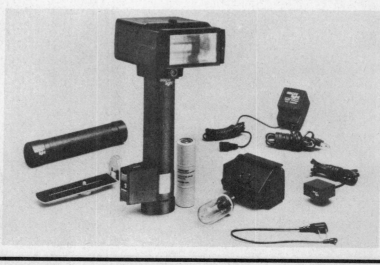

The Ascorlight Auto 1600 System is shown here with a remote battery holder, bare bulb adapter and remote sensor. This is an example of automation brought to a "pro" unit. It's good for 100 flashes per charge; recycle time is given by the manufacturer as six seconds. Due to storing unneeded light, recycling could be as short as a third of a second and the number of flashes per charge as high as 1000 if you're on a spree of close-ups.

WHY WOULD ANYONE USE FLASH ON A CAMERA?

Photographs by Duke Mander

Both photographs were made at 1/500th of a second at f/16 with one difference—the picture on the right was simultaneously exposed with a flash mounted on the camera. In this position the flash lights up those mysterious shadows, while hardly affecting the highlights.

You only had to visit the Electric Circus, a discotheque in N.Y.C. in the sixties, to realize how impoverished our sense of perception can be. Flashing strobe lights would intermittently stop the motion of the dancers, revealing attitudes you never noticed in normal light. A flash gun on a camera is your own electric circus.

Flash is the perfect technique for isolating a subject from a messy or confusing background. The near subject gets lit while the background doesn't.

You can't take photos without light. There are times when the difference between getting a picture or not is a small pocket flash unit.

The ghosts were shot during the day by letting the flash exposure dominate the daylight. Electronic flash exposures are not effected by the camera's shutter speed. The setting of 1/500th of a second at f/16 was four stops under the meter reading, but f/16 was "right on" for the flash-to-subject distance.

LIGHTS/studio electronic flash

PROFESSIONAL UNITS FOR LOCATION OR STUDIO WORK

As in computers, progress in electronic flash has been directed toward miniaturization. The basic 1200 watt-second studio unit averages about twenty pounds. It puts out about thirty times the light of a small amateur unit. Photographers still talk about watt seconds, although the industry rates units in BCPS (Beam Candle Power Seconds), which takes into account the efficiency of the reflector. An 800 watt-second Dynalite power supply weighs under ten pounds and does the same thing as an Ascor series 800 with supercharger, which weighs 160 pounds and costs $4000. (However, if you have about $55,000 kicking around, you can hook together 40,000 watt-seconds of Ascor Sunlights and get a heck of a big pop.)

The Balcars, Calumets, Thomas's, Dynalites, etc., are portable in the sense that they pack up and can be taken on location. When you get to your location, you need 110 AC. All of these studio units have built-in modeling lights in their heads to show you what lighting to expect when the strobe goes off. Most units will accommodate three or four heads. If you use three heads on a 1200 watt-second unit, the power will be divided equally among them and each will put out 400 watt-seconds of light.

Recent innovations include switches to split the power among heads assymetrically (Balcar, Calumet) and even flash "dimmers" to vary output continuously (Balcar, Nova). Photographers really are interested first in watt-seconds per dollar and secondly in compactness and low weight for portability. There are a number of comparable units priced around $1,000, depending on accessories.

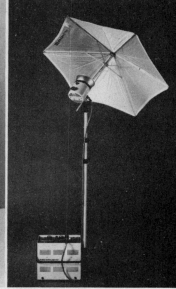

At far left is the control panel of the new Balcar 1200 watt-second unit. It can split the light evenly among three heads or in a number of varying combinations, according to the selector switch. Each head can, in addition, be dimmed or even turned off without affecting the other heads. The power pack weighs twenty pounds. The Balcar heads have many available accessories and can be used in many applications. At right is the Ascorlight QC-8, a 800 watt-second unit, shown with head and umbrella. The unit weighs twenty-five pounds and can recycle in one second.

Balcar 1200/Tekno Inc./221 W. Erie St. M/Chicago, IL 60610

Norman P 800 D/Norman Enterprises/2627 W. Olive Ave./Burbank, CA 91505

Thoma-Strobe/Thomas Instrument Co./1313 Belleview Ave./Charlottesville, VA 22901

Broncolor S 700 R/EPOI/PTP/623 Stewart Ave./Garden City, NY 11530

Dyna-Lite D 804/Dyna-Lite Inc./408 Bloomfield Ave./Montclair, NJ 07042

Ascorlight QC-8/Ascor Div./Berkey Marketing Co./25-20 Brooklyn-Queens Expwy./W. Woodside, NY 11377

Calumet Scientific/1590 Touhy Ave./Elk Grove Village, IL 60007

Strobasol X-8000/Larsen Enterprises, Inc./18170 Euclid St./Fountain Valley CA 92708

Monolite/Bogen Photo Corp./100 S. Van Brunt St., P.O. 448/Englewood, NJ 07631

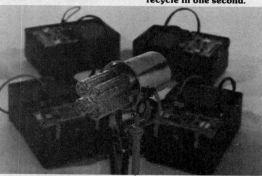

The Calumet Model 3058 6400 W/S Flash head. Four quartz tubes are clustered together in the space of one regular head. The four cables can be connected to four 1600 watt-second power packs for a total flash output of 6400 watt-seconds. Recycle time on such a setup would only be 1.6 seconds. This quad head uses a 250-watt modeling lamp. Calumets, the old French Balcars and Thomas strobe plugs can be used interchangeably on each others' units.

HEADS WITH BUILT-IN POWER PACKS

Self-contained strobe units in which the head and the works are combined have a great deal of appeal, at least in theory, for any photographer who has had to fight his way through tangles of cables lining his studio floor. With these units, you just plug the unit into your AC line, as you would a tungsten light. One head per power supply might seem like a limitation, but many photographers tend to use a number of conventional units—those with separate pack and heads—in the same way for positive control. Units fire each other by photocell.

Units currently available seem to be aimed at the portrait photographer. They are limited in power to 400 watt-seconds. In commercial work, it is often necessary to have a great deal of power at one source.

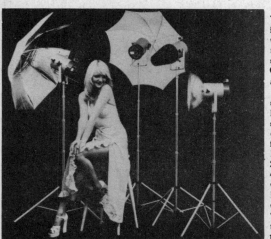

The Bowens Monolite is shown used with a white umbrella, a metallic umbrella, a snoot and a broad flood. Other accessories are available, including a 14½-inch flood, a shiny 11½-inch key light and an 18-inch softlight with a diffuser cap over the flash tube. The Monolite comes in a 200 watt-second and 400 watt-second version. Multiple Monolites can be used with photocells called "slaves," eliminating the need to wire one to the other.

The Strobasol X-8000 and the VX-8000 are two units that are self-contained and designed primarily for the portrait and school photographer. While the manufacturer avoids giving a watt-second output for these units, exposure data would indicate a 400 watt-second unit. The VX has the added feature of a variable flash output control switch. Both units have center mounting for umbrellas, a Soff Box (a folding small bank light) and other accessories.

HEAVY-DUTY STUDIO STROBE

Most of us think of massive power packs and fixtures as photographic history, but that is not the whole picture. The Ascor Sunlight series 800 system dates back to 1946. In advertising photography, 1946 meant E-1 Ektachrome (exposure index 8) and 8×10-inch view cameras. Power was everything and Ascor 800 condensors could be plugged together to produce it.

A cart groaning under the weight of six condenser packs and a supercharger is still regarded as a status symbol, although the power is no more than that of two twenty-four-pound Balcar 2400 watt-second units, which are also a fraction of the cost. But, if you really need light, put thirty or forty of these condensers together and pow! Though few of us will ever do it, it's nice to know the capability exists.

The big fixture, especially the manufactured big light, is becoming more popular. The trend is to the big source that simulates the artist's skylight, a light that makes people and objects appear at their best. Photographers have improvised such lights, each in his own way. They have become so standard around studios that manufacturers have decided to fill a need.

Ascor Div./Berkey Marketing Cos./25-20 Brooklyn-Queens Expwy. W. Woodside, NY 11377

Magnaflash/A & R Distributors Ltd./460 St. Catherine's St./W. Montreal, Canada H 3B 1A7

The "swimming pool" light by Magnaflash is 4×5 feet at the business end of the light. It contains four tubes that can carry a maximum of 20,000 watt-seconds of electronic flash power.

A small version of the Ascor Sunlight series 800, showing just four condensers, a supercharger and a head. The system is expandable for very high power. *Life* magazine actually did ship a truckful to Madison Square Garden to light up a basketball court.

MAESTRO MILI

Across the Street from the famed Flatiron building in New York City is a parking lot that once served as the foundation for a building housing the Gjon Mili Studio. It was a cavernous chaotic space with a stage on which Mili photographed many a star of the performing arts—a subject he holds a passion for to this very day. Lunchtime would bring editors from *Life* magazine or fellow photographers, where a delicious feast of cheese, olives, prosciutto, salad, bread, wine and fruit would be served on a workbench covered with Kraft paper. Mili, with his animated philosophical style, would dominate the conversation—which was always provocative.

All this ended in flames when the studio burned down, taking with it the lives of twelve firemen. Miraculously, much of his life's work survived the conflagration, when the old wooden cabinets storing many of his negatives and transparencies expanded, sealing their contents from the damaging heat and water. Although never a staff member of *Life,* his association with the magazine was of such a nature that the entire magazine's laboratory was put at his disposal to wash, clean, and restore what was salvageable.

An Albanian by birth, Gjon Mili came to America at eighteen. He graduated from M.I.T. (B.S. in

Electrical Engineering, 1927) and spent the next ten years doing lighting research for Westinghouse on high intensity light sources and their use in photography.

As an engineer at M.I.T., Mili was associated with Dr. Edgerton and produced some of the best photographs of motion studies ever made. He reached a new high in capturing the sense of movement in the still photographs he made of Jerome Robbin's "Dances at a Gathering." Of this assignment, done after forty years in photography, Mili had this to say, "I've always done moments in the ballet. This time I wanted to capture whole phrases . . . sequences that build to a climax. From the start I knew what I wanted to do, but I didn't know I had it until I saw the finished film. It felt as if I had drawn to an inside straight."

Besides being a still photographer Mili loves to make films. He might have become a Hollywood director had he accepted a five-year contract from Warner Brothers, after his ten-minute short called *Jammin' the Blues* was nominated for an Academy Award. But he turned Hollywood down upon learning that Alfred Hitchcock was the only director who was granted absolute autonomy—Mili would not tolerate having Mr. Warner cut his film.

Little known to most people is Mili's talent as a moviemaker. This sequence of Jo Jones is from *Jammin' the Blues*, a ten-minute short that won Mili an Academy Award nomination.

Mili has always photographed the performing arts. In this 1964 picture of Helene Weigel, in the title role of "Mother Courage" by Bertolt Brecht, he captures the essence of a woman who has endured hardships.

LIGHT METERS

As the built-in meters in cameras get better and better, separate hand meters get more and more sophisticated. Could there be a cause and effect relationship?

Camera meters run into most of their problems because of their location in the camera. Backlit situations, overall scenes in which the subject is spotlighted and dark subjects in the midst of light surroundings are examples of situations in which an automated camera is likely to fail. Most of the time, a photographer will be more in control by using an incident light meter and taking the trouble to measure the light at the subject.

Some, but not all, exposure meters have a wider range than built-in camera meters, especially at the low end of the scale.

A fairly recent addition to exposure meters is the spot meter. Basically a reflected-light meter, a spot meter is similar to a camera's built-in meter in the way it works. It's big advantage and *raison d'être* is its super selectivity in the angle of acceptance of the light. It can read the "important" part of your subject, leaving out extraneous factors that would throw a regular reflected-light meter for a loop. For theatrical photography, sports events and telephoto photography, it is the meter of choice. Flash meters are usually used in an incident reading mode to eliminate much of the math that usually goes with electronic flash exposures. Bad news for all meter manufacturers is the very wide use of Polaroid tests by the really careful photographer. Besides all the readings, bracketing exposures is still a good idea.

Gossen Div./Berkey Marketing Cos./25-20 Brooklyn-Queens Expwy./W. Woodside, NY 11377

Sekonic/Burleigh Brooks/44 Burlews Court/Hackensack, NJ 07601

Minolta Corp./101 Williams Dr./Ramsey, NJ 07446

Calumet Scientific Co./1590 Touhy Ave./Elk Grove, IL 60007

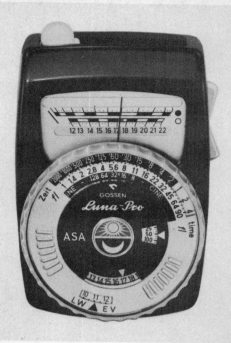

The Gossen Luna Pro is a very popular meter known for its extreme sensitivity in poor light. It can be used as an incident or reflected light meter; and with accessories, in the darkroom, etc.

The Sekonic Studio Deluxe is basically an incident exposure meter. Not a battery-powered meter, its sensitivty range is not too long and it is more delicate.

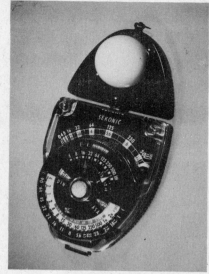

The Minolta Flash Meter II mainly measures electronic flash and gives you your f-stop in ⅜-inch high LED numerals. It will read any flash, continuous light, repetitive (cumulative) electronic flash, as well as combinations of flash plus ambient light. It does all this in the incident or reflected mode, with cord operation or without, with a wide range of accessories. Accessories include a 10-degree viewfinder, 4×ND diffuser, flat diffuser and mini receptor for reading in hard-to-reach areas.

The Minolta Auto Spot 1° Meter not only measures a very selective part of the subject, but you have to focus it. It has a built-in illuminating lamp and a folding lens hood, and it weighs in at almost one pound. Add a shutter, film, winding mechanism, and . . .

HOW TO TAKE AN INCIDENT READING

Place the meter in front of the subject, located in the area to be correctly exposed. For best results with both normal single or multiple light set ups aim the sphere *directly at the camera lens*. Be careful not to shadow or block the sphere with your body or hand. Back or key lights should be shielded from the sphere unless these materially affect total exposure.

The Calumet Electronic Flash Exposure Meter reads flash by both incident and reflected methods and ambient light that is bright enough to affect exposure. An inner calculator on the dial permits correct setting of shutter speeds in these cases.

6

Al Francekevich

THE DARKROOM

THE MOST PEACEFUL PLACE FOR PEOPLE

It should be a room of softly lit timeless bliss, both pleasant and efficient. To make it so it needs devices, components and gadgets—some absolutely necessary, some very helpful and a few downright luxurious. They are all described on the next several pages.

The size of your darkroom depends on available space, and what you intend to do—usually in that order. Some thirty-five to forty square feet of floor space are adequate for a compact but thoroughly professional one-person operation, complete with sink, plumbing, enlarger counter space and ample storage; all this is true if it is designed carefully and if procedures such as film and print drying are carried out elsewhere. Commercial operations often have one room exclusively for film developing, another for printing and a separate area for print finishing.

Clean and light-tight are the minimum requirements. A darkroom does not have to be painted black. Paint walls a light color—preferably in the yellow, orange or red family since reflection from these colors will have less of a fogging effect on enlarging paper. Use a vacuum and damp cloth to remove dust from pipes and moulding, and make sure the floor is sealed with paint or varnish or covered with tile. Masonite over windows is best, but for temporary installations, use heavy-duty aluminum foil and Scotch Black Photographic Tape No. 235. Flange-and-bead rubber weatherstripping, blocks light around sides and tops of doors; a vinyl or rubber "sweeper" weatherstrip does the same at the bottom. Both are available at local hardware stores.

If possible, divide the space into a dry side for the enlarger, paper and negatives, and a wet side for chemicals, trays and washing; have at least one electrical outlet on each side. Initially, the wet side need not have a full-fledged sink with running water and a drain: prints and film may be washed outside the darkroom in a convenient sink, and once film is loaded into a tank, you don't even need darkness (the same holds for processing color prints in a plastic drum). For black-and-white processing, you can even eliminate all chemicals in open trays by using stabilization machines and papers; stabilized prints can be fixed and washed days after the image has been developed.

Ventilation is very important if you are going to spend more than an hour or two over open fixer trays. Aside from the slightly acidic fumes, a small sealed room quickly makes you aware of the tremendous amount of heat and moisture your body generates.

After you have established such pleasant surroundings, if the quiet gets to you, turn on the radio. You're ready to go. Which brings us to the point where we hope you're ready to read, look and enjoy the rest of our "Darkroom" pages. Since many manufacturers make similar products, we have avoided unnecessary repetition by gathering all names and addresses together on p.98 as a shopper's reference for printing and processing equipment.

A DARKROOM IS A TIGHT SHIP

Somehow darkrooms are never large enough, so counter and storage space should be maximized. If you make use of vertical space with lots of drawers, shelves and cabinets, it's amazing what you can store.

An enlarger bench need not be fancy, but it must be *sturdy, rigid* and *clean*. The slightest wiggles will be transferred to your enlarger, giving all your pictures that soft, ethereal, turn-of-the-century mushiness. (Though it's tempting, never lean on any enlarger counter during exposure—*you* vibrate!) Dust being an ever-present nemesis, a smooth hard top is easiest to clean. Formica and Micarta are ideal and have the added benefit of being chemical resistant; varnished, laminated maple (butcher block) is also nice and looks super; two coats of good enamel over anything is also quite serviceable. If you frequently make large prints, or like to enlarge minuscule portions of a negative, consider a drop-top enlarger bench.

Counter space on either side of a sink is very useful, so is a nine-inch-deep shelf over the sink—both are even nicer if covered with plastic laminate. Under the sink put shelves for bottles and vertical dividers for trays; that space gets much hard wet use, so apply lots of enamel and coat it with polyurethane floor varnish.

Cabinets are available from photo furniture manufacturers, lab supply houses (*Yellow Pages*) and kitchen cabinet dealers (Sears has a big selection). Used is good so try your luck at auctions or garage sales. Wood is friendlier and, unlike steel, will never rust, a potential problem with chemicals around.

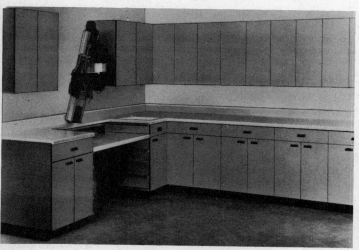

Kreonite makes an extensive line of plastic-laminate-covered darkroom furniture. Though most pieces are similar to standard laboratory furniture, they do make those special pieces photographers need: drop-top enlarger stations, counters with built-in light boxes, and light-tight drawers. A darkroom planning kit with grid sheets and paper cutouts is free for the asking. If you have a big job, they'll design your whole lab, gratis.

PHOTOLAB DESIGN
Eastman Kodak Company/Professional and Finishing Markets Div./Rochester, NY 14650/paper, $2

For years Kodak has been assisting in the planning of photographers' labs, and much of that experience is packed into fifty-three pages. Though aimed primarily at commercial, industrial and graphic arts operations, it contains much helpful information and sound general advice for the home lab. It is, however, a design and planning guide only; it does not tell you how to plumb a sink nor wire an outlet. A section of twenty-three sample layouts is particularly useful.

Darkroom entrances: The light trap or light lock is a unique feature of photolabs. A number of designs provide a choice for ease of access, space utilization, or light safety. The diagram with a projected ray from the outer entrance shows the requirements for constructing a maze-type light trap to block light reflections from outside.

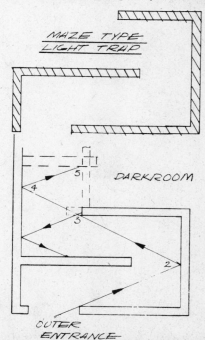

MAZE TYPE LIGHT TRAP

DARKROOM

OUTER ENTRANCE

VENTING THE HOT AIR

Chemical odors and fumes, high humidity from open trays, heat emitted by enlarger lamps and people—all mean air should be changed every eight to ten minutes. Fans and blowers are rated in cfm (cubic feet per minute), so multiply your room's length by its width by its height to get cubic feet. Divide that by eight or ten to get the required capacity of the ventilator. Special light-tight fans are best for getting rid of fumes. Small room air conditioners cool darkrooms off all right but are not efficient air exchangers.

The Stratfield Darkroom Ventilator brings fresh air in, keeps light out. Needs a nine-inch hole in the wall and 115 volts. Very effective, quiet, sort of ugly.

Provides 200 cubic feet of air a minute, which is adequate for up to a 2,000 cubic-foot space, *if* adequate exhaust louvers are provided. About $50.

Fans are useless if incoming air has no exhaust port; pressure builds up inside the room, effectively blocking additional fresh air. Install these B&J Light-Tight Darkroom Louvers in the lower half of the door or wall, using the largest size practical—8×10 to 12×24 inches. If no forced air is provided to the room, use two units on opposite sides.

THE DARK SIDE OF THE DOOR

An ordinary door can be light-sealed with weatherstripping, and a sliding door has the virtue of channels sealing out the light. The simplest door is a black cloth draped over an entrance way and secured in spots with Velcro fasteners. A light-lock maze works well but uses a fair amount of floor space. The cleverest and most expensive solution using minimal area is the consolidated revolving door. It is used in printing plants around the country and people can come and go without spilling a drop of darkness.

If you're tight for space but not money ($600 plus for the small size), this is a nifty solution to lightproof access to the multiple-person darkroom. It's a cylinder inside a cylinder; step inside, gently rotate the inner cylinder, and step out at your stop. It's available with openings into two, three or four rooms. For very heavy traffic, such as a teaching lab for twelve to eighteen students, this giant soup can may be a little slow; in such cases, the maze is still best.

YES, IT SHOULD BE CLEAN ENOUGH TO EAT OFF OF

Insidious millions of miniscule particles share our world and give photographers grief. On lenses they destroy sharpness; on film they leave pinholes that generate black spots on prints; on negatives they are opaque little light-stoppers, producing white spots on prints. The little buggers require relentless attack: periodically clean *all* darkroom surfaces with a damp sponge; eliminate flaking paint and rust; use a door mat at the entrance; don't mix powdered chemicals in rooms where you print, or process and load film; ground your enlarger to a cold-water pipe; keep the humidity above fifty percent with a humidifier, install an electrostatic air cleaner. When all else fails, learn to spot your prints.

Cleaning, to some degree, is just pushing the dust around, but the Southbank Model 300 Air Cleaner eats it up, with a set of fans for a mouth and an electrostatic stomach. Assuming you're careful about other dust-inhibiting procedures, this $350 wall-hanging 6×25×18-inch dust grabber is the ultimate for 1800 cubic-foot, or smaller, rooms. For $180 Calumet makes a similar, but bench-mounted air scrubber.

BE KIND TO YOUR FEET

Once you spend a darkroom session on this wonderful material, your feet will never want to do without it. Made of closed-cell vinyl, Ace Koralite Floor Matting makes standing a pleasure. Chemically resistant, it protects the floor from nasty solutions, while its ribbed surface prevents dangerous slips from spills and splashes; if you drop a beaker or a lens, there's a good chance it will survive unscathed. Place mats in front of washers, dryers, copy cameras, etc., for safety and to boost morale. It comes in six colors, two thicknesses (we recommend the half-inch "Extra Thick"), widths from 18 to 48 inches, and is sold by the running foot. At $3.50 per square foot, it's more expensive than carpet, but a good investment.

DARKROOM TECHNIQUES
by Andreas Feininger
Amphoto/Garden City, N.Y./cloth,
$7.95 per volume

There is an abundance of "how-to" darkroom books on the market, but Andreas Feininger's two-volume *Darkroom Techniques* (Amphoto, 1975, $7.95 each) is head and shoulders above most. This prolific writer—twenty-five books in thirty-six years—assumes his reader is a beginner, but writes in a mature, straightforward and anything but condescending manner. His goal is to disseminate proper technique, coupled with helpful suggestions on equipment selection, usage and working habits culled from years as a busy professional. Though some photographic examples are a bit dated and gimmicky, the validity of his methods are enhanced by continued reference to his "Prerequisites for success: Make cleanliness a fetish . . . Be well organized . . . Keep things simple . . . Follow the manufacturer's instructions . . . The three greatest obstacles to successful darkroom work are *false economy, carelessness,* and *forgetfulness.*" As in all his books, Feininger avoids mentioning specific products or trade names.

Vol. I covers darkroom design and set-up, film development and basic photo-chemistry. Contact printing and enlarging are left for Vol. II.

DARKROOM WITH A LENS

We were in Central and South America back in July, 1972, taking pictures for a high-school Spanish-language textbook—using four Nikons (two for black-and-white, two for color). In the course of the month, 200 rolls of film were exposed, showing natives in both city and rural life. The pay was $150 a day for thirty days ($4500) against a space rate, which averaged out at $100 a picture used. The client bought 100 pictures; the overall bill, then, was $10,000. Not bad: an exciting trip to exotic places, expenses paid and a nice profit.

We always look back on that trip with a slightly sobering piquancy. We remember Jesus E. Garcia, a colleague who never works on a day rate and never gets published. He is an itinerant portrait photographer who travels from village to village on a festival circuit. We met him in San Lucas and observed with wonder his modus operandi.

He sets his camera—a box with a lens at one end, a door at the other—on a tripod and focuses on a draped background. A chair is the only prop. Inside the camera he places a small tray of undiluted developer, another of hypo and a box of 5×7 Agfa Brovira enlarging paper; Señor Garcia does not use film. To take a picture, he slips his hands under the focusing cloth attached to the camera, opens the camera back, removes a sheet of paper and tacks it to the hinged door that is the camera's focal plane. After he has taken a number of portraits, he processes a batch of the paper, one sheet after the other, inside the camera. He rinses each in a bucket of water at his feet and hangs them up to dry. The result, of course, is a paper negative, which he then copies onto another sheet of enlarging paper. By the time customers have toured the festival, Señor Garcia has their portraits ready for them.

We didn't think it wise to mention Polaroid.

Señor Garcia itinerant photographer.　　　　Norman Snyder

LIGHTPROOF CLOTH

Only photographers and spelunkers (cave-exploring hobbyists) genuinely understand the true meaning of *dark*. An absence of light sufficient to fog film is hard to come by in our lit-up world. Although other kinds of cloth will show a multitude of pinholes when held up to the light, the Burke & James Darkroom Cloth is actually lightproof. It has a high-thread count, a rubber coating on one side, is $7.50 per yard and 41-inches wide. Tape the edges to the wall with Scotch Black Photographic Tape No. 235, it's excellent as curtains over windows in temporary darkrooms. Sew a chain into the hem and it will hang well at entrances to mazes and light traps and close on cue.

LIGHTPROOF SHADE

The Draper Lightproof Shade is the ultimate in a truly lightproof window shade. Woven, fiberglass-coated, with opaque black-vinyl slides in a black steel channel, it eliminates light leaks around all four edges. The "Lite-Lock" shade and heavy-duty roller are enclosed in a special headbox at the window top, which conceals the shade when not in use, yet gives complete access to the window. Custom-built for your needs, it's a no-nonsense, industrial-quality solution to flexible, opaque window covering. A typical 36×54 inch is $75.

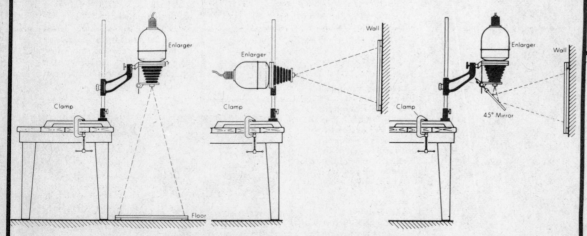

Three ways to outsized prints. Left: Swing enlarger head around the vertical column and project onto the floor, a box, chair, and the like instead of the enlarger baseboard. *Center:* Swing the enlarger head around a horizontal axis and project onto the wall. *Right:* Use a 45-degree mirror or prism in front of the enlarger lens and project onto the wall.

A DARKROOM IS JUST A DARK ROOM WITHOUT A SINK

With a depth of five to six inches, the photographic sink is designed to conveniently hold a number of shallow trays, side by side. In addition to containing splashes and spills, print and film washer effluent, it can, with the use of a short standpipe, serve as a tempered water bath around trays and tanks. Standard construction materials are fiberglass and, for about 25 percent more, type 316 stainless steel. While plastics tend to soften and sag if filled with hot (150°) water, stainless steel will take merciless beatings, yet look good and last forever with minimum care (Leedal makes an excellent cleaner). Keep conventional steel far, far away—iron rust is calamitous on stainless steel. Sink bases are available too in stainless steel, which is best, or painted steel, which will rust if not kept clean and unscratched. Metal sandwiched over a wood core provides the best sound-deadening and thermal insulation for a sink. Fiberglass requires more care to keep it nice looking, but doesn't sweat and has easy-to-clean round corners and seams and

molded-in duck boards—ribs that elevate trays to permit good water circulation. Duck boards and rounded seams are also available in stainless steel, but boost the price. Finally, fiberglass can crack if given a hard whack, like the blow from the corner of a dropped, chemical-laden tray.

For saving money, the most popular sink is the do-it-yourself fiberglass-and-resin-over-plywood project. It's a fair amount of work, the resin stinks, and it ain't gorgeous . . . but it really will work. Photo magazines periodically run how-to articles on this subject; also write The Plastics Factory, 18 E. 12th St., New York, NY 10003 for their $2 sink-making manual and $1 materials catalog/handbook.

Good stainless sinks are available from Arkay, Calumet, Leedal, Oscar-Fisher and Carr; fiberglass ones from Arkay, Kreonite, and Leedal; and a clever portable sink from Burke & James.

Round Inside Contour
Without Splash Panel

Square Inside Corners
Without Splash Panel

Round Inside Contour
Sink Only
With Splash Panel

Square Inside Corners
With Splash Panel

Standard shapes have either square (less expensive) or rounded (easier to clean) corners and seams. It comes either with a 7- or 10-inch backsplash, which protects walls, provides neat plumbing-mounting surface and convenient narrow shelf, or comes without one—when you want to save money or set it up as an "island" installation. Side splashes can be ordered on stainless-steel sinks. Manufacturers make a variety of stock sizes to fit most installations.

All manufacturers will install faucets, thermostatic mixers, shelves, light boxes and even custom build—in stainless only—to your dimensions. Shown is a TRP-2348 $732 Calumet; for $93 more, it comes with a shelf underneath.

This is basically a large tray. Its advantages? It's fire retardant, won't rust, rot or corrode. For black-and-white work, it's fine. For the experimenter, it should be noted that the material will soften above 150°F. Available in all sizes, the pictured sink made by Photo-Pro Corp. is 24×72, at $295.

Leedal makes a nice line of inexpensive fiberglass sinks. With ribbed bottom, smooth edges, rounded corners,

1½-inch PVC drain and no backsplash, the 24×60×5-inch (EF-1) size is yours for $165 if you build your own base (they provide instructions). If you buy their stand, add $75. A stainless-steel version with stand, backsplash and duckboard is $290.

THE DARKROOM PLUMBER

No photographer worth his film has gone through life without spending weeks searching for a metal or plastic doo-jiggy to connect the film washer to the faucet. The original cone-shaped rubber "universal" connector, having crumbled years ago like stale apple pie, was always falling off anyway and squirting water all over your enlarger and negatives. Well, good old Peter Pfefer from Easy Street (really!) in Simi, California makes a slew of adapters, connectors and quick connect couplings. Available at larger photo stores or direct (minimum order, $5); study their great catalog.

Everything but the kitchen sink. Every kind of adapter, connector, coupler imaginable is available, from 59¢ to $5.95, plus other kinds of products—a thermometer well, film washer, tray heater, valve assembly—for "darkroom quality control." For your photo equipment catalog, write to Pfefer Products, 485 Easy St., Simi Valley, Calif. 93065.

THE ESSENTIAL BALANCE

Not so long ago, all photographers owned a camera, a scale and a mule. Packaged chemistry has eliminated much drudgery and potential disasters from careless chemists, but a scale, if not a mule, is still essential if you experiment with special developers, work with nonsilver processes, desire archival quality, like special toners or want to save money by mixing your own. A scale with a 2000-gram (66-ounce) capacity is fine for preparing up to gallon quantities of any photographic chemical. Quart or liter quantities often call for minute amounts of some constituents—as small as 5g (1/6 oz). A scale with 0.5g sensitivity provides ten percent accuracy; 0.1g sensitivity is, of course, much better.)

The Ohaus Triple Beam No. 40028 is ideal for serious home use or a small commercial operation. Sensitivity, 0.1 gram; capacity, 2610 g.

Sliders on beams—like on a doctor's scale—eliminate messing with weights. $45.

At $20, inexpensive, but OK for occasional applications. The Ohaus 1200 has a sensitivity of 0.5g, (grams) a capacity of 2000g; it comes with a 1 to 50 gram brass-weight set; for convenience buy additional 0.5g, 50g and 100g weights.

WEIGHTS AND MEASURES—CONVERSION TABLES

In American photographic practice, solids are weighed by either the Avoirdupois or the Metric system and liquids are measured correspondingly by U. S. Liquid or Metric measure. The following tables give all the equivalent values required for converting photographic formulas from one system to the other:

Avoirdupois to Metric Weight

Pounds	Ounces	Grains	Grams	Kilograms
1	16	7000	453.6	0.4536
0.0625	1	437.5	28.35	0.02835
		1	0.0648	
	0.03527	15.43	1	0.001
2.205	35.27	15430	1000	1

U. S. Liquid to Metric Measure

Gallons	Quarts	Ounces (Fluid)	Drams (Fluid)	Milliliters	Liters
1	4	128	1024	3785	3.785
0.25	1	32	256	946.3	0.9463
		1	8	29.57	0.02957
		0.125	1 (60 mins.)	3.697	0.003697
		0.03381	0.2705	1	0.001
0.2642	1.057	33.81	270.5	1000	1

Conversion Factors

Grains per 32 fluid oz	multiplied by	0.06847	= grams per liter
Ounces per 32 fluid oz	multiplied by	29.96	= grams per liter
Pounds per 32 fluid oz	multiplied by	479.3	= grams per liter
Grams per liter	multiplied by	14.60	= grains per 32 fluid oz
Grams per liter	multiplied by	0.03338	= ounces per 32 fluid oz
Grams per liter	multiplied by	0.002086	= pounds per 32 fluid oz

Grams per liter approximately equals ounces per 30 quarts
Grams per liter approximately equals pounds per 120 gallons
Ounces (fluid) per 32 oz multiplied by 31.25 = milliliters per liter
Milliliters per liter multiplied by 0.032 = ounces (fluid) per 32 oz
cm × .3937 = inches inches × 2.5400 = cm

NEVER MIND, "A PINCH OF THIS, A SPLASH OF THAT"

Stick-a-finger-in-the-soup-and-then-taste-it may work for kitchen chemistry, but it's an inaccurate, not to say unhealthy, procedure in the darkroom. Best to have separate utensils for acidic solutions—stop, fixer—and another set for basic chemicals—developer, washing aids; then label them with Dymo tape. Avoid contamination by rinsing with lots of water immediately after use so you don't give chemicals a chance to dry. Developer will eventually brown-stain polyethylene—which shows that plastics *do* absorb some chemistry. If you can afford stainless steel, make certain it's type 316.

Storage tanks are for labs using five gallons or more of a chemical per month. Plastics (like the Arkay unit shown below) are usually fine and cheapest; stainless steel (like the Leedal, extreme right) cleans easily, looks great.

KEEPING CHEMICALS

All photographic chemicals are adversely affected by light, and even worse, by oxygen. The key to proper storage, therefore, is to prevent air from coming in contact with solutions. Don't store a quart of solution in a gallon bottle; keep smaller bottles around that can be filled to the top. Even when kept in a full, tightly stoppered bottle, few chemicals will last longer than a few months, although some chemicals, such as D-76, have amazing keeping properties. Floating lids and dust covers on storage tanks are effective in slowing down oxidation. To prevent any possibility of contamination, don't keep chemical A in a bottle or tank that once held chemical B, especially if the container is made of plastic.

In stainless steel a gallon graduate looks nifty, but small quantities are hard to read when you peer down into the bottom. A good ole Pyrex measuring cup is a winner at $1.50. It can be read easily and cleans up in a wiz.

The cylindrical laboratory graduate is very accurate for small quantities; read at the bottom of the meniscus, i.e., the concave curve of a liquid's surface. A 50 milliliter (ml) (1.6 oz) and a 200-250 ml (6 to 8 oz) are suggested. Because they are tall and light they tip easily. Buy plastic, it doesn't break.

Glass funnels are too easily broken, so get stainless steel or plastic. A 3 to 4-inch top diameter will fit a quart bottle's neck. A nice big 8 to 10-inch size is a real friend when pouring liquids from a tray.

STIRRING UP A STORM

It irks one to have to *buy* a stirring paddle. After all, in the kitchen any handy spoon or finger will do. But the family will not appreciate your using the heirloom silver to mix developer, and some metal utensils are downright bad for color chemistry. But chemicals must be mixed well and dissolved completely to prevent uneven results and spotted film and prints.

Kodak makes a 10-inch paddle (75¢), in yellow, naturally, which is useful for mixing quantities of up to a gallon (right, top). The hole in the business end makes for good agitation and is a handy place to stick a hook. The handle has a flared top for crushing particles of chemicals. Get a few: one for developer and one for acidic chemicals, such as the stop bath and fixer; this avoids contamination, although they should be rinsed off after use anyway. For mixing two to five gallons, a good paddle is a piece of ⅜×2×24 inch Plexiglas with some ¾-inch holes drilled in the bottom. For five gallons and up, get an electric mixer like the one from Leedal (right, bottom) or laboratory supply houses (Cole-Parmer, Welch).

Kodak 10-inch paddle

BASIC PHOTO SERIES
by Ansel Adams
Camera and Lens/The Negative /The Print/Natural Light Photography/Artificial Light Photography/Morgan & Morgan, Inc./Dobbs Ferry, NY/$7.95 to $14.95

To see an Ansel Adams print is to be fooled into believing that there exists a secret to printing that is solely his property. By reading his series of books, you begin to get the idea that maybe you too could master the ultimate technical capabilities of the photographic process. Each one is a no-nonsense, filled-to-the-brim exposition of everything Adams knows—well, almost; it's certainly a tour de force, but definitely not for the beginner, in spite of its misleading *Basic Photo Series* title.

His pictures prove that the ultimate print comes from the ultimate negative; and the ultimate negative is large—4×5 inches, 5×7, or better yet, 8×10—to provide those grainless, mellow tones, and the negatives are specially exposed and developed for the particular brightness range of the scene. This latter technique is the Zone System that Adams made famous and upon which much of the books' technical directions are based.

Ansel's philosophy is total technical mastery, coupled with persnickety attention to details each step of the way. In the forward to Book No. 1, *Camera and Lens,* he says, "Photography is more than a medium of factual communication of ideas; it is an exalted profession and a creative art. Therefore, emphasis on technique is justified only insofar as it will simplify and clarify the statement of the photographer's concept. These books are designed to present a working technique . . ." And they do; from the text one gets the impression that this is exactly how Adams works—no untried suggestions, no expounding on theories or techniques he has not personally evaluated.

Book No. 1, *Camera and Lens,* covers medium (2¼×2¼) and large-format equipment and studio and darkroom devices. It was completely updated in 1970, is the longest (300 pages) of the five and, at $14.95, the costliest. The other four are 118 pages and $7.95 each; they thoroughly cover the material indicated by their respective titles.

The Leedal M-25 Portable Electric Mixer does the job, with minimum aeration, for quantities up to 25 gallons. A clamp attaches the mixer to the tank rim. 115 volts, $140.

IT'S THE LITTLE THINGS . . .

Don't be a martyr—work comfortably, work carefully; the little things are often as important as the big ones. There can be times, always at 2 am, when you would give your motor-driven Hasselblad for a mere four inches of black tape. Should you get this feeling, wait for it to go away.

• Good stainless steel scissors, of surgical metal, a joy to use, should last forever—from Brookstone, No.G-1357.3, $9.95, 8½ inches. They'll never rust.

• For people with sensitive skin, try rubber gloves—you *can* get used to them—or a barrier cream like Kerodex 71 (100-application tube, $2 at pharmacies) or 3M's Skaid Water Repellent Lotion (80-application tube, $2 at camera stores).

• Pencil sharpener—place just outside the darkroom to avoid dust.

• A stainless steel bottle-top opener for opening 35mm cassettes. (A deli "church key" will rust.) Available at marine supply stores. Also get a stainless steel punch-type for opening cans.

• X-Acto Knife No. 1—a handy little razor knife available from art and hobby stores.

• Scotch Black Photographic Tape, No. 235, one-inch wide. Ideal for masking, patching, holding; leaves no residue.

• Darkroom apron, preferably black (Kodak, $7); photographic chemicals make holes and stains.

• Paper towels—they do cause some dust; an alternate is a kitchen or bath towel, changed frequently.

• Clothesline and *wood* spring-type clothespins for hanging film to dry.

• A radio or cassette recorder.

• Stool for those who can work that way.

• Sponges for cleaning up.

• Pencils and a note pad.

• A twelve and maybe eighteen-inch ruler.

• An Eveready penlight

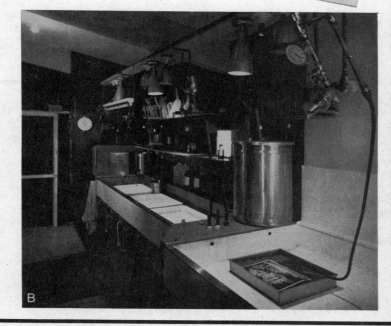

The Adams' darkroom—not fancy, but oh so practical, so usable, so effective. In a 10×30-foot space, he and his assistants produce hundreds of individually developed negatives and thousands of fine prints each year—the prints ranging in size from 8×10 to 40×72 inches. Not shown in this view are two enlargers—a horizontal one for 8×10 negatives and a conventional one for 4×5s.

RUNNING HOT AND COLD

For serious workers who require consistent quality, black-and-white film developers should be held to ±½°F (¼°C); other chemicals and wash water should be within 2°F (1°C) of the developer; and all color processes shouldn't vary more than ±¼°F (⅛°C).

Incoming water temperature and pressure are almost never constant; automatic or manual means are required to even out fluctuations and keep the temperature stable. The simplest thing to do is to put your film developing tanks into a tub of correct-temperature water; the large water volume keeps the temperature constant for quite a while. Or you can constantly monitor water temperature coming from your spigot with a thermometer. The most sophisticated and expensive devices—but a must for professionals—are the thermostatic regulators that blend hot and cold water to preset levels, automatically compensating for line fluctuations. They are most accurate when used at maximum flow.

Leedal C-2 Economix No. 2625 is the least expensive thermostatic mixer around. It will hold temperature to within a minimum flow rate of 1 gpm or more. Maximum output, 4½ gpm. $105.

Meynell Photomix model 155 is a quality thermostatic regulator that holds ±½°F (¼°C) even at low flow rates. Maximum output, 2½ gpm for 40-lbs inlet pressure. $200.

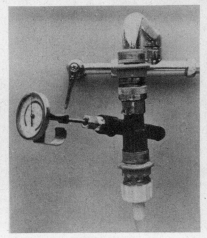

Flo-Temp is a clever plastic well that holds a dial thermometer (not supplied) conveniently in the faucet's stream. It swivels and has garden hose threads, top and bottom. $15.

The Lawler Series 9700 Temflow is a professional-caliber water control with built-in pressure-balancing, inlet-strainers and checks, vacuum breaker and cold-inlet volume control. It's great for color, and will hold ±¼°F (⅛°C) if used in designed flow rate range. It's available from ½-2½ gpm to 7-14 gpm with automatic shut-off if cold water fails. Stainless steel and plastic enclosures available. $200 and up in chrome but cheaper in brass.

PC. NO.	DESCRIPTION	PC. NO.	DESCRIPTION
1	HANDLE SCREW	23	PISTON SCREW
2	ADJUSTING SCREW	24	RETAINING RING
3	HANDLE	25	DISC RING
4	SPINDLE	26	LINER SEAT O-RING
5	THERMOSTAT O-RING	27	UNION TAILPIECE
6	O-RING	28	UNION NUT
7	NAME PLATE	29	STOP & CHECK BODY
8	COVER ASSEMBLY	30	STRAINER
9	THERMOSTAT ASSEMBLY	31	PUSHROD
10	SHUT OFF DISC	32	BODY SCREW
11	STRAINER PLUG	33	BODY GASKET
12	STRAINER PLUG O-RING	34	ADJUSTMENT STEM
14	RELIEF SPRING	35	BONNET
15	PISTON ASSEMBLY	36	O-RING
16	SEAL RING	37	SPRING
17	LINER	38	BONNET O-RING
18	HOT WATER DISC	39	SEAT STEM
19	WASHER	40	O-RING DISC HOLDER
20	PISTON SPRING	41	O-RING
21	BODY	42	BAFFLE TUBE
22	DISC HOLDING NUT		

PARTS IDENTIFICATION LIST

1. Mounting Bracket
2. Vent Screw
3. Vent Screw Gasket
4. Cover Nut
5. Cover Nut Gasket
6. "O" Ring Gasket
7. Cover
8. Tube Centering Ring
9. Center Bolt
10. Diamond Filter Tube
11. Shell Assembly
12. Drain Plug Gasket
13. Drain Plug

In ordering parts, other than those shown on page 4, please designate the model and serial number of your Filterite units, and refer to part as named above.

WHAT TO DO WHEN THE RUST SHOWS UP

Fairly large amounts of water are used in conventional photographic processing. Municipal and public water supplies are usually chemically pure, but particle matter and sediment in the water may not have been sufficiently filtered to prevent damage and spotting of soft emulsions. Iron pipes rust, and particles always enter a line when repair work is done in your building

The Filterite Water Filter LMO series is an industrial-quality unit. for water service, use brass with stain-less-steel shell. The LM010B-3/4 is more than adequate for a home lab. Optional mounting bracket is available, and a petcock for draining. $58, plus $1.90 for bracket.

or neighborhood. Elimination of 25-30 micrometer particles and larger is recommended for photographic purposes.

Leedal, Pako, Filterite, all make cartridge-type units; Oscar-Fisher has a novel filter that uses a reusable porous metal element. Plastic bodies, which are less expensive ($22-50), have been known to crack during installation and are not recommended if line pressure is above 55psi. Many are not safe on hot-water lines. Metal units ($50-100), like the Leedal 4440-B and Filterite, have petcocks for pressure relief and draining when changing elements. Pressure gauges installed on both sides of the filter indicate a pressure drop and the need for element replacement.

Water filters are a must in both lines preceding a thermostatic regulator; those mixers have delicate, close-fitting parts. Check capacity of filter; if insufficient, two or more may be put *parallel* to one another.

"LET THERE BE SAFELIGHT."

Except when handling panchromatic film, a darkroom need not be dark. To prevent eye fatigue, avoid pools of relatively bright areas against a background of darkness—for example, dark-colored walls. A number of small units, or a large fixture bounced off a white ceiling, are preferable to one or two bright "spotlights."

The tungsten bulb in a metal reflector with a glass safelight filter is the old tried and true. All housings seem adequate, but the Kodak filters, available in many sizes, are far and away the brightest and safest. Carefully follow directions as to maximum bulb wattage, filter type and minimum distance to sensitized materials. If you develop prints by inspection, hang a fixture over the developing tray; if it is closer than recommended, install a non-conductive pull-chain or footswitch so the light will be on only when absolutely necessary. Inexpensive bulbs painted with an orange or red coating are usually a poor bet, often having pinholes and marginal spectral characteristics. For big labs, the fluorescence of sodium vapor units provides large amounts of illumination. A safelight is *not* 100 percent safe: any of them will eventually fog sensitized materials. Test yours: make a print from a negative that gives lots of highlight detail (light tones). Before developing, cover half the print with cardboard and leave it face up on your counter for five additional minutes. Develop; if you can see a line of demarcation, your lights are too bright or too close or your filters have faded. After one year of eight-hour-a-day use, filters usually need replacing.

KODAK DARKROOM DATA-GUIDE, R-20

Eastman Kodak Company/Dept. 454, Rochester, NY 14650/$8.95

It's jam-packed with info on reciprocity correction, film developing calculator, paper samples and data, toners, chemical use and capacity, processing tips. Plastic-coated pages.

From the *Kodak Darkroom Dataguide.*

The Kodak Brownie Darkroom Lamp Kit is for temporary darkrooms or secondary illumination. It is ideal for lighting a chemical storage shelf or dark corner. The Kit contains a lamp socket and two molded plastic cups, a series 0 (yellow) and a series 3 (green). Above is the socket and series 0.

The CP Fluorescent Safelight, a conventional fluorescent tube with a top-secret coating, sits in a standard reflectorless amber-painted housing, giving a uniform warm, bright glow. It's particularly useful for larger darkrooms and safe even for Polycontrast Rapid paper.

KODAK Filter	Color	KODAK Materials	Bulb Wattage (120-volt) Direct Illumi-nation*	Indirect Illumi-nation†
0A	Greenish yellow	Black-and-white contact and duplicating materials, projection films	15	25
0C	Light amber	Contact and enlarging papers, High Resolution Plate, and TRANSLITE Film 5561	15	25
No. 1	Red	Blue-sensitive materials, KODAGRAPH Projection, and some LINAGRAPH Papers	15	25
No. 1A	Light red	KODALITH and KODAGRAPH Orthochromatic materials	15	25
No. 2	Dark red	Orthochromatic materials, green-sensitive x-ray films, EKTALINE Papers, and Orthochromatic LINAGRAPH Papers	15	25
No. 3‡	Dark green	Panchromatic materials	15	25
No. 6B	Brown	Blue-sensitive x-ray films	15	25
		KODAK Single-Coated Medical X-ray Film —Blue sensitive	7½	15
No. 7	Green	Some black-and-white infrared materials	15	25
No. 8	Dark yellow	Some EASTMAN Color Print and Intermediate films	15	25
No. 10	Dark amber	EKTACOLOR RC, PANALURE and PANALURE Portrait Papers	7½	25
		EKTACOLOR Slide Film 5028, EKTACOLOR Print Film 4109 (ESTAR Thick Base), and RESISTO Rapid Pan Paper (**Not** recommended for EKTACHROME RC Paper, Type 1993)	15	25
No. 13§	Amber	EKTACOLOR RC, PANALURE, PANALURE Portrait, and RESISTO Rapid Pan Papers.¶ **Do Not Use** with EKTACOLOR Slide Film 5028, EKTACOLOR Print Film 4109 (ESTAR Thick Base), and EKTACHROME RC Paper, Type 1993	15	25
Type ML-2	Light orange	Dental X-ray films	15	25

SAFELIGHT RECOMMENDATIONS

Note: Always refer to the carton or the instruction sheet packaged with the product for complete safelight recommendations.

The Thomas Duplex Super Sodium Vapor Safelight is the light to buy. Using a sodium vapor discharge tube—as in the new street lamps—it puts out a much narrower spectrum than conventional tungsten bulbs, in a region of maximum eye sensitivity and relative paper insensitivity. Designed (in France) to be bounced from a white ceiling, it has variable intensity filter flaps. $200.

The Kodak Darkroom Lamp, similar to Kodak's Adjustable Safelight, takes the same bulbs and filters, but has no positional adjustments. A lightbulb-type neck screws into a wall socket or drop cord (good over trays). It has no switch or power cord of its own. $12. Kodak also makes a 10×12-inch unit that's good for large rooms and indirect lighting: $40 without filter.

FILM PROCESSING: THE NAME OF THE GAME IS CONSISTENCY

Film developing is certainly the least creative of all photographic activities, but after the actual picture-taking, it is *the* most important operation. If you make a miserable print, you can always try again. But if you ruin your negatives, either during exposure or development, it's all over! Magic nostrums, proprietary chemicals and blue air not withstanding, You can't make great prints from lousy negatives! That is the first absolute law of photography. The second is that no matter how great the negative, in the words of Duke Ellington, "It don't mean a thing if it ain't got that swing."

For standard processing, follow the film manufacturer's directions found on that little piece of paper packaged with every roll of film as to chemistry, time, temperature and agitation. For consistent results, black-and-white developer should be within ½°F (¼°C) of aim point; color developers ¼°F (⅛°C); all other chemicals within 2°F (1°C) of the developer. Too much agitation causes over-development on film edges; too little leaves streaks and mottle. Failure to give film tank or hangers a good rap after each agitation cycle may leave air bubbles that cause spots on prints. *Do* use an acid stop bath: it will give more consistent results than plain water. Over-fixing is as bad as under-fixing; the former will bleach out subtle shadow detail; the latter will accelerate deterioration and staining in storage. Wash well at the proper temperature with good agitation, preferably after the use of a washing aid, such as Perma Wash, Hustler or Hypo Clearing Agent. Don't squeegee wet film with a sponge or, worse, fingers. Instead, dip in Kodak's Photo-Flo 200 and hang to dry in a dust-free room or cabinet.

For roll film or sheet film in a tray, use developer "one shot," i.e., dilute the stock solution with water as recommended, use once and dump down the drain—it's the cleanest system. In all cases, use fresh chemistry—it's so cheap. Kodak's *Darkroom Data Guide,* and *Processing Chemicals and Formulas* (see p. 91 and p. 94, respectively, in this book) both have charts of keeping properties and processing capacities of their chemicals.

SHEET-FILM PROCESSING

For developing a few sheets of film at a time, tray processing is quite satisfactory. In fact, it produces extremely uniform results across the film, since there are no mechanical obstructions to cause turbulence. With larger quantities, film held vertically in hangers and batch-processed in open rectangular tanks is standard operating procedure. Obtaining uniform development across these large areas of film is tricky with a hanger because of non-uniform turbulence around the hanger perimeter, so follow directions carefully; Kodak's booklet *Professional Black-and-White Films* No. F-5, at $1.50 and Ansel Adams' *The Negative* are both recommended. For even greater uniformity with hangers, or for large quantities of film, agitation by gas burst—nitrogen periodically bubbling up from perforated tubes in the tank bottom—is a good solution because it provides extremely uniform repeatable agitation. Regardless of the method used, it is extremely easy to scratch and gouge the soft emulsion when processing these big sheets: sharp film corners can dig into the film surface as one sheet slides over another in tray processing. Metal hangers and their clips can do similar damage in tank set-ups.

Developer streaks are often a problem with gas burst processing, particularly on Ektachrome, and black-and-white with large areas of uniform tone. To remedy this, Lektra makes "Sustension" hangers in various sizes (two-up for 4×5 inch, $22) that fit into 8×10 inch tanks only. They work well; film may be dried on the hanger, but they load slowly.

Hard rubber and plastic tanks are quite serviceable, if you don't interchange chemistry. They do respond to tempering water baths slower than stainless steel does. Kodak has hard-rubber tanks in 4×5 (½-gallon. $7) to 8×10 (3½ gallons, $21); and a 5½ gallon polypropylene unit with a gas distributor ($97) or wash water fittings ($28); similar fittings are available from Kreonite and Pfefer. Columbian and Kindermann make inexpensive plastic tanks. Get floating lids!

Hanger racks keep the individual film hangers separated for good solution flow, prevent scratches and simplify lifting batches of hangers between tanks.

Make sure your stainless steel tank is No. 316, the only kind that is impervious to all photographic chemicals except color bleach, which calls for brass.

The Kodak 4A stainless-steel film hanger has been the standard for years; 4×5 inch for a 1-gallon tank, $6.95. Also available are multiple-film hangers, which hold four 4×5 sheets per hanger in a 1 or 3½-gallon tank.

To control duration and interval of nitrogen burst, you'll need a burst cycling timer ($175-200) and a few other gadgets, all available from Lektra (shown above), Arkay, Calumet, and Kreonite. Definitely get Kodak's pamphlet *Gaseous Burst Agitation,* E-57, at 50 cents. (Eastman Rochester, NY 14650)

THE CRAFT OF PHOTOGRAPHY
by David Vestal
Harper and Row/New York/cloth $12.50

"This is an advanced course in 'straight' black-and-white photography for beginners and others." This first sentence in David Vestal's fairly meaty book (364 pages) is a fair evaluation of its contents. Covering picture-taking to print-making, and even a chapter on "What to Photograph?" (Lord, help us!), it is particularly strong on processing and printing techniques. Unlike so many photography books, which look more like anthologies of prose, *The Craft of Photography* has loads of pictures: how-to (including the reel-loading excerpt below), right and wrong, this way and that, and some good photographs from recognized artists. A good choice.

I am self-indulgent. When I photograph, I'm scratching the same itch that makes people gossip or tell

jokes; only this gossip is visual, not verbal. There is nothing exalted about it, and it does not transcend any reality whatever. It tries to pass an experience on as nearly intact as possible. The process is that something comes in my eye and stimulates me to shoot because I'm bursting to let it out again—preferably to inflict it on an audience. If the audience likes it too, so much the better; but my photography is selfish, not altruistic. I do it for me.

A JACKET OF WATER TO KEEP COOL

For repeatability and uniformity, especially with color film, you should have tempering water from a thermostatic regulator (see p. 90) flowing around your tanks. This can be done by placing the tanks in a sink having a standpipe or by purchasing a compact, self-contained unit—water jacket and insert tanks—that has infeed and outflow hoses and can sit on a counter or even a windowsill. For up to eighteen 4×5-inch black-and-white films, a jacket that accepts three one-gallon tanks—developer, stop and fixer—is recommended. (For greater quantities, use 3½-gallon tanks with multipe 4×5-inch hangers.) Hypo-clearing solutions and wash can be in separate tanks outside the jacket. Though some use the water jacket for a wash tank, more efficient film washers are available (see page 96). Water jacket/insert combinations, some with built-in

thermostatic water temperature regulators, are available in many sizes for color or black-and-white from Arkay, Calumet, Leedal, Kreonite, Oscar-Fisher and Burke and James. Get anti-oxidation floating lids for all tanks.

Shown is an *Arkay* **316 stainless steel processing unit with two one-gallon 4×5 insert tanks and a water jacket with inlet and outlet fittings. At about $125; extra insert tanks, $25. Other systems are available from ½-gallon to 3½.**

If you do both sheet and roll film, or a lot of roll film, get one of these stainless-steel wire baskets and use it in a tank-and-water-jacket line. A rack for 3½-gallon tanks holds thirty-six 35mm or eighteen 120 Nikor-type reels. It costs $50 from Arkay, Leedal or Kindermann; Calumet and Kindermann have similar racks for one-gallon 4×5 tanks. Reminder: use the recommended for "large tanks." And avoid buying more "solid" racks with closed-in sides.

(1) Place reel on a table in the loading position, with the outer end of the spiral facing right at the "12 o'clock" position (if left handed, reverse all instructions, and hold drawings up to a mirror).

(2) Open a reloadable 35mm film cartridge. To open reloadable Kodak, GAF, Ilford and Agfa-Gevaert cartridges, hold the cartridge with the long end of the spool against the table and push down on the sides until the top end pops off. If necessary, bang the cartridge on the table. Open Kodak factory-loaded cartridges by prying off their lids with a beer-can opener.

(3) Tear or cut the film tongue off, but leave the roll on its spool. Then pick up the film in your right hand, long end of spool down and with the film facing left on the far side of the spool. Pick up the reel in your left hand, keeping it in the same position as on the table.

(4) Feel for the open side of the reel's core. The reel is in the loading position; on the Nikor reel that means the core is between "4 o'clock" and "5 o'clock" when the outer end of the reel faces right at "12 o'clock." While holding the film spool by its ends, pull out the end of the film, toward the reel.

(5) Press on the edges of the film to curve it so it will fit easily between the top and bottom of the reel. Guide the film end straight in toward the core of the reel, and push it into place in the core (or the clip) all the way in until it stops.

Film end is pushed into the reel core: the reel has not been turned yet.

(6) Rotate the reel counterclockwise (away from its open outer end). After one-half turn of the reel, the film begins to track in the spiral. As you turn the reel, hold the film-hand thumb and index finger lightly against the top and bottom spirals, both to hold the film in the proper curve and to guide it into the reel. If the film is fed into the reel core off-center, the film will pull strongly to one side and "bind" on the first or second turn of the reel; if this happens, unwind back to the beginning and start over. If the film edges are badly bent, it is easier to unwind the whole roll, remove the spool, and begin loading the reel again from the other end of the roll.

(7) After three turns of the reel, the film fills three inner turns of the spiral. Keep turning the reel counterclockwise until all the film is on the reel. Tear or cut the film off the spool.

(1)

(2)

(3)

(4)

(5)

(6)

(7)

LOADING A REEL

Kindermann reels have the center clip, as do the new Nikor reels.

Any pro will tell you that the stainless steel spiral reel ("Nikor-type") and lightproof tank combination is the greatest thing to happen to film developing since the wet plate got dry. For a beginner learning to load a reel, however, what they would tell you while doing it is unprintable. But like riding a bicycle, eventually it's a snap; the fastest, easiest method around—honest! Practice on old film that isn't wrinkled or torn. We recommend the original Nikor reels without center clips, film grabbers, loading gadgets and other problems. *The reel cannot be loaded unless the spiral core is oriented clockwise.* Once the reel is loaded in the tank, and covered, the entire developing procedure is done in the light. (See Vestal's diagram and illustrations, at left).

Once you're committed to a stainless-steel reel, all the tanks are pretty much alike—good! But you must wash them thoroughly before the chemicals dry and harden, *especially* the baffled top. The top and caps on all-metal cans are not interchangeable, so label them "A," "B," etc. They're available in sizes that hold one to fourteen reels for 35mm or one to nine for 120. Cost is about $22 for a tank and two 35mm reels: Honeywell-Nikor, Kindermann, Brooks, Omega.

FILM DEVELOPERS

There are scores of prepackaged film developers and maybe a hundred published mix-it-yourself formulas. They all fall into a few basic categories: general purpose, fine-grain, high-contrast, compensating and high energy. Quite often the differences are quite subtle, so the important thing is to standardize your working procedures. A "fine-grain" product may produce a bit finer grain than a general purpose formula, but inevitably it will cause a slight loss of film speed and weaker shadow detail. You are strongly advised to run your own careful tests.

ACUFINE—
A Fine-Grain Developer

A high-energy, fine-grain developer is particularly useful when emulsion speed must be pushed in low-light situations. For example, Tri-X, rated at ASA 400 by Kodak, should be given an exposure index (EI) of 1200 when processed in Acufine. The

RODINAL—
A General Purpose Developer

A highly concentrated solution made by Agfa, it is designed for "one-shot" use after dilution with water at 1:25 to 1:100. Rodinal, unlike conventional developers, is mixed in different proportions to control contrast rather than by a variation in developing time. It's not a fine-grain developer, so use it only on Panatomic-X and Plus-X—not Tri-X—because they're fine-grain films which don't need fine-grain developers.

trade-off, however, is some loss of shadow detail. The stock solution can be used straight (with appropriate replenisher) or diluted and used as a one-shot. Developing times are short: Tri-X is 5¼ minutes at 68°F (20°C), and the 25 seconds it takes to pour chemicals through the baffled top of a Nikor-type tank can cause uneven results. Avoid problems by placing the loaded reel into the developer-filled but open tank in the dark, then replace the top and turn on the lights.

D-76—
A General Purpose Developer

There is no "best" developer for all requirements, but D-76 is the best developer, anyway! Referred to by most pros as "good old D-76," it's the standard against which all new and special purpose formulas are based. It produces a combination of full normal film speed, moderately fine grain, good acutance, beautiful shadow detail and normal contrast. When used in large tanks, it should

D-23—
A Compensating Developer

Formula for Kodak D-23

Water (125)24 oz.
Elon (metol)¼ oz.
Sodium Sulfite desiccated3 oz.
Water to make	...32 oz.

Scenes with extreme brightness ranges, such as an indoor picture with a window in the composition or a clear bright day with a subject half in shadow, are difficult, if not impossible, to print from negatives developed normally. Overexposing and underdeveloping help considerably, but even better results can be obtained with the use of a so-called compensating developer that renders maximum shadow detail while surpressing excessive highlight density in the film. D-23 used in a two-bath procedure works admirably. Unavailable prepackaged, you must mix D-23 yourself (see formula). For greater compensation, a two-bath procedure can be followed. The second bath is a two-percent solution of either Borax or Kodak Balanced Alkali. All chemicals are available in large photo stores; mix in the order given in Adams' book or in the *Photo-Lab Index* (reviewed on page 96). These advanced techniques can be quite successful, but only after careful testing on your film under specific lighting conditions.

be replenished with approximately ¾ oz. of D-76R Replenisher for each eighty square inches of film (one roll of 36-exposure 35mm or one roll of 120). For roll film developed in cylindrical cans, it makes an excellent "one-shot" (use once and discard) developer by diluting with water 1:1; in fact, the dilution increases the acutance somewhat. Ilford's ID-11 is the same; GAF Hyfinol is similar. Available in one-quarter, one-half, one and ten gallons.

KODAK PROCESSING CHEMICALS AND FORMULAS No. J-1
Eastman Kodak/Dept. 454, 343 State St./Rochester, NY 14650/$1.50

If you are going to do any black-and-white darkroom processing work at all with Kodak chemicals, this is a "must" book, a veritable data gold mine at $1.50, especially if you're not quite up for the five-pound *Photo-Lab Index* (reviewed on page 96). Processing principles, solution preparation and processing techniques comprise the first third. The balance of the 53-page manual has a plethora of helpful charts—keeping properties, useful capacities, toning classifications—and special formulas for tray cleaners, archival processing solutions, special developers, stop baths and fixers and intensifiers and reducers.

MONOBATH MANUAL
by Grant Haist
Morgan & Morgan/Dobbs Ferry, NY 10522/cloth, $7.95

"There must be a better way" is the impetus that Haist claims spurred companies and bathroom chemists into the search for a one-step processing chemical. Combining special developers with special fixers and additional exotic constituents does, in fact, produce a monobath chemistry that works surprisingly well, but has a way to go to catch the flexibility and quality of the three-step process.

By the way, did you realize that Polaroid is a monobath system? This book tells you how it started, how it works and how to mix and test your own concoction.

A monobath formulated to process your particular film choice with your conditions of processing can provide excellent results. But if you are to achieve top quality image formation with the simplicity of single solution treatment, you must make the bath yourself. At present there is little other choice. Making a monobath may

require you to become more knowledgeable in the science of photographic chemistry and in the evaluation of the photographic results of your tests. But scientific training is not absolutely necessary. Already, you have probably made experiments to determine the best guide number for your favorite size of flashbulbs or a new electronic flash unit. And I am certain that most of you were exposing film at higher than recommended ASA indexes long before the scientist decided to double the indexes to their present values.

DK-50—
A General Purpose Developer for Sheet Film

Designed primarily for sheet film, it is available prepackaged in 1, 3½ and 10-gallon sizes. DK-50 produces medium grain, is clean working and used for general-purpose development of continuous tone films. It is frequently used at a 1:1 dilution for processing cut film in a tray and is moderately fast-working.

HC-110—
A General Purpose Developer

A "small" 16-ounce bottle of this syrupy *liquid* ($3.50) can make almost four *gallons* of film developer for roll film. Its liquid form provides convenient mixing, and HC-110 has been designed for tremendous versatility with almost every conceivable continuous-tone black-and-white film. Depending on use, there are six possible dilutions (from 1:15 to 1:79) of the stock solution, which itself is made by diluting the *entire* bottle of concentrate 1:4. Grain and sharpness are similar to that produced by D-76, but developing times are shorter. It

Plus-X requires 4½ minutes at 68°F (20°C). As with all developers, once the stock solution is diluted, it should be discarded after use that day: the additional water brings additional oxygen, which hastens the oxidation/deterioration process, so dilute only as much as you need for each job. If you do use DK-50 straight, DK-50R Replenisher is available to increase its capacity to a maximum of 100 8×10-inch films or the equivalent per gallon.

appears that this chemical was designed for the commercial lab people who develop a myriad of film types and got tired of mixing so many different developers. With this one bottle, you can do everything from Pan Masking to Professional Copy film, and from 35mm Panatomic-X to 120 Royal-X Pan. Because a working-strength solution can only be mixed from the stock solution—it's impossible to accurately measure tiny quantities of the syrup—and because the stock solution only keeps a *maximum* of six months in a *full* bottle, Kodak's HC-110 is not for the home lab.... unless you really need four gallons of film developer every few months.

THERMOMETERS

Aside from the expensive digital sensors with remote probes used in commercial applications (for example, Calumet's DT-100 at $200), there are basically two versions: the dial-and-stem type and the classic mercury-in-glass tube. The former responds quickly, is more rugged—though only relatively—and releases no dangerous mercury if catastrophically damaged. (Not only is mercury bad for your health, but its fumes and insidious globules are absolute anathema to light-sensitive materials.) The primary advantage of a mercury-in-glass unit is the high accuracy, at reasonable cost, of a well-made model (see below). The inexpensive red or blue-colored alcohol thermometers are rarely accurate to even ±½°F (¼°C).

Because thermometers are fragile, careful workers have two: one is used day-to-day, the other is reserved for checking the first, say once a month, or after number one takes a fall. A good combination would be the Weston, above, used as a working tool, and the Kodak, below, for calibration or color developing. Accuracy and delicacy are synonymous to thermometer builders, and a good thermometer must be treated as the precious instrument that it is. Don't use them to stir five

Inexpensive dial thermometers abound, but the old reliable Weston 2265 is the most accurate. It has a removable clip that allows it to sit in a tray without drowning. It's fairly rugged, but be nice to your $15 investment.

gallons of fixer, or to measure the water temperature in your car's radiator or to open cans of chemicals.

The Weston has a mirrored band on its two-inch diameter face, which prevents parallax-caused reading errors and contributes to its ±¼°F (⅛°C) accuracy in the range 68° to 80°F (20° to 27°C). From 25° to 68°F (-4° to 20°C), and from 80° to 125°F (27° to 52°C)—the latter includes temperatures used in modern color processing—the accuracy is only ±½°F (¼°C). To guarantee these figures, the stainless-steel stem must be immersed at least two inches into the liquid.

The Kodak thermometer will give true readings of ±¼° at 59, 68, 77, 104 and 122 degrees on the Fahrenheit scale, and ±⅛° at 15, 20, 30, 40 and 50 degrees on the Celcius scale. No thermometer is uniformly accurate over its range; accuracy figures specified in this manner indicate that this unit has been calibrated as a laboratory standard at specific points, although at intermediate temperatures it is still more accurate than you will need for photographic purposes.

Officially called the Kodak Process Thermometer Type 3, No. 106-4955, it requires 3½ inches of immersion and costs $32.

PHOTO THERM TEMPERATURE BATH

This plastic tray with built-in water heater, temperature sensor and water recirculator is a very effective, not inexpensive—$125 for the 19×13×5-inch size—water bath. Holding ±0.2°F (0.1°C), it is more accurate than all but the most sophisticated, costly, thermostatic water-temperature controls, though it is a recirculating system and therefore uses almost no water. It's ideal for the home darkroom for bringing chemicals to temperature and for maintaining critical processing temperatures in film-developing tanks and color-drum processors. If you tray-process color prints, where the developer step is critical, it is possible to float a tray on this water bath, but tape it to two sides with gaffer tape to avoid spills. It maintains temperature in the 68°F (20°C) to 102°F (39°C) range—which makes it ideal for color.

Celsius degrees (C), the preferred term for what used to be called centigrade in high school, is almost twice as large as our Fahrenheit degree. This scale provides convenient conversion.

Curving Cutoffer is found when very long lenses are used and internal baffles built into the lens have been dislodged, cutting off part of the image.

Holy Curtain Striper is a member of the Pinhole Striper Family, but he may only make short bright streaks, some of them with larger heads. Sometimes when there is a pinhole in a curtain, light leaks through and makes stripes when the curtain moves. In other cases, when the pinhole is in the second curtain, and the shutter is rewound and film advanced, they move together at almost the same speed so any light reaching the film makes only a short streak of brightness.

GREMLINS
by David Eisendrath
Modern Photography/2160 Patterson St., Cincinnati, OH 45214/paper, $1, with a discounted price for 500 or more

Unidentified marks on film are not always caused by faults in processing. This snapshot album demonstrates the "signature" of every conceivable gremlin to haunt a *camera*. It includes pictures and explanations of how they did what to your defenseless film.

Modern Photography's Dictionary of Camera
GREM-LINS
David B. Eisendrath, Ph.G. (Professional Hunter of Gremlins)

TIMERS

The "time" half of time/temperature processing is as important as the temperature, if repeatable quality results are required. Film and paper developing require a 60-minute timer with a sweep second-hand and start/stop capability. A wind-up version, such as the $24 Kodak Timer, is adequate for roll film and for color paper developing, only if you work exclusively with a daylight tank. When tray-processing film or paper, and when deep-tank processing cut film, a large luminous timer like the Gralab, below, is mandatory.

Dimco Gray's Gralab 300 can be found in almost every darkroom in the country for good reason. Its eight-inch luminous dial is a snap to read in the light or dark, easy to set, has outlets for switching/timing electrical devices and lasts forever. 115V; $45. Get one!

PHOTO-LAB-INDEX

A prodigious compendium of a zillion technical photographic facts, formulas, tables, graphs and techniques. Not a text book, more like a companion; recommended for bedtime reading only if you're turned on by the *Yellow Pages* or the *Encyclopaedia Britannica*. Its thousands of pages stack up four-inches thick, and weigh in at five jam-packed pounds of almost solid type.

While not necessarily *the* definitive source on technique, it does touch on almost everything involved in laboratory procedures. Want to know how to retouch glass plates? See Chapter 11 for a brief mention of it. But there is nothing in the book on dry mounting, nor its equipment; nor for that matter is there anything throughout on any kind of equipment. Need a table that will relate ASA and DIN film speeds? Want to know the average life and color temperature of photoflood bulbs or the characteristics of Ilford safelight filters? It's all here, providing the benefit of being able to locate in one place all manufacturers' instructions. Where it really shines is in the individual chapters on Agfa, Dupont, Kodak, GAF, Ilford, 3M, Polaroid and miscellaneous companies' products. Just about every film, developer, time/temperature chart, pre-packaged and mix-it-yourself formula in the world is here. The basic looseleaf "lifetime" edition is $35, with updating supplements $9 yearly. From Morgan & Morgan.

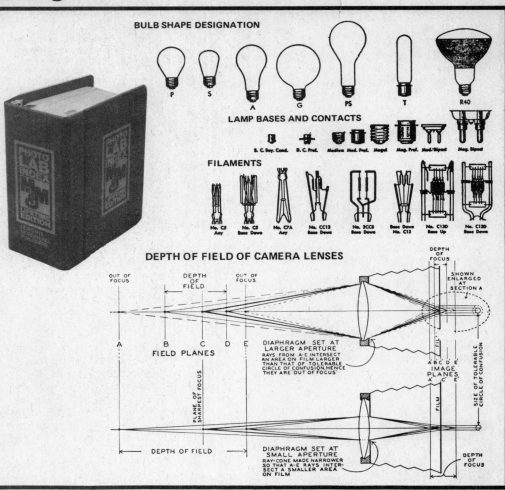

BULB SHAPE DESIGNATION

LAMP BASES AND CONTACTS

FILAMENTS

DEPTH OF FIELD OF CAMERA LENSES

Color film processing requires a non-contaminating wash between many of the steps, leading to lots of washers in a processing line. With this quick-dump tank by Arkay, $65, you only need one washer, since you can empty the five-gallon tank in seven seconds.

Wat-Air roll-film washers by Pfefer Products, pictured left, start at $16, come in seven sizes. A beautiful, functional, simple machine. Similar units come from Arkay and Brandess.

Small quantities of sheet film can be washed in a tray: Arkay's perforated stainless steel tray (right) $27, or Kodak's Tray Siphon, $13, work fine, but carefully agitate manually and keep films from sticking together.

An excellent washer for sheet film in hangers. "Hurricane" by Brandess comes in clear heavy plastic, 4×5 ($50) to 8×10 ($70), each holds twelve hangers.

THE ULTIMATE FILM FIX

If you want your precious negatives to really last, fix them properly in fresh fixer and wash them well. Good washing means 1) a pre-wash treatment in a hypo neutralizer, such as Perma Wash, Hustler Rapid Bath, or Kodak's Hypo Clearing Agent; 2) good circulation of water around every square inch of film; 3) frequent change of wash water—preferably one change every 2-3 minutes; 4) water of proper—and relatively constant—temperature (68-72°F, 20-22°C, or as close to processing temperature as possible). Contrary to the claims of the hypo neutralizer manufacturers, wash film *for at least twenty minutes,* even after treatment in their wonder potions. Any careful photographer who has ever run a residual hypo test will confirm this (see p. 83 of David Vestal's book, reviewed on p. 93).

Washing roll film by placing the reels in a tank under a running faucet is useless, since the film just soaks in its own hypo (fixer), which is heavier than water. (You can use that method if you dump the tank every minute or more.) In all cases, agitate films frequently to dislodge clinging air bubbles.

Roll film in cylindrical washers (see left) is easily agitated by the percolating water, which should be completely dumped every few minutes to remove residual air bubbles. Washers that are left filled with water will eventually grow all sorts of slime and other good stuff on interior walls. Dumping after use will prevent this; otherwise clean well every week or two.

HANG IT UP TO DRY

The best way to dry film is to hang it vertically from *wood* clothespins (plastic slips) or metal clips in a dust-free room or, preferably, in a cabinet at room temperature with no air motion. A clean bathroom that can be kept unused for two hours (quite a trick) often works well. Just remember to close any windows and lock the door after closing it *slowly* on your way out so you don't stir up any dust. A metal cabinet is luxurious, having smooth clean walls and usually filtered forced air and a heater for those in a rush. Heat is not the best for film. High on our list of photographs that got away are the pictures the late Robert Capa took of the Allied landing on D-day at Omaha Beach. All but eight frames were destroyed when a mindless technician left the negatives exposed to an electric heater till the emulsion melted. Never allow film to be dried by heat greater than 95 F. Also, keep the air filters and cabinet insides very clean. Roll film requires a clip weight at the bottom end to keep it from curling.

THE NEW SYSTEM ZONE MANUAL
by Minor White, Richard Zakia, Peter Lorenz
Morgan and Morgan/Dobbs Ferry, N.Y./$8.95

The Zone System is the practical application of photographic sensitometry (the precise relationship between exposure and density) for previsualization and control of tonal values in the final print. It was codified by

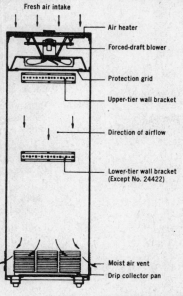

The Kindermann Porta-dri model 20 film drying cabinet shown at left generates filtered, thermostatically controlled hot air, and holds 18 35mm, 20-exposure rolls, or 15 36-exposure rolls with "loops." Loops aren't so good, because they can leave marks at the point where the film bends.

Get the model 40 Porta-dri which is taller, and $50 more. These have collapsible plastic sides and a zipper front to save weight and cost. They also make sturdier all-metal, more-money versions. The Burke & James all-metal No. 2024 holds 80 rolls of 35mm 36exp. without loops, or 150 cut sheets, and is $560.

Fresh air intake — Air heater — Forced-draft blower — Protection grid — Upper-tier wall bracket — Direction of airflow — Lower-tier wall bracket (Except No. 24422) — Moist air vent — Drip collector pan

Ansel Adams, whose prints of the American West epitomize the perfection of its practice. (It's long been rumored that Adams had all the rocks in Yosemite National Park painted Zone V.) He taught the system to Minor White, who carried it to equal perfection. This book is the revised edition of White's *Zone System Manual.* It is a step-by-step explanation of the technique, with integrated exercises for previsualizing the end result. For example, on a clear sunny day the brightness range of a scene can be 400:1 between the highlights and shadows, while photographic paper is capable only of producing a range of 50:1. Compacting that 400:1 range onto the paper without losing the quality of the scene is what the Zone System is all about. Because the technique requires individual development of each negative, it is most practical for large-format or interchangeable back cameras. But if that's your thing, this is the book.

Coupling Zone Rulers to Luminance Meters

The moment has arrived to elucidate the coupling of print zone rulers to the exposure scale of exposure meters.

Because of the numerous luminance meter types in use, we need a symbol for visualization. In the adjacent diagram, (A) represents the zone ruler and print exposure scale; (B) the meter's light value scale; (C) the aperture; and (D) the shutter speed. This form of the symbol originates out of the Weston exposure meters; but with some imagination may be applied mentally to connecting zone ruler to light measurements.

Coupling of zone ruler to meter is generally done by rotating dials so that some one zone of the ruler (A in the symbols) is opposite some one particular light value reading (B in the symbol). For example in the figure below, a 7 light value reading is shown opposite Zone V. With an ASA of 100, an aperture of f/8 requires a 4 second exposure.

Once coupled by *placement*, here light value 7 was placed opposite Zone V, the meter then indicates in what zones the other light value readings will fall. In the figure below, light reading 5 falls in Zone III and light value 10 falls in Zone VIII. Let's take another example: if light value reading 7 were placed in (opposite) Zone VIII, the aperture of f/16 would indicate 120 seconds exposure.

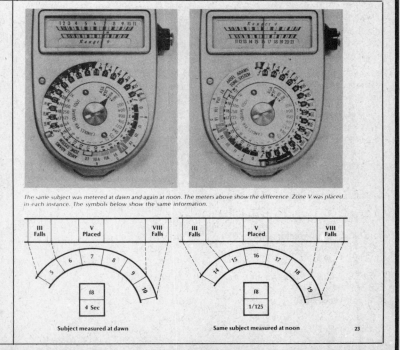

The same subject was metered at dawn and again at noon. The meters above show the difference. Zone V was placed in each instance. The symbols below show the same information.

III Falls	V Placed	VIII Falls
5 6 7 8 9 10		
	f8	
	4 Sec	

Subject measured at dawn

III Falls	V Placed	VIII Falls
14 15 16 17 18 19		
	f8	
	1/125	

Same subject measured at noon

0	I	II	III	IV	V	VI	VII	VIII	IX

Zone Ruler & Exposure Scale

Print Zone Ruler Coupled to Meter's Exposure Scale
The illustrations assume that an 18% gray card read light value 7. The diagram shows 7 opposite V. That is, it shows 7 placed in V. Now print zone ruler and exposure scale of the meter are coupled, connected, superimposed.

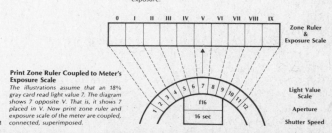

1 2 3 4 5 6 7 8 9 10 11 12 — Light Value Scale

f16 — Aperture

16 sec — Shutter Speed

22

23

Abbeon Cal, Inc.
123-20M Gray Ave.
Santa Barbara, CA 93101

Ace Lite-Step Co.
1516 S. Wabash Ave.
Chicago, IL 60605

Acufine, Inc.
439-447 E. Illinois St.
Chicago, IL 60611

Agfa-Gaevert, Inc.
275 North St.
Teterboro, NJ 07608

Amphoto Publishers
750 Zeckendorf Blvd.
Garden City, NY 11530

Aristo Grid Lamp Products
65 Harbor Rd.
Port Washington, NY 11050

Arkay Corp.
228 S. First St.
Milwaukee, WI 53204

Art Infinitum
432 E. 19th St.
New York, NY 10028

Bainbridge, C.T. & Sons
808 Georgia Ave.
Brooklyn, NY 11207

Bel-Art Products
Pequannock, NJ 07440

Beseler Photo Marketing Co., Inc.
8 Fernwood Rd.
Florham Park, NJ 07932

Bestwell Optical Instrument Co.
P.O. Box 74, Kensington Sta.
Brooklyn, NY 11218

Bogen Photo Corp.
P.O. Box 448
100 S. Van Brunt St.
Englewood, NJ 07631

Brandess Bros.
4849 N. Western Ave.
Chicago, IL 60625

Brookstone Corp.
122 Vose Farm Rd.
Peterborough, NH 03458

Brumberger, Inc.
1948 Troutman St.
Brooklyn, NY 11237

Burke and James, Inc.
44 Burlews Ct.
Hackensack, NJ 07601

Calumet Scientific
1590 Touhy Ave.
Elk Grove Village, IL 60007

Carr, M.W. & Co.
63 Gorham St.
West Somerville, MA 02144

Columbian Enameling & Stamping Co.
P.O. Box 4066
Terre Haute, IN 47804

Consolidated International Corp.
4501 W. Western Blvd.
Chicago, IL 60609

Consolidated Photographic Imports
358 Millburn Ave.
Millburn, NJ 07041

C.P. (Chemical Products) Co.
10 Beach St., P.O. Box 337
North Warren, PA 16365

Da-Lite Screen Co, Inc.
State Rd. 15 N.
Warsaw, IN 46580

Dimco-Gray Co.
8500 S. Suburban Rd.
Centerville, OH 45459

Draper Shade and Screen Co.
Spiceland, IN 47385

Durst (U.S.A.) Inc. Div. of EPOI
623 Stewart Ave.
Garden City, NY 11530

Eastman Kodak Co.
343 State St.
Rochester, NY 14650

East Street Gallery
723 State St., Box 68
Grinnell, IA 50112

Edmund Scientific Corp.
300 Edscorp Bldg.
Barrington, NJ 08007

Edwal Scientific Products Corp.
12120 S. Peoria St.
Chicago, IL 60643

E. Leitz, Inc.
Link Dr.
Rockleigh, NJ 07647

Emde Products
2040 Stoner Ave.
Los Angeles, CA 90025

EPOI Ehrenreich Photo-Optical
Industries, Inc.
623 Stewart Ave.
Garden City, NY 11530

Falcon Safety Products
1137 Route 22
Mountainside , NJ 07092

Faultless Rubber Co.
Abbott Laboratories
Ashland, OH 44805

Filterite Corp.
Timonium, MD 21093

GAF Corp.
140 W. 51st St.
New York, NY 10020

Ganz, A.J. Co.
115 N. LaBrea Ave.
Los Angeles, CA 90036

Harrington Cutlery
Southbridge, MA 01550

Heico, Inc.
Delaware Water Gap
PA 18327

Hollinger Corp.
3810 S. Four Mile Run Dr.
Arlington, VA 22206

Honeywell Photographic Products
P.O. Box 1010
Littleton, CO 80120

HPM Corp.
98 Commerce Rd.
Cedar Grove, NJ 07009

Industrial Timer Corp.
U.S. Highway 287
Parsippany, NJ 07054

Interphoto Corp.
45-17 Pearson St.
Long Island City, NY 11101

Johnke MFG. Co.
31-09 35 Ave.
Long Island City, NY 11106

Keeton-Cole Co.
P.O. Box 9442
Jackson, MS 39206

Kindermann Products
Photo Technical Products Group
Ehrenreich Photo-Optical
Industries, Inc.
623 Stewart Ave.
Garden City, NY 11530

Kreonite, Inc.
715 East 10th St.
P.O. Box 2099
Wichita, KS 67201

Kulicke Frame Co.
636 Broadway
New York, NY 10012

Lawler Automatic Controls
453 North MacQuesten Pkwy.
Mount Vernon, NY 10553

Leedal, Inc.
2929 South Halsted St.
Chicago, IL 60608

Lektra Laboratories
129-07 18th Ave.
College Point, NY 11356

Macbeth
Little Britain Rd.
Newburgh, NY 12550

Marshall, J.G. Mfg. Co.
167 N. 9th St.
Brooklyn, NY 11211

Matrix Systems, Ltd.
408 Grand St.
Chicago, IL 60610

Meynell Valves, Inc.
42 Jeffery Lane
Hicksville, NY

Nega-File Co.
P.O. Box 78
Furlong, PA 18925

Morgan & Morgan Inc.
145 Palisade St.
Dobbs Ferry, NY 10522

Nuclear Products Co.
2519 North Merced Ave.
S. El Monte, CA 91733

Omega Enlarger & Darkroom
Products Div.
Berkey Marketing Corp.
25-20 Brooklyn-Queens Expwy. W.
Woodside, NY 11377

Oscar-Fisher Co., Inc.
P.O. Box 2305
Newburgh, NY 12550

Pako Corp.
544 10th St.
Palisades Park, NJ

Petersen Publishing Co.
8490 Sunset Blvd.
Los Angeles, CA 90069

Pfefer Products
485 Easy St.
Simi Valley, CA 93065

Photo-Pro Corp.
P.O. Box 1323
West Cauldwell, NJ 07006

Photo Materials Corp.
500 N. Spaulding Ave.
Chicago, IL 60624

Photo Plastics, Inc.
5715 Woodward Ave.
Detroit, MI 48202

Photo-Therm Corp.
110 Sewell Ave.
Trenton, NJ 08610

Pike, E.W.
P.O. Box 4
Elizabeth, NJ 07207

The Plastics Factory
18 E. 12th St.
New York, NY 10003

Print File Co.
P.O. Box 100
Schnectady, NY 12304

Process Materials Corp.
329 Veterans' Blvd.
Carlstadt, NJ 07072

Retouch Methods, Inc.
P.O. Box 345
Chatham, NJ 07928

Richard Manufacturing Co.
5914 Noble Ave.
P.O. Box 2910
Van Nuys, CA 91404

Seal, Inc.
251 Roosevelt Dr.
Derby, CT 06418

Sorg Paper Co.
901 Manchester Ave.
Middletown, OH 45042

Southbank Electronics Corp.
205 West Wacker Dr.
Chicago, IL 60606

Spiratone, Inc.
135-06 Northern Blvd.
Flushing, NY 11354

The Stratfield Co.
434 Grand St.
Bridgeport, CT 06604

Structural Industries
96 New South Rd.
Hicksville, NY 11801

Testrite Instrument Co.
135 Monroe St.
Newark, NJ 07015

Thomas Instrument Co.
331 Park Ave.
New York, NY 10010

Three M Co. (3M)
Nuclear Products Div.
3M Center
St. Paul, MN 55133

Three M (3M) Commercial Tape Div.
P.O. Box 33600
St. Paul, MN 55133

Treck Photographic Headquarters
140 Allens Creek Rd.
Rochester, NY 14618

Twentieth Century Plastics
3628 Crenshaw Blvd.
Los Angeles, CA 90016

Verd-A-Ray
41 East 42nd St.
New York, NY 10017

Vue-All, Inc.
P.O. Box 1994
Ocala, FL 32670

Weston Instruments, Inc.
614 Frelinghuysen Ave.
Newark, NJ 07114

X-Acto
45-35 Van Dam St.
Long Island City, NY 11101

7

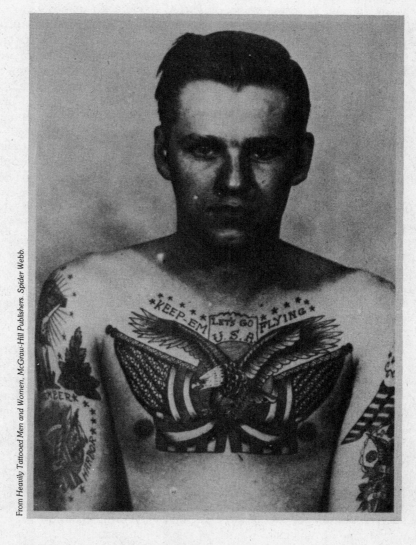

From Heavily Tattooed Men and Women, McGraw-Hill Publishers. Spider Webb.

PRINTING

PRINTING

DO IT YOURSELF

Printing—bringing your images to fulfillment—is a source of never-ending pleasure. If you leave your work to a commercial lab, you are missing half the creativity, half the control, half the excitement of photography. A literal interpretation of a scene frequently is *not* the goal of the creative artist; how "reality" is modified, what you choose to emphasize, what you choose to hide from the viewer can be controlled to a large extent in the printing operation.

Proper selection from contact sheets of *what* to print is as important as *how* you print it. Excessive talkers are often said to run over at the mouth; long strips of 35mm film and rapid-advance levers of cameras have contributed to photographers running over at the eye. With patience, a magnifier and cardboard mask, it is possible, with practice, to do a reasonable editing job from the dozens of pictures on a contact sheet, at least for commercial purposes. But a contact sheet's anemic little images are all printed at some average exposure, without consideration for or ability to control the esthetic necessities of the separate frames. The contemplative photographer might consider the following procedure. Make quick, entire-negative work prints from every frame that has even vague or remote possibilities: 3½×5 or 5×7 inches is fine, on cheap or even outdated paper. Use the contact sheet as an exposure guide: once you have homed in on the printing time for picture number one, the correct time for picture number two can be guessed at with sufficient accuracy by noting whether the contact-sheet image of frame two is lighter or darker than frame one. Increase or decrease the exposure time as required, remembering that a 20 percent time change will produce a mild density change. If your camera exposures were somewhat inaccurate, and your contact sheet looks a bit like a black-and-white checkered tablecloth, you may require a 50 or even 100 percent change. You will quickly learn to guess quite accurately. Once you have exposed and processed the first print satisfactorily, expose all the rest and place them in an empty lighttight box. You can even do some fast dodging and burning where it's obviously needed, and maybe try one "straight" print and another from the same frame, very dark and moody or light and bright. Then batch-process five to ten at a time (a technique clearly explained by David Vestal whose book is reviewed on page 93). In fifteen minutes, you can have a whole bunch of easy-to-see, nice-to-hold, isolated images. Live with them for a few days; experiment with various cropping possibilities using two cardboard "L's"; gently write ideas on the back of these proofs with a soft #1 pencil. Timely contemplation of reasonable-size pictures will pay off in better prints from negatives you may have passed over.

It is interesting to note that in some ways all prints are proofs. Many a photographer modifies his concept, his intention, and is in a different mood each time he or she returns to reprint an old negative. This renewable vitality is one aspect of photography that sets it apart from other visual arts—in this respect, it is much like a musical performance.

The basic requirement is a clean darkroom with a stable enlarger that has a good lens—the best you can afford. The peripherals, from easels to print dryers, do no good if your enlarger and your negatives are poor. Grounding the enlarger to a cold-water pipe with a length of wire will eliminate the build-up of static electricity that attracts dust in low humidity areas. Once a month, vacuum the inside of the bellows and clean the front and *rear* of the main lens and all condenser lenses.

Clean negatives can save hours of print spotting. A 35mm negative, and *every* bit of dust on it, is enlarged at least eight times to produce an 8×10-inch print. Use a Staticmaster electrostatic camel's-hair brush and/or ear syringe or canned compressed air to dust negatives. In severe cases, Kodak's film cleaner is quite helpful. For scratched negatives, Edwal's No-Scratch fills in the gouges. In lieu of that chemical, professional printers have for years been applying skin oil from their forehead or nose with a pinky. Some printers, as a matter of practice, rub each neg vigorously between thumb and forefinger with nose grease, just to clean off any debris.

Glass negative carriers guarantee perfect film flatness and maximum overall print sharpness, but do have four additional dust-catching surfaces. In dry weather the glass may cause ring-shaped patterns, called Newton's Rings, due to the microscopic air layer trapped between the smooth film base and the glass. Glassless carriers permit film to buckle from the enlarger lamp heat, resulting in loss of print sharpness as the negative "pops." If this happens, keep the enlarger on all the time so the negative stays buckled, and expose by using the enlarger's red filter as a shutter.

The standard way to print is to focus with the lens wide open; then close it down to one of its optimally sharp apertures, usually f/5.6 or f/8. Finally, use the timer to vary the exposure. This method permits exposure adjustment by examining a trial print and estimating the time correction needed for a better one: as noted earlier with the contact sheet, 10 to 20 percent is a subtle change, 50 percent a medium modification, and 100 percent and more for drastic corrections. Professional lab technicians often print by judging the brightness of the image on the easel and using a constant exposure time. They adjust the lens diaphragm until the image appears to match the reference brightness they carry in their heads—something like a musician with perfect pitch. This technique takes lots of practice and for dense negatives may require opening the lens beyond its sharpest apertures. These people get so good, they can expose dozens of negatives of varying density, batch process the prints at the *end of the day* and have at most one or two remakes!

If you are a beginner, test strips, properly made, can teach you what's happening. The idea is to position the strip so a bit of each of the major tonal elements in the picture is covered. Then hold a cardboard slightly above the test strip and make a series of exposures in bands parallel to the long edge of the strip. You then choose the exposure you like. We think test strips are a waste of time once you've logged some time in the darkroom. Be a sport; spring for a whole sheet of paper and see what the picture is. Then adjust your exposure accordingly.

For all but warm-tone papers, prints developed in Dektol diluted with two parts water for two minutes at 68°F (20°C) have optimum quality. Do not pull prints out of the developer if the image is getting too dark; wait the full two minutes, stop, fix and inspect under white light. If it's no good, ditch it, and make any necessary corrections by varying the *exposure*. This method will produce the best prints.

Variable-contrast filters are best placed *above* the lens in the enlarger's filter drawer: dust and scratches on them cannot degrade the image as when they are in front of the lens. Special acetate filters for this purpose are made by Kodak.

Fresh chemicals used according to manufacturer's directions and not overworked will also contribute to nice-looking prints. Use of a washing aid (Hypo Clearing Agent, Perma Wash) and more than minimum wash time with good agitation will ensure that those nice pictures last long enough.

FROM THE PEOPLE WHO BROUGHT YOU THE LEICA, THE LEITZ FOCOMAT AUTOFOCUS ENLARGERS

Ernst Leitz of Germany, the maker of the legendary Leica cameras, also produces small and medium-format enlargers that match their cameras' superb mechanical features, excellent optics, sound design, almost unlimited service life and stiff price. Both the Focomat Ic for 35mm, and IIc for up to 2½×3¼-inch (6.5×9cm) formats are unbelievably rigid in construction; the IIc weighs almost 90 pounds (40kg), which is twice the weight of any other enlarger of similar format. That factor, coupled with the precision glass-negative carriers (with anti-Newton-ring top glass) for perfectly flat film, unperturbable alignment between film, lens and baseboard and Leitz's traditionally fine lenses, result in a machine capable of getting the maximum quality from today's super sharp negatives. Both units are autofocus and so precise, skeptics take note, that once properly adjusted *via test prints*, they can produce pictures sharper than when focused manually, even with the help of a focusing magnifier! This is due to the fact that white-light eye focus does not always correspond to the blue-light sensitivity of most papers. One may benefit from this subtle distinction only with a precision enlarger like the Leitz.

Leica/E. Leitz Inc./Rockleigh, NJ 07647

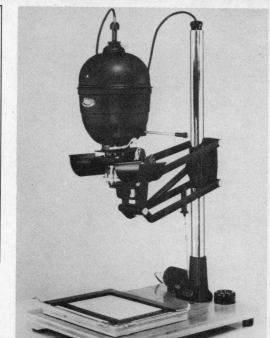

The image size and autofocus are simultaneously controlled by fingertip pressure on the head, raising or lowering the parallelogram arms. The autofocus range of the Ic is 2X to 10X, yielding prints 2×3 to 10×15 inches. One drawback is that prints—11×14 and larger and 8×10s from highly cropped negatives, must be manually focused, as must small images between 1:1 and 2X. But you can make manually-focused full-frame 16×20s right on the baseboard. With a 50mm Focotar lens and color-filter drawer, the price is $1,175.

Both the Ic, right, and the IIc, below right, have accessory tilting negative stages for the correction of converging parallels.

Focomat Ic

The condenser is fully raised and locked up to permit easy insertion or removal of the negative carrier. The Ic is shown.

The condenser head will stay partially open for scratch-free film shifting, without the film leaving the track.

With the lever fully forward, the lower surface of the condenser is in contact with the film, holding it flat.

For cleaning the condenser, which also acts as a pressure plate on the negative, the head is easily tilted backwards.

Focomat IIc

A —
B —
C —
D — Cable holder
Column
Lamp housing
E — Filter drawer
F —
G — Negative carrier
H — Lens carrier
I — Auto-focusing
J — cams
Cam-switching cable
Operating handle
Parallelogram guide
Enlargement indicator
K —
L — Baseboard
M — Power socket
N — On/Off switch

The autofocusing range of the Focomat IIc, right, is 2-11X for 35mm film, which is about 2×3 to 11×16 inches, and 1.4-5.7X with the 100mm lens, which is about 3×3 to 13×13 inches from a 2¼-inch square negative. Outside this range, manual focusing will provide enlargements on the baseboard up to 16X and 8.6X, respectively, from the 60mm and 100mm lenses.

30
31
32
33
34
35

The IIc has both 60mm and 100mm V-Elmar f/4.5 lenses on a quick-change turret; the autofocus mechanism is factory matched to each lens. The negative carrier is the glass-sandwich type, built in such a way that film may be conveniently inserted and removed without having to remove the carrier from the head. In the beautiful wood baseboard is a storage compartment for the negative masks that fit the one universal negative carrier. With two lenses, color filter drawer and illuminated magnification scale, it's only $2,600.

OMEGA, B66 SERIES

Omega (formally Simmon-Omega) produces an extensive line of enlargers. The B66 series, right, is their better quality medium-format (Minox to 2¼×2¼-inch) consumer-quality "system." The basic chassis accepts a condenser head for black-and-white, which can also do color with filter packs placed in the lamphouse, or a color head (see below). The standard inclined triangular aluminum girder is adequately rigid, black anodized—and conveniently disassembles from the white Formica baseboard without tools, for storage or for reversing for floor projection when making super large prints. If you print black-and-white exclusively, you can't go wrong with a used B22, the predecessor to the B66. It's actually a bit more rugged than the "new improved" version and, unlike the B66, has a tab to hold the head-lift lever in the up position for easier negative carrier insertion. Both have identical head-elevation lock screws terribly prone to stripping, so be gentle! Get the "XL" longer girder; you get 50 percent more potential print size. The B66XL condenser version without a lens is $220.

The Chromega B Dichroic color lamphouse for the B66 uses a filter and illumination system similar to that in their big professional enlargers and has stepless, fade-proof 0-170cc filtration with illuminated scales. If you have a B66 condenser enlarger, this color head, which will also work with black-and-white Variable-Contrast paper and voltage stabilized power supply, will cost $233.

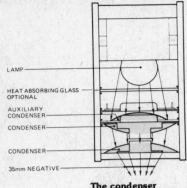

LAMP

HEAT ABSORBING GLASS OPTIONAL

AUXILIARY CONDENSER

CONDENSER

CONDENSER

35mm NEGATIVE

The condenser lamphouse of the B66 has a convenient sliding door for quick access to the bulb. An auxiliary condenser is inserted for the 35mm format, removed for the 2¼×2¼. A heat absorbing glass and filter drawer make placing Variable-Contrast Filters *above* the lens, where they belong for maximum print sharpness, a breeze. Get Kodak *acetate* three-inch (75mm) filter squares for this purpose.

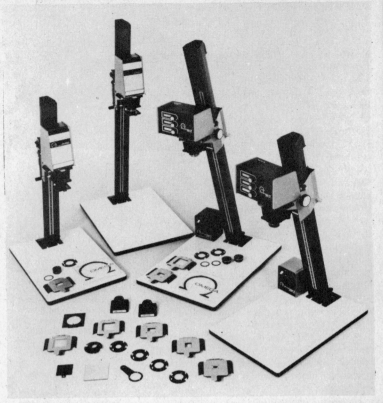

SIMMON-OMEGA ENLARGERS

Simmon-Omega produced this fine machine in the fifties and sixties for negative formats up to 2¼×3¼ inches. It has their successful condenser head, but these older models require a *separate* condenser lens set for each format/lens combination. The inclined double I-beam column was then, and still is, Omega's hallmark. The B-8 is very rugged, so a used one is probably quite serviceable if you check stage alignment, which can be adjusted. An autofocus version, the B7, was also made, but that automatic provision will be useless unless you have the original lenses, and lenses have improved considerably since the early fifties. However, Omega still has blank tracks for your new lenses, which will permit manual focus. In fact, almost all older Omega enlargers are still quite valuable for black-and-white work. Look into used B22's (up to 2¼×2¼-inch), D2's, D2V's, D3 and D3's (up to 4×5-inch).(see page 103).

The flying saucer at left is a fluorescent "cold-light" diffusion source made by Omega. (Today they're available from Aristo to fit Omegas.) They produce black-and-white prints with beautiful highlight gradation, though you must print one grade higher to get condenserlike contrast.

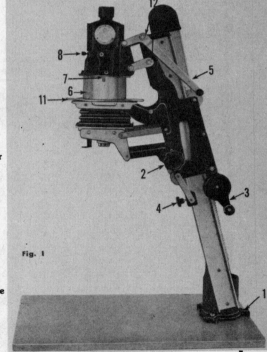

1. Lockscrews, fastening main column to baseboard.
2. Handwheel for focusing.
3. Rack and pinion for carriage movement.
4. Lock for carriage.
5. Lamphouse lifting lever (for inserting filmholders).
6. Condenser housing.
7. Knurled screws for condenser housing.
8. Screw fastening top lamphouse casting (loosen to insert supplementary condensers and heat absorbing or diffusing glass).
11. Filmholder.
12. Knurled screws holding lamphouse to lifting levers and carriage.

Fig. 1

The Simmon-Omega B8

Approximate On-Baseboard Magnification For Omega and Simmon-Omega Enlargers Past and Present

N.A. = Not Applicable

lens/format	A-2	A-2 Pro	B-8,B-10	B7,B9	B22,B66	B22,B66 XL's	B600	D2,D2V, D3,D3V	D2,D2V XL's	D5,D6	Super Chromeg C
25mm/ Minox	6.7-21X	6.7-27X	11.2-31X	N.A.	0.2-27X	0.2-36X	4-21X	13.7-37.2X	13.7-49.2X	0.11-49X	0.2-33
50mm/ 35mm	2-9X	2-12X	4-14X	4-15.2X	0.5-12.5X	0.5-18X	0.5-11X	5.2-17.7X	5.2-23.5X	0.2-24X	0.3-15.5X
80mm/ 2¼x2¼	N.A.	N.A.	1.6-8X	1.4-9X	1-7.5X	1-11.1X	0.9-6.7X	2-10.2X	2-14.2X	0.35-14.2X	0.6-9X
105mm/ 2¼x3¼	N.A.	N.A.	1.3-6X	1.4-7X	N.A.	N.A.	N.A.	1.5-7.2X	1.5-10.2X	0.5-10.3X	0.9-7X
150mm/ 4x5	N.A.	N.A.	N.A.	N.A.	N.A.	N.A.	N.A.	1.5-4.4X	1.5-6.5X	0.8-6.5X	N.A.

OMEGA, D-SERIES

The three Simmon brothers were German immigrants who began making enlargers in 1935 for the fledgling small-format market; their first real success came in 1939 with the introduction of the "D"-series machines. The original "D" was developed for the U.S. Army, which needed a good 4×5-inch enlarger for all the negatives produced by its photographers using Graflex press cameras. It sold for $175. Over 200,000 D-series are in use, attesting to its versatility and reliable, rugged performance. The structural heart is a pair of inclined aluminum I-beams, which have been thoughtfully black-anodized to mitigate stray light reflections on the new D5 models. Also new and quite handy is a built-in double-extension bellows that actually permits *reduction* of 4×5-inch negatives to 0.8 magnification (see chart on page 102). The top element of the triple-lens condenser must be positioned in the appropriate track in the lamphouse for each prime lens focal length. This procedure takes but a second, as does filter placement above the lens in the roomy box above the negative stage. All condensers and lens mounts are easily removable for dusting and for vacuuming the inside of the bellows, which should be done every month. Dozens of accessories are available for sophisticated artistic and scientific work in all formats from 16mm to 4×5-inch: e.g., point source lights for super sharpness and super-obvious grain; adjustable four-blade negative masks for flare control; a cooling blower when using very hot lights for mural work; wall mounts; a fine focusing control, which helps but could be a bit better; a three-lens turret. The basic D5XL with extra-length girder, oversized baseboard and no lenses lists for $675.

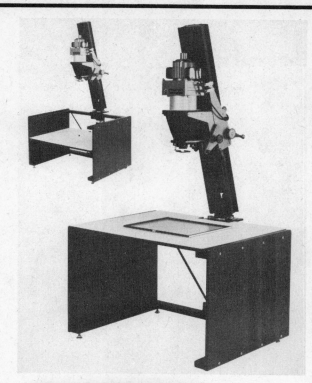

This 45-degree front-surface, optically ground mirror permits horizontal projection for photomural work without rotating the enlarger column and projecting onto the floor. But provisions must still be made for enlarger-to-wall easel distance to control image size; this mirror system renders the enlarger head-raising system unworkable as a means of image sizing. Cost is $50.

Available for the D-series enlargers are a floor stand and color head. The latter is a massive 175-pound steel-framed, Formica-covered "table." Its 43×38-inch top adjusts to three heights for up to 30×40-inch enlargements. Cost is $400. The color head is widely used in commercial applications, where the fade-proof dichroic filters are particularly valuable. Color-coded digital-illuminated readouts show the continuously variable settings in 1.0cc increments from 0-168cc. Convenient white-light focusing and ultraviolet and infrared filters are also built-in. The 4×5-inch Chromega D Dichroic Lamphouse II with power supply and voltage stabilizer is $830. For printing from 35mm or 2¼×2¼ the small-format "DB" Light Multiplier/Light Mixing Chamber is needed.

AN EXTENDED STORY . . .

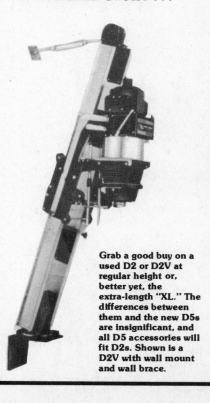

Grab a good buy on a used D2 or D2V at regular height or, better yet, the extra-length "XL." The differences between them and the new D5s are insignificant, and all D5 accessories will fit D2s. Shown is a D2V with wall mount and wall brace.

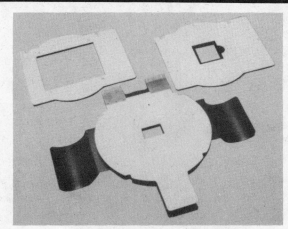

Forty-five different negative carriers are made for D-series enlargers, from 16mm to Polaroid 105, including 4×5-inch pin-registered color separation carriers to 2×10-inch electron microscope plate holders, many in glass. If you can't find what you need, Omega will custom make one. Most have white tops to boost illumination a bit and black lens-facing bottoms to reduce internal scattering. Glass carriers enhance picture sharpness by assuring maximum negative flatness; but they have four more dust-catching surfaces and may cause Newton's-ring patterns in the image.

NEGATIVE CARRIERS

	Glassless, sandwich type
	Glassless, rapid-shift type
	Glass, rapid-shift type
	Kodachrome, for mounted 35mm slides
	Kodachrome, unmounted 35mm slides. Has slot for gray scale
	Spool type, glassless, rapid shift*
	Spool type, glass, rapid shift*
	Electron Microscope, 2" x 10" plate holder
	Plate holder for glass negatives
	2-Pin Registration, 4" x 5", glass type for color separations
	Negative carriers for distortion correction attachment

BESELER 23C ENLARGER

1. Lamp House Cap
2. Lamp House
3. Color Head Filter Compartment
4. Condenser Housing
5. Upper Bellows
6. Negative Stage
7. Lens Stage
8. Negative Stage Lever
9. Filter Drawer
10. Elevation Handle
11. Negative Carrier
12. Condenser Stage Adjustment Knob
13. Condenser Stage Guide
14. Lamp House Cap Locking Screw
15. Elevation Brake
16. Enlarging Lens
17. Horizontal Lock

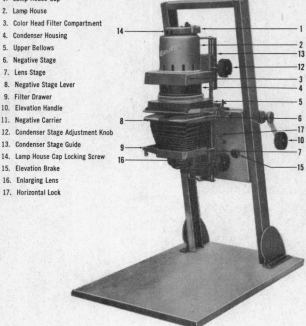

The entire body of the 23C rotates ninety degrees for wall projection when making super-large prints. Since the girders remain vertical, however, there is no convenient way to adjust the wall-to-negative distance, which determines image size. At best, you can push the whole enlarger back and forth on a table or on a cart, but it's a tricky matter to accurately align the enlarger perpendicular to the wall.

When cameras are pointed up or down from the horizontal, they generate pictures with converging parallels: building walls appear to taper and tilt backward. This artifact may be corrected in printing by tilting the negative and/or lens and easel in such a way that lines drawn through all three intersect at a common point. (the Scheimpflug Principle again) All Beseler enlargers employ a tiltable (twenty degrees, left or right) lensboard. The easel can be tilted by propping it up with books. Alignment is accomplished visually by studying the image on the easel.

The Beseler 23C condenser enlarger is a reliable performer in the medium format, semi-professional class; the design has proven itself during years of use. Capable of handling negatives from 8mm (Minox) to 2¼×3¼ inches (6×8cm), there is no need to change condensers for each format/lens combination. Instead, Beseler employs in all its enlargers a "cone of light" system: by use of a second bellows *above* the negative stage, the condenser head is raised or lowered as a unit to a height that causes the cone-shaped beam from the condenser to converges to the entrance pupil of the enlarger lens (see top of next page). On many small and medium-format enlargers, the negative carrier may only be inserted horizontally, requiring vertical images to be viewed on the easel from a slightly awkward position. The 23C, however, has rotatable negative carriers; if you have 346 vertical portraits to print, this could save a stiff neck. Filter holders are provided in front of the lens and in a compartment in the lamphouse. The latter position is advisable, since dust and scratches on color printing or Polycontrast Variable-Contrast filters are not within the image-forming rays. The double-post cantilever construction is extremely rigid and will permit enlargements from a 35mm negative up to 14×20 inches . If you make big prints—16×20s, or 11×14s from cropped negatives—it is not possible to floor project with this machine. It is capable of wall projection, see above, but that isn't really practical unless you set up for one size. Beseler does make the "BP Pak" ($43), which is a sheet metal height-extender box that goes between the girders and a larger, 20×27½-inch (51×70cm) baseboard. Unfortunately, some of the rigidity gets lost in the growth, so be careful. With the BP Pak, however, you can make 16×20s. The price is $270, without a lens, lensboard or negative carrier. A dichroic color head is available, from $190.

LENSES FOR ENLARGING (COPYING, TOO)

Almost any enlarger will do a creditable printing job if it has a good lens, so it's silly to put a $20 lens on a $200 enlarger. Enlarging lenses are specifically designed for one purpose: to form a flat image (on the easel) of a flat object (the negative) with maximum fidelity and uniform brightness at magnification ratios typically around 8X over a limited range of apertures, typically f/5.6 to f/16. Compare that to a camera lens that photographs three-dimensional objects, works over a 1/10,000 to 1/10 magnification range and is often required to take pictures at f/1.4 or f/2.

It's amazing how good a $20 lens is, *if* used at its optimum aperture, usually f/8 or f/11. However, the cheapies have poor resolution at larger openings, which you might need for printing very dense negatives, making large blow-ups or when using dense, 3½ or 4 Variable-Contrast Filters. Additionally, they may suffer from an aberration which causes the focus to shift as you stop down the lens to optimum aperture. A high-quality design, such as the classic 50mm Schneider Componon ($125), permits wide-open f/4 focusing of a bright image and retention of that focus at any aperture, though it too has an optimum aperture of f/8. Incidentally, it is

Componon lenses are designed for best performance at 6-12X magnifications, which is about equal to 5×7 to 11×14-inch prints from 35mm frames. But 8×10 prints from **4×5 negatives or 5×7s from 2¼ negatives require only 2X magnification. Here the Componon-S series, performing best about 3X, is suggested.**

possible to close a lens down too far. You can observe this if you have a focusing magnifier (see page 109). Due to an unrepealable law of physics, called diffraction, openings of f/16 and smaller will actually begin to decrease sharpness.

In general, the proper focal length lens for a given negative size is equal to the focal length of the *normal* lens of the camera that produced the negative; e.g., 50mm for a 35mm camera, 75mm or 80mm for a 2¼-inch (6cm) square negative. For maximum possible sharpness, it is recommended that a high quality lens of *longer* than normal focal length (which is designed to cover a larger negative) be used, such as a 60mm or 75mm for 35mm film. This way the negative is using only the lens' central sharpest field. The maximum degree of enlargement with a given enlarger, however, will be somewhat reduced, and the enlarger head will always be at a proportionally higher position.

Condenser enlargers produce contrasty, sharp, snappy prints; some feel a little too contrasty, especially in the highlights if the negative itself has lots of important highlight detail. These so-called "blocked-up" highlights are due to the Callier effect, where collimated condenser light passing through dense negative areas is scattered disproportionally more than light passing through less dense portions. Print highlights, therefore, receive relatively less exposure and contrast increases. A diffuse source, like the Aristo D-2 ($75) above, shown on the Beseler 45MCRX, passes light more uniformly through a negative and provides better highlight gradation. Also, because the source is diffused, a fluorescent head hides considerable amounts of grain and dust.

As with the 23C on the preceding page, Beseler's condenser system on their 4×5-inch (10×12cm) enlargers uses a vertically adjustable negative stage, surrounded by an upper set of bellows to set the condenser-to-negative distance for optimum illumination. With each format/lens combination, the negative stage is set to the appropriate scale-indicated position. The condenser forms a cone of light whose apex is the prime lens. As seen in the upper diagram at left, a 4×5 inch (10×12cm) negative must be placed near the top of the cone, a small 35mm frame towards the bottom where the cone narrows. Other manufacturers, such as Omega, use movable condenser lens elements or interchangeable condenser sets (Durst) to accomplish the same goal.

45M with color dichro head.

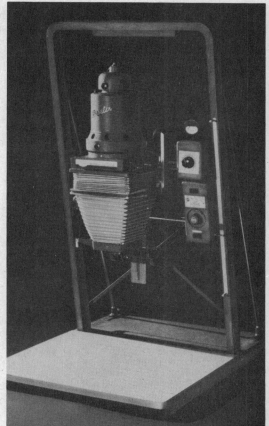

Top of the line CB7.

The frames of the 4×5-inch (10×12cm) Beseler enlargers, both 45M and CB7 series, are of triangular truss construction, making for a particularly stable structure. These machines have laterally moving bodies (for special cropping or split-easel exposure), tilting lensboards (for distortion control) and motorized vertical elevation (for the control of picture size). Both also come with "Resistrol" and "Bestrol," a rheostat and voltmeter combination for continuously-variable line voltage into the enlarger lamp; this ability to vary lamp brightness is particularly useful in black-and-white printing of thin negatives and very small pictures. Since variable-contrast paper responds to the blue and green components of white light and the reduction of line voltage to a lamp disproportionally decreases the amount of blue and green light output, this technique works best on conventional black-and-white graded papers. For mural and big-print production, the entire head rotates ninety degrees for wall projection, as on the 23C on the preceding page. To be practical, though, such a system requires the enlarger or wall easel to be mounted on floor tracks, so the easel-to-negative distance, which controls image size, is convenient to adjust while maintaining critical perpendicularity between the optical axis and the wall. If you are willing to do that, these are good professional machines to do it with. Numerous accessories are available, from color heads to camera backs, for conversion to a copy camera. The 45MCRX is $600; the CB7-F with motorized focus and tilting negative stage is $1,000.

RANGE OF PRINT SIZES OBTAINABLE FROM STANDARD NEGATIVES AND RECOMMENDED LENSES[1]

NEGATIVE SIZE	RECOMMENDED LENS		SIZE OF PRINT (INCHES)	
	mm	INCHES	MAXIMUM[2]	MINIMUM[3]
4" x 5"	135	5⅜	23 x 29½	2⅜ x 2⅞
	150	6	19½ x 25	2⅝ x 3⅜
	161	6⅜	17¾ x 22½	3⅛ x 4
3¼" x 4¼"	127	5	20 x 26½	1⅝ x 2¼
	135	5⅜	18 x 24	1⅞ x 2½
2¼" x 3¼"	101	4	19½ x 28	1⅛ x 1½
	127	5	14½ x 21	1⅜ x 2
2¼" x 2¼"	90	3½	22 x 22	1⅝ x 1⅝
	101	4	18½ x 18½	1⅜ x 1⅜
35mm	50	2	16½ x 24½	1⅝ x 2½
24 x 36mm or ¹⁵⁄₁₆" x 1⁷⁄₁₆"	75	3	10⅞ x 15¾	1 x 1½

(1) Without changing condensers and without using lens cones or other accessories.
(2) Working on base board (no easel).
(3) Working on easel 1" thick. Note greater reductions (smaller prints than those listed) are obtainable by special procedures.

DURST M800

A fluorescent "cold-light" diffusion head is available ($180), but not a special color head as such. However, a chamber above the condenser accepts variable-contrast and color-printing filters.

Durst manufactures an extensive line of enlargers, from the dinky F30 at $75, to a $17,000, 8×10-inch (20×25cm) color machine for the graphic arts industry. The M800 is a medium-priced ($250 with condenser for one format, no lens or lensboard), semi-professional enlarger capable of handling negatives up to 2¼×2¾ inches (6×7cm). The M800 will make 16×20-inch (40×50cm) prints on the baseboard from 35mm negatives and has both a tilting head and a tilting/translating lensboard, shown below, for maximum distortion control. An accessory cassette replaces the condenser head to convert the enlarger to a 2¼×3¼-inch (6×8cm) copy camera; even copy lights are available. The negative stage has four separate masking blades for special cropping of negatives.

Durst (USA) Inc./Division of Ehrenreich Photo-Optical Industries, Inc./101 Crossways Park W./Woodbury, NY 11797

THE ENLARGER AS A CAMERA

The Durst CE1000 is a formidable combination of components capable of virtually all enlarging *and* copying operations with film formats through 4×5 inches (10×12cm), in color or black-and-white. The basic black-and-white condenser enlarger, with a pair of condensers for a 150mm lens, is $570; a version with a fluorescent "cold-light" diffusion head is $10 less. Glass negative carriers are available only in the 4×5-inch (10×12cm) size; all others are glassless. For $1,000 more, and up, you can convert the enlarger to a reflex-viewing copy camera, handling 4×5-inch (10×12cm), 120 and 35mm film formats and all sizes of Polaroid film. Originals as large as 20×24 inches (50×60cm) may be copied. Additional accessories permit macrophotography to 35X, or photomicroscopy. In all, the CE1000 is very similar to Polaroid's MP-4 system. As an enlarger, it has no provisions for floor or wall projection; the largest print obtainable is 20×24 inches (50×60cm) from a 4×5-inch (10×12cm) negative, 16×20 inches (40×50cm) from a 35mm frame.

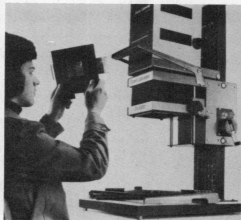

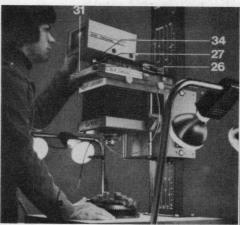

Shown above is the condenser lamphouse on the CE1000, which is being used as an enlarger. Separate condenser sets must be inserted for each film format/lens combination. The negative carriers are the sandwich type. No special provisions are made for distortion control.

As a copy camera, viewing is through an eye-level reflex hood. The viewing hood looks in on a groundglass focusing screen, which has inscribed format indicator markings. Sheet-film holders fit below the hood; Polaroid pack and roll-film backs and a 35mm film transport fit behind the sliding hood.

A full range of Nikon and Schneider lenses, from 19mm to 150mm, in shutters, are available for the copying and macro system.

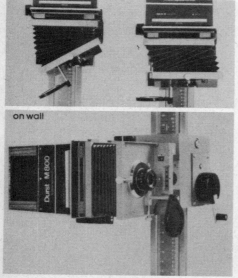

on wall

To make prints larger than 16×20 inches (40×50cm), the head of the M800 rotates 90 degrees for wall projection, shown lower left, or 180 degrees about the column for floor projection. The latter is more convenient for home use, but be certain to counterbalance the baseboard with lots of books or full one-gallon chemical bottles. Both glassless carriers and carriers with anti-Newton-ring glass are available. Because the support column is vertical and not cantilevered, floor projection must be done on a rigid table having open space between its legs; a cabinet with a closed front is not suitable.

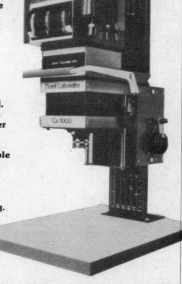

A professional dichroic color head, costing $1,050, fits the CE1000 enlarger system. Features include 0-195cc continuously variable filtration, 250-watt blower-cooled tungsten-halogen illumination and white-light focusing.

THE CAESAR-SALTZMAN 30WA ENLARGER

What weighs over 1,000 pounds, can precisely enlarge negatives from 35mm to 8×10 inches; is so strong, rugged and full of cranks it could be used to open a drawbridge, and, sadly, is no longer made but is available used. It's the Caesar-Saltzman 8×10 vertical enlarger. This company specialized in super-stable tripods, light stands and luminaires, and enlargers for the professional studios of the forties and fifties, with their 8×10-inch view cameras and elaborate, Hollywoodlike studio sets. Berkey Technical Corp., in the person of Ben Vallone, a master craftsman intimately connected with the Caesar-Saltzman organization for many years, still repairs, services and provides parts for these huge machines that will last to print the pictures from the battle of Armageddon. In 1953 the least sophisticated version sold for $1,100. By 1958 it was $2000 and in 1966, $4775. It sells today for from $500 to $1000, depending on condition.

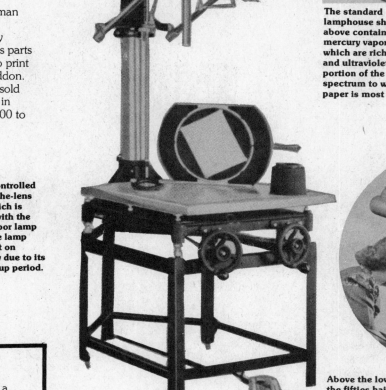

The standard lamphouse shown above contains mercury vapor lamps, which are rich in blue and ultraviolet, the portion of the spectrum to which paper is most sensitive. Such lights are five times faster than a conventional 1000-watt lamp, yet three times cooler. Condenser and fluroescent heads were also available.

The glass carrier permits negative rotation up to 200 degrees. Two large cranks on the cast-iron base, just below the baseboard, control magnification and focus via precision worm gears. The head structure is guided on the 4½-inch (11.4cm) diameter chrome-plated column by eight brass roller bearings. A foot pedal **actuates a solenoid-controlled in-front-of-the-lens shutter, which is necessary with the mercury vapor lamp because the lamp must be left on continously due to its long warm-up period.**

Ben Vallone/17 Union Ave./Little Ferry, NJ 07643

Above the lovely with the fifties hairdo are foam rubber bumpers, which protect operators from unhealthy contact with the massive chrome-plated tubular supports.

DOUBLE PRINTING

By printing more than one negative on a sheet of photographic paper, an apparent reality may be created that never existed.

In the picture at left, the photographer couldn't get the people and champagne

Summer drinks for the epicure. *Duke Mander*

bubbles coordinated, so first he shot the people against a white background, then the glass, also against white. When printed, the first negative left the lower section of the paper unexposed, i.e., white, since the negative was black in that area. After the first exposure, paper was placed in a light-tight box and the outline of the image from the first neg (still in enlarger) was traced on scrap paper. Now the second neg was projected, sized and aligned with the tracing, and the proper exposure was determined with a test strip. Then the scrap paper was removed and the second neg exposed to the enlarging paper that contained the latent image number one, which was carefully returned to the easel in the original orientation.

The negative of the basket and stand, right, had a totally clear background and would have turned the paper totally black in the corresponding area. So here the negative of the nun, who had been photographed against a black wall, was sandwiched with the first negative, and the two printed simultaneously.

The Nun, 1971. *Peter Collins*

PRINTING EASELS

Easels that are used to hold and crop photographic paper under the enlarger are available for a few bucks or for many bucks. They all do the job; what you get for more bucks is versatility, rigidity and larger capacity. If you don't crop you can even do without one by taping the enlarging paper directly to the enlarger baseboard with a bit of Scotch Photographic Tape #235 in each corner. This is particularly useful for making those infrequent but impressive larger prints. A piece of ¾-inch thick yellow-painted plywood will be quite serviceable and twenty times less expensive than a $200, four-blade, 20×24-inch super easel. If you like your borders neat and crisp, you will have to either trim your finished print or mount it behind a face mat. Single-size easels are okay and quick to load, if you like to print full neg in the center of a sheet of paper or don't mind having the identical size and proportion for every picture. If you crop your photos, you will at least need a two-blade easel; these restrict borders with one horizontal and one vertical side to a ⅛ to ⅝-inch range. But when the time comes that you want to make a neat 11×14 print centered on 14×17 paper, you will want a model with four one-inch-wide blades that permit unrestricted format placement anywhere on the paper. For borders larger than one inch, tape black cardboard to the blades. A black or yellow easel surface is best; white can definitely reflect light coming through light single-weight paper and back up into the emulsion, causing unsharpness and slight fog. Yellow reflected light, however, has little effect on most papers, which are blue-light sensitive. For critical sharpness in all cases, focus on a sheet the same thickness as your "good" paper. Autofocus enlargers will only function with special one-inch thick easels.

Borderless prints are easily made by slicing the borders off a picture with a paper trimmer or X-Acto razor knife or by dispensing with an easel altogether and using a *clean* piece of quarter-inch thick plate glass to flatten the sheet of enlarging paper placed on a piece of black mat board. A borderless easel is more convenient: the Saunders Adjustable Borderless easels are fine for the purpose.

They come in three sizes ($10-70), all are yellow and as a trio hold paper that ranges from 4×5 to 16×20 inches.

The A.J. Ganz Company makes nine single-size, non-adjustable, fixed-border easels. They load and unload quickly from either end. All metal construction; non-glare yellow finish; 2½×3½-inch ($3.50) to 20×24-inch ($50) models. If used with autofocus enlargers, put it on the board to bring the top surface one inch above the enlarger baseboard.

The Accura "4-in-1," from Interphoto Corp., is a compact two-sided easel that holds 8×10, 5×7, 4×5 and 2½×3½-inch paper with fixed quarter-inch borders. It loads quickly; the rubber feet keep it from sliding, and it's inexpensive at $12. Paint the white surface yellow.

These are Saunders' simple, extremely durable, non-adjustable, single-size easels for fast production work. Each one—5×7 inch, 8×10, 11×14, 16×20—has fixed 3/16-inch (skinny) borders, is yellow and black and costs from $18 to $50. Please, Mr. Saunders, make a 20×24-inch model.

The easel for serious practitioners is the Saunders Adjustable Universal. Accurate calibration on each of the four black-coated, stainless steel blades allows individual, no-slip, border control on all four sides that can run from a hairline to 1¼ inches on paper up to 11×14 inches. The masking assembly pops out for fixed 3/16-inch borders on 14×17-inch paper. All metal, rubber skid-proof bottom pad, semi-mat yellow easel surface, $90; 16×20-inch model, $220; 20×24-inch, $325. All models are available one-inch thick for autofocus enlargers.

HANDY HINT: BE AN ARTIST— LET THOSE SPROCKET HOLES SHOW

For some unknown but certainly weird reason, the openings in negative carriers are never large enough to permit projection of the entire image. Yet photographers are taught to crop *in the camera* and fill the frame as much as possible, both for aesthetic reasons of "presence" and to keep enlargement of small negatives to a minimum.

How will anyone know that you don't crop your prints? Without a black border around your photos, how will they know they are looking at Art? To remedy this, file out the opening of your negative carrier. Sandwich the carrier between two pieces of scrap wood and place in a vise. With a flat file (file both halves of the carrier simultaneously), remove an equal amount of metal from parallel edges so the negative will remain centered over the lens. For a neat job, scribe a line and slowly file to it. The opening should be just large enough to show sprocket-hole edges in the projected image on the long dimension and full-width frame lines on both sides of the short dimension. When the opening is the proper size, which is determined with a scrap negative, use a fine file for edge smoothing; then use steel wool to remove absolutely all burrs.

LOOK SHARP

If you have good eyes that can focus closely, you can do without an enlarger focusing aid. But many of us are a *wee* bit imperfect and become more so after eight hours in the darkroom. Omega's instrument, right, is the *ne plus ultra* of baseboard focusing devices. Built and priced ($100) like a precision microscope and a tank, it's the only one that permits use over the entire image area on the easel, thanks to its huge 3½-inch (87mm) long mirror and tilting eyepiece. The 10X magnification is less than for competitive brands, but the optical-quality front surface mirror, three-element Kellner eyepiece and precision assembly combine to make it the sharpest, brightest and easiest to use, permitting critical focusing on the film grain with the enlarger lens at *working* aperture. This eliminates the possibility of focus-shift problems (prevalent in inexpensive lenses), as the lens is stopped down. The ability to focus on film grain over the entire negative area provides a check on the curvature of field (the perimeter has a different focus than the center of the picture) when the lens is used at other than optimum design magnification.

The Micromega can assist in choosing maximum sharpness for the important subject matter. As with all such devices, place a piece of scrap enlarger paper under the base to bring it to true position of focus; select an area with medium density and coarse focus by eye before attempting to focus on the film grain with the magnifying device.

The Micro-Sight II by Bestwell is similar to the Micromega, above, but only works in the central portion of the image. It, too, has a user-adjustable eyepiece, and its front-surface mirror eliminates ghost images. Quite satisfactory for all but the most critical applications. 20X; $30.

PETERSEN'S BASIC DARKROOM
by Kirk Kirkpatrick
Petersen Publishing Co./8490 Sunset Blvd./Los Angeles, CA 90069/paper, $2.95

This eight-page magazine-format guide is aimed at the beginner. It's good and cheap, covering most 35mm film developing and printing basics. All kinds of equipment and materials are illustrated. The text is practical and step-by-step demonstrations make it all as simple as pie. There's a little bit about a lot, which could get you seriously into darkroom work.

At $15, the Bestwell "Magnasight" is okay for beginners. Its 3X magnification is still better than nothing at all. Focus with the lens wide open.

THE FINE PRINT
by Fred Picker
Amphoto/Garden City, NY/cloth, $12.50

In this beautifully printed (duo-tone) large-format book, Fred Picker demonstrates the day-to-day use of the Zone System with fifty-six specific, clearly documented examples from his own work. While he is not the world's greatest artist, his description of the conditions under which each photograph was made gives you a good idea of what goes on in this photographer's mind while he works. It is a good book for the photographer who already has a good fundamental background and some practical experience with the Zone System; it is not a "how-to" text. Picker's style is to show a photograph and discuss it from a technical, historical and his own esthetic point of view.

Sample format of The Fine Print.

Many young photographers feel hampered in their commercial work because they lack the funds for the extensive equipment owned by the major studios. It is refreshing (or perhaps discouraging) to remember that Edward Weston owned only a battered 8"×10" camera and a 4"×5" camera. His "studio" for the marvelous photographs of the peppers was his front porch. His "set" was an old tin funnel. The film was so slow that at f/128 his exposure lasted over three hours! He had no lights and needed none.

Sometimes a homemade setup can be as effective as a fancy studio set.

An artificial light was used for this picture—a mushroom-shaped 150W flood bulb on an extension cord with a cardboard "barn door" arranged to cast a shadow on the foreground. The background was a four-foot sheet of white paper taped to a wall and curved forward across a table.

CONTACT PRINTERS

One has only to look at the prints of Edward Weston to realize the clarity, the sensual tonality, produced by contact printing a large negative. Contact printing requires nothing more than a uniform source of illumination, a sheet of glass for flatness and a felt or rubber pad to hold film and paper in intimate contact. Non-critical contact printing of negative strips for "proof sheets" is easily performed under an enlarger. Project a uniform cone of light, lens at f/5.6, onto a black mat board. When the cone of light overfills the board slightly, turn off the enlarger, place the enlarging paper emulsion-side-up on the cardboard, then lay the negative strips, emulsion-side-down on the paper (film curl towards paper curl). A *clean* piece of quarter-inch (6mm) thick plate glass, 11×14 inches (28×36cm), acts as a transparent weight to the sandwich. (For safe handling, have the glass store round all edges and corners.) A 36-exposure roll of 35mm film, in six strips of six frames each, barely fits on an 8×10-inch (20×25cm) sheet; if you squeeze Kodak for one or two extra frames on a roll, you'll be sorry when it comes to proof-printing time. Larger stores stock 8½×11-inch (22×28cm) paper, which makes the proofing job somewhat easier. Factory-made proofers with hinged glass and clips to keep the negatives in neat, straight rows are made by Technal and others (see below). Serious contact printing of large negatives for final prints requires perfect contact: a print frame or conventional contact-printing machine is necessary.

STORYVILLE PORTRAITS
by E.J. Bellocq
edited by John Szarkowski
The Museum of Modern Art/$13.50

Around 1912, an obscure, reclusive New Orleans commercial photographer, E.J. Bellocq, made beautiful, sensitive portraits of the prostitutes of Storyville. The noted contemporary photographer Lee Friedlander met a man in a New Orleans jazz/art gallery who had eighty-nine glass plates rescued from a drawer in Bellocq's roll-top desk. These plates are the only known surviving negatives of this sad man, disfigured by hydrocephaly and a semi-dwarf in stature, who cultivated the company of prostitutes and photographed them.

It is interesting to note that old plates tend to be very contrasty by today's standards, since they were made to complement the very low-contrast "printing-out papers" of the day.

These P-O-P papers produce an image by long exposure to intense light, not by chemical development. Friedlander has faithfully reproduced this historic technique, which required exposures by "indirect daylight for anywhere from three hours to seven days, depending on the plate's density and the quality of the daylight."

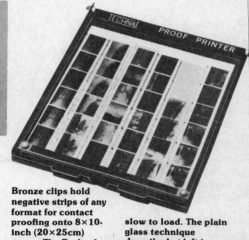

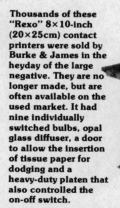

Popular in the days when even box cameras had negatives as large as 3×5 inches (7.6×1.3cm), this 5×7-inch (13×18cm) Brumberger contact printer is still available. Features are a four-blade margin adjustment, opal glass diffuser, red safelight bulb and hinged top platen that also controls the on-off switch. $50.

Good contact at a low price is available from these classic print frames, which have wood perimeters; a glass pane; and a strong, spring-loaded, felt-covered, two-section, hinged wood back. Expose under an enlarger or bare bulb four to five feet (1.2-1.5m) away. The 8×10-inch (20×25cm) size is $7; other sizes are available from 5×7 (13×18cm) to 16×20 inches (40×50cm). From Photo Materials Co.

Bronze clips hold negative strips of any format for contact proofing onto 8×10-inch (20×25cm) paper. The Technal Proof Printer by Bogen is $17. A number of similar units are **slow to load. The plain glass technique described at left is much quicker, though it doesn't produce rows quite as straight.**

Thousands of these "Rexo" 8×10-inch (20×25cm) contact printers were sold by Burke & James in the heyday of the large negative. They are no longer made, but are often available on the used market. It had nine individually switched bulbs, opal glass diffuser, a door to allow the insertion of tissue paper for dodging and a heavy-duty platen that also controlled the on-off switch.

One of the few professional-level 8×10-inch (20×25cm) contact printers left on the market, the Arkay AP-18 uses eighteen argon lamps, rich in blue and ultraviolet light, to produce average exposures in under three seconds. Each lamp is individually switchable for dodging and vignetting. Excellent contact is provided by an inflated rubber plate. Cost is $430, plus the cost of the special Lektra TM-501-M21 timer.

The diagram below shows the wiring of P-72 and its predecessor, P-59. When the enlarger is turned on to focus or to expose the paper, the safelight is simultaneously switched off. A footswitch frees both hands for dodging and burning.

A mainstay of active practitioners, the Time-O-Lites are ruggedly built, with four-inch (10cm) luminous dials, remaining-time and interval pointers, switched safelight outlet and an enlarger outlet that handles 1000 watts. The P-72 has an outlet for remote start by footswitch; timer and footswitch are $72. When new, the interval-setting pointer may be quite stiff. However, many printers hardly monkey with the timer's dial, finding it easier to give two or three exposures of five-seconds each, rather than to change the time for each exposure. From Industrial Timer Corp.

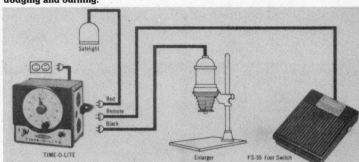

MARKING TIME

Mannes and Godowsky—the two musicians-temporarily-turned-chemists who in the early thirties invented Kodachrome, the first simple and effective color film—used a metronome while whistling specific segments of classical music to time the sensitive chemical reactions. The value of Kodak stock is sufficient indication that such a technique can work! Lacking a metronome or sufficient repertoire or even the ability to whistle, most mortals need some electro-mechanical—or today, *all* electronic—assistance to time exposures under the enlarger or in a contact printer.

Printing timers should have the following amenities: the ability to switch the enlarger light on and off for focusing and composing; a 0-60 second timing range with one-second increments; an outlet for a safelight switch such that the safelight turns off when the enlarger comes on and vice versa. (It's much easier to focus when it's very dark, and keeping the safelight off during those occasional two-minute exposures through very dense negatives helps prevent subtle fogging of highlight areas.) Numerals for setting time interval should be easily read under safelight illumination conditions: phosphorescent or electrically lighted systems are best. A footswitch that starts the exposure interval is extremely handy, since it frees both

hands for dodging and burning-in, but it adds $10 to $15 in cost. Models that continuously show "time remaining" are convenient for critical dodging and burning-in operations. And unlike timers used to process film or paper, enlarging timers should have an auto-reset feature, i.e., they should automatically reset to a fixed interval and be repeatable until that interval is manually altered. Not only does such a feature simplify producing multiple copies from one negative, but it also indicates the time used for a just-processed print, a known time which can then be modified if that print needs improvement. If possible, mount the timer solidly on a wall or counter in such a way that it's easy to steal a quick glance at the time remaining.

The safe's tambour door is raised to gain access to three shelves for 8×10-inch (20×25cm) paper and drops shut when released. Store most used paper grades on shelves and leave the space between the base and first shelf for exposed sheets to be processed later. All-metal construction; model 1810 is $28; an 11×14-inch (28×31cm) chest is also available at $51. From Brumberger.

FUTURE SHOTS: ELECTRONIC TIMERS

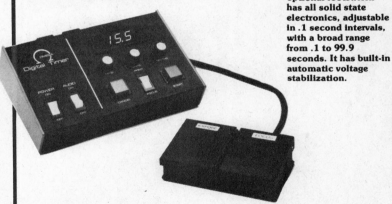

The Omega Digital Timer with the optional footswitch has all solid state electronics, adjustable in .1 second intervals, with a broad range from .1 to 99.9 seconds. It has built-in automatic voltage stabilization.

Enlarging timers have followed the lead of watches and pocket calculators and turned away from mechanics to all solid-state electronics with digital readouts. EPOI and Omega each have a similar unit, bristling with buttons, knobs and outlets. Similarities between them: red LED's (light-emitting diodes) that are easy to see in the dark; three-digit displays of interval set and, after pushing the "start" button, numerals showing the time remaining over a range of 0.1 to 99 seconds in 0.1-second increments; back-illuminated function buttons; automatic interval reset; provisions for an accessory single footswitch

(starts interval) or double footswitch (one starts interval, one turns enlarger on and off for focusing); switched safelight outlet. Unique features of the two units? The EPOI Digitrol has an intensity control, from full brightness to zero, of LED digits (for use with film or panchromatic papers; a "HOLD" button that interrupts interval during the cycle, then may be restarted; handles up to a 500-watt enlarger and costs $155 with a dual footswitch. The Omega Digital Timer (shown above) has an audible metronome signal for dodging; a "CANCEL" button that stops exposure anywhere in interval; handles up to a 650-watt enlarger and costs $165 with a dual footswitch.

PAPER SAFES

You can store light-sensitive paper in original boxes supplied by the paper manufacturer. Granted, it's a slow job removing individual sheets from the envelope-type packages that hold ten or twenty-five sheets, and 500-sheet boxes trap so much air that they produce vulgar sounds when closed quickly; so either use 100-sheet boxes for storage or buy a paper safe! Quite often an exposed sheet must be stored before processing, such as when printing two images as one photograph or when batch processing quantities of the same picture that have been exposed identically. Therefore, if you do buy a paper safe, don't get the type that automatically spits paper out each time it's opened, insidiously preventing paper from going *in*! Incidentally, if you do use the original box to dispense paper, there is no need to keep the heavy, black-paper moisture-barrier wrapped around the unexposed stack during a printing session: a sound box, with unsplit corners *is* light-tight if kept *fully closed.* We always make it a habit to tap the top of the box before turning on the white light, as though contact between the box top and bottom complete the electrical circuit. If a package left open is accidentally fogged, the middle sheets are often salvageable after a half-inch trim.

The Arkay safe is basically "a better box." It has a hinged top and an angled back that fans the paper stack for easy sheet removal. It's neat! Available in four sizes, starting at $20.

TRAYS

Except for mumbled epithets, trays are the most used and least expensive darkroom aids. They come in plastic, fiberglass and stainless steel (for the latter use type 316). When used with photo chemicals, fiberglass and plastic have similar characteristics, and both range in price from $4 to $18 in the 11×14 tray size, depending on material thickness. Plastic and fiberglass eventually turn brown in the presence of developer. The stain has no deleterious effect, except esthetically. The smoother the surface finish, the better the stain resistance, so abrasive powders should not be used to clean plastics. Edwal markets a liquid tray cleaner, and mix-it-yourself formulas are listed in most darkroom formularies. Ribbed bottoms facilitate print and film pick-up and add flexural rigidity, an advantage when pouring solutions back into a bottle. A moulded lifting rim and pouring lip also aid the transfer operation. Plastic and fiberglass do absorb chemicals; use separate labeled trays for each solution. Similarly, if the back of a tray of the unribbed variety is used to squeegee prints, it should be set aside just for that purpose. Stainless steel is highly chemical resistant, and any stains are easily removed with Leedal "Sta-Clean," an excellent powdered cleaner for all stainless steel. This metal also has a much higher heat conductivity than plastics, facilitating faster and more accurate temperature control, which is particularly advantageous when developing sheet film in a tray. For proper agitation, use a tray one size larger than the largest print normally processed. Round corners are easiest to clean; tapered sides permit stacking for storage. Workers who print daily, however, store stop bath and fixer in the trays; under those circumstances, square-sided trays permit easy construction of close-fitting floating lids—made from Plexiglas—to prevent oxidation.

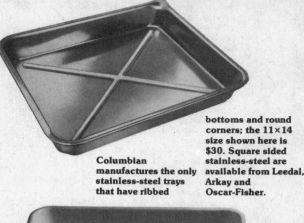

Columbian manufactures the only stainless-steel trays that have ribbed bottoms and round corners; the 11×14 size shown here is $30. Square sided stainless-steel are available from Leedal, Arkay and Oscar-Fisher.

Resin-coated paper and sheet film annoyingly stick to tray bottoms. Ribs help, but these regimented bumps in special Cesco-Lite (Columbian Mfg. Co.) plastic trays are even niftier.

Trays for fixer and holding water, but not wash-water, should be deeper than normal to accommodate larger quantities of liquid. A six-inch (15cm) depth is recommended. From Leedal, Bel-Art, Kodak, Arkay, Richards, Columbian.

RICHARD TRAY RACK

Space is often at a premium in the home darkroom; a sink or counter to hold an 11×14 tray of developer, stop fix and holding-rinse trays must be about five feet (152cm) long. With this vinyl-coated wire rack from Richard Mfg. Co., three of the four can be stacked vertically, cutting space requirements in half. It's not the easiest-to-use processing method—agitation is a bit cramped—but if you must print in a motel room or basement broom closet, this refugee from a coat hanger factory serves as a poor person's version of a sky hook. Model 1400 ($15) holds three 11×14 or 8×10 trays; #2000 ($20) supports; three 14×17, 16×20 or 20×24 pans. The rack fits Richard styrene-plastic trays or any trays with rolled rims, except for square-sided stainless steel trays with small-diameter rod-braced rims.

MURAL PROCESSORS

Large prints are a pain in the muscles to process. The largest size paper available in sheets is 20×24 inches (50×60cm); a set of conventional trays to process those sheets takes up 25 square feet (2.3m²) and costs $150. For murals, 30 and 100-foot (9.1 and 30.5m) rolls of paper are available in 40-inch (102cm) and even 54 inch (137cm) widths. Unless you have an Olympic-size swimming pool, consider the following for the occasional biggy:

Method #1—Build a frame of cheap 2×4 lumber. Place it on the floor or counter and drape 4 to 6 mil-thick polyethylene sheeting (Bel-Art or other plastics distributors) over it. If there are many sheets to process, fill each of these makeshift "trays" with a few gallons of solution (multiply length by width by height to get cubic inches; 230 cubic inches equal one gallon). If there are only a few prints, swab the solutions on quickly and gently with sponges, even sponge mops, from buckets of

chemicals. Expose so the image requires 3 to 4 minutes developing time instead of the normal 1½ to 2 minutes; this provides more working time and better uniformity with an unwieldly process.

Method #2—Build 12-inch wide by 6-inch deep (30×15cm) plywood troughs about 10 inches (25cm) longer than the roll-paper width. Coat with epoxy paint or fiberglass or even polyethylene sheeting for temporary setups. With pictures up to 6 feet (2m) in length, two people can see-saw the print in and out of the trough.

Method #3—This one uses the same troughs, but now the paper is quickly rolled back and forth, scroll-like, again using two people, and an exposure is made requiring 4 minutes developing time. For $865 Consolidated Photo imports the mechanical contraption shown here and a set of plastic troughs that accomplish this "scroll rolling" via a hand crank or accessory electric motor. The rolling mechanism is lifted from trough to trough for developer, stop, etc., and it can, says

the company, print a 35-foot (10.6m) long picture of your high school class on the steps of the Capitol. An accessory temperature controller and extra trays even allow color printing. Whichever homemade method is employed, the (well-cleaned!) family bathtub makes an ideal print washer. Wash for at least 2 hours, agitate and change water frequently—and no bubble bath!

The Mural 2000 roller weighs about five pounds, and is just under six-feet long. The purchase price includes three trays, as shown. Additional trays are $78 apiece; the accessory motor, $1300, the temperature control, $349.00.

STATICMASTER

Dust on a negative appears as insidious white spots on your beautiful print. Aside from dust that just settles on film, additional particles are attracted by the static electricity on the plastic film base, which is generated by friction when negatives slide on one another and are removed and inserted in negative envelopes. The magnetlike attraction of dust to film caused by this static electricity is cancelled by the mildly radioactive polonium element in the Staticmaster brushes; the polonium emits alpha particles that neutralize the static charge. Once so neutralized, the soft bristles can sweep away dust and lint. Alpha particles are non-penetrating, traveling a maximum distance of only 1½ inches (38mm) in air, so the brush must be used with the polonium element turned so that it faces the film. It's totally harmless as long as you don't eat it or give it to a child.

Like film, the polonium strip has an expiration date stamped on the case. Replacement elements are available from Nuclear Products Co.—$5 for the one-inch (25mm) brush, $10 for the three-inch (76mm)—and are easily inserted with a screwdriver.

The one-inch (25mm) wide, $8 brush is fine for 35mm negatives and lenses; for $16 a three-inch (76mm) model will sweep larger-size film and contact-frame glass. Don't touch the bristles; skin oil will transfer to them and then, in turn, to the negative.

3M FILM CLEANERS AND STATIC ELIMINATORS

The "Masterwipe Film Cleaner" employs a combination of wiping action from very slowly moving nonwoven fabric and a small polonium nuclear source to neutralize static. Rollers contain enough fabric for 1440 minutes of "on" time; replacement fabric is $4 in a three-inch (76mm) width, $6 in a ten-inch (254mm) width. The machine shown right, which can handle materials up to ten-inches wide, is $750, plus $230 per year for the nuclear element; the three-inch wide cleaner is $430, plus $85 per year for the element.

The 3M company produces an extensive industrial line of static and dust elimination devices, all based on the use of sealed polonium generating alpha particles, which ionize surrounding air (see Staticmaster brush, left). To prevent fogging, unexposed film should not be exposed to this radiation, which can only travel a few inches, for more than fifteen seconds. Static buildup is particularly troublesome on mechanical processors where moving film and paper rub on machine parts, producing static electricity and attracting dust. In addition to the devices shown, 3M makes bars that fit the outfeed end of print dryers.

The Model 902 nozzle fits a standard compressed-air line and contains the static-neutralizing nuclear element. It's ideal for vacuum frames, light tables and negatives in enlarger carriers. Cost is $85 per year; return to 3M every twelve months for replacement of the element.

TONGS

Bamboo tongs are classic, but the tips tend to soften, making grabbing difficult. Rubber-covered bamboo, shown here, works quite well.

Some people need to feel intimately submersed in print-processing mechanics, so they use their hands to agitate and transfer prints. Chemicals and moisture left on fingers inevitably lead to stained prints and negatives, to say nothing of hands that look and feel like the bottom of old hiking boots. Some use rubber gloves but a good pair of tongs are immensely preferable, and they *will not* damage prints if properly made and *gently* handled. Columbian's "Ball-Joint" stainless steel tongs are excellent (about $3 per pair). We have never seen a comfortable, non-scratching pair of plastic tongs.

WIPERS AND BLOWERS AND AIR AND STUFF

Can, nozzle and trigger are $13; 14-ounce (560ml) refill cans are $3. From Falcon.

Any crud, dust, smudge or unsharpness on a 35mm negative is blown up about ten times when making an 8×10-inch (20×25cm) print. Enter a disposable, lintless, non-abrasive cloth—the Sorg Professional Photowipe. A box of seventy-five, 13½×18-inch (34×46cm), two-ply wipes is about $2.50. They're good for cleaning lenses, glass-negative carriers, glass filters, glass slide-mounts, etc. For stubborn spots, slightly moisten the wipe, not the glass, with a drop of Kodak Lens Cleaning Fluid, but never rub hard. In low humidity areas, the static elimination brushes, above, are best for dust removal from negatives and carriers just prior to printing, but often a blast of air is also adequate. If you don't mind adding Freon to the atmosphere, try Dust-Off, a can of Freon-propelled compressed air. But just as good, much cheaper and considerably more natural is a big rubber ear or enema syringe from the local drugstore. We like the Faultless #270 four-ounce "See-Flo Infant Syringe" for $2. It's a doozy!

113

PRINTING/papers

ABOUT PRINTING PAPERS . . .

The number of combinations and permutations of black-and-white paper surface texture, base tint, image tone, paper weight, base material, sheet size, emulsion speed, contrast grade and package quantity is mind boggling. The latest *Kodak Photographic Products* catalog requires eighteen pages of tiny type to list its offerings. While leafing through its pages, certain basic ideas are good to keep in mind.

If you use an enlarger for either enlarging or contact printing with a glass sheet, you need an "enlarging" paper; use of a contact printer, with its brighter illumination, requires the use of a "contact" paper, which is twenty to forty times less sensitive to

light, or "slower," than enlarging paper. "Light weight" paper is very thin, intended for binding into a report or manual or folding without cracking; it's available in a smooth flat-lustre surface only, which Kodak calls an "A" surface. "Single weight" which is almost twice as thick as light weight, is okay for prints up to 8×10 inches (20×25cm); larger than that, prints tend to get easily beat up from handling. So for larger sizes, "double weight" paper, which costs about thirty-five percent more than single weight and is double its thickness is strongly recommended; it also has the big advantage of drying much flatter than single weight in all sizes. All resin-coated papers (see

"Ilfospeed" on next page) come in "medium weight," which is somewhere between single and double weight.

The most popular surface finish is "glossy," which has the greatest tonal range from white to rich blacks when ferrotyped (dried against a shiny chrome surface). For exhibit work, where reflections from the glossy surface are annoying, it is air dried, or dried upside-down on an electric dryer, to produce a semi-gloss finish. (Resin-coated glossy paper *always* dries glossy, no matter how you dry it!

Paper contrast may be matched to the negative's requirements by using either special filters with variable

contrast paper, such as Polycontrast or VeeCee Rapid, or by buying "graded" paper. The former is strongly recommended for beginners: with *one* package, you get lots of versatility. In both cases, numbers 0, 1 and 1½ have relatively flat contrast, so use them with contrasty negatives; 2, 2½ and 3 are "normal" contrast; 3½, 4, 5 and 6 are "hard" contrasts for "flat" negatives or special graphic effects.

As for choosing among the numerous other characteristics noted above, look at your dealer's paper sample book. Don't overlook the nice papers produced by Ilford and Agfa—the latter's Portriga is beautiful.

BLACK AND WHITE PAPER CHART

Name	Description	Contrast Range	Weights	Surface	Picture Tone
Kodak-Azo	Contact print paper	0-5	SW, DW	smooth-glossy	neutral-black
Kodak-Studio Proof F	Contact printing-out paper	——	SW	smooth-glossy	purplish-brown
Kodak-Kodabromide	Enlarging paper	1-5	LW, SW, DW	smooth-glossy smooth-lustre/fine grain-high lustre	neutral-black
Kodak-Polycontrast	Enlarging paper	variable	LW, SW, DW	smooth-glossy/smooth-lustre smooth-high lustre/fine grain-lustre	warm-black
Agfa-Portriga Rapid	Enlarging paper	2-3	SW, DW	smooth-glossy/fine grain-semi-matte	warm-black
Kodak-Panalure	B&W enlarging from color negatives	4	SW	smooth-glossy	warm-black
Agfa-Brovira	Enlarging paper	1-6	SW, DW	smooth-glossy/fine grain-lustre	neutral-black
Kodak-Mural	Mural enlarging paper 42" × 30' rolls 42" × 100' rolls	2-3	SW	tweed-lustre	warm-black
Kodak-Polycontrast Rapid R. C.	Enlarging with fast processing	variable	MW	smooth-glossy/smooth-lustre	warm-black
Ilford-Ilfobrom	Enlarging paper	0-5	SW, DW	smooth-glossy/smooth-semi-matte smooth-matte/stipple-velvet/ lustre-velvet/silk-rayon	neutral-black
Kodak Portralure	Enlarging paper	1-3	DW	fine-grain lustre/ smooth-matte/silk/tweed	brown-black

LW-light weight
SW-single weight

DW-double weight
MW-medium weight

Different papers give different results. The type you use depends on what you're doing and how you want the end product to look. There are many papers to choose from, and you could easily spend a year experimenting with each. The chart at left, while not all-inclusive, covers the majority of papers that photographers normally use.

PHOTOGRAPHER'S MATE 3 & 2
Supt. of Documents,
U.S. Government Printing Office,
Public Documents Distribution Dept.
N.W., Washington, D.C. 20402/stock no. 0847-0146, $9

This is the 650-page manual used by the U.S. Navy to train its Photographer's Mates—from scratch. You can tell it's a military book: the portrait section admonishes, "A broad smile . . . is seldom appropriate for personnel in uniform." Unlike a good, modern textbook (it looks like this was written in the fifties, regardless of the "1966 edition" imprint), there are few pictures, but loads of words. If you have or intend to acquire no-longer-made Leica M2's or M3's; Graflex Speed Graphics or Crown Graphics or Graphic View Cameras; Mamiyaflex C-2's or C-3's, this book may be helpful since there are very detailed chapters on each. Aside from the standard chapters on light, lenses, exposure, processing,

composition—as only the military could describe it—and films and filters, much of which is obsolete, there are chapters on motion picture photography and, of course, aerial photography (eighty-two pages on the latter). If you're into buying surplus aerial cameras that take nine-inch wide film and have twenty-inch focal length lenses (that's 500mm!), this book could be very helpful.

ILFOSPEED SYSTEM

Conventional paper processing requires *at least* 45 minutes dry-to-dry, assuming the use of a washing aid and an electric dryer; for air drying, figure 4 to 5 hours. But sandwich that paper between layers of polyethylene so chemicals and water can't get at the paper base, call it Kodak RC (resin-coated) paper, and dry-to-dry time is reduced to only 10 minutes if a dryer is used, 45 minutes if air-dried. Now Ilford has done Kodak one better: their impatient darkroom chemists have invented their own resin-coated paper, a special set of liquid, rapid-acting chemicals and a super-fast dryer; they call it Ilfospeed. With a pair of U.S. Keds on your feet, a stop watch in one hand, and lightening-like wrist action with the other, you can process

DAGUERRE LIVES

Rockland Halo-Chrome Mirror Developer

Well, not quite. Rockland Halo-Chrome Mirror Developer doesn't give you a daguerreotype, which is a bas-relief of mercury, but something of the effect—a black-on-silver print. It produces a mirrorlike deposit of metallic silver on regular photographic paper. The areas of the print that are most completely redeveloped by Halo-Chrome are those which have not already been exposed and developed normally—the highlights. What is normally white becomes silver.

Use a contrasty negative and overexpose by a stop. Develop normally in any cold-tone developer such as Dektol; rinse for 30 seconds in cool running water. Before stopbath or fix, immerse the print in a working solution of Halo-Chrome (100 cc of 1 to 7 dilution) for 60 to 90 seconds, then rinse, fix, blot and let dry. Later, polish with a soft cloth, rewet and ferrotype. It sounds complicated, but is actually very quick and easy to do. Halo-Chrome costs about $5.50 for 16 ounces, which makes 1 gallon of working solution.

For a silver-on-white print, use Halo-Chrome plus Rockland HC-2 Reducer. Here's how:

Use a contrasty negative and glossy bromide enlarging paper. Halo-Chrome works best with Kodak papers. Do not touch the surface of the print during processing. Expose normally. Develop in cold-tone paper developer—Dektol, diluted 1 to 2. Wash for 30 seconds in cool running water, and fix in a hypo solution. Immerse in HC-2 Reducer until the image fades. Rinse again. Now immerse in a working solution of Halo-Chrome. Agitate for 1 to 1½ minutes. And complete the print in the same way as a straight Halo-Chrome.

Rockland Colloid Corp./599 River Rd./Piermont, NY 10968

GEORGE TICE'S RECIPE FOR PLATINUM PAPER

Photographers are somewhat beholden to their materials, so much so that the Englishman Frederick Evans quit making photographs during the first World War when platinum paper became unavailable commercially. Platinum paper is capable of yielding rich blacks and a great range of subtle gradations, and the image is permanent. The drawback, however, is that it's very expensive to manufacture.

PANCHROMATIC PAPERS

A black-and-white print made from a color negative will have improper tonal balance if conventional black-and-white paper is used. Those papers are only blue and green-light sensitive, but color negatives contain all the (complementary) colors of the original scene. Red lips, barns and herrings will be too dark; blue eyes, skies and roses will be too light. A panchromatic (sensitive to all colors) paper solves the problem, though; because of its extended sensitivity it must be handled in *total darkness* until fixed. Use Kodak's Panalure or GAF's Panchromatic paper.

In recent years, George Tice succeeded in producing his own platinum prints after nine months of experimentation. He generously shares his hard-won knowledge with all who care to study with him. Here is the way he does it:
A sensitizer made up of three solutions is evenly coated on a sheet of 100 percent rag paper with a camel's-hair brush. After the paper has been dried, a contact print can be made on the yellow-orange sensitized surface. Use a contact print frame and expose to a sunlamp for 30 minutes or more. Process the

print for 2 minutes in the developer and then transfer to the "clearing" bath for 5 minutes with agitation. Treatment in this bath, which removes residual chemicals, must be repeated twice more, each time with a fresh solution. Finally the print is washed in water for 30 minutes and air-dried.

You will have to prepare three solutions (A, B, C) for the sensitizer, another for the developer, and one for the "clearer." Material for each print costs about $2.50.

Below are the solution formulas:

Sensitizer	Solution A	Solution B	Solution C
oxalic acid	8 grains	8 grains	- - - - -
ferric oxalate	120 grains	120 grains	- - - - -
potassium chlorate	- - - - -	2 grains	- - - - -
potassium chloroplatinite	- - - - -	- - - - -	¼ oz.
distilled water (125 F)	1 oz.	1 oz.	1¼ oz.

14 drops A, plus 8 drops B, plus 24 drops C, equal platinum coating.

Print Developer—one lb. potassium oxalate in 48 oz. of water,

Print Clearer—1 oz. hydrochloric acid to 60 oz. water.

The color negative above, produced the normal-looking print (middle) on Panalure. The picture on the far right is the same negative printed on conventional paper.

high-quality, permanent prints in 4 minutes flat!

Kodak's RC paper has a very smooth back, which is difficult to write on and often causes batch-processed prints to stick together, and their F-surface (glossy) type has an esthetically unpleasant slightly milky film over the blacks. Ilford has somehow solved the milky-look problem, and a special back coating alleviates writing and sticking annoyances. An advantage of all resin-coated papers is that the F-surface varieties automatically air-dry glossy, without the need for ferrotyping. Ilfospeed paper is available in six contrasts in glossy, four contrasts in semi-matte and "silk." Kodak's Kodachrome RC comes in five contrasts in both glossy (F) and matte-lustre. Polycontrast is also available resin-coated in F and N surfaces.

To use the Ilfospeed system: Ilfospeed

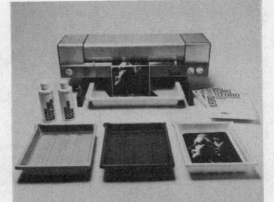

A half-gallon of developer and fixer, and 100 sheets of 8×10 paper will run you $41.50.

Developer, 1 minute at 68°F(20°C); stop bath, 5 seconds; Ilfospeed Fix, 30 seconds; wash, 2 to 3 minutes—all with continuous agitation. Conventional chemistry may be used with Ilfospeed and Kodak RC papers: develop 1½-2 minutes; stop, 5 seconds; fix, 2 minutes; wash, 4 to 5 minutes. Ilford's $1,125 dryer has a 16-inch width capacity, draws 16 amps at 115 volts and will dry an 8×10-inch (20×25cm) in 30 seconds! You can save $1,124 if you hang prints to dry on wooden, spring-type clothespins after blotting or gently sponging surfaces. Cheesecloth or plastic-screen drying racks also work very well (see East St. Dryer on page 121). Note: you can't leave resin-coated papers soaking in water as you can with conventional paper, because after 10 minutes RC paper will begin to swell. And never put an RC print face down on a conventional dryer or the plastic coating will melt.

DEKTOL

Kodak's Dektol is *the* most used paper developer, being recommended for Brovira, Polycontrast and Polycontrast Rapid, Kodabromide, Kodabrome, Medalist, Ilfobrom, Ilfospeed, Azo, Velox and Panalure. It remains free from muddiness, sludge, precipitation and discoloration throughout its normal life. The *stock* solution, which is mixed from single-powder packages—available to make eight, sixteen and thirty-two ounces, and one, five, twenty-five and fifty gallons of stock solution—will last six months in a *full,* tightly stoppered bottle, two months in a half-full stoppered bottle. (Bottles should be amber and kept away from sunlight and heat.) The *working* solution is prepared just before use from one-part Dektol and two-parts water; it will last only eight hours in a tray and will process approximately one 8×10-inch (20×25cm) print or its equivalent area for each ounce of stock solution used with two ounces of water. The working solution should never be saved once diluted, regardless of use. If many of the prints have very large areas of black, capacity will be somewhat less; but since it is so inexpensive—it is better to use more than you need and avoid possible staining and/or loss of contrast. Kodak recommends a 1½-minute developing time at 68°F (20°C) with constant agitation, but any good printer preparing exhibit-quality photographs will use two minutes to obtain rich, deep blacks. GAF's Vividol is similar to Dektol.

INDICATOR STOP

Some people process film by using a water rinse after the developer, instead of an acid stop bath. This is a holdover from the bygone era of thick emulsions, when carbon dioxide bubbles, generated from the reaction of the acid on the alkaline developer, could cause pinholes when trapped in that thick emulsion. But processing paper without an acid stop bath is definitely a no-no! Using only water as a stop, the exact time of development is uncertain, since water just slowly dilutes the developer that is still active in the emulsion; an acid stop chemically and swiftly neutralizes the alkaline developer. Secondly, the efficacy of fixer is dependent on a proper level of acidity; too much alkaline carry-over from the developer can lead to improper fixing and stained prints. Acetic acid, plus a yellow indicator dye, constitute Indicator Stop Bath; when exhausted, it conveniently turns a purplish-blue, which appears dark under safelight ilumination. Dilution is 1:64; always add acid *to* water to prevent boiling and spattering of the concentrated ninety-eight percent acid.

Indicator Stop is packaged in sixteen ounce and one-gallon bottles that will make eight and sixty-four gallons, respectively. Solution capacity is greatly increased by draining the print from a corner for five to ten seconds as it comes from the developer.

BEERS SOLUTIONS— THE CHAMPAGNE OF PRINT DEVELOPERS

This tip is for the perfectionist. A prepackaged print developer is actually a combination of two developers, Elon and Hydroquinone, in a standardized formula. A Beers Solution is simply these developers, each in their own solution, which allow you to adjust the proportions yourself to vary the contrast within a single grade of paper. The solutions are mixed from scratch as follows:

	Sol. A	Sol. B
Water	750.0 cc	750.0 cc
Elon	8.0 grams	—
Hydroquinone	—	8.0 grams
Sodium Sulfite (desiccated)	23.0 grams	23.0 grams
Sodium Carbonate (desiccated)	20.0 grams	27.0 grams
Monohydrated	23.4 grams	31.5 grams
1× solution of Benzotryzole	20 cc	80 cc
Water to make	1000 cc	1000 cc

Unlike the compromise of a medium-contrast prepackaged solution in one tray, the Beers Solution call for two trays of solution, one of extremely low contrast (solution A diluted 1:1 with water) and one of extremely high contrast (1-part solution A and 7-parts solution B). The contrast is controlled by alternating the developing paper between the two trays, the first working predominantly on the shadows and the second on the highlights.

FIXERS

General-purpose fixers contain an emulsion hardening agent and a chemical that dissolves away unexposed and therefore undeveloped, light-sensitive silver halide. In powdered fixers that chemical is sodium thiosulfate; in fixers that are packaged as liquid concentrates, ammonium thiosulfate is used. The latter are called "rapid fixers," because the fixing times are shorter, half as much for film. For prints, the time is only slightly less, but the greater dilution needed makes twice the working solution. Liquid fixers, such as Kodak's Kodafix and Rapid Fixer, GAF's Shurfix and Liquid Rapafix and Edwal's Quick-Fix are more convenient to prepare and eliminate pinholes in films and prints caused by fixer powder dissipating around the darkroom during mixing. Rapid fixers dry to leave insidious white stains that are a bear to remove, requiring scouring powder and loads of elbow grease; rinse all utensils and splashes with plenty of water while the fixer is still liquid. Liquid fixers will also bleach the image if film or paper is over-fixed, so carefully follow package directions. Resin-coated papers require much shorter fixing time than conventional paper. Over-fixing also allows the thiosulfates to attack the fibers in the paper base, making thorough washing difficult, if not impossible. Kodak's Rapid Fixer and GAF's Shurfix are two-solution liquid concentrates that dilute 1:3 with water for films, but 1:7 for papers.

TONERS

Using the right combination of paper, developer and toner, black-and-white prints may be toned with colors that cover the spectrum, from blues and greens (olive and otherwise) to yellows (lemon and golden) and even reds (fire-engine to subtle purple). The most numerous and most popular formulas produce chocolate browns, sepias and reddish browns in an infinite number of subtle variations, dependent first on the particular toner chosen and secondly on the type of paper. Toner concentration and toning time permit further variations with some chemicals, such as selenium toner and Kodak Poly Toner. The type of developer—cold-tone (Dektol) or warm-tone (Selectol)—used to process the original print and even the developing time influence the final color. Warm-tone papers—Allura, Portriga, Ektalure, Portralure—are particularly suitable for toning, though Kodak Brown Toner works fine on papers such as Polycontrast, Kodabromide, Brovira and VeeCee Rapid. A particular solution may not be recommended by the manufacturer for a particular paper, but experimentation and long soaking times just may produce pleasing results. In all cases, you must do tests, thereby allowing for individual toner characteristics: some toners, such as Kodak Brown Toner, tend to bleach the image, so a slightly darker original print should be made. To prevent stains, prints to be toned must be well fixed, but not over-fixed, and thoroughly washed—a washing aid such as Hypo Clearing Agent or Perma Wash is strongly recommended. Toning increases the permanence of the image; a standard treatment for archival prints is three to five minutes in a one-percent solution of Kodak Rapid Selenium Toner. Kodak's *ABC's of Toning* (G-23, 30¢) will get you started. Dozens of more unusual, historic and specialized mix-it-yourself formulas can be found in *Photographic Facts & Formulas* (next page) and the *Photo Lab Index* (reviewed on page 98).

EKTAFLO CHEMICALS

The introduction of premixed powders was a boom to photographers who had always "mixed their own" from dozens of white powders accurately measured on a laboratory balance. Then in the early sixties, Kodak introduced "Ektaflo," a set of four liquid concentrates—a warm-tone and a cold-tone developer, an indicator-type stop bath and a one-solution fixer—designed as a "matched set" for black-and-white print processing. The speed and convenience of working from liquids as compared to powders is obvious. That convenience costs almost twice as much as an equal amount of Dektol. If your printing technique includes using hot or concentrated developer the Ektaflo is less handy than Dektol. Surprisingly, Ektaflo Fixer costs less per gallon than powdered Kodak Fixer. Type II developer may be substituted for Selectol or Ektanol, and Ektaflo Stop is identical to Indicator Stop (see preceding page), except that the dilution is 1:31. Each concentrate

comes in a one-gallon Cubitainer—a strong plastic bag with a pull-out spout surrounded by a cubical cardboard carton. Unopened, storage life is indefinitely long; partially full containers last "several months," according to Kodak, but we have found no problems after one year of shelf life. This system is best for the fairly large-volume user; it's very convenient if you make approximately 1,000 8×10s in six months.

To take full advantage of the convenience of liquid chemistry, attach to the Cubitainers the Kodak Screw Cap Dispenser Tube, Model 2. It has a rubber hose and spring-type, finger-actuated flow valve. The Cubitainer with its dispenser is best placed on a shelf over the darkroom sink.

KODAK B/W PHOTOGRAPHIC PAPERS G-1

Eastman Kodak/Dept. 454, Rochester, NY 14650/paper, $1.50

This forty-five page, 8½×11-inch publication provides a good, non-technical understanding of paper characteristics that contribute to print quality, as well as the use of particular paper processing techniques. Much of it is intended for the commercial and studio photographer (dimensional stability of paper base, silver recovery, numerical relationship between negative density range and exposure range of papers), but most of what is discussed is very helpful to serious amateurs and semi-professionals. A general discussion of print processing

and relative printing speeds—the equivalent of "ASA" speed for paper—is informative. The booklet's greatest asset is the description of the characteristics of all twenty Kodak papers, which come in nine surfaces, four weights (thicknesses) and umpty-one sizes. For each paper, the data section lists recommended safelight filters, developers and developing time, toners and ANSI (American National Standards Institute) paper speeds. A book with this title should contain paper samples—how can you describe the difference between "smooth lustre," "smooth high-lustre" and "fine-grained lustre"?—but it doesn't. You'll have to shell out an additional $9 to get a nice set that comes with the *Kodak Darkroom Dataguide* (R-20), a booklet worth owning.

HOT SOUP FOR SICK PRINTS

Good prints are made by proper exposure under the enlarger, including all necessary dodging, burning-in and flashing, followed by development for a fixed time, usually two minutes. Quite often, though, the burning-in time may fall short of that necessary for a particular area when the overall print is developed normally. If the fall-short isn't too serious, try running hot water on the back side of the print in the area that needs pushing. For more local control the almost-perfect creation may be salvaged in the developer tray by application of a swab of hot concentrated developer in the weak areas with absorbent cotton or a large soft brush. Such a technique serves to accelerate development in the affected spots, generating comparatively more density than a similarly exposed area developed at the normal time,

temperature and concentration. This procedure is accomplished by inspection while under an appropriate safelight at the recommended distance. With a little practice, you can acquire an eye for how much is needed where. A beaker or drinking glass is kept near the developer tray and filled with developer *stock* solution; some workers place that beaker in a larger one filled with hot water—like a double boiler—to add extra zing to the process, since developer is more active when it's warm. With the recalcitrant areas chosen, after leaving the print in the developer at least one minute, take it out of the tray, hold it in the palm of one hand and vigorously, but gently, swab "the spot" with the concentrated solution. For the needs of the rest of the print, continue to periodically immerse and agitate in the normal developer.

HYPO-CHECKING SOLUTIONS

Almost all fixers, powder or liquid, have a capacity of 100 8×10-inch (20×25cm) prints per gallon, or the equivalent for different-size prints. One gallon of liquid fixers will process about 120 rolls of 35mm 36-exposure or 120 film. But it's a pain in the sprocket holes to keep track of numbers—counting on your fingers is difficult in the darkroom with a pair of tongs in hand—and prints that are mostly white, requiring removal of lots of unexposed silver halide, hasten the death of the working solution. A drop or two of a hypo-test solution—ones made by Edwal and Braun are available—visually indicates the condition of the fixer. If the fixer turns milky where the drops fall, dump that batch and mix a fresh solution. If nothing happens, it's okay. The milkyness is easier to see, especially in a white tray, if a dark print or even your hand is placed below the point where the test solution drops.

Archival printers and large-volume users should use a two-bath system in which almost all the unexposed silver halides are dissolved in bath number one; any that is left is removed by bath number two, which is fresher. Complete fixation is assured, since the silver is always in a form easily soluble in water and, therefore, easily removed by washing. To start, prepare two identical fixer baths; fix in each for half the recommended fixing time. After 100 8×10 inch (20×25cm) prints or the equivalent, replace bath one with bath two, and mix a fresh second bath. Repeat up to four times or for one week, whichever comes first.

PHOTOGRAPHIC FACTS AND FORMULAS
by E.V. Wall and F.I. Jordan; revised and enlarged by John S. Carroll
Prentice-Hall and Amphoto/Englewood Cliffs, NJ, and Garden City, NY, respectively/cloth, $19.95

This is a thorough updating of a classic work that first appeared in 1927 and was last updated in 1947. It is particularly valuable to those interested in pursuing the almost forgotten but fascinating and beautiful early printing processes—such as carbon, oil, bromoil, and transfer; platinotype; iron; gum-bichromate. A wealth of formulas are provided for these processes, as well as entire chapters on intensification, reduction, special negative and paper developers and toning

FIFTEEN-SECOND PRINTS

The history of photography is undeniably tied to the history of chemistry. In the early sixties, chemists found a way to integrate dry developing agents right into the enlarging-paper emulsion. This meant that when the paper is placed in a strongly alkaline solution, called an "activator," the image appears almost instantly. An equally brief treatment in a second chemical, the "stabilizer," stabilizes the image for a period as long as a number of months, depending on conditions of light, temperature and humidity—the less of each, the greater the longevity. Because uniformity of solution application and length of time of solution contact are critical, the process is carried out in a motor-driven, roller-transport machine that sweeps only the paper's emulsion side across the solutions. You get a stabilized print emerging damp dry in fifteen seconds!

The special paper is exposed normally, with contrast controlled by standard variable-contrast filters when using Kodak Ektamatic SC (selective contrast) papers. Agfa's "Rapidoprint" and Ilford's "Ilfoprint" stabilization papers are available in conventional separately graded contrasts. Chemicals come as ready-to-use liquids in plastic bottles, which are inserted upside-down into

Eastman Kodak Co./343 State St./Rochester, NY 14650

Kodak's 214-K, is an industrial quality stabilization processor. It is highly corrosion-resistant and handles sheets or rolls up to 14-inches (36cm) wide by 6-feet (1.8m) long. $720.

Agfa, left, has two "Rapidoprint" machines for continuous-tone materials. The model LD37 has a 14-inch (36cm) wide throat; the LD54, a 20-inch (51cm) wide throat; $650 and $690, respectively. Oscar-Fisher also makes stabilization processors.

the machine, where good old gravity assures accurate and automatic chemical replenishment. No plumbing, no critical temperature—anything between 65 and 85°F (18-30°C) is okay. No trays full of chemicals; minimal space requirements (nominally, $24 \times 12 \times 12$ inches); the use of less than 1 ampere at 115 volts.

Anytime after stabilization processing, prints may be conventionally fixed, washed and dried; they will then have conventional keeping properties. If

not fixed, stabilized prints must not be washed, nor can heated dryers be used to speed up the ten to fifteen minutes required for the slightly damp prints to air dry. The activator and stabilizer are quite corrosive: machines should be well-cleaned after use; roller assemblies are removable for hosing. Spiratone has a fine inexpensive machine for only $150, which is excellent for home use.

P.S. Stabilization paper may be tray processed like standard paper in regular chemicals.

Agfa-Gervaert, Inc./Photographic Products/ 275 North St./Teterboro, NJ 07608

INSTANT COPIES BUT NOT BY DR. LAND

Diffusion transfer (DT) processing is the development method used in the Polaroid and Kodak Instant processes. Light strikes a paper negative, which begins to develop when a chemical pod is ruptured as the pod, the negative and a "receiver sheet" are pulled through two rollers. The negative develops while in contact with the receiver sheet, into which the image diffuses, i.e., transfers. With black-and-white Polaroid film, you can actually see the negative in the throw-away sheet; in instant color films, it's hidden behind a sophisticated array of chemical layers.

Just such a system is employed on a larger scale in Kodak's Photomechanical Transfer (PMT) and Agfa's Copyproof systems. These are designed primarily for the graphic arts industry, where quick positive images of headlines, type and screened photographs are needed for reproduction. The final product of these DT processes is a positive reproduction fo the original, i.e., you start with a positive, you end up with a positive. A light-sensitive, paper-negative sheet is exposed in either a process camera or under an enlarger. Once exposed, the negative sheet is placed face to face with the positive "receiver" sheet, and the two are passed through a processor,

containing an activator and a set of rollers that presses the two sheets together. After they emerge from the processor, they are left to "cook" for thirty seconds before the negative and receiver sheets are peeled apart. Temperature is not critical—65 to 85°F (18-30°C). The image will last about six to twelve months before it begins to yellow, longer if washed. Kodak's PMT materials are only high contrast for photomechanical work; but Agfa's CPTN negative-sheet is very useful to the photographer since it is a continuous-tone material with a mellow, brown-black tone. In fact, we found that we could make quick black-and-white conversions from 35mm transparencies by projecting them directly onto the Agfa CPTN material with an enlarger and transferring the image onto an Agfa PPG receiver sheet.

To process PMT material, the negative and receiver sheets are fed into the processor, emulsion to emulsion, with the bottom sheet leading by a half-inch. Papers are separated as they enter the activator and then squeezed together by motor-driven rollers for diffusion transfer to take place. The print is ready in thirty seconds.

With Agfa's CPTN continuous-tone material and a diffusion transfer processor, you can make super quick, one-step black-and-white prints from a slide. For maximum life, prints should be washed for one minute to remove residual chemicals. Above is an Agfa Copyproof print and the slide from which it was made.

Agfa-Gervaert, Inc./Photographic Products/275 North St./Teterboro, NJ 07608

ZEN AND THE ART OF POTASSIUM FERRICYANIDING
by Joe Novak

The radio possesses a kind of magic in the darkroom. The amber safelight throbs with its thick honey glow, embracing you like a dragonfly. There is something very old happening here. In the tray of developer the image pulses into life below your fingertips—a silver ghost, vibrant as a fish gleaming in the darkness. The voice from the little paper cone shimmers through the medium of air, and the surface of your skin reaches out to greet it. "You are my speee-cial angel"You are no longer wading upstream against time, but are instead pulsing at a nodal point. This, then, is what is meant by immortality.

The image projected by your enlarger onto the printing paper is a kind of analog to memory. It is also a map of light, and as you dodge the thin shadows, you create shadows of the clouds that are your hands drifting over the patchwork landscape of tonal potentials. Projecting a thin pencil of light from a dense highlight to the spot on the paper where it will be recorded, you part the clouds *ever* so slightly. And this light, that you cause to dance over the landscape of memory, is orchestrated by emotions in very strict *time*. "Cause if it isn't, what you end up with is *mud*."

Stop bath can burn your lungs to a crisp, and that's no way to be immortal. So don't lean too close. The Buddha may be *everywhere*, but if he's in the stop bath, he isn't smiling.

It's in the fixer, or rather *over* it, where you're going to ferricyanide your prints. To ferricyanide is to make light where there had existed only gloom. He is laughing. And ferricyanide can brighten His teeth. It can also burn a hole right through His forehead, so watch it! Potassium ferricyanide is the photographer's napalm, and many a closet mass-murderer has done to his prints what he would really like to have done to his subjects. When I was at school, I had a schizophrenic roommate who once lunged at me from across the room and attempted to strangle me. Why did that memory come back just now?

Potassium ferricyanide is a pretty red powder that comes in one-pound jars at the camera store. You'll also need a cheap clear plastic measuring cup, a box of Q-Tips, and a couple of Japanese bamboo brushes. The jar of ferricyanide will last a very long time, and if you use it to make lemon Kool-Aid, it might last forever. What we're really going to do with it is make a kind of chicken soup, adding small amounts to some water in the plastic cup and stirring until the color looks right. Mixing ferricyanide by color is the only pure approach. Don't go ripping off an analytical balance from school for this. The true scales are internal. But do it in the white light. Since the stuff is yellow in solution, its strength is difficult to judge by safelight.

But first, cut some notches in the rim of the plastic cup to hold brushes across the top.

The brushes you use must not have metal ferrules, because the ferricyanide will react with them and stain the prints. When your ferricyanide solution approximates the color of straw, place it next to the fixing bath and turn off the white lights.

Again the radio, and the heavy, enslaved Flash Gordon . . . Ming and the Clay People . . . abandon-all-hope . . . Four Seasons' flagellating sound of "Rag Doll." Jesus, sometimes it's just too much. You begin to print. If by the time you reach the fixer you are unfortunate enough to see in the tray an image of a white dog that looks more like a dirty old rug, you can freshen up his coat by brushing it with ferricyanide. Begin the process when the print has been in the fixer for half the total required time. Turn on the white lights. While holding the print level over the fixing bath, gently apply the ferricyanide solution to the area of the print that you wish to lighten and brighten. Use a brush or a Q-Tip as an applicator. Just *before* the desired level of bleaching is visible, return the print to the fixing bath and gently rub the area you have just painted.

Use ferricyanide to accentuate natural highlights. It heightens the play of light upon hair, adds sparkle to eyes and teeth, sculpts and defines facial planes, and adds separation between darker tones. But don't overdo it. When you have attained wisdom, you will no longer seek out faces to burn. Your prints will speak to you. "Ferricyanide me," they will say, "but just a *little*."

Every now and then you are going to be possessed by a vision. A deep dark wood will vibrate with the eerie glow of a UFO. A mysterious person will be seen in your prints waiting for a bus with a nebula over his head. The sad fact is, you are going to get heavy and pretentious, and your old friend potassium ferricyanide is going to help you do it. You'll use the stuff to cut bold, ridiculous swaths of light right where they don't belong. Maybe *Aperture* will publish the prints.

I love you, darkroom. My old friends are coming to life in the developer's shallow, murky depths. There are no loud noises, no bright lights. Just me and the radio and a half-empty bottle of booze. And the Buddha.

101 EXPERIMENTS IN PHOTOGRAPHY
by Richard D. Zakia and Hollis N. Todd
Morgan & Morgan, Inc./Dobbs Ferry, NY/paper, $2.95

To genuinely *understand* the results of many of the experiments suggested in this brief paperback, one needs twenty-four years' experience in all aspects of photography, a master's degree in optical engineering and a friend who is employed by Eastman Kodak as an emulsion chemist. To *do* them all requires only a strong curiosity, some simple equipment—rulers, mirrors, etc.—and a familiarity with and access to a black-and-white darkroom and standard darkroom procedures and supplies. No analysis of results and frequently no hint of what results might be expected are given—there's no room: all 101 experiments are packed into 89 small pages. Just the briefest suggestion of what to do—a turn on—is provided. But if you do attempt some, preferably all, a tremendous amount of experience will be gained in the nuts and bolts of photography: light and optics, printing techniques, color, image quality (technical, not esthetic), optical illusions.

Experiment #80 suggests starting points for creating the Sabattier effect, commonly though erroneously referred to as "solarization," which is a complete reversal of the image during exposure. The Sabattier effect, on the other hand, is a partial reversal of the image caused by exposure to bright light during the development process.

PRINT FROM A NORMALLY PROCESSED NEGATIVE

PRINT FROM A NEGATIVE THAT HAS UNDERGONE SABATTIER EFFECT

PROCESSING FOR POSTERITY

During *Life* magazine's heyday, when the lab was under tremendous pressure to produce prints for a weekly magazine, washing time was a luxury that could not always be afforded. Ten to fifteen minutes was normal, but it was not unusual for a print to be washed for a mere forty seconds in an efficient circular washer before hitting the hypo-laden canvas of the massive Pako dryers. Forty years later, prints by Margaret Bourke-White and her contemporaries still exist, enhanced by their slightly yellow cast, like the patina of an ancient bronze. It only goes to illustrate that too much can be made out of washing.

With normal, sensible treatment, prints should last a lifetime. Bill Sumits, formerly the head of the *Life* lab and now chief photographer at the National Gallery of Art in Washington, D.C., believes in following the manufacturer's instructions. No under or over-fixing; treat in hypo neutralizer and wash for the recommended time. Assuming the use of a washing aid, adequate washing time consistent with forty to fifty year print life is thirty to forty-five minutes at 75°F (24°C). So-called archival processing should be reserved for those very special pictures you wish to bequeath to posterity.

Ideal washing equipment should change water at least once every five minutes. You also should spend a lot of time shuffling the prints around manually. Kodak's advice is available in *B/W Processing for Permanence* (J-19, 20¢): "... the time of washing and the rate of water flow are both meaningless if the prints are not separated constantly so that water can reach every part of every print throughout the wash time."

IT'S DE-LIGHTFUL, IT'S DE-LOVELY, IT'S DE-HYPO

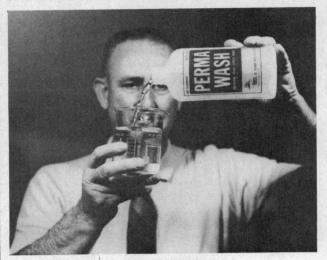

Perma Wash is sold as a liquid concentrate, which makes mixing convenient. Kodak

Hypo Clearing Agent is a powder, which must be dissolved in hot water.

Washing aids not only shorten washing time, but permit more thorough washing, i.e., greater elimination of residual fixer, than any length of washing could accomplish without them. After fixing, rinse prints for at least one minute in fresh water, then immerse and constantly agitate in such washing aids as Kodak Hypo Clearing Agent (KHCA) or Heico Perma Wash. Follow the manufacturer's mixing directions, but if you print for posterity, disregard the short recommended final washing times and wash for at least thirty minutes. KHCA has a useful capacity of "80 to 200 8×10-inch (20×25cm) prints per gallon of working solution." Be conservative, use the lower figure—it's cheap at $1.40 for five gallons. Perma Wash suggests 30 to 35 8×10-inch (20×25cm) prints per gallon of working solution. At a cost of $13.80 per gallon of concentrate, over forty gallons of working solution can be made.

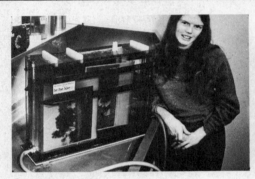

The greatest washer ever made for serious workers and archival processing. Each print is held in its own separate compartment while water vigorously and uniformly bubbles around it. Beautifully made! The East Street Archival Print Washer-Model 2: #11×6, $85, holds twelve 11×14-inch (28×76cm) prints or twenty-four 8×10s (20×25cm). A larger unit is also made.

Washers in which prints circularly rotate about a vertical axis do not provide the best agitation; therefore prints should be manually agitated frequently. Plastic units of this type are made by Richards. We recommend the 24-inch (61cm) diameter unit, at $70, for 8×10-inch (20×24cm) prints. They can be used in a sink or on a counter.

Arkay's Loadmaster 1620A consists of a perforated drum, which rotates about a horizontal axis by water pressure. It's constructed completely of stainless steel and claimed capacity is seventy-five 8×10-inch (20×25cm) prints; we suggest no more than fifty for archival washing, and a wash time of one hour, since the water-change rate is only six gallons per hour.

The Kodak Automatic Tray Siphon is one of the oldest gizmos still in production; the original came out in the twenties. It converts any tray into a print washer and has no moving parts. Use a tray *at least* one size larger than the prints and shuffle the prints around once in a while. It's a bargain washer at $14; at these prices you can use two.

Pako's Pakolux M-series washers were a mainstay in many commercial labs, having a capacity of almost 150 8×10-inch (20×25cm) double-weight prints or the equivalent. The drum, stainless steel on M-3's, Cycolac plastic on M-4's, is rotated by a small motor, with additional agitation by water jet and air aspiration. Size: 36×23×36 inches (91×58× 91cm). Water consumption: 4gpm; recommended washing time, one hour with a partial load, two hours with a full load, after the use of a chemical washing aid. Production ended in 1975 with the M-4, priced at $700. A used one is still a sound investment.

PRINT DRYERS

The biggest pain in the neck in photography is drying prints. Resin-coated (RC) paper mitigates much of the aggravation. After sponging off excess moisture, they can be hung from clothespins like underwear and will dry quickly, typically ten to twenty minutes, *and* they lay flat. If a darkroom that looks like a laundry room bothers your sense of professionalism, lay them out on plastic screens (see the East Street dryer, right). The only electrically heated dryers recommended for RC papers are the ones that blow warm air over the prints, like the Bogen-Technal below, although dryers with heated metal platens or drums will work if used at *very* low heat (160°F or 51°C) with the base side of the print facing the platen.

Conventional paper is more problematical, since the top and bottom have different moisture retention properties. The cheapest dryer is a blotter book or blotter roll, but because air cannot freely circulate, drying time can extend into days. The process can be speeded up by periodically transferring prints to a dry set of blotters. If prints are not fixed and washed properly, blotters and canvas aprons on electric dryers will absorb the fixer-laden water and contaminate succeeding prints. A glossy finish can only be obtained on conventional paper by drying F-surface paper in contact with a polished chrome (ferrotype) surface. A glossing agent, such as Pakosol is also useful. Prints, metal surface and apron must be hypo free or pictures will stick. Electrically heated dryers do a relatively fast job, typically twelve minutes for a well-squeegeed double-weight print, though the slower they are dried, the less tendency they have to curl. Air drying on *plastic* or *fiberglass* screens (see East St. dryer, right) is excellent, inexpensive, relatively fast (one to two hours) and archivally approved; but double-weight paper dries wavy and single-weight can curl like a mailing tube when the humidity is low. Flattening can be accomplished in a few minutes in a dry mounting press or in a few days under a stack of books. Speaking of books, an old bookbinder's press works great.

Ideal for free air-drying of standard black-and-white color, stabilization and resin-coated papers, the East Street Archival Print Dryer costs only $40 and has five 25×18½-inch (63×47cm) aluminum-framed fiberglass screens. Capacity: ten 11×14-inch (26×36cm) or twenty 8×10-inch (20×25cm) or 5 16×20-inch (40×51cm) prints. Units may be stacked to expand capacity. After used to dry stabilization paper or color prints and before drying standard or RC papers, screens must be well washed in soapy water to remove contaminants.

This is a large capacity, table-top rotating-drum dryer for conventional paper prints only, not for RC papers. Capacity is 100 8×10-inch (20×25cm) single-weight prints per hour. Size is 30×19×27-inches (76×48×69cm); 1300 watts, 115 volts. Model 150 from Arkay, $575; floor stand $50 extra. For a matte finish, dry prints by placing them face down on the apron; for glossy, place them face up.

Pako dryers were the workhorses of professional and commercial production-oriented operations until such establishments switched to resin-coated paper, which requires forced-air dryers. So Pako recently stopped making these beautiful machines. If you can find a used one and have fifteen square feet of floor space, latch onto it—parts are still available. Model 26, above, is electrically heated (230V) with a capacity of 200 8×10-inch (20×25cm) prints per hour. 26W warms the drum by electrically heated (230V) hot water; capacity is 400 per hour.

The Premier model AC-2 rolls up prints between a chrome-plated heated drum and a canvas apron, like a window shade. The 24×28-inch (61×71cm) unit has an adjustable thermostatic and a built-in rubber squeegee roller. Its drying surface has a capacity of six 8×10-inch (20×25cm) prints or its equivalent. Cost is $95; a smaller unit, model B-1C, is $58. From Photo Materials Co.

The only virtue we can see in resin-coated paper is the speed of the processing. This Technal A-1 Print Dryer, specifically designed for RC paper, can dry eight 8×10 prints in as many minutes. It works by a stream of filtered heated air, controlled with a variable temperature knob. Standard roll dryers made for paper-based prints melt the plastic base. Cost is $119.95.

121

UNCURLING YOUR PRINTS

It may sound like it's made in the same factory that produces sky hooks, wall stretchers and shore line, but print straighteners really do exist! Conventional photographic paper tends to curl because the gelatin emulsion side has different moisture retention characteristics than the plain paper base. When drying in air or on an electric dryer, the gelatin surface dries first, contracting and causing curl. When the humidity is low, as in the winter, the problem is particularly acute, and glossy paper, with its extra top layer of gelatin that is needed to produce the gloss, can curl into a tight maddening cylinder—photographs look like they were exhibited for six months inside a gas pipe. Resin-coated paper causes no such problem, since the polyethylene coating on both sides keeps moisture from penetrating to the inner paper substrate.

The least expensive way to flatten recalcitrant pictures—the problem is more acute with larger prints, and single-weight paper curls considerably more than double-weight—is to to slowly convince them who's boss by letting a pile of books sit on a *neat* stack of the curly devils. Put matte board between the top print and books to avoid indentations from the book binding. Seal, Inc. makes hefty weights with handles for this purpose. Much quicker is a few minutes in a dry-mounting press

(below) at 200°F (93°C). Upon removal from the press, place prints under weights for fifteen minutes. A *slightly* damp sponge lightly applied to the back of a print will also help, if, again, the prints are placed under a weight to dry. Don't stack dampened prints; they may stick together. In a straightening machine, curly prints are transported by a rapidly moving canvas belt, at about one per second, over a tank of hot water vapor where the *back* of the paper is steamed. As it exits, the print is given an adjustable amount of reverse curl. It works exceedingly well!

Kodak Print Straightener model G has an electric water heater with standby and working temperature thermostats and operates on 115 volts. Critical parts are of stainless steel. It handles single or double-weight paper to 14 inches (36cm) wide. Cost is $1,200. A similar unit is made by Johnke for $500; it has a 16-inch (41cm) width capacity.

SEAL MOUNTING PRESS

Photographic prints never lie perfectly flat; for exhibition, or any amount of handling, they must be sandwiched between glass and cardboard or mounted on a board. Photo corners and glue work for small pictures (use the special photo cement made by Kodak; rubber cement will eventually stain pictures). Best results, especially on 5×7-inch (13×15cm) and larger prints, are obtained from a dry-mounting press. A heaten platen melts a wax paperlike tissue (from Kodak or Seal) that has been placed between the photograph and the mounting board; at the same time, pressure is applied to the sandwich. Contrary to optimistic manufacturers' directions, a full minute at 225°F (106°C) is best for conventional papers. Higher temperatures may scorch pictures more than they speed up the process; with thick mounting boards and/or double-weight paper, use longer times, not higher temperatures. Two hints: 1) preheat separated board and print in a closed, but not clamped, press for one minute before beginning the mounting procedure, as this drives out residual moisture; 2) upon removing a mounted print, immediately place it face down on a *clean* smooth surface and place weights (see above) on the back of the matte board until it has cooled.

Resin-coated paper requires accurately controlled low temperature. Older presses, above, are fine, but get Seal's $3 temperature check kit if mounting RC paper. New Seal models have no-stick Teflon-coated platens and built-in dial thermometers.

They make five sizes from 8½×11½ inches (22×29cm) for $150 to 26×34 inches (66×86cm) for $1,000; but presses have open sides and can mount prints twice as wide as the press is deep, by any length, in sections.

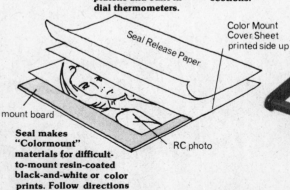

Color Mount Cover Sheet printed side up

Seal Release Paper

mount board

RC photo

Seal makes "Colormount" materials for difficult-to-mount resin-coated black-and-white or color prints. Follow directions carefully; it works well.

FLYPAPER—WATCH OUT

If these new adhesive mounting sheets and tapes from 3M Company's Commercial Tape division were cheap, they could make the dry-mounting press obsolete. The adhesive is positionable until firmly pressed with a hand roller, after which a high-strength bond—even to RC papers—is formed, unaffected by temperature, humidity or photographic lights. Bond can be released safely with rubber cement solvent. Type 567 materials incorporate a layer of microencapsulated air that prevents the adhesive from sticking until the capsules are broken and the adhesive contacts the substrate. A three-inch (7.6cm) hard rubber inking roller from an art supply store works well as a bubble-breaking burnishing tool, and it must be used on a hard, flat, clean surface. 3M claims accelerated aging tests show no migration of adhesive into photographs, though they hedge at promising archival (100+ years) life. Twenty-five sheet packages are $7 in 8×10-inch (20×25cm) size, $13 for 11×14 (28×36cm) and $25 for 16×20 (41×51cm).

Type 567 is for the person without a mounting press, but in the long run, the press is cheaper.

PAPER AND BOARD TRIMMERS

Paper cutters are fine for cutting paper. Period! And sometimes they're not so hot for that: the guillotine type can cause paper slippage if paper is not held firmly; they also leave a slightly ragged edge on matte board, and many people who have used one can be identified by the slightly abbreviated fingers of their left hand. The rolling wheel variety, such as the Beseler Rotatrim, below, and the Nikor Safety Trimmer from Honeywell, do a fine job on paper, up to oak tag thickness, and are much safer. Still the best method for cutting matte board is a strong matte knife or commercial safety razor against a heavy steel or aluminum ruler. The trick is to try not to cut the board in one pass; hold the blade lightly against the straight edge, and hold that straight edge down with more pressure than you apply to the knife. Blades dull quickly if they are not held at an efficient cutting angle, so change blades as frequently as necessary. While X-Acto razor knives are excellent for trimming prints and mounting tissue, even the largest one is too small for efficient matte board cutting. Art supply and hardware stores have matte knives: Stanley makes a good one. Keep that valuable left hand away from the ruler's edge; this writer has spilled all too much blood on precious prints while daydreaming with the head and flying with the knife. Of course, scrap board must be placed beneath the material to be cut, and it must be fairly smooth with no major gouges. Gray "chip board" is relatively cheap and works well for this purpose; it should be changed frequently. Finally, never cut on your grandmother's antique Chippendale coffee table; it's amazing how much cardboard a razor knife can go through.

The rotating, self-sharpening cutting wheel of the Beseler RotaTrim rides on twin-carriage bars, which provide good alignment and execute clean cuts of tissue-thin materials. Four sizes: 15-inches (38cm) square, at $120, to 54-inches (137cm) square, at $285.

Art supply and photo stores carry guillotine cutters in sizes from 12-inches (31cm) square to 30-inches (76cm) square, and prices from $17 to $100. The one at left is a Premier from Photo Materials Co.

TOOLS FOR CUTTING MATTES

A face matte is a rectangular cutout, usually with a beveled edge, in a piece of matte board that goes over a photograph to give it a neat, formal border and some depth. But they're tricky to cut. Some magicians can do it with a matte knife and plain straight edge, but most mortals require a tracked guide with a hand propelled "car" to hold the blade at the recommended 60-degree angle. X-Acto, Bainbridge (above) and Dexter (from Harrington Cutlery) all make relatively inexpensive devices that are okay for occasional projects. Museums and framing shops use a $300 Keeton Cole device that is a beautiful piece of precision machinery—with it, a gorilla could cut perfect mattes.

To use Bainbridge's "Matthewmatic," set the desired border width on the scale of the sliding cutter, apply pressure to the hold-down bar with the left hand and press and cut with the right hand, as above. Work slowly and carefully. It will handle boards up to 32×32 inches (81×81cm). The maximum border width is six inches (15cm). Cost is $60.

FRAMED

"A masterpiece is not a masterpiece without a frame." So said an obscure, unsuccessful Renaissance artist. Of course, you can hide your lack of framing funds by professing love of the "frameless modern look," with its borderless flush mounting. For hanging, however, even a flush-mounted print needs a Masonite backing behind the mount board or at least a wood stiffening strip. Those sleek modern metal frames are available in sectional lengths from five inches (13cm) to forty (102cm). A pair each of two sizes makes one frame, easily assembled with a screwdriver.

Kulicke originated the metal sectional frame in 1968, see right. It is available in anodized silver, gold, pewter, black and a number of enameled colors. Prices start at $3.50 for a pair of five-inch (13cm) sections and progress by about 20¢ per inch. Purists abhor the corner joint crack in the assemble-it-yourself frames. For them Kulicke makes a welded frame: $14.50 for an 8×10 (20×25cm) in aluminum, $30 in brass.

Shown here is a Kulicke welded frame and a sectional. An elegant and simple trap frame is also available, two sheets of acrylic sealed by four mitered aluminum channels.

Art Infinitum, Inc. manufacturers the Dax line of one-piece clear plastic frames, shown right. Totally simple design affords complete visibility. Acrylic scratches easily, so dust gently. An 8×10-inch (20×25cm) frame is $6.50. Versions with "wood grain" and "metal look" edges are also available.

ARCHIVAL PAPER

There is something deliciously egotistical about processing and mounting your photographs for archival permanence. The final step is the choice of proper mounting or matting board, which is available in prices that range from 15¢ to $1 for a single 11×14-inch (28×36cm) sheet. Quality ranges from mealy texture among the cheaper papers, which are atrocious and quick to yellow, to elegant, mellow and archivally stable papers that are more expensive. Inexpensive boards contain sulfur and acid, which is terribly harmful to photographic prints; in time, both board and print will yellow. Important work should be mounted on all rag boards, such as Bainbridge Museum Mounting Board, Strathmore Drawing Board, or the D' Arches acid-free rag boards from Process Materials or the Hollinger Corp. The latter two companies sell by mail order; the other boards are available through art supply dealers. A 32×40-inch (81×102cm) two-ply (very flexible) sheet of 100 percent cotton, acid-free board is about $4.50; four-ply is double the price.

PRINTING/editing

FROM DUST WE COME, WITH DUST WE LIVE

Unless you photograph, develop and print in a room designed for the assembly of missile computers, you can count on winding up with white specs on your prints from dust that has settled on or embedded itself into the negative. Fight the dust . . . then learn to spot. Use a magnifying glass; any clean paper used to lean on to protect the print from skin oil and dirt and a good #00 or #000 red sable artist's brush, twirled on the tongue to keep it pointed. Special dyes, shown below, are mixed in to match the image tone of each particular brand of paper. Hint—after mixing the dye, combine it with a water puddle on a 4×5-inch (11×13cm) glass plate. When it's dry, you will have various densities of dye available to lift off the plate with a tongue-moistened brush. Build up the image *SLOWLY* by stippling, not by painting. Beginners always go too far.

Photographic spotting dyes penetrate completely into the print emulsion, leaving no surface residue. Always use a dye dilution that is *lighter* than the area to be matched; it can always be made darker by successive applications. Retouch Methods, Inc., makes a kit of five different "Spotone" black dyes;

Marshalls' Spot-All set is identical. Kit directions indicate mixing proportions for various papers, toned and untoned.

Black spots on prints, caused by scratches in negatives, can be etched out with the edge of a #11 X-Acto blade. Stabilo graphite pencils write on glossy and RC paper and are good for minor retouching. Heavier brushes carry more color; skilled retouchers prefer the #0 or #1 Windsor and Newton Series 7 sables. All are available at art supply stores.

EYEBALLS

Pilots and photographers need good eyes. The Federal Aviation Agency screens pilots; nobody screens photographers. A good magnifier "loupe," 5-7X power, with an optically corrected lens, is far better than a Sherlock Holmes "magnifying glass" and especially good for checking transparencies and negatives. A translucent base allows light to illuminate prints, but for viewing contacts the magnifier should have its own light source. There are units made that operate on AC current, but the handiest are the flashlight cases with magnifying heads. For print spotting, a 2X magnifying glass is adequate; one on a gooseneck or swivel conveniently frees both hands.

Kodak's Achromatic (color-corrected) 5X magnifier is super sharp, with a focusing eyepiece and a translucent plastic skirt for light penetration. It's perfect for examining color slides on a light box and the critical evaluation of contact sheets and negatives. Cost is $28.

The stand magnifier, right, is about $17 from Edmund Scientific; a gooseneck version from Brook-Stone—both are mail order houses. The lens is simple magnifying glass, about 2X.

These inexpensive illuminated magnifiers are battery-powered and perfect for editing contact sheets. The unit shown is a "Flash-O-Lens" from E.W. Pike Co.

PROJECTION SCREENS

Projector manufacturers have come a long way in pushing lots of uniform light through a slide without burning it up. A good screen can further enhance the quality of those slides. The best screen for use by a few people in a well-darkened relatively small room is the ever-popular flat, white-painted wall. Changing tastes in living room and office colors, however, sometimes makes a formal projection screen a necessity.

Normally, a screen comes in one of three surfaces: matte, lenticular or beaded. A room that is shallow and wide requires a matte-white surface screen, since image-brightness is uniform in all directions; but because it does scatter the light in all directions, image brightness is relatively low and well-darkened rooms are a necessity. For the opposite situation—a long, skinny room or a place where viewers can be placed within a cone twenty degrees on either side of the

projection axis—a glass-beaded screen will give excellent brightness—about four times that of a matte surface. The beads act as tiny prisms or lenses, which strongly direct the light back toward the source. A lenticular screen has a regular pattern of tiny stripes, ribs or diamond-shaped areas that act to control the shape of the reflected light, while at the same time effectively controlling stray light that emanates from outside the viewing area. They are about three times brighter than a matte screen and require special tensioning devices to hold the screen surface flat. For general purpose use, especially in rooms that cannot be made totally dark, the lenticular screen is a good choice.
The Da-Lite Screen Company manufactures a broad range of high quality screens in all surfaces, from small portables to electrically operated wall-hung units; one of the latter might impress your neighbors, if your slides don't.

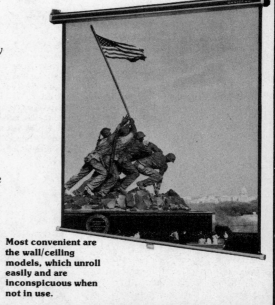

Most convenient are the wall/ceiling models, which unroll easily and are inconspicuous when not in use.

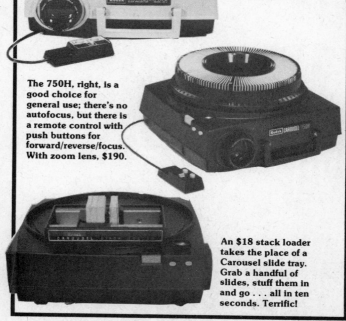

Matrix Systems makes an extensive line of professional light boxes/slide sorters. Slide-holding racks are removable. Unit #2049A, shown at top, holds 200 slides and costs $269; the lower unit holds 100 and is $186. Both stand seventy degrees vertically or horizontally.

SOMETHING BESIDES THAT BIG LIGHT BOX IN THE SKY

If you wish to fend off premature blindness caused by squinting at negatives and slides against a bare 60-watt light bulb in your mother's kitchen, get a light box. Not only are they good for sorting negatives, but they're almost a must for arranging and editing slides. If you view a transparency against blue light, it looks blue, right? Right! Therefore, the industry has adapted a standard colored light for viewing. For proper color rendition, special fluorescent tubes that have a 5000°K color temperatures and a CRI (Color Rendition Index) of 90 or more will keep you tuned in. Color-balanced fluorescent tubes are available from Verd-A-Ray, Macbeth or Duro-Test. Richards' "Idealite #010," at $35, is an excellent, small 10×10-inch (25×25cm) unit that is only 2-inches (5cm) thick and will stand up or lay flat.

GARBAGE IN, GARBAGE OUT

It is the practice to keep a complete set of negatives on every black-and-white contact sheet, even if there is only one select on the roll. When editing color slides, however, it is the wise photographer who files his rejects immediately into the waste basket. This practice not only upgrades the file, but saves hours when filling a picture request. Protect your slides with Kimac acetate sleeves, which fit around individual slides, if they are to be handled by anyone other than yourself. There are also several companies making 8½×11 transparent sheets that hold twenty slides; they're very convenient for filing, viewing and sending to clients.

If you use the services of a professional black-and-white lab, they will number and file your negs. If you do your own processing, store negatives in acetate or polyethylene envelopes as there is now evidence that glassine sleeves are harmful in the long run.

A CAROUSEL IS NOT ALWAYS A MERRY-GO-ROUND

The two greatest things Kodak invented were clear-base flexible film and the Carousel projector. In schools, professional labs, theaters, galleries and multi-media productions, *the* standard is the beautifully reliable, almost jam-proof Carousel. Circular trays hold all slides in 2×2-inch (5×5cm) mounts, are quick to load and come in an 80 or 140-slide capacity, the latter accepting only cardboard or *very thin* plastic mounts. If using glass-mounted slides up to ⅛-inch (3mm) thick, buy the gray eighty-slide "Universal" tray, not the black standard model. Prices range from $100 for the absolute plain Jane 600H, which requires slide-advance button pushing *at the* projector, to $265 for the AF-3 Ektagraphic —a heavy-duty industrial version with autofocus, auto slide change at five, eight or fifteen-second intervals and remote everything, including on/off control.

A total of eleven models are available, including one that gives random access to any slide in the tray in three seconds. Whichever you choose, we strongly recommend a remote control cord for forward/reverse and a zoom lens, which makes projector-to-screen distance more flexible. Scads of accessories are available, including a filmstrip adapter and tape recorder synchronizer.

Kodak Carousel "Ektagraphic" projectors "are designed and manufactured to meet the needs of the professional user and **incorporate special features for professional audiovisual application." Available only from Kodak audiovisual dealers.**

The best way to store slides is in good quality frosted-back vinyl sheets. Slides are well protected, easily accessible, and the frosted back makes viewing easy, even by window light. The best **are the new TL-20's from 20th Century Plastics. They're top-loading, hold twenty slides and are punched with nice oversized holes for three-ring binders. At 30¢ each.**

The 750H, right, is a good choice for general use; there's no autofocus, but there is a remote control with push buttons for forward/reverse/focus. With zoom lens, $190.

An $18 stack loader takes the place of a Carousel slide tray. Grab a handful of slides, stuff them in and go . . . all in ten seconds. Terrific!

GLASS MOUNTS

Maximum mechanical protection for slides is afforded by glass mounts. If they're going to be handled a lot, it's a must. Film frames are easily removed from cardboard mounts: cut them with a big X-Acto knife along the wide border, half-way down from the top, then bend them over and separate the cardboard. If an entire roll is to be glass-mounted, tell the lab "DO NOT MOUNT." Far and away the best thin-glass mounts (that fit Carousel 80-slide trays) are Gepe Super-Thin Glass Binders (HPM Corp.) and Perrot-Color Ultra-Thin Mounts (Leitz). Order them with anti-Newton-Ring glass. Protection doesn't come cheap; glass mounting is about 25¢ per slide, though they are reusable.

The above illustration photo shows Gepe mount components. At the right is the optional Gepe press to ease the joining operation. Perrot-Color has its own press, which is mandatory.

It will cost you an extra $3 to get a handle on any case. Beside the ones at left, they will make to order any type of portfolio case that you want. When ordering, they emphasize that you shouldn't send a check in advance. All charges will be billed prior to shipment. There is no shipping charge for any order over six boxes.

SPINK AND GABORC: THE CLASSIC CASE

Spink and Gaborc is a small bookbinding concern that has been in operation since 1911. Walking into their plant, the ninth floor of a loft building on New York's Lower West Side, you see a dozen or so men working. No big deal, right, but they've been making portfolio cases for years that are standard equipment for museums and collectors all over the country who want a quality case to protect their work. Light, but extra strong, they're also the favorite among artists and designers. They come in six sizes from 8×10×2½ inches ($15 each, $13 per dozen+) to 22×28×2½ inches ($21. each, $19 per dozen+). They'll also make any size on order to meet your specifications.

Spink and Gaborc, Inc./32 W. 18 St./New York, NY 10011

THE KRAUSE PRINT BOX

Viewing a George Krause portfolio is a memorable experience. Not only what's in it, but what they're in is a sign of his creativity. Whenever he would come to visit, he always had portfolios mounted on different-size mattes in corrugated cardboard boxes that he had made himself. We never forgot those packages, and when it came time to talk about print boxes, we asked for a sample and instructions for making it. It's inexpensive, easy to make and it does the job. Glamour is another thing, but an ace print-box full of crummy pictures won't help anyone. On the other hand, while great pictures in a shopping bag don't hurt the photographs, it's a crummy way to care for your work.

The total expenditure for this box is about $3 and an hour of your time. You can make it any size you like. The one at left is 10×10×4 inches and will hold fifteen matted prints easily.

10"×10"×4" PRINT BOX
1 square = 1"

1. Transfer markings (1 square = 1") to 30"×40 corrugated board. Use T square and triangle for straight edges. All lines should be parallel or perpendicular to corrugated ridges.
2. Cut-out outer edge of box, handle openings and slot.
3. Score all dotted lines with a paper clip and straight edge.
4. Apply Elmers glue to surfaces Ⓐ and Ⓑ then fold together creating a sturdy handle.

5. Fold in all scored panels
6. Puncture corrugated board with ½" paper fasteners at points Ⓒ and Ⓓ (head on outside of box)
7. Wrap 10" length of string to head of pin at point Ⓓ
8. Fold in sides Ⓔ and Ⓕ so edges touch.
9. Fold over glued handle
10. Fold in remaining panel and fit slot over handle
11. Wrap string from pin at point Ⓒ to secure closure of box.

8

Thomas Barrow, Courtesy of Light Gallery.

BOOKS

THE BEST IN BOOKS

A book is often the ideal showcase for a photographer's work. Many people cannot get to museum or galley shows, but they can walk into a store and buy or order a photography book. So a book affords a photographer a potentially larger audience. Generally, the quality of reproduction very nearly approximates that of the original photographs (in some cases we suspect it has helped a photograph or two), so the artist is assured that his full intention—down to what that original looks like—will be communicated. Perhaps, most importantly, photography books can be referred to time and time again—studied and examined in the context of changing tastes and a growing knowledge of the medium.

Over the years the history of photography has been pretty well documented (at least what we know of it to date) in thousands of photo books. Not all of them are triumphs, but a handful have contributed substantially to our knowledge of the medium and to our love of books. The books selected here represent the best. To know them is to know photography at its best. A number are out of print, but libraries can and should be tapped. If the municipal library doesn't have a copy, chances are that the major university or museum in your area does. Simply call them up, make an appointment, settle down to study, to learn, and most of all to enjoy.

THE HISTORY OF PHOTOGRAPHY
by Beaumont Newhall
The Museum of Modern Art/New York/paper, $7.50

Tintype, Civil War soldier, circa 1862. Unknown American photographer

This book, first written in 1937 in conjunction with a Museum of Modern Art exhibition, was revised in 1964. It is the basic history of photography (from 1839) and has served as a prime source for many a book and article published since. Newhall is currently working on an update that presumably will cover more recent discoveries—such as Lartigue—while dropping others who have fallen from fashion. However, the book is not simply a who's who, for it clearly chronicles the aesthetic ideas of different generations.

Tintyping was usually casual; when the results have charm it is due to the lack of sophistication and to the naive directness characteristic of folk art. Records of outings, mementoes of friendships, stiffly posed portraits of country folk against painted backgrounds are common: views are few.

A CHRONOLOGY OF PHOTOGRAPHY
by Arnold Gassan
Amold Gassan Handbook Company/Athens, OH/ out of print

After five years of research—the idea started when he was a student—Gassan has produced a history that shows the relationship of photographs to the times in which they were made. The third section, which lists important world events year by year, is especially interesting. A refreshing discussion of photographic history.

Two Girls, c. 1895. Photographer unknown

PHOTOGRAPHY AND THE AMERICAN SCENE
by Robert Taft
Dover Publications, Inc./New York/paper, $5

Originally published in 1938, this remains the definitive book on the first fifty years in photography—in spite of some errors and omissions. Taft, as a chemistry professor at the University of Kansas, had the knowledge to write a readable history that includes non-technical explanations of contemporary techniques and devices. He outlines the effects of photography on the social history of America and vice versa. A bargain at any price: it belongs in every library.

The real value of (William H.) Jackson's photographs became apparent the following winter when, through the efforts of Hayden and of N. P. Langford and William H. Clagett, a bill was prepared and introduced into both houses of Congress setting aside the Yellowstone as a National Park—the first National Park. Jackson's photographs were prepared and placed on exhibition and had an immense influence in securing the desired legislation.

PRINTS AND VISUAL COMMUNICATION
by William M. Ivins, Jr.
The M.I.T. Press/Cambridge, MA/ paper, $3.95

In a way, my whole argument about the role of the exactly repeatable pictorial statement and its syntaxes resolves itself into what, once stated, is the truism that at any given moment the accepted report of an event is of greater importance than the event, for what we think about and act upon is the symbolic report and not the concrete event itself.

This book is essentially about the development of the reproducible image and its impact on the world. First published in 1953, it develops the notion that the repeatable non-verbal description, such as the wood-cut and the photograph, have made possible our modern technological civilization. Ivins' thesis is that photographs are, most importantly, conveyors of information and, however vital, only secondarily a means of personal expression.

TEN MORE ON HISTORY AND AESTHETICS

Arnheim, Rudolf, *Art and Visual Perception,* 2d ed. University of California Press, Berkeley, 1974.

Coke, Van Deren, *The Painter and the Photograph,* 2d ed. University of New Mexico Press, Albuquerque, 1972.

Coke, Van Deren, *One Hundred Years of Photographic History,* 1st ed. University of New Mexico, Albuquerque, 1975.

Gidal, Tim N., *Modern Photojournalism: Origin and Evolution, 1910-1933,* 2d ed. McGraw-Hill Book Co., New York, 1969.

Kahmen, Volker, *Art History of Photography,* 2d ed. Viking Press, New York, 1974.

Lyons, Nathan, *Photographers on Photography,* 8th ed. Prentice-Hall, Englewood Cliffs, NJ, 1966.

Lyons, Nathan, *Photography in the Twentieth Century,* 1st ed. Horizon Press, New York, 1967.

Norman, Dorothy, *Alfred Stieglitz: An American Seer,* 1st ed. Random House, New York, 1973.

Pollack, Peter, *The Picture History of Photography,* 2d ed, revised and enlarged, Harry Abrams, Inc., New York 1969

Rudisill, Richard, *Mirror Image,* 1st ed. University of New Mexico Press, Albuquerque, 1971.

Scharf, Aaron, *Art and Photography,* 3d ed. Penguin Press, London, 1975.

BOOKS/aesthetics

THE DAYBOOKS OF EDWARD WESTON
by Nancy Newhall
Aperture, Inc./Millerton, NY 12546/paper, $17.50 (set)

As Edward Weston grew older, and more confident as an artist, he used words less and less. Nevertheless, for fifteen years, he kept diaries into which he spilled his guts by recording every meaningful personal experience. The result is a powerful description of how his way of working was forged. Volume I covers the time he spent in Mexico, while Volume II describes his California period.

I am not blind to the sensuous quality in shells, with which they combine the deepest spiritual significance: indeed it is this very combination of the physical and spiritual in a shell like the Chambered Nautilus, which makes it such an important abstract of life. . . . I knew that I was recording from within, my feeling for life as I had never before. Or better, when the negatives were actually developed, I realized what I felt,—for when I worked, I was never more conscious of what I was doing.
 Volume II. California

LOOKING AT PHOTOGRAPHS
by John Szarkowski
The Museum of Modern Art/New York/paper, $9.50

This book is a testament to the richness of photography. Szarkowski, Director of the Department of Photography at the Museum of Modern Art, writes about a selection of 100 pictures from the collection. Facing each photograph is Szarkowski's evocative and descriptive commentary. He spins a good story, as he leads us through each picture, pointing out details, while asking stimulating questions about the nature of photographs. In the end we come away with a greater understanding of how one professional reflects upon the photographs he likes.

Muray's picture of the great George Herman Ruth perhaps is innovative after all. The patent artificiality of the situation (suggesting somehow a bull in a china shop) emphasizes the direct natural force of the subject: a lion at rest. The retoucher has smoothed and softened Ruth's face slightly, but the hungry mouth and eyes might still inspire nightmares in aged baseball pitchers. The eyes seem unusually far apart; perhaps this improved his binocular vision, and enabled him to follow better the twisting little ball, as it came toward him as fast and hard as the other man could throw it.

From the essay accompanying Nicolas Muray's picture of Babe Ruth

CREATIVE PHOTOGRAPHY
by Helmut Gernsheim
Boston Book & Art Shop/Boston, MA/cloth, $15

Decade by decade, Gernsheim, one of the foremost scholars in photography, outlines photography's aesthetic trends. He points to the technical advancements that made certain kinds of pictures possible and to movements in painting that paralleled photography's growth. Starting with the simple purity of the daguerreotype, he ends with a discussion of modern photo-reportage. The author's main point: that photography is really a subjective process, a fact which has been proven by the photographic styles in evidence. The book, richly illustrated, details the past and provides short biographies of the included photographers. A glossary of old processes makes the book even more useful.

ELEMENTARY GRAMMAR OF THE IMAGE
by Albert Plécy
Editions Estienne/Paris, France/no price available.

Plécy has worked as a writer, editor, photographer, painter, movie-maker and designer. Working from the premise that today's civilization is picture rather than word-oriented, he attempts to establish a photographic grammar. To arrive at his rules, he analyzes problems concerning choice, picture-taking techniques, and the uses of photography. He includes a variety of picture types along with thought-provoking captions. It is a book well worth searching out. Look for the French/English edition (1968).

Execution of a criminal in the Middle East. *Photographer unknown*

If the intellectual is wrong to scorn the picture, he is right to fear it, because it is redoubtable. Far more than the written page, because it penetrates to the center of our mental faculties and influences not only the mind but our entire organism. "To have a knot in one's stomach," "To have shivers running down one's back" are expressions which depict admirably the consequences of vision. The emotional reactions provoked by pictures have been verified scientifically. It is therefore quite natural to think that for various reasons (publicity, even political or distractive) we are going to encounter an increasingly large number of "shocking," "disturbing" and "traumatizing" pictures which will arouse the entire psychic potential of the individual.

THE PHOTOGRAPHER'S EYE
by John Szarkowski
The Museum of Modern Art/New York/paper, $5.95

Before this book was written, most people used the painter's vocabulary to discuss photographs. In this book, Szarkowski suggests that photographs should be talked about differently than paintings. One by one, he takes five characteristics of the photograph—"The Thing Itself," "The Detail," "The Frame," "Time," "Vantage Point"—and illustrates the role they play in the way photographs look. The writing is clear, the book primer-like in its approach. The result: a book that has become a classic.

Couple with daguerreotype, circa 1850. *Photographer unknown*

To quote out of context is the essence of the photographer's craft. His central problem is a simple one: what shall he include, what shall he reject? The line of decision between in and out is the picture's edge. While the draughtsman starts with the middle of the sheet, the photographer starts with the frame.
 From "The Frame"

More convincingly than any other kind of picture, a photographer evokes the tangible presence of reality. Its most fundamental use and its broadest acceptance has been as a substitute for the subject itself—a simpler, more permanent, more clearly visible version of the plain fact. *From "The Thing Itself"*

BOOKS/monographs

ONE MIND'S EYE
by Arnold Newman
David R. Godine, Publisher/Boston/$27.50

Yasuo Kuniyoshi, 14th Street Studio, New York, 1941.
© *Arnold Newman*

This photographer has made pictures of famous people that are significantly more than representations or glorifications of what they look like. *One Mind's Eye* collects the best of them and also includes a short preliminary section of pictures made before Newman found his sure footing as one of the medium's finest portraitists.

> *The capability of the sitter actively to affect the photographer's approach to his portrait has been a commonly understood psychological relationship. The "facile" portraitist will allow the subject to command the entire picture from conception to retouched print. The more artistically exceptional photographer will use this potential as a catalyst to energize his own concerns and sensibilities.*
>
> Robert Sobieszek

SELF PORTRAIT
by Lee Friedlander
Haywire Press/New City, NY/$7.50.

You might think that a book of self-portraits of a man you've never met would be boring. On the contrary, Friedlander's imagination, wit, and joy at finding pictures where others would never care or think to look make this one special. He was the first to account for his presence—sometimes merely in the form of shadows—in the photographic act; the work attests to his originality.

> *At first, my presence in my photos was fascinating and disturbing. But as time passed and I was more a part of other ideas in my photos, I was able to add a giggle to those feelings.*

ANDRÉ KERTÉSZ: SIXTY YEARS OF PHOTOGRAPHY
by André Kertész
Grossman Publishers/New York/$19.95

There isn't a better book from which to learn—not only about the pictures that Kertész has taken in his sixty-odd years as a photographer, but also about the medium itself. For his career spans the history of contemporary photography, and he has explored many of its possibilities. His photographs also document the bygone days in Hungary, Paris and the United States through a sensitive eye that is tuned to life's gentler moments.

SEQUENCES
by Duane Michals
Doubleday & Company/Garden City, NY/out of print

This book is a collection of fifteen of Michals' earliest sequences. Together they demonstrate the foundation of his belief that a photograph does not necessarily have to represent just one moment in time. The reproduction is not the greatest, and Doubleday let the book go out of print, but it's worth tracking down.

Frames 1, 3, 4, 6, from "The Human Condition."

THE AMERICANS
by Robert Frank
Aperture, Inc./Millerton, NY/out of print.

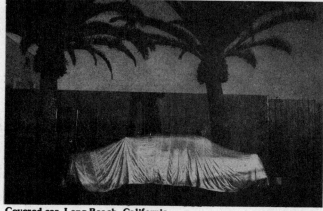

This book marks a watershed in contemporary photography. Since American publishers in 1958 didn't understand the pictures or what they showed of America, it was first published by Delpire in Paris. Grove Press brought out an English edition similarly printed in gravure in 1959. Ten years later, as the importance of Frank's pictures became apparent, an inferior offset reprint was issued. Both original editions are now collector's items.

Covered car, Long Beach, California.

Car shrouded in fancy expensive designed tarpolian (I knew a truck-driver pronounced it "tarpolian") to keep soots of no-soot Malibu from falling on new simonize job as owner who is a two-dollar-an-hour carpenter snoozes in house with wife and TV, all under palm trees for nothing, in the cemeterial California night, ag, ack—. . .

Jack Kerouac

THE FAMILY OF MAN
edited by Edward Steichen
The Museum of Modern Art/New York/paper, $3.95

U.S.A. *Homer Page* Germany. *Walter Sanders*

U.S.A. *Roy De Carava* Belgian Congo. *Lennart Nilsson*

It is the most popular photography book of all time, reproducing 503 pictures from the historic show created in 1955 for the Museum of Modern Art by Edward Steichen. Each time you dip into the book, there's another surprise waiting. Like no other collection of photographs, it sums up the period in photography that sought to present the dignity of mankind.

Photographs concerned with the religious rather than religions. With basic human consciousness rather than social consciousness. Photographs concerned with man's dreams and aspirations and photographs of the flaming creative forces of love and truth and the corrosive evil inherent in the lie. . . . The Family of Man has been created in a passionate spirit of devoted love and faith in man.

Edward Steichen

PORTRAIT OF A PERIOD
edited by J. Russell Harper and Stanley Triggs
McGill University Press/Montreal/out of print

Every once in a while a book of historical pictures comes along that is simply magnificent. This brilliantly reproduced book exemplifies how photos can help to clarify our past. Notman was a photographer who worked along with his sons during the late nineteenth and early twentieth centuries, photographing the spirit of his beloved Canada—its people, cities, industries. A memorable evocation of an era.

The matrons in their heavy furs; the complacent middle-aged men and women, unconcerned with dieting; the little boys with their sailor suits and their wonderful rocking horses; the little Alice-in-Wonderland girls; the young women with the poise and confidence of their Victorian diffidence: all these are the real people who lived in the high-stepped, stone-fronted houses.

Edgar Andrew Collard

THE SOMNAMBULIST
by Ralph Gibson
Lustrum Press/New York/$6.95

In order to control the presentation of his own work, Gibson published this book himself. It was the first of many, and it remains one of the best. (He has also published the work of Robert Frank, Mary Ellen Mark, Danny Seymour and others.) He utilizes pictures in sequence to tell a dream-story without words—a provocative package of some of his best pictures.

MORE MONOGRAPHS

Abbott, Berenice, *Berenice Abbott Photographs*, 1st ed. Horizon Press, New York, 1970.

Adams, Ansel, *Ansel Adams: Images 1923-1974*, 1st ed. New York Graphic Society, Boston, 1974.

Cartier-Bresson, Henri, *The World of Henri Cartier-Bresson*, 2nd ed. The Viking Press, New York, 1968.

Erwitt, Elliott, *Photographs and Anti-Photographs*, 1st ed. New York Graphic Society, Boston, 1972.

Harbutt, Charles, *Travelogue*, 1st ed. The MIT Press, Cambridge, MA, 1973.

Heath, Dave, *A Dialogue With Solitude*, 1st ed. A Community Press Publication, Culpeper, VA, 1965.

Krause, George, *George Krause*, 1st ed. Toll and Armstrong, Haverford, PA, 1972.

Koudelka, Josef, *Gypsies*, 1st ed. Aperture-Robert Delpire, Haverford, PA, 1972.

Lyons, Nathan, *Vision and Expression*, 1st ed. Horizon Press, New York, 1969.

Penn, Irving, *Moments Preserved*, 1st ed. Simon and Schuster, New York, 1960.

Steichen, Edward, *A Life in Photography*, 1st ed. Doubleday and Company, Garden City, New York, 1963.

Uelsmann, Jerry N., *Silver Meditations*, 1st ed. A Morgan and Morgan Monograph, New York, 1975.

Uzzle, Burk, *Landscapes*, 1st ed. Magnum, New York, 1973.

Winogrand, Garry, *Animals*, 1st ed. The Museum of Modern Art, New York, 1969.

BOOKS/monographs

THE TOP OF THE LINE: APERTURE BOOKS

Aperture, Inc./Elm St./Millerton, NY 12546

Aperture books concern themselves with the best: the best photographers, their best work and certainly the best in book production. They aim to achieve reproduction quality as close to the original works of art as is mechanically possible. In a manner of speaking, the books themselves become works of art, and it wouldn't be surprising if in the future they were collector's items. They are not cheap ($30-40 price range for the biggest ones), but there are paperback versions of many that are genuine bargains.

The selection right lists some of their best, but for a complete selection send for a catalog.

THE LIGHT IN ROCHESTER

*Light Impressions Corp./
Box 3012/Rochester, NY 14614*

What can you say about a company that tries to do everything right? Be thankful they're around, for one thing. Primarily, Light Impressions is a central mail-order source for the best photo books in print. They select from large or small publishers only those books that meet their quality standards. (If they distribute your book, they receive fifty to sixty-five percent of the list price, depending on whether or not they are the exclusive worldwide distributors.

Some of their services include the following:

● Updating Service: For $5 you can be put on a mailing list that insures you'll get the latest information about new books, offers and services for the rest of your life.
● Framing Service: Metal and wood custom-cut frames and archival materials can be ordered through the mail.
● Fine-Print Portfolios: In collaboration with George Eastman House, they produce limited-edition portfolios of prints from original negatives.

If you can't find a book or want to know about their other services, send for their 40-page catalog. Do you believe they ship orders on the day they receive them?

Light Impressions Corporation
Spring 1976 Book Catalog

Diane Arbus, text compiled from Arbus' writings, interviews, tapes, 184 pp., 80 photos.

Julia Margaret Cameron: Her Life and Photographic Work, by Beaumont Newhall, 208 pp., 80 photos.

Paul Caponigro, commentary by the photographer, 60 photos.

P. H. Emerson: The Fight for Photography as a Fine Art, by Nancy Newhall, 272 pp., 87 photos.

Frederick H. Evans, by Beaumont Newhall, 96 pp., 70 photos.

Clarence John Laughlin: The Personal Eye, introduction by Jonathan Williams, 136 pp. 80 photos.

Ralph Eugene Meatyard, edited with text by James Baker Hall, 144 pp., 100 photos.

W. Eugene Smith: His Photographs and Notes, afterword by Lincoln Kirstein, 148 pp., 120 photos.

*Paul Strand—
Retrospective Monograph: The Years 1915-1968* in two volumes, 384 pp., 309 photos.

Doris Ulmann: The Darkness and the Light, preface by William Clift, 112 pp., 70 photos.

Edward Weston: Fifty Years, biographical essay by Ben Maddow, 228 pp., 150 photos.

THE WORLD OF ATGET
by Berenice Abbott

Horizon Press/New York/cloth, $25

It's the best way to see the masterful scope of Atget's work; his street and architectural studies, street vendors and the parks with their monuments and trees. The moving introduction by Abbott makes up for the uneven quality of the reproduction.

He was probably surprised when only a few souls responded to his photographs. While he had the courage to be himself, to embark, as it were, on an uncharted course, most people were simply not used to seeing, or prepared to accept, such sharp images as art.

Photography is very easy. The visible world is such an interesting place that it doesn't take much in the way of passion, insight, sensitivity, or rigorous craft to make a picture worth looking at —at least briefly. But photography is very difficult. The visible world is so harshly recalcitrant. It stays where it is in its own context. It takes the quickest eye, the most penetrating insight, and the most painstaking technique to make a photograph that is a felt comment, bare of inessentials; a photograph that moves the viewer with an understanding of the meaning of what is photographed.
 Leo Hurwitz, Paul Strand, Vol. I

PHOTO-EYE
by Franz Roh and Jan Tschichold

Thames and Hudson/London/paper $12 available through Wittenborn Art Books, Inc., 1018 Madison Ave/New York, NY 10021

The art of the 20s was tied to the advent of the machine age—especially in European photography. This facsimile edition of a 1929 German catalog presents the best examples by masters like Umbo, Peterhans, Bayer, Buchartz, Lissitzky, Man Ray, Moholy-Nagy. As avant-garde artists, they believed that pictures up to their time owed more to painting than to photography. So they set out to create pictures that reflected the mechanical nature of photography, reproduction and graphic arts processes.

IS ANYONE TAKING ANY NOTICE?
by Donald McCullin
The M.I.T. Press/Cambridge, MA/cloth, $14.95

It is a masterpiece of book design and compels that it be read and looked at from cover to cover in one sitting. McCullin's pictures about war force us to consider our fellowman as a victim of worldwide social and political horrors. The photographer's words combined with excerpts from Alexandr Solzhenitsyn's Nobel Prize address drive home the point.

I actually saw a child drop dead | They pumped adrenalin into his throat and down to his heart tipped upside down | He was resuscitated only to face the same problem of again trying to survive | It was a pointless drama

TULSA
by Larry Clark
Lustrum Press/New York/out of print

If there was ever a book that packed a punch—this is it! Larry Clark photographs his friends—who are all drug addicts—and provides us with an intimate look at the pain, violence and death that permeate their lives. There are still a few copies around, but they are hard to come by. Since there are no plans to reprint, head for a library and witness the power of photography to communicate in a language without words.

THE GERMANS
by René Burri
Fretz & Wasmuth/Zurich/out of print

For some reason, this book, in the spirit of Frank's *The Americans,* has remained a little-known classic. Burri produced sensitive pictures of the German people almost fifteen years after World War II. There is an accompanying text (in German)

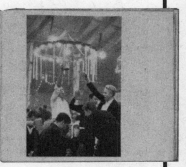

SUBURBIA
by Bill Owens
Simon and Schuster/New York/paper, $7.95

For two years, working like an anthropologist, Owens photographed and taped his neighbors in their California suburb. They are pictured in their houses, backyards, at parties; and their philosophies are quoted. The result is a sometimes funny, often touching word-picture documentation of their life-styles.

Tuo-Tuo, our dog, is a very expensive household pet. It costs 30¢ a day to feed him—that's $109 a year—and $13 a month to have him groomed—that's $155 a year—not including the vet bill. We spend over $350 a year, but we don't care. We love him.
From Suburbia

EAST 100th STREET
by Bruce Davidson
Harvard University Press/Cambridge, MA/$9.50

In the sixties, many 35mm photographers turned away from the reportorial picture to the posed frontal portrait so common to the view camera work of the nineteenth century. It was, therefore, only logical for Davidson, a photojournalist working in the style of the early documentary photographers, to lug his view camera into a Harlem ghetto. For two years he worked the block and the people collaborated, presenting themselves, not as a disenfranchised group, but as individuals.

East Harlem couple, from *East 100th Street*

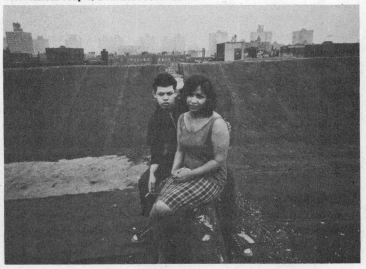

FRIDAY NIGHT IN THE COLISEUM
by Geoff Winningham
Allison Press/Light Impressions/Rochester, NY/cloth, $17.50

Hundreds of pictures of wrestlers, snapshots and fans; interviews, jazzy publicity stills and memorabilia—in short, the scene at the Houston Coliseum. You see Mil Masaras, "Man of a Thousand Masks," leap into the ring, Tim Woods deliver a dropkick to the head of Gorgeous George, Nick Kozak locked arm in arm with Sabu Singh. Overall a fine picture book.

By 7:30 the smell of fresh popcorn is in the air. Picking up my camera and tape recorder, I start down to ringside. In an hour . . . the action will begin . . . I find myself hoping . . . that tonight Bobby Shane can somehow find a victory over The Spoiler, a frightening ruthless man almost twice his size.

Bronko Lubich crouches over his partner Chris Markoff in between falls of tag team action.

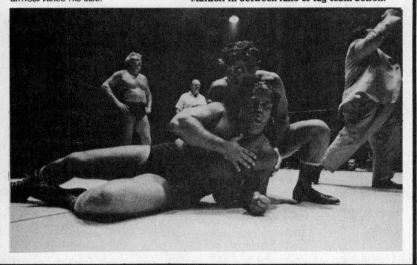

CIRCUS DAYS
by Jill Freedman
Crown Publishers/New York/cloth, $12.95, paper, $6.95

This book is lively, full of circus excitement. The introduction uses small pictures to illustrate the photographer's deep feelings for this dying tradition. Her observations about circus personnel, people/animal relationships—the whole works—gets the book off to a fine start. And then the portfolio. We see the circus come to life, move in behind the scenes for an intimate look few have experienced.

"Gramp's dead. I think I should close his eyes."

GRAMP
by Mark Jury and Dan Jury
Grossman Publishers/New York/paper, $5.95

This book is a gripping photographic record of one man's death. The pictures are not extraordinary, and the words accompanying the text are too often skimpy. But it hits you smack in the gut. It is photographed by two brothers, who along with their families, determined to treat death as an intimate family affair. For three years, they chronicled their grandfather's aging and acceptance of his own death.

VAGABOND
by Gaylord Oscar Herron
A Penumbra Project/Tulsa, OK/paper, $12.95

It is primarily a photography book, but it also uses paintings and words. In fact, it uses whatever it needs to achieve a visceral, highly personal expression about how the author feels about man's lot. The picture editing and layout superbly move together to evoke particular feelings, sensations and ideas. The care that went into producing it shows.

MORE JOURNALISM

Capa, Robert, *Images of War,* 1st ed. Grossman, New York, 1964.

Cole, Ernest, *House of Bondage,* 1st ed. Ridge Press, New York, 1967.

De Carava, Roy, *The Sweet Flypaper of Life,* 1st ed. Hill and Wang, New York, 1955.

Freed, Leonard, *Made in Germany,* 1st ed. Grossman, New York, 1970.

Gatewood, Charles, *Sidetripping,* 1st ed. Strawberry Hill Books, New York, 1975.

Heyman, Ken, *Family,* 1st ed. Ridge Press, New York, 1971

Jones-Griffith, Phillip, *Vietnam, Inc.,* 1st ed. Collier Macmillan, New York, 1972.

Klein, William, *Moscow,* 1st ed. Crown Publishers, Inc., New York, 1964.

Lyons, Danny, *Conversations with the Dead,* 1st ed. Holt, Rinehart & Winston, New York, 1971.

Magnum, *America in Crisis,* 1st ed. Ridge Press, New York, 1969.

Richards, Eugene, *Few Comforts or Surprises: The Arkansas Delta,* 1st ed. The MIT Press, Cambridge, MA, 1973.

Smith, Gene and Aileen, *Minimata,* 1st ed. An Alskog-Sensorium Book, Holt, Rinehart and Winston, New York, 1975.

A REPORT ON THE ANNUALS

Traditionally, annuals have been an excuse for bringing together a collection of pictures. In their best days, the 1940s and 50s, they were a unique outlet—even a decent showcase—for the best in serious and amateur photography. With the popularity of photojournalistic magazines and picture books, annuals started surprising us less and less, often showing the same pictures we've seen in other publications. Today it seems that editors run the same tried and true photographs, often excerpting from the popular books and shows of the year.

While it may not be immediately apparent, the annuals of today are chronicles for the future. As barometers of the picture tastes of their time, they report on the popular trends and styles.

PHOTOGRAPHY YEAR
Time-Life Books Editors

Since its network of correspondents can scour the world for the latest news in photography, Time-Life's focus is journalistic. Highlighting the year's major photographic events, this hardcover book is divided into sections: Trends, The Major Shows, Discoveries, Assignment, The New Technology, The Annual Awards, The Year's Books and Roundup. The structure gives the impression of thoroughness, but at times forces the editors to include events of little consequence. The reproduction and design are of high quality.

Time-Life Books/New York/cloth, $11.95

CREATIVE CAMERA INTERNATIONAL YEAR BOOK
Editors: Colin Osman and Pete Turner

This annual is not a sampling of the year's events, nor does it feature the latest stars on the photographic horizon. Instead, it is a quality publication, meant to be kept, read, savored and referred to time and time again. With generous gravure portfolios on people like Robert Frank—as well as contemporary photographers—interviews and seasoned articles, it is tops. The appendix has dealt with more technical subjects, including excellent articles on archival processing one year, the making, cleaning and copying of daguerreotypes another.

Light Impressions/Rochester NY/cloth, $20

THE GERMAN PHOTOGRAPHIC ANNUAL
Editors: Wolf Strache and Otto Steinert

This hardcover annual features fashion and reportage, and a fourth of the book is in color. You don't get a sense of where German art photographers are at as a whole, but the annual is a good source for picture researchers looking for the immediate picture that tells its own story. Fine German photographers such as Thomas Hoepker, are represented—sometimes by several pictures from an essay. Short descriptions at the end (there is an English edition) give interesting background information about the event, the picture and the photographer.

Dr. Wolf Strache/Stuttgart, Germany/no price available

THE BRITISH JOURNAL OF PHOTOGRAPHY
Editor: Geoffrey Crawley

There are over 200 pages in which you find just about everything. One third of the book contains articles that range from "The Evolution of the Slide Projector" to a profile of Paul Strand. The picture section, nicely printed, shows off the work of a good many people. Unfortunately, they are only represented by a few pictures (many just by one), so it's impossible to get a real sense of their worth or intent. The editors do try to limit the pictures to work done in the preceding year, a rule not usually observed by most annuals. It includes no color, but you don't miss it, either.

Amphoto/Garden City, NY/cloth, $16.95

PHOTOGRAPHY ANNUAL
Editors of *Popular Photography*

Sooner or later everyone gets published in *Pop's* annual. It's well reproduced and offers a wide variety of contemporary photographic styles for the enthusiastic amateur to dip into. The tendency in recent years has been to use fewer photographers but to give them more portfolio space. Text is kept to a minimum with short bios on each photographer. The technical section used to include the camera brand name used by each photographer, but that policy has since been dropped because of advertising conflicts.

Ziff-Davis Publishing Co./New York/paper, $1.95

U.S. CAMERA ANNUALS
Editor: Tom Maloney
U.S. Camera Publishing Corp./Out of print

They abound with photographic energy and clearly demonstrate the versatility of the medium in its freewheeling days, the 1930s through 1950s when a photograph could be anything—funny, informative or even a work of art. (Days before we all got so serious about photography as ART.) The editors, under the leadership of Tom Maloney, and with the support of people like Edward Steichen, Alexey Brodovitch, M. F. Agha, Paul Outerbridge and Charles Sheeler introduced photographers, who in many cases were to become masters of the medium. They were always concerned with the best. As a result, there is no more interesting collection of photos around.

The last annual under Maloney's editorship was published in 1965. The magazine changed hands several times and in the process the style changed.

U.S. Camera, 1936 *Frederick Shepherd*

U. S. Camera, 1942 *Lisette Model*

Excerpts from the Hippocratic Oath of a Photographer, by M.F. Agha.

I never have and never will, under any circumstances, take a picture of a nude holding a transparent bubble. Neither will I ever take, help to take, approve of taking, admire, discuss, or look at a picture of an egg.

. . .

I will not make close-ups of grapes so big that they look like apples, or apples so closed-upped that they look like watermelons.

. . .

I will not take pictures of nudes looking like tigers because of the striped shadows created by the light passing through Venetian blinds.

. . .

I will never again photograph plaster casts of Greek statues, or cabbages cut in half, or salad leaves with drops of dew on them.

. . .

I will not call a picture of a little boy standing against a wall "JUS' BOY," or a picture of a child hugging a small goat "TWO KIDS."

. . .

And last but not least: If I am compelled by the force of circumstances to photograph a Mexican child in Mexico, I will chase all the flies off his face before taking the picture (Thunder over Mexico notwithstanding). And if I can help it I will not photograph the brat at all. In fact, if I can help it, I will refrain from taking any pictures of any description, under any pretext whatsoever.

U.S. Camera, 1937

GRACE MAYER AND EDWARD STEICHEN

This grand lady ("my greatest contribution is that I never took a photograph") was curator of photography at The Museum of Modern Art when Edward Steichen was director of the department.

Now she is at work writing what is certain to be the definitive appreciation of the man who not only took photographs—from 1895, when he was 16, to 1973, when he died—but who also presented, with

his *Family of Man,* the most widely attended exhibition in photography's history. Grace plans to show 250 of Steichen's photographs and to quote copiously from his correspondence and notes. (The book will be published by Harper & Row within the next few years.)

When, early in her career, she was surprisingly selected to be a photography judge, she expressed trepidation, but was counseled not to worry. "Just stay with Steichen," she was told. Until then she had never met him. With very much of a twinkle in her eyes, she now recalls the scene of Steichen holding up a picture, nodding approval, and of her saying that it was quite satisfactory. The third judge was recalcitrant, but no matter, Steichen and Mayer racked up Steichen's choices. For one picture, Grace decided to be independent; Steichen scowled but he lost the count. When the afternoon ended Steichen said to her, "You have the most marvelously impeccable taste."

Soon after she asked him to write an introduction for her own fine look at New York, *Once Upon a City* (Macmillan, New York, out of print). He did, and then he asked her to help him put together a show called "Seventy Photographers Look At New York." She adds, "of course he asked me, what with my 'impeccable taste' and the good sense to seek him out as a writer. I didn't tell him for fifteen years about the 'stay with Steichen' bit."

In 1959 she became Steichen's full-time assistant at MOMA. With one title or another she's been there ever since, as much as anybody making of him a perpetual institution. As a side line, she corresponds with photographers from all over the world, the consequence of her work as a former curator. But there is something else that accounts for this lady receiving as many as a dozen letters a day: it is her commitment to and her great knowledge of photography, which she generously shares.

Don Myrus

INDEX TO ADDITIONAL BOOKS

Throughout *The Photography Catalog,* technical books and books of general interest have been reviewed in those chapters where they were most relevant. They are indexed here.

9

Courtesy of Norman Lipton.

MAGAZINES

WORLD PHOTOGRAPHIC PRESS REPORT

The photography magazines surveyed on these eight pages come as close as possible to being at the core of what photography is all about. Each covers at least some aspect of photography as a process or as pictures themselves. Since these magazines are published in many parts of the world, an overview of them shows photography's variety—aesthetic standards and styles—and also its unity—a growing internationalization. They vary in circulation from the great mass monthlies of America (*Popular Photography, Modern Photography,* with their combined circulation of about one-and-a-half million copies) to as few as a hundred copies, published twice a year and, at that, intermittently (*Novak's Photographic Magazine*). They represent on one end of the spectrum a huge industry involved in the production and sale of continually changing equipment, materials, processes, as well as the surprising offerings of lone artists.

On these pages the magazines have been arranged in categories according to their major purpose, i.e., amateur (for consumer, fan, hobbyist), portfolio (in which the major concern is the single picture or photo essay, whether artistic or journalistic), trade (technical publications for specialized professions) and little mags (in which we lump together newsletters, one-person-produced reviews or otherwise indefinable organs). It is this last category that seems the most exciting, as modern technology makes it possible for every person to be a publisher and as the widening interest in the field, especially among students, promises to make photography the first form of recorded expression available to everybody.

Typewriter typesetting and inexpensive photo-offset printing have made it possible for small, lightly-capitalized, technical experts to enter the photographic publishing field. An outstanding example is Ed Gately's *Photophile,* published from the Philadelphia suburb of Havertown, Pa. With editor Sarah Fought, he has created a quarterly which has quickly grown to 4,000 subscribers because its tests of films and chemicals result in no-nonsense recommendations, a feature seldom indulged in by the giant consumer magazines, who are very careful not to offend an advertiser or a potential one.

A wide sampling of the world's photographic periodicals strongly suggests that America (U.S. and Canada) is the center of great energy in photographic innovation, both artistic and technological, with the Japanese publishing quite similar work. The Europeans (French, Italians, Spanish) seem to be producing the more attractive periodicals in the slickest sense, especially in advertising photography. Since photography is a true *lingua franca,* we feel that everyone should take a look at what's happening. The price is right—no other form of education as inexpensive and as effective comes easily to mind.

Books are better to preserve what is already recognized as preservable and museum walls seem more appropriate for long study and deep appreciation, but for ideas, news, changing fashions, surprising pictures, there is no better way than the periodically printed page.

SLICK AND THICK IN JAPAN

In Japan, where photography has permeated life even more than in the United States and where a camera hanging from every neck is one of those truth-indicating stereotypes, there is an even greater need for photo magazines. Shoji Yamagishi, a photography magazine editor, points out that in his country there is not "a single art museum which collects and regularly exhibits prints" and that "most of our photo galleries belong to camera manufacturing companies and are not much more than places for advertising camera equipment." Thus the importance of the magazines for showing off pictures.

Another way to realize the weight the Japanese give their photo magazines is to weigh them. *Asahi Camera* and *Camera Mainichi* are both about the same: on an average they weigh about 700 grams and have some 370 pages, a typical issue of *Pop Photo* (Ziff-Davis Publishing, Co., New York) weighs half as much and has "only" 212 pages. (*Camerart,* the other magazine we consider, is atypical in that it has only 64 pages.)

The Japanese are big on photo contests, with *Asahi Camera* receiving as many as 10,000 entries a month.

Subscription: $35/Order from publisher

ASAHI CAMERA
Editor: Akira Okami
The Asahi-Shimbun
Yuraku-Cho,
Chiyoda-Ku
Tokyo, Japan

Asahi Camera is the oldest (April, 1926), has the largest circulation (150,000) and can be likened to a merger of Switzerland's *Camera,* the United Kingdom's *British Journal of Photography* and America's *Modern Photography.*

Subscription: $16/Wittenborn & Co./1018 Madison Ave./New York, NY 10021

CAMERART
Editor: Kunika Todoriki
Camerart, Inc.
Hinode Bldg. 11,
2-Chome, Kyobashi.
Chuo-Ku, Tokyo

It could pass for an American magazine, but it is produced entirely in Tokyo. That it's in English and has an 8½ × 11 page size are not the only reasons for making this statement. The fact is, American tastes in photography are much closer to those of the Japanese than to those of the Europeans. *Camerart* even runs test reports on equipment that will seem familiar to a reader of U.S. camera magazines.

Subscription: $10/Order from publisher

CANADIAN PHOTOGRAPHY
Editor: Irvine A. Brace
Maclean-Hunter Limited
481 University Ave.
Toronto, Ontario M5W 1A7

Striking front covers do not indicate its somewhat skimpy contents—by *Pop Photo* standards, anyway. Occasionally, there's an exceptional issue—for example, the one devoted to the Montreal Olympics on the subject of sports photography.

Subscription: $30/Orion Books, Export Dept./P. O. Box 5091/Tokyo International, Japan

CAMERA MAINICHI
Editor: Yoshihiko Uno
Mainichi Newpapers
Tokyo 100, Japan

With over 250 pages, it is a comprehensive publication, split among portfolio, criticism and technical evaluation. Its reproductions, especially those in color, are excellent.

MAGAZINES

A BRITISH VIEW
Excerpted from
The British Journal of Photography
February 27, 1976

The general feeling over here is that US photographic technical writing is too diffuse and vague. It must be emphasized that the literature in question is not the scientific, but that aimed at the advanced amateur and learning professional, which might be of use in schools. The US reader, to us, seems still in the stage that the British were in the early 50s, requiring not basic objective technical facts from which to arrive at a subjective technique but demanding a highly coloured subjective approach, which he can imbibe through the personality of the writer. Their photographic periodicals at this level derive from 'uncle' personalities as it were, writing with bluff joviality to their nephews. Sometimes the reader may have to interpret several columns of text in order to find solid ground. Most British periodicals, whatever other faults they may have, do seem to try and elucidate the basic technical principles behind whatever practical means they are discussing.

. . .

It is interesting that books and periodicals from Eastern Europe are much more in the style that we used to see in the West, almost certainly because the same abundance of off-the-shelf auxiliary equipment is not available there. Perhaps the liveliest contribution is made by the photographic press in Italy, where there are several monthlies hotly competing against one another. They are far less inhibited and contain a good proportion of fascinating and helpful technical articles. Since Japan is now the world's leading camera maker, their photographic periodicals should be of particular interest and it is a pity that the language barrier should be so complete. Their equipment test reports are, technically, very exhaustive although their interpretation of a camera's practical viability in the context of its competitors' does not match the best Western standards. In the long term it is difficult to see what the future of photographic technical writing will hold. As cameras and equipment become more automated, even the amount that the advanced amateur needs to know to cover his photographic ambitions lessens.

. . .

Perhaps, as in so many other matters today, we are in a transitional stage and the photographer is temporarily weighed down under, and bewildered by, the mass of gifts with which technology and commercial rivalry have provided him. The room for technological improvement in apparatus and materials is becoming narrower and narrower, so that when this stage is over, the natural urge to individuality and originality will, hopefully, lead to greater experimentation and the emergence of writers to describe it.

Subscription: $57.20/Order from publisher

AMATEUR PHOTOGRAPHER
Editor: R. H. Mason
IPC Business Press Ltd.
Oakfield House
Perrymount Rd.
Haywards Heath, Sussex
RH16 3DH, England

A nice fat *weekly*, chock full of ads and with plenty of good photos (lively, almost newsy); this is a great buy—$1 in the U.S., 25 p. in the United Kingdom.

Subscription: $11/Order from publisher

FOTO-MAGAZIN
Editor: Dr. Walther Heering
Ortlerstrabe 8
8 Munich 70, Germany

Good as it is, one expects more from Germany: the home of Leitz, of Zeiss, of Voigtländer. It is well organized, with its regular columns on technique, test reports, etc—but the photographs, although beautifully reproduced, are not edited to our tastes.

Subscription: $15/Order from publisher

ARTE FOTOGRÁFICO
Editor: Ignacio Barceló
Don Ramón de la Cruz, 53
Madrid 1, España

The picture editing is good and the serious photographs are printed one to a page in the manner of a fine monograph. If you are *un hombre preparado* and studied your Spanish in school, here is an opportunity to benefit from your industriousness. The magazine's technical articles and interviews with photographers are excellent.

Subscription: $14/Order from publisher

FOTOGRAFIA ITALIANA
Editor: Lanfranco Colombo
Editphoto
Via degli Imbriana, 15
Milano, Italia 20158

This magazine is unusual in that it is capable of running long thematic presentations, such as the forty pages it devoted to photographs of American Indians by the likes of Schindler, Curtis, Huffman, Brady, Soule, Vroman and Jackson. The conscientious front matter reviews books, movies and shows; the usual rundown of equipment completes the package.

Subscription: $38/Order from publisher

THE BRITISH JOURNAL OF PHOTOGRAPHY
Editor: Geoffrey Crawley
Henry Greenwood & Co. Ltd.
24 Wellington St.
London, WC2E 7DH, England

Compared to the vivacious *Amateur Photographer*, the *Journal*, established in 1854, is the distinguished don of British photographic publishing. It is so well written (an uncommon virtue among photo mags) that one thinks of it as the *London Times* of photography.

Subscription: $15/Order from publisher

FOTO
Editor: Guy Jamais
Box 3263
103 65 Stockholm, Sweden

Photography, in the Age of McLuhan, becomes increasingly internationalized. This magazine is part of the media network, showing the work of the celebrated: Duane Michals, Sam Haskins, Ernst Haas, et al. Product and process information are included too.

Subscription: $15/Order from publisher

NUEVA LENTE
Editor: Miguel J. Goni Fernández
Ardemans, 64
Apartado 8.425
Madrid, España

Any magazine that shows the pictures of Jerry Uelsmann and Eugène Atget in the same issue has got to be good, and this one does and is. Further internationalization of photography shows up in the ads (Kodak, Konica, etc.). The graphics and layouts are spirited and, like *Zoom* in France and *Fotografia Italiana*, it reviews comics.

Subscription: $18/European Publisher Representatives /11-03 46 Ave. /Long Island City, NY 11101

FOTO
Editor: Zygmunt Szargut
ul. Krolewska 27
00-950 Warsaw, Poland

Photos are mostly romantic, heavily-lighted portraits of long-tressed girls; there are also lots of pets and cute children. Lengthy articles appear, including a serialized history of photography, but there's nothing on technique or product.

MODERN PHOTOGRAPHY
**Editor: Julia Scully
Modern Photography
130 E. 59 St.
New York, NY 10022**

The two leading magazines in the field are more alike than they are different, and although *Modern Photography* is slightly the lesser in both scope and ambition, it has strong points all its own. It was the first with a black-and-white gravure section, perhaps because its editor Julia Scully is oriented more toward pictures than her counterpart at *Popular Photography,* Kenneth Poli.

Ms. Scully also knows how to present the technical side of things. Marvelous disassembly drawings are presented in ample space with clear captions so that the intricacies of the Hasselblad, say, are readily

apparent. This is true for new product developments, too. In the same month, both *Pop* and *Modern* presented luxuriantly illustrated articles about newly introduced Colorflo dichroic polarizers but *Modern's* clear layouts, picture selection and disassembled drawings gave it the edge in comprehensibility. This interest in explicating the technical is reflected in the thorough product tests made under the influence of Herbert Keppler, the magazine's publisher.

Subscription: $9/One Picture Place/Marion, OH 43302

POPULAR PHOTOGRAPHY
**Editor: Kenneth Poli
Ziff-Davis Publishing Co.
One Park Ave.
New York, NY 10016**

It is the best all-around (equipment, technique, processes) photographic magazine for amateurs (hobbyists, fans) in the world. About three-quarter million people buy it every month for a variety of reasons, such as its cast of technically expert writers, its informative, colorful ads (not exclusive to itself, certainly, but more abundant), its more and more frequent portfolios (now in black-and-white gravure), its equipment and materials evaluations, its reports on what is happening (from the small regional shows to *photokina*). From its pages several generations have learned photography—how it works and what to work with. Like school, it isn't always easy and, like the Sunday *New York Times,* not every part and department is read by everybody. Articles on basic craft tend to repeat themselves every year or two, and in general one gets the impression that the editors make photography seem harder than it need be.

At any rate, the teachers are tried and true: Norman Goldberg, who leads the technical experts, is an inventor (the first Leica motor was his brainchild) as well as a lucid writer; Jacob Deschin, who is a veteran reporter, seems to be getting more perceptive as he grows older; Norman Rothschild, who is by no means a Young Turk, is nevertheless jolly with the fun of photography; Bill Pierce is a successful photojournalist (Time-Life) who writes well with a pro's view. Then

there is Eathon S. Lothrop, Jr., the author of *A Century of Cameras,* who does a column on camera collecting, and Bob Schwalberg, an American who went to Germany to work for Leitz and who now knows as much as anybody about film, lenses, 35mm cameras. These names do not include all the regulars and none of the free-lancers, some of whom, David Vestal, for example, return to write again and again.

Although hardware is emphasized, there is virtually no important photographer in America who has not shown his work on its pages.

An index is sold for $2 a year, plus 25 cents for postage and handling (available through Falkenberg Press, Box 2228, Falls Church, VA. 22042).

Subscription: $9/P.O. Box 2775/Boulder, CO 80302

Seeing Stars and Stripes

CAMERA 35
**Editor: Willard Clark
Popular Publications Inc.
420 Lexington Ave.
New York, NY 10017**

It ran eleven pages of pictures by George Gardner on racial tension in Cairo, Illinois, in 1970 and twenty-six pages of W. Eugene Smith's essay on Minamata in 1974. It serialized, before book publication, David Vestal's *The Craft of Photography,* and when Al Francekevich—studio-photographer, technical-writer—and *Popular Photography* parted ways, it was *Camera's* 35 gain, *Pop's* loss. A. D. Coleman—the clear, perceptive, heavy-thinker of photography—writes for it as does Joe Novak, who in "Confessions of

a Street Photographer" (May, 1976) has revealed himself to be sensitive, even wise.

The *Camera 35* reader does not get the benefit of the extensive product reports and technical analyses provided by *Pop Photo* or *Modern.*

The magazine has changed ownership and editors several times; although, interestingly, the current editor, Willard Clark, was also the original one.

Subscription: $10/P. O. Box 9500/Greenwich, CT 06830

PETERSEN'S PHOTOGRAPHIC MAGAZINE
**Editor: Paul R. Farber
Petersen Publishing Co.
8490 Sunset Blvd.
Los Angeles, CA 90069**

This magazine is a regular banana split: lots of flavor, not so much substance, but good to get at. A year of it won't constitute a full-course in photography, nor do its technicians work into the night tearing cameras apart. It's for those who want to have fun in photography, the

do-it-yourself, build-it-yourself types who are dying to try out the latest gimmicks. As the hobby shop of the photo magazine mall, it takes itself a lot less seriously than it's older brothers.

Subscription: $9/Order from publisher

SUBMITTING PICTURES TO POPULAR MAGAZINES

There isn't a photographer alive who hasn't suffered at the hands of a magazine—especially when it comes to submitting work for publication. Pictures get lost, cracked, stained and burned in editorial offices throughout the world—a sad state of affairs but a real one. It's not that editors don't care. It's just that they are inundated with material, are sometimes disorganized and have busy schedules. Unless you like spending time in the darkroom, you'd best take some precautions to insure that your pictures are well treated.

If you're sending in unsolicited material, make sure your name, address and telephone number appear on the back of each photograph. (Editors work with voluminous material and an unidentified picture can get lost in the shuffle.) Of course, your material should be well packed—not just between two pieces of cardboard—and labeled "Do not bend." It doesn't hurt to include a self-addressed, stamped envelope, especially if you're submitting a few pictures to a small publication. Always indicate how you want the material returned, whether by first-class or registered mail—color work certainly should go registered. Some photographers even insist that pictures travel by messenger, if they are especially valuable.

If you're presenting your work in person, there is no one best way. Some editors flip through pictures as a card shark shuffles cards. (It's hard to imagine a good editor ever treating pictures or a photographer that way, though.) Others will want to talk—not necessarily about your pictures but about photography, your interests and feelings about your work. You'll be handled in a variety of ways. Be prepared. Sometimes you'll be told to leave your work with a secretary or assistant and never get to see the person who selects the pictures. (Try to avoid magazines that have this conveyor-belt mentality.) Although editors are busy, it's best to try and see them—not to explain your pictures, but to make human contact. If editors insist you leave your work, have them make a selection of pictures in which they're sincerely interested. If there's doubt in their minds, and you don't have to have the work to show elsewhere, leave what you can. Editors' needs always change and at the last minute something in which they had no interest can save their skins.

The worst thing about submitting pictures to photography magazines is the time it takes to get them back. If you're submitting to a European magazine, that time can stretch into months and months. Send a set of slides, even if your material is black and white, if you don't want to let prints go for that long. (We even know one editor who never returned material and ended up using it in a book and copying it for lectures—all without the photographers' permission.) If the publisher is local, a telephone call or two can usually pry your work loose.

Always, always get a receipt for what you're leaving behind. Count the pictures so you're sure one doesn't go astray along the way. The ASMP lawyer, Bob Cavallo, recommends that a "delivery memo form" be used with *every* submission. The form reproduced here protects the photographer from the kinds of lapses mentioned above. For some people it will seem too complicated, but it's thorough and protects you in all areas. If it's not your style, try a simpler version, but remember, the idea is a good one.

Terms of delivery:

1. All materials are submitted on a 14-day approval basis. Unless a longer period is requested, and granted by me, in writing, a holding fee of $5 per week per color transparency and $1 per week per black-and-white positive will be charged commencing with the 15th day and continuing until the return of the materials. A research fee of $ _____ will be billed on material requested and sent to recipient, but not used.

2. Materials may not be used in any way, including, without limitation, layouts, sketches and photostats, until submission of an invoice indicating Recipient's right to use same, or purchase of the materials outright, which shall be only on terms of use as specified in such invoice.

3. Recipient is responsible for loss or damage to all materials delivered to it, from time of receipt until their return to me. Projection of transparencies is specifically not permitted. Recipient shall be responsible for safe delivery and return of materials to me and shall indemnify me against any loss or damage to materials in transit or while in the possession of Recipient. This agreement is not considered a bailment and is specifically conditioned upon the items so delivered being returned to me in the same condition as delivered. Recipient assumes an insurer's liability herein for the safe and undamaged return of all materials to me. All materials are to be returned either by bonded messenger, or by registered mail (return receipt requested), prepaid and fully insured.

4. The monetary damage for loss or damage of a color transparency or photograph shall be determined by the value of each individual photograph or transparency. Recipient agrees, however, that the reasonable minimum value of such lost or damaged photograph or transparency shall be no less than $1500. I agree to the delivery of the materials herein only upon the express covenant and understanding by Recipient that the terms contained in this paragraph are material to this agreement. Recipient assumes full liability for its employees, agents, assigns, messengers and freelance researchers for any loss, damage or misuse of the photographs.

5. Any objection to these terms are to be made in writing within ten (10) days from receipt of this Delivery Memo. These terms are made pursuant to Article 2 of the Uniform Commercial Code.

6. Any and all disputes arising out of, under or in connection with this Delivery Memo, including without limitation, the validity, interpretation, performance and breach hereof, shall be settled by arbitration in _____, pursuant to the rules of the American Arbitration Association. Judgment upon the award rendered may be entered in the highest Court of the Forum, State or Federal, having jurisdiction. This Delivery Memo, its validity and effect shall be interpreted under and governed by the laws of the State of _____. Recipient shall pay all costs of arbitration, plus legal interest on any award.

© ASMP, 1975

Delivery Memo:

No. _____
Date _____
Client Project No. _____
Title _____

To: _____

Enclosed please find:

Set No. & Subject:	Format:	35	2¼	4x5	5x7	8x10	11x14	Contacts
Total Black & White	Total Color							

Kindly check count and acknowledge by signing and returning one copy. Count shall be considered accurate if said copy is not received by return mail.

MAGAZINES/portfolio

CAMERA
Editor: Allan Porter
C. J. Bucher Ltd.
Zurichstrasse 3
Lucerne, Switzerland

Founded in 1921 by the printer C. J. Bucher (Lucerne, Switzerland), this monthly, which rightly calls itself "an international document of nineteenth and twentieth-century photography" was sold in the mid-seventies along with the printing company. The American-born expatriate Allan Porter, who has been the magazine's editor for over ten years, has stayed with the magazine. The question still exists as to whether previous standards of quality will be maintained—superb printing, beautiful paper, luxurious (even extravagant) gatefolds and graphics,

From the December, 1970, issue.

which have included colored type and other rococo flourishes. (Since the sale, the magazine has been printed by offset lithography, not by sheet-fed photogravure.)

Of course, the real importance of *Camera* has been as a prestigious showcase.

Issues are sometimes devoted to the work of a single photographer; sometimes they have themes: "Coney Island" (March, 1971) showed that amusement park over a span of fifty years, as photographed by Steve Salmieri,

Robert Frank, Leon Levinstein, Lisette Model, Weegee, Byron, Adolph Wittman, Samuel H. Gottscho. The quality of the writing in *Camera* (it's translated into several languages, including English) has been sporadic, though a fine example is the essay in the December, 1970, issue entitled "1890-1914 Pictorialism" by R. E. Martinez—himself an earlier editor of the magazine.

Subscription: $29/Ralph Baum/Modemage Photo Services/319 E. 44th St./New York, NY 10017

OVO/PHOTO
Editor: Jorge Guerra
P.O. Box 1431, Station A
Montreal, Quebec H3C 2Z9

About 1,000 Canadians and Americans subscribe to this black-and-white quarterly. Although pictures are the same, there is an English text version and a French one. Portfolios of both nineteenth and twentieth-century photographers are well reproduced. Books and exhibitions are intelligently reviewed. All in all, it's Canada's answer to England's *Creative Camera*.

Subscription: $8/Order from publisher

APERTURE
Editor: Michael E. Hoffman
Aperture, Inc.
Millerton, NY 12546

Now 9×10½ inches in size and eighty pages, the magazine in its twenty-three years has gone through a lot of changes. It was begun in 1952 in San Francisco as a forum for serious writing about photography and as a showcase that would have the finest of reproduction. The

thought was that it would fill the need created when Stieglitz's *Camera Work* ceased publication in 1917. Founders included the photographers Ansel Adams, Dorothea Lange, Barbara Morgan, Dody Warren and Minor White. White was its first editor.

Current editor Michael E. Hoffman, responding in Volume 19, Number 4, to an irate subscriber's opinion that earlier *Apertures* embodied too much "book-like-ness" and that publishing practices were "eccentric," replied: "work is now underway to renew the magazine, to go beyond what has become 'the Aperture aesthetic,' although it was refreshing when first published. We hope to increase the number of pages as we have done in this issue, produce about eight pages of color per issue, and encourage the participation of a much wider number of people."

Since 1968, one or two issues of the quarterly have been catalogs of major exhibitions: *French Primitive Photography,* a joint venture of Aperture and the Philadelphia Museum of Art, is an especially fine issue. It reviews the important technical innovations in France and the early inter-relationship between art and photography.

Subscription: $17.50 for four issues/Order from publisher

HISTORY OF PHOTOGRAPHY
Editor: H. K. Henisch
Taylor & Francis Ltd.
10-14 Macklin St.
London WC2B 5NF,
England

This is to be a new international journal published quarterly from London by the same house that has done *Philosophical Magazine* since 1798. It will be edited by H. K. Henisch, who is a professor of the history of photography at Pennsylvania State University. Advisory board members include Jerome Borcoman, National Gallery of Canada; Helmut Gernsheim, Switzerland; Nada Grcevic, Yugoslavia; Beaumont Newhall, University of New Mexico; Otto Steinert, Museum Folkwang, Essen.

The journal will be mostly devoted to original scholarship and will be of interest, according to its editor, to those involved in history, science and art—both academics and knowledgeable laymen.

Subscription: Address inquiries to the publisher

REVUE FOTOGRAFIE
Editor: Daniela Mrázková
Dlouhá Tř. 12
Prague 1, Czechoslovakia

Hurrah for the East Europeans! and the Czechs in particular. Their handsome quarterly magazine presents the best in East European photography. In 1975 the conception and layout of the magazine radically changed. It was a stunner on war photography—many pictures we'd never seen, including some by Robert Capa. Another issue was on photography and sociology. Usually the magazine lets photographers speak for themselves. A short (Oh, how we wish it were more complete!) resume in English, French and German gives the reader the gist, but to fully appreciate this editorial effort, a course at Berlitz would help. All the same, if not for the reading, it's great for the looking.

Subscription: $13.60/Ebasco Subscription Service/17-19 Washington Ave./Tenafly, NJ 07670

PHOTO
Editor: Roger Therond
l'Union des Éditions Modernes
65, Champs-Élysées
75008 Paris, France

Lui was an imitation of *Playboy*, which was also imitated by *Penthouse*. *Oui* was an imitation of *Lui*. If Peter seems to be copying Paul, you haven't heard all of it yet. Daniel Filipacchi, the Frenchman who founded *Lui*, also publishes *Photo*, which, before we forget to say it, is a very well-edited magazine of photographs excellently printed on good paper. Anyway, Filipacchi has long been trying to get *Photo* to America. He tried to go into business with Hugh Hefner, his partner in *Oui*, but that union never came off; he did get a number of issues published through an association with Downe Publications, and that collapsed. Enter photographer/publisher Bob Guccione, the American who went to England and who came back with *Penthouse* to make a fortune. Now Dan and Bob have joined together to bring out *Penthouse Photo World*. It's in English.

Subscription (*Photo*): $17 for 12 issues/Order from publisher
Subscription (*Penthouse Photo World*): $12 for six issues/Order from publisher

PENTHOUSE PHOTO WORLD
Editor: Bob Guccione
Penthouse Photo World
909 Third Ave.
New York, NY 10022

CREATIVE CAMERA
Editor: Colin Osman
Coo Press
19 Doughty St.
London, WC1, England

Everything about this publication echoes its commitment to photography as a means of personal expression. If you're looking for technical mumbo jumbo you'll have to go elsewhere; there's not a page here. (Actually the magazine started out as a how-to mag called *Camera Owner* and slowly evolved over ten years to its present philosophy.) Now the editors labor over gravure portfolios and three special sections. "*Views*" excerpts pithy quotations from people involved in photography. Although it publishes fewer and fewer major articles, they are winners. "Gallery Guide" is a reasonably complete listing of what's on in galleries around the world; "Books Received" provides just the right kind of noncritical information that actually helps you make up your mind intelligently about whether a book's worth the price. All in all one of the best magazines around.

Subscription: $20/Light Impressions/PO Box 3012/Rochester, NY 14614

ZOOM
Editor: Joel Laroche
Société Publicness
2, Rue du Faubourg Poissonnière
75010 Paris, France

Brilliant graphics (especially the front cover) and the best photography in a magazine since the demise of the German *Twen*. *Zoom* is more sophisticated than *Esquire* although not as literary, less focused (on photography) than *Camera*, and far and away more maturely erotic than *Playboy*. But don't think *Zoom* is parochially prurient. No, rather, it is catholic in the type of photography shown: high-arty, graphic-designful, journalistic—the latter in the style of the great picture magazine, *Paris Match*.

The magazine deserves an American edition—deserves and needs, since each issue is very costly to produce.

Besides fancy layouts for its 9½ X 12¾ inch page, the magazine is of interest to equipment enthusiasts. Mostly, though, it serves

PHOTO-FORUM
Editor: John B. Turner
Photo-Forum
P.O. Box 10-163
Auckland 4, New Zealand

Although not as well reproduced as the other publications in this category, the magazine nonetheless does a good job of presenting the work of New Zealand photographers. It also reports on local workshops and schools publishing the best work. The "Assignment" section lets you test yourself. Each month a subject (e.g., reflections) is suggested, and the best results are published. A "Hardware and News" section keeps readers informed about technical, gallery, workshop and publishing activities. Major books are reviewed at length.

The page is in proportion to the popular uncropped 35mm frame. Since the horizontal format is the more natural, the *Photo-Forum* designer presents horizontal pictures on their sides. That is, you have to turn the magazine 90° on its axis to look at many pages. We like that—to look at big pictures unbroken by the gutter.

Subscription: $9/Order from publisher

photography with portfolios lusciously presented. It's in French.

Subscription: $45/Order from publisher

143

HOW TO START YOUR OWN NEWSLETTER, LITTLE MAG, WHATEVER

If you have an overwhelming need to proclaim, you possess the essential drive to be an editor-publisher. The process is demanding but not much more so than writing a long—very long—letter. A little money is essential, and its absence probably keeps more people from saying their say and otherwise showing off in print than any other single factor. Once you know how, the mechanical part is easiest. These days, for a "low-budget" publication, copy is typed on an IBM Executive with a carbon ribbon (essential to get a clear impression). In one case, the 8½ × 11-inch typing paper is lined with light blue pencil, which doesn't photograph, in two columns of four-inch width each. The columns are typed up flush left, ragged right. The copy is then cut into sections and re-arranged according to importance and conditions of fit. Photographs—not pasted down and not to size—are sent with the type script to an offset printer, who "shoots" the type, makes correct-size halftones out of the photographs, strips them together, makes a negative and offset prints onto two 17½ × 22½-inch sheets of fifty-pound paper that is then folded, inserted and stapled into a sixteen-page, 8½ × 11-inch "booklet." The cost is about $300 for 1,000 copies. The publication is then labeled and mailed by bulk rate. Who to? That's up to you . . . to whoever you want to reach with what. There are direct-mail brokers with lists of names of about every category of person. See the *Yellow Pages.*

PHOTO REVIEW
Editor: Larry Siegel
Midtown Y Gallery
344 E. 14 St.
New York, NY 10003

A simple, four-page newsletter in typewriter type by a gallery director, photographer and teacher who is concerned that New York City does not have enough publications for photographic criticism.

Subscription: $5/Order from publisher

THE PHILADELPHIA PHOTO REVIEW
Editor: Stephen Perloff
Dry Mount Press
3619 Baring St.
Philadelphia, PA 19104

This ten-pager, published monthly, is tastefully done and tends toward the serious side. It lists shows, classes, workshops, lectures, has decent reproduction, nice picture-selection.

Subscription: $5/Order from publisher

ASPP NEWSLETTER
Editor: Helen Faye
Box 5283, Grand Central Station
New York, NY 10017

Sixteen pages of typewriter type and photos stapled together, it's sent to members of the American Society of Picture Professionals five times a year.

Subscription: $2/Order from publisher

DOCUMENT
Editor: Richard Kasak
Document Magazine
416 Park Ave. S.
New York, NY 10016

Each is a single portfolio in newspaper format, excerpting from a recent exhibit or publication—in one issue, the work of Arthur Tress; in another, cult hero Spider Webb's photo collection of examples of tattooing in the early 1900s. The offset reproductions are on newsprint, so not of high quality. A low-cost experiment.

Subscription: $18/Order from publisher

PHOTOGRAPHICA
Editor: George Gilbert
The Photographic Historical Society
of New York
P.O. Box 1839 Radio City Station
New York, NY 10019

This publication seems on its way from a newsletter to a magazine. For collectors and historians, it has knowledgeable contributors, good reviews of books and it's illustrated.

Subscription: Included in $15 annual membership.

THE PHOTO REPORTER
Editor: Jacob Deschin
Modernage
319 E. 44 St.
New York, NY 10017

An old-timer at five years of age, this sixteen-page decently reproduced illustrated newsletter covers photographic news mainly out of New York City. By a photo columnist of wide experience.

Subscription: $5/Order from publisher

PHOTOPHILE
Editor: Sarah S. Fought
57 W. Hillcrest
Havertown, PA 19083

A craft-oriented quarterly of 32 pages, which is cleverly designed—with alphabetical-numerical corner notations and three punched holes—so that its parts can be filed and used by category. Worth ordering for the subject index of articles from *other* photo magazines.

Subscription: $8/Order from publisher

NOVAK'S MAGAZINE
Editor: Joe Novak
Sensitive Zimmerman Press
3 Everett St./Cambridge, MA 02138

This solo effort by the Woody Allen of photography is brilliant and funny as hell. In long-hand, spiral bound, in a printing of 100 copies, it comes out, unpredictably, twice a year. No back copies. Unique and bawdy. (See page opposite for a sampling.)

Subscription: Order from publisher/$3 each

HOW to BECOME a PHOTOGRAPH-IC SUPERSTAR ☆ ★ ☆

Simon Nathan did it. Minor White did it. I did it. Plenty of no-talent slobs have done it. Norman Rothschild almost did. Ed Meyers gave it his best shot. Maybe you can do it. Here are some tips to help you on your phony way. But first, a list of equipment which might prove useful:

acceptable 35 mm cameras:
- very new Canon F2
- old black Nikon F, with a lot of brass showing through the black (sandpaper if necessary)
- black-taped Leica M-2
- two dented Pentaxes, with leather coming unglued.
- Nikon SP

Other acceptable cameras:
- (in Cambridge, Mass.) the SX-70
- the Simon/Wide
- anything frightfully expensive and esoteric

acceptable medium-format:
usually only Hasselblad, but if you're old and funky, you can get away with a Rollei.
(Imogen, Dickie Avedon)

acceptable light meters:
- any Weston but model 6 and the XM series
- most spot meters
- any Spectra
- flashing a Luna Pro will neither help you nor hurt you. any other Gossen meter will lose you points, except the special-purpose ones, e.g. color temp. meter.

large format:
Linhof, Cambo, Sinar - most o.K. Arca-Swiss is the "in" cheap camera. But don't be seen with those cheap cameras with red bellows. People will think you're a shipping clerk taking a home-study course, and you will never make it in that area.

PROP BOX

No photographer who ever made it big neglected this all-important piece of equipment. When ideas just won't come, the prop box will save your skin again and again. The contents of top photographers' prop boxes are remarkably similar:

1/ BROKEN DOLLS - these are a great pathos-generator, and almost never fail to please. Very versatile - can be used to illustrate desolation, poverty, loneliness, catatonia - anything at all. Delightfully ambiguous. According to Jerry Berndt, a very successful film crew in Vietnam carried a broken doll from one bombed-out village to the next. They'd always have some footage of the doll lying on a pile of rubble.

2/ GAS MASK - What photographer can you think of who hasn't been helped by one of these? Can you photograph a pregnant woman without one?? Not in Secaucus, New Jersey.

3/ BRA, GARTER BELT, and NYLONS. You can always ask a friend to play "Queen For a Day". Everybody's buying transvestite pictures!

4/ Vampire Blood - That's the brand-name. Buy it at the joke shop. A personal favorite of mine for low-key shockers.

THE PROFESSIONAL PHOTOGRAPHER

Mgr. Editor: Donald L. Wiley
PPA Publications
1090 Executive Way
Des Plaines, IL 60018

Slick, slick! And professional. Every once in a while even a little arty. This magazine states that it is the oldest professional photographic publication in the Western Hemisphere (founded 1907), and it is the official journal of the Professional Photographers of America. It is not as high in content as other magazines in this category, but it touches all bases, and if you are into wedding or portrait photography it'll be up your alley. We especially like its ads which rival each other for sheer imagination. Issues often focus on one subject—portraiture for men, markets—and when they concentrate they do a better job.

Subscription: $10/Order from publisher

BULLETIN

Editor: Henri Dauman
The Society of Photographers in Communications
60 E. 42 St.
New York, NY

It took twenty-four years, but this guild magazine of the ASMP—originally the American Society of Magazine Photographers, now the Society of Photographers in Communications—finally found its own voice. For years, as *Infinity*, it was relevant to its membership—some 1,200 communications photographers. Ironically, when they kicked the pictures out, things fell in place. Now, the magazine covers virtually all areas of interest to the members: stories on the marketplace, on legal protection, technical evaluations by *members* who have tried certain equipment and found it good; even some esoteric articles on things like psychology and photography—all find their way into its pages. It reports on guild activities, has a calendar of coming events and a small classified section. Although the magazine is intended for members, its articles are interesting to anyone.

Subscription: Free to ASMP members

NEWS PHOTOGRAPHER

Editor: Marjorie Morris
170 West End Ave.
New York, NY 10023

A good place for news photographers in the National Press Photographers Association to show off their better work and for Minolta and Kodak—to push their products to a specialized audience. In 1974 the title was changed from the *National Press Photographer;* since then it has been edited with the idea that news photography can be of interest to a wide variety of media people—TV producers, for example. One issue per year features winners of the NPPA "Pictures of the Year" contest—in a recent issue, a 27-page portfolio, some in color. The regular Pictures of the Month section also appeared, including judges' comments like this one about a "1st Place, News" winner of Senator Henry Jackson being spit on by a demonstrator: "In ten years, this picture will still be a sign of this election." Besides running contests and the portfolios of Pulitzer Prize winners, articles are published that have been written by managing editors, and the like, which deal with improved ways to get and to show pictures. A classified section (jobs, used equipment) was added recently.

Subscription: $7.50/Order from publisher

INDUSTRIAL PHOTOGRAPHY

Editor: Barry Ancona
United Business Publications
750 Third Ave.
New York, NY 10017

Chock-full of ads and heavy with photos of specialized equipment, this monthly might put off the uninitiated. But it repays careful attention, even if you're not on assignment for IBM. Here are the titles of two articles in a recent issue: "Think Custom—even the largest in-house photo units sometimes turn to an outside lab" and "A Basic Rapid-Access System—exposure to multiple prints in less than ten minutes." An effort is made to show the better work of the profession. There is a classified section in which an ad appeared for an industrial film writer-producer: "top salary, ideal Southern California location, excellent benefits." Nice work if you could get it.

Subscription: $10/Order from publisher

PHOTOMETHODS

Editor: Fred Schmidt
Ziff-Davis Publishing
1 Park Ave.
New York, NY 10016

For the professional photographer who wants to keep up with the latest equipment and techniques that will enable him or her to do the best job, this magazine does its job admirably. The *Scientific American* of industrial periodicals, it is aimed at people in science and industry—those who use photography as a tool in their work. It covers areas most magazines ignore: astrophotography, medical, photomicrography. Major articles are written by experts in the field and extensive bibliographies are a unique feature of the special issues. The regular sections on books, equipment, shows, education and upcoming events are all technically slanted. Even if you're not a pro, but are interested in the technical side of the medium, you'll have a good read here.

Subscription: $10/Order from publisher

10

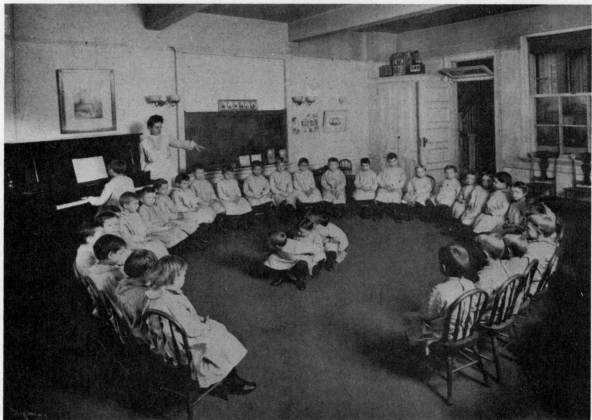

The Byron Collection, The Museum of the City of New York.

SCHOOLS

MR. PHOTOGRAPHER, BSc., MFA, PhD

Edward Weston once remarked that he could teach his sons the basic photographic process in an afternoon. His comment was not meant to underscore his sons' intelligence nor to belittle the medium to which he was devoted. Weston was instead explaining how, when you come right down to it, taking a picture is a fundamentally simple procedure. He knew that anyone can master the equipment, materials and techniques and produce pictures almost at once.

Weston died in 1958, a decade before photography captured the enthusiasm of young Americans. In his day, most photographers were self-taught mavericks who lived in an environment that was at best indifferent to photography as an art and just tolerant of it as a respectable profession. From where he stood and considering where photography stood, there was no way that he could have foreseen that photographic education would evolve as a major force in American society.

During the 1960s college students revolutionized American education by demanding courses that related to their everyday lives. Numerous photography courses were offered, and by 1967 some 800 students were studying the medium. Only three years later there were 4,000 students, and by 1976 the number had risen to 75,000. Today over 250 colleges offer undergraduate and graduate degrees.

Because of the increasing number of students and the popularity of photography courses, today's good teachers enjoy prestige within the photographic world. More and more photographers from the commercial and fine arts fields are turning to education to earn a living. The fact that faculty members can easily obtain sabbatical leaves to re-educate themselves, to work on personal projects or to teach at other schools makes teaching an attractive profession and the movement from school to school lively.

Since photography generally divides into specific areas of study—history, journalism, commercial courses or fine arts programs—the schools can be grouped according to their emphasis. Schools like the University of Missouri, with its excellent journalism program, or the Rochester Institute of Technology with its emphasis on commercial/vocational training are numerous. We've selected some of the best and listed under Journalism and Vocational/Commercial schools.

The students who study fine arts photography and the history of the medium consider the picture-making process an end in itself. They study the medium either to be artists or art historians. Each year more American programs are oriented toward teaching, studying the history of the medium and using the camera to produce art. You'll find a list of prominent ones under History and Fine Arts Schools.

Why study photography formally? If you plan to go commercial, i.e. feed yourself and family via it, then a thorough study of the principles and techniques of photography is a definite advantage. The competition for jobs is fierce—there are ten graduates for every job and who knows how many non-graduates—so having a thorough foundation in the medium could give you an edge. Today a graduate degree is absolutely necessary to finding either teaching or museum jobs.

For art students, the reasons for a formal education are less clear, since no one can be taught to be an artist. Neither Atget nor Picasso needed a degree to do their work. But schools do provide a community of fellow artists, and getting a degree does mean that you've at least gotten a liberal arts education.

THE SOCIETY FOR PHOTOGRAPHIC EDUCATION—STANDARDS FOR THE FUTURE

Every profession has a society, but this one is less exclusive than most. Membership is open to anyone in sympathy with its stated aims to promote high standards for photographic education and to work to support high standards in the art of photography. These are lofty goals and purposely ambiguous enough to accommodate the many diverse directions that thinking in the field has taken. Specific programs are not so well defined. The organization mainly acts as a focus for bringing together people active in photography to discuss current work and ideas. Meetings are held annually and in the past have included panels on photo education, specific problems in the history of photography, non-silver and early processes, contemporary work, self-publishing, artist-museum relationships, grants, workshops. Regional chapters support the national organization. Their address is the Society for Photographic Education P. O. Box 1651, F.D.R. Post Office, New York, NY 10022.

THE NEW SCHOOL FOR SOCIAL RESEARCH

This institution, located in New York City, is the archetype for continuing education. There are no degree programs with traditional academic majors yet a range of courses on various subjects are offered to any and all who have the motivation to learn. Both day and night classes are offered, one day a week per class, in three sessions throughout the year. Prices start at $150 per course. For photographers, there are over seventy courses, many of which are taught by leading professionals in the field. In fact, one of the chief functions of the place is to bring together the practicing artists and professionals with students interested in the various disciplines. Classes are arranged by the administration, who solicit New York area photographers to teach their specialty, provided enough students are interested. Thus, you can take a course on master printing from George Tice or learn directly from Philippe Halsman about portraiture. Every type of photography is taught, and the facilities are excellent.

66 W. 12 St./New York, NY 10011

Exposure is the journal of the SPE. It summarizes the ideas of the national meetings, has interviews with practicing photographers, reviews of the latest publications and current activity on the workshop circuit. If you want to teach, you'll find the section of want ads invaluable, with its current listings of available positions. Free to SPE members, it's a good reason to join.

An Interview with HARRY CALLAHAN

THE "NEW" HISTORY

The history of photography as a discipline is relatively new, only about ten-years-old except for the past efforts of a few individuals and institutions, like Beaumont Newhall and the Eastman House. Not surprisingly then, there is not a single institution today that offers a degree specifically in the history of photography. Art and photography departments offer the most courses, but largely in support of their own programs. Art history, journalism, mass communications and American studies are other areas it's studied under. But, the need for sophisticated knowledge of the field is growing. Programs are beginning to appear and will increase.

Newhall's *History of Photography* is still, after almost forty years and many revisions, the definitive work. Practically *every* history of photography course uses it. But even he admits that it is insufficient today. While the main thrust of the study will continue to be art history, a new scope is being recognized. Photography is art, science, technology, social science and commerce, and the history will stress this breadth. Robert Wagner of Ohio State talking about a history of photography curriculum said: "You will have to be knowledgeable in the chronology of photography . . . in the technical processes . . . some knowledge of the craft . . . of art history, particularly in the 19th century . . . to know something about history as history, the discipline of history, the historical methodologies . . . the technological developments of the 19th and 20th centuries . . . some knowledge of library science, the management of archival materials and information retrieval . . . of music and other related arts . . . of behavioral science and its research methods . . ." A lot to know, but if we are to search beneath the pictorial quality of photographs and try to understand their

visceral effect upon our senses, it will take more than simply finding a niche for photography in the pantheon of the arts. A very practical reason for the versatility of this program is the state of the job market for photo historians. The demand is there (for example, there's not a complete cataloging of the work of any photographer), but the money isn't and knowledge of related fields will help in job hunting. (Most experts say it's mandatory.) But don't be discouraged. The field is still in its infancy.

Here are some of the best schools to go to.

ARIZONA STATE UNIVERSITY
Art Department
Tempe, Arizona 85281
Degrees: B.A., M.A., in art history with history of photography emphasis.
Teachers: Bill Jay
Courses: 19th-century, 20th-century, photography in the 70s, graduate seminar, independent study. Fast-expanding from fine arts supportive role to full department, but right now doesn't have strong source materials, library, etc. Grow with it.

BOSTON UNIVERSITY
Department of Fine Arts—Room 205
725 Commonwealth Ave.
Boston, MA 02215
Degrees: B.A., M.A., Ph.D., in history of art with photography history emphasis.
Teachers: Carl Chiarenza
Courses: Photography and the American scene, Problems in history of photography, approaches to, seminar in, independent study. Focus is the aesthetics, psychology and philosophy of art with photography emphasis.

OHIO STATE UNIVERSITY
Department of Photography and Cinema
156 West 19th Ave.
Columbus, Ohio 43210
Degrees: B.A., B.F.A., M.A., Ph.D., theory, history or criticism of photography.
Teachers: Robert Wagner, Alfred Clarke, Walter

Craig and staff.
Courses: Survey history, the early years, 20th-century to 1940, 1940 to present, reality image I & II, 19th-century processes, independent study. Interdisciplinary, Department head Wagner's word for photography is "ubiquity."

PRINCETON UNIVERSITY
104 McCormick Hall
Princeton, New Jersey 08540
Degrees: Ph.D., in history of art with an emphasis in history of photography.
Teachers: Peter Bunnell
Courses: Survey history, 20th-century history, seminar in 19th-century photography, seminar in 20th-century photography. Only one faculty member but extremely articulate and well connected. You won't leave here without a thorough art history background.

UNIVERSITY OF NEW MEXICO
Art Department
Albuquerque, New Mexico 87131
Degrees: B.A., M.A., Ph.D., in the history of photography and graphic arts.
Teachers: Beaumont Newhall, Thomas Barrow, Van Deren Coke and staff
Courses: 19th- and 20th-century photography, photography since 1950, graduate seminar, "problems in art history"—seminar subject rotates with semesters, independent study. Many perspectives available, the best around.

UNIVERSITY OF ROCHESTER—GEORGE EASTMAN HOUSE
900 East Ave.
Rochester, New York 14607
Degrees: B.A., in art history with history of photography emphasis.
Teachers: Robert Doherty and staff of Eastman House
Courses: Introduction to 19th-century, 20th-century, seminars in 19th, 20th-century, and photojournalism. The Eastman House is *the* photography museum, and Rochester is a major photography center—everybody who's somebody is there sometime.

Pictured here is the study center of the Center for Creative Photography at the University of Arizona. It will house the archives of Ansel Adams, Harry Callahan, Wynn Bullock, Aaron Siskind, and Frederick Sommer. It is also amassing a collection of anonymous snapshots for use by historians as historical aifacts. Headed by Harold Jones, former director of the Light Gallery in N.Y.C., the center's only a year old, but has a varied and ambitious program to circulate knowledge of twentieth-century photography.

845 North Park Ave., Tucson AZ 85719

HISTORY OF PHOTOGRAPHY INSTRUCTION
Donald Lokuta
Kean College/Union, NJ 07083/$2, order c/o author

This is an in-depth study on the state of photographic history instruction in the United States. The contents include a survey of all institutions offering courses, interviews with experts, listings of courses by school and a detailed list of all the books used in these courses.

WHY VOCATIONAL SCHOOL?

These schools exist to provide students with a complete grasp of photographic techniques needed for commercial work. The idea is not the development of a personal style. Of course the best commercial people do have one, but that comes later.

The two keys to commercial success include being able to bring your technical knowledge to bear on a problem-solving situation for a client and keeping that technique diversified enough to adopt it to the changing styles of commercial presentation. Developing these qualities is what these schools are about. Some experience in the complicated business side won't hurt either. Don't think you'll get out of one of these schools and become an immediate superstar. The next step is usually to work as an assistant (see the box below). You don't necessarily need school to become an assistant, but a bigwig commercial man won't hire someone without formal training or lots of experience. These schools offer the training minus the real-life intense pressure of commercial work that is so often the death of someone who doesn't know what he's doing. Eventually, you'll have to deal with that pressure, so get equipped. Schools are the best place to acquire the solid fundamentals in hardware, processing, lighting and camera technique (all formats) that are essential for even getting a foot in the door.

This student at work in an R.I.T. studio. Knowledge of lighting, camera technique, studio supports, film and processing are required for even this seemingly easy shot.

COMMERCIAL PHOTOGRAPHER'S ASSISTANT

"Can you load a Hasselblad and a Nikon fast?" That's the first thing a photographer will ask a potential assistant. Then you'll hear the story about the guy who got fried by dismantling a strobe unit with the power still on. These items translate into the main jobs of an assistant: know the equipment and play an essential supporting role to the photographer. This is the traditional idea of the master-apprentice relationship and is the best way to break into commercial photography. You can expect long hours for little money and a lot of drudge work at the beginning.

There are two kinds of assistants, free-lance and staff. Staffers get steady work and can learn everything about a photographer's technique. Free-lancers must know how to operate all kinds of professional equipment and some experienced hot-shots command as much as $75 per day. Of course, the idea is to eventually set up your own studio. This transition is tough and people who know say that patience is the key to success. It's not unusual for people to assist for ten years or more to really get the business down, and that's what it's all about.

BASIC PHOTOGRAPHY, PROFESSIONAL PHOTOGRAPHY
by M. J. Langford
Amphoto, Garden City, NY 11530/paper, $10

For those who want to be commercial photographers, but can't go to one of these schools for whatever reason, these books are the most complete and authoritative treatment of the entire field. Don't be fooled by the title *Basic Photography*. Anyone who absorbs the contents of this book will know more about photography than you'll ever need. It deals in depth and in great technical detail with every variable of the process. The theory and physics of light, laws of optics, the equations and reactions of the chemistry, are but a few of the subjects covered. Despite its technical nature, its format is planned for self instruction. At the end of each chapter is a summary of the contents and review questions to check your retention of the material. *Professional Photography* explores all aspects of photography as a means of earning a living. Three sections deal respectively with the profession's structure: its history, opportunities and the roads to them; how to handle the jobs you get; the intricacies of needed equipment, additional staff and smooth follow-through; and the business expertise, that is, calculating your hourly costs, legal aspects and promotion. All this and more are covered. In fact, these are standard texts in many schools and are valuable to anyone interested in a thorough knowledge of photography.

ART CENTER COLLEGE OF DESIGN
Photography Department—1700 Lida St. Pasadena, CA 91103
Degrees: B.S., B.F.A., M.S., M.F.A.
Teachers: Charles Potts and staff (20)
Courses: technique, lighting, art and design, advertising, amgazine and industrial illustration; b&w and color. Mentioned in the same breath with R.I.T. "All photography must combine craftsmanship and concept." Excellent facilities, with a program designed to qualify students for any and all photographic situations. Many successful art directors are graduates of the Art Center School.

BROOKS INSTITUTE
2190 Alston Road
Santa Barbara, CA 93108
Degrees: B.A. in photography
Teachers: Herbert Boggie, director and staff (18)
Courses: six major areas of study—illustration, industrial, color technology, motion picture production, commercial, portraiture. The program is 2½ years, year-round; gives students a complete background in technique, studio management and sales techniques.

HALLMARK INSTITUTE OF PHOTOGRAPHY
At the Airport, Turner Falls, MA 01376
Degrees: none per se
Teachers: Ted Sirlin, Donald Jack and staff (12)
Courses: environmental portraits, commercial illustration, studio management, promotion and marketing. A one-year vocational school, b&w, color, 50 percent studio shooting, 50 percent business management with objective of self-employment in one's own studio.

HAWKEYE INSTITUTE OF TECHNOLOGY
Admissions Office—P.O. Box 8015
Waterloo, Iowa 50704
Degrees: Associate Degree in Applied Science
Teachers: Richard Kraemer and staff (6)
Courses: three majors in portraiture, commercial, illustration and industrial. A two-year program with a strong basic applied-photography emphasis, b&w and color technique. Requirements for admission include having a 35mm system camera and a 4×5. The program is filled 1½ to 2 years in advance.

ROCHESTER INSTITUTE OF TECHNOLOGY
Admissions Office—One Lomb Memorial Drive
Rochester, NY 14623
Degrees: A.A.S., B.A., B.S., M.A., M.S.
Teachers: William Shoemaker, director and faculty of more than sixty.
Courses: five career-oriented areas of study: illustration, professional, biomedical, photo science and instrumentation, photo processing and finishing management. The best in the world, over two million dollars worth of equipment, 200 darkrooms and labs for every related subject.

SOUTHERN ILLINOIS UNIVERSITY AT CARBONDALE
Department of Cinema and Photography
Carbondale, IL 62901
Degrees: B.S., M.A., M.F.A.
Teachers: David Gilmore, Garth Goodger-Hill, C. William Horrell, Tom Petrillo, Charles Swedlund
Courses: Ten professional-commercial courses, two photo history, nine fine arts; b&w and color $500,000 worth of equipment for training in all formats. Good reputation for commercial, but also fine arts, with excellent faculty.

JOURNALISM IN PRACTICE

So, you want to be a photojournalist: glamour, world travel, fame, right? Maybe, but it's a long shot. You can count the heroes on one hand. For thousands it's hard work. Discipline and perseverance (for the heroes too.) These schools are for learning the ins and outs of the field, and there are lots of them: technical proficiency so that an editor will know that you can be trusted to do the job and meet the deadline; salesmanship so that the editor will know you at all; visual sensitivity or what is the point at all? All this and the confidence it gives you come from doing. The schools have a place in the process because you get the experience and the feedback that busy editors rarely have to time to provide. You also get the overall view, learn to conceive ideas, write and do layouts. And this feedback is from professionals. Rare is the school that is not in some way connected with a professional publication. Even rarer is one whose faculty doesn't consist of past or practicing members in the field, and a couple of inside contacts never hurt anyone.

Whether or not you decide to go the degree route, remember that the profession is competitive, and an impressive portfolio is a must. Compiling it takes even the best people a long time, and spending part of that time in one of these schools won't hurt you.

ARIZONA STATE UNIVERSITY
Department of Mass Communication
Tempe, AZ 85281
Degrees: B.A., B.S., in journalism or broadcasting
Teachers: Cornelius Keyes

Courses: basic, advanced and color techniques, seminar work, internships at local paper and wire service.

BOSTON UNIVERSITY SCHOOL OF PUBLIC COMMUNICATION
640 Commonwealth Ave.
Boston, MA 02215
Degrees: B.S. in journalism with emphasis in photojournalism
Teachers: Harris Smith, Ken Kobre, Norman Moyes
Courses: basic to advanced technique in b&w, color; emphasis is on conception of an idea to a finished book form with integrated text and pictures.

INDIANA UNIVERSITY SCHOOL OF JOURNALISM
Ernie Pyle Hall
Bloomington, IL 47401
Degrees: B.A., M.A., in journalism with photojournalism emphasis.
Teachers: I. Wilmer Countes, John Ahlhauser
Courses: B.A.—introduction theory of seeing, non-verbal communication, photographic communication, high standards, newspaper-type assignments, all b&w. M.A.—seminar in nonverbal communication, specialization in portfolio compilation, video, color or picture story done as professional assignments.

SYRACUSE UNIVERSITY
Photography Department-School of Public Communication
Syracuse, NY 13210
Degrees: B.S., M.A., M.S., in communication with emphasis on photojournalism
Teachers: Fred Demarest, T. Richards, Frank Hoy, Arthur Golden
Courses: photographic technique, b&w, color, writing, graphic arts and editing. Thrust is toward technical proficiency with creative and communicative results.

UNIVERSITY OF KANSAS
William Allen White School of Journalism
Lawrence, Kansas 66045
Degrees: B.A. in journalism, M.A. in communications, both with emphasis in photojournalism
Teachers: Garry Mason, Charles Barrett, Rich Clarkson, Jim Richardsen
Courses: Photo I—basic technique to photo story, Photo II—publication emphasis requiring a published picture to pass, Photo III—management, picture editing, design-layout. Photo II is a bitch, as it entails the necessary art of hustling.

UNIVERSITY OF MINNESOTA SCHOOL OF JOURNALISM
111 Murphy Hall
Minneapolis, MN 55455
B.A., M.A., in journalism with emphasis on photojournalism
Teachers: R. Smith Schuneman, James Brouns
Courses: basic to advanced technique in b&w, color, picture editing, picture story, history and development of the field. Many outside professionals rotate, filling a fifth adjunct position on the faculty.

UNIVERSITY OF MISSOURI SCHOOL OF JOURNALISM
100 Neff Hall
Columbia, MO 65201
Degrees: B.J., M.A., in photojournalism
Teachers: Angus McDougall, Arthur Terry, Manual Lopez
Courses: b&w technique, journalistic writing and independent study. Acknowledged as the best school of its kind in the country, the emphasis is heavily newspaper, specialized-magazine-oriented. With the photographer as visual reporter, the final project for publication demands your own idea, research, shooting, layout, text and captions.

TOPEKA INTERNSHIP

When President Ford's daughter became interested in photography, she went to a program in Topeka, Kansas. While this may strike some people as an obscure place for the biggest big-shot's daughter to end up, in fact, it's the aspiring photojournalist's Eden. What it is is a summer internship at *The Topeka Capital-Journal.* The arrangement is this: every summer, one student is selected to fill in for the vacationing staff photographers, who each take a couple of weeks off with the student as the extra manpower for whoever is gone. After a one-week orientation, he is a paid staff worker for the paper, digging up stories,

Jeff Jacobsen, Topeka Capital-Journal

Topeka Capital-Journal summer intern Rick Wood worked on a picture layout in the front office of the photo department. The C-V newsroom is in the background.

doing photography, layout and even writing copy.

There are many internships of this kind in papers around the country. This one headed by Rich Clarkson, current president of the National Press Photographers Association, is one of the best. To apply for the program, submit a portfolio in March for the following summer. The competition is tough, usually twenty serious applicants for one place, so unless this is really the kind of work you want to train for, don't waste your time, or theirs. Send the portfolio to Rick Clarkson—Director of Photography, *The Topeka Capital-Journal,* 616 Jefferson St., Topeka, KS 66607.

PHOTOGRAPHIC COMMUNICATION
by R. Smith Schuneman
Hastings House, New York/paper, $9.95

Each year for the last twenty-one, the Wilson Hicks International Conference on Photocommunication Arts has been held at the University of Miami. This book is a compilation of the best thoughts to come out of it. Its contributors make up a "Who's Who" of photographers (Duncan, Halsman, Mili), and editors (Hicks, Whiting, Rothstein). This book is the definitive work on the theory and practice of photojournalism.

FINE ARTS—PHOTOGRAPHY FOR EVERYMAN

Why get a degree in this area? Art is a subjective thing, so who's to say what's good or bad. Some people will tell you that a formal fine arts education is the surefire route to getting locked into the past. Others will insist that all art has traditions that one must learn to break. However, if you don't know the traditions or ideas that precede your time you can't really react against or for them. Also, there are many techniques being employed by art photographers, and learning them could be the best reason for going to school. At worst, schools provide access to a great deal of equipment and people for whom its use is second nature.

Today almost every undergraduate program has some type of photography course. The best schools have a wide range of courses. Graduate programs are generally oriented toward independent study, and most will not accept a student who hasn't previously demonstrated some personal development. In many cases, you'll find that a program's orientation largely reflects the concerns of its faculty. Most are practicing artists who teach what they themselves are interested in, and many students choose a school in order to study with a particular photographer. Other considerations are environmental. The resources and priorities of an art school and a major university are different. Depending upon how certain you are of where you're going, schools are sometimes more valuable for finding out what you don't want to do. A broad exposure to different ideas is, after all, education's *raison d'être*. Here are some of the best.

ART INSTITUTE OF CHICAGO
Michigan Ave. at Adams St.
Chicago, IL 60603
Degrees: B.F.A., M.F.A.
Teachers: Barbara Crane, Harold Allen, Ken Josephson, Frank Barsotti and staff.
Courses: b&w, color, visual and technical history of, nonsilver, view camera technique, graduate reading course, student teaching. Sense of department is creative exploration M.F.A. requires studio and art history courses. Well established, one of oldest programs in the country.

PRATT INSTITUTE
Photography Department
Brooklyn, NY 11205
Degrees: B.F.A., M.F.A.
Teachers: Arthur Freed, Phil Perkis, Bill Gedney, Marvin Hoshino, Diana Edkins and others
Courses: basic to advanced, history of, large format work, color, photographic book, criticism; main emphasis an MFA program, which is directed by Freed, but access to all courses. Stiff program in professional art school setting, draws on the considerable resources of New York art world.

RHODE ISLAND SCHOOL OF DESIGN
2 College St.
Providence, RI 02903
Degrees: B.F.A., M.F.A.
Teachers: Burt Beaver, Paul Knot, Doug Prince, Dick Lebowitz
Courses: strong courses in all aspects of design, photography—b&w, color, nonsilver, history of, filmmaking. M.F.A. heavily slanted toward gaining teaching experience, besides own independent work; ten grad students each year. The direction is basically in transition from Siskind-Callahan era.

ROCHESTER INSTITUTE OF TECHNOLOGY
Admissions Office
One Lomb Memorial Drive
Rochester, NY 14623
Degrees: B.A., M.A.
Teachers: William Shoemaker, director and faculty of more than sixty
Courses: fine arts is pursued under the illustration major with emphasis on art and design from R.I.T.'s vast selection of courses. Already mentioned on our vocational list, you can't miss in any area of photography at this school and in this city.

SAN FRANCISCO ART INSTITUTE
800 Chestnut St.
San Francisco, CA 94133
Degrees: B.F.A., M.F.A.
Teachers: Jerry Burchard, Jack Fulton, Linda Connor, John Collier, Hank Wessel, Judy Dater and others.
Courses: beginning to advance, b&w, color, nonsilver, independent study; excellent facilities and faculty, up to five grad students total, enter spring or fall. Wessel runs grad program, which is mainly independent work.

TYLER SCHOOL OF ART OF TEMPLE UNIVERSITY
Beech & Penrose Ave.
Melrose Park, PA 19126
Degrees: B.F.A., M.F.A.
Teachers: Bill Larson, Michael Becotte, Elizabeth LaMonte

Courses: basic to advanced, color I & II, view camera technique, nonsilver, senior and graduate seminar. Excellent facilities, stresses compliment of equipment and ideas, full offset plant, video, holography, sound-image lab. Experimental and exploratory of interrelation of visual and other media.

U.C.L.A.
Department of Art—405 Hillgard Ave.
Los Angeles, CA 90024
Degrees: B.A., M.A., M.F.A.
Teachers: Robert Heinecken, Judith Golden, Robert Fichter
Courses: B.A.—beginning to advanced photography with idea served by technique orientation. M.A. (2 years), M.F.A. (3-4 years) is all tutorial following an already illustrated line of development. Six students in the grad program, which reflects Heinecken's multimedia, experimental approach.

UNIVERSITY OF FLORIDA
College of Fine Arts
Gainsville, FL 32611
Degrees: B.F.A., B.A.A., M.F.A.
Teachers: Jerry Uelsmann, Todd Walker, and staff
Courses: B.F.A., basic with idea orientation. B.A.A., requires extra quarter for best students. M.F.A., foundation orientation, then individual concentration. Facilities for b&w only, nonsilver, 3-5 grad students. The program is integrated with total art department and students are encouraged to explore all media.

UNIVERSITY OF NEW MEXICO
Department of Fine Arts
Albuquerque, NM 87131
Degrees: B.F.A., M.A., M.F.A.
Teachers: Van Deren Coke, Thomas Barrow, Wayne Lazorik, Betty Hahn, Anne Noggle & staff
Courses: B.F.A.—photo I. II. III. includes fundamentals to advanced, b&w, color, nonsilver Grad programs are mainly independent study. Check our history of photography list New Mexico is another place you can't miss in any area of photography.

YALE UNIVERSITY
Department of Fine Arts
185 York St.
New Haven, CT 06520
Degrees: B.F.A., M.F.A.
Teachers: Jerome Leibling, John Hill, Thomas Brown, Jerry Thompson
Courses: B.F.A.—basic to advanced with idea orientation; M.F.A.—independent study; architectural and landscape, documentary, nonsilver, technical available for B.F.A. and M.F.A. Facilities for b&w only, four grad students per year. Approach is as catholic as possible.

"Untitled, 1975." *Jon Countess*, San Francisco Art Institute, San Francisco.

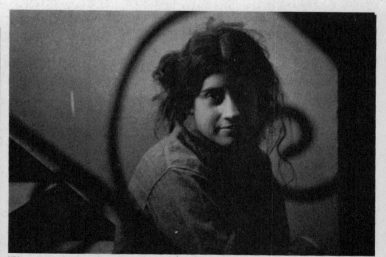

"Untitled, 1973." *John Garbarini*, The New School for Social Research, New York.

SCHOOLS/teachers

STUDENTS' PETS: 17 GREAT TEACHERS

The late Alexey Brodovitch, art director pre-eminent of Harper's Bazaar, was once quoted as saying: "Art education can be dangerous. It often kills individuality and establishes a mold. Certainly you must know fundamental tools and materials and how to use them, but you must do the discovering yourself." With that statement, Brodovitch, one of the medium's most influential teachers, defined the limits of education. He had that special combination that makes for a good teacher—talent to accomplish his own aims, generosity of spirit to encourage others in theirs.

Being a photographer and a teacher are different occupations that have tended to come together in recent years. More and more photographers are taking to teaching as a way of augmenting their meager artist's living. But the process of evolving a personal photographic style is different than attempting to teach it to the relatively uninitiated. Not all photographer/teachers understand the distinction. What any good photographer/teacher does know is that he must teach the feeling for and the discipline of the process, rather than his own style. All too often, though, students' work tells you nothing more than with whom they studied.

Teaching is tough. An eclectic spirit is one prerequisite. Henry Holmes Smith demonstrated another quality. A great photographer and teacher, who is now inactive, he once said; "Before I can make any estimate of photography, I need to know what a photograph should look like, and I am not at all certain that I do." The honesty and rare courage of the statement exhibits an important aspect of a good teacher.

Sid Grossman was another influential teacher. He's been dead for over twenty years and is hardly remembered outside the New York photography world. In the forties he taught photography as the director of the Photo League School in New York, a progressive organization and prototype for many schools and workshops today. His idea was simple: "to help the student to develop a personal approach to photography . . . to make his individual interpretation of his immediate world." Significantly, he didn't once teach as a secondary activity. It was equally as important as his own work.

There are many photographer/teachers active today who exemplify these ideas. Some of the best are listed on these pages.

BILL ARNOLD
(1941—)

He mainly uses half-frame 35mm cameras for his own work, printing on a modified Itek reader-printer, like those found in libraries for microfilm. Residents of Boston and New York got a respite from the bombardment of commercial ads on public vehicles when he organized photo exhibitions hung in buses. He started photographing in the early sixties while studying political science. Subsequently, he studied with Jack Welpott, Jerry Burchard and John Collier and is presently teaching at Hampshire College in Amherst, Massachusetts.

JERRY BURCHARD
(1931—)

After getting out of the Navy, and free-lancing in New York for five years, he found that the continual hustling for jobs was not for him. He turned to teaching to earn a living and found it suited his style. Presently, he teaches at the San Francisco Art Institute where he initially sets up situations (problems) for his students to deal with, like nude figure studies. Believe it or not, it's more work than play; all in the name of discipline.

HAROLD FEINSTEIN
(1931—)

Harold is an optimist. He will tell a beginner to start working right away so as not to be afraid of the equipment, which is consistent with his philosophy of celebrating yourself in your work. Key Heyman, who in 1976 won the World Understanding Award given by the National Press Photographers Association, Nikon and the University of Missouri, was one of his students and a member of his first class in 1957. Feinstein's workshops, held mainly in New York City, are some of the best—and least expensive—around.

Harold Feinstein, 1973.
Barbara Lobron

BEN FERNANDEZ
(1936—)

While earning his living as a crane operator, he became known for his documentation of the sixties' protest movement with his book, *In Opposition.* When the Brooklyn Navy Yard where he worked closed down, he became a full-time photographer/teacher rather than be retrained by the government as a hair stylist. His highly successful ghetto workshop in New York City established him as a rare breed of teacher. He is now dean of photography at the New School for Social Research in N.Y.C., a school which he transformed into the major photographic educational institution that it is today.

LARRY FINK
(1941—)

Larry gave up a successful career as a free-lance photographer for such magazines as *Time* and *Paris Match* to become a teacher because he said it was a more hopeful occupation. He initiated the Har-You-Act workshop in Harlem for the poverty program and has taught at many schools. He has been a consultant to the New York Council for the Arts, has received two CAPS grants and a Guggenheim. Presently, he teaches at Lehigh, as well as Bucks County Community College.

ARTHUR FREED
(1936—)

Freed considers himself a student of photography; therefore, he and his students are in the same boat. His teaching stems directly from his own experience as an artist. Since he also paints and draws, he encourages his students to study forms other than photography. He's as likely to have students read Degas' diaries as Newhall's *History.* Presently, he teaches at Pratt Institute in Brooklyn, New York.

Robert Heinecken, 1974.
Eva Rubinstein

Charles Harbutt, 1976.
Joan Liftin

CHARLES HARBUTT (1935—)

One student of Harbutt's said that he had the gift of getting students to question their approach in a constructive way. The self-conscious student is encouraged to give more leeway to his intuition and the snapshooter prompted to give more thought to his intent. He has exhibited widely and has a book of his photographs, *Travelogue*, published by the M.I.T. Press. He mainly teaches on the workshop circuit and is a member and past president of Magnum.

RALPH HATTERSLEY (1921—)

He takes a psychological approach to his teaching. He believes photography is a tool for self-discovery, that the treatment of the subject in the photographs tells you as much about yourself as about that subject. In his book, *Discover Yourself Through Photography*, he talks about teachers: "You've never had a teacher, except in some books, who wasn't blind. The way to use a blind teacher safely is to listen to him with selective and suspicious open-mindedness."

ROBERT HEINECKEN (1931—)

His own work stresses a multi-media approach; this openness to new forms and juxtapositions characterizes his teaching too. A well-read artist, he is equally at home transforming photographs into sculpture or lecturing on the formal qualities of a picture. Presently, he is the chairman of photography at U.C.L.A., a school quickly gaining a reputation as an experimental outpost in photography education.

JEROME LIEBLING (1924—)

He learned photography at the Photo League of New York and Brooklyn College. He is both a photographer and a filmmaker. His collaboration with Allen Downs produced the highly acclaimed films, *The Tree Is Dead* and *The Old Man*. A founding member of the Society of Photographic Education, he has taught for many years and is currently professor of photography at Yale University. His work is in the collections of the Museum of Modern Art in New York, the George Eastman House in Rochester and the Museum of Fine Arts in Boston, among others.

JULIO MITCHEL (1942—)

He's not a man to mince words. "You must be a photographer first and teacher second. I see too many photographers who turn to teaching and stop taking pictures." He teaches one-and-a-half days a week at the School of Visual Arts in New York. The rest of his time is spent working in the documentary-journalist mode, concentrating on book length projects. He's a founding member of the new photo agency, Vision.

Self-Portrait, 1976.
Arthur Siegel

LISETTE MODEL (1906—)

She has been around for a long time and has always been reticent about showing her own work. Since the late fifties, she's been teaching at The New School in New York. Diane Arbus was one of her students there, as were Eva Rubinstein and Larry Fink. Her goal has always been to get her students to capture in photographs what they feel.

MELISSA SHOOK (1939—)

She is currently teaching at the Massachusetts Institute of Technology. For the last two years she has been teaching a course with the writer Sandy Kaye, which combines writing and photography. She's best known for her series of daily self-portraits, some of which were recently acquired by the Museum of Modern Art. About her work she says, "I am very committed to the long-term statement built up of a lot of photographs rather than the single image."

ARTHUR SIEGEL (1913—)

In his long career as a photographer, writer and teacher, his influence has been subtle, but pervasive. He photographed for the F.S.A. in the late thirties and organized the photography department at the Art Institute of Chicago under Moholy-Nagy. His writing has been published in *Aperture*, *Modern Photography* and Nathan Lyons' *Photographers on Photography*. His photographs are in the collections of M.O.M.A., Eastman House and many other institutions. He is presently professor of photography at the Illinois Institute of Technology in Chicago.

DAVID VESTAL (1924—)

Vestal has been a photographer for over twenty-five years. Well-rounded is a just description. He has had numerous one-man shows; his writing has appeared in *Popular Photography*, *Infinity*, *Camera 35*; and his *The Craft of Photography* is one of the best technical books around. As a teacher, he has been described as inspirational. You will be hard pressed to find a student of his who doesn't think his classes were one of the most important experiences in their lives. He lives and teaches in New Mexico.

JACK WELPOTT (1923—)

He studied with Henry Holmes Smith and has been teaching at San Francisco State College since 1959. He collaborated with his wife, Judy Dater, on the book *Women and Other Visions*. A well-respected teacher, students report that his critiques of their work are excellent. His teaching style is so relaxed that during a workshop called "The Nude in the Landscape" at Yosemite, you couldn't tell the students from the models from the teacher. Open and unthreatening is another way to put it.

HANK WESSEL (1942—)

Hank is interested in the classroom situation, but stresses to his students that the way to learn photography is to do it constantly. The classroom is the place for the student to articulate his ideas and reflect upon them in the larger context of photo history, in which Wessel is well versed. He invites participation, sometimes demands it and will use various ploys to keep the discussions going. One student tells of Wessel giving his own work to a student to show as his own and then critiquing it contrary to the class's opinion. He teaches at the Art Institute in San Francisco.

Leonard Soned.

Julio Mitchel, 1975.

Melissa Shook, 1976.

Sandy Kaye

Jerome Liebling, 1975.

Robert Lyons

11

Arnold Genthe, The Museum of Modern Art

WORKSHOPS

WORKSHOPS

RIDING THE WORKSHOP CIRCUIT

A workshop might best be described as a photographic high. Free from the pressure of achieving grades, let loose to defend or find your own photographic voice, you'll find workshops offer a unique chance to work with, live with and learn from some of the medium's heroes and artists.

It was at the end of the 1960s, as an antidote to the formal photographic instruction offered by universities, that individuals started to move the classroom into less formal settings—to the hills of Vermont, along the Big Sur Coast, onto the farmlands of New York and Oregon. In doing so, they set out to eliminate the distance between teacher and student and to compress a semester's work into a month's time or, in some cases, a week's—the combination of which makes for an intense learning experience.

Today there are upwards of fifty different programs available.

They run for different lengths of time, cost anywhere from $10 to $500 and expound contrasting points of view, depending on whether they're coming from Jerry Uelsmann or Garry Winogrand. Some, like the Visual Studies Workshop, are now permanent thousand-dollar facilities and are affiliated with accredited institutions. Others, like the International Center for Photography and the Friends of Photography, are centers for a variety of photographic activity. Still others squeeze into one weekend all that the teacher can give out and the students absorb.

Most students choose one workshop over another because of the teachers participating. But others might prefer a program in California's Yosemite to Vermont because of the locale. Whatever the variables, when the spirit moves you, a workshop is a good way to mix photography and a vacation into a fun time.

FRIENDS OF PHOTOGRAPHY

Since 1967, the Friends of Photography has been spreading the word about photography in California and its neighboring states. From its headquarters in Carmel, the center, which includes exhibition and publishing programs, sponsors a network of educational programs throughout the area. Galleries and schools in La Jolla, Los Angeles, San Francisco and as far north as Seattle and Tacoma, Washington, provide the setting for prominent photographers and interested students and laymen to come together.

The lecture series, which began in 1973, brings to various sections of the state such diverse people as Peter Bunnell, Dody Warren Thompson, Lee Witkin, Morley Baer and Ralph Gibson. Some speakers conduct two-day workshops designed as print critiques, in conjunction with their lecture.

The workshops vary in duration and in price. One three-day inexpensive session ($35 for center members, $50 for non-members) on "Color Experience" was taught by members who are expert color photographers—M. Halberstadt, Steve Crouch and Glenn Wessels, among others, have donated their time as teachers. These three-day workshops are usually held at the Friends' Carmel gallery, with field work taking place on Monterey Peninsula or the Big Sur Coast.

In addition to the lectures and weekend workshops during the course of the year, two longer sessions are held annually. A six-day Easter Workshop usually brings together in Carmel between thirty and forty photography students for a technical "how-to" workshop with an emphasis on field work and the craft of photography. In addition to studying traditional black-and-white techniques, students work with Polaroid and nonsilver processes. Staff members have included Ansel Adams, who is the Friend's Chairman of the Board of Trustees, Imogen

The Friends South Gallery has presented over sixty exhibitions since it opened in 1967. The show changes every four to six weeks and includes pictures by such prominent photographers as Brett Weston, Henry Holmes Smith, Paul Caponigro. There is an annual show in which the center brings together a representative group of photographer-members' work.

Friends use promotional material like this workshop poster to advertise their activities.

UNTITLED 5

Quarterly of the Friends of Photography

To involve members outside the California area and to convey its point of view, the center publishes *Untitled*, a quarterly magazine. It evolved from an informal newsletter that addressed itself to technical questions about archival processing and large-format photography into a portfolio format publication with high-quality reproduction and a wider intellectual range. Special issues have included one on change and artistic growth, as discussed by Ansel Adams, Aaron Siskind, Naomi Savage and others.

FRIENDS OF PHOTOGRAPHY
1976 PHOTOGRAPHY WORKSHOPS

Cunningham, Darryl Curran and others. The complete Easter program runs $225, but you can take a single one-day workshop for $35. Some years there is a particular theme to the workshop, like "Practical Aesthetics," which included one session with Ansel Adams in which he demonstrated printing in his own darkroom. More often, the plan is to bring together a diversity of photographic opinions

and instructors who best exemplify each point of view.

The Creative Experience Workshop, the other longer annual workshop, is a 12-day symposium organized by the Friends each summer and gathers together artists from a wide range of media to explore, in performances, lectures and panel discussions, the relationship of photography to other arts.

Students are usually asked to bring their own prints for evaluation and critiquing. Although the gallery supplies all darkroom equipment and chemicals, students must supply their own printing paper.

Friends of Photography/P.O. Box 239, Carmel, CA 93921/James Enyeart, director/year-round lectures, workshops/from one to twelve days/$35-$300.

IN FOND MEMORY OF MINOR WHITE'S WORKSHOP AT THE HOTCHKISS SCHOOL

One was advised to bring informal clothing, sneakers, a light jacket and rain gear. Suggested reading included White's *Zone System Manual*, Richard Boleslavski's *Acting: The First Six Lessons*, Carlos Casteneda's *A Separate Reality* and Eugen Herrigel's *Zen in the Art of Archery*.

Mornings would start out on the wide lawns of the school with pre-breakfast exercises; from then on it would be a day of photography and philosophy. Afternoons were devoted to processing negatives and printing via the stabilization process. Evenings usually ended with music, movement exercises and something called "Creative Audience," that is, "exploring photographs in heightened awareness."

In addition to workshops on photographic technique, White held others on the editing and sequencing of pictures in order to help us discover, through the editing process, things about ourselves.

White's workshop brought together teachers, professionals who used photography as an avocation, students and anyone else concerned with the **relationship of the viewer to the photograph. Applicants were required to submit samples of work and a statement of aims.**

LIGHT WORK/COMMUNITY DARKROOMS

LARRY FINK

The only gallery in central New York State, Light Work exhibits local photographers and nationally known artists. Under its auspices, a pilot video program of taped interviews with visiting artists was planned but abandoned because of insufficient funds; the directors continue to investigate new approaches that will enable them to make the tapes and still sell them at minimal cost. A three-year children's program designed to integrate photography into elementary schools led to a staff-prepared resource manual enabling teachers to design their own programs.

At $10 a workshop, it is the best bargain on the circuit. The program is strongly committed to involving local residents, as well as to bringing in out-of-staters. For eight months a year, the four-day weekend workshops, held in the gallery, are taught by instructors like Larry Fink, James Jachna and Adál, among others. Syracuse provides the space and equipment; the funds come from public funding sources.

Sometimes the focus is on the craft; at other times a critique format encourages participants to talk about pictures and ideas. Along with the workshop, the directors try to coordinate an exhibit of the visiting artist's work and usually sponsor a free lecture. The lecture series is open to the public ten months a year and has drawn as many as 400 people when Gene Smith spoke.

Light Work/Community Darkrooms/316 Waverly Ave., Syracuse, NY 13210/Tom Bryan and Phil Block, co-directors/year-round/four-day workshops/$10, lectures free.

THE FLOATING FOUNDATION: A MOVING WORKSHOP

It floats, it's purple and it has served as a kind of cultural mission since 1969. Through a variety of year-round workshops, the directors have taught photography to mentally ill patients, prisoners and drug addicts, as well as to children and senior citizens. Maggie Sherwood, the director, combines the value of photography as therapy with a knowledge of its place as an art.
Instead of having people come to the houseboat, the boat travels to places like Sing Sing and Riker's Island. But it will also venture into any underprivileged community—even a wealthy one like Piermont, N.Y., which has no museums, libraries, schools or other kind of cultural center.
The teachers come from anywhere and everywhere and have included people like David Vestal and T.J. Marino, as well as ex-addicts and patients.

Floating Fd./79th St. Boat Basin/New York, NY 10024/Maggie Sherwood, director.

One of the many successes of the FFP was the program that taught photography to woman inmates of New York's Bedford Correctional Facility. The workshop, which started as a pilot project in 1971, was funded by private money and a grant from the New York State Council on the Arts. There are four semesters to the program, each ten-weeks long. A student starts with a Polaroid and Diana F—a $2 plastic camera with lens—and masters basic techniques and lighting before moving on to more complex 35mm work. As confidence grows, so does involvement. There is currently a waiting list of some 150 inmates. The strongest pictures were exhibited in a show called "Is It Really Me in Here?"

PHOTOGRAPHY IN PRISON

THE FIRST ANNUAL

Maggie Sherwood and students.

Fred W. McDarrah

GRANTED . . .

At least two workshops we know of offer grants that assist photographers in generating new work. You don't need to be a workshop member in either case—just a worthy photographer.

Light Work in Syracuse awarded four $500 grants recently to photographers living in central New York State, who are within a fifty-mile radius of Syracuse. Grants were made on the basis of a brief description of the projected project, a resume and portfolio of work. Upon completing the project, the photographers submit a representative sampling of the work, which goes on exhibition at the gallery.

For the past five years, the Friends of Photography has awarded a $1500 Ferguson grant to assist photographers in their careers. Anyone is eligible who submits ten samples of work and a proposal. For further information, contact either as listed below:
Light Work/Community Darkrooms, 316 Waverly Ave., Syracuse, N.Y. 13210, or Ferguson Grant, Friends of Photography, P.O. Box 239, Carmel, Calif. 93921

Other workshops are likely to begin following suit, so inquire about financial assistance from them. Who knows? Your inquiry might get the ball rolling.

WORKSHOPS

THE INTERNATIONAL CENTER OF PHOTOGRAPHY

Run on the energy of one Hungarian dynamo with some 100 volunteers and a few paid assistants, the ICP's museum was opened in 1974 when Cornell Capa succeeded in establishing under one roof (and a beautiful one at that) New York City's only non-profit institution devoted exclusively to photography.

Although the center has many facets, the educational program is its most distinguished feature. Through its publishing program and exhibitions, the organization has, since 1967, promoted the notion of "the concerned photographer"—a term that has come to stand for those documentary photographers who use the medium to communicate social ideas. The educational program takes a more democratic point of view toward photography. In lectures, seminars and workshops, Capa and his staff manage to assemble an illustrious body of lecturers, visiting artists and instructors. The two lecture series are both bargains at $65 each for ten sessions. One brings together authors like Sean Callahan, critics like Hilton Kramer of *The New York Times* and publishers, gallery owners and collectors to discuss aesthetics and how pictures are used. The other series features photographers like Pete Turner (on color) or Jill Krementz (on photographing the literati).

The workshops, which usually run two consecutive weekends ($145), are conducted by prominent photographers—like W. Eugene Smith, Bruce Davidson, Art Kane or Fritz Goro—who discuss their specialties. (An interview and portfolio review are required.) There are also one-weekend workshops ($65) in which teams like Peter Beard and Larry Rivers talk about photography and painting, or Ken Heyman and Margaret Meade tackle the role of photographer and anthropologist.

The two-day community workshops for elementary and high-school students and another program for adults over 60 ($65 for each) aim at teaching the basic craft. The Vision and Craft workshops delve into photographic conception while offering professional guidance in techniques. ($160)

International Center of Photography/1130 Fifth Ave., New York, NY 10028/Cornell Capa, director/year-round lecture series/workshops and seminars vary from one day to ten/$65-$145, lab fees extra.

The International Center for Photography is comfortably housed in an early twentieth-century townhouse that New York City declared a landmark in 1968. In addition to office space and lecture rooms, there are three galleries with a total of 2,000 square feet of exhibition space.

Dr. Roman Vishniac

Howard Sochurek

A. D. Coleman

Ernst Haas

Duane Michals

John Szarkowski

Robert E. Gilka

Hilton Kramer

David Doubilet

PACKAGING PICTURES THE ICP WAY

In the bookstore on the ground floor of ICP, you'll find books, postcards, portfolios, audio-visual materials, posters and the like. The center publishes books by important humanistic photographers—Robert Capa, Werner Bishof, David Seymour, Lewis Hine, Dan Weiner and Roman Vishniac—which make up the *ICP Library of Photographers*. The excellent *Images of Man*, an audio-visual series on contemporary photographers, done in collaboration with Scholastic Magazines, Inc., uses the pictures of such photographers as Bruce Davidson, Brian Lanker and Don McCullin as well as their own words to define their work.

Roman Vishniac

Portfolios by David Plowden, Marc Riboud, Weegee, Feininger, Dennis Stock and others provide a chance to buy master prints. If you can't afford the real thing, there are posters from the more than twenty-five ICP exhibitions in the center's short lifetime.

ICP postcards, beautifully reproduced and printed by the Rapoport Printing Co., show off works by the medium's documentary photographers. The one above is of Leon Trotsky, and was taken in Copenhagen in 1931 by the legendary Robert Capa—late brother of the director of ICP.

The Country School teaches industrial, sports and nature photography in an informal, if not rustic, setting. It attracts teachers like Grant Heilman, who specializes in agricultural photography.

COUNTRY SCHOOL OF PHOTOGRAPHY

Richard Simon, Philippe Halsman and Yousuf Karsh encouraged their friend John Doscher to start a photography school way back in 1946. He did, in the relaxed atmosphere of Vermont. Over the years the school has grown, adding summer workshop programs to its regular year-round course offerings.

Specializing in color photography, the school now pays considerable attention to black-and-white work. Much instruction is given via slides. Doscher especially likes to demonstrate the difference between "automation and carefully planned or preconceived pictures" by showing a situation photographed several ways.

The school is technically well-equipped with about forty enlargers in nine darkrooms, a large studio, a slide and sound room and a room for copying and duplicating slides.

Country School of Photography/South Woodstock, VT 05701/John W. Doscher, director/June-October/five to ten-day sessions in basic and advanced color and black-and-white/$75-$100 a week plus accommodations.

NORTHERN KENTUCKY UNIVERSITY WORKSHOP

Here's a workshop that offers scholarships, even though the price is very reasonable—$54 for Kentuckians and $120 for out-of-staters, plus $30 lab fees for each. If you submit ten color works (be sure and include return postage) and a resume, it's possible the school will pay your way.

A recent workshop was devoted specifically to non silver processes—enlarged negatives, blueprinting, gum-printing, brown printing, salt-paper printing, et al—and was taught by three leaders in non-traditional photography: Doug Prince, Robert Fichter and Robert von Sternberg. The workshop is limited to twenty students who can, if they choose, earn three college credits for their work. Instructors are expected to provide solid technical information, as well as their own personal viewpoints. Since each teacher's know-how is expected to supplement that of the artist who precedes or follows him, at the end of two weeks the student has a thorough working knowledge of the processes and three visual directions to consider.
The facilities, which are professional, include ten B-22 enlargers, one D-2V color enlarger, two model C color enlargers, temperature-controlled water, a Leedal Sea Wave washer and a Simplex dryer. The workshop is temporarily housed in a basement, but a move to a new fine arts building is anticipated. Sessions are intense, starting at 10 a.m. and running until 10 p.m. with two two-hour breaks during the day.

Northern Kentucky University/Highland Heights, KY 41076/Barry Andersen, director/May-June/twelve-day Workshop/$54 in-state, $120 out-of-state, ($30 lab fee), scholarships available.

PHOTOGRAPHY: SOURCE AND RESOURCE
by Steven Lewis, James McQuaid and David Tait
Turnip Press/144 Clinton Ave./State College, PA 16801/paper, $6

Rarely does one come across a book that doesn't duplicate something that has already been done. An exception is this resource book of creative photography compiled by three men when they were teaching assistants at Ohio University. As a catalog, it contains the results culled from questionnaires and collated by the authors.

People like Lionel Suntop, president of the book distributing company, Light Impressions, and Peter Schlessinger, director of Apeiron Workshop, are just two of the individuals who talk about their own experiences in developing their projects. The bibliography lists 139 dissertations, theses and papers, while an index to collections enumerates the holdings of major American institutions by photographer. For example, we found out that there are 3,000 Ben Shahn photographs at Harvard's Fogg Museum and that the National Gallery in Washington owns the only complete set of photographs produced by Alfred Stieglitz (approximately 1,442 pictures). Yet the book only scratches the surface of what needs to be done in the field of picture research. On to the second, third, fourth . . . editions.

PHOTOGRAPHY
source & resource

TEACHING
WORKSHOPS
PUBLISHING
CRITICS
GALLERIES
BIBLIOGRAPHY
COLLECTIONS

a source book for creative photographers by
STEVEN LEWIS, JAMES McQUAID, & DAVID TAIT

THE OGUNQUIT PHOTOGRAPHY SCHOOL

When is a workshop more than a workshop? When it's a vacation as well! As the school's brochure describes: "A unique opportunity to tour the Northeast's most majestic national park, a naturalist's paradise with a scenic change at every turn. . . . Photograph the sunrise on Cadillac Mountain and be the first on that day to see the sun rise in the United States. . . . Walk along the rocky coast and capture violent waves breaking on natural jetties and in "Thunderhole," or aim your lens at gnarled trees shaped by coastal storms. . . ."

There are two Roving Eye Traveling Workshops, one to Bar Harbor and Acadia National Park (described above), and the other to Nova Scotia. Both combine a vacation with a chance to photograph spectacular scenery. The Nova Scotia excursion provides first-class accommodations on a Scandinavian ship, private station wagons for land travel, as well as rooms in motels and manor houses.

The workshop tries to develop an awareness of photography as a means of expression through seminars entitled "Photographic Sensitivity." Efforts are made to help students recognize potentially photogenic subjects and to maintain total picture control. These sessions are limited to ten students and are held in the studio-workshop, which houses a library of photographic books, an antique camera collection and a print gallery.

The Ogunquit Photography School/P.O. Box 568, Ogunquit, ME 03907/Stuart Nudelman, director/summer workshops, July-August/$70-$410.

ANSEL ADAMS YOSEMITE WORKSHOPS

In case you haven't heard, a photographer named Ansel Adams runs what is the country's most famous and popular workshop. Concentration is on the Zone System, the basis of the Adams teaching method, and the intensity is grueling.

For twelve days, eighty students work in groups of ten to twelve with Adams and his seven instructors in California's Yosemite National Park. There are lectures, field work, darkroom study, critiques. While one group works with Morley Baer on architectural photography, another spends a morning with Adams on previsualization. The groups rotate so that by the end of the workshop they have studied with each instructor.

Ansel Adams Yosemite Workshops/Box 455, Yosemite National Park, CA 95389/Norman Locks, director/twelve days in June/$300 plus room and board.

Mrs. Cameron and Mr. Gernsheim — page 6

AFTERIMAGE

This, the voice of the Visual Studies Workshop, is not for those uninterested in the philosophy of picture-making. "Heavy" is a fair description, but there is a time in every photographer's life when he should give some deep thought to the subject of images. On these pages you'll find analysis by some of the most acclaimed critics and historians of photography. There is a lot of academic procedure—for example, a letter from Peter Bunnell responding to a lecture by Nathan Lyons is accompanied by thirteen footnotes. But even if you are not comfortable in the semantic underbrush of aesthetic criticism, this is a valuable magazine.

Subscription: $10/Visual Studies Workshop/4 Elton St./Rochester, NY 14607

Preservation and restoration of books and prints is taught at the Visual Studies Workshop's Research Center. The Center's print shop houses an offset proof press and students gain firsthand experience in the production and printing of books and newspapers.

THE VISUAL STUDIES WORKSHOP

Anthropologist Ray Birdwhistle, who completed a study on the frequency and intensity of smiles in the United States, confirmed something that the photographic community knew for a long time: that Rochester, NY, is a mighty serious place. (He found that Rochester was in the area with the lowest frequency of smiles of any section of the country.)

Nathan Lyons, a very serious man himself, founded the Visual Studies Workshop in 1969 after resigning his position as associate director and curator of photography at George Eastman House. To start with he had $450 severance, his reputation, and the good sense of the State University of New York at Buffalo to go along with his goal of education on *all* visual levels.

The Visual Studies Workshop has grown rapidly to where its annual budget is now $300,000. From its original quarters in a corner of an old woodworking factory, it now occupies the entire building—filled with all kinds of expensive hardware. Lyons credits the generosity of photographers for helping him get started by donating equipment and prints for sale. Grants and subsidies enabled him to continue. Today the Visual Studies Workshop is still only 60 percent self-sufficient, with its major source of income derived from tuition.

There are twelve full-time instructors who represent a wide range of photographic attitudes.

Certainly there is variety of activity. If you're interested in gallery work, you can organize traveling exhibitions. If it's curatorial experience you're after, there's the Research Center which houses over 7500 books, with an emphasis on 19th century illustrated books. There are some 250 magazine titles, 5,000 prints, 200 tapes—all of which, by the way, are accessible to outside researchers. You can gain teaching experience, learn about preserving and restoring, writing, editing and actually producing a newspaper

or visual book. There are activities in straight still-photography, video, multi-media, and every nonsilver process. (There has been a trend over the years toward emphasizing nonsilver work. Recent graduates bemoan the fact that fewer and fewer history and straight-photography courses are being offered.) The technical facilities are enviable with over 14,000 square feet for darkrooms, film editing, print-making and exhibitions. There's equipment for xeroxing, photo-etching, lithography. Also available are a process camera and printing presses.

Everything fits in with Lyon's own strongly held belief that students should be equipped with a coherent overview of the field. He believes that one learns by doing and that doing should include more than still photography. The intent is noble, but many ex-graduates describe the atmosphere as wordy. A lot of time is spent analyzing—pulling apart theories and putting them back together again. Lyons' own writing exhibits this tendency toward too many words and his enthusiasm is often obscured. In short he's been accused of being a pedant—albeit a smart one. Without a doubt his personality affects every nook and cranny of the operation. Lyons himself feels that it takes a certain maturity to benefit from the programs, so he prefers graduate students. There is no undergraduate studies program.

Here are some of the available programs:

● *Graduate:* Fifty percent of the students study for master's degrees. In cooperation with the State University of Buffalo, a two-and-one-half year program specializing in photography, mixed media and museum studies is offered. It culminates in a six-month internship.

● *Workshop:* No undergraduate degrees required but really not for the kid just out of high school and wanting to become a photographer. Often those who attend are interested in photography as a tool for anthropology, art, literature, sociology, history or criticism.

● *Summer school:* Intensive one-week and two-week programs in specific areas; limited to twelve students. Subjects cover basic and advanced photography, history, color theory, criticism, conservation, restoration, video.

● *Evening classes:* Eight-week courses for children and adults held throughout the year with instruction in basic and intermediate photography as well as nonsilver processes.

● *Children's studies:* Elementary and secondary school teachers study questions of visual perception.

To get the most out of this place it's best to have a sense of what you're after—the stronger that sense, the better. If not, you're likely to be overwhelmed by the diversity of it all.

The Visual Studies Workshop/4 Elton St., Rochester, NY 14607/Nathan Lyons, director/year-round/summer workshops, four to twelve days

APEIRON WORKSHOPS

You've paid $265 and are driving to the Apeiron Workshops located on a ninety-acre farm two hours north of New York City. For that sum, you will get room and board, twenty-four hour access to well-equipped darkrooms, and the chance to personally interact with a nationally known photographer—all for one week. The experience will be what you make it.

In this self-contained photography community—created by photographers who second as administrators, carpenters, maintenance men—committed artists and insight-seeking students join together. Financial support is from tuitions, donations, the National Endowment for the Arts and The New York State Council on the Arts. Student and teacher portfolios and traveling exhibitions bring in a little revenue and help promote the workshop.

The inherent problem with this kind of setup is the limited time you get to deal with so much new stimuli—the thirty-odd strangers, the environment and the artistic reputations. Be prepared to examine your own feelings about the medium—what you want to say, how you want to say it, how much of your life you're willing to devote to photography. This consumes energy. In one week, a guest artist can do little more than convey his presence, indicate his own answers.

The schedule is year-round and very diverse. There are one-week, one-month, three-month workshops. Special projects appear intermittently. (In the spring of 1973 a one-month workshop included seventeen days in Iceland photographing landscapes and twelve days of darkroom work at Apeiron, all for $875.)

Apeiron Workshops, Inc./Box 511, Millerton, NY 12546/Peter Schlessinger, director/year-round/one-week master workshops, July-Sept.; one-month residential, June-July; three-month programs, spring and fall/$285-$550, room and board included.

Lisette Model, surrounded by her summer, 1973, Apeiron workshop class in Millerton, NY. Active in photography for over forty years, Model was a major influence on the late Diane Arbus.

THE UNIVERSITY OF MISSOURI WORKSHOP

Every October some fifty people descend on a small Missouri town to participate in what is the "Outward Bound" of photography. Their assignment is to produce a picture story about the town, and through an intense critical process, to learn more about photojournalism. Founded in 1948 by Cliff Edom of the University's School of Journalism, the students are selected from over 300 applicants—among their lot are students, writers, editors, and freelance photographers. The heart of the week's work, according to Lee Romero, a former student and former *New York Times* staff photographer, is in the shooting and the criticism of each day's pictures. A student is assigned a panel of three teachers—experienced editors and photographers from prestigious national magazines—given ten rolls of film for three days and the workshop begins.

Day one is spent getting acquainted with the town, meeting its citizenry and researching its history. Day two begins with a search for a picture story. Once an idea is approved by the panel (and you're expected to sell it as if you're asking for a $5000 advance from *The National Geographic*) you're on your own. You drop off the exposed film during

the day and two hours later either you, if you're around, or the faculty edits the contacts. That same night, students and teachers gather in a large hall and the day's pictures are projected. One former student says that the workshop is successful largely because the faculty tries to "demoralize" you. The experts do their homework and know each student's strength and weakness. And it's the weak points that they hammer at. If they think you're coasting—doing what comes easily—you'll be in for even a harder time. The camaraderie between the students grows in the face of the faculty's harsh teaching methods. All-night bull sessions in which students compare notes, talk about their ideas and generally support each other are vital to the intense and energetic atmosphere.

On the third day, you're trying for better pictures. So it continues. Work, criticize, reflect, work, criticize. About the fifth day you begin laying out your story, going through the same critical process. The aim is to finish a spread suitable for a professional magazine.

University of Missouri Workshop/School of Journalism, Columbia MO 65201/Angus MacDougall, director/held one week each October/$100, plus living expenses and transportation.

THE MAINE PHOTOGRAPHIC WORKSHOP

If you want a crash course in photography or a three-month resident program that totally immerses you in technique, history, photojournalism and commercial photography, this workshop is for you. If you're uncertain as to which program best suits your current needs, the directors suggest you send them contacts and a paragraph describing where you are and where you want to be. Based on the submitted material, a course of action will be suggested.

The action takes place all year-round but the summer is the high season—probably because of the workshop's idyllic setting near a small fishing village on the edge of Penobscot Bay. Nearby restaurants, sport facilities, sailing centers and artist colonies add variety to the remoteness.

The master-craft sessions on the Zone System, printing, silk-screening and photographic chemistry are highlights. Wilderness photography is taught while on expeditions to nearby Maine islands.

The Maine Photographic Workshops/Rockport, ME 04856/David H. Lyman, director/year-round/one week to three-month programs/$125-$750.

John Loengard, former *Life* photographer, teaches at the Maine Workshop.

WORKSHOPS

OREGON PHOTOGRAPHY WORKSHOP

The "Western Experience"—photographing while traveling throughout the Western United States—is at the heart of this ten-year-old workshop program. It started as part of the University of Oregon's summer program, but when the University cut corners, its founder, Bernie Freemesser, a professor at the school, and George Beltram, who runs the shop in spring and winter, carried things on independently.

A variety of workshops, all tied to photographing the wide open spaces, are offered all year long, but summer is the high season. In the past, students have come from as far away as Siam, Paris, Montreal and Mexico City to learn, travel and get some sun. There is a technical darkroom program that includes learning to pre-visualize with the Zone System. Another program is designed for teachers, or would-be teachers, to discuss basic teaching philosophies, while teaching alongside the workshop director.

Another course of study concerns itself with design, editing, sequencing and presentation of photographs for publications and books. A seminar is also held on the evolution of photography in the American West and discusses personalities and their contrasting photographic styles.

Charles Kogod

Described as the culminating experience of the summer workshop is the "Travel Experience," a month-long workshop in which students travel (in private cars sharing costs), work, camp, and visit with other working photographers throughout portions of California Nevada, Utah, Colorado, New Mexico and Arizona. A unique photographic experience and a way to see the West.

Oregon workshop students combine learning while traveling throughout the Western USA. A month-long camping, working, exploring and photographing excursion (which includes visiting regional photographers) can be had for $250.

Oregon Photography Workshop/3241 Donald St., Eugene, Ore 97405/Bernard Freemesser, director of summer session: June through August/$500 includes all workshops/individual workshops, $50—$250.

Abigail Heyman, Class '75.

Tony Calabreese

LIGHTWORKS

It moved from a chicken coop near Chicago to a Wisconsin farm and now makes its home in the city of Minneapolis. During its first four years as the Country Photography Workshop, it was a one-man operation with the director, Peter Gold, an ex-ad man, handling all the teaching. A decision to invite name photographers was an experiment that succeeded. Gold found out that a good photographer could be a good teacher, and in recent years Charles Harbutt, Ralph Hattersley, David Vestal, Abigail Heyman and Ralph Gibson have been a few of those on hand.

Intense one-week sessions throw teacher and student into close association—not to encourage imitation of the teacher's work, but to get students to work better on their own. A session is intended to help students recognize their own personal direction and to learn what they share with other students and teachers.

In that week a person generally acquires greater confidence and freedom. The high emotional charge felt while the session is going on

Cradled in a corn crib with instructor Abigail Heyman, Lightworks students work closely with the teacher in intense one-week sessions. The goal is to equip students with basic skills and to give them the confidence and freedom necessary to pursue personal goals.

quickly fades, but Gold believes that the time after the workshop is what counts. "Weeks, months or years later, as the work changes, the influence of the workshop can be seen."

Lightworks/25 University Ave. S.E., Minneapolis, MN 55414/Peter N. Gold, director/One week sessions, $200 plus room and board

THE PHOTOGRAPHY PLACE

This center started out to teach photography to people who wanted to take pictures on holidays and birthdays. In the process, a new audience was created and as interest mounted, the director added guest speakers, started to exhibit and began to operate a full-scale gallery.

During the summer, The Littlebrook Farm, 100 acres of lush mountain greenery, is the setting for the workshops, which cover basic and advanced techniques as well as photography as a personal art form. For the most part, students camp out but avail themselves of the instructor's facilities. The weekend workshops at The Place bring in people like Peter Bunnell, Neal Slavin, Arnold Newman, Duane Michals and George Tice, while the Littlebrook sessions are run by Tom Davis, the director.

The Photography Place/Spread Eagle Village, 503 W. Lancaster Ave., Strafford, PA 19087/Thomas L. Davis, director/April-May, weekend workshops; one to two-week August workshops, basic to advanced, at Littlebrook Farm/$60-$150; campground, meals available at $40 per week extra.

SUN VALLEY CENTER FOR THE ARTS AND HUMANITIES

It is located in Sun Valley, Idaho, some 6000 feet above sea level, smack in the center of a posh sports facility. But the schedule of events is anything but leisurely. Students can, if they desire, earn university credit for full-term photography courses, as well as for the shorter summer workshops. This year-round program develops the student's capability for making fine art photographs and for possibly making photography a life's work.

The summer program offers the widest array of workshops—from basic techniques to intense, highly sophisticated technical programs. Special workshops attract instructors like Frederick Sommer, who has taught on the relationship of photography to other arts; Nathan Lyons, on photography as a process of abstraction; Oliver Gagliani, a six-day program on the Zone System and Dick Durrance's workshop on photojournalism and how to use the picture story as a communications tool. There are sessions on the history and criticism of photography and others on the simplified dye-transfer process.

Classes benefit from having access to the William Janss Print Collection, one of the largest photographic print collections in the Northwest, and to a small library and slide collection. The photography department has its own gallery with new exhibitions of old and new masters every month.

Sun Valley Center for the Arts and Humanities/Box 656, Sun Valley, ID 83353/Peter de Lory, director/year-round/one to eight-week advanced courses.

Peter deLory

Evaluating students' pictures is part of what goes on at Sun Valley. Here Norman Locks critiques a student's work. Considerable attention is paid to print quality as well as to photographic content.

Sun Valley's summer workshops are held on seven wooded acres in the open spaces of the Wood River Valley in Idaho. The modern, professionally equipped photography building is one of a five-building complex that includes facilities for other arts and crafts taught at the center. Dormitory space is available for $2.50 a night per person or in the Sun Valley condominiums at $75 a person per month (double occupancy).

FESTIVAL d'ARLES

Make no mistake about it, the atmosphere is uniquely French. There is a proper setting, a lot of good wine and food, trips to nearby cultural sites and hours of intellectual repartée. Voila! Since its inception in 1969, the Festival of Arles has been a three-week cultural "gathering" that some people call an orgy—all in the land that invented photography. If you hang loose and don't demand too much structure, you will learn along with students and photographers.

The workshops last ten days and cover subjects like the nude, the portrait, even the "New York style," with exponents leading the way and holding forth in all-night talkathons. Normally, these workshops are designed for about thirty-six people, but in recent years they have accommodated up to sixty. Since there is only one film-loading room, one print dark-room and one developing area, things can get hectic.

Another feature of the festival is the *colloque* or panel discussion, which lasts the morning and presents a broad spectrum of photographic opinion on any number of subjects—gallery directors will wax on about the art market while photographers and curators will turn over aesthetic ideas.

Sometimes a lot gets lost in the translation. The activities are supposed to be conducted in both languages, and they try. Translators, tucked away behind glass booths, try to keep up with the pace and the ideas being hurled about. Occasionally they succeed. If things get too confusing, you can always slip away to a cafe and talk with a photographic hero like Gene Smith, Andre Kertész, et al.

Festival D'Arles International Meeting of Photography/Bureau du Festival 35,/Place de la Republique,13200, Arles, France. $100–150/per workshop, $100—150, plus transportation and accommodations.

A VOICE FROM THE ISLES: CAMERAWORK

If the Visual Studies Workshop newspaper *Afterimage* tends to mystify the medium, *Camerawork*, a publishing venture by the Half Moon Photography Workshop in London, pulls in the opposite direction. Their bent tends to be political rather than academic, with articles that ask verboten questions like whether there is any alternative to Kodak, Agfa or Ilford films. By letting photographers speak candidly, we learn that there is nothing magic about their success or failure, that sometimes assignments are not at all glamorous—in fact, sometimes boring. Another piece encourages people to undertake their own publishing ventures and reports vital data about costs to underscore the fact that such projects are possible.

Subscription: L2.00, plus postage/editors: members of the workshop Publishing Project, Half Moon Photography Workshop/27 Alie St., London, E. 1, England

WORKSHOPS

INDEPENDENT PHOTOGRAPHY
by Robert Foothorap,
with Vickie Golden
Straight Arrow Books/San Francisco
CA 94107/paper, $6.95

Most writing about photography tends to mystify rather than clarify. This book is unusual in that it has a true ring of authority without making photography more difficult than it really is. One of the authors is a free-lance photojournalist with years of practical experience; the other is a writer of considerable skill—the combination is unbeatable. Whether they're describing what actually happens when you change an aperture setting or are passing on information about sophisticated professional equipment, they speak clearly.

The subtitle of the book is "A Biased Guide to 35mm Technique and Equipment." The prejudices, for instance, toward single-lens reflex cameras are stated straight out. But other equipment is thoughtfully considered. If you've never held a camera in your hands, you'll be able to pick up this book and not feel like a dummkopf. If you're an experienced photographer, there's something for you, too. Besides, it's a good read.

The first step in establishing a good working relationship with your camera is to take it off its pedestal. You may have spent several hundred dollars for it, but it is money wasted if you treat your camera too delicately and protectively.

• • •

I do want to express a certain reverence for the photographic image as it is recorded on film. It does have an integrity of its own. Among photographers there are different attitudes toward purity; one of the most prevalent is the belief that photography is a magical process which exists on its own and that once the photographic image has been recorded it should be left unencumbered as much as possible by gimmicks or afterthought. However, there are different philosophies of photography, and it's up to you to choose how much you wish to edit your photograph.

• • •

In spite of what the photo magazines indicate, slight differences in resolving ability among brands of lenses are relatively inconsequential in terms of the final picture. In fact, most lenses resolve detail more precisely than most films. Only the really cheap lenses have noticeably poorer resolving ability. This whole question of sharpness will come up later, and you'll see that the quality of the lens is only one aspect of sharpness. In the final print, what's important is the impression of sharpness created by the type of light and subject matter.

12

James Carroll

FILMS

FILM, LIKE FISH, SHOULD BE FRESH

There are a multitude of different films available to the photographer, many designed with a special purpose in mind. Some photographers find time to experiment, but most prefer to expend their efforts making pictures rather than worrying about various media. For them, learning to use three or four films expertly is the key to success. The photographer relies on his knowledge of those films, and as long as they respond consistently from one day to the next he is in business. Any announcement by a film manufacturer of a change in his product is bad news to a person who feeds himself by making pictures.

Unfortunately, film manufacturing is tricky. One batch of film can vary from the next. For this reason, different batches are noted on the box by an emulsion number. Film characteristics also change with age or under adverse storage conditions. Color films are, of course, more complicated to make and therefore most vulnerable in this regard.

Since we need to be as consistent as possible, we want the freshest, least traveled film we can get. For us, this means using domestic film from Kodak and Polaroid. These companies are big and ubiquitous; wherever we go in the Unites States, we know that what we need will be available. If we go abroad, we take our film with us because we know how it responds. If we lived abroad, however, we would most likely be using film made by Agfa, Fuji or Ilford for exactly the same reasons noted.

HOW TO LOAD A FILM HOLDER

In the dark, insert film into the bottom of the holder with the emulsion side up, which is the case when notches are in the upper right-hand corner.

Film must slide under two tracks and finally rests under a third perpendicular channel at the head of the holder. After it is in place, insert the slide,

silver-rim-up, into the top of the holder. Silver indicates unexposed film.

SHEET, PACK AND ROLL HOLDERS

Film should lie flat at the focal plane or else the resulting picture will be out of focus. Cut-film holders, such as the Fidelity Deluxe, shown at right, permit the greatest security in this matter. Only one sheet has to be considered (per side), and if loaded correctly, it won't buckle. Sheet film is available in different emulsions, including color, from 2¼ × 3¼ to 11 × 14.

Film packs are riskier. With the sixteen sheets of thin-based film that are in a film pack, there is a chance of buckling, especially in dampness. (Only the black-and-white Tri-X Pan Professional and the Plus-X Pan Professional are available and only in 2¼ × 3¼ and 4 × 5.) Packs are expensive: about $8.50 for 4 × 5 Tri-X, whereas an equivalent sixteen separate sheets is priced at under $3. They are convenient but, unfortunately, the adapters that hold the pack on the camera back are no longer being made.

You can shoot roll film with press and view cameras. Instead of a 4 × 5 sheet-film holder, the Calumet roll holder is inserted. It carries the film, constrained by the edges, between machined rails so that the flatness achieved approaches that of sheet film. The holder takes both 120 and 220 film. The latter is regular 120 film with twice the number of exposures, i.e., 20 instead of 10,

Fidelity holders have two white tabs on each side. Lens opening, shutter speed, light reading, date and type of film can all be noted in pencil, which can be erased. The process can be repeated without damage to the surface.

Fidelity Manufacturing Co. 9931 Glenoaks Blvd./Sun Valley, CA 91352

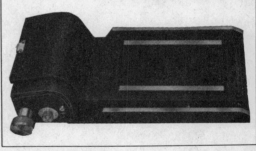

The Calumet roll-film holder fits into the camera back like a sheet-film holder.

Calumet Photographic/1590 Touhy Ave./Elk Grove Village, IL 60007

Film packs are expensive, yet great for location work. One holder holds sixteen exposures and can be loaded in normal light.

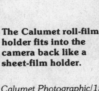

which is wound on a 120 spool. By splicing the paper leader and trailers to either end of the roll, thereby eliminating paper backing, double length is achieved.

LOADING FROM BULK

Some infrared and duplicating films aren't available in cassettes, so they must be loaded from bulk. You insert a 100-foot roll of film in the holder in complete darkness; after that, all spooling is done in normal room light.

As for loading film that is available in cassettes, we don't recommend it —not for professional work, anyway. There is too much chance of scratching and picking up dust. If you shoot a lot of film, however, and must be thrifty, the savings are about like this: first there is an outlay of about $12 for the loader and $8.50 for two dozen cassettes (the number needed to use up 100 feet of film at 36-exposures each), not counting the initial investment, you'll save about two-thirds the cost of pre-rolled and packaged Tri-X.

Burke & James/44 Burlews Ct./Hackensack, NJ 07601

CHANGING BAGS

When away from the darkroom, to load or unload holders, packs, tanks, etc., Burke & James sells changing bags. They are made in five sizes, ranging from 25×27 inches to 34×60 inches, and consist of an inner bag and an outer one. When in use, zippers are closed and hands are inserted into sleeves.

If you don't have a changing bag and you need one, a jacket, especially a zippered nylon parka, does just fine. Zipper up. Tape over track. Fold at shoulders, so the neck opening is covered. Tape. Insert material through the bottom of the jacket, then fold over. Tape. Manipulate through the sleeves.

Burke & James/44 Burlews Ct./Hackensack, NJ 07601

A FILM PROTECTOR

X-rays at airports can and do cause fogging of film; just how seriously and under what conditions have not yet been established. But why take chances? The best thing to do, if you don't have to do much of it, is to carry your film with you. At the passenger checkpoint, have it passed by hand *over* the hand baggage X-ray. Occasionally, a security checker will open each box, which is a bother.

You can also protect your film with the Sima Film Shield, which holds up to twenty-two rolls of 35mm film. It is a container constructed of lead foil, triple-laminated to polyester and to a barium-saturated lining. The material is also available as Sima Filmwrap in rolls 20½-inches wide by 6-feet long.

Sima Products Corp./7574 N. Lincoln Ave./Skokie, IL 60076

LEARNING FROM KODAK

About the only thing negative (and we recognize the pun) that can be said of this Kodak information literature is that it achieves clear exposition at the price of being bland. You could go to sleep, if you weren't so interested. Just a slight hint of irony, never mind sarcasm, would be welcome, but the company (every last technical writer among them) is "right on target." All frustrated expectations aside, the books and pamphlets do succeed. You can and, what's more, will, unless you are a complete dummy, learn everything you'll need to know. If an amateur, read the introductory literature; if a pro, there is more.

There are three books published by Kodak that deal with their films, *Films for the Amateur, Kodak Color Films* and *Kodak Professional Black-and-White Films.*

Among the three shown above, *Films for the Amateur* is a short course not only in film, but in exposure and processing as well. You'll learn, for example, that Kodak Vericolor II Professional Film, Type L, should be stored under refrigeration and that after exposure, due to rapid changes in the latent image, the film should be processed as soon as possible. (By the way, the company doesn't over-promote

itself. The booklet makes it clear that you can get your film processed by Kodak or "other companies.") The other two books are more detailed. As your need for even more sophisticated information grows, just write for their *Index to Kodak Literature L-5,* Dept. 454, Eastman Kodak Co., 343 State St., Rochester, NY 14650.

FILMS/black and white

TRI-X: ANOTHER WAY TO SIMPLIFY

For most black-and-white work, Tri-X is just fine. We like it and we've never heard a pro complain, although once in a while there is an advocate of Ilford's HP4.

The Tri-X of today is not the same as the one originally introduced, being less grainy and sharper. Kodak is always making improvements without actually announcing such, and today's film is extraordinary for the combination of speed and quality it yields. The "book" says one should shoot Plus-X for one condition and Panatomic-X for another. The professional photographer finds it simpler and more practical to shoot everything on Tri-X. For one thing, by using one film, the photographer gets to know its possibilities intimately, including the versatility of Tri-X, which often makes the difference between getting a picture or not. For another, most professional 35mm negatives are printed no larger than 8×10 inches, and the grain of Tri-X is barely evident at that size.

Tri-X Pan is rated at ASA 400, but it can be pushed to an exposure index (EI) of 1200 to achieve satisfactory density of the negative. Some photographers underrate the ASA, which overexposes the film, in order to get greater shadow detail.

This photograph, contact printed from a sheet of Tri-X, is virtually grainless and could be blown up to a mural twelve-feet long.

Daly City, California, 1970. *Norman Snyder*

KODAK COPY FILM

In copying, the selection of a film is most important. Some of the films offered by Kodak for particular black-and-white jobs are as follows:
- Kodak Tri-X Pan Professional Film 4164 (Estar Thick Base) is good when a fast film is needed to compensate for reduction of light by polarizing screens. The screens reduce reflections from varnished surfaces when copying paintings.
- Kodak Contrast Process Ortho Film 4154 (Estar Thick Base) is a continuous-tone emulsion of moderately high contrast, which when exposed and developed for medium contrast is just the thing for copying etchings, pencil and crayon drawings. Background density is strong, while at the same time the varying densities and thicknesses in the line work are preserved. (Although this type of art work is made up of lines, it contains intermediate tones that would be filled in if copied on line film.)
- Kodalith Films are of extremely high contrast and are made for copying true-line originals, which have no intermediate tones between the lines and the background.
- Kodak Professional Copy Film 4125 is designed for getting greater highlight contrast in continuous-tone copy negatives. Contrast can be controlled by exposure and development to give a fairly accurate reproduction of most originals.

FAST & FASTER

If you can see it, even if it is moving, you can photograph it in black-and-white. If you are using your Hasselblad or Rolleiflex, you can, if have to, push Kodak Royal-X Pan Film to an exposure index of 4000. Just increase development time fifty percent. The film is available only in 120 size.

For 35mm users, Kodak's highest speed film is 2475 Recording Film, which can also be pushed to 4000. It is normally rated at 1000 by Kodak, and the results at this exposure index are considerably different from those you would get by rating Tri-X at 1000. With 2475, the mid-tones ranging into the shadows are full of detail and opened up, giving the photograph an overall gray value. With Tri-X, these tones would all go to a deep black, with only the highlights rendered as tones.

The grain of Royal X Pan pushed to 4000 can look like "golf balls" which can be appropriate for certain subject matter.

Kodak Films in Rolls for Copying and Duplicating

Kodak Black-and-White Films	Speeds		Color Sensitivity	Roll Sizes Available					
	Daylight	Tungsten		35mm Magazine	35mm Rolls	46mm	70mm	3½-inch	2.423-inch
Panatomic-X	ASA 32	ASA 32	Pan	X	X		X		
Ektapan 4162 (Estar Thick Base)	ASA 100	ASA 100	Pan			X	X		
Tri-X Pan	ASA 400	ASA 400	Pan	X	X				
Tri-X Pan Professional 4164 (Estar Thick Base)	ASA 320	ASA 320	Pan				X		
High Speed Infrared (With Kodak Wratten Filter, No. 25)	50†	125†	Infrared	X*	X				
Ortho Copy 5125	—	12†	Ortho				X		
Direct Positive Panchromatic 5246	80	64	Pan		X				
Eastman Fine Grain Release Positive 5302	40†	10†	Blue		X				
Kodak Color Films									
Internegative Color 6008	—	—	Color Film		X	X			X
Ektachrome Slide Duplicating 5038	—	—	Color Film		X	X			
Ektacolor Slide 5028	—	—	Color Film		X	X			

*20-exposure only. †Meter settings for trial exposure.

CROPPING THE PAST

Talk about quality; talk about fine grain. The Chicago photographer, archivist and filmmaker, David R. Phillips takes a wet-plate collodion negative and blows up a detail from it 1800 percent. That's resolution. Phillips likes what he does; in fact, he has pretty much given up contemporary picture-taking. The quality of the old negatives, Phillips' industry and skill and the widespread interest in what "it was like then" have combined to give him a new career. He has made a big thing of buying collections of nineteenth-century glass negatives, poring over them and then printing up segments. "I look at it as if I were walking back into history with my 35mm."

His collection of some 200,000 negatives includes those of the Chicago Architectural Photographing Company, which Phillips claims is the best source of pictures of the

Chicago School of Architecture.

Although he does some stock business, Phillips uses the details he makes to illustrate his books, which are as follows: *The West, An American Experience; The Taming of the West* and *That Old Ball Game.* The three have been published by Henry Regnery. He expects soon to publish *Chicago: Port on the Prairie.*

In 1976, he won an Emmy for a film titled: "And the World Watched." Made with an Oxberry animation stand to pan his stills, it is a thirty-minute view of Chicago by photographers who worked from the 1850s to the 1930s. Orson Wells narrates.

The Steamboat *Louella* at Leavenworth, Kansas, 1871, by E.E. Henry. The stereo view, left, was made with two six-inch Dahlmeyer lenses on 5×8-inch wet collodion plates. The picture is extremely sharp because the films were monochromatic and didn't need lenses so finely corrected for chromatic aberration— the collodion being sensitive only to blue light. An 11×14 print of the detail at right was made from one half of the stereo view.

MAMA, PLEASE DON'T TAKE MY KODACHROMES AWAY

Kodachrome is the best color film we've ever seen. Our only regret is that Kodak makes it only in cassettes for 35mm (20 and 36 exposures), although in years past it was available in other sizes, including 8×10 sheets.

Which brings to mind the history of the film. Briefly, Leopold Mannes and Leopold Godowsky, young classical musicians and amateur photographers in New York City, were experimenting with color processes in 1919. There was no satisfactory color film at the time. In 1922, they were encouraged by Dr. C.E. Kenneth Mees, managing director of the Kodak Research Laboratory, and Lewis L. Strauss, then a partner in Kuhn, Leob & Co. and later an Atomic Energy Commissioner. Strauss arranged for a loan and Mees supplied materials at cost. Later Mees put both of the inventors to work in Rochester, where on April 15, 1936, Kodachrome, a three-layer color reversal film in 16mm format, was officially introduced. The following year it became available in an 18-exposure 35mm cartridge at $3.50, processing included.

Early Kodachrome was rated at ASA 10. It was a stable film that consistently rendered super-rich colors. Never have skies been so blue, lips so red.

Andreas Feininger reports that he has transparencies dating back to then, which are still as brilliant as the day they were made, whereas color slides from other films, made much later, have faded.

Over the years, both Mannes and Godowsky continued an association with Kodak, even as they went their own professional ways. Mannes became director of the Mannes College of Music (founded by his father); he died in 1964. Godowsky continued experimenting with color processes from his home in Westport, where he still lives.

In 1961 Kodachrome II was brought out. It had a rating of ASA 25 and was even sharper than its predecessor. Thin layers of emulsion account for this sharpness.

KII was a film much beloved during its time and deeply mourned when Kodachrome 25 and Kodachrome 64 replaced it in 1974. (Ernst Haas and a number of other photographers bought large batches of KII and froze it.) The ASMP issued a bulletin chastising Kodak for the failures with the newer films. They were too green in the shadows and too variably red in highlights when exposed with electronic flash. The film improved and improves; some batches are excellent. We are all hopeful that the best gets better.

IF NOT KODACHROME, TRY EKTACHROME

It is a professional practice to have Kodachrome developed by Kodak and Ektachrome processed in custom labs. Ektachrome can also be processed at home—those films designated E-4—but we don't recommend it. There is nothing creative about processing color film; all that is required is that you keep a consistent color balance. This requires very close temperature control, proper acidity and consistent replenishment of chemistry, so that the first roll from a batch will have the same color balance as the last. Custom labs have trouble. Do it yourself, you'll have trouble.

Pros take advantage of the speed with which labs can process the films. The general practice is for a studio photographer to shoot several test rolls in the morning, send them off to the lab, have them back in a few hours and then adapt filtration and exposure to get just what is wanted. Ektachrome is not as sharp as Kodachrome 25, but it is faster, and High-Speed Ektachrome can be pushed to ASA 400. While Kodachrome has virtually no grain, Ektachrome is fine grain, and while most of the time Kodachrome has good color balance, Ektachrome has a strong tendency toward a blue cast when subjects are photographed in shadow. This characteristic is one reason the pros are forever testing to find the filter that will eliminate this excess.

plus 1 stop

plus ½ stop

Normal

— ½ stop

— 1 stop

The model holds color bars so the photographer can bracket to test (normal plus two half-stops over, two half-stops under) for exposure and color balance, which are related. Film emulsions are numbered and the professional reserves a numbered batch and tests it. If the batch requires little or no filtration, he buys; if not, he searches on. Tests are necessary because films are inconsistent from batch to batch. The Kodak literature says: "It cannot be emphasized too strongly that any settings given for these films [Ektachrome] should serve only as a guide, since so many techniques exist for taking meter readings. Each user should make complete exposure tests to establish his exposure level before using these films for production work."

PETE TURNER: SLICK COLOR FOR COMMERCE AND ART

Lush, imaginatively-manipulated color is characteristic of the work of the New York studio photographer, Pete Turner. He makes his living—and a very good one it appears to be—by creating photographs for advertising, sometimes by exactly following an art director's sketch, at other times, with considerable freedom to interpret a general mood. Having seen pictures Turner makes for himself, art directors want similar sorts of emotive situations for their ads. (Turner portfolios appeared in *Photo*, May, 1972; *Photo*, May, 1973, and in *Communication Arts*, March-April, 1976. In the fall and winter of 1976-77, forty-six of his color prints will be shown in Paris, New York and Minneapolis.)

More and more, Turner is turning to the manipulation of photographs . . . "to go beyond reality," is the way he puts it, "to take advantage of color, of the inherent abstractions in it . . . to get the sort of effects I feel when I read science fiction." Turner still takes pictures, but he spends a great deal of time making dupes . . . working with his Honeywell Repronar . . . working all night at making pictures out of pictures.

Peter Turner posing in his Carnegie Hall Studio while he is photographed by Casey Allen, interview host of the New York City TV program about photography called "In and Out of Focus." Turner's assistants hold the reflectors.
Don Myrus

Pete Turner is a color photographer, so it is a bit unsettling to have to show a sample of his work in black-and-white. Believe us, the colors are brilliant, Kodachrome brilliant. The title of the picture is "Electric Earring." It was taken in Namanga, Kenya.

In *Photography*, noted on the next page, Eric de Maré summarizes what, in our view, is Turner's direction. "The greatest aesthetic scope in color photography undoubtedly lies in tricks and experiments, and that field has yet to be more fully explored: color filters to provide strange, unnatural effects, the deliberate distortion of the colors in the outer world, the patterns made in space-time by fireworks or moving lights, colored photograms, colored physiographs, the diffusing of some colors and so on."

At age forty-plus, Pete Turner is still very much the commercial advertising photographer, but he is now saying, "in seven years I hope to be able to do just what I want." To be an artist in color photography.

TV STILLS

It takes 1/30th of a second to make a complete picture on a TV screen—the odd number of 525 scanning lines tracing at 1/60th of a second; then the even number, also at 1/60. Therefore, if you use a shutter speed faster than 1/30th of a second with a leaf shutter or faster than 1/8th with a focal-plane shutter, a dark band will appear across the picture.

Television test patterns at the beginning and end of the day are good for checking focus and exposure. Careful photographers bracket the test patterns, note the varying aperture settings and use what turns out best when they shoot programs.

For photographing color TV, use daylight film. (Movie film projected in a theater should also be shot on daylight film.) Interesting effects can be achieved by playing with the set's controls—tuning it out, so to speak, so that the colors are wrong or exaggerated. By using neutral density filters and very long exposures, a sense of motion can be expressed by the colored blurs.

For greater color saturation, the TV set should be in a darkened room. If you want to show the TV set and the screen, then a double exposure is called for. First, shoot the image from the TV screen. Then, after placing a black sheet of paper over the screen, make a second exposure on the same frame with the room lights on.

TV's are so prevalent, they often appear in photographs. To prevent an irritating horizontal line on the screen, shoot slower than 1/30th of a second.
Duke Mander

NEGATIVE FILM: VERICOLOR II PROFESSIONAL

Wedding, bar mitzvah and publicity photographers are the big users. Film Type S is for daylight, Type L for tungsten.

The film can be processed in sink-line equipment with Kodak Flexicolor chemicals for Process C-41. The negatives can be printed on Kodak Ektacolor 37 RC paper or as dye transfers. Transparencies can be made with Kodak Ektacolor Print Film 4109 (Estar Thick Base) or black-and-white prints on Panalure.

The film is not used by advertising photographers (product, annual report, etc.) because they want to have a "true" original of what was photographed, not a negative that has to be interpreted in the printing process. The wedding photographer is perfectly willing to sell either color or black-and-white from the same color negative; so long as he gets acceptable color, he's satisfied. That he often has to accept any compromise is simply the result of shooting conditions: churches, temples, theaters often do not permit flash, and so to get a picture at all, slow speeds have to be used. Type S

has a rating of ASA 100 in daylight, ASA 32 for photolamp (3400K) and ASA 25 for tungsten (3200K). Both the latter require filtration. These slow speeds can be a bother, but Martin Hershenson says he has a "solution" . . . that he can push the film to an effective exposure speed of ASA 320 and that he gets excellent color prints. Further, he says that he gets good results at ASA 1000. "It's all in the chemistry," he says. Hershenson does his pushing in his New York commercial lab, Ultra Color, a division of Studio Chrome.

One other thing interests us about this film. Besides being available in rolls and cassettes, it also comes in sheet size to 8×10. The thought occurs to us that art photographers might be wise to try using it. Can you imagine the pleasant flexibility there would be in contact printing both a big black-and-white print and a color one? The Vericolor films have better granularity and sharpness than the now discontinued Ektacolor Professional films. That means better enlargements, too.

LIFE LIBRARY OF PHOTOGRAPHY

Time-Life Books/New York, NY 10020/cloth; $7.95 plus shipping and handling, from Time-Life; $9.95 in bookstores

The series was created during the great days of Time-Life Books when the editors and designers spared no expense to illustrate their books. When you realize that as much as $5000 would sometimes be spent for a one-page photo illustration—more than most publishers would spend for an entire book—you can understand why Time-Life Books in the sixties was like the Hollywood of the forties. In fact, for some of their projects, stage designers and model makers were commissioned to recreate scenes from classic battles, and at one time a replica of the Parthenon was constructed and photographed—in an attempt to evoke its glory.

With these resources the *Life Library of Photography* undertook the ambitious task of explaining every facet of still photography to everyone, even the unitiated.

Separately indexed, each of the seventeen books has a theme—*The Camera, Color,* etc. Yet each contains a mixture of how-to, explanations of the scientific principles that make photography work, a fine selection of the work of classical and contemporary photographers as well as some history and esthetics. Undoubtedly, the *Library's* forte is in the picture selection and in the graphic demonstrations that illustrate the principles and techniques of the craft.

But if the pictures and the graphic presentations soar, the text tends to sag; it lacks in content the sound advice and experience you'd expect from a publisher so intimately associated with what was once the mecca of photography, *Life* magazine. Qualifications aside, the *Library,* which was published as enthusiasm for photography grew, has served the new adherents well.

The seventeen-volume *Life Library of Photography.*

PHOTOGRAPHY
by Eric de Maré

Penguin Books/Baltimore, MD/paper, $1.95

This is a thorough, inexpensive, basic book. Most of all, it is a well-written one. After a more-or-less standard history of photography, beginning with Leonardo da Vinci and the *camera obscura* and ending with the invention of Kodachrome, the author shows his unusual learning in chapters on aesthetics titled, "Photography As Creation" and "Composing." Most of the rest of the book is a straightforward craft account. Sections are devoted to "The Camera and How to Use It," "Processing," "Color." About color, de Maré has a lucid chapter that explains the additive and subtractive systems, and he has a definite philosophy about the relative place of color in photography. "Amateurs," he writes "tend to think that color photography will oust black-and-white entirely in time—merely because it has color . . . Broadly speaking, I would say that the possibilities of personal expression are far more exacting, far more rare, far more restricted and restricting in color than in black-and-white. . . . the [color] photographer must escape from the conventions of the painter by realizing that he is dealing, not with solid pigments with their special effects and textures, but directly with colored light recorded with clear dyes."

Technical matters are illustrated in line drawings. And for example and illustration, de Maré has chosen a fine collection of photographs by Weston, Cartier-Bresson, Clarence White, Bill Brandt, Werner Bischof, Man Ray, etc.

Unusual pictures and good stories are evident throughout. A sultan and his son are portrayed by Ernst Holtzer, whose glass-plates of Persia in the 1880s weren't discovered until 1963.

Imaginative design and graphics combine in the *Life Library of Photography* to simplify complex subjects. Here a double-page spread demonstrates the characteristic curve of ASA 32 film.

The series is superb in the visual way in which the principles of photography are explained. Typically, the editors manage to intertwine technical information with the history of the art. Here we see that the amount of light is inversely proportional to the square of the distance. The text relates the evolution of flash from the time when artificial light meant flaming jets of oxygen and hydrogen.

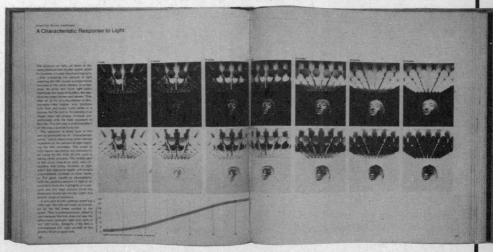

BETWEEN LIGHT AND HEAT: INFRARED

There's a fashion photographer in New York City named Ann Kuhn, who has been working with infrared for seven years. The results she gets are still unpredictable, but surprise is something of what art is all about.

Kodak Ektachrome Infrared Film has three image layers sensitized to green, red and infrared, instead of to blue, green and red as in normal color film. The result is modified or "false-color" rendition of a subject. That's where the interest comes. One of Ann's infrared prints, for example, shows a model holding a baby out-of-doors in a place heavy with flora. Ann made the picture by available light late in the fall when most of the foliage was either dead or dying. Those plants, still green, turned out flaming red; those dead, blue; those in between, chartreuse and turquoise. The woman's shift, originally turquoise, shows up violet. Because both she and the child are very fair-skinned, they photograph almost pure white. Then, too, she used a No. 12 Y filter to help correct for skin tones. (Interestingly, she says that the skin of black people, when photographed under tungsten light, glows with a dark richness.) Kuhn says that infrared film is anything but reliable. Although she follows the recommended ASA 100 rating, she is lucky to get three or four proper exposures out of a 20-exposure cassette. She says another difficulty is that the heavy-base film jams unless a half-dozen inches of the film are rolled into the take-up spool before closing the back. What's more, infrared film is difficult to focus because lenses are chromatically corrected for visible light. Kuhn focuses the normal way and then "pulls back a bit." Sometimes she says, it works. (New lenses have a compensating red dot for infrared focusing on them, right in the distance scale.)

From M-28, p. 9.

APPLIED INFRARED PHOTOGRAPHY M-28

Eastman Kodak Co./Rochester, NY 14650/paper, $3

Otherwise unexciting architectural shots can be jazzed up with infrared film. The top photograph was made with infrared and a Kodak Wratten Filter, No. 87; the one above was taken with pan film.

PHOTOGRAPHY ITS MATERIALS AND PROCESSES
by C.B. Neblette
D. Van Nostrand Co./Cincinnati, OH 45202
cloth, $22.50

This is the serious, general survey of photography by the former Dean of the College of Graphic Arts and Photography at Rochester Institute of Technology. It is intended for technicians in industrial plants, laboratories and research centers; to exact its full value, a reader should be educated in chemistry and mathematics. For all others, it's comforting to know that such a work exists and that by extraordinary application it can be used to great benefit. The author does his scholarly, scientific duty with probability statistics, then fortuitously sums up in simple prose. For example: "Although granularity, as indicated by the microdensitometer trace or evaluated in terms of the deflections of such a trace, is important in some applications of photography, as in spectrography, most photographs are intended to be viewed by a human observer, and granularity in itself is therefore of importance only insofar as it produces a sensation of *graininess* in the mind of the observer."

From time to time, a standardized Ektachrome processing strip is run through the line at a custom lab to test the consistency of temperatures and chemicals.

C. B. NEBLETTE

SIXTH EDITION

PHOTOGRAPHY

ITS MATERIALS AND PROCESSES

L. P. CLERC'S PHOTOGRAPHY THEORY AND PRACTICE
edited by D.A. Spencer
Amphoto/Garden City, NY/cloth; $8.95 each, $49.95 for the set

Originally published in 1926 as *La Technique Photographique*, it was completely revised in 1970 and issued in six volumes: (1) *Fundamentals: Light, Image, Optics* (2) *The Camera and Its Functions* (3) *Films, Subject and Exposure* (4) *Monochrome Processing* (5) *Positive Materials* (6) *Color Processes*. The work is technical and only for serious students of photography as a science.

THE SEVERAL REASONS FOR DUPING AND HOW TO DO IT.

Photography is continually amazing. Printers get used to large transparencies, and when photographers almost universally submit small ones (35mm being easy to work with), the printers seek out a way to "dupe up." Manufacturers and film processors provide the means, then photographers use the new equipment and films for their own creative purposes. The duping art begins . . . Pete Turner and those like him show us transparencies never seen in "real" life. Other photographers dupe as a means of insurance and as a source of multiple sales. Others use dupes to "improve" their work . . . to increase color saturation and contrast . . . to crop . . . to color correct.

The Honeywell Repronar and the Bowens Illumitran 3 are convenient pieces of duping equipment. Excerpts from the Honeywell Repronar Manual give an idea of what to expect: "Normal camera lenses are not recommended. . . . Most normal lenses (especially fast ones) exhibit too much curvature of field to provide sharpness over the entire picture. If you focus on the center, the edges will be out of focus. If you focus on the edges, the center will be out of focus. If you want sharpness, use a lens designed for close-up or copy work. An enlarging lens or a reproduction lens will give good results. . . . An enlargement of three times magnification requires an original transparency of excellent quality. . . . Every system has its limits. You can't get a picture out of something that's just not there . . . Some experimenting may be necessary to arrive at a solution for slides that are more than one f-stop over or underexposed. . . . If your original is unusually dense or underexposed, you may have to flash the unit a few times using the open flash technique to make a correct copy."

The Repronar is for 35mm cameras and with a copy stand accepts up to 6×7. The Bowens Illumitron 3 accepts half-frame to 4×5 formats. As standard equipment, the Bowens has a filmstrip holder, which accommodates mounted and unmounted slides. As well as being able to copy a filmstrip, frame by frame, using a suitable half-frame camera (such as the Olympus Pen FT), Illumitran users can, by rotating the transparency holder 90 degrees, enlarge individual frames from an existing filmstrip to full 35mm size or larger without having to cut the strip.

As for other possibilities in duping, this is how the Bowens people sum it up: "Your imagination is almost the only limit to the special effects you can create. You can superimpose titles, add textures and vignettes, create montages or double exposures, substitute trick lenses for multiple images, diffuse too-sharp slides for soft focus effects."

It's a whole new thing.

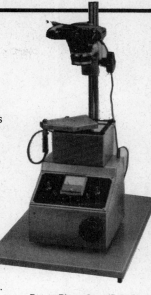

Bowens Illumitran 3 is an electronic color slide duplicator with variable-light output. It accepts transparencies from half-frame to 4×5. Direct metering measures the light transmitted through each slide and indicates correct exposure. Enlargements can be made to 4×5 from 35mm with a single-flash exposure. Light output is a constant 5600K. Illumination for focusing is provided by two low-wattage tungsten lamps, which have no heat effect on the originals being copied.

Bogen Photo Corp./P.O. Box 448/100 S. Van Brunt St./Englewood, NJ 07631

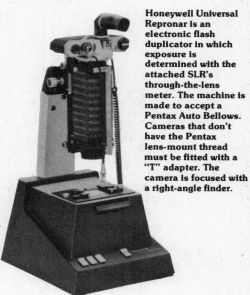

Honeywell Universal Repronar is an electronic flash duplicator in which exposure is determined with the attached SLR's through-the-lens meter. The machine is made to accept a Pentax Auto Bellows. Cameras that don't have the Pentax lens-mount thread must be fitted with a "T" adapter. The camera is focused with a right-angle finder.

Honeywell Photographic Products/5200 E. Evans Ave./Denver, CO 80222

COLOR BALANCING YOUR FILTER PACK

All transparencies should be viewed on a 5000K light box. If the color balance of a dupe is wrong, the procedure is to add or subtract a filter from the pack. The Kodak data sheet for 5038 offers the following table:

If the overall color balance is:	Subtract these filters:	or	Add these filters:
Yellow	Yellow		Magenta + Cyan
Magenta	Magenta		Yellow + Cyan
Cyan	Cyan		Yellow + Magenta
Blue	Magenta + Cyan		Yellow
Green	Yellow + Cyan		Magenta
Red	Yellow + Magenta		Cyan

TO BE A SUPER DUPER

Kodak Ektachrome Slide Duplicating Film 5038 is the one to use. First of all, it is of fine grain on the scale of granular measurement. (Ratings from 6 to 10 are categorized as extremely fine, from 11 to 15, very fine. In other words, the lower the number, the finer the grain.) Where Ektachrome X is rated at 12, Ektachrome 5038 is rated at 7.

Secondly, 5038 has good color-reproduction characteristics and low matched contrasts. What is needed when duplicating is to hold the highlights while getting shadow detail. This film does do the job. The only trouble is that it is color balanced for tungsten (3200K) light and electronic duplicating machines flash at 5600K. Filters are necessary. For example, when using a Honeywell Repronar and Ektachrome or Kodachrome, the following filteration is suggested: Infrared Cut-Off Filter No. 304, plus Wratten Filter No. 2E, plus CC606 Y, plus CC100 R. Print exposure at high beam should be at f/4.5.

Another complication is that 5038 is available only in 100-foot rolls (35mm and 46mm widths) and 1000-foot rolls (35mm width). This means bulk loading. The film can be processed separately or along with other Ektachrome films processed in E-4 chemistry.

There is another way. Some dupers use the 5038 with tungsten illumination. They invert a dichroic enlarger head and place the transparency to be duped on top of it, or they use a light box fitted with tungsten bulbs.

Kodak is scheduled to bring out new duplicating films soon—5071 (E6) to replace 5038 and 6121 (E6) to replace 6120 (E3). The latter is used especially for making enlarged transparencies from Ektachrome and Kodachrome slides. It is available in sheets (twenty-five or fifty to a pack) of from 4×5 to 16×20. It, too, is for tungsten illumination; electronic flash and fluorescent light sources are not recommended.

If increased contrast and saturation should be desired when duping, Kodachrome 25 can do the job. Duping and reduping can add contrast and brilliance to all colors. Shadows block up and highlights bleach out to white. Because Kodachrome has such high resolution, even through four successive dupe stages, sharpness is not lessened.

In the July, 1976, issue of *Photomethods*, Gene Balsley writes: "Going from one manufacturer's original transparency to another manufacturer's duplicating stock is going to involve a lot of corrective color matching. This in no way means a film is better; or that a film is not a good product. But every manufacturer uses his own 'dye-set,' and one set of dyes does not 'see' the other very correctly. To the human eye an Agfachrome original may look superb. The duplicating film sees something entirely different. There's nothing wrong with the original. The duplicating film has its own opinion. Unless you like hassles, use the duplicating stock offered by the folks whose film you like."

THE LOVE OF MYLAR AND TITANIUM

Inventing the SX-70 was really tough, to hear the engineers tell it. They will describe with rapture the special off-axis Fresnel mirror that was designed to direct the image from the lens to the viewfinder on a path that diverges from the optical centerline. They will point out in pride how they "wobbled" the cutting tool to produce grooves of steeper pitch near the sides of the camera. When they see how impressed you are, they will drone on about how they made this mirror function like groundglass by roughening the plastic master with a fine mist of solvent. Seizing the advantage, they'll floor you with the fact that the design of the lens alone required some thousand hours of computer time. After all, it had to be made to focus from 10.4 inches to infinity by moving only the front element one-quarter of an inch! While you're down, they'll kick you with elaborate descriptions of their wonderful little high-torque, 12,000 rpm motor, that is directed by an IC "brain" the equivalent of hundreds of transistors. By that time you will be unconscious, but as soon as you come to they'll tell you about the film, layer by microscopic layer. You'll delight in the account of the great search for the chemical "opacifier," the green stuff that allows the picture to develop before your eyes in light a billion times as strong as that which formed the image. On the day the chemists made it work, Dr. Land brought them a cake upon which was written "and the darkness shall become light . . ."

But has the importance of Dr. Land's prize invention been overstated? Quite simply, no. He has created a pocket photographic system of such sophistication that it can provide pictures of extraordinary beauty to even the inexperienced photographer.

They have a kind of calm, quiet glow to them—a lovely pearly depth. This effect comes from the mylar window and the brilliant titanium dioxide backing that reflects light through the multi-layered positive. This quality gives an SX-70 print a uniqueness. There isn't anything else quite like it. And there's something else that makes an SX-70 print unique: You only get one. Andy Warhol makes good pictures with his SX-70. If he can, so can you.

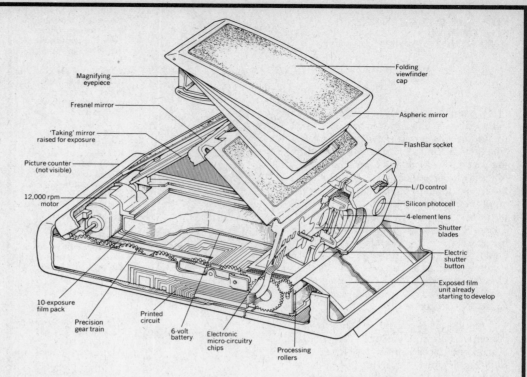

Magnifying eyepiece
Fresnel mirror
'Taking' mirror raised for exposure
Picture counter (not visible)
12,000 rpm motor
10-exposure film pack
Precision gear train
Printed circuit
6-volt battery
Electronic micro-circuitry chips
Processing rollers
Folding viewfinder cap
Aspheric mirror
FlashBar socket
L/D control
Silicon photocell
4-element lens
Shutter blades
Electric shutter button
Exposed film unit already starting to develop

THE POLAROID SX-70 LAND CAMERA

Focusing isn't easy. You must align your eye exactly with the magnifying eyepiece to see what you're doing. And like the young woman here, you must keep your hand clear of the picture as it is ejected; otherwise there is a chance the camera works will jam.

The model 2 is our preference. It has exactly the same features as the chrome deluxe model except that it is made of plastic and is $40 cheaper.

FICTCRYPTOKRIMSOGRAPHS
by Les Krims
Humpy Press, Inc./187 Linwood Ave./ Buffalo, NY 14209/paper, $8.95

Even though Dr. Land has apparently succeeded in creating "Absolute One-Step Photography," there are still plenty of jokers eager to louse it up and make it into two or three steps. Artists are forever refusing to do what they are told. The most popular method of torturing SX-70 prints is to blend the colors and alter the shape of the emerging image by rubbing it with a stylus.

One such inquisitor is none other than the famous Les Krims, who got that way on the strength of his mother's chicken soup. Bazooka bubble-gum stock must be soaring now that Les is sticking bosoms to it. We've always said that if you put a thousand Polaroid cameras into the hands of a thousand creative perverts, and fed them all the free film they could burn, few titillating images of socially redeeming value would result. Krims makes up for the nine hundred and ninety-nine who didn't come through. Les brings his stylus to bear upon his erotic fantasies, applying pressure to the mylar sandwich and rupturing some of the many layers within. The result is, to the uninitiated, startling. Vibrant color and texture pulse and throb like the hearts of Krims' audience when they view one of his comely young lady friends relaxing in a bathtub full of floating falsies, or holding a candle flame to another's breast. Is this art? *Geez,* we don't know, but it isn't hurting anyone, least of all Krims. *Fictcryptokrimsographs,* as he calls his creations, have appeared in a book and in publications as popular as *Oui* and as lush as *Zoom.*

What Krims has done is to take nudity and sexual explicitness beyond the erotic to the wacky. It's nip and tuck as to whether the captions or the pictures are funnier—funny, that is, if you can stand ambiguity, distortion, and general ridiculousness.

"Holding A French Fry With Ketchup In The Middle Of A Face."

It folds, it pops, it develops on its inside like a wet-plate miracle. And its a single lens reflex. Light enters through the four-element glass lens, strikes a permanent mirror and reflects down onto a special Fresnel mirror, which projects it to an aspheric mirror just below its center-line, and passes through the magnifying aspheric eyepiece to the viewer's eye. What you see is right-side-up and correctly positioned left-to-right.

POLAROID 195

Labels on camera diagram:
- Folding range/viewfinder
- Leather carrying strap
- Accessory shoe
- Shutter release
- Distance scale
- Focusing push button
- Developer spread roller system inside camera
- Picture door
- Mechanical developer timer on back of camera
- Shutter cocking lever
- Shutter speed ring
- Aperture control ring
- Flash outlet
- Tripod socket on camera base
- Flash synch and self-timer lever

Between-the-lens shutter is synchronized for both flashbulbs or electronic flash, and built-in mechanical timer on back of camera affords the user precise control of development time for different Polaroid film types.

The 195 made its debut in 1974, along with Type 105 pack film and the Model 405 film holder. Dr. Land also demonstrated a new film that year, still in research, which produces dry color negatives less than 20 seconds after exposure, immediately ready for printing or enlarging.

Serrate and Kane after the shoot-out in Puerto Escondido. Is Kane crying on the inside?

Top gun in Polaroid's arsenal of pack film cameras is the Model 195. Not only does it feature the best lens they offer, a Japanese-made 114mm f/3.8 Tominon with a Seiko leaf shutter synchronized for bulb and electronic flash, but exposure is controlled *manually*. Masochists will delight in being able to set their own shutter speeds from one to 1/500th of a second, and their own apertures from f/3.8 to f/64. With Type 107 the 195 is an available-light camera; with Type 105 positive-negative in the chamber, it becomes a light, economical large-format camera for shooting everything from passports to greased chickens. And the Model 195 is *the* camera for fast-buck nightclub operators. The camera lists for $199.95, and a hustler can make that much with the thing in a single night.

An amusing example of the hustler from the East brought in to face the local badman occurred when Polaroid sent a film crew to Mexico to produce a publicity movie about Art Kane shooting Polacolor 2. The "big iron" on Art's hip was a Polaroid 195, and his opposition was the widely respected Sr. Alejandro Serrate, a wet-bath street photographer who was shooting up a storm in Puerto Escondido. The film crew thought it would be jolly to have some footage of the famous pro photographer exchanging portraits with the local hero, so citizen Kane and Sr. Serrate faced each other at high noon. Each was loaded for bear with the new Polacolor 2 film. With cold precision Art leveled the 195 on his Tiltall toward the calm Alejandro, who directed the lens of his old wooden view camera right between Art's eyes. Two clicks broke the dreadful silence, and it was over in an instant. When the pictures were peeled, Alejandro Serrate was still the top photographer in Puerto Escondido.

B/W POLAROID + N.D. FILTER = PERFECT COLOR

More than once upon a time and long ago, many a photographer saw black upon receiving his color film. The model fee for three cats, two dogs, and a child star . . . down the drain all because the electronic flash was not properly synchronized to the camera. Testing with Polaroid has put an end to such basic oversights as well as more sophisticated ones. The idea is to preview the results by shooting Polaroids first, then, when all is perfect, expose the shot on color film.

By using the proper neutral density filter, the speed of the Polaroid can be perfectly matched to that of the color film used for the final shot. For

example, Type 52 Polaroid (ASA 400) is three stops faster than 4×5 Kodak Ektachrome film daylight (ASA 50). With a .90 neutral density filter, three stops worth of light are absorbed. Therefore, when exposure on Type 52 through a .90 neutral density filter is correct, it will also be correct for ASA 50 color film without the N.D. filter.

This technique has proved so

The ASA of Polaroid can vary half a stop. Fastidious workers establish the relationship between batches of color transparency film and Polaroid film by shooting a test such as this, using a gray scale and color bar. From a bracket of color transparencies the best exposure is selected. With the camera at this setting, neutral density filters are used to produce a black-and-white Polaroid whose tones match those of the color transparency. The neutral density filter that does the job is then noted on every box.

successful for judging lighting (it has become operating procedure for most professionals doing commercial work) that photographers have learned to trust their Polaroids over their meters.

POLAROID FILM CHART

PACK FILMS

FILM TYPE	EXPOSURES IN PACK	SIZE	PICTURE DESCRIPTION	E. I.	DEVELOPING TIME
105	8 exposures	3¼x4¼	medium-contrast black & white print and negative	75	30 sec.
107	8 exposures	3¼x4¼	medium-contrast black & white print	3000	15 sec.
87	8 exposures	3¼x3⅜	medium-contrast black & white print	3000	15 sec.
88	8 exposures	3¼x3⅜	full-color print	75	60 sec.
108	8 exposures	3¼x4¼	full-color print	75	60 sec.
SX-70 Land Film	10 exposures	3⅛x3⅛	full-color print	AUTOMATIC	

SHEET FILMS

FILM TYPE	EXPOSURES IN BOX	SIZE	PICTURE DESCRIPTION	E. I.	DEVELOPING TIME
51	20 exposures	format 4x5 image 3½x4½	high-contrast black & white print	125-T 320-D	15 sec.
52	20 exposures	format 4x5 image 3½x4½	medium-contrast black & white print	400	15 sec.
55	20 exposures	format 4x5 image 3½x4½	medium-contrast black & white print and negative	50	20 sec.
57	20 exposures	format 4x5 image 3½x4½	medium-contrast black & white print	3000	15 sec.
58	10 exposures	format 4x5 image 3½x4½	full-color print	75	60 sec.

ROLL FILM

FILM TYPE	EXPOSURES IN ROLL	SIZE	PICTURE DESCRIPTION	E. I.	DEVELOPING TIME
42	8 exposures	3¼x4¼	medium-contrast black & white print	200	15 sec.
47	8 exposures	3¼x4¼	medium-contrast black & white print	3000	15 sec.
46-L	8 exposures	3¼x4¼	continuous tone, black & white transparency	800	2 min.
146-L	8 exposures	3¼x4¼	high-contrast black & white transparency	100-T 200-D	30 sec.
410	8 exposures	3¼x4½	high-contrast black & white print	10,000	15 sec.
* 32	8 exposures	2½x3¼	medium-contrast black & white print	400	15 sec.

* Film used by professionals in custom-made roll-film backs for the Hasselblad.

LUCAS SAMARAS: PHOTO-TRANSFORMATIONS
by Lucas Samaras
California State University, Long Beach, CA, and E. P. Dutton, New York, NY/paper, $7.95

Samaras' pictures are startling even to the initiated. For a series of images that will shock and terrify you with electric color and melting swirls of screaming flesh, pick up a copy of his book *Lucas Samaras: Photo-Transformations.* And keep yourself under observation.

As Krims' work is wacky, Lucas Samaras' is weird and frightening, as from a horror film, and working with a SX-70, painterly, as in finger painting.

SHOOTING IN THE STREETS

There's a charming little Hungarian named "Lucky" who has been making his living for years selling portraits on the street at Fisherman's Wharf in San Francisco. He works with his wife and an old Crown Graphic fitted with a 127mm Kodak Ektar and a Polaroid pack back. After having his camera blown over by the wind a few times, he began mounting his rig on a Majestic tripod. The last time we saw him he told us he had been working since four o'clock that morning. It was nine o'clock, and dark outside. His pictures were out of focus. He attributed this to eye fatigue, but we soon discovered that his rangefinder was out of whack. He quit for the night, figuring that nineteen hours was enough for one day.

Lucky's beautiful. Wears dungarees and a fisherman's hat and has even offered his coat to a shivering soul in the cool San Francisco night. Once Lucky hurled his Polaroid 180 (a discontinued camera that took pack film, had adjustable controls and a combination viewfinder-rangefinder) to the street and stomped on it because it malfunctioned once too often, but he is otherwise a gentle man. He even kept the rollers for a souvenir. He charges $2 for a picture he mounts on a button.

Dapper Dick Turnbull on one of his two-dollar buttons. You can also get photos on dollar bills, posters, T-shirts, and belt buckles. Get your picture on a beer mug and drink with your best friend.

Meanwhile, three thousand miles away, Dick Turnbull stands hustling his Polaroid photo buttons in Times Square. Dick tends to specialize in photographing queens and pimps, but if you tell him you're from Iowa he'll smile and do you up brown. "I can put you in pictures. Make you a *star* on *Broadway!*" he announces in a deep theatrical voice tinged with just the right amount of self-parody. Dick is tall and slender, with long sideburns and a fondness for studded clothes. Once he chased a thief down the street with a scissors. It isn't easy working the streets of New York at night. Dick is probably the most famous street photographer in America. He's good. Want to be photographed by him? He can be reached at his studio at 35 W. 8th St., in the Village.

A TECHNICAL REPORT ON TYPE 105 BY OUR SLIGHTLY MAD FILM MAN

What would you say if you were told you could have a fine-grain black-and-white print in just thirty seconds, as well as a matching negative with a resolution of 150 lines from a convenient filmpack that you could use in both your Super Shooter and your Cambo? You'd say "Gimme!" we know. But when you discover that you have to carry around your own bilge bucket, your enthusiasm may wane just a bit. You may wish to acquire a coolie.

Here's the way it works: One coolie can carry comfortably on his pole two Polaroid clearing tanks of sodium sulfite solution. Or four buckets uncomfortably. To shoot Type 105 in any quantity in the field, at least one coolie is required. This is because a sodium sulfite solution is needed to clear the negative. A handy measuring cup is supplied (cheerfully) with each slop pail to make mixing the 12 percent sulfite solution easy enough for someone like yourself. Although the negative will obligingly shed its residual developer and opaque backcoat in about thirty seconds, it will happily sit in your sulfite all day without harm. A five-minute wash and a dip in a wetting agent, and you can hang 'em up to dry. And here's a special bonus: at the bottom of each sulfite tank soon forms a nifty precipitate that resembles a giant sand dollar.

1 Peel print off in a **swift**, continuous motion.

2 Holding negative top tab, tear off leader (A) just above pod (B) and discard.

3 Holding negative by top tab, remove paper mask from negative and discard.

4 Holding top tab, agitate negative in sulfite **30-60 sec.**, or store in solution.

5 Remove from sulfite, pull off top tab and black backcoat (C); inspect negative.

6 Pull off bottom tab (D); store negative in sulfite or go to finishing process.

We call 'em sulfite cookies, and you can pierce 'em, thread 'em with leather thongs, and hang 'em around your neck. You'll get white powder all over you, and make your dog sick.

Type 105 positive-negative pack film will get you off whether you are a commercial hack or a phony "art" photographer. For those of you who are wading up to your knees in the mainstream of creative visual expression, a pack back full of Type 105 shoved into the breech of a view camera offers advantages Edward Weston never had and contrastier negatives, too. The material has only been available for a short time, but already some impressive work has been done. Jim Cornfield took some Type 105 down to New Orleans at Mardi Gras time and produced a striking set of images called Fat Tuesday. Prints made from 105 negatives are pearly and mellow.

THE POLAROID LAND PACK FILM HOLDER 405

Moronically simple, this nifty device enables you to shoot Polaroid pack films in your 4×5 camera. Essentially, it's a precision black plastic box containing heavy-duty stainless steel rollers and a flexible dark slide. The film pack is inserted into the pack back; the pack back is inserted into the back of the view camera, and you're ready for eight quick ones. Buy a couple, so you can shoot color and black-and-white at the same time.

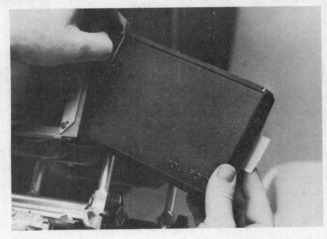

Some springbacks are not flexible enough to accommodate the thickness of a 405 pack, which, at 1-1/16 inches thick, is more than twice that of a normal film holder. For instance, the pack will fit into our studio Sinar, but not a Deardorff 4×5 reducing back. While the manufacturer says the pack is compatible with most 4×5s, it couldn't hurt to check it out beforehand on your particular camera.

Unlock and open the holder back. Push up both ends of the back door latch and open the back all the way. Be sure the dark slide is pushed all the way into the holder before loading film. Insert the pack. Hold the film pack by the edges as shown. Push the closed end of the pack under the light shield (B), and then down into the holder.

Check the white tabs. Be sure that they are not caught between the pack and the holder.

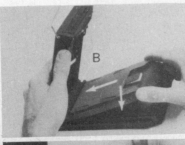

Close and lock the back. Hold the back closed and push down on the center of the latch (A). The black tab (B) of the safety cover must stick out in front of the latch.

Remove the safety cover. Grasp the holder as shown, and get a grip on the black tab, which is the end of the safety cover. Pull the safety cover all the way out of the holder. Pull straight and be careful not to tear it.

SINGULAR IMAGES
by Ansel Adams
*Morgan & Morgan/Dobbs Ferry, NY/
paper, $7.95*

Some 53 plates represent twenty years' worth (1954-73) of Ansel Adams' work with Polaroid materials. Also included are introductory comments by Polaroid's Dr. Edwin Land and Jon Holmes, Ansel Adams, and diary excerpts from David Hunter McAlpin's experience with the photographer.

When Edwin Land introduced the revolutionary concept of "one-step" photography, Adams was intrigued and began to experiment with the Polaroid Land cameras and films. My wife and I were in San Francisco in the late 1950s and we found that Adams had mounted a splendid exhibit of his own Polaroid Land prints. This was the first time I had seen such a collection; the subject matter was varied and the tonalities most subtle. David Hunter McAlpin

MISTER 4×5

Polapan Type 52 4×5 material is fast (E.I.400) and fine-grained. And it's smooth as Duane Michals' pate. Takes a nice tan, too, if you spray it with a fine mist of Kodak Rapid Selenium Toner just after the print is peeled and before coating. This quality makes it a favorite among the "instant tintype" crowd, who are getting rick quick in studios all over the country. Many photographers use it to check exposure and lighting before exposing conventional films. With neutral density filters, any lower film speed can be simulated. But even a good printer finds it difficult to match the gentle gradation of Type 52 with conventional materials.

Type 52 for 4×5 holder

SHOOTING IN THE DARK

With a pack of Type 107 in your camera, you can photograph all the skeletons and queens in your closet without a flash. This remarkable material lets you shoot available light at f/8 instead of f/2.8. At 3000 ASA equivalent, it's one of the fastest films available. Not especially grainy, either. And even if you don't want any, remember that a pack of 107 is the cheapest way to get one of those nifty print coaters that ooze the pink goo that smells so nice. Enjoy your bus ride home! In 4×5 sheets, the same film is called Type 57, and if you buy a box of twenty sheets you get *four* coaters. That's enough for a small gang of "black-and-white punks on dope," and you won't even care if your prints fade.

Type 57 for 4×5 holder
Type 107 for film pack

YOU'VE GOT TO ACCENTUATE THE POSITIVE, DON'T ELIMINATE THE NEGATIVE

Type 55 P/N film is not exactly the 4×5 equivalent of Type 105. The major difference is that there is a separate optimum exposure for the positive and the negative. That wasn't so hard to take when it was the only positive-negative instant film around, but many large-format workers find the incredibly sharp 105 negative to be plenty big enough. Like 105, the 55 P/N negative is cleared in a sulfite bath, but it should be a bit stronger (18 percent).

P/N Type 55 for 4×5 holder

SOMEWHERE OVER THE RAINBOW

The new Polacolor 2 film, available in filmpack (Type 108), and 4×5 sheets (Type 58), is sharp enough to cut your throat. If you haven't shot any Polacolor lately, are you in for a surprise! The metalized dyes employed in the stuff are the same that were developed for the SX-70 and are among the most stable ever produced. Someday, if it hasn't happened already, you're going to wake up and see a faded face looking back at you from the mirror. But your Polacolor 2 snapshots will still be crisp and bright. Isn't that depressing?

YOU DO SOMETHING TO ME

Those who see the world in black-and-white will embrace the brutal rendition of Type 51, Polaroid's answer to Kodalith. A copy camera loaded with this extremely high-contrast 4×5 film enables you to create instant line copy and special graphic effects, at an obvious savings in time, money, and frustration.

Type 51 for 4×5 holder

Polaroid Corp./549 Technology Sq. Plaza/Cambridge, MA 02139

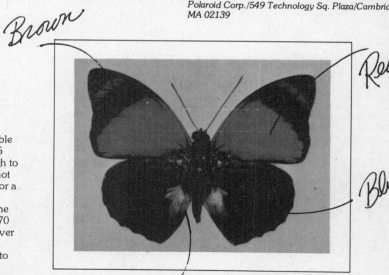

Brown
Red
Blue
Yellow

Type 58 for 4×5 holder
Type 108 for film pack

MODEL 545
4×5 SHEET FILM HOLDER

How does a Polaroid 4×5 sheet film packet and holder work? It's like the light in the refrigerator. Nobody really knows. If you look, you fog the film. But the theory goes something like this.

The negative and positive in the packet are shielded from light by a paper envelope. At one end of this envelope is a metal cap which is attached to the negative within. When the envelope is inserted all the way into the holder while the arm is set to the "L" or "load" position, a tab in the holder engages the metal cap and holds the negative in place when the paper dark slide is withdrawn through the open rollers. After the exposure is made, the envelope is slid back into place and the arm of the holder is set to the "P" or "process" position. This releases the metal cap and closes the rollers. The entire sandwich is then pulled through the rollers, bursting the pod and spreading the reagent. At the end of the imbibing time, the envelope is ripped open and the print lifted out. There is a switch on the holder which enables you to remove the exposed packet for processing later. If it's cold where you're shooting, you'll be grateful for that feature—development below 40 degrees yields gray pictures.

When time is of the essence because the sun is quickly setting, and you're shooting a model at a high hourly rate, you might not want to wait the necessary minute to see what it is you're getting. What to do? Photograph but don't process by first exposing film, then releasing the packet by pushing the release button (not shown here). Be sure to mark each exposed packet by crimping the envelope.

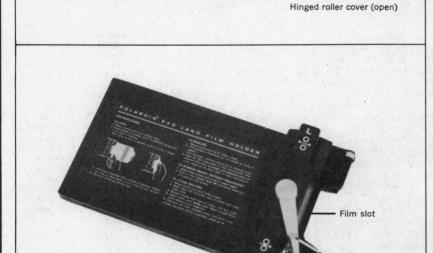

Focal plane
Steel processing rollers
Rubber light seal roller
Cover latch
Roller hooks
Hinged roller cover (open)

Film slot
Control arm
Film release lever

Loading film—With (1) control arm at L (load), (2) rollers are apart so (3) film packet can pass through freely. (4) Cap is held by (5) spring-loaded retainer. (6) Pod of developer is attached to negative, and lies between it and positive sheet.

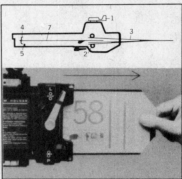

Making exposure—(1) Control arm is still at L and (2) rollers are apart. (3) Envelope, which is lightly held by (4) cap is withdrawn along with positive print sheet. (4) Cap, held in place by (5) retainer, is tightly crimped to (7) negative, which stays in holder for exposure.

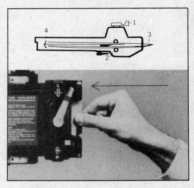

After exposure—(3) Envelope is pushed back into holder.

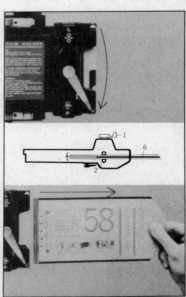

To develop—(1) Control arm is moved to P (process). This brings (2) rollers together and presses them tightly against (3) film packet, crushing pod and spreading (6) developer evenly between positive and negative. This starts development of picture.

179

NOT EXACTLY ONE, TWO, THREE . . .
LOADING POLAROID LAND FILM IN A ROLL-FILM BACK

Polaroid Corp./549 Technology Sq. Plaza/Cambridge, MA 02139

Polaroid has this CB-40 back for roll film that can be adapted to different cameras, even microscopes. All Polaroid film used to come in rolls and most emulsions are still available in this form. The black-and-white transparency film is only available in rolls. This back is the same as on the discontinued 110A and 110B cameras, which many professionals used for testing because of their full range of f-stops, shutter speeds and flash synchronization. Here's how to load the back.

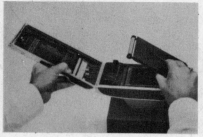

1. Lift open the back cover as far as it will go. Lower it gently; don't let it fall. Then lift open the inner panel and gently lower it as far as it will go.

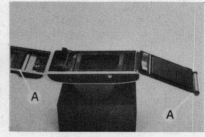

2. This is the position in which the holder is loaded. Before loading, examine the two steel rollers (A). **It is important to keep these rollers clean.** Use a damp cloth to remove any specks or deposits that may appear on the rollers from time to time.

3. Drop the rolls into the wells on either side of the holder, as shown. Insert the large positive roll first, and then the small negative roll.

4. Now close the inner panel.

5. Fold the film leader over the steel roller on the edge of the panel, and lay it flat between the guides (A) at the hinged end of the panel. Be sure the material lies flat and smooth, and is not tucked into the well at (B).

From the manual for the CB-40 Land Camera Back.

OLD MAN LAND:
WANNA BUYA DUCK?

Edwin Land's face is one of such chiseled intelligence and compassion that he reminds one of the owl that used to be on the Wise Potato Chip package. You may have heard that the brilliant doctor was maybe just a *little* strange. We have to admit that we haven't seen a great deal of evidence to the contrary.

In 1973 he ordered three incubators full of duck eggs from a farm in New Jersey. His original plan to bring life into a shareholders' meeting was to photograph the ducks as they were hatching. But the ducks wouldn't wait. Land looked at the little buggers waddling around and decided that they were just too stupid. The ducks were canned, and two cargo 707's full of tulips were flown from Holland instead.

At the 1976 annual shareholder's meeting he paced the floor lost in reverie as he described with obvious rapture the beautiful young woman in Renoir's masterpiece, *Le Bal à Bougival.* It seemed like he went on about her for a good five minutes, until some of the less artistically inclined in the crowd became a little fidgety. He then unveiled, with characteristic flair, a three by six foot replica of the great painting made on Polacolor 2. It was not a blow-up, but a one-to-one reproduction, so faithful that it brought a gasp from the audience.

If you're thinking of hiring him, here are the vital statistics:

Land, Edwin Herbert. b. *1909,* Bridgeport, CT. raised Norwich, CT. *1926,* graduate Norwich Academy (excellent student, prize-winning debater, track team). *1930,* Harvard—leave of absence same year to conduct independent research in the polarization of light, at the New York Public Library and unofficially at Columbia University. Assisted by Helen ("Terre") Maislen. (The two later married and had two daughters, Jennifer and Valerie). *1932,* announced the substance Polaroid, which eliminated glare through polarization. *1934,* first Polaroid sheets patented but not used as intended by auto makers to reduce headlight glare, because Polaroid deteriorates when exposed to heat. *1936,* Polaroid lenses used in the sunglasses of the American Optical Company. *1937,* founded Polaroid Corporation in Cambridge, MA. *1941,* profitably made film for glasses to view 3-D movies. *World War II,* worked on the development of infrared searchlights, gun sights and guided missiles. *1947,* announced a one-minute camera. *1948,* camera and film made commercially available and brought a profit of $5 million. Camera was the Model 95, which weighed almost four pounds. The developing method was the application of diffusion-transfer reversal, which is a simultaneous negative and positive image-forming system. The principles of DTR were applied concurrently but independently by Rott in Belgium, Weyde in Germany

and Land in the U.S. Sepia-toned pictures were developed by what basically remains the Polaroid process: a negative is exposed, brought into contact with a positive sheet, both pass between rollers during which a pod of chemicals bursts and spreads. *1956,* visiting professor at the Massachusetts Institute of Technology (the "Dr." signifies honorary degrees; he never did go back to college as a matriculated student.) *1959,* start of "high-speed" program with a film fast enough for indoor available light pictures. Development time fell from sixty to ten seconds. Introduction of Type 55 P/N that produces both a print and a negative in twenty seconds. *1972,* introduction of the SX-70. *1973,* Walker Evans said, "I'm very excited about that little gadget (the SX-70), which I thought was just a toy at first."

With this camera, Dr. Land took modern photography out of the darkroom. In 1947, in a flamboyant fashion that has since become typical, he demonstrated his one-step photography before the Optical Society of America, using an 8×10 view camera. The following year, the model 95 was introduced along with type 40 orthochromatic sepia roll film, ASA 100. (Type 41, the black-and-white film was introduced in 1950.) Model 95 has a 135 mm f/11 lens; the diaphragm is coupled to shutter. Roll film has eight exposures sized 3¼×4¼; development time, 60 seconds. In 1950, the camera cost $89.75. Now, it's a collector's item.

13

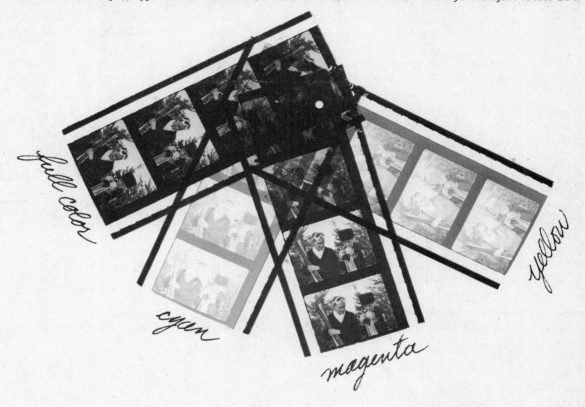

full color

cyan

magenta

yellow

COLOR PRINT SYSTEMS

COLOR PRINT PROCESSES

Current color print processes are divided into two categories, negative-to-positive and positive-to-positive. Most professionals and the majority of non-professionals still opt for the original film, regardless of type, to be processed by an independent commercial laboratory. More and more, however, they have taken to producing their own prints. The underlying reasons are simple. A major capital investment is not necessary. Secondly, the simplicity of the printing processes released in recent years has made it an almost "can't miss" procedure. Anyone with practical black-and-white printing experience can now successfully make his own color prints. Virtually any enlarger/lens combination used for black-and-white can be employed. A darkroom capable of producing black-and-white prints can turn out color. Some minor additions, such as color filters, correct safelight filter and voltage stabilizer, are needed.

Question: Should I choose the negative-to-positive or the positive-to-positive system? *Answer:* Both are good and each has its advantages and disadvantages. The negative-to-positive method is more complex for the beginner. Working from a negative, it is difficult to judge the unknown values contained therein (i.e., exposure, contrast and color). The orange mask in color negative film adds a density of its own, thus compounding the problem. Still, the user, in making prints, is working under the disadvantage of having to try to render the color values of the original scene, if indeed he made the original photograph. The advantages are that prints made by this system will produce more faithful color recordability, be of lower contrast than those made by the positive method and the processing of the paper is about half that of positive to positive.

The positive-to-positive system offers a visible starting point, the slide or transparency. The goal is to make the prints appear as close to the original as possible. Recent developments, such as the Cibachrome system, have made this form of printing the simplest to master. Some positive-to-positive systems have a great deal more latitude built into them than their negative-to-positive counterparts. In some cases, processing temperatures can be varied to control contrast, while negative-to-positive temperature recommendations must be strictly adhered to. Both types of papers are manufactured on a resin-coated base, shortening wash times and accelerating drying.

PRINTING COLOR NEGATIVES, E-66
PRINTING COLOR SLIDES AND
LARGER TRANSPARENCIES E-96
Eastman Kodak Co./Dept. 454, Rochester, NY 14650/paper, $2.50 each

Upon entering color printing, one can be overwhelmed by its many facets. The gathering of knowledge is usually empirical. This is a slow process, which is frustrating to the novice. There are two publications available from Eastman Kodak Company that are helpful. Specifically, they are *Printing Color Negatives* E-66 and *Printing Color Slides* and *Larger Transparencies* E-96. Although they deal essentially with Kodak materials and equipment, they contain a tremendous amount of information that can be applied towards other processes.

Both books start by giving an easy-to-understand description of how their two processes work. They then go into the specifics involved in exposing and processing the paper. Covered in great detail is the color evaluation of test prints. This phase of color printing, especialy in the negative-to-positive system, is the most difficult for the beginner. The books pay for themselves by educating the reader to a simple yet analytical method of determining proper color balance and exposure. Overall, these are two books that the serious color printer should read before attempting the first print.

General Processing Specifications for Tube-Type Processors with KODAK EKTAPRINT R-500 Chemicals
Nominal solution temperature of 38°C (100°F)

Processing Step	Time in Minutes*	Accumulated Time in Minutes
1. Prewet (water)	½	½
2. First Developer	1½	2
3. Stop Bath	½	2½
4. Wash	½	3
5. Wash	½	3½
6. Color Developer	2	5½
7. Potassium Iodide Wash	½	6
8. Bleach-Fix	1½	7½
9. Wash	½	8
10. Wash†	½	8½
11. Stabilizer	½	9
12. Rinse (water)	¼	9¼

*All times include a 10-second drain (to avoid excess solution carry-over). Some processing tubes may require a **slightly longer** drain time. Be sure to allow enough time to make certain that the tube is drained and to add the next solution **on time** for the next step. The next step **begins** when the solution contacts the paper.

†An additional step (new Step 11) may be required, depending on the processing tube you are using. To determine if this step is required, see page 23.

These tubes are designed for processing in a constant-temperature water bath. Their solution inlets and outlets are either closed or positioned in such a way that the tempering water is prevented from entering the tube. It is essential that none of the tempering water enters the tube during the processing procedure. Select the processing procedure that is appropriate for the type of tube you are using.

From Kodak's *Printing Color Slides* E-96.

Off-easel spot readings are made with the negative positioned so that the image of the reference area is under the probe. Shown is the Macbeth TD504 color transmission densitometer, manufactured by the Macbeth Corporation, a division of Kollmorgen Corp., Newburgh, New York.

From Kodak's *Printing Color Negatives*, E-66.

COLOR PROCESSING EQUIPMENT

Although color paper can be processed like black-and-white in a tray, there are at least five better ways that are more consistent and less tedious. The one usually picked by beginners is the simple drum. It gives good chemical economy and can even be motorized. Prints up to 16×20 inches can be easily processed.

The next step up can be a more mechanized method, such as the Agnekolor processor. Here the paper is held stationary and the chemicals are pumped across by what is called laminar flow. No plumbing is necessary. Only a level surface and a room that can be briefly darkened are required. All the elements necessary for processing, except drying, are self-contained in this unit. A major plus for the Agnekolor is that it only uses one ounce of chemistry per 8×10-inch print.

The next alternative is the completely motor-driven drum/tube processor, such as the Kodak Rapid Color Processors, available in three models and capable of processing prints up to 30×40 inches. With the small and medium-sized unit, the paper is placed on the outside of a motorized metal drum. A plastic blanket holds it in place. As the film rotates, it receives fresh chemicals from a tray in the unit. At the end of each step the tray is tipped up, dumping the chemicals. Temperature is controlled by a recirculating water method. A major advantage to this method is that the total processing time is only five minutes when printing from a negative, no matter what the machine. In the larger unit, the paper is placed inside a lighttight tube. The processing cycle is six minutes. Positive-to-positive paper can also be handled in these processors.

Yet another choice is basket processing. Here the paper is placed in compartments made of a special type of plastic screening. In a 3½-gallon tank, prints up to 8×10 inches can be handled. The prime advantage to this method is that large amounts of prints can be processed in one batch. Larger-sized paper baskets can handle prints up to 20×24 inches.

Agnekolor Systems Corp./460 Totowa Ave./Paterson, NJ 07522

Requiring no plumbing or darkroom, the Agnekolor is a favorite of many color printers. The chemical temperatures are maintained by a central water jacket. During processing, the chemicals flow across the surface of the print. Illustrated is the model 1114 Laminar Flow Processor. It can handle prints up to 11×14. It is capable of processing black-and-white prints as well as sheet films. An accessory heater is available for many of the newer elevated-temperature print processors.

Calumet Scientific, Inc./1590 Touhy Ave./Elk Grove Village, IL 60007

Eastman Kodak Co./343 State St./Rochester, NY 14650

The Kodak Rapid Color Processor is a fast and efficient means of developing color papers, but all operations have to be performed in total darkness. Both negative to positive and positive to positive can be put through. The paper, as it revolves with the drum, is constantly receiving fresh chemicals. At the end **of each step the tray below the drum is upended, thus dumping the solution. A water reservoir inside the drum maintains the temperature during the cycle. Special developers must be used with these processors when running Ektacolor 37RC and Ektachrome 1993 (positive-to-positive) papers.**

Medium-capacity batch-type print processors offer good production at a minimum of floor space. Most are fully equipped with automatic water temperature controls and automatic agitation.

Print processing baskets are used with standard 3½-gallon tanks. Up to thirty 8×10-inch prints can be processed in one batch. Both negative/positive and positive/positive papers can be used.

In a darkroom, the print is inserted into the drum. The emulsion of the paper must face in. The drum must be both clean and dry prior to use.

The lighttight cover must be sealed correctly on the drum. If not, it will result in unevenness in the prints and possibly light fog.

The amount of chemicals suggested by the drum's manufacturer should be adhered to. Skimping here will definitely lead to a problem print and a makeover. Chemicals should be poured in at a moderate rate. Care must be exercised that one solution does not splash into another, thus causing contamination. Good work habits are mandatory for good results when drum processing. Agitation rate and time and temperature requirements must be adhered to. For the sake of consistency, each print should be developed EXACTLY as the previous one.

Beseler Photo Marketing Co./8 Fernwood Rd./Florham Park, NJ 07432

1-8"X10" print. 2-5"X7" prints.

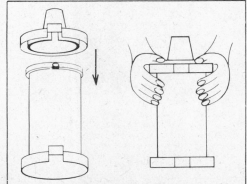

COLOR PRINT SYSTEM/equipment

COLOR ANALYZERS

Color analyzers are, at first glance, a bit frightening to the consumer. Dials, knobs, numbers, etc.—all very necessary, yet confounding. In reality they are no more difficult to use than an exposure meter. The function is simple. Rarely will two batches of negatives match one another in inherent values. Differences in exposure, film processing, lighting, etc., all create variables. To speed up the trial and error system of printing, an analyzer is used.

Basically, all work on a similar principle. All have a probe in one form or another. This probe contains a photomultiplier tube. Over the input side of the tube is a disc containing red, green and blue filters. These read each corresponding layer of dye in the negatives selectively. In doing so, they give a readout on a built-in meter of the printing filters needed for that negative. The information is based on a program that is fed in by the user. This is based on what the individual color printer feels is a perfect print. The same procedure is used for exposure. That "channel," as it is referred to, is best understood as an exposure meter. If, for example, the perfect print was exposed at f/11 for twelve seconds, by stopping down the lens to get the meter to read twelve seconds, exposure determination is virtually instantaneous. This, as well as the filtration analysis, is what pays for the analyzer—in savings in paper and chemicals that would be used in making tests. Some instruments can hold more than one program, which is particularly useful when using more than one type of paper. They may even be set up to use with black-and-white papers strictly as an exposure meter.

After the initial setup, the actual use is most simple. The unknown-value negative is projected onto the probe. All that is required is to bring the needle on the meter to zero, which is referred to in analyzer jargon as "null." Whatever filter pack this gives should produce a fairly good print on the first try. Usually a second one, based on a visual judgment, is made to finesse the final result.

THERE IS A SIMPLE WAY TO MAKE COLOR PRINTS

Besides a basic paper-chemistry combination, you need an enlarger with a filter drawer above the negative stage (so the light is filtered), a set of color printing filters (which go in the drawer), a plastic processing drum and an accurate thermometer.

To eliminate infrared rays, insert heat absorbing glass in the filter drawer. Insert a Kodak CP 2B to eliminate ultraviolet rays.

Besides the CP 2B filter, you need magenta, cyan and yellow filters. You also need each color in increments of 5, 10, 20 and 40—two of the last, in fact. This combination provides a density range of filtration from 5 to 115—enough to achieve the desired color balance in the finished prints. After exposure in total darkness with the recommended filter pack, insert the paper in the drum. Now, it gets a bit unusual. Pre-heat the paper by filling the plastic drum processor with hot water, always at exactly the same temperature (e.g., 110°F—that's what the thermometer is for). Dump the water, then process as recommended by the manufacturer, using the chemicals at room temperature. By following this procedure for every print, your processing will be consistent, and you have established a constant. Now by changing the filter pack, you can correct any print with predictable results. Don't evaluate a wet print for color balance; dry print before deciding upon any filter change.

That's all folks!

The Lektra PTM-11 (above) is the standard analyzer of many professional printers. A true workhorse, the PTM-11 incorporates many state-of-the-art features. Plug-in replacement modules provide "instant maintenance." Exposures from .7 to 300 seconds are determined at the touch of a button. Repeatability is ±.02, a virtue that is paramount in analyzers. The PTM-11 is equally at ease with negative/positive and positive/positive materials.

The EPOI MM-9 Analyzer features plug-in memory banks. These are used to "punch in" the pre-programmed values (color and exposure) for different emulsions of paper. The unit also includes a built-in instant reference program.

The Cosar/Mornick 321 offers an interesting option. It can be used as a standard on-easel analyzer. It can also be used as a reflection analyzer of the *prints* themselves. The 321 comes equipped with *four* separate programs. This feature is most useful when working with different-size color papers that all require different filtration.

Incorporating many features found in professional analyzers, the Omega Simitron II is moderately low in cost. A primary feature is the "subject failure" indicator. This is most useful when printing negatives that have an overabundance of one color (example: a golf ball lying in grass).

Fig. A

The Beseler PM2L is unique in its simplicity. Only four knobs for programming appear on its face. Correct filtration is indicated when the needle is dead center on the meter at the null point. The PM2L probe is not affected by sudden blasts of room light. The usable exposure range is from 1 to 100 seconds.

COLOR PRINT SYSTEM/processes

NEGATIVE-TO-POSITIVE SYSTEMS

Printing from color negatives did not come into its own until 1942 when Eastman Kodak introduced Kodacolor Film. The film had to be returned to Rochester for processing and printing. During the fifties, Kodak introduced Kodak Ektacolor Paper Type C and its companion chemistry, Process P-122. For the first time, this enabled consumers to make their own color prints. It had such far-ranging impact that to this day color prints made from negatives are generically called Type C prints.

Many commercial laboratories were born as a direct result of the marketing of Ektacolor Type C materials. A great deal of exposing and processing equipment for this paper soon appeared on the market. Further developments in both paper and chemicals helped to shorten the entire printing cycle. Things have progressed to the point where now only two chemicals are needed to process the paper.

An interesting spin-off in recent years has been that of manufacturers other than Kodak marketing color papers that could be processed in Kodak chemicals. Conversely, some are selling their own chemistry that can be used for processing Kodak paper. We have reached a point where one can successfully expose, develop and dry a color print in under ten minutes with little more effort than that required for a black-and-white.

Kodak's Ektacolor 37 RC Paper

The Kodak system of negative/positive employs Ektacolor 37 RC Paper along with Ektaprint 3 or 2 chemicals. The paper, available in surfaces F, N or Y, is made in sheet sizes from 8×10 inches up to 30×40. It can be exposed in virtually any enlarger that is capable of using CP (color printing) filters or dichroic-type enlargers. After exposure, the paper is processed in under ten minutes and dried. Drying is rapid since this material is on a resin-coated (RC) plastic base. It may also be processed in tube-type drums or in a Kodak Rapid Color Processor. The color balance of the prints is adjusted by changes in the magenta and yellow filtration used during exposure. A safelight with either a #10 or a #13 filter may used.

Unicolor

Unicolor offers the color printer anything but a single choice. Possibility number one is their R-2 chemistry and companion resin paper called RB, which is available in sizes from 5×7 inches up to 16×20. Choice two is the Ar chemistry, for use with Kodak's Ektacolor 37 RC Paper. Option three is Unicolor B chemistry, which is used with their own standard base paper. Would you believe a fourth choice? It's called the total color system. First, the chemicals can be used to process all process C-41 films; then they can be re-used to process virtually *any* resin-coated color paper. The only thing they haven't thought of is a pair of print tongs that shut the darkroom lights off by themselves at the end of the printing session.

Color by Beseler

In most color-print processes, strict attention to temperature control is a must. The Color by Beseler System allows you to use any temperature that is convenient. It is this panthermic capability that makes it a rapid, easy system for processing color paper. The paper is standard Kodak Ektacolor 37 RC. The chemicals include a developer and a bleach fix. The usable temperature range is 66°F to an unbelievable 125°F. With Color by Beseler, the user can choose either tray or drum processing. At the 125-degree temperature, developer step one is only 1 minute. This is followed by a 1-minute bleach-fix. A 2½-minute wash completes the process in under 5 minutes. Since the system allows chemistry to be re-used, per-print cost is relatively low.

Kodak Retouching Colors

These dyes can be used for spotting with a wet brush or applied locally with a Q-Tip to enrich colors. They work with any of the processes discussed here, except Cibachrome, which has its own dyes to match its exceptionally glossy finish. If too much color is applied, a reducer included with the set will remove the excess.

Ektachrome RC Paper, Type 1993

The Kodak positive-to-positive system uses Ektachrome RC Paper, Type 1993. It is available in sheets from 8×10 inches up to 16×20, in surfaces F and Y. If the Kodak Rapid Color Processor is to be utilized for the processing, Ektaprint R-500 chemicals must be used. Other means require Ektaprint R-5 chemicals. The print must be re-exposed to light with the R-5 chemicals; with R-500 this is done chemically.

The exposing equipment is the same for negative-to-positive printing, with one exception: every color film transmits a different amount of infrared light. Although the eye cannot perceive it, the print material does. Therefore, if you are going to print more than one type of original film, an infrared cutoff filter must be in the enlarger. Also, a 2E untraviolet filter should be used.

Cibachrome

The Cibachrome P-10 system offers a simple four-step (three chemical, one wash) method of paper processing. A drum is the preferred method. The Cibachrome manual (sold as a separate item) is one of the most comprehensive in all of color printing. The processing can be done at any one of three temperatures—68°F, 75°F or 82°F. Depending on temperature, the full cycle averages twelve minutes. To a degree, contrast can be controlled with the choice of temperature: the lower the developer temperature, the lower the contrast and vice versa. The material is noted for its extremely wide latitude in filtration and exposure and its processing tolerance. Due to its construction and processing chemistry, it has long-term color stability.

Beseler's RP5

Beseler's RP5 Reversal Print system centers around the use of Kodak Ektachrome RC Paper, Type 1993 and Beseler chemistry. All processing recommendations assume the use of a drum. The rather extensive instruction sheet that accompanies the chemicals gives starting filter packs for five different original films. As with the Kodak system, proper infrared and ultraviolet filtration *must* be in the enlarger. In keeping with their ambient temperature principle, RP5 can be used at temperatures from 68 to 110F degrees. Logic dictates that the higher the temperature, the shorter the process. At 110 degrees, the entire cycle is 10½ minutes. At 68 degrees, it is 21½ minutes. As with the use of Ektaprint R-5 chemicals, the print must be re-exposed to light. Careful attention must be paid to the mixing instructions. Failure to do so may result in color imbalances that *cannot* be corrected for.

Unicolor

Unicolor also offers their own chemistry called PFS to be used with Kodak's RC Paper, Type 1993. It can be used at 75°F with a five-degree allowable range. Processing times vary from eight to fifteen minutes. The chemistry is available in both quart and gallon sizes. All are liquid concentrates, which speed up mixing. A word to the wise on handling RC (resin-coated) papers: they are prone to showing fingerprints, so the emulsion side must never be touched. Gloves are a must when working with these papers, such as the cotton kind worn by film editors. In fact, Unicolor even sells disposable plastic ones. It is not infrequent that one may produce a beautiful print, but have to throw it away due to fingerprints.

POSITIVE-TO-POSITIVE SYSTEMS

The ability to produce quality color prints directly from slides or transparencies has been a dream of color printers for many years. Up until now, the various systems lacked quality. Today we have the luxury of two different methods of positive-to-positive color printing. One is the silver dye bleach (dye destruction) method, incorporating azo dyes. Its proponents claim greater sharpness and color stability. This is the system found in Cibachrome materials. The other is a chromogenic system—it works like color film with a paper base—such as that found in Kodak's Ektachrome RC Paper, Type 1993.

The exposing equipment necessary for prints from positive materials is similar to the equipment used for negative-to-positive printing. Having a known aim point, namely the slide or transparency instead of an orange negative, evaluation and judgment during printing are simplified. The objective is to make the print as close to the original as possible. In some instances, the original may be improved on, e.g., with underexposed or off-color slides. The positive-to-positive segment of color printing has stirred more interest than any other in recent memory. It has caused a return to the darkroom for thousands of color printers, both amateur and professional.

COLOR PRINT SYSTEMS/processes

THE DYE TRANSFER PROCESS

The highest quality color prints are those made by the Kodak Dye Transfer Process. Its controls and manipulative techniques are unlike any other color print system, the results are preferred since they will reproduce on the printed page far better than any other type of color print. Let's take a look at how they are made.

From either a color negative or transparency, a set of masks are made on black-and-white film, which insure proper highlight rendition in the prints as well as contrast control. Some color corrections for imbalances in the original are possible at this stage. Then three color separation negatives are produced: the original is exposed to three separate pieces of black-and-white film through red, green and blue filters. From each of these negatives a matrix is made, which is a positive gelatin relief image, capable of absorbing dyes.

After processing and drying, the matrix made from the red separation negative is placed into a cyan dye solution, the one made from

the green filter negative into magenta dye and the matrix from the blue filter negative into yellow dye. After two brief rinses to remove any excess color, the cyan-dyed matrix is rolled in contact with moistened paper. The paper used contains no light sensitivity; its job is to act as a receiver for the dyes. The dye is then transferred to the paper; hence, the name of the process. The cyan matrix is then removed and replaced with the one dyed magenta. The same is done with the yellow. All three dyes must be transferred in perfect register.

If there is an overabundance of one color in just the highlights, it is easily removed. Additionally, if the contrast of any *one* color is too high or low, it can be adjusted accordingly by adding constituents to the dyes, without affecting any other color. Local areas can be improved or enhanced. For example, in a photograph of a bowl of cereal with strawberries in it, the client is selling the fruit. By making a separate matrix of just the

berries and applying it on top of the original three transfers, the berries will have far greater color saturation. They will probably look better than they did in the original photograph. By altering the normal sequence described earlier, complete color changes can even be affected—a red automobile can be changed to a blue one. Extensive retouching or airbrushing can also be done.

A little known fact about the dye transfer process is that it is capable of producing top-quality transparencies as well. Instead of paper, a film base is used. These are primarily used for display purposes when color fidelity is of paramount importance.

At this point, dye transfer truly stands above all other color printing techniques. Over the years, it has become the criterion for making subjective judgments in color printing. Frequently, one will overhear a conversation which ends with, "Well, it's not bad, but it's no dye transfer!"

Outline of Matrix Processing and Transfer Procedures

From *Kodak's Dye Transfer Process* E-80.

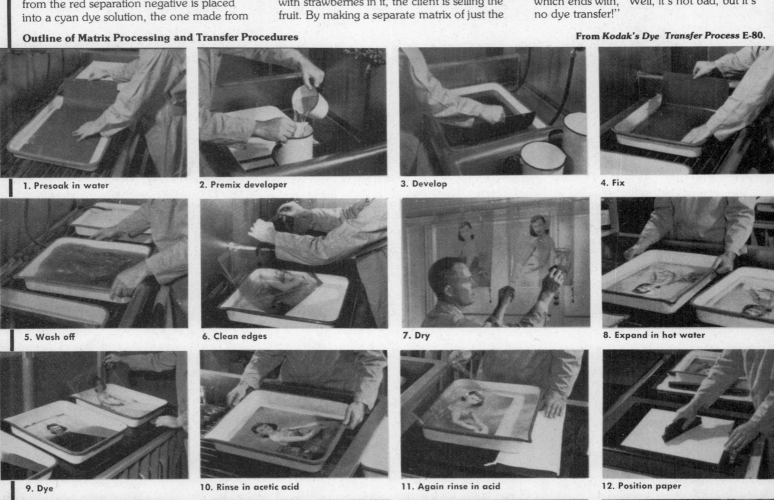

1. Presoak in water
2. Premix developer
3. Develop
4. Fix
5. Wash off
6. Clean edges
7. Dry
8. Expand in hot water
9. Dye
10. Rinse in acetic acid
11. Again rinse in acid
12. Position paper
13. Position matrix
14. Roll into contact
15. Remove matrix
16. Dry

14

Duke Mander

UNQUE PROCESSESS

UNIQUE PROCESSES

UNIQUE PROCESSES—
SOME NEW, SOME OLD

Not long ago the *pure* photographers frowned on the making of manipulated photographs. Walker Evans, for example, sought to make pictures free of personal handwriting . . . free of any hint of painterly construction. But attitudes change.

In the field of nonsilver chemicals and highly manipulative processes, Peter Bunnell, director of the Princeton Art Museum, has had a strong influence. Several years ago he put together a show at the Museum of Modern Art called "Photography into Sculpture." The pictures were printed by many means and on all sorts of surfaces. The result, if not exactly a craze, has been a very strong artistic movement toward new techniques and materials: "topographic structure, image participation, tactile materiality, procedural time, and the technology of plastics, liquid emulsions, fabrics, dyes, film transparencies, and emitted light," to quote Bunnell.

In the spring of 1975, Gary W. Crawford directed a show called "12 Photographers" at the New Organization for the Visual Arts in Cleveland, Ohio. One of the exhibitors, William G. Larson, chairman of the department of photography at Temple University, had this to say: "I have a great respect for the tradition of photographic image-making; it is out of that tradition and framework that my pictures are made. . . . At times I have found the existing photographic vocabulary inadequate . . . and have attempted to extend its grammar to accommodate my personal linguistical needs."

Perhaps all this energy and perception will result in the emergence of a major, novel photographer. In the meantime, here are brief instructions for processes now in vogue. They were prepared mostly from notes made by Amy Stromsten, photographer and teacher at the New School and at Rutgers.

KODALITH FILM

For working in photo silk-screen, 3M Color Key, blue print, or gum bichromate, it is important to know about graphic arts film. Most people call it Kodalith, which is the Kodak trade name for over twenty kinds of its films used in the printing industry.

What makes graphic arts film different from films like Tri-X or Plus-X? Contrast.

Supplement No. 138 of the *Photo Lab Index* (Morgan & Morgan, Dobbs Ferry, NY) has this entry for Kodalith Ortho Film 3556; "An extremely high contrast, orthochromatic film on a stable Estar support. It is designed primarily for making line and halftone negatives and positives for photochemical and drawing reproduction when size holding is of critical importance. This film has wide exposure and development latitude and will produce sharp halftone dots suitable for dot etching. It is available in both sheets and rolls."

Orthochromatic film can be observed under red light. Estar is a polyester plastic.

When printing on Kodalith, the white areas become transparent. This positive can be contacted to produce a negative. Negatives can also be made from color slides. A positive or negative can be used for Color Key, photo silk-screen, or offset, and they can be sandwiched, spliced or cut. Opaque can be applied to delete distracting areas and to fill in pinholes. A Kodalith can be placed over colored tissue, textured material, color slides.

To get gradation of tone it is necessary to put a dot pattern on the silk screen. Without a process camera this is done by using Kodalith Autoscreen Ortho Film 2563 (Estar Base). The *Photo Lab Index* says: "When exposed to a continuous-tone image, a dot pattern is produced automatically, just as if a halftone screen had been used in the camera. It can be exposed in an ordinary view-camera film holder . . . Halftone negatives made on this film may be enlarged on Kodalith Ortho Film, Type 3, to provide a suitable positive for silk-screen work."

A normal print on continuous-tone paper.

A high-contrast print on Kodalith Film made from the same negative as above.

A high-contrast negative print on Kodalith made from the positive Kodalith above.

CREATIVE DARKROOM TECHNIQUES
Eastman Kodak/Consumer Market Div./ Rochester, NY 14650/AG-18, cloth, $7.95

Individual feelings toward working in the darkroom vary. Some photographers, like Jerry Uelsmann, will literally spend days at a time there, while Polaroid Corporation has spent millions of dollars to eliminate it altogether. *Creative Darkroom Techniques* is a Kodak "idea book" meant for those who have mastered basic techniques and want to explore the numerous possibilities of darkroom manipulation. The illustrations are excellent and the procedures followed to obtain the effects are fully explained. If you thought that solarization went out with Man Ray, there are forty-five pages on variations possible with the Sabattier effect.

In addition to some great demonstrations of making photograms on color material the book, in detail, covers toners, reduction and intensification of film and prints, masking, reticulation, posterization, Kodalith, gum-bichromate printing and photo silk-screening.

PHOTO SILK-SCREENING
Ulano Film and Rockland Colloid

Andy Warhol's "paintings" of Marilyn Monroe and Campbell Soup cans are really silk-screened photographs. (The man is ingenious in his use of simple means—making portraits with an Instamatic, Polaroids and recently the Minox 35-EL.) Anyhow—for those who don't know—silk-screening is a stencil process in which heavy ink is forced with a squeegee onto a surface. In *photo* silk-screening, the stencil surface is made pervious or impervious, according to which part of the graphic arts film is exposed to the light; the exposed part eventually gets washed away.

As with all printing, there is no gradation of inking—the ink either gets through the opening or it doesn't. Generally, there is no sharp detail in silk-screening.

Silk-screen ink is close to poster paint—thick and brilliant. Each color needs a separate screen.

Stencil Film

Ulano makes four presensitized films:

Photo silk screen. *Barry Matus*

Hi-Fi Green, for hiding tape marks; Super Prep, for finer resolution; Blue Poly No. 2 and No. 3, for wide-latitude—the No. 3 for large stencils. Open the film of your choice in amber light, place in contact with transparent artwork or with a positive. Cover with glass. Expose through the backing side from 18 inches above with a No. 2 photo-flood for 8½ to 9 minutes. Develop for 90 seconds at between 64° and 75° F in Ulano A and B, which come in packets that have to be mixed. After development the exposed areas are washed away by a warm (100° F) gentle stream of water. The sticky side of the film will then adhere to the silk screen; apply with care. Blot with unprinted newpaper stock, let dry for about 45 minutes. Peel off plastic backing.

The trend is away from film and toward direct emulsion, which is made under a variety of trade names. Visit a silk-screen supply house to get what is needed. After mixing the emulsion with an ammonium bichromate solution, apply evenly (in semidarkness) to a silk screen, then expose to actinic light. The screen is then washed with warm water to remove the exposed areas. Direct emulsion is difficult to work with when relative humidity is high.

Rockland Colloid makes an emulsion to expose under an enlarger light. Open the bottle of emulsion in the darkroom. Lay the screen flat, with the cloth up, and pour a thin ribbon of emulsion along one side of the frame. Squeegee. Dry the screen.

Expose a high-contrast positive film by contact-printing a negative onto Ortho Film, such as Kodalith Type 3. Placing the two emulsion sides together, use the enlarger as a point light source. Develop in FC12, which comes with the emulsion. The stock solution should be used 1 to 32.

A color slide, which is a positive, can also be used. Take it out of the holder and put it in a negative carrier. Expose the coated screen like photographic enlargement paper. Place black paper or cloth underneath the screen to prevent light from bouncing up. Either the top or the bottom of the screen can be toward the enlarger lens.

To develop, stand the screen in a tray with developer for 3 to 5 minutes. Agitate or sponge-develop. Use shortstop for 3 minutes. Wash under a gentle flow of warm water until unexposed portions are dissolved.

Rockland Colloid Corp./599 River Rd./Piermont, NY 10968

J. Ulano & Co., Inc./610 Dean St./Brooklyn, NY 11238

BLUEPRINTING (CYANOTYPE)

One of the oldest photographic processes, blueprinting has been largely the province of engineers and architects who use it to reproduce drawings. Invented in 1840 by Sir John Herschel, the man who gave us hypo, the method has remained unchanged.

It is a contact-printing process, so unless you have a large-format negative, an enlarged negative can be made with Kodak Direct Duplicating Film SO-015 for continuous tone or Ortho Film Type 3 for high contrast. In general, a slightly contrasty negative works best. A drawing on tracing paper can also be used.

Paper or cloth is coated with a mixture of ferric ammonium citrate, 50 grams to 160 ounces of distilled water and potassium ferricyanide, 35 grams to 16 ounces of water. Each solution is stored separately and mixed in equal volumes for use. Sensitize by soaking in a tray of this mixture for 3 minutes and let dry in the dark.

This work entitled "The Bathroom," by Catherine Jansen, is done with blueprint and fabric sensitizers. The proverbial morning after, it is one way in which artists are beginning to exploit this process. The impressions on the shower curtain, bathmat, towel and the water in both the sink and the toilet are cyanotype. The resulting print can also be toned or painted.

"The Bathroom." Catherine Jensen

Exposure can be made with sunlight, a quartz lamp, carbon arc, sunlamp or photoflood. Two sunlamps about ten inches from the negative need an exposure of between 15 and 30 minutes. The color of the paper indicates the correct exposure. The image will go from chartreuse to a reddish-brown and then stop.

Wash in circulating warm water for 30 to 60 minutes and hang up to dry. For a richer blue, add a few drops of concentrated hydrochloric acid to the wash, but watch out for fumes—that stuff can be dangerous. Remember that this is a widely used commercial process and blueprinting paper is available, probably of higher quality than you could make yourself, but what a bore to just go out and buy it.

For more information:

Handbook of Contemporary Photography/ Arnold Gassan/Light Impressions/Box 3012/Rochester, NY 14614

Encyclopedia of Photography/ Arno Press/ 330 Madison Ave./ New York, NY 10017

UNIQUE PROCESSES

THE KEY TO COLOR-KEY

One of the easiest nonsilver processes to use is 3M Color-Key. Color-Key pigments can be transparent, opaque, negative or positive, depending on the type purchased. Each sheet, which is a separate color, is exposed in direct contact with transparent artwork, such as a print made on Kodalith. With positive Color-Key, those areas exposed to bright light soften and are wiped away with cotton dipped in Color-Key developer. Negative Color-Key works in reverse: the exposed areas harden. The result is a monochromatic print, not on paper but on a transparent film, which can be combined with other images to produce decorative effects. Or as one wise

photographer put it: "You can combine two bad shots to produce a third."

The material is not affected by ordinary room light and requires an exposure of 4 to 8 minutes with a 500-watt bulb 18 inches from the work. Using a light source high in ultraviolet radiation, such as a 3M Art Design Light, reduces exposure time to about 2 minutes. For those in a rush, exposures can be reduced to seconds with special light sources designed for the printing industry.

There are fifty-seven colors plus opaque black and opaque white. Sheets range in size from 10×12 inches to 20×24 inches—the smallest costing about $1.50 a sheet.

3M Company Printing Products Division/3M Center/St. Paul, MN 55101

A three-color sandwich made from two yellows and one opaque black Color-Key. The white was obtained by off-registering the image so illustration board mounting shows through. Ken Biggs likes the transformation he got from his original, which was shot at the zoo.

Ken Biggs

1. Place "Color-Key" in exposure unit.

2. Expose to solid 4 or 5 on gray scale with ultraviolet light source.

3. Place exposed "Color-Key" on level glass (surface temperature of 70°F-80°F).

4. Wrap Webril proof pad around special "Color-Key" developing block.

5. Pour negative "Color-Key" developer smoothly, spread immediately with light, sweeping motion.

6. Begin development using light figure-8 motion to remove most background coating.

7. Turn fresh side of pad out.

8. Finish development using moderate pressure and tight, circular motion.

9. Rinse both sides in water at 70°F-80°F.

10. Blot dry with newsprint or other absorbent paper.

VARIATION 2
by René Groebli
Hastings House/New York/cloth, $25

So far nobody has done anything very amazing with Color-Key, not in a novel, artistic way. For the striking art that Color-Key only hints at, see René Groebli's *Variation* volumes. *Variation 2,* shown here, is a tremendous buy at $25 with its heavy glossy paper and beautifully printed color plates. Many of the 10½×12½-inch pages are double gatefolds.

Here is Groebli's commentary about his portrait of the abstract painter Aja Iskander Schmidlin:

"I first of all used a formal, severe photograph of the head, with the lighting disposed so that it was suitable for a color transformation. To this were added the photos of Schmidlin's hand with a brush, the texture of the white canvas, and a typical detail from one of his paintings.

"There is no grey and black in Schmidlin's art. Distorting the colors in the laboratory enabled me to approach the character of his pictures: the shadows of the head became red, that of the hand on the canvas and his black pullover became blue."

Groebli often prints black-and-white negatives or positives on Ektachrome film with colored light—thus creating his own transparent Color-Keys. It took 32 different pieces of film and a final sevenfold multiple exposure to produce this work.

Aja Iskander Schmidlin

A BOX OF SUNSHINE

A great light source for Color-Key is the Aristo Prep-Printer 14. Actinic light provides for exposures ranging from under 30 seconds—for red or yellow color sheets and up to one minute for opaque black. The foam rubber lined cover uniformly flattens the transparency against a sheet of glass with no irritating, bright light escaping during exposure. A mechanical timer provides for accurate short exposures. It is also good for blue prints and Diazo, but its 11 × 14 size is limiting.

Aristo Grid Lamp Products, $315
65 Harbor Road/Port Washington, NY 11050

PUT A PICTURE ANYWHERE (ALMOST)

Print-E-Mulsion

Want to see yourself departing as you are arriving? Print your photograph right on your front door. You can do it—with Rockland Print-E-Mulsion.

There are three types:

CB-101. Medium-fast emulsion for all-around use. Has warm black tones, above-average contrast, fine grain. For enlargement and contact printing.

BB-201. Fast enlargement-speed emulsion. Medium contrast, warm black tones. Best for oversize enlargements, wall murals. The stuff for your door.

BX-201. Slow contact-speed emulsion. High contrast. Requires bright incandescent or fluorescent light for exposure.

Print-E-Mulsion can be coated on plastic, metal, wood, stone, cloth, leather or almost any other surface. No special preparation is needed for wood, stone, paper, leather, concrete or cloth, but plastic and metal must be primed with polyurethane, and glass and ceramics with a special powder enclosed.

Soften the emulsion by placing the container in hot water until it liquifies. Work under any colored safelight. The object can be coated by pouring, spraying or painting with a brush.

Make test strips by spreading a few drops of the emulsion on a white index card. Let the emulsion dry thoroughly. Expose with any negative or contact-print with graphic arts film.

Processing is identical to any paper processing. Use a cold tone developer such as Dektol, diluted 1 to 2. Develop by immersion or with a soft sponge. Rinse in water or stopbath and fix for five minutes. Wash for fifteen minutes in cool running water; drain and dry.

Caution: In focusing, be sure to compensate for the height of the object from the baseboard of the enlarger. Since paper is flat, it is no problem, but if you are projecting onto a seashell, for example, use a red filter while you focus.

Recent chemical changes in manufacturing at Rockland have made the emulsions more stable and less likely to fog. It is critical to follow instructions very carefully, particularly in regard to coating and drying. It is also important to give *long* exposures (a minute or more).

Dust pan, coated with Rockland Emulsion was developed, fixed and washed in the usual way. The work however, no longer exists. When the pan was accidentally dropped while on exhibition the emulsion with its image cracked off.

Rockland Colloid/599 River Rd./Piermont, NY 10968

SILLY SILVER AND FOOL'S GOLD

Rockland Photo-Aluminum and Silver Minnies

The material described below is unique and therefore qualifies for inclusion, in that it is made by only one company—the Rockland outfit.

Something else that can be said for it is that innovative photographer Jerry Uelsmann has experimented with it. We are awaiting a report of the results.

The photo-aluminum material is exposed with an enlarger or by contact printing. When it is used in a camera in place of film, the result is a reversed negative image on the aluminum plate.

Development is in a slow-acting paper developer for 1½ minutes at 65-70°F. Rinse the print under cool running water. Fix the print for twice as long as it takes the emulsion to clear or turn transparent—about 10 minutes. Finally, wash the print in running water for an hour. To avoid streaks, it is best to use Photo-Flo in the final wash water.

Photo-Aluminum costs $33 for ten 8 × 10 inch plates. It also is made in 4 × 5, 5 × 7, 10 × 12, and 20 × 24.

Rockland has been making coated aluminum for years. Recently, the company began packing its scraps and calling them Silver Minnies. These are processed just like Photo-Aluminum because that's what they are. Silver Minnies are snapshot-size. They are priced at about $6.50 for a package of ten.

Avoid mounting in the old-fashioned Minnie Folders that Rockland sells. The effect of the Silver Minnie is not anything like early photographs on metal.

Both the Photo-Aluminum and the Minnies can be treated with Rockland Gold colorant to give a gold finish.

Neo-Colonial Quilt—Photo Sensitized Linen.

Amy Stromsten

Rockland Colloid Corp./599 River Rd./Piermont, NY

GLADDING THE RAGS

Rockland Fabric Sensitizer FA-1

This stuff works best on cotton, which "locks in" the precipitate that forms the photographic image because there is no colloidal binder in the sensitizer. Most synthetics will not hold the fine-colored particles.

Saturate the fabric with the sensitizer, wring out the surplus (which can be reused) and dry. Expose with an actinic light source, such as sunlight, or sun lamps. Exposure is through a large negative made on graphic arts film or glass coated with emulsion. Usually 1 to 2 minutes exposure is correct. The image will appear faintly tan. The image is developed in cool running water for 30 to 60 seconds.

Next, immerse in fixative solution for 15 seconds, until the image turns from orange-brown to gray-brown. (Caution: If allowed to remain in the fixative too long, the image will fade.) Then wash in cool running water for 10 minutes; dry.

FA-1 Fabric Sensitizer includes simple instructions for mixing the stock solutions. Powder to make a gallon costs about $25.

191

PUSHING THE LIMITS

There are many photographers attracted to processes that utilize photography but that result in pictures that do not look like traditional photographs. Photo silk-screen, for example, is ink on paper, not silver halides developed and fixed. In the process of preparing a photo to be silk-screened, the work loses its photographic qualities—that look modern critics consider to be the characteristic nature of the medium.

In fact, when compared with an Andy Warhol portrait, the work by the photographers on these pages looks more like twentieth-century art than photography. This is fascinating since the nineteenth-century photographers who worked from a painterly aesthetic are considered by historians to be less significant contributors to the development of the medium. However, it is the nature of artists to be iconoclastic, and on these pages is an introduction to some of the best who choose to experiment with the medium.

Born in 1943, Doug Prince now teaches at the Rhode Island School of Design. His best known work combines several transparencies within constructed Plexiglas boxes. Like a miniature theatrical set, the combination of superimposed images and the space between them provides a three-dimensional effect. His work is in the permanent collection of the Museum of Modern Art and is available through the Light Gallery, 724 5th Ave., New York, NY 10022.

Untitled Plexiglas box, 5×5×2 inches, no date. *Doug Prince*

William Larson is a professor of photography at the Tyler School of Art at Temple University. Since 1969, he has been interested in the Graphic Sciences Teleprinter, which is the heart of global wire service photography. Each of his pictures made with this machine is unique. His work is available from Light Gallery, 724 5th Ave., New York, NY 10022.

Untitled, telephone transmitted image, no date. *William Larsen*

Robert Heinecken is best known for his combination of sculpture and photography, in which he employs many different elements, such as video images and advertising copy—and varying reproduction methods and materials—3-M Color-in-Color, photo-linen and offset presses are some. A major retrospective of his work was recently held at the George Eastman House. His work is available through the Light Gallery, 724 5th Ave., New York, NY 10022.

Robert Heinecken

Keith Smith, a 1972 Guggenheim recipient, is currently teaching generative systems at the Art Institute of Chicago. He makes use of a range of materials, incorporating color by means of selective toning, stitching and hand coloring. His work is available through Light Gallery, 724 5th Ave., New York, NY 10022.

Scott Hyde has earned his living as a free-lance photographer for almost thirty years. In his personal work, he utilizes an offset litho press as an original print medium. He also works with 3M Color-in-Color, gum bichromate, silk screen and other processes. His work is available through the Witkin Gallery, 41 E. 57 St., New York, NY 10022.

Keith Smith

Betty Hahn has been working with gum bichromate since 1965, and for the last five years has been combining the process with fabrics and stitching. With this picture, she created a textural-visual analogy: a seed stitch overlays a garden. Born and educated in the midwest (M.F.A., Indiana University, 1966), she presently teaches at the University of New Mexico. Her work is available through the Witkin Gallery, 41 E. 57 St., New York, NY 10022.

Dark Garden #143, 1973. *Betty Hahn*

Penny Bridge and Country Road, Stony Point, NY 1917, 1968. *Scott Hyde*

The picture at right by Naomi Savage is a line-cut photoengraving on silver-plated copper, a derivative of the copper plate used in halftone reproductions. A niece of Man Ray, Ms. Savage has been working with photoengraving for twenty years, and her work has been widely published. It is available through the Witkin Gallery, 41 E. 57 St., New York, NY 10022.

Mask, 1965. *Naomi Savage*

THE PAINTER AND THE PHOTOGRAPH
by Van Deren Coke
University of New Mexico Press/ Albuquerque, NM/paper, $15

This book is a history of the various ways in which artists have used photographs directly or indirectly in their work. The best known example of this phenomenon is the change in the way running horses were depicted after Eadweard Muybridge's famous study proved that at a certain point all four legs of a horse are off the ground at the same time. Yet, few historians and critics were aware of the extent to which photographs had influenced the work of various painters, not just second-rate painters either: Picasso, Degas, Gaugin and Duchamp all used photographs as starting points for major compositions. The writing is both informative and readable and the pictorial layouts are effective, with photographs and the paintings they influenced seen side by side. This is a much needed study, excellently done.

193

HOLOGRAPHY— LIGHT MAGIC

Somewhere in a haunted house in Disney World appears a ghostly head of a fortune teller inside a crystal ball. A photograph, you think—but as you move around the ball you can see the side, back and then the other side of the head. It has dimension; it's like nothing you've ever seen. It is a hologram.

Unlike photographs, holograms are not made with a camera and lens. But as in photography, a sensitized plate is developed and fixed, yet it yields no image on its surface. Instead, the plate contains a record of the light pattern given off by a subject. By transmitting light through the plate, the original light waves emitted by the subject are reconstructed, and a virtual image is apparent where the subject once stood. What's more, this pattern can contain all the views necessary to provide a complete three-dimensional image.

Until recently, holography was something only scientists dared. Today artists are experimenting, and the once underground science is surfacing.

A holograph at an International Center of Photography exhibit.

© S. Borns, 1975.

In 1975 the International Center for Photography rounded up nearly fifty holograms made by an international group of scientists and artists. Three galleries were jammed with all varieties of three-dimensional illusions. There were Multiplex holograms, like the one above, in which the subject performs a brief action. Some holograms (360-degree types) enable the viewer to see the subject from all sides. Until the show, scientists were the people primarily interested in holography, so innovations to date have been technical. With interest mounting, talented devotees can be expected to turn out some quality images.

THE MUSEUM OF HOLOGRAPHY

It's the only museum of its kind in the world. Although it had an erratic start, the directors seem to have gotten it together. They anticipate that with time the newly opened museum will become a center toward which all holographers—scientists and non-scientists alike—will gravitate.

Its permanent collection traces the historical development of holography. In its archives are over 400 holograms, including the first Laser hologram made in 1964 of some dime store toys. There are prototypes of all developments in the field—the first single-shot 360-degree transmission, Lippman reflection holograms, white-light transmissions, dichromates, even 3-D moving pictures.

Museum members have access to a reference library of technical journals, physic abstracts and books for the layman. They have a file on businesses that produce holograms and another on holographers around the world. Educational movies about the process are available, and their bookstore sells magazines, books, holograms and related products.

11 Mercer St./New York, NY

NEW GALLERY IN TOWN

A holography gallery? And why not? In addition to running a commercial research company called Laser Light Concepts, Ltd., a photographer, filmmaker, optical physicist and a research engineer operate the only holography gallery-showroom in the country. You can buy a hologram for as little as $60 (image-plane holograms) or spend as much as $5000 for a work of art by Harriet Casdin Silver, who is an acknowledged artist in the field. The proprietors carry the work of a half-dozen holographers who are concerned with holography as an art. If you want to utilize the quartet's expertise in making holograms, you can consult their research and development service. Presently, they are developing a system that will produce holograms in full natural color, rather than the rainbow colors we're used to seeing.

57 Grand St./New York, NY 10013

WORKSHOP AT THE SHORE

One of the best places to learn how to make holograms is at a summer workshop taught on the shores of Lake Michigan. Run by a former atomic physicist, who is credited with being able to make the science understandable to anyone, three one-week sessions are held in June and July. The workshop combines lectures with intensive afternoon sessions spent making actual holograms; a laboratory is available.
Holography Workshop/Physics Department/Lake Forest College, Lake Forest, Ill. 60045/Dr. T.H. Jeong, director/three one-week sessions, June and July $300.

HOMEGROWN HOLOGRAPHY
by George Dowbenko
Amphoto/Garden City, NY 11530/$7.95 paper

What with all the scientific journals, physics and math papers that keep coming out on the subject, it's refreshing for a book to come along that tries to teach the layman about holography. The author, himself a teacher, sets out to provide simple, explicit information for making holograms in your own low-cost studio. There are three chapters: one about the qualities and composition of light, a second about basic concepts that includes a comparison between photography and holography, and a third that details basic holographic techniques in a step-by-step fashion. The book is amply illustrated, and with its extensive appendices and a bibliography help to clear away some of the scientific mumbo jumbo that seems to throw so many people.

HOLOSPHERE
Editor: Bill Bushor
P.O. Box 7822,
College Park Sta.
Orlando, Fla. 32804

No doubt, holographers are a dedicated lot. The editor of this newsletter spends his days as a director of information services. On his free nights and weekends, he single-handedly turns out the only publication devoted exclusively to holography. Published monthly, it started four years ago as an offshoot of a publication called *Lasersphere* when the interest in holography warranted it. Articles on acoustic and laser holography are intended to reach those who care what's happening in the field.

Subscription: $45, one year

BRINGING HOLOGRAPHY TO THE PEOPLE

"The medium is dynamite and we want to make it publically consummable," are the words from a former CPA who teamed with his next-door neighbor, a research physicist, to start Holex, Corp. Since 1972 they've been supplying schools with holograms; hobbyists with mini-labs, film and developing kits—even Texas' famous department store, Neiman Marcus, with $500 lasers for the man who has everything.
Holex Corp./2544 W. Main St./Norristown, PA 19401

15

Norman Snyder

PICTURE SOURCES

PICTURE SOURCES

TAPPING THE STOREHOUSE OF PHOTOGRAPHS

Photography has become an integral part of our daily activities. People in all fields—education, law, history, science—use photographs as an important source of information. It's not unlikely that someday in the frightening future a person wanting to see photos of American urban architecture will merely dial a request, sit down before a TV terminal while a computer displays a selection of pictures culled from all over the country. A professional picture researcher would have programmed the computer using his or her knowledge of collections and a sensitive eye to separate the wheat from the chaff. Until that day, if you need photos you will have to make like a picture professional and do your own legwork. Here is what you need to know to get started.

The primary distinction between one collection and another has to do with the reason each collects pictures. Quite often the function of a *public collection* is archival and pictures are organized for study purposes. Government collections, city and state historical societies, some university collections and municipal museums fall into this category. They encourage use of their material, but they are not geared for fast service, so a researcher must be patient. *Commercial agencies* privately owned, are out to make money. They compete with each other and do what they can to be more helpful than their rivals.

Another factor that differentiates collections is the scope of the material they house. A complex like The Library of Congress collects across the board. The nature of the pictures is diverse: all subjects are represented; vast stretches of time are covered. There are photographs, engravings, paintings, maps, posters, memorabilia—the lot. Historical societies may emphasize the history of a state, city or region, but they also end up with material that has nothing to do with their geographical location. The Wisconsin State Historical Society, for instance, documents the development of the Midwest, but it also houses important pictures of Germany in World War I and New Jersey beach resorts.

All collections have dedicated staffers who administer and protect the material. They spend hours adding to, preserving and maintaining countless pictures. Most researchers consider the archivist an impediment rather than an access to the material. Only when an archivist is convinced of a researcher's seriousness will he or she be of full assistance. This makes it important to get to know a collection on a firsthand basis. Visit it in person. Establish personal contacts with staff members. Communicate your appreciation of their work and the value of what they collect and preserve.

When it comes to the actual job of researching, first narrow down the sources. The same type of picture can be obtained from more than one source. How much time and money you have are important considerations. Public sources are cheaper, but they take longer to provide reproduction prints. Rarely are you permitted to borrow the original material. Since there is no room to keep duplicates, it is necessary to have prints made; copies are made either from the original photograph, if there is no copy negative, or from the original negative. Usually it takes two to six weeks to receive prints, so check into Xerox facilities. If you Xerox pictures, you'll have something to work with while you wait for prints. Some collections allow researchers to make research pictures. Any old 35mm camera equipped with a macro lens will enable you to make close-ups.

Because commercial agencies are competitive, service is always better. You can borrow original material, or if they need to make a print it will arrive within a few days. Of course, you pay for the service. Reproduction charges parallel the recommended ASMP rates and in some cases are higher.

Unfortunately, fewer than fifty percent of the collections publish any sort of brochure or catalog that describes the scope of what they collect. Source books (some of the best appear on the following page) become even more valuable until you are personally familiar with the collections. Whether you visit a collection in person or telephone in a request, be specific. There's nothing that drives a staffer more insane than a vague request that takes his or her time to unravel.

Since they are understaffed, there is a limited amount of research that can be done over the telephone. Some archivists draw the line at filling a specific written request. It's a good idea to call ahead and make sure the source has a particular picture. Even if you're not asked, it's best to follow up a call with a letter. If you've found a picture in a book, include a Xerox of the picture or at least the book title and page number. It will cut down research time at the other end. Certain collections undertake what amounts to research, but it's limited.

There is no standard organization of material from collection to collection. If you visit George Eastman House in Rochester, New York, or New York City's Museum of Modern Art, for example, you'll find that photographs are cataloged by photographer. Since these institutions collect photographs that trace the history of the medium by the artists who used the camera, their method is logical. Historical societies, on the other hand, usually organize according to subjects: farming, buildings, ethnic groups, etc. Some files are cross-referenced. The National Archives organizes material according to governmental department or program for which the pictures were made.

So much for the people who collect and preserve pictures. Until recently, photographers paid little attention to making their own stock work available to others. On assignment, they were automatically paid for taking pictures. And taking pictures, after all, is what a photographer enjoys the most, not thinking about where the last dozen might be sold. Then the commercial demand for stock pictures increased as assignments decreased. Publishers, educators and advertisers warmed up to the notion of finding the right picture instead of assigning it. The rates got better and photographers sensed they could add to their incomes by selling pictures that were stored in drawers.

Some photographers try to sell their pictures themselves, and anything you do yourself takes time. A knowledge of the market is a prerequisite: who's who, how to get to them, their work schedules, methods. If you're a novice you'll spend considerable time making yourself known, hounding editors, trying to be in the right place at the right time. If you're lucky you'll make an impression. Usually this happens only after you've had your pictures used. Editors lean on dependable sources, and if you become one of them, they will automatically call you.

A big headache, right? That's why most photographers are willing to pay an agent forty to fifty percent of a sale to do all the work. You become associated with an agency by showing them your work. They all review portfolios. Whether they take you on or not depends on their needs and how closely your work coincides with the markets they are hitting. If you're interested in an intimate relationship, then go to a smaller outfit that handles a select group where you'll get special attention. If all you want is to see your stock sell and are willing to turn over material in exchange for a monthly check, then look for someone who moves pictures.

PICTURE SOURCES/books

PICTURE RESEARCHER'S HANDBOOK
**by Hilary and Mary Evans
and Andra Nelki**
Charles Scribners, New York/cloth, $15

This book is a remarkable international guide to picture sources and how to use them. The information was gathered by sending out questionnaires with the best general and specialized collections chosen. The compilers are well-equipped to handle the job. Two of them are founders of a picture library and the third is a practicing picture researcher. The book was written for an English market, so there's a natural bias. But not one that hurts.

Part One includes a quick education on techniques of illustration and reproduction methods. There's a brief history of photography, followed by a description of a picture researcher's job. A section copyright

adds more useful information; another on rates—stressing European ones—provides general guidelines. Then on to the hundreds of collections from a four-and-a-half page entry on the British Museum to a single line for Juan Fernandez' Spanish wildlife picture collection.

THE MAGIC IMAGE
**by Cecil Beaton
and Gail Buckland**
*Little, Brown & Co., Boston/
cloth, $19.95*

The flap copy tells the reader that the biographical and technical details on each photographer were written by Gail Buckland, while the assessments of each photographer's contribution to the art were made by Sir Cecil. However they divided up the task, their accomplishment is impressive. The book lists the "geniuses" of photography from 1839 to 1975.

One glance through the book, and it's obvious: the selection is subjective. The authors admit to including those they admire most. Fortunately, enough of the time they

make the right choice; the rest of the time there are pleasant surprises—photographers you've never heard of and might like to know. It's a good book for boning up on major influences.

The book, however, does have one major drawback. There is no discernible organization to the material. At first one thinks the arrangement is chronological. Not so. Nor is it arranged alphabetically, nor according to the development of the medium. Never was an index so indispensible.

GUIDE TO THE SPECIAL COLLECTIONS OF PRINTS AND PHOTOGRAPHS IN THE LIBRARY OF CONGRESS
compiled by Paul Vanderbilt
The Library of Congress, Washington, DC/out of print

The Library of Congress is a vast complex of picture collections. The references to them were for the most part scattered in reports, card catalogs and inventories until this book was published. The editor brought together

those "special collections"—the bodies of pictures that document a general area of interest. Recently the library published a large illustrated book, *Viewpoints*, another handy reference.

The *Guide* is arranged alphabetically. Entry 1 is the Abbott Collection, approximately 5,518 negatives and forty-nine salon prints taken by George C. Abbott between 1906 and 1949. The pictures primarily document Mexico and Guatemala—their scenery, flora and fauna, architecture, street scenes and local inhabitants. The last collection listed is number 802, the Zwaizek Strzelecki Collection. Some eighty-five pictures (mainly snapshots) made between 1934 and 1938 document the French and Belgian para-military organization devoted to the athletic training of Polish youth. In between A and Z is a treasure.

PICTURE SOURCES 3
edited by Ann Novotny
Special Libraries Assn., New York/cloth, $17

There have been two other editions of this book that might be called the picture researcher's right arm. By far, number three is the best. The editors sent out some 10,000 questionnaires to American and Canadian picture sources, then chose the best sources for inclusion in the book.

The material has been conveniently divided into fifteen chapters according to the emphasis of the collection. General picture collections include public libraries, university collections, newspaper archives and commercial sources like Rapho, Magnum and Bettman Archives. Then there are collections that specialize in geography and history; those housing pictures on military history; more on health, education and welfare subjects. There are 1,084 entries. A typical entry lists the name of the source and gives vital statistics: address, telephone number and director's name. The size and nature of the collection is followed by a brief description of the subjects covered.

The introductory essay on how to do the job well and a copy of the Code of Fair Practices from the American Society of Picture Professionals makes the book complete.

PHOTOGRAPHY MARKET PLACE
edited by Fred W. McDarrah
R.R. Bowker Co./New York/paper, $14.95

What you've got here is the Literary Market Place of photography. There's nothing qualitative about the entries. It lists the facts, and it lists them in a straightforward manner. The scope is enormous: lists of the places that buy pictures, photography mags, review sources, grants, stock photo-sources, manufacturers, package express services, schools, prizes, retouchers, photographers' reps. On and on and on.

It's hard to imagine anyone who couldn't use the book in some way at some time. As long as the publisher keeps updating the information, dropping those services that are no longer in business, adding new sources, changing addresses and telephone numbers, the book should remain a handy source and get better and better.

PICTURES FROM THE PAST

America abounds with picture sources that document its rich history. There are national collections in Washington, D.C.—vast complexes of photographs from which, for instance, you can obtain a good 8×10 Walker Evans print for a mere $2.50. It takes some patience to learn the ropes, but finding "goodies" in these files is rewarding. Local historical societies and university collections are still untapped treasures. Often they contain work by some of America's finest photographers—Solomon D. Butcher (Nebraska Historical Society), Caufield and Shook (University of Louisville), Alice Austen (Staten Island Historical Society). Private sources are jammed with delightful surprises. If you want an opportunity to know what it must have been like to visit the Collier Brothers,—the penultimate compulsive collectors—visit these photographic collections one by one. Source books lead you to them all; we've picked a few to whet your appetite.

Courtesy Solomon Butcher Collection/Nebraska State Historical Society

Solomon D. Butcher was an Easterner who headed West. He was 30 years of age in 1886 when he started to document American pioneers. For fifteen years he crisscrossed Custer County, Nebraska, announcing in local newspapers that anyone who wanted to could have his picture taken for "Butcher's Pioneer History." His wagon was his studio. He allowed subjects to pose as they wished. Often they arranged themselves with their prized possessions in front of their sod houses. Butcher's collection of glass plates—many of which have been cataloged—are at the Nebraska Historical Society.

STATE HISTORICAL SOCIETY OF WISCONSIN

Scandinavian Family, Madison, WI, Ca., 1877. *Photographer unknown*

If a model exists for the way in which a historical society should accumulate, organize and disperse information, this one is it. Like all societies, it was chartered to accumulate data on its own region, and its strength is in Midwestern American life from 1880 to 1925. But Paul Vanderbilt, who headed the operation for so many years, conceived of the society's scope as national and its function to organize material under broad social themes. Everything is cross-referenced. The picture collection numbers over a half-million items under such headings as Land, War, Organized Society, etc. The attempt is to be inclusive, to present an organized visual history of the country, not just the region. In the last decade, the main emphasis has been on acquiring material that will establish the society as a national center for the study of the performing arts. The United Artists' Film Library and that of RKO is there, as are the collected papers for the years 1928 to 1971 of Groucho Marx. This place is an invaluable cultural resource.

816 State St./Madison, WI 53706

UNIVERSITY OF LOUISVILLE PHOTOGRAPHIC ARCHIVES

This collection was started in the early sixties as a teaching collection for the university's fine arts department. In 1967 it was established as an archival department of the library with a full-time curator, Robert Doherty, who now is director of George Eastman House. Its stated concentration is documentary photography, but it also has an excellent though small collection of art photographs. Primarily, it serves students and a teaching faculty and its reproduction fees indicate this ($2 for students, $3 for faculty, $15 for others.) The staff is small and only about ten percent of the 500,000 items are cataloged. So if your project is large, be prepared to do your own legwork. Of course, the real value of any archive is in its holdings and Louisville's is one of the best. Here are some items:
• Caufield & Shook Collection—comprises 200,000 negatives made between 1915-1950 by the commercial firm of the same name and depicts the life and people of Kentucky and southern Indiana.
• Laughlin Collection—Over 17,000 negatives and an equal number of prints that represent the life's work of Clarence John Laughlin, one of the important photographers of this century (see page 217).
• Stryker Collection—Roy Stryker's personal collection from the three documentary photography projects that he directed: the Farm Security Administration project documenting rural America, 1935 to 1942; the Standard Oil project, 1943 to 1950; Jones and Laughlin Steel Corporation project. Also included are his correspondence and other papers.
• The Standard Oil of New Jersey Collection—the complete collection of Stryker's project, consisting of 85,000 pictures of the oil industry's

effect on life in the twentieth century, which is a complete record of the people and places throughout the world where Standard Oil had installations.

Photographic Archives/Louisville, KY 40208

View of Market St. looking east, Louisville, 1921. *Photographer unknown*

Theodore Roosevelt speaking at Grant's Tomb, Declaration Day, 1910. *Unknown photographer*

LIBRARY OF CONGRESS

France has its Bibliothèque Nationale, England its British Museum. In America, the country's national picture trust is the Library of Congress. There's no way of describing over twenty-million items, which cover events from the fifteenth century to the present. Many have been carefully classified; others are still in storage, unsorted and unannotated. Various card catalogs and subject files lead you to the material, and a decent research staff helps when all else fails. The Farm Security Administration files are open to the public. There are Brady's Civil War pictures, Frances Benjamin Johnston's early news photos and portraits, pictures from the Office of War Information of World War II, Roger Fenton's Crimean War photos.

Otto M. Jones

Prints and Photographs Div./1st St. between E. Capitol and Independence Ave., S.E./Washington, DC 20540

BROWN BROTHERS

Moving from New York City to the Pocono Mountains hasn't hurt Brown Brothers' service at all. They're still prompt, friendly and deliver some of the best historical photographs around. They house several million items, but their strengths are in the areas of American daily life and in world history. The original Brown Brothers (there were two of them) started the business in 1904, and it seems they never threw anything out. Their successors have added to the files through the years. Write or phone in your requests, and two imaginative researchers will do a thorough job.

Sterling, PA 18463

THE NATIONAL ARCHIVES

Since it opened in 1934, the Archives has been a repository for photographs that document American life. The emphasis is on Federal projects, but there's a lot more among the five million items. The Military Agencies Archives contains war photographs, yes, but there's also reportage on peacetime programs. *The New York Times'* Paris Office Files—a gift of the *Times*—contain over 200,000 non-government pictures that record newsworthy world events between 1900 and 1950.

Audiovisual Archives Div./Pa. Ave. at 8th St. N.W./Washington, DC 20408

BOSTON PUBLIC LIBRARY

Courtesy the Boston Public Library

The photography collection, which was started over a century ago, is based on a unique collection of thousands of nineteenth-century photographs of Boston streets, monuments, buildings, personalities and events in local history. The emphasis is on architecture and includes prints by such prominent photographers as Josiah Johnston Hawes. But the library is not entirely chauvinistic. There's a fine collection of Western pictures by the likes of Watkins, Russell, O'Sullivan, Jackson, Bell and Muybridge; Civil War pictures by Gardner and two albums from 1871 that relate to the Commune period in France. And lots and lots of personalities: Thackery, Webster, Ibsen, Teddy Roosevelt, Whittier, Edison, Kipling, Twain, Alexander Bell, among others.

"Widow," 19th-century American period. *Southworth and Hawes*

Rare Books and Manuscripts Dept./Box 286, Copley Sq./Boston, MA 02117

UNDERWOOD AND UNDERWOOD NEWS PHOTOS, INC.

It is only the very young who have not heard of Underwood and Underwood. The agency is probably the oldest—it is certainly the most important—collection of historical pictures in the world. The Underwood brothers began it all in 1882, when they set out to make the stereographs that were the popular entertainment of their day. Over the years, they hired other fine photographers, who traveled the world, covering news events. Their reportage of the historic events of their times provide a measure of the changing world.

3. W. 46th St./New York, NY 10036

California sorority girls emulate "Old Sol."

THE NEW YORK PUBLIC LIBRARY AT LINCOLN CENTER

The New York Public Library's most important collection of pictures is not housed on 42nd St., but in the heart of Lincoln Center. The Theatre Collection contains materials from all phases of theatrical art and entertainment: drama, stage, cinema, radio, television, circus, fairs, vaudeville, magic, minstrels and marionettes. There are over one-million movie stills in one collection alone, and that doesn't include the Universal and Paramount files. Nor does it take into account the Vandamn Studio Collection, or the Belasco Collection. Unfortunately, things move just as slowly as they do at 42nd St. Once you leave your coat downstairs and find yourself a seat, you're allowed three requests at a time. Patience, because you're bound to come away with most of what you came after.

Library and Museum of the Performing Arts/111 Amsterdam Ave./New York, NY 10023

PICTURE SOURCES/agencies

IMAGE BANK

Smart. Madison Avenue smart. That's the characteristic that best describes the people who founded Image Bank back in 1974. By bringing to bear their knowledge of the picture business, they managed to tap a hitherto untappable market for selling stock photographs—Madison Avenue advertising agencies.

Intelligently, they set out to determine why ad agencies shied away from using stock pictures. They talked with art directors, account executives, corporation types, and found that the most common complaint was about the poor quality of color photographs available through picture agencies. Since advertisers have specific needs for ads, annual reports and promotional materials, photographers are assigned to make pictures to order. Rarely, insisted these picture buyers, were they able to find "high-quality, advertising-type" pictures in stock agencies. Another complaint was that most picture agencies were out of the way, cramped and badly organized.

One by one the Image Bank directors attacked each problem. Quality: they signed fifty to sixty of the best advertising photographers around (Maisel, Kirkland, Turner, Bebee), to exclusive five-year contracts, with those photographs to be turned over to Image Bank's central file. The rates would vary according to how a picture would be used and the photographer and agency would split fifty-fifty. Physical environment: they opened offices in the heart of the advertising district. Not just any old office but a plush, carpeted, modernly decorated penthouse office that would make any advertising type pay heed. Service: they hired eight energetic, attractive, go-getters —some of whom had been photographers' reps, all of whom showed good sales abilities—and called them account executives. Each was assigned a specific list of clients and was responsible for selling material and acting as that all-important liason whenever the client wanted pictures.

That was just a few years ago. From all reports, things seem to be going well. A few photographers complain now and then about not receiving payments on time, but the directors talk enthusiastically about expansion. They opened licensing offices in Montreal, Washington, California and Japan, with plans to add Chicago and Atlanta and maybe even Europe.

Their New York files consist of some 65,000 35mm slides on 4×5 mounts, 5,000 to 6,000 2½-inch transparencies and an undetermined number of plastic sheets of 35mms. A portion of the central files has been duplicated and distributed to other offices. They welcome picture researchers to their offices, but will also service accounts by telephone.

If you're a photographer who wants to be included in their stable, then you show a portfolio to one of the directors. If he likes what he sees, that's that. Your material is edited and you're one of the group.

Penthouse, 88 Vanderbilt Ave./New York, NY 10017

A selection of the work of Image Bank photographers.

PRINT LETTER

Editor: Marco Misani
P.O. Box 250
CH-8046 Zurich,
Switzerland

The *Print Letter* reflects the growing internationalization of photography. Published out of Zurich in three languages (French, English and German), it's a lively, packed newsletter that reports on what's going on in Europe and America. Contributing editors and writers are experts from all over the world. A recent issue—it comes out six times a year—ran a report on photographic education in Europe, a rundown on the Arles Festival, reviews of several photographers' work, lists of current exhibits, prices for a host of photographers' work and lots of ads for books, portfolios, galleries. Altogether, the *Print Letter* communicates that there's a lot going on in photography these days and that their little mag will keep us abreast.

Subscription: $12 (air mail), Order from publisher

SYGMA

Sygma moves fast. In fact, that's one of the prerequisites of a syndication service whose job it is to distribute pictures throughout the world. Their selling point is speed: twenty-four hours to edit, print, write and deliver a story anywhere in the world.

The emphasis is on political reportage, which can be taken to mean world events. Sure, they'll cover a war in Angola, but they'll also stalk Hollywood personalities because they sell. The photographers make their own assignments. Once a story is shot, if it is international in scope, it is turned over to editors in Sygma's main office in Paris. If the story is uniquely American, then the New York office will handle the editorial work.

That editorial work includes editing and sequencing the pictures and writing the accompanying text and captions—in the style particular to the magazine that will receive it. The editorial control ends when the stories are shipped. The client at the other end does what he pleases with the package. The same material might run in the United States, France, Argentina and Australia, but each publisher uses the material as he sees fit. For Sygma's services, magazines pay a monthly fee against page rates (whichever is higher).

Sygma is a cooperative run by twelve photographer-members who get first choice on stories and decide communally on all business matters. Some twenty-four free-lance associates complete the stable of photographers. The money is split fifty-fifty for all photographers, members and associates alike. The same goes for expenses. Even if

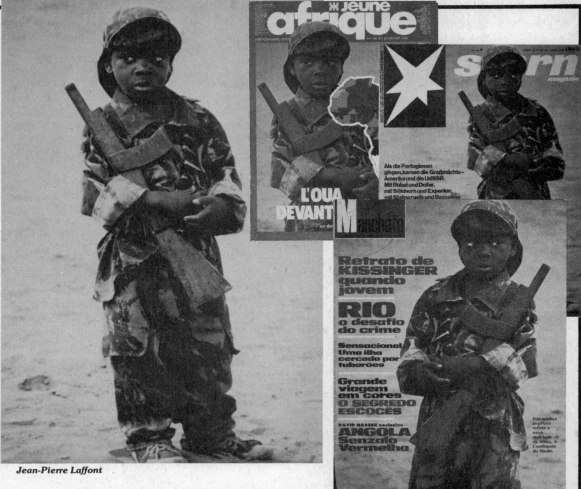

Jean-Pierre Laffont

you're not a regular, if you have a good picture story or set of pictures, Sygma has been known to do business with anyone with a good product.

For those who want to tap their stock, it is extensive. When Sygma

was formed, it was necessary, according to French law, to purchase a defunct picture agency that had been compiling stock for over forty years. Because Sygma is more concerned with photographing current events, their picture research and retrieval systems leave

something to be desired. But if you call up and make an appointment to go through material yourself, you're likely to find some fine photojournalistic work.

*322 W. 72nd St./New York, NY 10023
5 Reu des Vignes/Paris 16, France*

NEWS PICTURE SOURCES

There's really only one kind of picture source that provides a continuing chronicle of daily events: newspaper and wire service picture collections. Into their files, which are usually in the bowels of the newspaper labyrinth, pour hundreds of pictures—the best photographs of the world's events, a record of what was news.

Access to them is easy; rates are very reasonable. Usually pictures are arranged by subject matter (at UPI on conveyor belts and in boxes). Sometimes they are organized by publication date. (Most collections include pictures that go back to the early 1900s.) Usually, they are well-captioned, a welcome bonus compared to most collections.

If you're a photographer who happens to be present at some sort of disaster, and you manage to get off a few frames, you'll certainly want to head for the nearest wire service office to try and sell your pictures. (You should also check with leading newspapers and magazines to get the best price.) Wire services buy newsworthy

pictures and send them out over picture machines to thousands of American newspapers. You negotiate a price for your picture based on a number of factors: the subject, the picture's quality, its uniqueness and when you appeared with pictures in hand. Timing is of the essence. Someone can come in with a lousy picture and if it's one of a kind and of an important event to boot, there's money to be earned. Sometimes the service (or newspaper or magazine) will buy exclusive rights; in other instances you'll negotiate for one-time rights.

The major and best sources are listed below. Don't forget that your local paper probably has its own files.

Associated Press (Wide World Photos), 50 Rockefeller Plaza, New York, NY 10020

New York News (Daily and Sunday), 220 E. 42nd St., New York, NY 10017

NYT Pictures (*New York Times* News Service), 229 W. 43rd St., New York, NY 10036

United Press International (COMPIX), 220 E. 42nd St., New York, NY 10017

New York Daily News, Alan Aaronson

PICTURE SOURCES/agencies

MAGNUM PHOTOS, INC.

Let it be said once and for all. Magnum is part of photographic history. Its inception in 1947, as a world-wide cooperative for select free-lance photographers, coincides with the heyday of photojournalism; its growth parallels the development of modern photography.

Much has been spoken or written about Magnum's history. In this instance, it's enough to say that the idea started out in the mind of Robert Capa as World War II was grinding down. Capa had worked for *Life* and knew the power of the documentary photograph. He also knew that to make it alone as a free-lancer was going to take some doing, especially since he wanted to continue being reasonably well-paid and to maintain control over his work. Particularly, he believed that a photographer should own his negatives. A photographer-friend, Henri Cartier-Bresson, agreed. Slowly the need to band together was defined and the possibility of a cooperative became stronger.

It was largely through the efforts of seven people that Magnum (which Capa later named after the two-quart size bottle of champagne) got off the ground. Capa, Cartier-Bresson, George Rodger, David "Chim" Seymour, Maria Eisner, William and Rita Vandivert each invested $400. The photographer-members stationed themselves throughout the world; the others manned offices in Paris and New York. Since they were good at what they did, and a few people were willing to gamble, billing in the first year totaled $40,000. (Today it's closer to $500,000.)

Magnum has remained remarkably faithful to its original intentions—first and foremost, to provide a base of mutual support while allowing members the opportunity to do individual work. Over the years the notion of using the camera to report on events that affect the world has been the backbone of the projects undertaken. But in accordance with the times, other markets have been pursued: films, annual reports, books—all of it, surprisingly enough, anticipated in the group's original charter.

Most importantly, the organization has grown naturally—from the inside out—always with care taken to measure the demands of the times against the standards set by the founding members. Some would have it that Magnum's development has been too slow; others feel that the group's participation in the commercial world (annual reports, advertising) has overshadowed its editorial accomplishments. At best, a delicate balance is maintained—one that is tested, acted upon, retested and allowed to evolve when the group feels it is appropriate.

Probably one of the reasons that Magnum has remained strong is that it is selective in its membership. The question of how one becomes a member is not shrouded in mystery. As in any organization that perpetuates itself, there are rules. There are even some unwritten regulations that may seem elitest to outsiders but do insure the cooperative's growth.

It almost goes without saying that to become a member a photographer must have considerable talent. A certain degree of success or potential for success is examined, but generally earning power is the least important consideration. After assessing a potential member—which means evaluating his or her work and attitudes toward photography, as well as anticipating how he will fit into the cooperative structure—an invitation to join is extended. The majority of members are men; two women are full members, one is a contributing member.

If the photographer accepts, he becomes an associate member. He works in this capacity for about a year, at which point he is or is not made a full member. Along with becoming a full member come full voting privileges and a requirement to buy stock in the corporation. The group's track record is excellent. Only a few members have given up active status (they still contribute work), and fewer still have been asked to leave.

As the photographers reap, so Magnum receives. Whether a photographer's income shoots over the $100,000 mark or dips below $10,000, each contributes the same part of his gross earnings to the group. From assignments that the photographer secures himself, Magnum gets thirty percent. For work that the agency gets, forty percent is turned over, and for sales from stock photographs the split is fifty-fifty.

Magnum produces photographs. One of the advantages of having so much talent is that they make a lot of good pictures. The fact that someone had the notion of collecting them in a library and re-selling them is the public's good fortune, for there is no better contemporary stock picture source than Magnum. Its position at the top certainly has to do with the quality of its photographs (some 100,000 color slides and countless black-and-white prints), but equally important is the nature of its library—the quality of its research

staff and how the collection is run.

Researching at Magnum is a pleasure. The researchers care about pictures and are eager to pool their knowledge of who shot what, when and where. Usually one researcher handles a request, but to some degree or another everybody contributes ideas. Requests are taken over the telephone, or you can work in person. A research fee of $20 is charged non-educational clients (tradebook publishers, etc.) if nothing is used. For advertising clients it's $30.

The pictures are cross-indexed. Code numbers for each subject lead you to various folders. There are rows and rows of contact sheets that contain reasonably complete assignments—not just the famous pictures but everything that Bruce Davidson shot on the teenage gang. But the files are the primary source. There has been a concerted effort in recent years to add new pictures to the files. The classic Cartier-Bressons, Chims and Dennis Stocks have been augmented by younger photographers' work: Gilles Peres' work on European immigrant workers, Richard Kalvar's French families, Sepp Seitz' Chinese-Americans. Eve Arnold's work on women from various cultures and Dennis Stock's landscapes are represented in abundance. All of which points out another of the collection's strengths. Certainly, if you're looking for a single picture of an immigrant laborer working on the street, you'll find it. But along with that one shot, you'll find much more. Peres, for instance, has shot a complete story on the workers in various countries—doing different jobs, living in their make-shift homes, visiting their families back home, adjusting to an alien culture. There is depth to his reportage. Such riches stimulate editorial thinking, and there's many a researcher who has walked out of Magnum with better ideas than when he went in. Once you've made a selection of pictures, they are checked out on a consignment sheet that lists the pictures and photographers. If prints have to be made, the charge is $2.50 to $3. The client is expected to decide within twenty-one days which pictures will be used. Fines can be applied if loans drag on and on. Rates are standard. If you lose a transparency, be prepared to pay $1500.

15 W. 46th St./New York, NY 10036

German cemetery, 1969. *Leonard Freed*

Hubert Humphrey campaign, 1968. *Mark Godfrey*

Farmer resting, 1956. *Erich Hartmann*

Italian sailors, 1966. *Bruno Barbey*

Tet offensive, Ben Tre, Vietnam, 1968. *Philip Jones Griffiths*

Erich Hartmann

Burk Uzzle

Gilles Peres

Dennis Stock

Bruce Davidson

Leonard Freed

Marilyn Silverstone

Inge Morath

Elliott Erwitt

Ian Berry

Burt Glinn

Paul Fusco

Bruno Barbey

Wayne Miller

Costa Manos

Mark Godfrey

Cornell Capa

Marc Riboud

René Burri

Josef Koudelka

Charles Harbutt

Philip Jones Griffiths

Erich Lessing

David Hurn

Eve Arnold

Not pictured

Robert Azzi

Richard Kalvar

Montage by René Burri

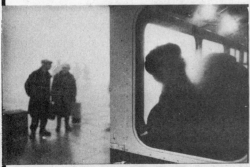

Northern Ireland, 1975. *Gilles Peres*

Train to Paris, 1975. *Charles Harbutt*

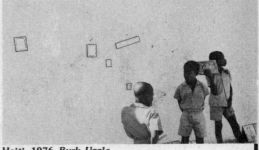

Haiti, 1976. *Burk Uzzle*

PICTURE SOURCES/agencies

TIME-LIFE PICTURE AGENCY

When architects were designing the Time & Life Building in the 1950s, so the story goes, they toyed with the idea of using the company's massive picture archives as a stabilizer by centering this great weight in the basement. But magazine editors depend on instant access to the photographic files, and since none of them relished setting up offices in the lobby, the Time Inc. Collection was given a home on the 28th floor, between *Time* and *Life* magazines. *Life,* of course, has folded, but the building hasn't—even though the Collection, growing at the rate of 400 new photographs a day, now contains some 19,000,000 pictures.

You can tap this resource by applying to the Time-Life Picture Agency, which represents this, the world's largest indexed collection. On the 28th floor is virtually *every* photograph *ever* shot on assignment for the various Time Inc. publications—*Time, Fortune, Life, Money, People* and Time-Life Books (only *Sports Illustrated* maintains a separate collection). Photographs from other sources that were used in these magazines and books are also filed, but the agency cannot sell them. Only a third of the collection is for sale.

The Collection's two strong points are obvious. It serves as a comprehensive and easy-to-use photographic index to the current events of the past four decades—there's scarcely a war or a scientific breakthrough or a coup d'état or a messy Hollywood divorce that isn't pictured here.

In addition, it contains complete takes of the photo essays shot by the company's staff and contract camera men since *Life's* Carl Mydans logged in the first, on Depression-ridden Texas, in 1936. Time Inc. has always paid top dollar for its photographers and sent them out on assignments with open-ended expense accounts. As a result, during the halcyon days of *Life,* practically all doors opened to them. This is particularly noticeable if you study the way the Collection grew in breadth. At the beginning, *Life* emphasized the events of the moment. But by its folding, its photographers had turned in quality essays in such fields as history and religion and the arts. In fact, though few people realize it, the Time Inc. Collection houses color transparencies of the masterpieces stored in virtually *every* major museum in the world. The success of these stories led to the founding of Time-Life Books, which in turn has published entire series on the different aspects of human civilization.

The Collection is the handiest source for photographs on modern life. The Time-Life Picture Agency is now taking pains to help you use it, which wasn't always the case. At an earlier stage, it had a deserved reputation for treating its clients haughtily and for slapping exorbitant prices on its photographs—especially those by staff and contract photographers.

Happily, the situation has improved immensely since February 1975, when the Agency was brought in under the wing of the Collection. Since then several bureaucrats have been eased out, and better yet,

reproduction fees have been scaled down to the ASMP guidelines.

Tracking photographs through the Agency is pretty painless. The Collection is broken down under some 9,000 entries, which makes handling a specific request easy. For example, if you want a shot of FDR and Churchill at Yalta, just write the Agency and arrange for a print to be mailed. For broader topics, though, the Agency is the first to suggest that you do some preliminary winnowing by consulting the various Time Inc. publications, which most libraries have in bound sets. Say you're interested in American fads of the 1950s. You'd be asked to leaf through the Time-Life Books volume *This Fabulous Century: 1950-1960,* as well as *Life* and *Time* of that decade. From these sources, you can order up any photograph that was taken by a Time-Life photographer. If you want to go further and canvas other photographs that didn't run, it's better to make an appointment to do research work in the Collection. The staff there is uniformly bright, well-versed in the files, and helpful—and unless you encroach heavily on their time, the service is free.

The one reservation about the Agency is the handling fees it charges in addition to reproduction rights: $10 for an 8×10 b/w print, and not the best quality at that; $15 for a 35mm dupe transparency and $35 for a 4×5 dupe transparency. Fee reductions are made for large orders.

Time & Life Building/Rockefeller Center/Room 28-58 New York, NY 10020 / (212) 556-4800

LIFE STAFF PHOTOGRAPHERS (86) 1936—1972

Carlo Bavagnoli
Jack Birns
Margaret Bourke-White
James Burke
Horace Bristol
Larry Burrows
Cornell Capa
Robert Capa
Edward Clark
Ralph Crane
Myron Davis
Loomis Dean
John Dominis
Paul Dorsey
David Douglas Duncan
Alfred Eisenstaedt
Eliot Elisofon
Bill Eppridge
J. R. Eyerman
N. R. Farbman
Andreas Feininger
Arthur Fenn
Johnny Florea
Herbert Gehr
Fritz Goro
Allan Grant
Arthur Griffin
Henry Groskinsky
Marie Hansen
Rex Hardy Jr.
Bernard Hoffman
Martha Holmes
Yale Joel
Mark Kauffman
Robert W. Kelley
Dmitri Kessel
Wallace Kirkland
George Lacks
Bob Landry
Nina Leen
W. H. Lane
Tony Linck
John Loengard
Michael Mauney
Vernon Merritt III
Thomas McAvoy
Leonard McCombe
Hansel Mieth
Francis Miller
Ralph Morse
Carl Mydans
John Olson
Gordon Parks
Charles Phillips
John Phillips
Hart Preston
Bill Ray
Co Rentmeester
Arthur Rickerby
George Rodger
Michael Rougier
Walter Sanders
Erich Schaal
David E. Scherman
Frank J. Scherschel
Joe Scherschel
Paul Schutzer
John Shearer
Sam Shere
William Shrout
George Silk
George Skadding
Ian Smith
W. Eugene Smith
Howard Sochurek

Peter Stackpole
Charles Steinheimer
George Strock
William Sumits
William Vandivert
Grey Villet
Hank Walker
Stan Wayman
James Whitmore
Hans Wild
Jack Wilkes

Edward Villella, 1969. *Bill Eppridge*

Dr. Land's glasses on 3-D moviegoers, 1952. *J.R. Eyerman*

Baboon's death scream, 1965. *John Dominis*

Mark Spitz, 1972. *Co Rentmeester*

Nursing mother, 1971. *Co Rentmeester*

Mechanical quadruped, 1969. *Yale Joel*

General Douglas MacArthur snapping orders, 1950. *Carl Mydans*

Vietnam, 1966. *Larry Burrows*

205

EASTMAN HOUSE

It looks like any run-of-the-mill mansion—impressive driveway, meticulous landscaping, elegant facade. But inside the house, which was in fact George Eastman's home, is the world's largest and most definitive collection existing today on the history of photography. It's called the International Museum of Photography at George Eastman House and contains over 300,000 photographs, plus 30,000 of the best books and bound periodicals.

What has become America's treasure was, in a sense, France's loss. For the bulk of the initial collection was a gift way back in 1939 from the Frenchman Gabriel Cromer. Cromer had privately assembled an impressive collection of nineteenth-century French photographs, including the *Portrait of a Painter* by Daguerre, the only known photograph signed by him.

Today it seems, in retrospect, that when the museum officially opened in 1949, it grew by leaps and bounds. In 1951 the Boyer Collection was donated; it included an impressive number of books that were to form the core of the museum's excellent research library. Artists sensed the importance of the museum as a serious center for studying the medium and made gifts of their work. Georgia O'Keeffe gave a representative Stieglitz collection. Paul Strand contributed generously over the years from each of his projects, and Coburn, Adams, Siskind and Käsebier each contributed bodies of work. In fact, about ninety percent of the holdings have come through donations.

The Museum is much more than an archive. Just about anyone who's anyone in photography has spent some time there. As staff members, they've contributed and in return have learned. The museum considers part of its responsibility to train interns who will eventually work in the field.

To make their material accessible to an ever-widening public, they publish a journal called *Image,* in which they run intelligent articles, interviews and reports on activities in the field—always relating current interests to the medium's history. Another project has been the publication of portfolios on the work of photographers like Lewis Hine and Frantisek Drtikol. They are faithfully printed from original negatives in the museum's collection. The Dritkol, for instance, sells for a modest $175 for nine prints. There are over 3000 pieces of apparatus in the museum's collection of cameras, including a nine-lens aerial mapping camera originally carried on the *Graf Zeppelin.*

You can tap into the Rochester riches by making an appointment to use the archives a week or two in advance. When you arrive to research, you are warmly welcomed and handed a policy and procedures sheet that underscores the value of the material. "Make sure your hands are clean. . . . There is no smoking allowed . . . Only pencils may be used in the room . . ." Respect is what they ask for and what they deserve.

900 East Ave./Rochester, NY 14607

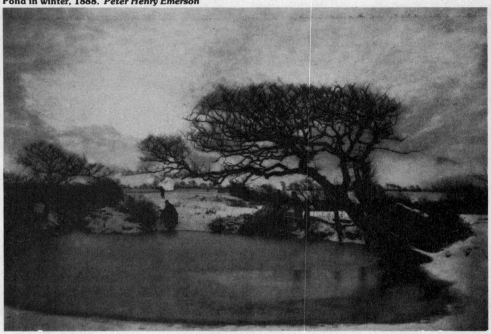
Pond in winter, 1888. *Peter Henry Emerson*

From the Harlem Document project, New York, ca. 1935. **Jack Manning**

Veiled Woman. *Photographer unknown*

There couldn't be a more fitting setting for the world's most important photography museum than the home in which George Eastman lived. Eastman committed suicide in 1932 at the age of 77, leaving a note that stated: "To my friends. My work is done. Why wait? G.E." His mansion went to the University of Rochester as a residence for its president. Then, in 1949, the trustees opened the house as a photographic museum. On the second floor is a permanent exhibition of the art of photography. Other sections of the mansion are given over to historical and contemporary shows, cameras and early photographic images.

THE MUSEUM OF MODERN ART

Put aside the notion of the MOMA Photography Department as a power broker, as an arbiter of taste, a maker or breaker of artists' careers. For some people, especially photographers, that's hard to do. Consider, instead, the fact that the people who work in the Department of Photography are not concerned with wielding power, but with collecting and maintaining an archives on the art of photography. Over the years it has been, for the most part, a job well accomplished, because since it started to acquire photographs in 1930, with a photography department officially established in 1940, the museum has assembled one of the country's most impressive collections. Its collection traces the history of the medium as a modern art, a job that has been accomplished by recognizing the work, familiar or unknown, that contributes to our understanding of its history.

One of the ways in which the museum keeps abreast of new work is by reviewing contemporary photographers' portfolios. They do so not to discover new talent for exhibitions, but to follow the "changing ideas and interests expressed in current work." In a note to photographers who leave portfolios for review, John Szarkowski, the Director of the Department, explains that each portfolio is given serious attention, but that the heavy work load shared among the small staff (six permanent employees and an intern) prohibits critical evaluations. Szarkowski points out that only rarely does the department ask to acquire pictures for the collection or for exhibition—especially after seeing work only one time. He feels it is necessary to follow work over a period of time in order to intelligently judge its quality and seriousness, so each staff member reviews each portfolio, making notes. As new work is submitted, new reactions are added to the old ones.

Since the museum sees about eighty portfolios a month, the job takes considerable time. A photographer is expected to leave his portfolio for a week and to follow standard procedures for submitting that work, a limited portfolio of about two dozen selections. Of course, if you're flying in from Kracow, Poland, and will only be in town for a day or two, they'll try and accommodate you. There are also shows to be mounted, the acquisition of books and pictures, cataloging, conservation and curatorial responsibilities and too much clerical and administrative work within the museum and out for anyone's peace of mind.

Everyone has his job. There's only one person to supervise the requests for access to the collection that come from all over the world in letters, on the telephone and when someone appears in person. For this reason, the library is only open three afternoons a week. Practically speaking, it is open to anyone, that is, to anyone who is serious about using the material—most people who come there are. Whether you're an interested person who wants to educate yourself about photography or a scholar tracking down specific information, you are treated with the same respect.

What is it that makes the collection so important? Well, everyone knows about the Eugène Atget material and the Edward Steichen Archives. Some people even know about the Westons, Adams, Sommers and Moholy-Nagys. In its pattern of collecting, the museum has not gone out just for the classics, but for the supporting pictures that provide an overview of the artist and the medium. With the approximately 17,000 pictures of twentieth-century artists, the emphasis has been on quality not quantity, with a concern for assembling the best cross section of the history.

Realizing, too, that they are in the center of a photography metropolis, the Museum makes an effort not to duplicate what other institutions own when they do acquire work.

Each work of art is cataloged by artist. There's no way of going after a particular subject, say trees, unless you know that Edward Steichen spent years making pictures of a shad roe tree. If you don't know who did what, you'd best stop at the public library first.

Considering all the activity, service is efficient and fast. Once you know whose work you want to see, the research supervisor will bring it to you. The usual care must be taken when reviewing work. Expect to be cautioned and don't be embarrassed when someone asks you to wash your hands and to put away your pen. If you want to order a print for study or reproduction purposes, there'll be no problem if the museum holds the rights. If, however, it is the work of a living photographer, you'll be required to obtain written permission from the photographer. The same holds true for work controlled by a photographer's estate.

In addition to the photographs, there's a library strong in twentieth-century monographs. The biography files, which were started when the museum was, contain articles, reviews and other published data on various photographers.

21 W. 53rd St./New York, NY 10020

ART INSTITUTE OF CHICAGO

Way back in 1900, the Institute got into the photography act. With the Chicago Society of Amateur Photographers, they co-sponsored the country's second photographic salon. (The first had been held in Philadelphia two years before.) The Institute sponsored salons until 1938. When their program was resumed in 1943, they held a series of impressive one-man shows.

It was a gift from Georgia O'Keeffe in 1949 that formed the nucleus of the Institute's photography collection. They acquired 150 pictures by Stieglitz and over 50 photographs by his contemporaries. The pictures represented what Stieglitz thought to be the best photography of his day.

Work by outstanding contemporary photographers were added in the fifties, and in 1959 they concentrated on collecting nineteenth-century masterpieces. Today that collection includes eighty Fox Talbots, over thirty Hill and Adamsons, work by Cameron, Fenton, Frith, Annan. The list goes on and includes important illustrated books. That same year 204 Edward Westons were added.

During the sixties additional gems were added—127 Atgets of the gardens of Versailles and work by modern artists. Today some 6,000 items make the Institute's collection one of the country's finest.

S. Michigan and E. Adams St./Chicago, IL 60604

Nude, 1945. Edward Weston Courtesty of The Art Institute of Chicago

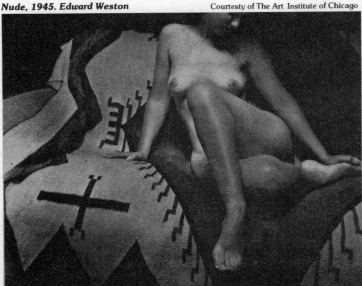

MOMA'S BIG MAN IN PHOTOGRAPHY

In 1961, when John Szarkowski was asked to direct the Museum of Modern Art's Department of Photography, few people had heard of him. As it turns out, his appointment was an inspired choice. But when the museum directors tracked him down in the northernmost reaches of Wisconsin, where he was living and photographing, they could not have fully realized how dramatically this photographer/teacher/author would effect the museum's collection and program.

Szarkowski had been photographing since he was eight years old (chief photographer for the senior yearbook and postcard photographer for a local business). While studying art history at the University of Wisconsin, he worked in a portrait photographer's studio. His first job out of college was as staff photographer for the Walker Arts Center in Minneapolis, copying paintings and sculptures. Then he taught photography and art history.

His big move was to Chicago, where he photographed the architecture of Louis Sullivan, supporting himself, meanwhile, with an $80-a-week job as a commercial food photographer. In 1954 he received a Guggenheim; when it ran out, he tried unsuccessfully to find a New York publisher for the Sullivan pictures. The University of Minnesota Press ended up publishing *The Idea of Louis Sullivan*. His second book, *The Face of Minnesota*, was a *New York Times* bestseller for ten weeks.

All this work-a-day experience as photographer, editor, teacher and author was to be a rare combination in a museum director. His understanding of photography books and his writing ability enabled the museum to establish an impressive book program. He, himself, has authored two classics, *The Photographer's Eye* and *Looking at Photographs* (see page 129).

In the shows he has presented, he has tried to demonstrate the limitless possibilities of straight documentary photography. Although he has hung shows by such classic photographers as Kertész, Evans, Cartier-Bresson, his impact on contemporary photography has been in his acknowledgement of the works of the likes of Arbus, Friedlander and Winogrand.

HUMANITIES RESEARCH CENTER

Helmut and Alison Gernsheim, respected photographic historians, began collecting photographs in the 1940s. Over the next twenty years they assembled one of the greatest photographic collections in the world. Photographs by the important practitioners of the art in every period are represented (there's an especially strong body of work on European photography of the Victorian era), a large library of books and journals going back to the sixteenth century pre-history of photography and numerous pieces of equipment. The University of Texas acquired the Gernsheim collection in 1964 and has since augmented the Gernsheim material with nine other noteworthy collections. The archives now house over 150,000 photographs, 6,000 books and journals and 1,600 pieces of equipment.

The Harry Ransom Center/The University of Texas/Box 7219/Austin, TX 78712

The Harry Ransom Center at the University of Texas houses the Gernsheim Collection. In addition to the material collected by the historians, the research center has added to the archives. The Goldbeck Collection consists of panoramic views of U.S. military bases, personnel and scenics. The Smithers Collection contains over 12,000 photographs that document life of the trans-Pecos area since 1890. The Hare Collection of slides and negatives covers the Spanish-American and Russo-Japanese Wars, the Mexican Revolution and World War I. And that's only the beginning.

THE CARPENTER CENTER FOR THE VISUAL ARTS

The most exciting thing about the Carpenter Center is not the 500 art photographs by masters like Weston, Frank and Evans, but two other collections of photographs that have been compiled because of their value as social documents. One archive includes pictures that depict American reform and social conditions from 1895 to 1905: the American experience—immigration, Americanization, work groups, living in the city, pursuing the rural ideal—are depicted in over 6000 photographs.

The second body of work that makes up the Harvard Photographic Archives, as it is called, contains photographs and negatives from the files of old professional photographers. For the most part, they are unknown photographers who used the camera to accomplish a specific job—at weddings, as staffers on newspapers, etc. Unknowingly, these photographers made pictures that today are of inestimable value because they tell us facts about our culture, our people, our values and behavior. "Wedding" a show and catalog that grew out

of this ongoing collecting process, underscores the value of the photograph as a document of infinite and subtle information about the behavior of people before, during and after that ubiquitous American ritual, the wedding.

Harvard University/Cambridge, MA 02138

OTHER NOTEWORTHY COLLECTIONS

COMMERCIAL SOURCES

Black Star Publishing Co.
450 Park Ave. S., New York, NY 10016
General documentary

Photo Researchers, Inc.
60 E. 56 St., New York, NY 10022
General documentary

Woodfin Camp and Associates
50 Rockefeller Plaza, New York, NY 10020
General documentary

HISTORICAL SOCIETIES

Chicago Historical Society
Clark St. at North Ave., Chicago, IL 60614
Over 300 daguerreotypes—

Abraham Lincoln collection and portraits of American Presidents

New York State Historical Association
Cooperstown, NY 13326
Smith and Telfer collection of 53,000 negatives made in and around Cooperstown, 1865-1953

The State Historical Society of Colorado/Colorado State Museum
200 14th Ave., Denver, CO 80203
7000 glass negatives by William Henry Jackson

MUSEUMS

Fogg Art Museum/Harvard University
Cambridge, MA 02138
3000 Ben Shahn photographs

High Museum of Art
1280 Peach Tree St., N.E., Atlanta, GA
General art-of-photography collection

Oakland Museum,
10th and Falton, Oakland, CA 94607
General art-of-photography collection; special collection of 50,000 Dorothea Lange photos and memorabilia

Museum of Fine Arts/Department of Prints and Drawings
Boston, MA 02115
108 Southworth & Hawes daguerreotypes

Smithsonian Institution
1000 Jefferson Dr. S.W.,

Washington, D.C. 20560
General history of photography collection

UNIVERSITIES

The Bancroft Library/University of California
Berkeley, CA 94720
Western History emphasis—Watkins, Muybridge, Jackson, O'Sullivan, etc.

Georgetown University
37th and O Sts. N.W., Washington, DC 20007
Quigley Movie Archives, 40,000 items

University of Oregon/The Library
Eugene, OR 97403
Clarence L. Andrews, Alaska 1892-1920; and 10,000 Doris Ulmanns

16

From Photographie im Wandel der Zeiten

PHOTOGRAPHS AS ART

PHOTOGRAPHS AS ART

PHOTOGRAPHS AS ART

Collecting art means collecting artists as well. Whether it's in painting or photography. It is not enough to simply buy a "great" photograph; for a picture to have value in the art world, it must have been taken by a "great" photographer. A portrait of Gloria Swanson by an unknown studio photographer may be exquisite and worth some money to the movie buff, but it is worthless to the collector of art prints unless it was taken by the likes of a Steichen. Then it might be worth thousands.

Who shall be deemed an artist and who shall not? Shows, books and articles about the photographer all contribute to his status, but in the final analysis time is the most important determining factor. For that reason alone, older photographers predominate this selection of collectible photographers, and since the prices for nineteenth-century photographs are out of sight, we've restricted ourselves to twentieth-century masters. You'll find no surprises in our choices, for we have not gone out to find unknown talents, of which there are many. Instead, we have reviewed those artists who have consistently produced photographs that have gained them acceptance by the photographic art establishment and deemed them collectible. Along with a brief evaluation of their work, and in some cases their unique contributions, we've listed where you can see more of their pictures—maybe to purchase or just to appreciate more fully. These then are the names people are paying good money for, particularly in America.

It took Americans a long time to make up their minds about photography being an art. When they did, the market for fine art photographs exploded in a typically American way. It was in the late 1960s that photography was welcomed into the big business art world. Paintings and drawings had become too expensive for the average collector to acquire, so photography, which could be purchased at much lower prices and in greater quantities, became the thing. From 1970 until 1975 the number of photography galleries in New York alone went from six to thirty, an example that the rest of the country followed. These new galleries ran the gamut from informal cooperatives, which exhibited anyone who passed certain subjective criteria, to rigid, prestigious Madison Avenue galleries that had traditionally exhibited the best in paintings and graphics.

Along with the gallery explosion came general confusion. The confusion had to do with standards, for when people realized that photographs could bring in money, they had to determine which photographs were actually of value and why—in short, what was worth what. The dust is not near settling, but over the recent years curators, collectors and gallery directors—those people involved in setting standards—have been grappling with the questions.

One fact that has emerged is unquestionably clear: the law of supply and demand is increasingly important to a medium capable of producing unlimited repeatable images. Nineteenth-century pictures are more valuable than twentieth-century works, largely because commercial value depends a good deal on how rare something is. Makes sense. If Julia Margaret Cameron made but one print of Lord Alfred Tennyson, then that single picture is more valuable today than if she had made fifty equally fine prints of the poet. But given a large enough group of serious collectors, say 5,000 in number, the price of the fifty could skyrocket because there would be *only* fifty. Therein lies the intrinsic value of photographs made by nineteenth-century photographers: the supply is simply limited.

The dilemma for living photographers, then, is how to limit their pictures, for it is by controlling the number of prints that they control their value. Until recently, twentieth-century photographers did not have to worry about the market's demand —there were few collectors around. In his lifetime, Edward Weston's best selling print was *Pepper No. 30*. He sold twelve of them. Aaron Siskind tells how, in all his years of photography, he has never sold more than ten copies of one particular picture. He ventures a guess that in a few cases Harry Callahan may have sold up to ten to fifteen prints of certain pictures, but suggests that Ansel Adams is probably the only living photographer who makes a good living from print sales. Today, the bonafide number of collectors willing to invest in photography as art is growing. Individuals, museums and universities that ignored photography are starting collections. They usually begin by collecting the twentieth-century masters and fill in where possible with nineteenth-century works. The contemporary photographer, if he is to participate, must by necessity play the traditional art games.

In the graphic arts, with etchings, for example, the artist pulls and numbers a limited edition, signs each one and pulls a few extra "artist's proofs." Then he destroys the original plate, thereby guaranteeing that no more etchings will be pulled. In photography the equivalent to the original plate is the negative. All things being equal, by destroying a negative upon completing a limited-edition portfolio, the photographer enhances the value of the prints tremendously. But photographers are wary of doing this. Many feel that to destroy the negative is contrary to the nature of photography and that it is the *negative* that represents the work of art. Over the years some photographers have talked about "retiring" negatives, and some have even toyed with the notion of slicing off an almost imperceptable sliver so all editions would be unique.

No standard practice has emerged, but one thing is clear——almost to a person, photographers are reluctant to deface their negatives. Some gallery directors believe that as soon as photographers can make a decent living off an edition, they will be willing to cancel negatives. According to Lee Witkin of the Witkin Gallery in New York, if Aaron Siskind pictures are selling for $150 it seems silly to ask the man to destroy his negative. If, on the other hand, his pictures sell for $2000, the buyer, it seems, has certain rights. Witkin also suggests that as the market grows, there will be more and more editions of, say, 100 portfolios—as in the case of Ansel Adams, who completed his seventh portfolio in 1976. A gallery director will pay the artist on the spot and sell the pictures immediately as in any graphic art medium. It's at this point that the artist might donate or "retire" the negative to a museum.

While the market grows and defines itself, the tendency is to print to order rather than to publish an edition. In 1971 Diane Arbus issued a boxed portfolio of ten photographs in a limited edition of fifty. It sold for $1000 and received wide publicity. Only two portfolios were sold, one to Jasper Johns. The value of the work is inestimable because it now appears that Arbus did not complete the edition of 50, but only printed each set after the sale was secured. Of course, had she lived, there is no standard that would have prohibited her from going beyond fifty and signing a later edition.

Duane Michals definitely limits his sequences to an edition of twenty-five, although, like a growing number of photographers today, he prints to order. It is a self-imposed control. Michals represents another factor that concerns some collectors. He does not print his own prints. *Original*, or *vintage*, prints are the most valuable prints. For the most part, they are printed by the photographer himself about the time the picture was taken. Prints made

by an authorized printer, under the artist's supervision, are also considered originals, but some people maintain that the only truly valuable works are those made by the artist's own hand. They hold that no matter how skillful and understanding of the photographer's intention a master printer is, he never achieves what the photographer himself manages. Michals disagrees and prefers to have his pictures printed by an able technician. So do Cartier-Bresson and Kertesz. Although such a practice is controversial, there are precedents in the traditional art world. From Toulouse-Lautrec to Picasso, for example, artists have used technicians to help with etchings, lithographs and the like. The important thing has always been that the artist signs his work. His imprimateur is his sign of approval that the print is as he would have done it himself. Of course, this renders any posthumous prints inferior because they lack the artist's approval. Bernice Abbott's prints of Atget's work sell for $500-600, whereas the Frenchman's own prints sell for $1200. Edward Weston's prints are valued at $800-1800, if you can find one, while his son Cole's prints of the same pictures go to $200.

When a photographer does not print a limited run but prints on demand, there can be substantial differences from one print to another. The difference in materials between a Weston print made in 1928 and one made a few years before his death in 1958 can be detected only by a trained eye. Of course, such detective work takes years of experience, not to mention an intimate knowledge of the particular artist's printing style.

Last but not least, it is important to remember that not every photograph produced by a master photographer is of equal value. As historians and scholars study the medium and discover new artists, finer and finer discriminations will be made between the good, the average and the downright ordinary. Only those pictures that exemplify a particular photographer's artistry and represent significant contributions to the history of the medium will be considered valuable.

With this in mind and to help you make up your own mind as to a photograph's worth, we bring you an essay (see page 226) on pictures and photography in particular by Rudolph Arnheim, former professor of psychology at Harvard University. He is the author of *Visual Thinking, Toward a Psychology of Art* and *Art and Visual Perception,* classic books on the aesthetics of art.

THE COLLECTOR'S COLLECTOR

Arnold Crane is a collector. When he was a child he collected rocks, Indian arrowheads, stamps—you name it. Back around 1964, before photography got a foothold in the art market—that is, when prices were a real bargain—Crane began collecting photographs. And he made some wise investments: an Alfred Stieglitz gravure of *The Steerage* for $15—it recently sold for $4500; a $400 purchase of *Camera Work* (the complete set minus five volumes), which if you can find one today goes for over $40,000. Crane's enthusiasm for the medium, matched with his own sensibilities, has helped him amass one of the two largest and most important private collections of photographs and photographic books in the world. About seventy percent of the photographs are by nineteenth-century masters. The twentieth-century photographs are largely by Man Ray, Moholy-Nagy, Walker Evans and Aaron Siskind. Some people value the collection at $10 million. When we wanted to ask some questions about collecting photographs in today's market, we went to the expert himself.

● On Acquiring Photographs
When Crane began collecting, he personally attended auctions and searched out bargains. He feels that it's virtually impossible today for an individual to buy on his own. With the number of dealers and runners (people who look for material for dealers), it's hard to compete. When he buys these days, and it's rare since he owns just about everything that he wants, he goes through a dealer or private collector who has duplicate works of art. With luck and a lot of time, it's possible to search out material in obscure places, but real finds are hard to come by.

● On His Favorite Purchases
If Crane ever decides to sell his collection, say to an institution, there are fifty to sixty pieces that will not be part of the sale. For when Crane talks about favorites, he talks about those works to which he has an emotional attachment; they are not necessarily the most valuable in the collection. Probably his favorite is a collage self-portrait of Max Ernst, a portrait of the artist holding a bust of Caesar. Another work, a signed C.H. Gay daguerreotype ca. 1850 of the Harbor of New London, has special value for him. It's a rare panorama consisting of six two-third daguerreotype plates. His Man Ray and Moholy-Nagy collections also occupy a prominent place in his affections, as does Barnard's *Sketchbook of Sherman's Campaigns,* an album consisting of 150 prints.

● On Signed Prints
Crane prefers that a photograph bear some personal mark of the artist. Ideally, it's a full signature, but an initial or the artist's stamp also adds the touch that Crane believes gives the print an "extra magic."

● On Archival Processing
Like a growing number of individuals today, Crane feels that archival processing is over-emphasized. His own Man Ray prints have acquired a special beauty because of oxidation. He points out that all works of art age and, accordingly, we incorporate such changes into our appreciation of the work.

● On Collecting Color
For the most part Crane feels that by their very nature color photographs are ephemeral. With the exception of a few processes—he mentions Cibachrome and dye transfers—the life of a color photograph is still

Mary E. Fanette

unknown. In spite of this, he does own a few color prints, because they give him pleasure.

● On Limited Editions
Crane believes that some contemporary photographers are forcing themselves to make limited editions. Part of the reason, he suspects, has to do with the simple fact that most photographers dislike darkroom work. If a photographer manages to produce a number of fine prints at one time, he will not have to face the boredom of the darkroom time and time again. Another reason he suggests has to do with controlling the market for contemporary photographs. (See above essay) But Crane is adamant in his belief that not everyone need own a masterpiece. He is horrified

by posthumous editions. For instance, in the case of Diane Arbus, according to Crane, there is no need for a single new print to come out.

● On Advice to Prospective Collectors
It is still possible, according to this seasoned collector, to put together a fine collection of photographs in spite of higher costs. Whereas it may take $1 to $1½ million to bring together a basic painting collection, one can manage a solid foundation in photography for $35,000-$50,000. He advises that one best go through a reputable dealer (they are located in most major cities). According to Crane, nineteenth-century work is still vastly underpriced, and there are still masterpieces around.

BERENICE ABBOTT
(1898—)

As a young Midwesterner in Paris of the 1920s, Abbott made the first of her many contributions to photography. Her ingenuous portraits of James Joyce, Jean Cocteau and Edna St. Vincent Millay won her artistic recognition and defined her clear-thinking, unpretentious approach to picture making. It was also in Paris that she discovered the photographs of Eugène Atget, who so inspired her that she single-handedly rescued him from obscurity by bringing his work to the attention of the world.

She returned to New York in 1929 and photographed scientific subjects for *Life* and businessmen for *Fortune* with a "plainspoken directness." It was in the late 1930s that she came into her full power while photographing New York City for the Federal Arts Project. The photographs are collected in *Changing New York*.

Berenice Abbott/RD 1/Abbott Village, ME 98007

Marlborough Gallery/40 W. 57 St./New York, NY 10019

Fifth Avenue at Eighth Street, ca. 1938.

Versailles, ca. 1903.

EUGÈNE ATGET
(1857—1927)

He is one of the most important of all photographers. When he died, at the age of 70, impoverished after having photographed for 36 years, he left some 10,000 albumen prints of widely varying subjects in and around Paris. During his lifetime the municipal administration bought some of his work to keep a record of the changing city. The painters Braque and Utrillo bought some for subject matter reference. In 1925 Man Ray published four prints in *La Revolution Surréaliste*. Ray's assistant, Berenice Abbott, made a portrait of the old, kindly looking—if somewhat bemused—man dressed in a new overcoat. When she returned to his apartment with the print, he was dead. Legend has it that he had lived for years on "nothing but milk, bread, and bits of sugar." An old friend inherited Atget's work and then sold the treasure to Abbott.

The pictures Atget achieved with his camera were completely exceptional before his time and profoundly influential after. There is a quiet, serene quality in the lighting and a loving presentation of the subject matter that engenders long and repeated satisfaction.

Museum of Modern Art/21 West 53 St. New York, NY 10020

ANSEL ADAMS (1902—)

When you stand before an Ansel Adams print, you can't help but be overwhelmed by the sheer lusciousness of his technique. The virtually grainless photographs offer up a seemingly infinite gradation of tones from jet black to pure white.

He joined other young West Coast photographers like Weston and Cunningham in 1932 to found the f/64 Group, which believed that photographs should be made with maximum clarity of focus and depth of field. Then, by himself, Adams began a series of painstaking experiments to coax a greater range of tones from his prints. From this came the Zone System that allowed him to previsualize the tones and determine exposure and developing time at the moment of shooting.

Adams has always done his own printing, for he treats his photographs as though they were traditional art prints. In fact, if you want one of his limited-edition signed portfolios—the sixth sold for $8,000—you virtually have to order before publication.

In addition to his own photography, Adams has taught the craft since the 1930s, and he began proselytizing his Zone System in a series of five Basic Photo Books and workshops.

Ansel Adams/Rte. I, Box 181/Carmel, CA 93921

DIANE ARBUS (1923—1971)

Her pictures are intent on discovering the strangeness in what is familiar and the familiar in what is strange. In a sense, her photographs of nudists have as much to do with costume and disguise as her photographs of masked people or transvestites.

Some of her work is the result of a momentary encounter, portraits of people she happened to see on the street. More often, however, her photographs are the product of a long and intense pursuit, whether of individual people—such as the Jewish giant whom she photographed over a period of ten years—or of a general subject that interested her, such as contests or carnivals or twins. Hers was that rare artistic accomplishment: interpreting special subject matter in such a remarkably personal way that anyone else who does it again will be charged with imitation. Hilton Kramer wrote in *The New York Times:* "The subjects face the camera with interest and patience . . . fully aware of the picture-making process. They collaborate." He felt that this participation gives the pictures dignity and that dignity gives them power. Susan Sontag, writing in *The New York Review of Books,* had a negative reaction, seeing the photographs as devoted to lowering the "threshold of what is terrible." Arbus herself said, "It's very subtle and a little embarrassing to me, but I really believe there are things which nobody would see unless I photographed them." She committed suicide July 26, 1971.

Witkin Gallery/41 E. 57 St./New York, NY 10022

Graphics International Ltd. 3243 P St. N.W./ Washington, DC 20007

Mexican dwarf in his hotel room in New York City, 1970.

Dwight David Eisenhower, President of the United States, 1964.

His prints are very stark and of high contrast, the blacks very black and the whites without detail. The result is drama, sometimes even melodrama. He was a pupil of Man Ray, and you can see the influence.

In 1936 Brandt's "upstairs, downstairs" study of the English middle class and their servants was published as *The English at Home*. During World War II he photographed not the horror of a bombed London but the beauty of its moonlit empty streets and the incongruity of its air raid shelters improvised in the Underground. Then for fifteen years he staged the female form—often strikingly distorting parts of the anatomy against wild views of the sea and shore. These graphically exciting pictures were published in *Perspective of Nudes*.

René Magritte, 1966.

Brandt's sense of the dramatic and penchant for imaginative settings combine in his portraits, of which the one of a derby-topped René Magritte holding a surrealist painting is a classic.

Marlborough Gallery/40 W. 57 St./New York, NY 10019

RICHARD AVEDON (1923—)

"Youth never moves me. I seldom see anything very beautiful in a young face. I do, though, in the downward curve of Maugham's lips, in Isak Dinesen's hands," is Avedon's explanation of one reason why he creates the portraits he does. They are never sentimental, seldom flattering, and always stark, with but an occasional prop: Jean Cocteau holding a sprig of lily of the valley, Elsa Maxwell with a telephone in one hand and a pet skunk in the other, Alger Hiss with a newspaper tucked under his arm.

In September 1975, Avedon had a major exhibition of his portraits at the Marlborough Gallery in New York City. The show was spectacularly presented by graphics designer-painter Marvin Israel, who in explaining the variation in size of the prints (8×10 inches to 8 feet high) said: "Avedon's pictures are incredibly sparse. The danger is that they can become caricatures, and sometimes on a page they do. But in such large scale, every feature means something—a hand becomes a landscape."

The show reinforced Avedon's supremacy as a portraitist of celebrities and socialites. His prints were offered for sale at from $175 to $2,000.

Richard Avedon/407 E. 75 St./New York, NY 10021

BRASSAI (1899—)

Gyula Halász left Hungary to study art in Berlin. Later, in Paris, Halász became Brassai, and Andre Kertész introduced him to photography. In the 1930s, Brassai loved to roam the City of Light at night to shoot its *demi-mondians*. When Henry Miller saw his shadowy evocations of hookers, street toughs and tramps, the novelist dubbed him "the eye of Paris." Brassai returned the compliment by writing a biography of Miller. This beautifully produced book is introduced by 16 pages of Brassai's photographs of Miller et al.

Now, not only an author but also a painter and sculptor, it is Brassai's early Paris pictures that have made him famous. Seldom has a camera done so much when used so little.

Marlborough Gallery/40 W. 57 St./New York, NY 10019

MANUEL ALVAREZ BRAVO (1902—)

There is a special serenity about Bravo's best work—perhaps in the lighting, certainly in the moment of exposure—that gives it a lineage with Eugène Atget and with Paul Strand.

In 1968, on the eve of an exhibition of Bravo's photographs made over the course of forty years, Strand said: "He has become Mexico's greatest photographer and one of the outstanding photographers of his time. His work is rooted firmly in his love and compassionate understanding of his own country, its people, their problems and their needs. These he has never ceased to explore and to know intimately. He is a man who has mastered a medium which he respects meticulously and which he uses to speak with warmth about Mexico as Atget spoke about Paris."

Witkin Gallery/41 E. 57 St./New York, NY 10022

HARRY CALLAHAN (1912—)

In his long career (he's been photographing since 1938) Harry Callahan has mainly made pictures with three different subjects: his wife, Eleanor—as a generalized representation of Woman—cityscapes, and nature views. The most memorable of these depend for impact on bold graphic patterns; contrast always plays an important role, with some parts printed totally black.

There are those who see in Callahan's work such cryptic effusions as "an indescribably complex set of perceptions beyond the tension between photographic reality and mythic archetype." Perhaps. But indubitably, Callahan has made simply beautiful pictures.

They have value, too—$350 each for prints up to and including 11×14, $450 for larger. Callahan does not set a limit on the number of prints he will make. Only a few "vintage" prints exist, and they may be seen at the Center for Creative Photography, University of Arizona, in Tuscon. The value of Callahan's work is expected to increase as a result of his latest exhibition at the Museum of Modern Art.

Light Gallery/724 5th Ave./New York, NY 10022

Chicago, ca. 1950.

PAUL CAPONIGRO (1932—)

If photography has an answer to religion, it might well be "equivalence"—the concept coined by Stieglitz in the early 1920s and taken up since by Minor White, Harry Callahan, Aaron Siskind and Paul Caponigro to denote the emotional volume within the triangle of photograph, photographer and viewer.

Caponigro makes unmanipulated pictures of nature to express his mystical feelings. His prints, which are beautiful, rely on the emotive value of shapes and textures. Ambiguous in meaning, they are not records of the physical world, but objects for meditation.

"I have no other way to express what I mean than to say that more than myself is present. I cannot deny or put aside these subtle inner experiences. They are real. I feel and know them to be so." He is one of photography's true believers.

Paul Caponigro/603 Agua Fria/Santa Fe, NM 87501

Banks of the Marne, 1938.

Agave Design 1, 1920s.

The Imogen Cunningham Trust/862 Folsom St./San Francisco, CA 94107

IMOGEN CUNNINGHAM (1882—1976)

Cunningham was in her nineties when portrayed in Judy Dater's shot of a pixie old lady, wearing a long dark dress and a peace-symbol bib. Hanging from her neck is a Rolleiflex. She and a beautiful nude woman are looking at each other in the woods. Symbolic.

She spanned the history of modern photography: she printed for Edward S. Curtis, mingled with Alvin Langdon Coburn, Alfred Stieglitz and, with Edward Weston, was a member of Group f/64. She took pictures of nude *men* before Betty Friedan was born. She also made delicate, sexually suggestive horticultural studies.

HENRI CARTIER-BRESSON (1908—)

Gjon Mili—one of Cartier-Bresson's photographer friends—many years ago made a silent movie of the Frenchman at work. There is he on a sidewalk: wily, furtive, kinetic, darting in and out, bouncing up and down, pirouetting, his camera going quickly to his eye and just as quickly being hidden from the intended subject.

"I want to be unnoticed. That is why I have to go on tiptoes, no?" is the explanation he gave *Rolling Stone* photographer Annie Leibowitz for his furious objection to being photographed.

Mrs. Helen Wright, of the Leitz company and a longtime friend of his, says that photography for him is a "physical pleasure" and that he has "a tremendous appetite for life, you could even call it a lust."

In making his candid, mostly celebratory 35mm pictures, he never uses flash, never crops, and he doesn't like color. His work and his "persona" as a photojournalist have made him the most considered documentary photographer of the last forty years.

Magnum Photos, Inc./15 W. 46 St./New York, NY 10036

WALKER EVANS (1903–1975)

In the late 1920s it was Walker Evans vs the formidables—arty Alfred Stieglitz and Edward Steichen, the chichi commercial portraitist. Evans, the undeclared iconoclast, some place along the road of an affluent youth, determined he'd make a mark beyond not only commerce but art as well, at least as it was known. Raised in upper class Kenilworth (*the* WASP suburb of Chicago), educated at Andover, Williams, and the Sorbonne, he began his picture taking a broke bohemian in New York City.

Lincoln Kirstein—that rich, brilliant patron of the arts—got him to photograph Victorian houses around Boston. From 1935 to 1937 he was a member of the Farm Security Administration's Historical Unit. Evans, it was said, was the main force in the conceptualization of how to document America's Great Depression. He didn't last with the FSA.

His great work came with the book, *American Photographs*. Lincoln Kirstein commented, "Only newspapers, the writers of popular music, the technicians of advertising and radio have in their blind energy accidently, fortuitously, evoked for future historians such a painful moment of our time." Evans visually documented James Agee's text in their book about impoverished share croppers—*Let Us Now Praise Famous Men*. He then worked for twenty years as a sort of photographer-writer in residence at *Fortune* magazine, not artistically a profound period. He photographed subway riders, people on Chicago's streets, scenes from moving trains.

He was a slow, painstaking, intuitive worker; his "poetry" came from way down and couldn't be taught. The results were pictures unmistakably his—marked with his style.

Lunn Gallery/Graphics International/3243 P St. N.W./Washington, D.C. 20007

Robert Schoelkopf Gallery/825 Madison Ave./New York, NY 10021

Main Street Architecture, Selma, Alabama, 1935.

ANDREAS FEININGER (1906—)

He is a technologically-oriented, widely-experienced, self-assured master photographer. "Chance," that concept so important to photography in the sixties and seventies, isn't his approach. His pictures and their execution are carefully planned. He loves the forms, textures and shapes of the world around him—and uses his command of the craft to solve the technical problems of revealing them.

As a former cabinetmaker he often builds his own equipment to simplify his tasks—he pioneered the technique of flattened perspective with telephoto equipment he built himself. He has always been an experimenter. He made solarized prints at the same time as Man Ray, and in 1949—the same year Gjon Mili did—he attached lights to objects in motion to make dramatic pictures of moving patterns.

He is the author of 26 books—most of them on photographic technique—a former *Life* photographer (1943-62), and the son of the painter Lyonel Feininger.

Neikrug Gallery/224 E. 68 St./New York, NY 10021

The Photojournalist, 1955.

ROBERT FRANK (1924—)

"Assuredly the gods who sent Robert Frank so heavily armed across the United States did so with a certain smile," Walker Evans wrote about Frank's great book *The Americans.*

The smiling gods no doubt approved of seeing human hypocrisy put down, and Frank's pictures did just that. He shocked the photographic sensibility by untidily picturing trivial subjects (jukeboxes, TV sets glaring into empty rooms, scenes glimpsed from moving automobiles) and presuming to call the results "art." One of the "wise guys" of the Beat Generation, Frank's often cynical, biting pictures were an antidote to 1950s complacency, patriotism, saccharinity. He influenced an entire generation of photographers so that now his once unusual view is commonplace. In short, he is imitated . . . but not by himself. After publishing *The Americans* he gave up still photography.

Light Gallery/724 5th Ave./New York, NY 10022

RALPH GIBSON (1941—)

He is a young fellow who learned photography in the U.S. Navy (after dropping out of school) and as an assistant to Dorothea Lange. "At the end of the day, we had obtained two or three prints from hundreds of attempts—but these prints were really perfect."

Now, it is the high contrast of his prints that most signifies his style—that, and his choice of subject matter: big, bold, surrealistic-like details selected because of their power to symbolize his unconscious dreams and fantasies. Gibson is a very conscious artist, one who thinks before he shoots, and he is one of those photographers who simplifies his tools as much as he can: Leica M3 with Summicron 50mm lens, Tri-X.

Castelli Graphics/4 E. 77 St./New York, NY 10021

Untitled, 1975

LEE FRIEDLANDER (1934—)

His pictures are not easy to understand. They are complicated—to some people, confusing. Certain ones look like montages—bits and pieces of the world pasted together—but they are all straight photographs of what the camera and photographer see. In the late 1960s, Friedlander was lumped together with Garry Winogrand, Bruce Davidson, Danny Lyon and Duane Michals and used to describe a style dubbed social landscape photography. So he has become known primarily for his tension-filled pictures of America's urban sprawl.

But he has photographed everything from sensuous flowers and trees to himself drunk, sleepy or simply goofing off. He is confusing because he breaks all the rules Kodak invented for making "good" pictures. Heads appear at the bottom of the frame while feet step in from the top. When he uses flash, sometimes he overexposes subjects close to the light source, turning them into ominous white shapes—a mistake everyone is told to avoid.

Rather than trying to eliminate his own shadow or reflection in pictures, he included it in a series of self-portraits which were a statement about his own relationship to photography—a relationship best summed up in his own words: "I'm not a premeditative photographer. I see a picture and I make it."

Haywire Press/44 S. Mountain Rd./New City, NY 10956/Witkin Gallery/41 E. 57 St./New York, NY 10022

Barry, Dwayne, and Turkeys, Danville, Virginia, 1970.

EMMET GOWIN (1941—)

He photographs what he knows best—his family and friends as they live from day to day. Sounds deceptively simple; it's what any amateur does when he makes a snapshot. But whereas the amateur concentrates on the few dramatic moments among countless ordinary ones—birthdays, anniversaries, graduations and the like—Gowin does the opposite. His pictures suggest that it is in the uneventful moment that the real drama is found. The ripple beneath the surface is what interests him most. He says, "I like a photograph to show something unexpected, to reveal the ominous potential in the ordinary moment."

Even his printing technique heightens these photographic dramas. Looking at a Gowin print, one is seduced by the infinite, descriptive detail, and dreamlike softness. He enlarges on Kodak's Azo contact-print paper, which yields a wider range of tones in the shadow areas.

Light Gallery/724 5th Ave./New York, NY 10022

PHOTOGRAPHS AS ART/collectible photographers

Bonnetted girl with doll and purse, ca. 1910.

KEN JOSEPHSON (1932—)

As there are word games, there are picture games. Josephson plays picture games, which in a serious sense question how photographs differ from the real world. In a surrealistic manner he places pictures inside pictures—a hand grasping a picture postcard of a Swedish castle in summer thrusts itself in front of the "real thing," the castle in the background in wintertime, which itself is not real because *it* is a picture. A child covers his face with an upside-down Polaroid of himself taken moments earlier—another picture of a picture.

Ken Josephson/14425 Eggleston St./Riverdale, IL 60627

ANDRÉ KERTÉSZ (1894—)

He might have been a banker or a book-seller in Budapest, Hungary, for he stems from the bourgeoisie. Instead, he became one of photography's most original artists. Starting as an amateur, he kept a picture journal. During World War I, he photographed the soldiers with whom he fought side by side. Afterwards he returned to the business world but continued to photograph life in the Hungarian countryside. It wasn't until his early 30s that he screwed up his courage, packed his bags and left to pursue photography professionally. In Paris, his photographs were exhibited and acclaimed. He worked as a photojournalist for the evolving European picture magazines and published several books. His evocative pictures of French life and the artists who were his friends comprise a portrait of a Paris long gone. He arrived in New York with a two-year commercial contract. But events took a turn. The contract did not work out; the second World War started, and New York became his new home. Had he been able to find work, all would have been well. But *Life* magazine editors failed to recognize his potential for them. He ended up working for *Better Homes and Gardens*, making proper pictures of the interiors of rooms.

It was not until 1963, when the Museum of Modern Art honored him with a major show that he was "rediscovered."

André Kertész/2 Fifth Ave./New York, NY 10011

LEWIS HINE (1874—1940)

He documented the construction of the Empire State Building and at the grand moment he had himself swung away from its peak so he could show the topping of what was, for so long, the world's tallest building.

One of the masters of the hand-held Graflex, he was widely published in his day in magazines such as *Charities and Commons* in what was described as a magazine "photo story." The backs of his prints bore the stamp "Interpretative Photography," defining for the first time the subjective nature of journalism we take for granted today. His commitment "to show the things that had to be corrected . . . and appreciated" bore progeny in the string of "concerned photographers" who followed him.

Even before he became a serious professional he was interested in photography. He gave instruction to hobbyists at the School of Ethical Culture. One day Paul Strand, age 12, showed up carrying a Kodak Bull's-Eye box camera his father had given him. In due course, Hine introduced Strand to Stieglitz.

Hine had taken his undergraduate degree in sociology at the University of Chicago when John Dewey and Thorstein Veblen were teaching there. In his last years he met frequently with the young members of the Photo League in New York City who were then documenting the ravages of the Depression. Thus, the generations influence each other.

Janet Lehr/45 E. 85 St/New York, NY 10028

EIKOH HOSOE (1933—)

His latest work is a sequence of thirty-seven photographs entitled *Kamaitachi,* which he describes as a novel, a story of local Japanese legend. Hosoe is one of a number of young photographers who are working in book form with a preconceived idea and characters directed through the shooting by the photographer. He has done five books. Single images, exquisitely printed, stand alone, and are used for their ability to retain a single instant within an essentially cinematic series. A single print sells for between $150 and $200. Copies of his book, *Ordeal by Roses,* a limited edition, can be ordered for $250.

Light Gallery/724 5th Ave./New York, NY 10022

A Tragic Comedy: #1

GEORGE KRAUSE (1937—)

There are some photographers who just won't be pigeonholed. They are the opposite of the instantly recognizable stylists. When Krause's pictures, on the other hand, are shown, they impress only because of their beauty, form, originality—all those generalizations that make art criticism such a fuzzy form. Krause—like Cartier-Bresson—tries to remain unseen until the actual moment when he has to reveal himself so he can make a picture. He is also an exacting worker, some days shooting only four rolls of film with his Leica IIIg with the hope of getting one or two satisfying pictures.

*Witkin Gallery
41 E. 57 St.
New York, NY 10022*

Boy in fountain, 1969.

LES KRIMS (1943—)

Just as photography has become widely recognized as an art, many of its artists have become academicians. Les Krims' *curriculum vitae* is comprised of ten closely typed pages: they note his Bachelor of Fine Arts from the Cooper Union, his master's from Pratt Institute, his associate professorship at Buffalo, and more than 100 exhibitions, publications, grants, awards, guest lectureships. Very traditional, very establishment.

Yet Krims is the photographer who amused many and shocked some with the pictures of his topless mother making chicken soup, and who published other little boxes of pictures showing brutish-looking deerslayers, midgets at a convention, and a fantasy titled *The Incredible Case of the Stack O'Wheats Murders*. He has assaulted middle-class sensibilities with the startling effectiveness one would have expected from a struggling bohemian in Montparnasse or Greenwich Village.

*Light Gallery/724 5th Ave./New York, NY 10022
Witkin Gallery/41 E. 57 St./New York, NY 10022*

JACQUES-HENRI LARTIGUE (1894—)

About the photograph at right, Lartigue said, "Close your eyes again, this time the better to breathe the suave perfume which this imposing lady trails in her wake."

Lartigue started young as the Maurice Chevalier of photography. From the ripe old age of seven, he rose to the occasion by using a fully-assembled camera and tripod one foot taller than himself. He focused his beauty-and-fun-loving child's eye on the grand ladies, fashion, toys and games, new-fangled flying and motor machines, racetracks and beaches that were part of the athletics and antics of his well-to-do family.

Although Lartigue still works as a photographer—primarily he's a painter—the best photographs were made by that child three-quarters of a century ago. They first came to public attention in an exhibit in 1962, organized by the late Charles Rado—followed by the publication of a family-album-style book. His latest book (1973) includes black-and-white and color pictures—some are the early autochromes—of seventy years' worth of the subject he adores—*Les Femmes*.

Neikrug Gallery/224 E. 68 St./New York, NY 10021
Witkin Gallery/41 E. 57 St./New York, NY 10022

Avenue du Bois de Boulogne, Paris, 1911.

The Unending Stream, 1941.

CLARENCE JOHN LAUGHLIN (1905—)

An eccentric man, he has been married four times, but now lives alone in an attic apartment in New Orleans. He spends his time working on his photography, writing and reading. He is prolific in all three and insists that they are necessarily inter-related. He claims to have had over 25,000 books in his apartment at one time. Despite never having had his own darkroom, his files contain over 17,000 negatives which he has grouped into twenty-three categories. This extensive body defies categorization.

He is both documentarian and surrealist, psychic traveler and Faulknerian eccentric. About his work he says, "the mystery of time, the magic of light, the enigma of reality—and their inter-relationships—are my constant themes and preoccupations."

Light Gallery/724 5th Ave./New York, NY 10022

HELEN LEVITT (1913—)

She shares with Walker Evans the distinction of presenting her pictures in a book accompanied by the writing of James Agee. She also shares with Evans an affinity for street photography, for making artful pictures of the everyday life of common people. In her case, her importance as a still photographer rests mainly on the collection of photographs of New York neighborhoods in the 1940s. It is an interesting world she shows us—one that seems long gone, yet her pictures are not now sentimentally nostalgic, but serious, even sad. She shows us mostly women and children, occasionally an old man.

The children play and make believe, but there is no doubt that life is serious for them too.

Her black-and-white pictures, those published in A *Way of Seeing* (which is out of print) are priced at $250 each. In his essay James Agee said, "like most good artists Miss Levitt is no intellectual and no theorist . . . The over-all preoccupation in these photographs is, it seems to me, with innocence."

In 1974, she had a show of her color photography, also street work, at the Museum of Modern Art.

Janice Giarracco/31 Washington St./Brooklyn, NY 11201

Easter Lilly, ca. 1940.

PHOTOGRAPHS AS ART/collectible photographers

MAN RAY (1890—)

He is one of those names that seem ancestral . . . that go back to the beginning of modern art . . . a name that is synonymous with surrealism and dadaism. But, of course, he did much more. As with many photographers, in this, the infancy of the form, he helped us to see in a graphic way: the teardrop, the photograph almost fully occupied by a woman's lips, patterns of light and shadow on a torso.

In Paris, in the early 20s he exhibited his rayographs (light pictures made without a camera) and solarizations. He made his living as a fashion and portrait photographer. Among artists he portrayed early in their careers are Braque, Giacometti, Léger, Matisse, Picasso.

As a dadaist, it's not surprising that he participated in 1965 in a wackily titled show, "Pop for Pop Corn Corny." At a time when so many artists seemed unsmilingly serious, even sullen, it is good to remember he was saying, "I want to enjoy myself—my aims are both the pursuit of liberty and the pursuit of pleasure."

Donna Schneier/251 E. 71st St./New York, NY 10021

RALPH EUGENE MEATYARD (1925—1972)

Before his death from cancer, Meatyard made his living as an optometrist and photographed on the weekends, developing his film only once a year. One of his hobbies was collecting strange names: T. Bois Dangling, Jr., Everette Derryberry, Decimus Ultimus are but a few.

His photographs are highly personal. People attuned to the fine prints of Edward Weston might combine that appreciation with a touch of Kafka and Cézanne to begin to understand Meatyard's work.

Witkin Gallery/41 E. 57 St./New York, NY 10022

RAY K. METZKER (1931—)

The burgeoning of photography courses, lectures and workshops started in the late 50s; Ray Metzker was one of those who answered the need for teachers. After studying at the Institute of Design in Chicago with Harry Callahan, Aaron Siskind and Frederick Sommers, he began teaching in 1962 at the Philadelphia College of Art, where he is now an associate professor.

As an experimenter in photography, he has gone through several stages: repeating a print with tonal variation; juxtaposing images formed at different moments but linked by the interval between frames (the pictures shown below); overlapping successive exposures on roll film so that the entire strip is seen as one print; conventional single framing. The last, exteriors of walls boldly splashed by fully black shadows, are those he chose to show in *The Photographers' Choice,* a photo anthology published in 1975.
Ray K. Metzker, 733 S. 6th St./Philadelphia, PA 19147

Sunbathers at the Shore, ca. 1969.

From the sequence, "Things are Queer."

DUANE MICHALS (1936—)

"I believe in the invisible" would seem to be an odd statement for a photographer to make—yet this philosophy is the basis for Michals' approach.

When everyone was just beginning to get comfortable about photography as the art of the apparent, he compelled our attention to photographs in series that seemed realistic, that we knew were fantastic, that suggested the supernatural. These "sequences," as he calls them, are like Rorschach tests. While they suggest a story, the viewer must arrive at his own interpretation. In his more recent work, Michals has added words to these narratives by actually writing in

the margins with ink. Evidently he wants to tell us more.

"I don't care for found photographs, I mean those pictures that were discovered by the photographer in his travels. I do prefer those photographs that had no life until the photographer's imagination called them into being. For me the idea of being creative means to create, not only to report, to make become. Photographs should ask questions, suggest dramas, reveal rather than merely describe."

Light Gallery/724 5th Ave./New York, NY 10022
Duane Michals/109 E. 19 St./New York, NY 10003

LISETTE MODEL (1906—)

The grande dame of American photography could easily be called the reluctant photographer. Not only has she studiously avoided publicity, and until recently, books and exhibitions, but, like the man who came to dinner, she came to America in 1937 for a three-week visit and has stayed a lifetime.

While still living in Europe, Model's intent was to support herself by becoming a darkroom worker. In the process of teaching herself photography in 1937, she produced essays that focused on two forms of suffering in France: the effects of the

Depression in a workingman's quarter in Paris and the boredom of the rich on the Promenade des Anglais in Nice. It was these pictures she used to apply for a job at *PM* newspaper in New York.

In the fifties, she fell into teaching when the work she had been doing for Brodovitch, the art director of *Harper's Bazaar* was no longer forthcoming. Her friend Berenice Abbott said, "Lisette you must teach." For the past 20 years her class at the New School in New York City has been the place to study.

Lisette Model/137 7th Ave. S./New York, NY 10014

LÁSZLÓ MOHOLY-NAGY (1895—1946)

Born in Hungary, he was a man of unequalled energy, an abstract painter, photographer, designer, teacher, author and filmmaker. He is well known for his "photograms," made without a camera by flashing light on everyday objects placed on sensitized paper. As a "straight" photographer, he always chose an unusual angle of view that would emphasize formal design. Beaumont Newhall called Nagy's photograms a branch of abstract painting. For Nagy, photography was a means rather than an end. "In photography, we must learn to seek, not the 'picture,' not the aesthetic tradition, but the self-sufficient vehicle for education." His work is hard to obtain and very expensive.

Robert Schoelkopf Gallery/825 Madison Ave./New York, NY 10021

BARBARA MORGAN (1900—)

Her name suggests the freezing of motion, especially that of the dance; since the mid-30s she has worked as a photographic choreographer—directing the performers so that her art and theirs collaborate.

About her work she has written: "Photographic expression thrives on continuing experiment. Each time I print a negative, I try to let new waves of feeling for tone, space and texture aid me in finding subtleties of interpretation that have matured through 'Post-Vision.' Therefore, since my work usually involves movement, I almost always shoot the original negative with a little all-around space for future experiment."

She married Willard Morgan who founded the photographic book publishing firm, Morgan & Morgan, which is now run by their sons.

El Penitente (Erick Hawkins Solo, "El Flagellante," 1940.

Barbara Morgan/120 High Point Rd./Scarsdale, NY 10583

Witkin Gallery/41 E. 57 St. New York, NY 10022

ARNOLD NEWMAN (1918—)

A former art student (he had to drop out of the University of Miami in the Depression), he began photographing artists before their successes and while he was still a portrait studio assistant. Frequently, he received a work of art in exchange for a print. Like the late *Life* photographer Eliot Elisofon, he also collects primitive African art—he once bought a seat on a plane for a sculpture he was importing.

Besides artists, he gained fame photographing the famous, including such diverse types as the German armsmaker Alfried Krupp and the Israeli founding father David Ben-Gurion. He is known for including in the portraits some aspect of his sitter's environment.

Light Gallery/724 5th Ave./New York, NY 10022

Henry Geldzehler, 1972.

© Arnold Newman

IRVING PENN (1917—)

Ever question if the success of portrait photography as art needs to depend on the fame of the people pictured? If so, first consider the work of August Sander, whose vast 1930s project to portray the Germans is a remarkable testament to how pictures of common people can continue to attract attention. Also consider Irving Penn's two books: *Moments Preserved* (1960) and *Worlds in a Small Room* (1974), books showing that the importance of a portrait lies in the talent of the portrayer and in the interaction with the portrayed. Whether the subject is famous turns out to be irrelevant.

All the photographs in *Moments Preserved* were taken for *Vogue;* they include fashion and product advertising work and portraits of celebrities, as well as editorial assignments involving people unfamiliar to the public eye. The celebrity likenesses are compelling, no doubt about it, but so are Penn's pictures of the peasants of the Andes or the tradespeople and workers of London, Paris and New York.

That *Worlds* has no pictures in color, unlike *Moments,* which has a dozen or so, would indicate that Penn was quite serious when six years after the publication of *Moments* he said, "I think that I have never seen a really great color photograph."

Penn likes the security of a studio—the control, even removal, of variables—and the north light it provides him. He has set one up in the foothills of the Himalayas, in the savannas of West Africa and on the edge of the Sahara. Of the people he portrayed for *Worlds* he says, they rose to the experience of being looked at by a stranger "with dignity and seriousness of concentration" that they would never have outside the studio.

Marlborough Gallery/40 W. 57 St./New York, NY 10019

Pianist, Cologne, Germany, 1925.

W. EUGENE SMITH (1918—)

Stubbornly dedicated, impassioned, and sometimes heroic in proportion, he demands that the photographer be both observer and participant. He is angrily uninterested in objectivity. "Photography is a small voice, at best, but sometimes—just sometimes—one photograph or a group of them can lure our senses into awareness . . . To cause awareness is our only strength." Gjon Mili has said, "if passion makes a photographer, Smitty is the greatest."

He suffered for and with his subjects. His legendary World War II photographs were made at the cost of severe shrapnel wounds. His refusal to compromise the integrity of his work resulted in his parting with *Life* magazine—a sorry case in which the medium lost its messenger and vice-versa. For his *Minamata* book, he was severely beaten by Japanese corporate toughs.

Witkin Gallery/41 E. 57 St./New York, NY 10022

JOSEF SUDEK (1896—)

In a long lifetime of work this Czech master has created rich, dark, beautiful prints of classical feeling.

After losing an arm fighting in World War I, he had to give up his trade as a bookbinder. He turned to commercial photography.

In 1940 he saw a photograph printed in 1900. It was a contact print whose textures and excellent quality fascinated him. "From that day on, I never made another enlargement."

In talking about his recent international popularity among young people he said, "I never cease to be surprised at their interest in my pictures. I can only explain it in the context of a certain longing for romanticism for 'good, old handwork.' (But) one shouldn't ask too many questions—one must do what one does properly, never rush, and never torment oneself."

Light Gallery/724 5th Ave./New York, NY 10022

From the cycle. Memories, 1959.

Cut Paper, 1971.

FREDERICK SOMMER (1905—)

One could rhapsodize over the lovely composition shown above. That says a great deal about the artist's subconscious, since it is an example of what the surrealists term "automation," which is for the plastic arts the equivalent of automatic writing. What Sommer has done is to stick a large sheet of paper on a wall and slash at it with a matte knife, then photograph the composition.

Not all his work is so lovely. He has been known to gather up dead and vile objects—the amputated foot and leg of a tramp—and then, to transform them into fantastic somewhat frightening landscapes.

His landscapes, reassembled found-objects and cut-paper photographs range in price from $450 to $3,500.

Light Gallery/724 5th Ave./New York, NY 10022

PAUL STRAND (1890—1976)

In 1916 Stieglitz exhibited the work of Paul Strand at the "291" gallery, the only photographic exhibition held there since Stieglitz showed his own work in 1913. Subsequently, the last two issues of *Camera Work* were devoted to Strand's photographs, and the "brutal directness" which Stieglitz saw in them would become the prototype for an entire generation of photography. Ansel Adams said that viewing the New Mexican landscapes of Strand was one of the most important experiences of his life. Edward Weston worried that his own work might be considered an imitation, and Walker Evans, who paid homage to few photographers, named the "Blind Woman" as a major catalyst in his own development.

Cubist abstractions, still lifes, portraits, landscapes, and architectural renditions, as well as motion pictures, were all handled with consummate skill. He was a master technician and, as an artist, searched for the lyric and heroic qualities in life.

Aperture, Inc./Millerton, NY 12546

AUGUST SANDER (1876-1964)

The Nazis persecuted him; the reason why is obvious when you look at his portraits of German peasant workers, musicians, salesmen, landlords, soldiers, revolutionaries. None, not even the children, seem really happy; hardly any have even a hint of a smile, none are a romantic advertisement of the glorious Aryan master race. They are a people seen as powerful, but distraught. Thick, intense Germans—even a virgin, even a Jew. Only his circus performers seem to have a sense of frivolity, and this might be a hint of decadence that Sander is showing us.

And yet one senses that Sander had a real sympathy for his subjects . . . a sympathy so intense that we can look at portrait after portrait, of mostly common people, and never grow bored. An outstanding example of camera work as art, which has now appreciated to the value of $1,200 for "vintage" prints.

Sander Gallery/2604 Connecticut Ave. N.W./Washington, D.C.

AARON SISKIND (1903—)

Two distinct bodies of work by Siskind exist. He began as a documentary photographer in the 1930s, evolving an aesthetic which combined a respect for the objective world with his own ideas of tonality and rhythm. But while he enjoyed a high reputation as a documentary photographer, his work changed dramatically.

In 1945 he wrote, "the worship of the object per se in our photography is not enough to satisfy the man of today. The interior drama is the meaning of the exterior event." For this internal satisfaction, he turned his camera toward details of man-made objects: walls, signs, broken windows and graffiti, but photographed them so that they became nonobjective abstractions in which shape, tone and texture became the only defining elements.

His friendship with the abstract-expressionist painters, particularly Franz Kline, provided him with moral and artistic support at a time when the photographic world ignored him.

Light Gallery/724 5th Ave./New York, NY 10022

Shared Closet, 1967.

GEORGE TICE (1938—)

He always wanted to be a photographer and at the age of fifteen joined the Carteret, New Jersey, Camera Club. From then on, he taught himself—no art school, no apprenticeship. He has a reputation for being an extraordinary print-maker and is sometimes called upon to restore and reprint negatives of the old masters. When he wanted to print on platinum paper (no longer available) he spent nine months learning to make his own.

His pictures, straight photographs of traditional subjects—nature, cities, some people—are always done as part of a series rather than as isolated photographs.

His pictures of the Amish community in Pennsylvania, of Paterson, New Jersey, and the seacoast of Maine have all been published as books.

Witkin Gallery/41 E. 57 St./New York, NY 10022

MINOR WHITE (1908—1976)

If you went to a lecture by Minor White, chances are the first thing he'd have asked you to do was to meditate. He was the most mystical and philosophical of the photographer/teachers: a guru.

His objective was "to photograph some things for what they are, and others for what else they are," an idea rooted in Stieglitz's Equivalence. He was the dean of the Equivalence Photographers, having added the ideas of Gurdjieff and the Zen, Taoist and Gestalt philosophies.

Not all his accomplishments were so ethereal. He helped start *Aperture* and was always its editor, writing extensively on a wide range of photography. In line with his demand for absolute technical control, he wrote *The Zone System Manual.*

Light Gallery/724 5th Ave./New York, NY 10022
Ice, 1961.

JERRY UELSMANN (1934—)

Entering his darkroom, he feels he has little idea what will happen inside. Surrounding himself with disparate negatives—natural landscapes, desolate man-made interiors, nude women, hands (both clenched and groping) and trees of all varieties—he then lets his unconscious go, producing a composite print of multiple negatives. The result is a photographic "post-visualization," the opposite, say, of an Ansel Adams "pre-visualization."

Uelsmann manipulates his photographs, a style that stems from the tradition of Victorian England's O. G. Rejlander and Henry Peach Robinson; they fell into disfavor, charged with excessive staginess, even sentimentality. Uelsmann's "multiples," on the contrary, are quite hard, to some "scary." His photographs look real enough, but because of the technique of sandwiching negatives the final product is peculiar—a huge hamburger hovers over the horizon, an uprooted tree flys through the sky.

Witkin Gallery/41 E. 57 St./New York, NY 10022

"Navigation without Numbers," 1971.

EDWARD WESTON (1886—1958)

So much has been written about him, *especially by himself,* such a legend has grown up about his passions—his loves, adulteries, peccadilloes—that if one newly seeks to appreciate his artistic greatness, one should ignore the talk and look at the pictures.

His great work began in Mexico where he set up a studio with actress-turned-photographer Tina Modotti, whom he loved and photographed; the picture of her nude body on the Azotea is not easily forgotten by an appreciator of female sensuality. His portrait of cigarette-smoking, Bohemian-looking, slouched-hat-wearing Diego Rivera has come to symbolize our idea of what a Mexican painter-revolutionary should look like.

Within a few years Weston was back in California. From that period we have the massive close-ups of nautilus shells and, best of all, the pepper series—six peppers that photographer-critic Lou Stettner says "heave, roll and sigh like tormented figures in a storm. No previous photograph, painting or sculpture has ever taken so humble a vegetable and turned it into such an explosive manifestation of energy."

He loved the West and when, in 1937, he was granted the first Guggenheim fellowship given to a photographer, he traveled 25,000 miles for a period of 18 months, making 1,200 negatives.

GARRY WINOGRAND (1928—)

If you enjoy city street life, ie. hanging around parks, going to the zoo, or attending parades, you are bound to run into Garry Winogrand. Year after year Winogrand pounds the same beat—hunting with his Leica on the streets of the city. Being on familiar ground enables him to react spontaneously to the little things that happen, a gesture, an attitude—life's small pleasures. To the uninitiated his photographs seem unconsidered, for his craft lies not in the print quality but in his ability to capture what his roving eye notices. You must search around within a Winogrand photo for what he apparently sees instantaneously. For example, in a photo of a group of canine bitches one discovers a woman who at first glance was camouflaged. Not a joke—but if eyes could laugh you'd have to say it was funny.

Light Gallery/724 5th Ave./New York, NY 10022

One hundred of them were exhibited and a reporter at the time said "Landscapes covering miles of territory are perfect gems of composition. The studies of texture, of bark, sand and ocean surf show his love of detail. There are cloud studies, snow scenes in the Yosemite, gnarled trees—all are breathtakingly beautiful."

Witkin Gallery/41 E. 57 St./New York, NY

GROWTH STOCKS FOR COLLECTORS

ROBERT ADAMS
(1937—)

Ansel Adams captured the glorious American West. Robert Adams, a Westerner of another generation, also turns his camera toward the Western landscape. His attempt is to account for man's presence on the land. His pictures are precise and minimal. Earth, sky, a lineup of track houses, weather-worn telephone poles, a billboard; man-made objects occupying enormous expanses of space, bathed in bright Western light. Somehow, both Adams reinforce the vision of the glorious American West.

Castelli Graphics/4 E. 77th St./New York, NY 10021

LEWIS BALTZ
(1945—)

One can get lost looking at a Baltz print. His pictures of Southern California factories verge on abstraction—almost to the point where the viewer forgets the subject. One begins to concentrate on the lines, spatial relationships and tones—from one half-painted wall to another of a considerably or slightly different color. Just as the abstraction begins to take hold, the photographer pulls you back. You are reminded that you are looking at an industrial structure. The subject has been carefully observed and fully described by a sophisticated photographer.

Castelli Graphics/4 E. 77th St./New York, NY 10021

MARK COHEN (1943—)

Cohen moves in on his subjects with an impressive confidence. His flash pictures of people and everyday scenes do not attempt to represent the subjects in their entirety. Rather, he selects a significant detail: a child blows a bubble; the bubble occupies virtually the entire picture and becomes the subject. In the process, such a fragment loses all its familiarity and takes on other qualities. The overall body of work has a mystical, almost religious, sense about it.

Castelli Graphics/44 E. 77th St./New York, NY 10021

MARIE COSINDAS
(1924—)

In the 1960s when everyone else was shooting in black-and-white, Cosindas was among the first serious photographers to turn to color. She used Polacolor film to produce a unique series of romantic color portraits of handsome men, elegant women and beguiling children.

Marie Cosindas/770 Boylston St./Boston, MA

Twinka Thiebaud, 1970. *Judy Dater*

JUDY DATER (1941—)

She works in the tradition of the studio portrait photographer, using a large-format camera both indoors and out, and always carefully composing the elements in her pictures. There the analogy ends. She is not out to capture her subject. Instead, she leaves just enough to chance to allow for a collaboration between herself and her subjects, which for the most part have been women and other photographers. All of which lead one to conclude that as an artist, Dater is largely interested in self-discovery of one sort or another—perhaps, of herself as a woman and artist. Hence, her pictures are not so much about the people they depict as about the process, both psychological and photographic, that occurs when a picture is made.

Witkin Gallery/21 E. 57th St./New York, NY 10022

BRUCE DAVIDSON
(1933—)

He's one of the world's finest photojournalists, who's documented almost every aspect of American culture. Stemming from Robert Frank's tradition, Davidson's famous essays on a Brooklyn gang, the Civil Rights movement and the urban landscape are classics. In the late 1960s, he used a view camera to produce his powerful document of an East Harlem community.

Magnum Photos, Inc./15 W. 46th St./New York NY 10036

ROBERT DOISNEAU
(1912—)

Rare is the Doisneau picture that does not bring a smile to one's lips. Some even make you laugh aloud. For over three decades he has photographed his fellow Frenchmen with wit and charm, always drawing attention to life's amusing moments.

Witkin Gallery/21 E. 57th St./New York, NY 10022

WILLIAM EGGLESTON
(1936—)

His pictures have pleased few people and irritated many. Eggleston is credited by those who are for him with using color in an original manner to record snippets of banal Southern life—family and friends, neighboring environs, architecture and objects seen and appreciated. Those against him say it was a waste of money to make dye transfer prints of such artless transparencies. If time resolves this controversy in his favor, these photographs will revolutionize the standards of color photography, which up to now have been rooted in the print media.

Lunn Gallery/Graphics International Ltd./ 3243 P St., N.W./Washington, DC 20007

ELLIOT ERWITT
(1928—)

It's hard to imagine any photographer having more fun with a camera than Elliot Erwitt. His pictures are visual proofs of his deep sense of humor. Sometimes they are unabashed visual puns that call attention to a juxtaposition that has long since disappeared. His work also reveals an intelligent mind and eye—a person with a great deal of compassion for the human and not-so-human condition. His photographs of animals—especially those of dogs—are particularly poignant. *In Son of Bitch,* which collects the best of them, Erwitt finds in man's best friend the range of human emotions through which to tell us something about man himself. His career as a photographer who has had shows in the world's major museums is paralleled by his successful work as a photojournalist, as well as an advertising and annual-report photographer.

Magnum Photos, Inc./15 W. 46th St./New York, NY 10036

LARRY FINK
(1941—)

For years and years he photographed ordinary people on and off the street. The he put aside his 35mm camera, picked up a Mamiya C33 with flash attached and walked into the rich salons of America. It wasn't quite that easy, but once he was there he was at home. The wealthy Americans (mostly in the art and political scenes) had to be accounted for, and Fink was the photographer to begin that work. The substance of his portraits and party scenes reveal a tough political difference between the photographer and his subjects. As pictures they go a long way in documenting the ways in which the rich are different than you and me.

Larry Fink/P.O. Box 295/Martins Creek, PA 18063

GARY HALLMAN
(1940—)

His pictures are large—usually 30×40 inches—and almost metallic-silver in appearance. There is nothing spectacular about the content. Most of them are taken in and around East Minnehaha, Minnesota, where he lives and teaches. They are often taken at nighttime—glimpses of a sleeping town, alleyways, edges of houses, fences, foliage. What makes his work powerful is the combination of the photograph's size and the long exposures he uses, plus the fact that he often moves the camera during exposures. The effect is a soft, shadowy, ephemeral sense of a specific time and place.

Light Gallery/1018 Madison Ave./New York, NY 10021

CHARLES HARBUTT
(1935—)

His pictures are always intense. Often they are direct confrontations with himself—with his beliefs, fears, prejudices—his intellect and his psyche. He has grown from the tradition of Cartier-Bresson and Robert Frank toward a more emotionally-charged statement, but grown comfortably within the documentary tradition. In the end he works largely from his intuition, encapsulating his reaction to the world in his pictures.

Magnum Photos, Inc./15 W. 46th St./ New York, NY 10036

WILLIAM KLEIN
(1928—)

He's been involved in all phases of visual expression. As a painter, he's studied with Fernand Léger. His films have been awarded international prizes. His photographs have been collected in books about various cities—New York, Rome, Moscow and Tokyo. The people and places in his pictures are inextricably intertwined—so much so that you come to understand the city through its people and the people through their environments.

William Klein/5 Rue des Medicis/ Paris 6, France

JOSEF KOUDELKA
(1938—)

His work for the past ten years has primarily concerned one subject: gypsies. Roaming Europe, searching out his subjects, he has grown to know them intimately and to appreciate their dignity. Such dedication has led to a series of pictures that capture the epic, even operatic quality of their rich lives.

Magnum Photos, Inc./15 W. 46th St./ New York, NY 10036

JOEL MEYEROWITZ (1938—)

In 1963, while working as an art director for an ad agency, he accompanied a photographer unknown to him named Robert Frank on a commercial assignment. Within a week, he quit his job and was on the street photographing with a Leica. Working in the tradition of street photography, but in color, he sees description as the photograph's main strength. Color, he feels, adds to that description, while at the same time compounding the photographer's problems. Like three-dimensional chess, one must learn to contend with the dimension of "color," in addition to all the other elements that make up the picture.

Joel Meyerowitz/817 West End Ave./New York, NY 10025
Witkin Gallery/41 E. 57th St./New York, NY 10022

Joel Meyerowitz

Air Force Academy, Colorado, 1972.

Two garbage cans in an Indian village, New Mexico. *Ikko Narahara*

IKKO NARAHARA (1931—)

At first glance, everything seems to be in order in Ikko's pictures. Then one looks. Glowing palm trees humorously grow out of a motel roof. A small mound of snow rests atop a car parked in a blazing macadam car lot. Two airborne garbage cans hover mysteriously among billowing clouds. Things are not at all what they seem to be.

Light Gallery/1018 Madison Ave./New York, NY 10021

NEAL SLAVIN (1941—)

About four years back Slavin began crisscrossing America to photograph Americans as they banded together in groups. Sometimes they were work groups (the maintenance crew of the Statue of Liberty). Others showed people coming together because of their special interests (The Begonia Society). Still others were fraternal or social groups (The Mormon Tabernacle Choir or the American Legionnaires). His collection depicts the individual in the group context—sometimes with humor, sometimes satirically, often with compassion.

Light Gallery/1018 Madison Ave./New York, NY 10021

TOD PAPAGEORGE (1940—)

One senses that Papageorge uses his camera as if it were an extension of his own person. He enjoys the act of taking a picture and it shows. Many of his photographs document how people behave in public places, particularly at public sports events. The celebration by cheerleaders and band members, the relationship of spectators to players—both emphasize the ritualistic, even epic quality of such events and their importance to American culture.

Tod Papageorge/130 E. 96th St./New York, NY 10028

Tod Papageorge **Shea Stadium, 1970.**

BURK UZZLE (1938—)

He's been a photographer since he was fourteen and has photographed babies, weddings and people for passports. There was a three-year stint on a newspaper and another six years at *Life*. As a free-lancer he's had innumerable assignments. Most importantly, he has consistently produced a highly personal body of work while fulfilling professional requirements. His pictures are direct, even simple, in their scheme. Each is an emphatically strong response to a world of which he feels very much a part.

Magnum Photos, Inc./15 W. 46th St./New York, NY 10036

TONY RAY-JONES (1941—1972)

He spent a good deal of his life documenting the comings and goings of the English people, their rituals and celebrations—in short, the underpinnings of their society. His pictures reveal a subtle humor and warm understanding of his countrymen.

Anna Ray-Jones/47 Renwick St./New York, NY 10013

STEPHEN SHORE (1947—)

He works in color with an 8×10 view camera, so his pictures are sharp, bright and formal. His only teacher was Minor White, so he tends to depict his subjects—the section of a corner of a room, a view down an undistinguished California street, a roadside fruitstand—with an almost poetic eye. Unlike White, though, he does not see the world as an abstraction of nature. He is as worldly as Edward Hopper.

Light Gallery/1018 Madison Ave./New York, NY 10021

EVA RUBINSTEIN (1933—)

Partly because of her quiet, gentle eye, Eva Rubinstein's pictures at first glance look old-fashioned. They are, for certain, classic in their appearance. Whether she's photographing people, interiors or nudes the classic elements—light, texture, form and the like—are used to reveal the subject.

Neikrug Gallery/224 E. 68th St./New York, NY 10021

Judy, 1975 *Jeanloup Sieff*

JEANLOUP SIEFF (1933—)

His photographs are imbued with a haunting melancholy that gives his work great style. Some of that style was learned working for prestigious fashion magazines. Mostly, it comes from a deeply felt personal estimation of his subjects. Often he photographs women—quite often they are nude. There are also his portraits and landscapes in which his simple natural vision is allowed the upper hand.

Jeanloup Sieff/87 Rue Ampère/Paris, France 75017

JACK WELPOTT (1923—)

Welpott's pictures are always dramatic. That is to say, the viewer often feels like an intruder stepping in on the middle of some unfolding story that may or may not turn out to his satisfaction. He says his pictures are about the "psychological landscape" and that they attempt to define how reality changes depending on one's perception. Always, he asks questions. The people in his portraits seem to have just sprung from some unfathomable dark side of the moon. His precise landscapes are strangely familiar yet ultimately unknowable.

Witkin Gallery/21 E. 57th St./New York, NY 10022

THE PHOTO-SECESSIONISTS

"What is Photo-Secession?" Asked this by the chairman of the exhibition of The National Arts Club, Stieglitz answered, "Yours Truly for the present—and there will be others when the show opens. Stieglitz was clairvoyant as ever, for a year later an informal group calling themselves The Secessionists rallied round him; they wished to distinguish themselves from the dilettantism of the camera clubs. Their aim was to advance photography through excellence. Together they created their own publication, *Camera Work,* and opened The Little Galleries, better known as "291" after its address, 291 Fifth Avenue. At that gallery

Stieglitz's place in American photography was that of a seer. His magnetism inspired some of the greatest thinkers of the twentieth century, and for a young photographer taking your work to Stieglitz was like going to see Mahatma. Walker Evans, Arnold Newman, and even Weegee made their pilgrimages.

CAMERA WORK: THE GREAT WORK

This magazine was the vehicle of the Photo-Secession and was edited by Stieglitz with the assistance of Joseph Keiley, Dallet Fuguet and John Strauss. It has never been equaled for the quality of its reproduction or the breadth of its writing. Each reproduction was an individually printed photogravure tipped into the pages by hand. George Bernard Shaw, H.G. Wells and Gertrude Stein were contributors. Articles range from those on Puritanism to the philosophy of Nietzsche, Impressionism to the art of Matisse and D. O. Hill to Paul Strand. Yet at one time it was so ignored that copies were burned because the price of storage was a burden. In the 1940s and 1950s, a complete set might cost $50. Today a set in good condition would run $40,000, if you could find one.

CAMERA WORK: A CRITICAL ANTHOLOGY
by Jonathan Green
Aperture/Millerton, NY/paper, $17.50

This consists of selections from the originals of both the writing and the reproductions. It is a valuable source for the study of this period.

The Sun Has Set

ART is dead.

Its present movements are not at all indications of vitality; they are not even the convulsions of agony prior to death; they are the mechanical reflex action of a corpse subjected to a galvanic force.

Yes, Art is dead. It died when the atmosphere which was necessary for its life became rarefied and exhausted. It died when pure faith died; when the passive fear of the unknown disappeared; when religious hope was dissipated. It died when the positivistic spirit proclaimed that Art was no longer necessary to humanity; when it convinced humanity that Science and not Art was the solver of the great riddles of the Sphinx. Pagan Art died when the gods died, and when God was suppressed, Christian Art died.

M. De Zayas

they exhibited their own work as well as that of numerous painters and sculptors. They had the first American exhibit of Picasso and Rodin. They exhibited Matisse when he was still known in Paris as the "wild man." Max Weber, John Marin and Georgia O'Keefe were among the Americans shown there. Stieglitz' underlying purpose for all this activity was to win recognition for photography as a fine art. For Alfred Stieglitz there was never any doubt that photography could be art. What was Art and what, specifically, was the art of photography? These were questions Stieglitz devoted a lifetime to answering.

Other members of the group made their own contributions. The Clarence White School was an important center of photography until his death in 1925. Joseph Keiley's writing in *Camera Work* was particularly noted. Edward Steichen's accomplishments are numerous. A painter himself, it was he who introduced the avant-garde French painters to Stieglitz. After

an illustrious commercial career, he returned to the museum world. The famous *Family of Man* exhibition organized by Steichen was perhaps the most influential exhibit ever held. In fact, the influence of Captain Steichen—as he was called after his services in World War II in the U.S. Navy—can still be felt through his inspired appointment of John Szarkowski,

Director of Photography at The Museum of Modern Art in New York.

The Secessionists legitimatized art photography in America. The photography market which flourishes today on this assumption is beholden to their efforts. Justly so, photographs by one of this group always command high prices.

Stieglitz saw "291" as an "experimental station." When Steichen first proposed the gallery, he demurred, saying that not enough good photography was being done to warrant it. But the idea of a switcheroo was hatched. If photographs could not be hung in art galleries, they would hang art in their photo gallery, and the result was the most progressive gallery in the history of American art.

Most prints on the market by members of the Photo Secession are not originals. They are photogravures, the printed results of a reproduction process noted for its quality. Prices range from $175 to $800, with the exception of certain stellar examples like "The Steerage," which recently sold for a high of $4200. Vintage platinum prints are much scarcer and more expensive. A Stieglitz runs from $3000 to $10,000; a Steichen, $1200 to $6000; a White or Käsebier, $2000 to $3000.

"Miss N," circa 1903. Gertrude Käsebier

"Steeplechase Day, Paris Grandstand," 1905. *Edward Steichen*

"New York," 1908. *Alvin Langdon Coburn*

"Doctor Emanuel Lasker and His Brother," 1910. *Frank Eugene*

"The Steerage," 1907. *Alfred Stieglitz*

"Morning," 1905. *Clarence White*

The Founding Members of the Photo-Secession

Alfred Stieglitz
John G. Bullock
William B. Dyer
Frank Eugene
Daliet Fuguet
Gertrude Käsebier
Joseph T. Keiley
Robert S. Redfield
Eva Watson Schutze
Edward Steichen
Edmund Stirling
John Francis Strauss
Clarence White

SEEING, DEPICTING AND PHOTOGRAPHING THE WORLD
by Rudolf Arnheim

EDITOR'S NOTE: As an art student I was fascinated by what was considered beautiful or ugly and what constituted good or bad art. The Ubangi maiden with her distorted lips may be attractive, to those raised in the tribe, but it was not my style. It soon became apparent that concepts of beauty and art had to transcend cultural differences and could not be based merely on fashionable styles or tastes of a period. If one wanted to play that game—question the nature of visual art—it would be necessary to get down to a more primal level—to basics. I found this approach in the writings of Professor Arnheim, who has spent a lifetime analyzing art, specifically painting and drawing, in terms of the psychology of perception and creation. (*Art and Visual Perception, Visual Thinking, Toward a Psychology of Art, Film as Art.*) As the editor of the *Life Library of Photography,* I commissioned this essay in the belief that photography lent itself very well to this kind of analysis. It is published here for the first time, courtesy of Time-Life Books.

—N.S.

Seeing the world

The world was not made to be photographed, and yet it lends itself remarkably well to the photographer's purpose. Most of the things of nature did not even come about to be seen, and yet many of them are quite visible. It is worth marveling about this. As far as we know, the planets and the suns of the galaxies operate in a sightless world, for all the dazzling light they produce, and on earth the rocks and waters rise and crash and flow with no regard to their awesome or lovely appearance.

Only in the organic world of plants and animals, nature acknowledges the existence of eyes. The flowering plants, for example, developed the display of their colors in response to the evolution of insects capable of seeing them. The patterning and hues of the bodies of insects, reptiles, birds and mammals serve to hide them, to mislead their enemies or to attract their mates. And most man-made objects, although serving some physical function, are given colors and shapes that distinguish and identify them. The clothes of women are made for the eyes as much as for the body, and paintings, photographs or books exist only to be seen. Touch them and you find empty surfaces.

Eyes develop in evolution, not as a luxury but as a precious instrument of information, enabling animal and man to observe happenings beyond the reach of touch and smell and even of sound. The sensitive eye-speck of a barnacle can tell only the difference between light and sudden darkening, enough to let the animal withdraw its foot and close its shell in time. As eyes acquire lenses, which condense and sort out the light, images become available to the creature. Pictures, rich in detail, deliver a surplus of facts.

Within the limits of the field of vision, the eye is not selective, but the mind behind it is. The animal or human being, guided by some purpose, singles out what is striking, interesting, looked for. The more a cat or a child is occupied by his needs and the more the sense of what is practically important has been developed in him by nature or by his upbringing, the more limited becomes his use of the rich visual information available to him. The businessman or the student, rushing to his place of work, may reduce his visual experience to catching the train, avoiding street accidents, finding the right elevator button. Pictures, we shall observe, are a precious means of counteracting this impoverishment of the sense of sight.

Man, then, views the environment in his role as an active participant. The world perceived is always the world acted upon. The person is always a part of the scene he sees, ready to meet its challenges.

Although eyesight reaches to the stars, it does not enable a person to be everywhere in the same way at the same time. At any moment, one occupies a definite place. Visual experience mirrors this location. We see ourselves in the center of an endless sphere, which stretches in all directions, wherever floor and walls and other objects do not block the view. This sphere reaches all the way around us, even though the range of the visual field is actually constricted by anatomical and physiological conditions: it extends to about 45 degrees above and 65 degrees below the level of sight and covers 180 degrees to the left and right when both eyes cooperate. What is more, the range of acute vision is limited to an angle of less than 2 degrees, corresponding, as Helmholtz put it, to the size of the index-finger nail viewed at arm's length. These blinders, however, would be an obstacle only if the eyeballs were glued to their sockets, if the head sat immobile on its neck, the body were tied down to a chair. In practice, vision profits constantly from the mobility of man. The roving eyes supply a stream of ever-changing images, fitted together by the brain to a coherent and complete visual world, through processes that still defy scientific understanding. The resulting stable panorama is acted upon by the person's conscious attention, selecting a few items here and there and discarding the rest.

An observer's location at a particular station-point is reflected in the subjective distortion of his visual world. Objects or persons close by look large, detailed, dominant, whereas the more distant ones merge into a background of lesser significance. A bunch of flowers located at a distance of two feet may hide from sight an entire building across the street. Similarly, a person will be seen front face or in profile, an airfield at eye-level or from high above ground, depending on where the observer is placed. The distortions are partly compensated for by the observer's awareness of distance and position, and as he moves about, the changing views complete and correct one another. Yet there is always a "point of view," a visual bias, with regard to anything we see.

An object can be perceived when it is neither too distant nor too close and only to the extent to which it is turned toward the beholder. Also, nothing but the outer surfaces of things are accessible to the sense of sight—as distinguished, e.g., from the sense of hearing, which can receive the sounds of a radio through the walls of a house. These limitations remind us again how remarkable it is that the eyes tell us so much about what is going on in the world. Fortunately, the surfaces of things are quite eloquent. While hiding the inside, they also reveal it. The prime example of this eloquence of surface is the human face, on which fleeting moods and the character traits of the person are often so readably imprinted.

Surfaces are able to speak to the eyes because many organic and inorganic things are made of material that is or was pliable enough to reveal the effect of forces operating within. Also, a great variety of textures distinguish smooth from rough substances, the grain of wood or skin from the shininess of metal or plastic. It is fortunate, furthermore, that different materials absorb different amounts of light and reflect different wavelengths. This behavior discriminates them for the eyes. We can tell them apart by what we experience as their colors. Even the mere difference between dark and bright is sufficient to create informative and impressive images.

Depicting the world

It is true that the sense of sight tells us much about the nature of things around us. But it is also true that all this visual information leaves a great deal to be desired. For example, since most of our fellowmen are not in the business of displaying themselves to us, as actors or fashion models are, they rush past us haphazardly, unexpectedly and in accidental combinations. Sometimes they are caught by chance in a significant stance; but there is also much disorderly coming and going that confuses us more than it enlightens. Objects present themselves in random fashion, and their appearance is often puzzlesome. Who can truly follow the bare branches of a tree in their beautiful but intricate intertwinings or find comprehensible shape in the overview of a city or a microscopic preparation or the many constellations of the night sky?

Perhaps the saddest shortcoming of daily vision is that no sight can be made to last. The most precious moment vanishes as irretrievably as the most trivial. At every second, the human nervous system must be ready to receive the next experience. The mind does possess memory, but memory traces tend to be dim, impermanent, liable to contamination.

This is why man came to make images—an ability no other species possesses. Pictures serve to remedy the deficiencies of sight. They make things display their nature by their appearance. Each view is chosen with care, essentials are cleared of accidentals and combinations are arranged to show meaningful relations.

Pictures are man's most successful teachers. This is true for the oldest paintings of animals and hunters on the walls of prehistoric caves, and it is still true for the photographs of today. Since pictures are indispensable, they have been produced by every civilization, even the most backward. In some instances, picture-making is practiced by many men, women and children; in others, it is an occupation reserved for the specialist. Whether layman or expert, however, the picture-maker must assume a unique attitude, which he shares with the philosopher. He must detach himself from the give and take of society, if only for a moment. He must become a stranger or intruder in the very situation he tries to capture. This is evident in our day by the stir a camera produces. The self-consciousness of the victim, the momentary paralysis seizing a birthday party or ceremony or beach scene when the photographer takes aim, indicates that the picture-maker breaks the rules of the social game. In dramatic situations, loaded with strong emotions, his detached recording of grief, violence or joy may even be resented. And yet, only by stepping out of context can he subject a life situation to the sort of contemplative scrutiny that may produce a visible answer to such questions as, Who are we? What is the nature of things around us? What are we doing?

Through the ages until little more than a century ago, there was only one way of producing images. They had to be made by hand. This meant that pictures translated a person's observations into shapes producible with a given technique. Lines are the element of all drawing, scratching, engraving, but they hardly exist in nature. They are an invention of the draftsman. Similarly, the colors of paintings are not so much properties of the objects depicted as choices made by the painter according to his observation, understanding and preference.

The advantages and disadvantages of this traditional procedure of making pictures by hand are evident. Being the sole producer, the draftsman or painter is in complete charge. He can put down any shape he pleases, regardless of whether anything like it ever existed. He can combine things never before thus combined. And he can choose and fashion his shapes in such a way that the human mind has no trouble understanding them. On the negative side, any such handmade picture is at the complete mercy of the person who produced it. It presents the impressions of one individual, profoundly true and beautiful though they may be. It also reflects the pictorial conventions of a particular period. This is most evident when pictures are used to provide factual information. What exactly did the animals look like that were depicted by Stone Age Africans on the rock walls of the Sahara? What were the shape and size of a comet whose crude image is preserved in a popular woodcut of the fifteenth century? How are we to picture the true George Washington, forever hidden behind the imperfections and flatteries of his portraits? In a word, when authenticity is called for, the handmade picture must let us down.

Photographing the world

Early in the nineteenth century it became possible to make objects of the physical world themselves impinge upon a sensitive surface and thereby create their own image. Instead of an artist looking at, say, the rooftops of Paris and then trying to invent their equivalent in lines or paints on paper or canvas, those rooftops themselves traced their image of dark and light shapes on the plate. They did so by means of the rays of sunlight reflected from them and sent forth to and through the lens of a *camera obscura*. The invention was made possible not simply by the fact that in the days of Niepce and Daguerre the new development of photosensitive substances had caught up with the century-old optics of lenses. The new tool was favored also by an attitude that demanded faithful copies. Even during the Renaissance, artists and scientists had turned their attention to the mechanical creation of lifelike images. The Western mind had become concerned with the exploration of physical reality. The exact shape or texture of a plant or mineral had not mattered much to the thinkers or physicians of those earlier centuries; but it began to matter now. The invention of photography, in other words, is to be credited not only to the chemists of the nineteenth century but, more essentially, to a civilization that had use and need for faithful pictures.

The principal virtue of photography, however, was not clearly envisaged from the beginning. Photography dispensed with the pencils and brushes of the human picture-maker, but it could not do without the contribution of man altogether. On the contrary, the camera as a mere instrument of the human mind depended on its master for the selection and arrangement of the subject matter to be taken and indeed for the very style of its pictures. Just as the first automobiles were designed in the image of carriages, although they needed no horses, so the early photographs endeavored to look like paintings, although they were produced without painters. This effect was obtained, for example, in portraits by softening the characteristic detail of human features and emphasizing instead the broad patterns of light and dark shades, characteristic of academic painting at the time. Also, the poses, attributes and backgrounds of conventional portraiture were imitated by the early photographers, and sometimes several negatives were combined to create one complex scene.

This much is history. What matters for our present purpose is that although the painterly style of photography produced a few early masterworks, such as the portraits of David Octavius Hill, it was more often unsuccessful, namely, when it interfered

(Continued on next page)

with the inherent realism of the photographic medium by stilted arrangements and when it tampered with the characteristic texture of the optically and chemically obtained image. In the course of the years, an intuitive sense of what suited the particular character of the new medium made photographers conform ever more strictly to what may be called the photographic principle. This principle has been formulated with some clarity only quite recently, in particular by Siegfried Kracauer. In his book, *Theory of Film,* Kracauer pointed out that the character of the photographic medium is determined by the basic technical phenomenon that distinguishes camera work from all other picture-making, namely, the encounter of the raw material of reality with the formative powers of the human mind. This means, every photograph is, on the one hand, a mechanical imprint made by the reflections of the object on the film or plate and, on the other hand, a subject selected and controlled by the photographer's eyes and hands. This interaction of two opposing principles, said Kracauer, should not be concealed. On the contrary, it should be made evident. A good photograph should not pretend to be entirely a product of human invention and skill. Instead, it should cultivate some indefiniteness and incompleteness; it should look unstaged and contain an element of randomness, as though its subject had been caught napping. Photography, in other words, is at its best if the uniqueness and novelty of its technique produces unique and novel results, unmatchable by any other kind of picture-making.

One can express this principle by saying that every photograph should contain an element of authenticity. This is most obvious for pictures of documentary value—news reportage of historical events, portraits of individual persons, photographs of rare objects, unreachable or otherwise invisible phenomena. Such photographs inspire an unrivalled trust. We are confident that whatever their technical imperfections, the deviations from the truth are not due to a subjective slant imposed by the particular viewpoint or interest of a picture-maker. Reluctantly do we listen to the expert who reminds us that a clever choice of camera angle or of the right moment, an artful cropping of the print may make the difference between an attractive and a repulsive view of one and the same subject; and a faked photograph is among the most shocking of forgeries.

The authenticity of photography makes us look with great attention even at pictures that are unrewarding visually. This dark dot in the far sky is the space rocket at the moment of re-entry! On this ordinary balcony a famous man was struck down by a bullet! The very insignificance of the sight conveys a fascinating paradox, which would be pointless in a painting.

"No matter how fuzzy, distorted or discolored," writes the French critic, André Bazin, "no matter how lacking in documentary value the image may be, it shares, by virtue of the very process of its becoming, the being of the model of which it is the reproduction; it *is* the model." Therefore, to look at a photograph means to be aware of the fact that the things one sees existed or exist in the real, physical world beyond the picture.

We realize why there is so much admiration for photos depicting ordinary scenes of everyday life. To be sure, even the work of the most skillful photographer is not distinguished by the exquisite composition, color scheme or originality of treatment that can make a still life of fruit or vegetables a great work of painting. Some celebrated photographs show nothing less ordinary than a street corner with a newsstand or an old lady and her dog on the front porch. It is true that only a gifted

craftsman captures the particular mood and significance of such a scene. But there is always that additional attraction, deriving from the authenticity of the photograph. Even the most trivial subject arouses in the viewer the curiosity of the explorer. He approaches the scene of the picture as virgin territory, untouched, as it were, by human hand. The roaming eye discovers an abandoned Coke bottle on the jukebox of a teenage hangout, a dent in the fender of an automobile, a lady bug on a leaf. These small, but authentic testimonials of the world in which we live deliver their message when we cease to behave as active participants and scrutinize the familiar scene with the detachment of a curious onlooker.

The most characteristic trait of photographs, therefore, is that they are to be seen as direct manifestations of physical objects, which existed beyond the picture and whose effect is visible in it. This is true even when a print shows nothing but a sample of some undefinable texture, which may be wool or snow or Styrofoam, or when we look at some mysterious shot taken through an electron microscope or telescope or from an airplane. Although we cannot tell whether the objects represented are distant suns or tiny molecules or the craggy ridges of a mountain range, their physical existence is testified to by the randomness and elusive quality of half-formed shapes on the print, so different from those created by the direct control of the artist's hand. When a photo lacks this particular surface quality, its articulate precision may make it look like a man-made design; and vice versa, when an etching produces a special grain through the chemical action of acids upon certain substances, it may look somewhat photographic. Even the so-called photograms, recorded without a camera on a photosensitive surface by the shadows of objects, reveal their photographic nature when we see them as the reflections of things unseen.

Any photograph at all, taken by an accidental tripping of the shutter, offers some of that sensuous pleasure of textured surface, of accidental revelation, partial definition and partial mystery—but this sort of surface pleasure alone cannot satisfy us for long. We remember that a photograph is a picture and a picture is a visual sight and sights fulfill definite needs of the mind. Biologically, as was said earlier, sights provide the human animal with information, and good pictures serve to clarify this information by selecting, organizing, ordering and sharpening it. Pictures make the information more readable. This function of all picture-making imposes certain conditions that have been known for ages and hold true for photography also. Even though photography, for good reasons, avoids imitating the effects of painting, it inevitably uses many of its procedures simply because they are the prerequisites of any successful picture. A good photographer develops a sense of what is significant and expressive. From the continuous visual field around him he lifts a small area, which, isolated and framed, will speak for itself. He provides an orderly distinction between dominant and secondary elements, a concentration on essentials, a balance of darkness and brightness, a clarity of relations.

These and other means satisfy the pleasure of understanding the world through the sense of sight. They are applied by the photographer to the scenes he captures with his camera. His skill relies on the luck of the fisherman and the scent of the hunter. In looking over his catch, he selects with care but due respect for the particular ways in which reality chose to display itself. He shapes and orders with the delicate caution of a gardener or flower arranger, who knows that unless he leaves nature free to reveal its own ways he will defeat his purpose.

PHOTOGRAPHS AS ART/galleries

ON THE WALLS

When you come right down to it, photographers need galleries. So does the public. True, more and more museums show photographs these days, but once they've hit the museum walls, they've been institutionalized and people tend to accept what they see as gospel. Not so with galleries. Even though they take themselves just as seriously as do the museums, the shows they mount are more often subjective, adventuresome and in the end provocative. Their job, after all, is to bring to the public's attention the best in photography and, in most cases, to sell the work of the photographers they represent.

When Lee Witkin founded his photography gallery in 1968, his first two shows featured young American photographers. He sold only three or four prints. It didn't take long for Witkin to find out that collectors wanted rare vintage prints—those by famous masters like Ansel Adams and Edward Weston. So he altered his policy and business grew. Other "strictly photography" galleries like Light, also in Manhattan, have their modern masters like Harry Callahan and Aaron Siskind, but they are staunchly committed to the young "next-to-be" master photographers. In fact, today most commercial photography galleries combine the old favorites with contemporary suprises.

How do you get a show in one of these galleries? All of them review portfolios (Light says they see about 300 a year), but most admit that they've never discovered a new talent by going this route. Usually, it's by word of mouth. A person who is represented by the gallery mentions a friend whose work is impressive, and the ball starts rolling. Of course, there's always the possibility that you'll strike by submitting a portfolio on your own, so try. If you succeed, then the gallery will represent you in whatever way you determine. When it comes to sales, the standard policy is to split sixty/forty. Some photographers let their galleries handle all business matters—sales, shows in museums and other galleries, publishing ventures. Others prefer to keep a hand in things. A photographer like Harry Callahan is exclusively represented by Light Gallery in New York because he chooses to be. Garry Winogrand, on the other hand, makes individual arrangements with a number of galleries. Until recently, all agreements were verbal, but recently there's been a tendency toward more formal arrangements, which are usually spelled out in a letter of agreement. The direction, though, is definitely toward contracts aimed at binding a particular photographer to a particular gallery.

The scene has taken this turn since the prestigious Madison Avenue art galleries, like Marlborough, started showing photographs. They may be the Johnny-come-latelies to the photography scene, but their impact has been felt. Because there's a lot of money behind those beautifully designed facades, they've turned the buying and selling of pictures into big business—much like painting has been in the past. For the most part, these galleries have their pick of photographers because they can offer them the best money deals. Rest assured, they don't want just anyone. Your work has to warrant a hefty price tag. Even though they look at "unsolicited" portfolios, the curators are hard to get to. Many fine photographers feel that such galleries merchandise, not represent, their artists, and they choose to stay with strictly photographic galleries. At the other end of the continuum are the galleries not so concerned with commercial success. Some are cooperatives in which members assume operating costs; others are non-profit and are supported by the institutions of which they are a part. Because the pressure to make money is off, they are more concerned with giving good photographers decent exposure.

Once you've gained membership into a cooperative gallery, like New York's Soho Gallery, you're eligible to exhibit every month. There's a $10 hanging fee to participate in the monthly group shows, $15 if prints are submitted for two shows. One-person shows cost the exhibitor $150. For that price tag, you get space in the large gallery, the chance to participate free in group shows for three months, publicity, press releases, announcements and refreshments—the usual fare of wine punch, cheese and crackers—at your all-important opening reception. There are other chances to exhibit at other prices, but the idea is the same.

Galleries like the Midtown Y in New York are self-supporting, so they pick up most of the tab. An exhibitor pays only for the announcements, which can be as elaborate or as simple as the photographer chooses. Usually, they run around $200. Group shows are open to the public, and anyone who wants to can submit work. When a sale is made, the gallery takes only a third, but that's not the main concern (The Y averages about ten print sales a year.)

The directors of these non-commercial galleries are constantly reviewing and, if asked to, critiquing portfolios. In fact, they consider it a large part of their job to provide the feedback normally lacking in the photography world between the people who make the pictures and those who sell them. Consequently, if you're a relative unknown, someone will pay attention and there's a better chance to snag a show.

On the following pages we've listed some galleries here and in Europe. Many are long-established; others are new to photography. Whether you're a photographer who might want a show (remember the European galleries; that whole scene is just opening up), a potential collector or someone who just wants to see what's going on, the gallery scene is lively. Partake.

A gallery is not the only setting in which to hold a photography show. In recent years they've been held in banks, libraries, community centers, movies, theaters, schools—even on Boston and New York City buses. The point is to get exposure—to show other people work, to get a reaction, some feedback—if you're lucky, a review. In 1969 Gjon Mili mounted a major show of his photographs of the performing arts in a most appropriate place, the Museum of Performing Arts at New York's Lincoln Center. The show reflected Mili's passionate love for the theatre, music and the artists who perform. By virtue of its setting, it found a natural audience.

GALLERIES THROUGHOUT THE UNITED STATES

Arizona

Northlight Gallery
Department of Art
Arizona State University, Tempe
85281

California

University Extension
University of California, Berkeley
94720

Friends of Photography Gallery
Sunset Center, Carmel 93912

Frederick Sommer Sel...
November 1 throu...
Carl Siembab Gallery ...
162 Newbury St., Bost...

illusions

...n Green
...RC Paper
...976
...allery
...eet
...16

JOHN BROOK
RECENT PHOTOGRAPHS
FEBRUARY 1-23, 1974 — TUES.-SAT. 10:00-5:30
CARL SIEMBAB GALLERY OF PHOTOGRAPHY
162 NEWBURY STREET, BOSTON, MASS. 02116

Beautifully produced promotional pieces announce the shows held at the Carl Siembab Gallery, Boston's first one devoted exclusively to photography.

Creative Eye Photo Gallery
414 First St., East, Sonoma 95476

Colorado

Colorado Photographic Arts Center
1301 Bannock St., Denver 80204

Connecticut

Center for the Arts
Wesleyan University, Middletown
06457

District of Columbia

Lunn Gallery/Graphics International
Ltd.
3243 P St., N.W. 20007
Harry P. Lunn, director

Photo Impressions Gallery
1816 Jefferson Pl., N.W. 20036

Scott Hyde

Lee Witkin turned a $6000 investment into a million dollar gallery on Manhattan's posh 57th Street in less than ten years. A former trade editor and writer, he began investing in photos in 1969 just as the photography boom got underway. He set out to sell the work of contemporary photographers to a young audience, but ended up making most of his money from select institutions and collectors who wanted 19th century vintage prints. The new gallery has luxurious space and a friendly atmosphere, with a large section given over to photographic books.

Center for Photographic Studies
722 W. Main St., Louisville 40202

Maryland

Camera Work Gallery
108 W. Main St., Frostburg 21532

Massachusetts

Carl Siembab Gallery of
Photography
162 Newbury St., Boston 02116
Carl Siembab, director

Enjay Gallery of Photography
35 Lansdowne St., Boston 02215

Panopticon
187 Bay State Rd., Boston 02215

Vision Gallery of Photography
216 Newbury St., Boston 02116

Carpenter Center for Visual Arts
Harvard University, Cambridge
02138
Barbara Norfleet, director

Michigan

Union Gallery
530 S. State St., Ann Arbor 48104

831 Gallery
560 North Woodward, Birmingham
48011
Thomas Halstead, director

Detroit Institute of Arts
5200 Woodward Ave., Detroit
48202

Missouri

Master Slide
118 E. Lockwood, Webster Groves
63119

New Jersey

University Center Gallery
Drew University, Madison 07940

Squibb Gallery
Rt 206, Princeton 08540

Weston Gallery
6th Ave. and Delores, Carmel 93912
Margaret Weston, director

Lang Photography
1450-A South Coast Hwy.
Laguna Beach 92677

G. Ray Hawkins Gallery
9002 Melrose Ave., Los Angeles
90069
G. Ray Hawkins, director

Ohio Silver Gallery
3380 S. Robertson Blvd. Los Angeles
90034

Feather River Photo Gallery
279 Main St., Quincy 95971

Focus Gallery
2146 Union St., San Francisco
94123
Helen Johnston, director

Phoenix
257 Grant, San Francisco 94108

The Secret City Gallery
306 4th Ave. at Clement, San
Francisco 94118

The Camera Work Gallery
145018 Big Basin Way, Saratoga
95070

Sander Gallery
2604 Connecticut Ave. 20008
Gerd and Christina Sander, directors

The Washington Gallery of
Photography
216 Seventh St., S.E. 20003

Illinois

Columbia College Photo Gallery
469 E. Ohio, Chicago 60611

The Darkroom
2424 N. Racine, Chicago 60614

Douglas Kenyon
620 E. Ohio, Chicago 60611

Exchange National Bank
La Salle and Adams, Chicago 60603
Joel Snyder, director

Indiana

Ball State University Art Gallery
Muncie 47306

Iowa

Des Moines Art Center
Greenwood, Des Moines 50312

Kentucky

Nexus Gallery
838 E. High St., Chevy Chase

New York's Soho Gallery, a cooperative supported by member photographers, offers members' shows each month. Submit a portfolio for review; if accepted you pay $35 annual dues and you're part of it all—including relaxing in the gallery's Cafe Atget, shown below.

Elmon Webb

Bob Clark

Establishments like San Francisco's Focus Gallery, which opened in 1966 in a six-room Victorian flat, aim to put people at ease. Some photographs are kept in bins to allow potential customers access to work without the aid of the director. Others are kept in a print collector's room. Focus maintains a book shop and mail-order service that offers some 750 titles of in-print photography and cinematography books.

New Mexico

Quivira Photograph Gallery
111 Cornell Dr., S.E. Albuquerque 87106

Gallery f/22
338 Camino del Monte Sol, Santa Fe 87501
W. T. Scott, director

New York City

Diana Gallery
Diana Custom Prints
E. 21 W. 46th St. 10017

Discovery Gallery
Modernage
319 E. 44th St. 10017

Donna Schneier
251 E. 71st. 10021
Donna Schneier, director

Wish You Were Here

THE HISTORY OF THE PICTURE POSTCARD

Cattle Punching on a Jack Rabbit

Educational Alliance Photography Institute
197 E. Broadway 10002

Grey Art Gallery
New York University
100 Washington Sq. E. 10003
Robert Littman, director

Helios
26 E. 78th St. 10021
Scott Elliott, director

Janet Lehr
45 E. 85th St., 10028
Janet Lehr, director

Kodak Photo Gallery
1133 Ave. of the Americas 10036
Alan Hulse, director

Light Gallery
724 5th Ave. 10022
Victor Schraeger, director

Under Robert Littman's direction, the Emily Lowe Gallery of Hofstra University in Hempstead, Long Island, N.Y. has mounted provocative photography shows. Most galleries organize one-man exhibits of artists they represent; university galleries seek, instead, to define ideas about photography. Littman's 1974 postcard show assembled some 2,000 postcards, dating from Victorian England to modern-day Ogden, Utah. It defined the picture postcard as a rich source of social and historical data and a photographic folk-art in its own right.

Neikrug Gallery
224 E. 68th St. 10021
Marjorie Neikrug, director

Nikon House
50th St. and Madison Ave. 10022

Parents' Magazine Gallery
52 Vanderbilt Ave. 10017

Robert Schoelkopf Gallery
825 Madison Ave. 10021
Cusie Pfeifer, director

Soho Photo Gallery
34 W. 13th St. 10011
George Alpert and David Chalk, directors

Witkin Gallery
41 E. 57th St. 10022
Lee D. Witkin, director

New York State

Emily Lowe Gallery
Hofstra University, Hempstead 11550

Light Work
316 Waverly Ave., Syracuse 13210

Ohio

Silver Image Gallery
Ohio State University
156 W. 19th Ave., Columbus 43210

Oregon

Shado' Gallery
621 Main St., Oregon City 97045

Pennsylvania

The Photography Place
885 Lancaster Ave., Berwyn 19312
Thomas L. Davies, director

Janet Fleisher
211 S. 17th St., Philadelphia 19103
Janet Fleisher, director

Photopia
404 South St., Philadelphia 19147
David Mansini, director

Tennessee

Middle Tennessee State University Photographic Gallery
Murfreesboro 37130

Texas

The Center Gallery
12700 Park Central Pl.
Suite 105 Dallas 75230

Cronin Gallery
242 Bissonnet Ave., Houston 77005
Anthony G. Cronin, director

Utah

Edison Street Gallery
231 Edison St., Salt Lake City 84111

Washington

Photographer's Gallery
83 S. Washington St., Seattle 98104

Silver Image Gallery
727 Commerce St., Tacoma 98402

Vermont

Garden Gallery
Londonderry 05148

Wisconsin

Gallery 38A
Beloit College, Beloit 53511

Madison Art Center
720 E. Gorham, Madison 53703

Infinite Eye
1117 E. Brady St., Milwaukee 53202

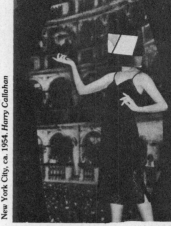

New York City, ca. 1954. Harry Callahan

This atypical picture by Harry Callahan, represents the Light Gallery's philosophy. Light seeks to provoke new thoughts about established masters in terms of how they have undertaken to define current trends. Making the connections between photographic history and contemporary work is one of their major concerns.

LOCUS
by Cheryl Filsinger

Filsinger & Company, Ltd./150 Waverly Pl., New York 10014/$10, plus tax and postage

In New York City where might you see Man Ray's work? If you don't know and do care, pick up *LOCUS*. In this spiral bound, typewritten, offset-produced handbook, you'll find there are six New York galleries that handle his art.

In the first section, *LOCUS* lists artists—including photographers—alphabetically. Reading across the page in a chart-like fashion, you'll find the artist's name, his representative, where you can see his work and what editions are available. A second section lists the most important and reputable galleries with their addresses, telephone numbers, who they represent and what works they carry. There's also a list of New York City museums and a geographical breakdown of galleries.

GALLERIES OUTSIDE THE UNITED STATES

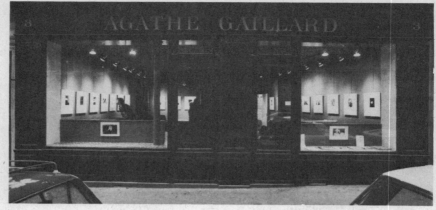

Australia

Brummels Gallery
95 Toorak Rd., South Yarra, Victoria

Austria

Fotogalerie Schillerhof
Cafe Schillerhof, Schillerplatz, Graz

Galerie Die Brücke
Backerstrasse 5, Vienna A-1010
Werner Mraz and Anna Auer, directors

In 1975, Agathe Gaillard opened a gallery on Paris' charming Ile St. Louis. Since 1968 she had been publishing photographic postcards—picture masterpieces by Kertész, Lange and other artists. Although she sometimes sells nineteenth-century pictures, her interest and emphasis are on twentieth-century work.

In a socialist country the function of a gallery is not commercial. Hence, the gallery supported by the government's official Union of Polish Art Photographers does not sell pictures. Instead, they push culture. Their shows attract over 500 people a week. Situated in Warsaw's Old Town, the gallery has held over forty shows since 1970. Shows run for four weeks and contain 60 to 100 prints by Polish photographers, as well as international ones like Ernst Haas and Takuya Tsukahara.

Belgium

Foto Film Centrum
Meir 50, B-2000 Antwerp

Foto Galerij Paule Pia
Kammenstraat 57, 2000 Antwerp

Galerie 5.6
St. Michielsplein 14, B-9000 Ghent
Jo Boon and Jan Pollaerts, directors

Brazil

Sociedade Fluminense de Fotografia
C.P. 118, 24000 Niteroi RJ,

Canada

Yajima/Galerie
1625 Sherbrooke W., Montreal
Michiko Yajima, director

The Photographers' Gallery
234 2nd Ave. South, Saskatoon

Baldwin Street Gallery
23 Baldwin St., Toronto 130
John Phillips and Laura Jones, directors

David Mirvish Gallery
596 Markham St., Toronto 174

Déjà Vue Gallery of Photographic Art
122 Scollard St., Toronto

Gallery of Photography
3619 W. Broadway, Vancouver

Denmark

Gallery Huset
Magstraede 14, Copenhagen DK-1204
Arne Andreasen and Niels Lundo, directors

England

Midlands Arts Centre
Cannon Hill Park, Birmingham 12

Arnolfini
Narrow Quay, Bristol BS1 4QA
Jeremy Rees, director

Creative Camera Gallery
19 Doughty St., London WC1N 2 PT
Colin Osman and Pete Turner, directors

Gallery of Photography
112 Princedale Rd., London W 11

Hayward Gallery
South Bank, London SE 1

Kodak Photo Gallery
High Holborn St. 246, London

The Photographers' Gallery
8 Great Newport St., London WC 2
Sue Davies, director

The RPS Gallery
14 South Audley St., London W 1 Y5DP

Spectro Arts Workshop
Whitley Bay, 18 Station Rd., Northumberland

The Photographic Gallery
The University, Southampton S5095NH
Leo Stable, director

Impressions Gallery of Photography
39a Shambles Market Pl., York
Val Williams and Andrew Sproxton, directors

The Sutcliffe Gallery
1 Flowergate, Whitby, Yorkshire
W. Eglon Shaw, director

France

Agathe Gaillard
3, Rue DuPont Louis-Philippe 75004, Paris
Agathe Gaillard, director

Galerie Nikon
1, Rue Jacob F-75006, Paris

Nicephore
8 Rue de la Gare, 68 Bolluiller

Odeon-Photo
110 Blvd. St.-Germain, Paris 6

La Photogalerie
2, Rue Christine F-75006, Paris
Georges Bardawil, director

GALERIE DIE BRÜCKE
DEALERS IN FINE PHOTOGRAPHY

European galleries have readily accepted photography as an art for years. So it's not surprising that their catalogs, newsletters and portfolios are highly sophisticated. The Gallery die Brücke, smack in the middle of Vienna, has an active program that includes exhibitions, publishing a newsletter, *Interview*, and a stock catalog designed as a lifetime edition, with book screws so you can add supplements. The directors travel to major European art fairs in an attempt to find the best work for the best price.

Holland

Canon Photo Gallery
Reestraat 19, Amsterdam
Lorenzo Merlo, director

Galeri Fiolet
Herengracht 86, Amsterdam
Gerry and Marijke Fiolet, directors

Italy

Galleria dell' Immagine
Piazza Vecchia 4, 1-24100 Bergamo

Il Cupolone,
Via del Servi 12 r, 50122, Firenze

Il Diaframma
Via Brera 10, Milan
Lucilla Clerici, director

Norway

Galleri for fri Fotografi
Pilestredet 49, Oslo

Poland

Union of Polish Art Photographers
Plac Zamkowy 8, 00-277 Warsaw

Spain

Spectrum Art Photographic Gallery
Balmes 86, Barcelona 8
Albert Guspi and Sandra Solsona,
directors

La Photogalerie
2 Place de la Republique
Argentina, Madrid

Switzerland

Galerie Form
Predigerplatz 2, CH-8001 Zurich

West Germany

Galerie Lichttropfen
Mauerstrasse, 7, 5100 Aachen
Rudolf Kicken, et al, directors

Galerie A. Nagel
Markelstrasse 46, D-1000 Berlin 41

Galerie M
Haus Weitmar, D-463
Bochum-Weitmar
H.L. Alexander v.
Berswordt-Wallrabe, director

Galerie Wilde
Försterstrasse 30, D-5 Cologne 30
Jürgen and Ann Wilde, directors

Camera Galerie
Bolkerstrasse 49, 4 Dusseldorf

Galerie im Riek
Im Riek 64, 43 Essen-Bredeney
Christine and Steffen Boeckmann,
directors

Raum 315
University of Essen, Essen-Werden,
Abtei Ute Eskildsen, director

Staaliche Landesbilostelle
Photogalerie
Kielerstrasse, 171, D-2000 Hamburg

Galerie Spectrum
Holzmarkt 6, D-3000, Hannover
Heinrich Riebesehl et al, directors

Fotoforum
Gesamthochschule Kassel,
D-350 Kassel

Yugoslavia

Galerie Spot/Galerije grada Zagreba
Katerinin Trg. 2, YU-4100 Zagreb

Most gallery directors, like Ann Wilde, shown left, make a point of reviewing new work—not so much *expecting* to uncover new talent as *hoping* to come across previously unknown photographers. The Wilde Gallery in Cologne, Germany, maintains an ambitious exhibition schedule. The appearance of work by European masters—like Jan Sudek, Albert Renger-Patzsch, August Sander and John Vink—comprises one aspect of their program, while the exhibition of American photographers—like Duane Michals, Ralph Gibson and Les Krims—gives their clients a sense of the contemporary scene. They also organize shows in various galleries and museums throughout Europe.

Hideki Fujii

One of the responsibilities that photo galleries undertake is to educate their public. Spectrum Gallery in Hannover, Germany's bustling photographic center, exhibits examples of all kinds of photographic excellence. Pictures by top-notch advertising and fashion photographers, like Hideki Fujii (right and below) and Charlotte March, commonly grace their walls. In well-reproduced catalogs—some in color—they spread the word. Since they care first and foremost about education, they do not sell pictures. The six directors devote their time to carrying out a program that brings in some 2000 people per show and moves the shows into museums.

THE LITERATURE OF PHOTOGRAPHY (ARNO PRESS REPRINTS).
Advisory Editors: Peter C. Bunnell and Robert A. Sobieszek
Arno Press/New York, NY 10017/cloth, individually priced

Someone once said that the sixty-two books in this series looked like silver oven mitts trimmed in blue. Granted, they won't ever win a prize for their silver covers or blue stamping, nonetheless their value is substantial. Peter Bunnell, McAlpin Professor of the History of Photography and Modern Art at Princeton University, and Robert Sobieszek, Associate Curator of the Research Center at George Eastman House, selected the out-of-print titles to answer the demand for original photographic source materials. *The Literature of Photography* series covers most segments of the relatively short history of photography. If you haven't got $903 for the facsimilie series, encourage your library to invest,—or investigate and buy individual titles yourself, some of which are listed below:

The History and Practice of Daguerreotyping, A. Bisbee. Dayton, Ohio, 1853.

Photographing the Invisible, James Coates. Chicago and London, 1911.

Scientific Memoirs, John William Draper. London, 1878.

Naturalistic Photography for Students of the Art, Peter Henry Emerson. 1st ed., London, 1889.

Roger Fenton, Photographer of the Crimean War, Roger Fenton. London, 1954.

Principles of Pictorial Photography, John Wallace Gillies. New York, 1923.

Composition in Portraiture, Sadakichi (Sidney Allan) Hartmann. New York, 1909.

Words and Pictures, Wilson Hicks. New York, 1952.

Tom Wedgwood, The First Photographer, R.B. Litchfield. London, 1903.

Victorian Snapshots, Paul Martin. London, 1939.

The Art of Retouching, J. P. Ourdan. 1st American ed., New York, 1880.

Letters on Landscape Photography, Henry Peach Robinson. New York, 1888.

THE PRINT COLLECTOR'S NEWSLETTER

Editor: Jacqueline Brody
Print Collector's Newsletter
205 E. 78th St.
New York, NY 10021

Conveniently punched with holes so you can keep them for years in a binder, this bi-monthly report on new shows, sales, publications and the comings and goings of the art world's finest is the journal for fine-print collectors. Photography plays an impressive role in each issue, with articles by critics, curators and historians, who keep you abreast of the medium's current activity.

Contents

Subscription: one year, $15

THE PHOTOGRAPHIC AUCTION BLOCK

Finally photographs are right in there with fine European furniture, ceramics from the Ming Dynasty and jewels from the crown heads of Europe. Since 1967, when the prestigious Sotheby Parke Bernet auction house started offering photographs for public sale, the value of a photographer's work is partially established by the prices his pictures get on the auction block. How the bidding goes usually depends on a good many factors, including the physical condition of the lots being sold and just which pictures are being offered. Early auctions attracted a select group of private collectors and dealers. Now when the gavel goes down, the dealer bids against university curator, gallery owner and in some cases your next door neighbor.

Recent Parke Bernet prices for contemporary work reflect the growing photography market. Twentieth-century work is a bargain when compared to nineteenth-century masterpieces. At the same auction, from which top prices below are taken, Edward Curtis' forty volumes of *The North American Indian* went for $11,000 and John Thomson's *Antiquities of Cambodia* for a cool $6400.

Ansel Adams $4,900 for a 15-print portfolio
Diane Arbus $1,000
Eugene Atget $1,000
Brassai $550
Walker Evans $475
Lewis Hine $275
Man Ray $1,200
Aaron Siskind $150
Eugene Smith $700
Paul Strand $225 (photogravures)
Weegee $650
Edward Weston $1,050

Parke Bernet publishes an illustrated catalog for every major sale. Each item is carefully described, and those of special interest are pictured. Also included is an estimate for each lot. The cost of these catalogs varies depending on number of pages and illustrations. For an additional $1.50 they will also send you the final sale prices for each lot.

Parke Bernet Galleries Inc./980 Madison Avenue/New York, NY

COLLECTOR'S GUIDE TO NINETEENTH CENTURY PHOTOGRAPHY
by William Welling
Collier Books/New York/paper, $7.95

This is the only book of its type in print. If you're interested in collecting early photographs—daguerreotypes, ambrotypes, stereos, albumen prints, et al, then Welling's guide will be useful. He divides up the material process by process, describes how each was made and tells how to restore, date and value old pictures, citing auction prices as guidelines. The sections at the end of the book listing photographic archives, libraries and societies are excellent reference sources. There's a catalog of lost daguerreotype views of the American West, for the truly ambitious.

Welling's guide lists English and Scottish photographers in the daguerrian era, as well as regional American photographers working from the 1840s to 50s.

17

Dan Farrell, Courtesy of the New York *Daily News.*

CAREERS

BUT CAN YOU EARN A LIVING?

The answer is yes. There is certainly enough money when all the facets of photography are considered. Whether or not you can make it taking pictures depends. If you consider yourself an artist and want to shoot only what your muse dictates, then you will probably come near to starving, although a few photographers are now getting enough for their salon prints to eke out a living that way if they have to. Paradoxically, most who do sell don't have to, eke out a living, that is; those few who are "collectible" seem versatile enough to make satisfactory incomes by doing commercial work or by teaching.

Surely, if you are energetic, at least moderately bright and somewhat personable, you can do nicely with a neighborhood portrait studio or as a yearbook photographer or as a commercial all-arounder. In the beginning of a career, it usually turns out that if you can't get a job, you have to go into business. It is not the best way, but some two out of three graduates with an emphasis in photography either don't know what to do, which means they join the unemployed, or they turn to free-lancing, which is a euphemism for hustling. If you are the local kid with the camera and you work hard at pushing yourself, you, as many others before you, can get your start taking pictures of weddings and bar mitzvahs, of children and pets, of store openings and real estate offerings. Experience is what must be sought, and whether you succeed will depend on an assortment of grit, luck, personality and talent. In the meantime, a supportive parent or mate is a definite asset.

Since professional photography means getting a job done, in fact means work, and since work is rewarded with money, it is important to have a realistic view of who is paying how much for what. A random survey of alphabetical listings shows minimum black-and-white rates for consumer magazines—*After Dark* ($5), *Fortune* ($50), *Yachting* ($25); for Sunday magazines—*New York Magazine* ($50), *Waterbury Republican Magazine* ($5); regional magazines—*Atlanta* ($25); trade magazines—*MD Medical News Magazine* ($50).

For steady work and unlimited experience—if you get the chance—take a job as a staff photographer (an assistant even) with a multi-national corporation or with the government, the military, a university. The pay might only be average, but the fringe benefits are very favorable and the equipment superb—far beyond the reach of most young photographers when you consider that a full Hasselblad system goes for $5,000. There are countless bread-and-butter but not particularly creative jobs for photographers—in police work to make identifications, in industry to help machinists design nuts and bolts, in hospitals to help doctors study operations, in the area of human keepsakes, to record weddings and bar mitzvahs—jobs which we do not cover here but are out there and do mean a livelihood.

What we've done in this section is to consider a few of the several possibilities open to would-be professional photographers (newspaper, magazine, studio—besides free-lance) and we touch on those who hope to (and can) make a living in photography by many non-picture-taking means—for example, as marketers, researchers, curators. The profiles presented are of people we found to be both exceptional in and representative of their particular specialities.

THE PROFESSIONAL PHOTOGRAPHER AS A PROPERLY PAID PERSON, OR WHY TO JOIN THE ASMP

Samuel Gompers, when he was running the old AFL, had an explanation of what his union members wanted. He summed it up in one word: "more." The same could be said for the ASMP, although its members as a group project a professional gentility which is less financially direct. (ASMP which now stands for "The Society of Photographers in Communications" was originally the acronym for the "American Society of Magazine Photographers," when it was formed in 1944.)

The "more" it strives to get its members includes bargaining with publishers and advertising agencies to establish minimum payments for photographs and various rights associated with their use, such as bylines, ownership and resale. The Society proclaims: "Unless special arrangements—with additional fees—are made, 'Photographs shall be used for a single editorial publication and only for the purpose specified in the assignment. All residual rights belong to the photographer.'" Members, who are generally free-lancers, are eligible for low-cost group medical and disability insurance.

The *ASMP Guide, Business Practices in Photography*, was first published in 1973. There is soon to be a new edition with updated minimum prices for photographs used in all media, with a standard recommended book contract, an agent contract, model and property releases, copyright procedures—in short, much of what the professional needs to know about business matters.

Membership involves proof of being a professional, sponsorship by current members and the payment of dues, which range (for associate members) from $75 to $500 (for superstars earning over $100,000 per year). For information, write ASMP, 60 E. 42 St., New York, NY, 10017.

HOW MUCH TO CHARGE

It's been a long time now, since 1973, that somebody sat down to figure out what minimum rates for photographs should be. If you call the offices of the ASMP (212-661-6450) and ask, the answer you'll get is that those figures in the *Business Practices Guide* are still the minimum, but that adding on twenty percent for inflation is recommended. Remember, though, that these numbers are just a bargaining point. If you can get more, get it, and don't feel the least bit greedy; photographers, in our opinion, are for the most part notoriously underpaid.

And remember, too, it all depends on the market you are selling to. If you have been hired to take the photographs for a special seven-page advertising insert in the *Reader's Digest*, your price will be high, but that's because of the *Reader's Digest* mass audience. One of those pages, just for the space alone, is priced at $64,995—less discount for multiple pages. When a client is paying hundreds of thousands for space, he won't blink an eye at spending $10,000 for a photographer's fee, plus expenses. And when Burt Glinn or Jay Maisel go dashing off to do an annual report for one of the great multinational corporations, one of those glossy, posh jobs turned out in the hundreds of thousands (even millions, if the job is for AT&T), nobody is surprised that they get $1,000 or more a day.

Which brings up the matter of the day rate. The ASMP recommends a minimum of $200 a day when shooting and the same for stand-by or travel. For publications of fewer than 250,000 copies and for all newspapers, the Society says you may take $150 a day. If *Time* magazine wants to cover a UN Security Council crisis, a free-lancer will be sent at $200 a day. If the session lasts three days, that $600 is applied against the page rate. If the editors decide on a color cover from the "take" ($300) three half-pages of color ($200 each), a half-page of black-and-white ($150), then the photographer makes not $600 but $1050.

To be businesslike when selling stock, for each request a research fee of at least $15 should be charged. A holding fee of $15 after 14 days, and $1 a day thereafter is also legitimate and is applicable against the fee for reproduction rights. For reasons we don't agree with, the ASMP still insists that minimum fees should be higher for color than for black-and-white. The logic for this position is hard to understand. There is little difference in the working process, and black-and-white prints actually cost more to produce than color transparencies. Nevertheless, the practice of higher rates for color prevails in the industry.

THE GREENING OF NEWS PHOTOGRAPHY

The old stereotype of the cigar-chomping, low-man-on-the-totem-pole characterization of the news photographer is dead. Not only is the Speed Graphic gone, not only has the 2¼ × 2¼ given way to the 35mm, but now news photographers have become socially aware, concerned, even dedicated, which just goes to show what twenty years' worth of example by the great magazine photojournalists has accomplished.

We talked to Mel Finkelstein, now a color photographer for the *New York Sunday News Magazine,* who has been shooting spot news since 1950—the year he decided not to go to college but to free-lance. "If you weren't just a button pusher, I knew there was a career to be made." Now he is one of fifty *New York News* photographers (there are nine printers). He makes more than $500 a week.

Asked if he'd do it all again and if so why, he not only replied "yes" but that one of his three daughters is now on scholarship at the Columbia School of Journalism and that he whole-heartedly approves. Like father like daughter. What higher recommendation.

Why? He said, "I've seen a lot of people start off in the field, and they drop by the wayside. I've thought about it and could only conclude that they were in it for the adventure . . . to see exciting things happen. That's just not good enough. The real reason I love my profession is that I find it is a privilege to record history, whether in Chicago in 1968, at Watergate or when I was starting out, down at the local school-board level."

CREDIT PHOTO, BY WEEGEE THE FAMOUS

The irony is that he was hardly famous—certainly not as a "great" photographer—until his forty-sixth year. But then, with the publication of his first book *Naked City,* he found himself the darling of the media people, who realized a newspaper photographer had risen to the level of an artist of the first rank by having taken exciting, gripping pictures of city life in all its ribaldry, violence and multiple passions. Weegee, who left home at twelve, soon became a door-to-door tintype photographer. Then for twenty years his day job was as a printer in a news picture-agency darkroom. At night he prowled New York City, photographing it with a flash-fitted Speed Graphic.

Pictures available through Wilma Wilcox/451 W. 47th St./New York, NY 10036.

Sleep Shift. *Weegee*

Don Myrus

TO START OUT, KNOW YOUR NIKON AND SMILE A LOT

Bill Owens, a small community newspaper photographer in California *(Livermore Independent),* estimates that there are about 6,000 like him across the country. He says that if he were asked to replace himself, he would take someone right out of college who had worked on the school paper, knew 35mm cameras, wide-angle lenses, strobe and how to bounce it. He would select someone with good social skills, who could get along in suburban America and who would respect the members of the Rotary Club, the Elks, the Junior Women, and attempt to understand their rituals. He says that although the pay is modest, $150 a week, the salary can be supplemented with free-lance work—portraits, weddings, small business ads and the like. The biggest attraction of the job is that the pictures he takes get printed. "Sometimes I do eighteen assignments a day, and they all appear. When I visit my friends at the *San Francisco Chronicle* and witness how little they work and how frustrated they are, I realize why I never pursued the big job."

Owens now has a Guggenheim to work on a book about leisure. His other books are *Suburbia, Our Kind of People* and a not-yet titled book on working.

Bill Owens, California newspaper photographer.

$4 A PICTURE—A WAY TO BEGIN

Michael O'Brien, age 25 and a $320-a-week *Miami News* photographer, says that when somebody asks him now to become a news photographer, "I tell them what I did." More or less, it happened this way. After he finished high school, he met a free-lancer who lived in a cheap apartment that was full of books; among them, those of W. Eugene Smith, Henri Cartier-Bresson. "I read through Nathan Lyons' *Photographers on Photography,* and I was especially impressed by the Alfred Stieglitz section. I got a taste." O'Brien's friend helped him buy his first camera, a $35 Minolta Autocord (2¼ × 2¼). O'Brian then went across the state to the University of Tennessee. "I was a pretty lonely kid who needed something to do, so I started taking pictures. I waited a year, and then took them down to the school paper, a daily. They liked them and paid $4 each. I also sold to the yearbook, another $4 each. Sometimes I sold seventy-five pictures a month. A real lot of money."

But it was more than that. He began to love taking pictures every day and now feels that he would never have become a photographer who takes a picture now and then. "I tell people who want to be professional that it just doesn't work out, shooting once a month." When he graduated, he had a degree in philosophy. There weren't many jobs for philosophers, nor for photographers. He put together a portfolio and looked for six months. Meanwhile, he had joined the National Press Photographers' Association. Through its publication, the *News Photographer,* he was able to see what his colleagues across the country were doing. He also broadened his vision by studying the news photographs handled by Jack Corn's picture agency in Nashville. "When you look at the monthly magazines from New York, you learn what Lee Friedlander and Garry Winogrand are doing, but I was fortunate to get a chance to study the best of the news pictures." In September, 1973, he landed a job with the *Miami News* at a starting salary of $185 a week.

The paper has a staff of six photographers and one picture editor. Each photographer does his own lab work. O'Brien, who now works with Nikons and six lenses (20mm, 35mm, 55mm micro, 105mm, 180mm, 300mm), processes Tri-X in Ethol UFG and when it has to be pushed, in Acufine. The paper's enlarger is a Leitz Focomat; sometimes he spends thirty-five to forty-five minutes making a print.

In 1976, he won first prize in the NPPA newspaper feature picture category for the picture below.

Reginald Phillips of Los Angeles shadow boxes in an Orange Bowl bathroom in Miami, Florida, preparing for his light-heavyweight match in the quarterfinals of the National Golden **Gloves tournament.** *Miami News, Michael O'Brien*

SITUATIONS WANTED: STAFF PHOTOGRAPHER FOR A MAGAZINE

Even in the great years of photojournalism, the thirties to the sixties, there never were a lot of staff jobs on magazines. Now there are less than a couple dozen. *Sports Illustrated, Newsweek,* etc., buy photographs from stock and use the work of free-lancers; but to be assured of a steady supply, the magazines rely on the contract photographer. The deal is simple. A magazine guarantees the photographer a certain number of days and pay, say seventy-five days at $200 per day for the year (that's $15,000 a year), and expects him to be available (within reason) when called. Why this system? Why not staff? It's cheaper for the magazines, provides tighter accountability, allows greater versatility. In the old days of the staff stars, a *Life* photographer might receive $40,000 per year plus benefits, which were considerable and included an allowance for buying equipment. For that the magazine might or might not use a goodly number of pictures in the course of the year. Obviously, the contract photographer isn't as well off, but then, photography, as far as pictures go, is pretty much a buyer's market.

EDDIE ADAMS: CONTEMPORARY PHOTOJOURNALISM

"I just shot by instinct—any idiot could have taken it," Adams says of his 1968 photo catching the instant that a South Vietnamese officer put a bullet in the head of a suspected Viet Cong. But Adams' Pulitzer-winning instinct was honed by two decades of searching for spot news. Having covered Viet Nam, ghetto riots and the Middle East for AP and now *Time,* Adams' collection is strong on action shots. But he'd rather be known for pictures that depend on more than luck, and his portfolio does include discerning essays, like Rubinstein on tour, West Virginia miners, a Marine boot camp. His best works show a combination of preparation, patience and balls. For instance, he recently wanted to contrast old and new Turkey by having five jets overfly Istanbul's Hagia Sofia mosque from out of a setting sun. When the planes broke formation, Adams calmly ordered them to do it again.

**Haiti, 1975.
Eddie Adams**

THE PHOTO ESSAY: PAUL FUSCO & WILL MCBRIDE
**How to Share Action and Ideals Through Pictures
by Tom Moran (writer)**
Alskog/Los Angeles, CA/paper, $4.95

Larry Schiller is the former photographer who achieved fame and ephemeral fortune when he promoted the idea of *Marilyn,* getting various photographers who had photographed her to participate and Norman Mailer to write the text. Schiller then launched the *Masters of Contemporary Photography* book series. Besides the one on Paul Fusco & McBride, shown here, there are dual presentations on Mary Ellen Mark & Annie Leibovitz and Mark Kauffman & John Zimmerman, with single volumes for Bert Stern, Duane Michals, Art Kane, Elliott Erwitt, J. Frederick Smith. The series is characterized by excellent reproduction, generally good picture selection, magazine-like design that frequently mars good photographs by jumping them across the gutter. The technical section is basic stuff and well written by the former picture editor of *Playboy,* Vincent Tajiri.

PHOTOGRAPHY AND THE LAW
by George Chernoff and Hershel Sarbin
Amphoto/Garden City, NY/$8.95

If you take pictures for money, this is a book you'd better read. The authors, who are both lawyers, and Sarbin, who is a former publisher of *Popular Photography,* write in the foreword to the fourth edition: "It is virtually impossible for a photographer not to be confronted at times with legal problems that affect practically every phase of his work—from the moment he clicks the shutter of his camera and has to determine whether the subject may be properly photographed, to the time he receives the finished picture and has to decide where and how it can be used . . . he should have sufficient understanding . . . to enable him to recognize the existence of a legal problem and obtain legal advice or assistance before any damage is done." We who have been sued couldn't agree more.

MARGARET BOURKE-WHITE: *LIFE'S SWEETHEART* IN THE DAYS WHEN A JOB WAS A JOB

When *Life* began as a picture magazine in 1936, Bourke-White's shot of Fort Peck Dam, Montana, was picked as the first cover. She was an original staff photographer on the magazine, and for the next seventeen years she relied on publisher Henry Luce's money and clout to get her from one continent to another in pursuit of stories. To her credit, she used these chances to take chances. Bourke-White plunged from planes into battle, roamed famine-struck areas and lingered in ghastly death camps to record scenes that were sometimes so graphically nauseating that they have never been published.

Life became the perfect showcase for developing her compassion into poignant essays, the classic shots of which—Depression flood victims queued in front of an ironic billboard, dazed Buchenwald survivors, Gandhi reading near his spinning wheel, black South Africans sweating in a diamond mine—can be seen in her book *The Photographs of Margaret Bourke-White.* Her pictures are available from the Time-Life Picture Agency.

Louisville flood victims, 1937.

THE VIEW FROM NATIONAL GEOGRAPHIC

Being a staff photographer for the National Geographic Society's magazine that Gilbert Hovey Grosvenor first edited more than three-quarters of a century ago is such a great job that it is said the only worry those who work there have is that there's no better place to go . . . thus, the cost of having found room at the top.

What's it like up there? We did some asking around and here's what we found out. There are three categories, with "masthead" photographers being first, foremost and best paid—say, $25,000 to $36,000 a year plus all the posh benefits anyone could ask for. There are eighteen staffers, including one woman, Bianca Lavies. Several staffers have pilot's licenses; most are certified underwater photographers and all speak at least two languages. The staffers take about sixty percent of the photographs that actually get into the magazine. They are said to work very hard and generally spend six months of each year in the field, with each trip not likely to exceed six weeks. When a photographer has accumulated 400 field days, his wife receives a transportation-paid trip to join him for twenty-one days and a per-diem allowance. *National Geographic* is the last magazine that spares no expense for the working photographer. Need an airplane? Rent one.

Where do they come from, these favored few? Mostly from the other two categories, from the contract photographers and from the free-lancers who have proven their work to Robert Gilka, the man who now runs the

photographic staff, and who has been with the society since 1938. (Gilka is a graduate of the journalism school at Marquette University in Milwaukee. Later, he was picture editor of the *Milwaukee Journal*.)

There are generally eight contract photographers. It works this way: Gilka offers a contract to one of the proven free-lancers or to a photographer whose work he has seen as a result of his visits to workshops or his activities with the National Press Photographers' Association. The contract can run from as short as two months to as long as a year. A figure is agreed on and the contract photographer can take his pay at a weekly,

monthly, even yearly rate. Unlike staffers, who have no proprietory rights to their pictures, the contract photographers own everything they take that is not published by the society. The contract is with the society and work, both the mundane and the exciting, is done for whatever department has a need. A photographer might be assigned to make a filmstrip for the educational division, or to illustrate a book (eight to ten big ones are done a year), or to take pictures for the society's other periodical, the fabulously successful *World*, a magazine for eight through twelve-year-olds.

Whereas staffers are expected to be all-around photographers (capable of shooting most anything), the contract photographers are often picked for their specialities, such as landscape, people, architectural, boating, adventure.

The third category is the free-lancer. Gilka is said to have an incredibly good eye for just what he wants and to buy pictures if they fit the bill; you don't need credentials and you don't have to know somebody who knows somebody to be considered.

In the event that you have in mind selling to him, it should go without saying that you must study the magazine; there is a particular style. When looking at the magazine, we think frequently of very slick postcards, although the way the magazine looks has changed over the years.

A notice in the magazine states: "Articles and photographs of travel, natural history and expeditions to far places are desired. For material used, generous remuneration is made." Good luck.

WHERE & HOW TO SELL YOUR PHOTOGRAPHS
by Arvel W. Ahlers
Amphoto/Garden City, NY/paper, $7.95

Peter Gowland, who wrote the foreword for the first edition in 1952 and for this, the seventh, says: "After studying this book, you will feel as though you have been personally conducted through the offices of many types of picture buyers, have gained insight into their specialized needs, and have collected an address book filled with leads on buyers who welcome the kinds of pictures you can best produce." It's true.

Some photographers prefer a card file system for keeping track of exactly when and where a picture has been sent to market, sold, the price received, and all other data.

THE PHOTOGRAPHY GAME
by Arthur Goldsmith
The Viking Press/ New York, NY/$8.95

It is fitting that Arthur Goldsmith is the top editor at *Popular Photography*, for he is a "popular writer" in the best sense of that phrase.

With many years experience as an insider, he knows a great deal about all facets of photography and expresses this knowledge in clear simple interesting prose. No topic frightens him; in this book he tackles a variety of subjects, ranging from "The Biology of Vision" to "The Mythology of Test Reports" to "The Ambiguity of the Photo Image." Yet not all chapters are so esoteric; his hints for success are sprinkled throughout. Goldsmith is one of the senior members of the photographic establishment, and when he describes what it's like to attend a bash at Modernage labs or a show like *photokina*, you should know you're getting it from the horse's mouth.

. . .

The human eye is equipped with a 25mm, f/28 super-wide-angle lens system that covers an angle of view of more than 180 degrees horizontally and about 130 degrees vertically. The area of sharpest vision is a much smaller part of its large field, covering an angle of less than two degrees. Thus, . . . the human eye is about as narrowly selective as a photographic spot meter. From the chapter "The Biology of Vision"

. . .

Don't think, just look. Allow the photograph to take over your consciousness fully. . . . Don't strain for a response or try to put what you feel into words. . . . Just let come whatever response comes naturally to you, flowing out of the visual contact with the image. . . . Don't be in a hurry to break off and move on to the next one. There may be good reasons for lingering. From "How to Look at a Photograph"

. . .

I now will make a radical proposal which would save an enormous amount of time, money, and effort, but which nobody will adopt: stop running test reports. . . . I don't believe we'd be missing much: a factual report listing the features of a new product plus some informed opinion—frankly labeled as such—would be a sufficient guide for the ultimate step. From the "Mythology of Test Reports"

THE WORKING PLACE

A studio in contemporary still photography is a small factory. A rep brings in the business, usually from an art director of an ad agency, who in turn gets the assignment from a marketing manager of the client. Most big studio jobs are for advertising, with full-color magazine ads the biggest earners. Studios that specialize in photography catalogs for department stores and mail-order houses are less prestigious. Top of the line are the fashion photographers—Avedon, Hiro. In the big studios, a manager oversees the work of the assistants (lighting man, prop man), fashion, food and hair stylists, plus other support people, such as a bookkeeper—to count the money. Going out, sometimes more than several hundred thousand annually for salaries and overhead; coming in, as much as $5,000 for one picture. Some studio photographers are rumored to bill close to a half-million dollars, with some TV accounts, a year; but only the IRS knows for sure. Not all studios hum along all the time. Many good, financially successful photographers work by themselves, hiring all the people they need only when they need them on a free-lance basis. It depends on the sort of clients and the personality of the photographer. We've seen photographers work in their studios wearing cut-off jeans and sneakers, others in shirt and tie; we've heard talk that some real-with-it types even wear red satin pit-stop suits. There's a place for all sorts.

HIRO MEANS GLAMOUR AND THAT MEANS MONEY

Good taste that rises to the heights of elegance cannot be taught, but the proclivity can be nudged along, nourished and then rewarded. Hiro, born Yesuhiro Wakabayashi, is the photographer of advertising elegance, chic-chic commerce; his style always includes just a touch of ornamentation, whether it be with a prop or with lighting, but never too much.

Behind this ineffable quality of aesthetic judgment lies more substantial stuff—Hiro *knows* photography. He is an obsessed worker who has spent hours on a set arranging tiny details and days in a darkroom getting special effects. As for technical knowledge, Owen Edwards reported with astonishment in *The Village Voice* that after a day of watching Hiro's exhausting shooting, he heard him deliver "a succinct lecture on the physics of lenses to no one in particular," but presumably for the benefit of his "exhausted entourage."

Hiro was born forty-five years ago. He arrived in the United States in 1954 from Japan, where he had studied the work of Avedon, Penn and Leslie Gill. In the U.S., he went to work for Rubin Samberg, a still life photographer. Later he was an assistant to Avedon, who after a few months gave him studio space of his own on a credit basis. Avedon introduced him to Alexey Brodovitch, art director of *Harper's Bazaar*. That meant fashion work. Hiro has been a contract

Faye Dunaway.

photographer with the magazine ever since.

Now that the great days of *Harper's* and *Vogue* are over, there is no telling where Hiro's heirs will show themselves, but one thing is sure, there will be a market for good taste.

The Pagano Studio in New York City during its heyday in the 50s and 60s, when it virtually monopolized the merchandise catalog business. We count seven sets going at once. Starting at ten o'clock, we make out an operation, a courtship, a murder (is it?), a hay storing, hunters shooting, sunbathers sunning and a lady primping. There are forty-nine people visible—models, photographers, stylists, lighting specialists, etc. Large-format cameras are used—4×5, 8×10 and 11×14 color transparency film—which took a lot of light, most of it tungsten. Probably in these energy expensive days it would cost $10,000 a month just to pay the utility bill. Behind the scenes here there were retouchers and lab technicians—in fact, a whole self-sufficient photographic operation that was worthy of Hollywood.

THE CREATIVE BLACK BOOK
Editor: Stu Waldman
Friendly Publications
109 E. 36 St.
New York, NY 10016

Ninety percent of the ad agencies who bill over two million are said to have this handy $10 annual directory in their offices. Listings are free to professional photographers, both those who do original assignment work and those who sell from stock. If you need models, stylists, props, sets, locations, retouching—that sort of thing—look here.

BEN ROSE: A MOTION MAN

"Gypping the GI" was the subject when he was assigned back in the fifties by *American Weekly* magazine to recreate a photographic illustration of what was then a nefarious racket. It seems that the mob used to pick up soldiers and sailors in midtown Manhattan and transport them to New Jersey to be fleeced. The GIs traveled in style, i.e. limousines and compliant broads. So Ben arranged for a limo, hired a couple of guys to play the suckers and the most curvaceous blonde he could get from his agency. The location was Times Square. No sooner did the camera start clicking, then a crowd gathered with a cry going up, "Marilyn . . . Marilyn Monroe." It became a surging mass with police cars screaming; even mounted police appeared. All the while Ben was shouting, "She is *not* Marilyn Monroe." The model, basking in celebrity-hood for the first time, told him to shut up.

Twenty-five years later, Ben Rose is still making illustrations; by now, though, he has become a specialist, America's foremost problem solver when the picture desired involves stroboscopic photography. He generally works with a self-built rapid-firing electronic flash coupled to a motorized 50mm to 300mm Nikkor Zoom. Mini-computerized controls fire fast-recycling electronic flash units in rapid sequence. A self-made feedback electro-mechanical system

synchronizes the operation of camera, lights and lenses. Generally, effects of motion are gotten by moving the camera, not the subject. While the shutter is open, motors drive the camera in pan and tilt directions and another motor drives the zoom lens.

All very technical? You bet. Rose loves to employ his knowledge of mechanics and electronics to solve problems. With all of his skill and ingenuity, Ben credits Tony Karp, a man he terms "an electronic genius," as one who's helped him over the years. But just as often, Rose's imaginative use of common instruments does the job prisms, beam splitters, projectors, etc. He knows how to use them, and when the right job comes along he does.

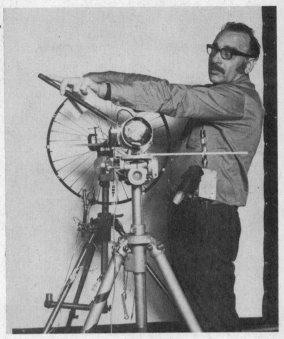

Ben Rose and his Rube Goldberg construction. Rotated by a motorized belt, the bicycle wheel turns the camera so that it describes a full circle. On its simplest level, using multiple exposures, the result is that the subject is repeated around the perimeter of a circle. On this theme, Ben plays variations, combining carefully rehearsed model movements, moving platforms, zoom lenses and flashing strobes in any combination he might imagine. For example, by placing a car on a lazy-Susan-type turntable and synchronizing its turning rate with that of his camera, he can create the illusion of the car racing around a track. Eight years ago this rig was superseded by an electronic computer outfit.

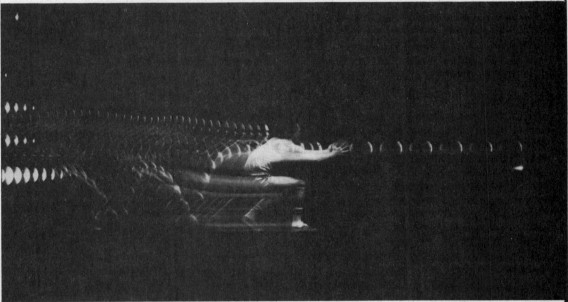

Sports motion study.

PHOTOGRAPHIS
Editor: Walter Herdeg
The Graphis
Press/Zurich,
Switzerland/$37.50

It calls itself the international annual of advertising, editorial and television photography. We've never known an art director who didn't make sure he had a copy. Its tri-lingual: English, German, French. Photographers, designers, art directors, agencies, publishers and advertisers may submit what they consider exceptional samples of photography or graphics. No fees are involved. Closing date for entries is December 15. It is available in some book stores.

High quality and high standards in commercial photography are evident in the pictures in *Photographis*. If you're trying to find a new look for an old idea, any number of fine photographers are represented. These photographs are made to attract attention, to sell the consumer things he may or may not need. To succeed, these ads must be imaginative and unusual enough to surprise. The *Photographis* annuals are also valuable as a reference and as a social history, because in one way or another, they encapsulate the values that are important to society.

GRAND FEASTS WITH A MINIATURE CAMERA

Don Myrus

There are so many variables that a studio photographer must control—the set, models, lighting, let alone unexpected last-minute disasters—that some photographers have opted for the versatility of a 35mm camera over the large-format cameras traditionally used in studios. Working in 35mm gives someone like Dick Jeffery, the chance to move around, to shoot more and to shoot faster. His clients receive many variations from which to choose *the* shot.

Think of the traditional studio photographer, think of the large format cameras (of Sinars and Deardorf), think of 8×10 transparencies (the better to retouch), think of Polaroid tests; don't think of Richard Jeffery.

He has been a photographer for twenty years and for a good many of them has worked with 8×10 view cameras, so his turn to 35mm was not from lack of equipment or experience. He has a studio in Manhattan that is a "nice" working place, to say the least, what with its 4000 square feet, two skylights covering 40 square feet and two terraces. It isn't from want of space that he turned to 35mm. Why, then?

"I like the freedom 35mm provides. It's like sketching. I can vary the angles, move about hand-holding, and the client gets a real selection. Let's say I'll provide ten varied chromes for every one that an 8×10 photographer would."

Jeffery makes advertising photographs for such clients as General Foods (does its annual report, too) and shoots a lot of editorial food pictures for the women's magazines. He did the photographs for nine of the Time-Life cook books.

He always uses Nikons (three bodies) and just three lenses: 55mm, 35mm and 20mm. Whenever possible, he photographs by available light, using a tripod if the light level is low. Occasionally he shoots with strobe; frequently, though, he combines strobe and available light. Looking at a tray of his slides (his "book"), it is frequently impossible to tell whether the lighting is natural or mixed.

To measure daylight, he uses a Luna-pro meter; for strobe, a Calumet. Never Polaroid. "I went the Polaroid route. The trouble is that the art director becomes the photographer, and the photographer becomes a mechanic." He doesn't want to be a mechanic ("I like the creative excitement of photography"), nor does he want to constantly repeat himself as so many studio photographers have to. "I've often wondered why very successful guys quit still photography to go into films. Now I know the answer, boredom."

Jeffery's whole emphasis is on staying loose and working fast. He explains that when making photographs of food, the great waste of time is waiting for the food to be ready. What he does is arrange with the home economist to have food cooked by a given time; then he shows up an hour earlier. As for what the food looks like, he says, "Her job is to make it photogenic; my job is to photograph it."

He believes a photographer shouldn't fuss too much, that an element of naturalness shows through when there is spontaneity. "When I first began photographing food for Time-Life, the photographers there would take all day to make one picture with their 8×10s and their Polaroid tests. You'll think I am kidding but I'm not—I saw Mark Kauffman up to his knees in Polaroid tests for one shot."

Almost always, Jeffery uses Kodachrome. After the usual exchange of praise for the wonderful colors and resolution of Kodachrome II, we asked what he thinks of Kodachrome 25. "I've been very lucky. It runs in batches. I order a batch, 500 rolls at a time; test a couple of rolls; if it's right, I take delivery."

Jeffery agrees with our contention that if there has to be a price differential, black-and-white photographs should bring more than color. "For every hour in the studio shooting black-and-white, it takes two hours in the darkroom. Besides, it takes a better photographer to shoot black-and-white."

Asked if he would choose photography for a career if he had to start over, he animatedly responded in the positive. "I have a gorgeous studio and a farm 150 miles out of the city where I raise prize sheep. Photography has been good to me. It is an ego-trip—just to know that you've solved a problem or that you've made something beautiful."

BEHIND THE AD: STYLIST, HOME ECONOMIST, ART DIRECTOR

Two women, not young—the oldest born in 1912—are absolutely essential to the making, with all due speed, of the photograph. That's what the photographer says, anyhow; and the art director nods agreement.

One of the ladies is Yvonne McHarg, who has been a stylist for fourteen years, ever since she was associate editor of *McCall's*. Before that she was fashion editor of *Vogue*, and even earlier, head of the mail-order department at Elizabeth Arden. She was privately educated in England and France by a governess. "I wouldn't wish it on anyone."

She says of her job: "It's fabulous . . . so varied. I never know what assignment I am going to get next."

Basically, what she does is find suitable props to be used in a studio shooting. She gets them from rental agencies, antique shops, her own collection of things, which she is constantly adding to. As for the variety of her work, during one week in July she got the props for a picture of a Thanksgiving left-over dinner to run in the November issue of *Woman's Day* and a Christmas dinner ("same old thing in early

Don Myrus

The home economist, Janet Glenn, left, who is fiddling with the food, is in charge of preparation—making sure the roast is a juicy, delicious, medium-rare pink. In short, she makes the food look good. The food stylist, Yvonne McHarg, seen in the shadows, concerns herself with other elements that will make or break the photograph. If a photograph of a cheese souffle is meant to appeal to a sophisticated audience, she must find the right plates, table settings—any accessories appropriate to selling that dish to that audience. Both are an indispensable part of the photographer's team.

American style") for the December *True Story*. Her main clients are magazines: *Ladies' Home Journal, Woman's Day, McCall's, Good Housekeeping*. Sometimes the magazines employ her directly, sometimes the ad agencies, but most often photographers.

She seldom has a free day. Although she works on a per job rate, more

for advertising assignments than for editorial, others in her category are known to charge $150 a day. On this job she is concerned with such matters as whether the apple will float in the carmel fondue.

The other woman, Janet Glenn, is a home economist who studied nutrition at Carnegie Tech in Pittsburgh. She has been a

free-lance for twenty-two years. When on the job she prepares a rough setting of the food, and then keeps fussing with alternates so that as the food wilts or dries, the photographer's assistant can rush new plates to the set. She is a gracious woman and generous with praise: "Yvonne is the best stylist in New York . . . by far the best; what to others may seem junk, she can turn into just *the* missing prop."

In a studio there is a fairly constant bustle; the sign of professionalism is lack of flappability.

Overseeing the shooting on this particular job is the thirty-four year old art director, Hal Goluboff. He is a graduate of Cooper Union in N.Y.C. with a major in fine art. He has been in the ad business for fourteen years. He works for the three-year-old ad agency, Mathieu, Gerfen & Bresner. The client is the Heublein Company; the product, Irish Mist. The assignment is to promote the product as a flavor in food. The concept is to indicate that big-drinking, zesty-appetited Vikings would have been delighted with the liqueur. To this end Yvonne and Janet have to provide an authentic-looking, tasty Viking feast. Yvonne had five days to get together the props and ten days for shooting; Janet will be preparing food for ten days. Twenty-nine photographs are to be taken.

NOTES ON A RETOUCHER

The tall ships were sailing up the Hudson on July 4, 1976, when an Armenian . . . well, anyway, since 1948, an American began to talk about what seemed to us an intriguing career and what turned out to be, in his opinion, a very satisfying one.

Here are our notes:
Peter Bitlisian, retoucher, born 1924 in Persia (now Iran). Father was the first photographer, it is reported by his son, to have in Iran a portrait studio, although there long had been itinerant photographers about. Papa Bitlisian claimed to his son that during the Great War he had processed film sent to him by T.E. Lawrence from Arabia.

The son began to learn his craft by carefully (can you imagine the attentiveness of the kid?) watching the retouchers employed by his father, who were working on glass negatives. They worked with their Faber pencils with very sharp points. Said Peter, "I picked it up all very fast."

When Peter arrived in the U.S. in 1947, he stayed close to his countrymen; there was the language barrier and the general anxiety of new immigrants. Armenians gravitated to the photoengraving and the photo retouching businesses. Right from the beginning, Peter free-lanced, sometimes hiring out on a piecework basis in the big studios. He coated negatives with dope and over a light box used sharp pencils to soften wrinkles on men and remove them from women. In some instances he used a very sharp etching tool to remove layers of silver.

In those days, he worked with Kodachrome, which was available in 5×7 and 8×10. While doing a job in a studio, Grace Kelly was a model posing for a mail-order catalog. She gave Peter a chrome of herself to work on. "She was so beautiful that I stayed up all night experimenting with additive colors . . . From then on I experimented, working on transparencies with reducers and bleaches." Today he can make red into green or turn dark into light with these same techniques.

Most of the color retouching he does these days are on dye transfer prints, which he retouches with an air brush and color dyes. "I am asked to put something that is in the right hand into the left, to combine a smile that is in transparency No. 5 with the highlights of the hair in transparency No. 2—all with flesh tones of transparency No. 12. I recreate in composite form from an entire take."

Is the work satisfying? "I get a kick out of supporting photographers in either correcting their mistakes or by emphasizing something in a picture that is only hinted at. It is also satisfying to work with a fine photographer. Right now I am spotting Irving Penn's platinum prints for exhibition. I must wear white gloves so as not to touch them, and I use water colors, no air brushing. "How much do I make? Fifty dollars an hour. How much in a year? About forty thousand, although I once made eighty thousand. (Yes, sometimes I have helpers.) Sometimes a client will order four or five dye transfers at $350 each and will be willing to spend a couple of thousand for retouching."

How could one get into the field? "Go to work in a big catalog factory where there is a row of retouchers working away. After you get a lot of experience, go out on your own."

Duke Mander

Tyrone Power, against the wall, is in full color and looking as good as if he were a dye transfer. The point, though, is that the original photograph was in black and white. Bitlisian is a master of the Flexichrome process that Kodak discontinued a dozen years ago. He skillfully applies colors to a print, made not on opaque paper but on a transparent film matrix. The matrix is then transferred to matte paper.

Peter Bitlisian in his New York apartment-studio with Irving Penn platinum print of the British painter Augustus John, which Bitlisian has spotted,

Duke Mander

KEN MANN: CREATIVITY BROKER

Don Myrus

To be a "rep," you have to be a good talker. And if you are, you can make $25,000 in your first year and $75,000 by your seventh. Ken Mann has and does. He's very proud of his accomplishments, and we are impressed. Mann, who says he is a combination of salesman, diplomat, promoter and messenger, is thirty-three years old. He is slim and well dressed in a relaxed contemporary manner—expensive-looking leather loafers, tan flared trousers, an antique metal belt buckle, a $125 St. Laurent bush jacket.

He arrived at our studio to discuss

The relationship between a photographer and his agent is always a tricky one. Ken Mann recognizes the necessary balance that must be struck. The agent must get work for his client, but not drive him too hard. As for himself, the strain of selling reaps substantial rewards —in Mann's case some $75,000 a year.

his job, huffing and puffing since he had to make the three-flight climb carrying two 20×24-inch portfolio cases ($75 each). We listened into the night, learning that there are reps who work for editorial photographers who sell mostly to magazines and reps for annual-report photographers. Like Willy Sutton, Mann goes where the money is—to ad agencies.

From having talked with him, this is what we now know. First of all, you have to find the right photographer, or two, to represent, but not more than that since photographers are

very jealous of your time, as well they might be since they have to shell out twenty-five percent off the top to the rep. Your expenses (for lunches, Christmas presents, taxicabs—you never walk, not with lugging around those big portfolios) are about thirty percent of your gross. After you have this photographer, who should be extraordinarily capable and must never blow a job, you take his "book," which must be strikingly attractive, around to as many art directors as you possibly can see—there are about 1,000 of them in Manhattan, which is where the ad business is, and in Mann's case we speak only of advertising photography. Fees for photographing an ad run from $500 to $3,000.

You must mingle among these art directors, and by virtue of your charming personality and that of your photographer, who also must relate to the art director, you must hope to bedazzle the advertising world with your photographer's work. You must do all this without

being thought aggressive. Sammy must not be perceived to run.

Since you are, after all, a salesman, you must be prepared for frequent rejection, for days when you will feel "down in the pits." You must be patient; sometimes it will take several years to land an account.

Advertising is a volatile, high-pressure business and whether an ad sells a product or not is not easily determined. Each year as many as one-third of the art directors might be changing jobs. And you might lose your photographer. In fact, it frequently happens that for one reason or other there is a falling out; that's why there is a six-month residual agreement—that is, you get your fees on accounts you sold six months after the split. You then look for another photographer to represent.

Your chief function is to bring art director together with photographer and, thereby, to save them both a lot of time and difficulties. In the fast moving, always uncertain world of advertising, you are well worth what you do. Kenny Mann certainly is.

CAREERS/freelance

FREE-LANCING IS A BUSINESS—AND A TOUGH ONE AT THAT

In free-lance photojournalism the big money comes with on-location advertising photography (mood shots in the Caribbean for an airline is an example) and in annual reports. Experience pays off with rates varying from $350 to $1000 per day. Photographers with the most and best credits get the lucrative jobs.

To get into the big time, a photographer should have considerable experience, as a staff photographer for a company or a newspaper, for instance; have good business sense and lots of hustle and an engaging personality (they won't hire you if they don't like you).

Picture editors and, on occasion, art directors make assignments. How do they decide who to call? The recollection of a similar published picture story or outstanding picture (that's the importance of a picture credit to a photographer), or a portfolio with an emphasis on the subject desired. Art directors and picture editors are like most people; they think, if you've done it before you can do it again. Said another way, free-lance success seems to be correlated with specialization and with a discernible style. If a picture buyer wants an author portrayed, chances are the call will go out to Jill Krementz; if a rock star, probably Baron Wolman or Jim Marshall.

Those who have broken the free-lance barrier seem never to stop working, and when they take their samples to *Car and Driver* you can be sure it is full of pictures of speeding, crashing, racing cars.

MARY ELLEN MARK: LIVING OFF PHOTOGRAPHY

Mary Ellen Mark, making like a model.

On several occasions she has talked about the lonely life of the free-lancer, of nights alone in motel rooms. That's why, she says, she likes to work with writers on an assignment; also because writers are analyzers and help her understand what she otherwise might not.

The result of one collaboration is scheduled to appear in the spring of 1977 with the Da Capo Press book titled either *State of Mine* (if Da Capo gets its way) or *Ward 81* (if Mary Ellen and the writer, Karen Folger Jacobs, get theirs). Mary Ellen's agent, Lee Gross said that the two months Mary Ellen was taking the pictures she had to turn down work.

Lee, who has been Mary Ellen's rep for three years, says candidly that an important reason for her client being very busy is that she does have a rep; that there is a knowledgeable person to make the rounds to art directors at advertising agencies, to picture editors at magazines; that there is someone who can sell the services that Mary Ellen offers. As Lee says, "you can't do a job until you get the job."

For getting the jobs, Lee takes thirty-five percent right off the top. A lot of money, a very big bite, you wonder. Maybe, but consider that sometimes it takes several years of "pitching" to get an assignment. And consider, too, that the busy professional can't be selling and photographing at the same time. So when Mary Ellen is off covering the making of a film, for which she gets a $1,200 to $2,500 a week with production lasting about three weeks, Lee is off trying to line up an advertising agency assignment or phoning the magazines, where, by the way, the pay is nowhere as lucrative as for advertising or film work. A cover of Marlon Brando on *Rolling Stone* and a page or so inside are $500 (cover), plus $250 (page rate), minus thirty-five percent (Lee's cut). Mary Ellen gets $487.50 and great exposure; art directors look at *Rolling Stone*.

For Lee to make those rounds to the agencies, she has to have something good in her bag, to use the parlance of the sales world. Mary Ellen provides a great portfolio which, according to Lee, "shows a very distinctive style, a very distinctive way of seeing." It is the fact that Mary Ellen is good that caused Lee to become her rep in the first place. How did she get good? How did she break in?

In 1964 Mary Ellen received a Master of Fine Arts degree from the Annenberg School of Communications at the University of Pennsylvania, where she studied photography. She submitted a portfolio of pictures to the Fulbright Scholarship committee and was selected; she spent a year in Turkey photographing.

In 1968 what she considers to have been her "big break" occurred. She was "visiting photographer for a day" at Rosemont College in Pennsylvania, where she met one of the school's alumnus, Patrica Carbine, then the managing editor of *Look*, later editor of *McCall's*, now the publisher of *Ms.* Carbine had Mary Ellen come to New York to show her portfolio. When *Look* staffer Paul Fusco flipped over the photographs, Mary Ellen got an assignment to go to London to photograph heroin addicts at St. Clement's hospital. It was a successful shooting.

Meanwhile, Mary Ellen was moving at high speed. One photographer says, if you went up to *Time*, there was Mary Ellen; if you went over to *Saturday Review*, there she was . . .She submitted her work to *Infinity*, and it was published; she took it to *U.S. Camera Annual* and it was published. Her pictures also appeared in a *Popular Photography Annual*. When TV did a special on photography, she was one of those profiled. Hard work and publicity, or as Truman Capote has put it, "You gotta hustle." And believe it or not, this already successful woman, keeps applying for grants, "to get time to do really serious projects." You watch, she'll get another one. These days you just don't get to be among the elect unless you are willing to go through the drudgery of filling out forms.

How does one become a documentary photographer and make a living at it? she was asked. "For young people starting out now, it seems like it would be an incredible struggle. I just have no idea." Nor, sadly, do we. As for Lee Gross, she said, "I have never seen it so competitive, not since I started out in 1958. The corporations buy stock for their annual reports, and you just can't live on magazine work."

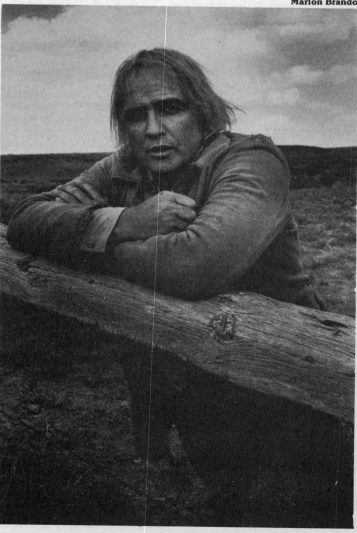

Marlon Brando.

JAY MAISEL:
THE KID FROM BROOKLYN

Success is not hard to determine when it is measured by the number of pictures published and the price tag of each. For Jay Maisel, both numbers over the last twenty years have been very high, tangible evidence of which is the bank at the corner of Spring and the Bowery in lower Manhattan. Yes, Maisel owns an entire old-fashioned bank building. The basement vault is an editing room; the main lobby, a gallery; the floors above are living quarters for Jay and his wife. Surely the sign is clear: he is successful.

The next thing to find out is why and how. It is often a tough question that some successful people just don't know how to answer, can't figure out even for themselves. Not Jay, though. He says, "It's an easy question. I work my ass off. Simple as that. I am a compulsive."

Jay remembers taking a course with Alexey Brodovitch—who could ever forget? "It was as if he were a Black Belt; that man had a reputation that

demanded respect, and he got it." What else could he remember of him? "Only that he told me to work, work, work." And also that in the one-night a week, two-month or so course, classmates included Art Kane, Lee Friedlander, Marvin Israel, Frank Cowan.

When asked if he has an agent and told "no," then asked "why?" he replied, "too much work." After a moment, he explained, "What I mean is that you should only have a rep if you want to make a lot of money." Now, his reasoning got a bit convoluted, but what it came down to was that Jay does not want to work all the time on commercial assignments, but to have time to make his own photographs, which of course he also sells. He needs money to live (really well) and to capitalize the other money-making, time-consuming aspect of his photography. He also takes pictures (now, always in color) for his massive stock files, which his assistant Irving Hansen administers.

Jay Maisel, at home in his bank.

Don Myrus

"The files take time. First, I take the pictures. I shoot a lot." (An understatement when one sees the wire wastebaskets full of rejected slides.) "I spend hours editing and more time supervising the printing of the dyes."

His ad in *The Creative Black Book* says in part: "I've compiled over a million of my own chromes, which you can buy for your ads, brochures, layouts, even your walls. These aren't inexpensive stock photos. (My prices are based on my assignment rates.) These are photos that you buy because you can't get them anywhere else. If you'd like to buy something from my files, call. . . ." (Etc.)

Where does he come from; this successful, hard-working, forty-five-year-old free-lance photographer? He talks about Abraham Lincoln High School in Brooklyn, New York, where two years before him Bernie Kornfeld was a student and four years before,

Arthur Miller; where he had a brilliant art teacher, Leon Friend, who also taught Irving Penn, Ben Somoroff, Milton Green, Gene Frederico, George Ancona—all subsequently very accomplished photographers or art directors.

Jay went to Yale and studied painting under Joseph Albers, "a genius when it came to color; but, we didn't get along. . . he didn't like my painting . . . and I found myself sneaking out to take pictures."

Jay was not a rich kid. His father was a shirt-lining salesman. Jay went to Yale on a scholarship. After graduation he got a job in a big bakery greasing a batter chute. He worked the noon to 8 pm shift and then, without authorization, spent most of the rest of the night printing in the Yale darkroom the pictures he had taken in the morning. On his days off he went from New Haven to New York, trying to place his prints.

He could see that he wasn't getting anywhere on a part-time basis, although he did get some work, for example, covering a dance festival for *Dance* magazine. Because his father had set some money aside for his education and he hadn't had to use it, he agreed to lend him $50 a week for a year. By 1955, Jay was shooting album covers at $150 each for Columbia Records. Then he got a big job for a drug company, which had just begun marketing pills for the treatment of the mentally ill. The company wanted shots of sick people, but couldn't get into an institution, nor did they want to shoot real patients. Jay figured out a solution. "I hired models and shot them in New York City public schools on weekends and at night. Those places look as bad."

Work, yes; but also ingenuity and personality. He's a pleasant, articulate man. If you're thinking of becoming a free-lancer, think of Jay, of Mary Ellen Mark, of Burt Glinn—they are each quite charming. After all they are in sales, aren't they?

JAMES ABBÉ (1883—1973)

Bessie Love in Paris Studio, 1928

"Photography was a free pass through life," he contendedly said. Born in Alfred, Maine, he stalked the world's great and near great, photographing the likes of Stalin and Hitler, covering wars and revolutions, Chicago criminals and the haute couture of Europe. His Hollywood portraits, though, are among his best. Using dramatic, studio-type lighting on location, his pictures of John Barrymore, Mary Pickford, Carole Lombard and the Gish sisters document the glamour and sophistication of their glittery world.

Kathryn Abbé Brookville Rd. Jericho, NY 11758

245

BURT GLINN: FROM MAGS TO RICHES

Burt Glinn phoned from Southern California, where he had gone to photograph a chicken farm for one of the annual reports he does. When we asked him to tell us about his sort of photographic work (eleven annual reports in 1975 at $1,000 a day and (many days each) he said, "I do this because there is no widespread use for what I used to do, which was to take pictures of journalistic events, like the coming of Khruschev, the Cuban invasion, that sort of thing." He quickly added that he was able to take pictures showing people at work and make it look exciting because he had learned in his magazine days "the necessity of conveying information." Now that so few magazines are using picture stories, did he think young photographers were getting adequate training? His answer was that he hadn't seen any great number of capable photographers coming along, but that he thought that might be the result of picture-taking being too easy. "We used to have to care about exposure," he said. As further explication of his point, he continued, "Even Cartier-Bresson, who hates to be called a technician, is an absolute master of that one camera, those three lenses, that same film. He knows his trade. Not so with the snapshot-chic boys."

Glinn was speaking at a time when the William Eggleston exhibit was still on at the Museum of Modern Art in New York City. Glinn said he had just finished writing a letter to photography department head John Szarkowski, criticizing him in no uncertain terms for claiming Eggleston had discovered color photography. "Didn't he ever hear of Pete Turner, Jay Maisel, Doug Kirkland . . . all the others? The nerve of him. The trouble with curators is that they have to cause a commotion, and then the worst thing of all is to be pretentious."

A fine imbroglio. The craftsman as a successful commercial operator criticizing the establishment critic! One thought back to the Academics vs. the Impressionists, to the Armory Show, to the outrage over Andy Warhol. One thing about photography is that people care and when they do the anger can bubble and finally explode.

Before we get down to the nitty-gritty of how Glinn works, what he carries, how he gets organized—the bread and butter information—we asked just how many successful photographers he thought there might be at the top, the stars, so to speak. He mentioned the names: Jay Maisel, Burk Uzzle, Elliott Erwitt, Eric Hartman, Bruce Davidson, and others—there are others. We could think of Ernst Haas and Eva Rubinstein, for example. Moreover, New-York-based photographers have no exclusive control of the field. We learned that there are good ones who do annual reports who are based throughout the country: Dennis Brack, Washington, D.C.; Gene Daniels, Camarillo, California; Shelly Katz, Dallas, Texas; Dan McCoy, Housatonic, Massachusetts; Harry Redl, Phoenix, Arizona; Flip Schulke, Miami, Florida; Doug Wilson, Kirkland, Washington. Our joint conclusion was that the group of top people probably does not much exceed two dozen.

Earlier, Glinn had been interviewed for *Bulletin 76* of ASMP by Cheryl Rossum. He told us that what he said was accurate and we could repeat him. Here are some of the things he said: "I contact each person to get a firsthand description of the situation. I may talk directly to the man who makes the potato chips or the foreman in quality control. My phone expenses, which I bill the client, may be high, but I save money by not going to the wrong place at the wrong time. I keep

Burt Glinn on the job.

For a Xerox annual report.

folders on every job. Clipped to the first folder is everybody's phone number and inside are all the dummies and concepts. In another folder, I keep the day's receipts and each night I note the expenses on a yellow sheet and clip the receipts to it. At the end of the job, I make Xeroxes of the receipts for myself and then send the originals with the bill to the client."

When asked what equipment he took with him, he ticked off a photographer's cornucopia: two 1200 and two 400 rapid Thomas units with four heads; the entire Lowel light kit—four 1000-watt units; white cards and umbrellas; tripods; light stands; cords; 150 rolls of KR64, 60 rolls of EH, 40 of EHB and Kodachrome A, color Polaroid film and a Hasselblad to use it with; an Ascor strobe meter; polarizers, filters; right-angle finders, extra batteries; two motorized Nikons, three Nikon bodies with 50mm, 35mm and 24mm lenses on them respectively; extra lenses—300mm, 180mm, 135mm, 105mm, 85mm, 20mm, 15mm; three meters, a

Spectra and a Luna Pro, and a Minolta Spot meter.

Although he says he has done almost one-hundred annual reports, Glinn still shows his portfolio, which is made up of eighty slides: "red-hot cows, green back-lit tunnels with men working and sparks flying, ten executive portraits that are very special; pictures that say I have been to Bali, Russia. . . . my most striking covers for prestigious companies."

Glinn says that he wouldn't work for any company for less than $500 a day, but recognizes that if a photographer doesn't have experience, he should take anything to get started. Rather candidly, we thought, he admits to having been replaced by other photographers who did jobs that clients liked better and, as a consequence, Glinn studied their work.

As for advice to the young he says, "Shoot for yourself. When you're older, there is no time." Glinn believes that "if you don't see the world in a very special way, maybe you should not be a photographer."

THOMAS HÖPKER: EUROPHOTOGRAPHER

Cairo.

Important international recognition came to him in the late 1960s when, as a free-lancer, he began getting his pictures published in the two now defunct, but then very important, German magazines *Kristall* and *Twen*. In 1968, he received the highest medal in photojournalism from *Deutsche Gesellschaft Für Photographie* (German Society for Photography).

Now forty-years-old, he began his career at eighteen when he won a first prize at *photokina*, the international photographic industry's mammoth exhibition in Cologne, Germany. He discontinued his studies in archeology and art history to take up free-lance newspaper photography. He has never gone to

photography school.

The sort of photographer that *Life* and *Look* made famous but who has all but disappeared from America Höpker is widely traveled (he's been to all the continents) and is constantly recording human affairs, in all countries his speciality is colorful people. He was a staff photographer and then a contract photographer for *Stern* magazine and is now a free-lancer. Besides selling to magazines, he illustrates books—for example, one on Vienna in a Time-Life series. Another on East Germany, with words written by his wife Eva, is soon due. Once in a while he achieves what is the dream of many still photographers—he makes a documentary film for TV.

His agent, who is occasionally in New York, and who speaks with a broad German accent says, "He's a little bit rich, he makes much money really." And then, a little later, she amends the thought with a shy boast, "He's the richest photojournalist in Europe, although he'll be angry with me for saying it." Whether this assessment is exaggerated or not, Höpker must do well, what with his busy assignments and the fact that his agent keeps his files and sells his stock photos—30,000 transparencies and 10,000 black-and-white prints. If you're interested in buying, write c/o Frau Anne Harmann, Studio Thomas Höpker, 8 Munchen 81, Felix-Dahn-Str. 2.

MAKING PHOTOGRAPHY WORK WITHOUT CAMERAS

Forget about making a living as a photographer and photography can still be a career. There are jobs to be had, such as lab technicians, editors or writers for photo magazines and advertising agencies with photographic accounts, picture researchers, curators in museums, agents, etc.

The people who do these jobs have sometimes fallen into them. For example, the medieval literature student who became a picture researcher; but more commonly picture professionals have been those who from early in life—twelve seems to be the favorite turn-on age—have had an almost religious experience in finding joy in taking or looking at photographs.

The point of these few pages is to show how a select group of people in varying jobs have achieved very satisfying professional lives in photography without taking pictures.

ANN NOVOTNY: SUPER-SLEUTH OF PICTURE RESEARCHERS

To understand the scope of the picture research business that Ann Novotny heads up and calls Research Reports, all one has to do is read the bulletin board that faces her desk in a modest garden-apartment office. Some fifty pieces of paper detail research projects in various stages of completion.

Those just finished are tacked with blue push pins, symbolizing the tranquility that sets in after finding pictures for a book on the history of American labor, for a film studio commissioned to do the title stills for a movie, for a series of book jackets and a foundation newsletter. The current projects are tacked with red pins: a forthcoming book on Alice Austin's photographs, still-picture research for a series of documentary films on Polish-Americans that required gathering some 5000 pictures, the writing and researching a pamphlet for a hospital's centennial observation, pictures for Xerox posters. White pins signify projects on the horizon. At any moment, Ann and her associate, Rosemary Eakins are busy with a dozen projects.

For whatever's in front of them, there's an impressive backlist of projects successfully accomplished: books, movies, television commercials, lectures, catalogs, advertisements, consulting jobs. The list goes on for fourteen pages.

It didn't happen overnight. In 1960 as a young graduate of McGill University in Montreal with a masters degree in medieval English and French literature, Ann moved out to conquer the New York publishing world. Soon enough, she realized that the available jobs were limited and those that were open to her were boring. So she landed a job on a small public-relations magazine. For two years she worked as a researcher/reporter out of a tiny triangular room overlooking Times Square. She interviewed people like Hans Holzer, the ghost hunter, and dug into libraries and public collections to find illustrations that would liven up the text. It was the start.

Then a friend told her that Grolier's Publishing Company was hiring a phalanx of picture researchers to find illustrations for a forthcoming set of encyclopedias. The work was rigid. Picture researchers were handed lists of required illustrations: find one vertical picture of a two-year-old, black, brown and white collie dog, glaring at the camera, tail flying, etc., etc., etc.

As unimaginative as the job was, it did put her in touch with more picture sources. In between she free-lanced at other research jobs and, like a snowball, one thing led to another as she acquired knowledge and experience. A stint working with Time-Life added more know-how. Some five years after leaving Canada, Ann decided she could make a go of it solo. During the first year, there were just enough jobs to get by, but slowly the business gained momentum.

Some fifteen years later her work runs the gamut. No longer does she accept assignments like the Grolier job. The projects that interest her are the ones that require her to use her considerable detective abilities, tracking down the seemingly nonexistent picture or uncovering new treasures. When pressed, she admits to particularly enjoying historical picture research—jobs like her book *Strangers at the Door,* a story of American immigration. Her recent book, *Alice's World,* is about the life and times of Staten Island's fine but little-known photographer Alice Austin. She ran across the pictures at the Staten Island Historical Society while researching for another project. Several years later, the book that she masterminded, researched and wrote was published.

Such "dream" projects come and go. In between there's interesting work finding stills for Hollywood movies (the highest paying client), picture research for text and trade books, exhibition work, filmstrips—the lot.

There's no single talent that accounts for her success. First and foremost, though, she is a fund of information about which pictures are where. If necessary, she can probably function on shorter notice than any other researcher around. To make sure her system accommodates any crash project that comes up, she has a network of a half-dozen or so associates in Europe and throughout America and several part-timers in New York.

To have completed so many projects as well as she has takes the kind of organization that few people have. She's unflappable—in short, the equivalent of a UN diplomat working to please four or five people at one time, the archives and photographers on one end and the clients on the other.

Above all, she likes photographs and respects the kind of information they contain. Add a good eye for pictures, a knowledge of the law and the sense of an accountant to a woman with enormous energy and physical stamina and you've got an unbeatable formula for success.

PRINTING TO ORDER

Richard Mather of Chicago is an exceptional printer. For one thing, he charges $7.50 for an 11×14 black-and-white print, a price that causes him to just about break even. He makes about two prints an hour, as do the two printers he employs at $200 a week each. Mather says he only makes money on "rush" work with its 100 percent overcharge and with occasional multiple orders.

As for customers, Mather feels that his are the carriage trade, that he is in business to cater to the one percent who want what he terms "the very best, with no compromise in quality." He always makes and processes one print at a time, burning and dodging, but never hot-spot developing or bleaching back.

Mather printed the Nathan Lerner exhibition, which was first shown in Chicago at the Allan Frumkin Gallery, then went to the gallery of the same name in New York and then on to the Harry Lunn Gallery in Washington, D.C. Interestingly, Mather and Lerner worked on the prints together in the darkroom. "It was an education for me working with a photographer. I wanted to find out how such a collaboration would work out commercially. I found out; it didn't. To have made money, I would have had to charge $100 a print, since it took about four hours to make one."

At 28 and only in business a few years, Mather is quite concerned about the relationship of service to pricing. "I must charge enough to stay in business, but I don't expect to get rich." He says that to get started, he got a bank loan and that his start-up costs were about $25,000. He gets most of his business by word of mouth, one photographer to another. He reports that he is very busy. It would appear then that quality pays.

Just what a slight difference, maybe not even a discernible one to the average eye, is worth is the real question. Since a great number of professional photographs are taken to be reproduced in print and since the reproduction process generally means a significant loss in tonal quality and definition (those dots never much helped a print), one has to consider carefully whether a print is worth $7.50 or the more usual professional price of $3.

The three-dollar printers are not slouches, by any means. To survive at all as a printer you have to know your stuff . . . know how, in spite of Mather, to print fast—even as many as 200 different negatives a day. There are techniques. If you apprentice to a processor, you might very well see a master printer rubbing a small portion of the still developing print to bring up lagging detail . . . or stop development of part of a print by slipping it in stop bath while the rest of the print remains in the developer. Another technique is selective bleaching, whereby diluted ferricyanide on a cotton swab is put on certain spots to open them up. And, as already stated, the custom printer, after high daily production, may expose as many as 50 negatives at a time, then put them in a holding box for tray development later in batches of a half dozen.

Mather, although it is not his way, has great admiration for a printer who can get quality even as he achieves quantity." Jack Leb at Gamma [the custom lab in Chicago formerly owned and operated by Mickey Pallas] is a superb black-and-white printer who is phenomenally productive. He can oversee the production of 2,000 prints a day. Amazing." Having seen Jack's work firsthand, we agree.

ANOTHER SORT OF LIFE IN PHOTOGRAPHY

John Garbarini

Norman Lipton, 40-year career man.

Norman Lipton is an elder in photography whose vast knowledge of photographic processes enables him to write about and explain any new product or technical innovation to the public, lay and professional alike. His career, which began four decades ago, has affected the way *we* think about cameras, equipment and materials, and it has influenced *the manufacturers* to make certain products—an f/1.4 lens instead of an f/2.8, for example, by creating a need for it.

Today, Lipton is a public relations man (for years he handled the account of the Camera Industries of W. Germany). From 1951 to 1957, he was managing and technical editor of *Popular Photography* and before that a technical lecturer, which today would be called a technical rep. Since the age of twelve, his has been a life in photography and a lesson to the wise—for he points out that the careers of many photographers have come and gone but that people like him continue to remain active and become more valuable with time.

At the age of twelve his father gave him a Brownie (didn't Strand's father do the same and Weston's father, too?). The next year, the teenage Lipton bought a Voigtlander Avis 9×12cm, which was all things in that it took sheet film, glass plates and film packs. He amazed his family with enlargements and was "hooked."

In 1937, Norman Lipton was graduated with a degree in chemistry from the poor man's elitist school, CCNY (City College of New York), where Jonas Salk, the polio vaccine man, was a classmate. There Lipton was, at the height of the renewed depression, a Jewish boy from Brooklyn. Who would give him a job? Not Kodak. When he applied for employment, he sadly found that at the time it was at least as anti-Semitic as many a large corporation in American industry.

Ironically, a Jew named Gus Wolfman—later famous for his reports on the size of the photographic industry—was working for E. Leitz, New York, the American branch of Leica. "Come to work for us here," said Wolfman to the incredulous Lipton, who reports that not only was Leitz not anti-Semitic but that the company was engaged in a most remarkable endeavor: the saving of Jews. It seems that Dr. Leitz hired Jews in Germany in the late 1930s and gave them a short training course in photography at Wetzlar; then as the *Europa* and *Bremen* left port, those same Jews with Leicas around their necks for "stake" money were on board, having been given passage to New York. At the dock they were met by Alfred Bach, head of Leitz in the U.S., and Lipton's boss. The refugees were housed in the Great Northern Hotel, while the Leica people found them jobs. Eventually, Kodak, too, gave Dr. Leitz "employees" work.

Lipton is a literate, articulate man who can speak engagingly for hours about photography, because he enjoys it. (Being a photographer sounds more glamorous, but that is a stereotyped notion—Norman Lipton has a good time in photography.) His work proves that the field of photography is kinetic enough to productively involve very bright people in all manner of ways besides pressing camera release buttons or printing pictures.

HAROLD JONES: "A VERY HIGHLY QUALIFIED MECHANIC"

Don Myrus

Harold, Director of the University of Arizona's Creative Center for Photography.

He considers himself an educator and a professional administrator whose job it is to make a museum, gallery or photographic center run smoothly. "I think of myself as a very highly qualified mechanic who sees that the artist's pictures are well taken care of," he commented. What Jones is metaphorically saying here is that academically-trained and institutionally-experienced though he is, he nevertheless doesn't want to forget that he too is a worker, as he believes the artist/photographer is. Besides keeping his own feet on the ground with this sort of thinking, he recommends such an attitude for others interested in museum careers.

Museum work, relatively speaking, is low paid. Nevertheless, jobs are scarce and much sought after because, as with politics, there is little money but lots of power.

Jones, who was an assistant curator at the George Eastman House in Rochester and the first director of the Light Gallery in New York City and is now the director of the University of Arizona Center for Creative Photography in Tucson, believes that those who feel they might like museum careers should take all the business administration courses available. They should hang around museums so they can get the feel for the reality of how and why they work—that inside those houses of art men and women spend most of their time seeing to it that numbers are written on cards, that catalogs and storage areas are organized, that the roof doesn't leak and that the payroll can be met. "The glamour of opening night when the staff mingles with artists and important patrons is a very small part of the job."

In his early thirties and already an important force in photography, Jones has a beguiling attitude about his success: "I've been lucky and in the right place at the right time," he says with a boyish smile. You just know, though, that somehow Lady Luck has shown her favor because of his very real charm, his obvious educated intelligence and his conversational ability.

He is a photographer, too, one who got his start when he sent a box of photograph-cum-paintings to Van Deren Coke, who looked at them and took Jones as a graduate student at the University of New Mexico. One summer, Coke told Nathan Lyons about Jones, who invited him to participate in the Museum Studies Workshop at Eastman House. A year later, on the verge of receiving his master's (his thesis was a dissertation on Paul Strand and Edward Weston) and wondering, as students have since time immemorial, "What will I do now?" the telephone rang. Lyons asked him to join the staff in Rochester. Three years later the phone rang again. A Mr. Tennyson Schad was saying that he was starting a gallery in New York to show photographs exclusively and to represent the photographers. Would Jones be the director?

INDEX

INDEX

And Now We Bring You PHOTOGRAPHY'S TIMES

With *The Photography Catalog* in hand, you have solid evidence of the quality you can expect from **PHOTOGRAPHY'S TIMES**—a completely new magazine about photography in our lives—people (the stars like Ansel Adams and Dr. Land), news, sports, politics (the way pictures are used to affect our opinions). In short, a general interest monthly with a special interest in photography that will cover the medium. If you want to keep up with cameras and other equipment for camera work, then this new magazine is a must. If you miss (or missed) the great years of *Life,* you will have another chance to see what photography can do to inform and entertain. Imagine that *Rolling Stone* were not about music, but about photography. In other words, think of a good, really well-illustrated periodical involving photography, which we believe to be the single biggest force in communication.

As readers of *The Photography Catalog* you know that we, its editors, will recognize your intelligence, assume your good taste, respect your maturity. What's more, since we will be bringing you a monthly periodical, we will be able to keep you up-to-date with photographic events that occur all over the world. We will have the opportunity of covering the profession *and* the art of photography and the way photography records commerce, society and culture. By interviewing photographers, inventors, manufacturers and marketers, we intend to heighten your interest and knowledge of photography's role in our daily lives. And we will surely gossip, as friends do, for we love a good, juicy story, as we expect you do.

Which brings up the point of just where our loyalties lie. The answer is with you, reader, with you . . . not with any advertiser. It's not that we intend to be self-righteous, it is not that we don't value advertisers or their products (on the contrary, we will welcome ads and hope to have many pages full), but as profit-minded publishers we know which side our bread is buttered on—the customer's side. We believe that if we sell magazines, advertisers will buy space.

All of which is to say that we feel certain there is an audience and that as a reader of *The Photography Catalog* you are very much at the heart of it, and that you are ready as we are for a serious but lively magazine to keep up with the burgeoning photographic phenomenon . . . a magazine different from any other, one that will be greeted each month with pleasureful anticipation, one that will have such articles as these:

- **Fear and Ecstasy at the Avedon Studio**

- **The First Technological History of Photography (in twelve installments)**

- **Focus On: Gene Smith—from Sixth Avenue to Minimata, a Tormented Odyssey**

- **Polaroid vs. Kodak—a Patent Lawyer's Analysis of the Coming Epic Battle**

- **An Interview with the Designer of the Sexy Contax RTS**

- **The Private Life of Diane Arbus—a Personal Reminiscence**

- **Who's Photographing The Male Nude?**

- **A Letter from Japan–Photo Contest Fever**

- **Sex on the Workshop Circuit**

- **My Work is Done—A Serialized Biography of George Eastman**

- **A Week on Location with Ebony's Pulitzer Prize Winning Moneta Sleet, Jr.**

and reports about camera collecting, print collecting, gallery openings—the works.

Let **PHOTOGRAPHY'S TIMES** come. As a charter subscriber, you will receive the first twelve issues for just $12, and we'll pay the postage.

Pleased with *The Photography Catalog?* Then to get more of photography's best in your home every month, subscribe now! Please send no money. We'll acknowledge your subscription and bill you later.

Please send us your Name, Street address, City, State and Zip Code Number. Address your envelope to:

PHOTOGRAPHY'S TIMES,
GPO Box 1896,
New York, NY 10001.